RENDEZVOUS

Masterpieces from the

CENTRE GEORGES POMPIDOU

and the

GUGGENHEIM MUSEUMS

Centre
Georges Pompidou

GUGGENHEIM MUSEUM

ISBN 0-8109-6916-5 (hardcover)
ISBN 0-89207-213-x (softcover)

Guggenheim Museum Publications
1071 Fifth Avenue
New York, New York 10128

Hardcover edition distributed in the U.S.A. by
Harry N. Abrams, Inc.
100 Fifth Avenue
New York, New York 10011

Printed in Germany by Cantz

Design: Bethany Johns Design, New York
Typography: Lora Ewing

front cover:
Detail of Pablo Picasso, *Woman with Yellow Hair* (*Femme aux cheveux jaunes*), December 1931 (cat. no. 95). Photo by David Heald.

back cover:
Detail of Henri Matisse, *The Dream* (*Le Rêve*), 1935 (cat. no. 94).

CONTENTS

Rendezvous: Masterpieces from the Centre Georges Pompidou and the Guggenheim Museums
Solomon R. Guggenheim Museum, New York,
October 16, 1998–January 24, 1999

Madame Georges Pompidou, *Honorary Chair*

Organized by Bernard Blistène, *Deputy Director and Chief Curator of Exhibitions and Contemporary Art, Musée national d'art moderne–Centre de création industrielle,* and Lisa Dennison, *Deputy Director and Chief Curator, Solomon R. Guggenheim Museum*

Andrée Putman, *Exhibition Design Consultant*

This exhibition is sponsored by

REVLON

Transportation assistance is provided by

This exhibition is supported by the French Ministry of Foreign Affairs through the Cultural Services of the French Embassy, New York and an indemnity from the Federal Council on the Arts & Humanities

Additional support is provided by
The Florence Gould Foundation

SPONSOR STATEMENT

Revlon is proud to sponsor this unique collaboration between two of the most distinguished museums of Modern art in the world—the Centre Georges Pompidou and the Guggenheim. The unprecedented joining of these superb collections serves as a framework to explore the history of the art of our time, in all of its variety and richness.

Paintings, sculptures, photographs, drawings, and objects of design, created by over 150 international artists, are celebrated in this landmark exhibition. The spirit of excitement and innovation that these artworks engender is in keeping with Revlon's own worldwide vision.

We are pleased to offer our support for this worthwhile endeavor. We believe that the viewers of this exhibition will benefit greatly from both the artistic and broader cultural significance of this project, and congratulate both the Centre Georges Pompidou and the Guggenheim Museum for such a creative sharing of their greatest resources, their permanent collections.

REVLON

SPONSOR STATEMENT

"Paris–New York is the reflection of a vast, complex two-way process between two cities, between two continents, and between individuals who settled here or there . . . and who furnished the twentieth century with the artworks that have shaped its future. The history of the present century is, to a considerable extent, the history of these exchanges." So wrote Pontus Hulten in his introduction to *Paris–New York*, the inaugural exhibition at the Centre Georges Pompidou in Paris in 1977.

In this connection, I might ask you whether similar exchanges are not the chief raison d'être of an airline? Air France, if you remember, launched its first transatlantic service between Paris and New York on June 24, 1946. In its own way, the French flag carrier contributed to the migration of these artists who were fascinated by the New World or irresistibly drawn to the Old.

Consequently, it must be deemed nothing less than a great honor to be invited to this prestigious Franco-American rendezvous—a remarkable dialogue between two of the world's richest Modern art collections, the Solomon R. Guggenheim Museum and the Centre Georges Pompidou. Air France is proud to be entrusted with such priceless treasures, comprising over 150 works of art, which, thanks to the expertise of Air France professionals, have been transported over thousands of miles to be seen and admired by many thousands of visitors to the United States.

Finally, I would like to express my thanks to the two French and American institutions that chose Air France to serve as the air link in this unprecedented cultural exchange.

JEAN-CYRIL SPINETTA
Chairman and Chief Executive Officer, Air France

PREFACE

This two-collection rendezvous is one of the largest in the world of twentieth-century art. On more than one level, for the Solomon R. Guggenheim Museum and the Centre Georges Pompidou, as well as for the public, it represents an exceptional event.

The desire to bring these two collections together was born in the 1980s and has since continuously engaged the teams at the Guggenheim and the Centre Georges Pompidou, and my predecessors, Dominique Bozo and François Barré, in particular. The decision to begin major reconstruction on the Centre Georges Pompidou building—Renzo Piano and Richard Rogers's masterpiece—was to offer a perfect and historic opportunity to execute the project; today it is part of a large program presenting major portions of the Centre Pompidou's collection in museums in France and abroad.

A joint Guggenheim and Centre Georges Pompidou initiative, *Rendezvous* reunites several masterpieces of twentieth-century art for the first time, including final paintings and their studies, and several works in a series. Unique parallels between the works of different artists, linked across the Atlantic by subject, form, and spirit, are established.

Nevertheless, this rendezvous is much more than a simple compilation of masterpieces. It stimulates and even rejuvenates how one sees creation and the major artists of this closing century by developing an intimate, silent dialogue within Frank Lloyd Wright's magnificent building.

In this dialogue of the works and the artists, *Rendezvous* also raises the question, through comparison, of the essence of an art collection and the phenomenon of its composition, as well as the tasks of the museum institution in two worlds that are culturally and sociologically very different.

Each of the two collections—which nevertheless originally drew inspiration from very dissimilar sources—develops a perspective on the art of this century. Their encounter reveals, especially in the period after World War II to the present, two distinct memories, two viewpoints on the evolution of

taste and the relationships of a society with art and its artists.

Whereas today the Guggenheim Museum's collection still bears the deep, fine trace of two brilliant collectors, the specific slant of the Musée national d'art moderne collection has only recently taken its shape. Figures like Louis Hautecoeur from as early as the 1930s and Jean Cassou from postwar years would help forge its identity; but it was not until 1974, when it legally became part of the Centre Georges Pompidou, that the Musée national d'art moderne would be able to form and develop a unique Modern and contemporary art collection. Decisively propelled by Pontus Hulten and then, notably, by Bozo's passion, the collection was to encompass many disciplines, acting as an international authority and influence.

Our contemporary angle is resolute and always updated. There is a desire to be open to the world, to present, in accordance with President Georges Pompidou's wish, many disciplines, placing all cultural and creative forms in perspective, both within the very collection (in which design, architecture, video, film, etc., retains a central place—and this is not to mention the unequaled archives of the Musée national d'art moderne) and with the other parts of the establishment. These are, notably: the Bibliothèque publique d'information and the music-research institute, IRCAM. Thus, an ambitious exhibition program helped provide the Pompidou's collection with its innovative character which is, and will remain its own, while also confirming its international role.

Consequently, since 1977—that is, barely more than twenty years ago—one of the most remarkable collections of twentieth-century art has been assembled. When it reopens in January 2000, the Centre Georges Pompidou, under one roof and in spaces that have been considerably enlarged and restored, will present France and Europe, and enthusiasts worldwide, with a unique panorama of twentieth-century art as well as contemporary creation.

Several projects, single pieces especially, were pursued at once, thus attesting to the interest the two institutions shared

in French, European, and American artists. *Rendezvous* belongs to this continuity, but bears very particular meaning and importance.

I would like to thank Thomas Krens, Director of the Solomon R. Guggenheim Foundation, for his major commitment that enabled this historic meeting to take place. I would also like to thank Werner Spies, Director of the Musée national d'art moderne–Centre de création industrielle, and Isabelle Monod-Fontaine, Deputy Director and Chief Curator of the Collections. I would like to honor Bernard Blistène, Deputy Director and Chief Curator of Exhibitions and Contemporary Art, Musée national d'art moderne–Centre de création industrielle, and Lisa Dennison, Deputy Director and Chief Curator of the Solomon R. Guggenheim Museum, for their pertinent perspectives on these two huge collections. I also applaud both teams from the Guggenheim and the Centre Georges Pompidou for their successful completion of the project.

Finally, I would like to express my sincere gratitude to Madame Georges Pompidou, Madame Catherine Trautmann, Minister of Culture of France, and H. E. François Bujon de L'Estang, Ambassador of France to the United States, who have lent their ever kind and enthusiastic attention to *Rendezvous*, and who have supported *Premises: Invested Spaces in Visual Arts, Architecture, and Design from France, 1958–1998*, a parallel exhibition that is being presented at the Guggenheim Museum SoHo, with as much zeal.

Translated from the French by Molly Stevens

PREFACE

The Musée national d'art moderne–Centre de création indus- trielle of the Centre Georges Pompidou and the Solomon R. Guggenheim Museum are different enough to guarantee surprising confrontations when their collections are jointly shown. The mutual proximity into which the masterworks from Paris and New York are brought in Frank Lloyd Wright's spiral structure engenders fascinating effects, an unforgettable *pas de deux* between great artists and groups of works that reciprocally heighten each another. Yet it is just as exciting to see what distinguishes the two collections from one another, and what ultimately makes them complementary.

The point of the exercise is not simply to mix two incredi- bly rich treasure troves, but to realize what insights can be gleaned from such a rendezvous. As often as the selection reveals similarities in taste and aesthetic judgment, it just as often reveals differences. This would indicate that we are not dealing here with cool and calculated shareholders' reports on Modernism. Each of the two collections has its unique character. Each has been shaped by preferences and passions, resulting from the vicissitudes of arts policy and relationships between collectors and artists. In this context the dialogue between Paris/Europe and New York, which the present project hopes to fuel, can provide decisive impulses.

The more comprehensive review of the art of the 1950s and 1960s at last made possible by this exhibition, offers an opportunity to challenge certain paralyzing certainties. Entire chapters of recent art history await rethinking and rewriting. The catalogue is intended to help viewers *see* the works, per- haps for the first time. Many Modern works cannot exist without commentary, without the effort of conceptualization. Behind this lies the famous *mot* of Marcel Duchamp, who stated that the "*regardeur*," the viewer, "*made*" the picture.

Duchamp's statement sums up a practice that in the course of the twentieth century gradually mutated into a compulsion to interpret. This is why the question as to the intellectual background against which art should be seen has come so strongly into the foreground. It marks a search for knowledge and information that no viewer can evade.

For the Centre Georges Pompidou, which in anticipation of its reopening in the year 2000 is involved in revising the presentation of its rich, multidisciplinary holdings, the New York *Rendezvous* has a special meaning. Thanks to this exhibi- tion of works from both collections, we are in a position to view our own from a distance. *Rendezvous* will surely help us to focus our discussions concerning the criteria applied to the selection of works and their presentation. What is more, this stocktaking comes at the right historical moment.

We see the new beginning that the Centre Georges Pompidou is approaching as a challenge. This is no more and no less than the fundamental challenge facing all institutions that have collected Modern art and convey it to the public: the twentieth century is on the verge of relinquishing its statute. Soon it will become a century that we will suddenly be forced to view in retrospect. Many a judgment will be revised; a place in the sun of history will grow harder to find. Recall the mali- cious words of Henri Michaux: "*On ne peut guère loger à plus de vingt dans un siècle. De là, la grande dispute pour la célébrité*" (There is room in a century for no more than twenty. Hence the great battle for celebrity).

What conclusions can be drawn from a look back over the century and the key concepts that nourished the avant-garde? Will concepts such as modernity and the break with tradition, which long kept the art scene in motion, continue to interest us and determine the discussion? This question certainly arises in the context of *Rendezvous*. For in a certain sense this exhibi- tion again underscores, in a spectacular way, the victory of the concept of the avant-garde. Everywhere we come upon works that, in the moment of their emergence, attempted to entirely avoid historical derivation. This attempt at individual artistic self-determination cannot be separated from the observation that the art of the avant-garde initially and principally remained the art of those generations who followed upon the historical

revival period. The refusal of historical continuity championed by Expressionism, by Cubism, by Giorgio de Chirico in his metaphysical phase, by Henri Matisse in his colorism, by Vasily Kandinsky's *Improvisations*, and by the strategic skepticism of Dada, invite us to underscore once again the thrust of Modern art, which consciously challenged the rational construction of a historical world and the diachronic development of styles in art. In the present exhibition we are continually confronted with this argument for self-realization, which sets caesura against tradition, personal recipe against studio convention.

Speaking very generally, it can be maintained that as a source of energy and justification the avant-garde needs radical decisions that continually and untiringly attempt to capture and shape the ahistorical moment of the new on the basis of innovations just achieved. In this regard the epoch on which this exhibition focuses remains defined *and* distinguishable from any that went before.

Translated from the German by J. W. Gabriel

PREFACE

This rendezvous between the collections of the Centre Georges Pompidou (through its Musée national d'art moderne) and the Guggenheim Museums has had a lengthy genesis. The idea of a project that would celebrate the arts of France was initiated in the late 1980s in conversations with Jack Lang, Minister of Culture under François Mitterrand, and continued years later with Jacques Toubon, Minister of Culture under Jacques Chirac. The concept also found a strong advocate in Madame Georges Pompidou, the widow of Georges Pompidou and a valued and longtime member of the advisory boards of both the Centre Georges Pompidou and the Peggy Guggenheim Collection, Venice. There was further enthusiasm for the idea by the administrations of the Centre Georges Pompidou, in particular by its former Presidents Dominique Bozo and François Barré, and former Director, Germain Viatte, as the notion of both an uptown and downtown show, one focusing on collection, and the other on contemporary art in France, began to take shape. But the projects found their real voice and support under the leadership of my esteemed colleagues, Jean-Jacques Aillagon, President of the Centre Georges Pompidou, and Werner Spies, Director of the Musée national d'art moderne–Centre de création industrielle. What was not predicted when we began with the modest idea of a dialogue of forty paintings from the two collections was that the Pompidou would close its doors this year to allow for the renovation and expansion of its interior spaces. This meant that the Musée national d'art moderne's extraordinary core collection of masterpieces could travel in significant number to New York for the first and perhaps the last time in the institution's history.

The Guggenheim Museum and the Musée national d'art moderne have had a long tradition of lending singular works from their holdings to each other on the occasions of special exhibitions. It is through this vehicle of exchange that an appreciation of the exceptional nature of each other's treasures arose, and in many cases, the parallels were striking.

Both museums were founded at roughly the same time, and their collections were profoundly marked by the vision of their first directors: Jean Cassou for the Musée national d'art moderne and Hilla von Rebay for the Museum of Non-Objective Painting, which later became the Solomon R. Guggenheim Museum. Both institutions are very much defined by the landmark buildings that today house their collections. Both museums share concentrated depth in the work of particular twentieth-century masters, including Constantin Brancusi, Robert and Sonia Delaunay, Jean Dubuffet, Alberto Giacometti, Vasily Kandinsky, Fernand Léger, Joan Miró, and Pablo Picasso. In the case of others, such as Marc Chagall, Marcel Duchamp, František Kupka, and again Kandinsky, we have found quite frequently that one institution owns the preliminary study for the final painting in the collection of the other. This pairing of the collections also unites an artist's works from the same series. And in some instances, it demonstrates how the collecting priorities of a state-owned, national museum were in sharp contradiction to the more subjective perceptions of the private art patrons whose collections form the foundation of the Guggenheim's holdings. The virtual absence of Fauvist painting from the Guggenheim, and German Expressionism from the Pompidou, is one such example. In the postwar period, the nature of this transatlantic dialogue shifts dramatically, with a particular focus on the prevailing art capitals, Paris and New York. The juxtaposition of the simultaneous movements of Abstract Expressionism and Art Informel; American Neo-Dada and Pop Art, and French Nouveau Réalisme; and Minimalism and Supports-Surfaces encourages a reconsideration of creative production in both Western Europe and the United States, and the different interpretation of artistic ideas as they cross international boundaries.

As director of the Solomon R. Guggenheim Foundation, with museums in both America and Europe, I am delighted to be participating in this Franco-American collaboration. The

spirit of internationalism has been a guiding principle of the Solomon R. Guggenheim Foundation, as reflected in the scope of its collection and the breadth of its exhibition programming, which was frequently dedicated to the arts of particular nations. In the 1980s, we featured a series of exhibitions of emerging artists, each devoted to a specific country or continent, including Australia, France, Great Britain, Italy, Scandinavia, and Spain. We have also valued the opportunity to show extraordinary collections to American audiences. In 1988, shortly before his retirement, my predecessor Thomas Messer brought the exhibition *Modern Treasures from the National Gallery in Prague* to the Guggenheim, and we reciprocated by sending *Modern Treasures from the Solomon R. Guggenheim Foundation* to Prague. During my tenure as director, we have looked at periods of stylistic innovation or significance in exhibitions such as *Refigured Painting: The German Image 1960–88; The Great Utopia: The Russian and Soviet Avant-Garde, 1915–1932; The Italian Metamorphosis, 1943–1968;* and *Japanese Art after 1945: Scream Against the Sky.* Most recently, *China: 5,000 Years* explored Chinese art and culture over the course of its 5,000 year development, through objects of great rarity and high quality. And in our 1997 exhibition *From Dürer to Rauschenberg: A Quintessence of Drawing, Masterworks from the Albertina and the Guggenheim*, we worked collaboratively with the Graphische Sammlung Albertina in Vienna to create a unique exhibition that combined the two collections, highlighting the development of drawing over the past 500 years. Unlike *Rendezvous*, this dialogue did not interweave the two collections, but rather presented them in chronological sequence.

Rendezvous spans the art from the turn of the century to 1970. Never have so many works of such exceptional quality from another single collection filled our museum, and we have taken the unprecedented decision to devote all the gallery space of the Solomon R. Guggenheim Museum, including the entire Frank Lloyd Wright building, the Thannhauser Galleries, and the Gwathmey Siegel tower, to this ambitious project. Included in our *Rendezvous* are more than 300 paintings, sculptures, drawings, and photographs, in addition to a selection of design objects from the Centre de création industrielle, which merged with the Musée national d'art moderne

in 1992. In all, more than 150 international artists are represented. Through our two collections alone, we have created an end-of-the-century exhibition that takes the history of Modernism as its subject.

A project of this magnitude depends on the full cooperation of its collaborators, and I would like to extend my sincere thanks to all of our French partners. I am especially indebted to Madame Georges Pompidou, who is the distinguished Honorary Chair of this exhibition and its events; to Madame Catherine Trautmann, Minister of Culture of France, and to H. E. François Bujon de L'Estang, Ambassador of France to the United Sates, all of whom have endorsed our efforts at critical stages. As I mentioned above, without the unflagging support of Jean-Jacques Aillagon and Werner Spies, who opened their collection for curatorial selection with no holds barred, we would not have the superb selection of seminal works on view here. They also lent the talents of their remarkable staff to this show, making this endeavor an institutional priority. Other advisory groups have also helped us achieve our goals. I would also like to express my gratitude to Bernard Blistène, Deputy Director and Chief Curator of Exhibitions and Contemporary Art, Musée national d'art moderne–Centre de création industrielle, and Lisa Dennison, Deputy Director and Chief Curator of the Solomon R. Guggenheim Museum, as well as their respective staffs, whose teamwork, knowledge of their respective collections, and dedication to the concept of this *face à face*, made the exhibition a reality.

And finally, I must acknowledge our generous sponsors who have made this project possible. We would like to extend our sincere gratitude to Alice Whelihan, Indemnity Administrator, and the Indemnity Advisory Panel of the Art and Artifacts Indemnity Program of the National Endowment for the Arts, for granting an indemnification for the exhibition. On the same note, we are most grateful to the Florence Gould Foundation, which awarded money to this project with the goal of encouraging international collaboration. We also wish to thank Air France, for its generous support in acting as the official carrier for the exhibition. And finally, we are indebted to Revlon, which sponsored this exhibition.

BERNARD BLISTÈNE

AND LISA DENNISON

ACKNOWLEDGMENTS

As curators of the exhibition, we must recognize at the outset the remarkable spirit of cooperation and collaboration that this project has engendered since its inception. We wish to thank above all Thomas Krens, Director of the Solomon R. Guggenheim Foundation, and Jean-Jacques Aillagon, President of the Centre Georges Pompidou, for developing such a unique and extraordinary exhibition concept. It has been a dream to work with two of the greatest collections of Modern art in the world, and, indeed through this experience, we have learned so much about our respective holdings, and the history of Modern and contemporary art. We would also like to thank the senior administration of the Centre Georges Pompidou for their cooperation, most especially Guillaume Cerutti, General Manager, Werner Spies, Director of the Musée national d'art moderne–Centre de création industrielle (MNAM–CCI), and Isabelle Monod-Fontaine, Deputy Director and Chief Curator of the Collections, Musée national d'art moderne. A great debt of gratitude is also due especially to Marie-Laure Jousset, Chief Curator of the Design Department, who, with Raymond Guidot, Curator, Project Manager, of MNAM–CCI, selected objects for the two design sections of this exhibition, which focus on the relationship between the visual arts and design in the decades of the 1920s, 1930s, and 1950s.

The institutions whose collections form the core of this exhibition are MNAM–CCI, Paris, the Solomon R. Guggenheim Museum, New York, the Peggy Guggenheim Collection, Venice, and the Guggenheim Bilbao Museoa, Spain. Architectural drawings of the Centre Georges Pompidou and the Solomon R. Guggenheim Museum, two landmark buildings that revolutionized museum architecture, have also been lent; for this, our gratitude goes specifically to Renzo Piano (who, with Richard Rogers, designed the Centre Georges Pompidou) and Bruce Brooks Pfeiffer, Director, and Margo Stipe, Registrar, of the Frank Lloyd Wright Archives. In addition, we would like to thank Juan Ignacio Vidarte, Director General of the Guggenheim Bilbao Museoa, and Philip

Rylands, Deputy Director of the Peggy Guggenheim Collection, for facilitating the loans from their respective institutions, and to Max B. Ludwig, Esq., executor of the Thannhauser estate, for his cooperation with respect to the use of the Thannhauser Collection works in this installation.

For such a collaboration between America and France, we looked for a designer to help us realize our vision in the extraordinary spaces of the Frank Lloyd Wright building. Our choice was Andrée Putman, one of France's leading designers, whose elegant aesthetic is renowned on both sides of the Atlantic. Our sincere thanks are extended to Madame Putman, and her talented colleagues, Elliott Barnes and Erwan Le Bourdonnec. Their subtle and exquisite design works with the effects of changing light over the course of the day, and enhances our viewing experience of these masterpieces of Modern art from the American and French collections. In addition, we would like to thank Hervé Descottes from l'Observatoire for his expertise in handling the lighting design for the exhibition.

For their seminal essays in the exhibition catalogue, we would like to thank the following distinguished authors: Yve-Alain Bois, Joseph J. Pulitzer Jr. Professor of Modern Art at Harvard University; Stanley Cavell, Walter M. Cabot Professor of Aesthetics and General Theory of Value of Harvard University; Jean-Louis Cohen, Professor at the University of Paris and the Institute of Fine Arts, New York University; and Mark C. Taylor, Cluett Professor of Humanities and Religion at Williams College. Their contributions have enriched this book immeasurably, adding to its depth and interest.

Our deepest gratitude goes to H. E. François Bujon de L'Estang, Ambassador of France to the United States, as well as Richard Duqué, French Consul Général in New York.

The French Cultural Services in New York have lent invaluable support to the cultural programs in conjunction with this exhibition. We wish to thank Pierre Buhler, Cultural

Counselor, Béatrice Ellis, Cultural Attaché, and their staff, Estelle Berruyer, Patrice Blouin, Fanny Malaurie, and Emmanuel Morlet for their assistance.

We thank Mary Sharp Cronson, Guggenheim Trustee and Producer of Works and Process at the Guggenheim, for her support of the programming. Her love of French art has proven inspirational to all of us. We also thank Manny Rodriguez, who works with Ms. Cronson, for his administrative assistance. Over the course of this exhibition, in the Peter B. Lewis Theater of the Solomon R. Guggenheim Museum, we are pleased to present concerts of French contemporary music interpreted by musicians from Ensemble Fa and the IRCAM Institute, both of France, as well as the American group Ensemble 21, in the presence of composers themselves including Philippe Fénelon, Jacques Lenot, and Tristan Murail, in addition to two theater performances by the UBU Repertory Theater, directed by Françoise Kourilsky. We would also like to thank the Miller Theater at Columbia University, which in conjunction with this exhibition, is presenting Ensemble Sospeso, which will perform works in the presence of composer Marc-André Dalbavie.

The engagement of the entire staffs of the Centre Georges Pompidou and the Guggenheim Museum has assured the successful realization of this exhibition. We wish to acknowledge the tireless efforts of our legal and administrative staffs, specifically Sophie Aurand, Production Director, and Martine Silie, Head of Exhibitions of the Centre Georges Pompidou, and Judith Cox, Deputy Director and General Counsel; Gail Scovell, Associate General Counsel; and Julie Lowitz, Assistant General Counsel, of the Guggenheim Museum for their involvement in the contractual negotiations between the two institutions. In addition, Marion Kahan, Exhibition Program Manager, Guggenheim Museum, has proven herself a valuable resource.

The curatorial staffs of MNAM–CCI and the Solomon R. Guggenheim Museum worked continuously on this project over the course of several years. We are grateful in particular to Nicole Gersen, Curatorial Assistant at MNAM–CCI, and Craig Houser, Curatorial Assistant at the Guggenheim, who worked together to oversee every aspect of this exhibition and publication.

At the Centre Georges Pompidou, we would also like to thank Agnès de la Beaumelle, Chief Curator of the Drawings Department, and her team: Laure de Buzon-Vallée and Messody Zrihen; Alain Sayag, Chief Curator of the Photography Department, and his team: Annick-Lionel Marie and Lucia Daniel; Martine Moinot and Danielle Janton from the Design Department; Didier Schulmann, Curator, Collections Manager; Nathalie Leleu, in charge of Loans and Deposits; as well as Evelyne Pomey, in charge of the Documentation of the Collections, for her precious help.

We would also like to thank the members of both of our teams: at the Pompidou, Françoise Bertaux and Juliana Montfort, for their contribution to the start of the project; Hervé Derouault, assistant, for his cleverness and flexibility; Sophie Blasco, Administrative Assistant, and Orida Djada, secretary, as well as the research interns Samuelle Verley, for her great involvement, Paule Oltra, and Zoe Jackson; and at the Guggenheim, we thank Sara Cochran, Project Research Assistant, and Sophie Prieto, Curatorial Intern, who were tireless in their research and organization; Erica Strongin, Curatorial Administrative Assistant; and the curatorial interns Karen Kienzle, Jennifer Kingsley, and Jonathan Lackman.

For their contributions to the realization of this catalogue, we would like to extend our sincere thanks to the Publications Departments of both institutions: at the Guggenheim, Anthony Calnek, Director of Publications, who skillfully oversaw all aspects of this publication; Elizabeth Levy, Managing Editor/ Manager of Foreign Editions; Carol Fitzgerald, Associate Editor, who was the project editor of this volume; Melissa Secondino, Production Assistant; Domenick Ammirati, Editorial Assistant; Edward Weisberger, Editor; and Jennifer Loh, Administrative Assistant; at the Centre Georges Pompidou, Martin Béthenod, Director of the Publications Department, Philippe Bidaine, Associate Director, Benoît Collier, Editor/Manager for Foreign Rights; Mathias Battestini, Agreement Management; Claudine Guillon, Copyright Management; Colette Dhos, Assistant; Martial Lhuillery, Production Manager; and Valérie Loth, Editorial Assistant. We would like to thank Bethany Johns and Jackie Goldberg of Bethany Johns Design, New York, for designing this catalogue. In addition, we are grateful to Nicole Gersen and

Craig Houser for obtaining the many photographs and organizing the biographies and catalogue entries that appear in the catalogue.

We also thank Susan Hapgood, who edited the numerous biographies and catalogue entries that appear in the back of this book; Susan McNally, who supervised the printing of the catalogue; editor Deborah Drier; and Keith Mayerson. Alison Gingeras, Project Curatorial Assistant, offered advice on the catalogue, particularly our curatorial "Dialogue." We would like to thank the Guggenheim authors who over the last year contributed catalogue entries and biographies to this catalogue: Tracey Bashkoff, Robin Clark, Sara Cochran, Susan Cross, Vivien Greene, Craig Houser, Jon Ippolito, Melanie Marino, Sophie Prieto, Vanessa Rocco, Claudia Schmuckli, Karole Vail, Janice Yang, and Joan Young. In our research on the Guggenheim, Joan M. Lukach's biography *Hilla Rebay: In Search of the Spirit in Art* (George Braziller, 1983) proved most useful. We would also like to thank the authors of texts for works from the collection of MNAM–CCI, specifically Jean-Paul Ameline, Agnès de la Beaumelle, Jean-Pierre Bordaz, Claude Laugier, Isabelle Merly, Martine Moinot, Alfred Pacquement, Nadine Pouillon, Jacques Saur, Claude Schweisguth, Barbara Stehlé-Akhtar, and Marielle Tabart.

For the many illustrations in the catalogue, we would like to give special thanks to Laurence Camous, Curator, Head of the General Documentation, MNAM–CCI, and her team, including Brigitte Vincens, Christine Sorin, and Teresita Araya-Monge; as well as France Sabary, Hélène Amar, Fatima Oussi, from the Photographic Archives; Hervé Véronèse, Registrar of the Photographers; and the team of photographers at the Pompidou: Jacques Faujour, Georges Meguerditchian, Philippe Migeat, Jean-Claude Planchet, Bertrand Prévost, Adam Rzepka; as well as Jean-François Tomasian, Scientific Photographer; and the Photographic Laboratory team. We also thank Pierre Brullé, Christian Parisot, Marie-Laure Verroust, as well as Brigitte Léal and Anne Baldassari, curators at the Musée Picasso, Paris. From the Guggenheim, we would like to acknowledge David Heald, Chief Photographer and Director of Photographic Services; Ellen Labenski, Assistant Photographer; Kim Bush, Photography and Permissions Associate; and Ilene Magaras, Associate Librarian/Archivist.

We would also like to express our gratitude to our respective registrarial staffs, particularly Annie Boucher, Head Registrar; and Bruno Veret, Associate Registrar of the Centre Georges Pompidou, and Suzanne Quigley, Head Registrar for Collections and Exhibitions; Joan Hendricks, Associate Registrar, and Lisa Lardner, Assistant Registrar, of the Guggenheim for their tremendous skill in organizing and coordinating the safe transport of these masterpieces from Europe. Special thanks go to the Crating and Preparations management team at the Centre Georges Pompidou: Jacques Demay, Alain Fucher, Paul-Marc Giletta, Stéphane Lecocq, and Robert Thomas.

In exchange for their advice, expertise, and hard work, we thank the members of the Exhibition and Management Department of the Guggenheim, including Karen Meyerhoff, Director; Jocelyn Groom, Exhibition Design Coordinator; Marcia Fardella, Senior Graphic Designer; Jessica Ludwig, Graphic Designer; and Susan Lee, Graphic Designer. In addition, thanks go to Scott Wixon, Manager; F. Joe Adams, Assistant Manager; Mary Ann Hoag, Lighting Designer; Richard Gombar, Construction Manager; and James Nelson, Associate Preparator; all from the Art Services and Preparations Department of the Guggenheim, as well as to Peter Read, Manager of Exhibition Fabrication and Design, and Stephen Engelman, Fabrication Specialist. From the Centre Georges Pompidou, we would like to express our gratitude to Gérard Herbaux, Head of Exhibition Technicians, Noël Viard, Exhibition Technician, Michel Boukreis, Exhibition Technician, as well as to the members of framing teams: Bruno Bourgeois, Jean-Alain Closquinet, Robert Groborne, Daniel Legué, Gilles Pezzana, and Nicolas Stenghel. In addition, we would like to acknowledge Fabrice Merizzi, Associate Production Director, who coordinated the Centre Georges Pompidou production teams in Paris and New York.

Further, we wish to express our gratitude to our talented conservation departments, including Paul Schwartzbaum, Chief Conservator; Gillian McMillan, Senior Conservator; and Eleonora Nagy, Associate Conservator, of the Guggenheim, as well as Jacques Hourrière, Chief Conservator, Ingrid Novion, Registrar, Géraldine Guillaume-Chavannes, Chantal Quirot, Astrid Lorenzen, and Anne-Catherine Prud'hom, of

MNAM–CCI. Our thanks are also extended to Claire Bergeaud, Natalie de Bournet-Becdelièvre, Denis Chalard, Benoît Dagron, Christine Devos, Edouard Déchelette, Cécile Dubruel, Pascale Hafner, Christel Joubert, Carole Juillet, Pascal Labreuche, Bénédicte Mercier, Isabelle Prieur, Véronique Roca, and Sophie Spalek, for their participation in the restoration of the works and for the writing of many condition reports.

We would like to acknowledge the individuals in the public affairs departments of both institutions who have helped us promote our project, including, at the Guggenheim, Scott Gutterman, Director of Public Affairs; Alexandra Bodner, Public Affairs Coordinator; and Kathryn Chevreaux, Public Affairs Assistant; and, at the Centre Georges Pompidou, Jean-Pierre Biron, Director of the Communications Department; Nicole Richy, Associate Director in charge of the External Relations, Anne de Nesle, Public Relations Manager; Vitia Kirchner, Public Relations Assistant; Marie-Jo Poisson, Associate Director in charge of Information; Carol Rio, Chief Press Officer; and Bénédicte Baron, Press Officer. We also wish to thank, at the Guggenheim, Gina Rogak, Director of Special Events, and Stephen Diefendorfer, Special Events Manager, for their organization of the opening events of the exhibition, and Marlene Kristoff, Director of Retail Distribution, and Laura Miller, Director of Marketing and Visitor Services, for their efforts in marketing and advertising the exhibition.

We thank Marilyn JS Goodman, Director; Felicia Liss, Education Program Manager; Bettina Goldstein, Education Program Coordinator; and David Bleecker, Education Program Assistant, in the Education Department of the Guggenheim, and Laura Miller for their advice and management of programming around the exhibition, as well as Michael Lavin, Technical Support Manager, who handled the technical services for events taking place in the Peter B. Lewis Theater.

Also at the Guggenheim, we owe a debt of gratitude to Ben P. Hartley, Director of Corporate Communications and Sponsorship; Anne C. Haskel, Manager of Corporate Sponsorship; Anne Chase-Mustur, Development Coordinator; Julia C. Schieffelin, Director of Institutional Giving; and Melanie Forman, Director of Development; and Max Hollein and Greg Jordan, Executive Assistants to the Director, for

their efforts in securing funding for the show. We would also like to extend a special thanks to Diane Dewey, Executive Administrative Coordinator to the Director. We also thank Michael Wolfe, Director; and Peter Katz, Senior Budget Analyst, from the Budgeting and Planning Department, for their skillful budget management. Through their computer expertise and support, Leonard Steinbach, Director of Information Technology and Chief Technology Officer; Shahid Khan, Network Manager; and Sabina Cornley, Senior User Support Specialist, of the Guggenheim saved us in a couple of dire situations and made this project run smoothly. Finally, many staff members and friends provided advice and volunteered services during the course of this project, including Nancy Spector, Curator of Contemporary Art; Matthew Drutt, Associate Curator for Research; J. Fiona Ragheb, Assistant Curator; Susan Cross, Curatorial Assistant; Robin Clark, Collections Curatorial Assistant, from the Guggenheim, and John Alan Farmer, as well as Amy Sandback.

At last we would like to thank Jean-Pierre Marcie-Rivière, President of l'Association des Amis du Centre Georges Pompidou, and François Trèves, President, and Micheline Fried of the Société des Amis du Musée national d'art moderne.

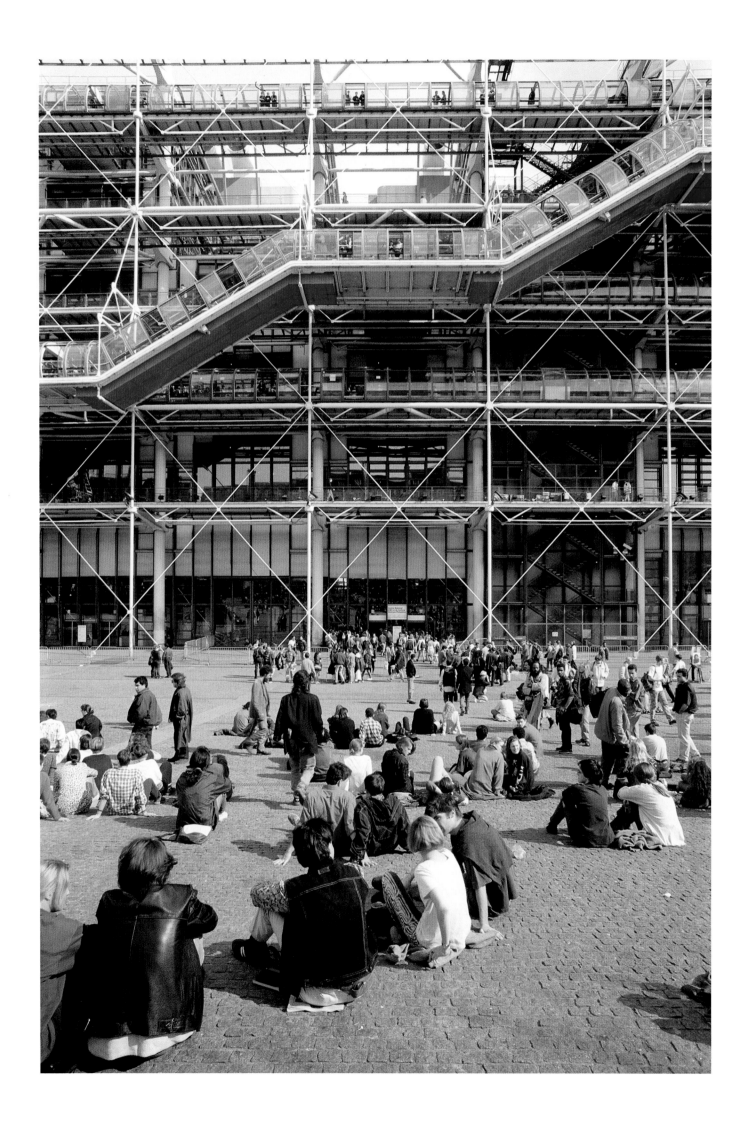

MONUMENTS FOR A MASS CULT

The Solomon R. Guggenheim Museum and the Centre Georges Pompidou have much in common, both in urban and cultural terms. They are fundamental and contested landmarks in the cityscapes of New York and Paris; they call into question the relationship between twentieth-century architecture and art with comparable acuity; and the urban impact of each picks up on the discussion of the renewed values of the monument in modern times introduced by Aloïs Riegl in his *Der moderne Denkmalkultus* of 1903.[1] Both projects were generated by architectural principles propagated in the fertile soil of European and North American architectural cultures, with some of the most ancient archetypes of antiquity thrown in for good measure.

Opened within eighteen years of one another, the two museums also occupy unique positions in the professional careers of their authors, the Guggenheim being a late great work and the Pompidou a first major commission.[2] As a key episode in the last part of Frank Lloyd Wright's long career, the Guggenheim constitutes both a break and a personal reassessment. To him, the building represented a recapitulation of the experiments of the twentieth century, just as the Pompidou did to Renzo Piano and Richard Rogers. (The latter have since admitted to having been fairly naive throughout the entire process—even to having acted like kids thumbing their noses at their examiners, but they were consistently supported by the inventiveness and experience of the consultant engineers, Ove Arup & Partners.)[3] Yet, despite these similarities, at first glance the two museums appear to belong to radically opposed schools of thought, as though the concept of the modern museum, to which architects have devoted so much energy, had given rise to two distinct types in the course of the century.

Shared Architectural References

The circumstances surrounding the commission and design of the two buildings are well-known, in general at least; there is even a blow-by-blow account of the Pompidou's design and construction.[4] The issue of the modern museum had of course already been addressed years before Wright was asked to design a building to house Solomon R. Guggenheim's collection of non-objective art. The most recent museum buildings of significance in an eclectic or classical idiom were John Russell Pope's National Gallery of Art, Washington, D.C. (1936) and the twin municipal and national museums built to designs by Jean-Claude Dondel, Viard, and Marcel Dastugue for the 1937 Paris *Exposition International*. Those great reformers of European architecture, Hendrik Petrus Berlage and Henry van de Velde, had been the first to suggest new forms of spatial organization, the former at the Gemeentemuseum, the Hague (1927–29), and the latter at the Folkwang Museum, Hagen (1901–02) and at the Kröller-Müller Museum, Otterlo, the Netherlands (1937–54). In the United States, the Smithsonian Institution's attempts to create a gallery of Modern art were thwarted, despite the quality of competition projects submitted from 1936 to 1937.[5]

Yet it was not so much in museum buildings but in art galleries and international exhibitions that new spatial strategies were devised for the presentation of works of art. Such configurations were to be all-important in the strategies adopted by Wright and by Piano and Rogers. Indeed, both the Guggenheim and the Pompidou were undertakings in which historic or creative programs that had been conceived for the most part outside museums found permanent form as institutions—the former private and the latter sponsored by the French government.[6]

Centre Georges Pompidou, west side view.

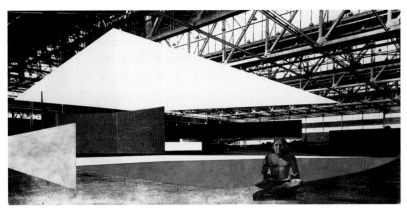

Ludwig Mies van der Rohe, Concert Hall Project, 1942. Collage over photograph, 75 × 157.5 cm (29½ × 62 inches). The Mies van der Rohe Archive, The Museum of Modern Art, New York, Gift of Mary Callery.

Nevertheless, the authors of both projects developed a number of common architectural precedents, most of which can be traced back not so much to the canons of art as to marginal undertakings in which reforming zeal and architecture came together. Such was the case with the spiral and the uses made of its symbolic charge by the avant-garde, such as Vladimir Tatlin's Monument to the Third International (1919–20). Imbued with Tower of Babel connotations, the spiral had already been deployed to didactic ends in the project Globe terrestre (1897–98, unbuilt) designed by the Parisian architect Louis Bonnier at the behest of the geographer Elysée Reclus for the 1900 Paris *Exposition Internationale*, and in a museum designed by Henry Mercer in Doylestown, Pennsylvania (1912). A spiral was also featured, albeit in a rectilinear configuration, in the Mundaneum ziggurat designed by Le Corbusier [Charles-Edouard Jeanneret] for his Cité mondiale (1928) project, which was probably familiar to Wright.[7]

The Guggenheim and the Pompidou also share the spatial approach suggested by Ludwig Mies van der Rohe's early American projects. Mies's Museum for a Small City (1942), a theoretical project following work done by his student George Danforth at the Illinois Institute of Technology, was based on the play of internal horizontal and vertical planes in relation to the system of enclosure walls he had employed in his courtyard houses.[8] The separation of mobile planes from the building envelope extended to a contemporary "concert hall," which in theory at least was intended for musical events. In the background of Mies's photomontage of the concert hall was a photograph of lattice trusses at the Albert Kahn–designed Glenn Martin bomber factory in Baltimore. Piano and Rogers were certainly familiar with these projects—which were widely publicized by historians—as was Wright, who was criticized by Solomon Guggenheim's art adviser, Hilla Rebay, for a lack

of humility. She encouraged Wright to call upon Mies as a consultant, an idea he dismissed in 1945, replying that "the van Rohe [sic] way is his own way."[9]

It is tempting to see the two buildings in terms of two opposing paradigms of twentieth-century architecture: the ancient archetype of the dynamic spiral versus the machine-building, derived from interpretations of mechanical objects that had been promoted by the avant-garde. Yet in both cases, these references were shared, albeit unequally. The Tower of Babel spiral used at the Guggenheim recurred at the Pompidou, where it unraveled to form the access escalators. The Miesian notion of open partitions within exhibition spaces was present in both projects, while the image of spaces inserted within larger reticulated structures, such as the Glenn Martin factory, was reproduced almost literally by Piano and Rogers.

But the central issue around which both projects revolved was the utopian ideal of the synthesis of the arts, forged simultaneously by the German Expressionists and by Russian radical groups of the 1920s. For both, this synthesis was heavily conditioned by architecture. It was put "under the wing of the great architecture" by the artist's and architect's collective Arbeitsrat für Kunst in 1918, and Le Corbusier reiterated this approach as he became interested in the idea. At the Pompidou, the synthesis of the arts was an institutional aim; as we shall see, it was incorporated in Wright's project for the Guggenheim as well, despite the doubts expressed by many artists.

Two Models of Patronage

The built forms of the Guggenheim and the Pompidou were fashioned by delicate transactions between the will of the clients and the determination of the architects. In spite of Wright's public reputation and the authority Piano and Rogers had acquired as the result of a high-profile international competition, the architects were asked to implement rigorously defined aims that were sometimes inflexible.[10]

The two men to whom the buildings owe their eponyms could scarcely have been more different: one was a collector who committed funds from a foundation he had himself created to an increasingly costly project, the other was a somewhat disenchanted statesman who was gifted with a degree of

foresight.[11] Both died before seeing their buildings completed, and their memories were frequently invoked, by the architects and others, to defend the projects. Wright never ceased to refer to Solomon Guggenheim as a man who "intended to face the future," unlike his nephew Harry F. Guggenheim and director James Johnson Sweeney, both of whom he believed lacked courage as interlocutors and failed to uphold the spirit of the initial project.[12] Every time Wright threatened to resign—as he did repeatedly—he invoked Solomon Guggenheim's memory to back up his case.

The methods used to appoint the architects could scarcely have been more dissimilar. Rebay first approached László Moholy-Nagy before asking Wright for "a temple of spirit, a monument!" on June 1, 1943.[13] Wright, who knew how to present his project, charmed Rebay and convinced Guggenheim of his own authority and the cost savings he would ensure, notably in interminable discussions about construction costs and his own fees. In 1951, for example, Wright wrote to Rebay, "If great paintings by great painters are worth paying for by the Foundation, why isn't great architecture by a great architect?"[14] Relations between the Guggenheims and Wright were always direct, despite the presence of Rebay, who was in charge of the project from its inception until 1953, and then of her successor Sweeney, whom Wright considered a conventional museum man, and by whom he was always annoyed. Compared with these architect-client relations, which were essentially akin to those surrounding a commission for a private house, the intricacies of the commissioning procedures established for the Pompidou were of a wholly different order. The project broke new ground, not least because the French government had not commissioned a foreign architect since the occasion three centuries earlier when Louis XIV invited Gianlorenzo Bernini to draw up a project for the east front of the Musée du Louvre, Paris. Complexities arose, too, from the novel conception of the Pompidou's mission. President Georges Pompidou had first announced his intention of creating a new art center in Paris, in conjunction with a long-planned public library, in December 1969.[15] In 1972, he announced that it was to be a cultural center, combining a museum with a "centre de création," where the *création* in question would "of course be modern and would evolve continually."[16]

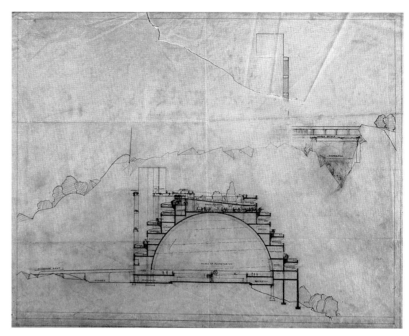

Louis Bonnier, Globe terrestre for Elysée Reclus, 1897–98, for the 1900 Paris *Exposition Internationale*.

From 1969, a growing number of people were brought in to work on what promised to be "the central convergence point of hopes, fears, energies and anxieties."[17] A commission of library directors and museum curators prepared a report and, after it had been submitted by Sébastien Loste in July 1970, the task of realizing the "Centre Beaubourg," was delegated to Robert Bordaz on August 26, 1970.[18] Unlike the Guggenheim, which was intended to house a collection with closely defined aims, the new center was to house both the Musée national d'art moderne (MNAM), and the Centre de création industrielle, a center for industrial design founded by François Mathey in 1969. Moreover, the Bibliothèque publique d'information, which had been the subject of proposals raised by librarian Jean-Pierre Seguin since the 1950s, was to be attached to the center. So too was the Institut de recherche et de coordination acoustique-musique, an experimental-music institute set up to pursue the work undertaken by Pierre Boulez since the creation of the Domaine musical, a program of avant-garde musical events, in 1953.

The basic brief was completed by the engineer-architect François Lombard in the summer of 1970, and an international competition was organized at the express request of President Pompidou, who was eager to see public commissions opened up in a manner previously unknown in France. The jury, which was itself international, included such architects as Emile Aillaud, Philip Johnson, Oscar Niemeyer, and Jørn Utzon, as well as such other prominent figures as the iconoclastic museum director Willem Sandberg. The chair-

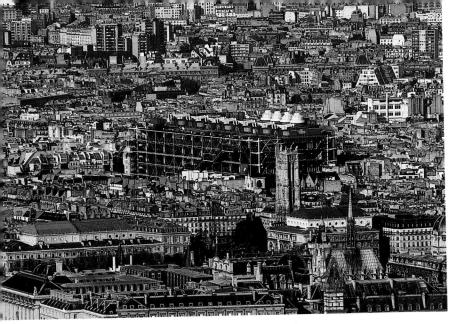

Southwest view of the Centre Georges Pompidou.

man was Jean Prouvé, who was much respected on artistic, technical, and moral grounds.[19] The subject of the competition was the design of an "ensemble d'art contemporain" or "a center dedicated to a public library, to art and to contemporary design"; and its "originality" lay in the "conjunction in one and the same place of books, the visual arts, architecture, music, cinema, and industrial design."[20]

The competition results were announced on July 15, 1971. To general surprise—and their own stupefaction—an entry by two young architects, one Italian, the other British, was selected the winner by eight votes out of nine. According to Piano, it was largely thanks to Prouvé's presence on the jury that he and Rogers had decided to enter the competition at all. Prouvé himself later stressed the clarity of the jury's decision, as well as its great interest in the Robert Venturi–like communications circus proposed by Cosco, East, Galbreath, Huffmann and Weeks.[21] Other prominent entries included a prismatic pile by Moshe Safdie, a megastructure by Kisho Kurokawa, and modular configurations based on principles derived from the work of Louis Kahn by Platonov and by Gülgönen/Aran.[22]

Although skeptical, Pompidou declared he would not "assume the right to refuse the chosen project." Until his death, on April 2, 1974, he continued to follow its progress quite closely, holding as many as ten meetings a year to monitor its course. His final contribution was his approval of Pontus Hulten's appointment as director of the museum. In contrast, the next President of France, Valéry Giscard d'Estaing, who was elected in 1974, did all he could to derail the project. However, Bordaz's presence assured continuity. He remained delegate in charge until the Centre Georges Pompidou—as it was finally named—opened on January 31,

1977, and did much to facilitate the project, successfully tailoring the budget, and defending the design against the hostile reactions of the administration, Parisian politicians, and a certain amount of adverse public opinion.

A whole range of novelties in the management of major public projects in France was generated by the Pompidou, most notably the highly detailed brief, a new fee structure for the architects and a new public-sector project-management structure called an "établissement public."[23] Moreover, the Pompidou is a genuinely European building, both in ambition and in the Italian/British roots of the design team, to say nothing of the German manufacture of some structural components.

The differences in the way the two buildings were designed and executed reflect marked differences between the original notions of what each was to be. In New York, the aim was to house a unified collection and, since an "experimental department" was included in the brief, space was also to be allocated for recent developments. It was not to be a generalized museum like the Museum of Modern Art, New York, as Wright wanted it to be, but "a highly specialized museum of distinguished quality," in accordance with the wishes of Solomon Guggenheim.[24] However, the exact number of paintings and precise details concerning the collection were not specified until July 1954, nine years after the project was first launched.[25]

In contrast, a highly detailed brief was instituted from the start for the future Pompidou. The French developed the practice of *programmation*, a term encompassing both the definition of the brief for building and the scheduling of events in the completed structure, in conjunction with the Pompidou project. From the outset, the center at the so-called "plateau" Beaubourg was intended to eschew rigid policies and to attract a wider public than traditional museums. The notion of flexibility was included in the brief from a very early stage. From an administrative point of view, the collaboration of two divergent government ministries—Culture and National Education—was envisaged. But the essence of the project lay in the notion of an institution that was to be defined more by its programs and activities than by the content of its collections. A utopian dimension was thus in place at the inception of the project.[26]

Selecting the Sites

The iconoclastic projects for the Guggenheim and the Pompidou were designed by architects who were strangers to the host cities. Wright's long-standing hostility to New York verged on obsessional hatred, and it fueled some of his design decisions.[27] In a way, he wanted to provoke New York, which he had always seen as a "soulless Shelf."[28] As for Piano and Rogers, they were outsiders in Paris to whom both the nature and language of French governmental procedures were foreign. Wright put down roots in New York at the Plaza hotel, where he took over a suite and dubbed it Taliesin East, while Piano and Rogers opened a Paris office (since taken over by Piano). In both cases, their outsider status found metaphorical expression in the structurally and formally provocative relationships the two buildings established with urban space.

Curiously enough, the early histories of both projects are marked by rootlessness, so often did initial plans for their siting fluctuate. Indeed, in Wright's first contract, the commission for a museum was subject to the acquisition of a site. Possible options included sites in Riverdale, New York, and in midtown Manhattan. At first, Wright favored the Riverdale site, which was suggested by Robert Moses, New York City's Park Commissioner. Wright imagined visitors would be able to get there easily by helicopter,[29] and seemed to want to express his disdain for Manhattan by putting the metropolis into a wider territorial context, as in his project for Broadacre City (1934–35), a low-density integration of urban and rural conditions. He wrote to Rebay, "our desire is now all upstream."[30] Evident feelings of rivalry with the Museum of Modern Art at the start of the project surfaced in this debate when Wright asserted, with a certain amount of belligerence, that the Museum of Modern Art would envy the Riverdale site.

The other locations considered were on Fifty-fourth Street, near the Museum of Modern Art; on Park Avenue; and on Madison Avenue. As late as 1952, Moses would *in extremis* suggest yet another site, near Rockefeller Center.[31] In the end, a site was chosen on upper Fifth Avenue. Initially, it occupied only three-quarters of the lot. Wright saw this location as a defiant gesture toward New York: "Why not step aside and be safe and serene on the border of Central Park?" he wrote to Rebay.[32] The link between site and project is revealed by the

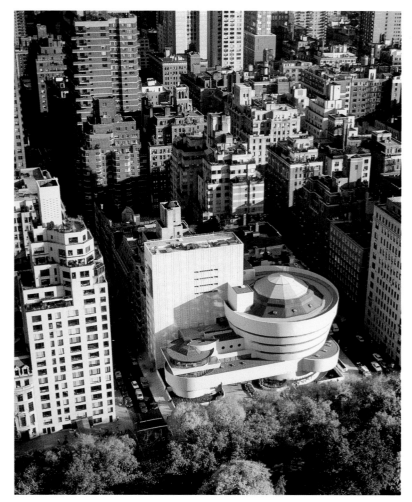

The Solomon R. Guggenheim Museum, with the new tower addition designed by Gwathmey Siegel and Associates Architects.

fact that, as soon as the final location had been chosen, Wright stressed he would be working on a "vertical building" from then on.[33] Even so, he seems to have changed his mind as soon as the final location seemed to have been chosen in December 1943, for on January 20, 1944, he was talking about designing the building first and then finding the right site, as though the project could be detached from an existing context.

The roamings of the Parisian project were of an entirely different order. In the early 1960s, André Malraux had asked Le Corbusier to design a "*musée du vingtième siècle*" (museum of the twentieth century), in association with a campus comprising schools of art and architecture, for a site at Nanterre. But the location, behind La Défense, did not please Le Corbusier. In March 1965, only five months before he died, he was planning to arrange a meeting with Malraux to "relocate the twentieth century in Paris" on the cleared sites of the Grand Palais and Petit Palais.[34] The trajectory suggested by Le Corbusier was to be continued eastward, for the project decided by Pompidou was initially envisaged on the site of Les Halles, the leveling of which had long been

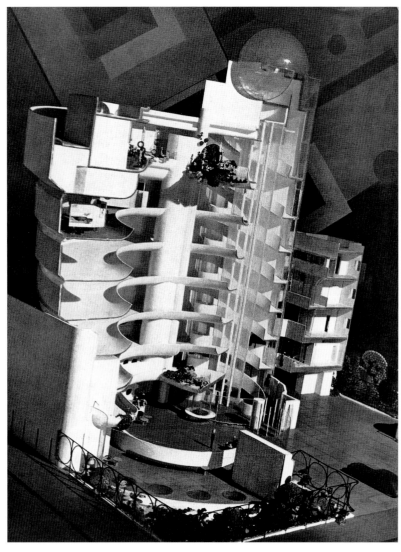

Cross-section through Frank Lloyd Wright's 1945 model of the Solomon R. Guggenheim Museum showing the interior of the rotunda.

decided, before again shifting to the plateau Beaubourg.

Used as a parking lot and appropriated from time to time for political demonstrations, this large open space had resulted from an interwar slum-clearance program aimed at "îlots insalubres" (unhealthy islets). In 1919, the city administration designated seventeen areas as having the most appalling tuberculosis mortality statistics. The Saint-Merri sector adjacent to Les Halles was deemed in 1923 to be "one of the most insalubrious, among the most central and one of the most extensive of the designated îlots."[35] The demolition of ninety-five buildings in one zone was ratified by the Conseil municipal in 1924 and their expropriation followed from 1927 to 1934. The discourse used to justify these measures smacked of social racism. Social reformers argued that "the decontamination to be achieved by the demolition of these filthy buildings which harbor this evil tribe" would be "as much moral as material." Indeed, this report continues,

"oozing from these dingy buildings" was a "strange population" of "raddle-faced old crones with yellowish hair hanging in appalling locks, the vagabond habitués of soup kitchens, shifty arabs, sordid effeminate youths." It also mentions the picturesque aspects of the area, where house-fronts "bear the traces of the medieval past: little doors, barred windows on the ground story, overhanging stone jetties."[36]

The first project for the site, drawn up in 1930 by the Société d'études et d'aménagement urbains, which was run by the town planner Maurice Rotival, proposed burying the rue Saint-Martin beneath a large public open space and building a set of new municipal offices, linked by an underground passage to the Hôtel de ville. Until 1954, the City of Paris envisaged using the site for a "Palais de la fleur," while the Left campaigned for social housing and a garden. Be that as it may, in the late 1930s the buildings were demolished and from the 1960s on, ideas about the future of the site were further modified by plans to move the central market out of Les Halles. In designs by Albert Laprade and Rotival, the plateau Beaubourg was envisaged as an open space within a system of major public facilities stretching westward to the Bourse de Commerce and, as a result, the plateau was included in the ideas competition launched in 1967 for the redevelopment of Les Halles. Works undertaken to clear a view of Saint-Merri church meant the future center could be enlarged.[37] Although Piano and Rogers were not particularly interested in the urban fabric, theirs was the only scheme among the 681 entries in the 1971 competition to maintain the urban breathing space provided by the plateau Beaubourg, since they proposed a building that would occupy only the eastern part of the site.

While the Guggenheim and the Pompidou were produced by processes that could not have been more dissimilar, both adopted a frontal approach in relation to the city. Wright's satisfaction that his building could be "a becoming feature of the Avenue and the city" derived from the challenge the spiral form of the museum would represent in the context of the Fifth Avenue street frontage and the foliage of Central Park.[38] At Beaubourg, the Pompidou was to present the eye with a vast screen saturated with contemporary images, with no regard for the vertical rhythm of surrounding medieval and classical façades.

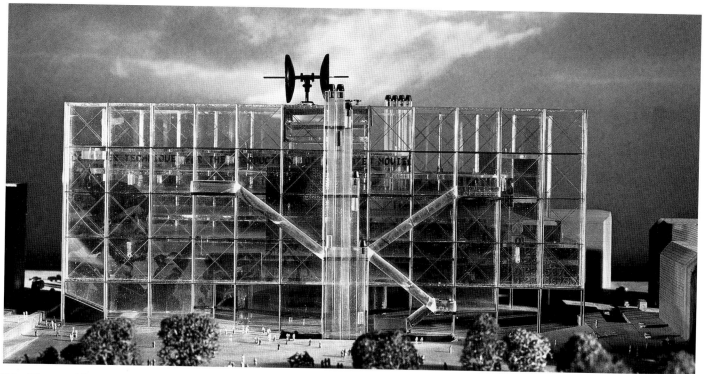

Richard Rogers and Renzo Piano, competition model showing view from the piazza, 1971.

Movement as an Architectural Parti

In reaction to two highly predetermined urban contexts, both Wright and Piano and Rogers adopted an architectural *parti*, in the sense conventionally attached to the word at the Paris Ecole des Beaux-Arts. Both their projects, that is, can easily be reduced to a single principal concept.[39] The simplification that is characteristic of the Piano and Rogers project, which had to be radical to attract the attention of the jury, is common in architectural competitions. In New York, Wright had decided upon the concept in the very early days of the project: initially horizontal, it was already vertical by the end of 1943. He immediately adopted "Optimistic Ziggurat" as a slogan, though without saying exactly what it meant, for in his early sketches it appears both "top side down" and "down side up."[40]

As he developed the design, Wright increased the width of the spiral. This led to a fundamental change in the proportions of the central void. Moreover, the orientation of the plan was inverted in 1948, or perhaps in 1951, when the rest of the lot was purchased. There is no mystery about the precedents for spirals in Wright's works. The "top side down" version was manifestly based on his scheme for the Gordon Strong Automobile Objective and Planetarium project on Sugarloaf mountain, Maryland of 1924–25.[41] The project's road-based antecedent only reinforces the perspicacity of Reyner Banham's remark that the Guggenheim was the best illustra-

tion of the concept of *route*, which he saw as originally expressed by Le Corbusier at the Villa Savoye, Poissy (1929–31), in the form of "a series of partitions of infinite space experienced by an observer moving through them."[42] As for Wright, he underlined his intention to "once and for all, eliminate the to and from, the back and forth" and to provide "a better circulation for viewing paintings."[43]

Le Corbusier developed the theme of the ramp in a more radical form at the Centrosoyuz, Moscow (built 1928–36 and visited by Wright in 1937), where he used it as the building's principal means of vertical circulation.[44] If it is internalized at the Guggenheim, the main circulation route is externalized at the Pompidou, in the form of the escalator, which, as we shall see, has Futurist overtones. In both cases, the visitor's initial sensation is the physical reaction to or kinetic challenge provoked by the ramp.

Wright was no less determined about the implications arising from the key element, the spiral. He was adamant that a monolithic material should be used, a decision which ran counter to prevailing building practice in New York. As far as he was concerned, the museum "ought" to be built in concrete. To this end, he worked on three alternative methods of building the spiral. The columns shown in an early model of the "Modern Gallery," in conjunction with perimeter struts, were to be replaced in the definitive version with a system of "webs" or vertical load-bearing planes and, as a result, the

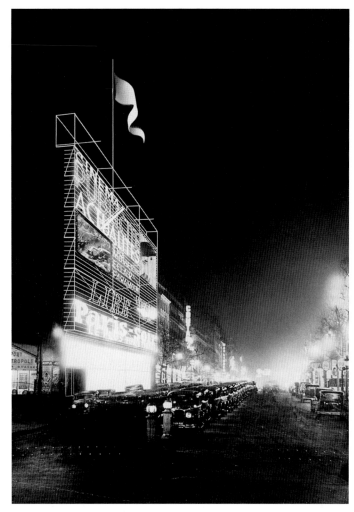

Oscar Nitzchké, Projet de la Maison de la publicité, Paris, 1934–36. Gouache and photomontage, 71.1 × 52.1 cm (28 × 20½ inches). The Museum of Modern Art, New York, Gift of Lily Auchincloss, Barbara Jakobson, and Walter Randel.

parapet lost all structural function.[45] Piano and Rogers's refusal of concrete in favor of steel was no less critically charged in a French context.

These construction techniques had implications for the tactile quality of the two buildings. The reconstituted white marble initially chosen by Wright for a Manhattan in which dirty red brick and brownstones still predominated suggested perpetuity, while the painted steelwork at the Pompidou assimilated it with ship-building (and, indeed, requires the same level of continual maintenance). In the case of the Guggenheim, concerns about the museum's future public were strikingly absent from the design process. The question of how many visitors might be anticipated seems to have been raised only when construction was about to begin on site.[46] This vagueness contrasts sharply with the precision manifest at the plateau Beaubourg.

In 1943, Wright had responded with interest to the commission offered him by Rebay. Three decades later, Rogers was less than enthusiastic about participating in an open competition. Only the prospect of Prouvé's presence on the jury persuaded him to send in a "completely provocative" entry.[47] The project was designed in London and Genoa by him, Piano, Su Rogers, Gianfranco Franchini, and a good many others. The two engineers leading the team from Ove Arup & Partners were Edmund Happold, who was in favor of entering the competition,[48] and Peter Rice, who had just returned from working on the structure for Utzon's Sydney Opera House (1956–73) in Australia. In complete contrast with Wright's conflictual relations with engineers on the Guggenheim project, the engineers from Ove Arup & Partners made a major contribution to the Pompidou and formed an integral part of the design team from the outset.

Piano and Rogers responded to the official brief by recommending the concept of a "Live Center of Information, covering Paris and the whole world. . . . This center of constantly changing information is a cross between an information-oriented, computerized Times Square and the British Museum, with the stress on two-way participation between people and activities/exhibits."[49] The communications theme was expressed by the west elevation, which was to be alive with images of movement and change. Nonstop news and continually updated information—on shows, events, exhibitions, television programs, remote-control gadgetry, temporary installations, electronic games, computers, and the like, were to be displayed on giant video screens clipped onto the external structural frame and suspended from cranes on the roof.

In comparison with the autobiographical and symbolic beginnings of the Guggenheim, the origins of the Pompidou were more complex.[50] The Pompidou's use of precedents operated on several different levels, from the exploitation of borrowed images in the competition drawings to the assimilation in the design of principles that were both more conceptual and less obvious.

The concept for the west elevation derived from Oscar Nitzchké's project for the Maison de la publicité on the Champs-Elysées (1934–36, unbuilt), whose main façade was composed of a lightweight structure carrying various information systems, including a cinema screen.[51] (Rogers had crossed Nitzchké's trail at Yale University, New Haven.) As far as

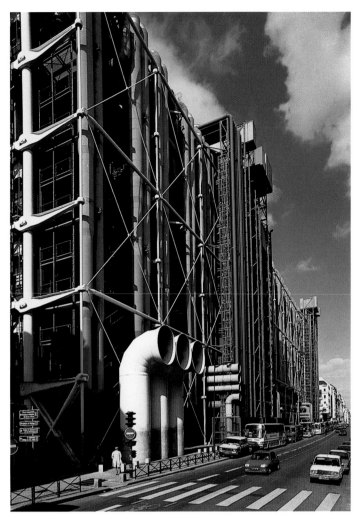

Centre Georges Pompidou, rue du Renard façade.

British architectural references were concerned, Cedric Price's Fun Palace (1962, unbuilt) was probably a more fundamental source than were the technological fantasies of the British Archigram group. Designed with and for the theater director Joan Littlewood to accommodate a multiplicity of activities and events, the Fun Palace was a vast flexible structure complete with rolling gantries, akin to a dry dock for a shipyard. In Price's words, "The activities designed for the site should be experimental, the place itself expendable and changeable." On the one hand, "the organization of space and the objects occupying it should challenge the participants' mental and physical dexterity and, on the other, allow for a flow of space and time, in which passive and active pleasure is provoked."[52]

But the use of movement and frenetic kinetic effects in the Piano and Rogers project stems from earlier sources: the visions of the Italian Futurists. The escalators at the Pompidou are nothing short of a built encapsulation of a 1914 manifesto, in which Antonio Sant'Elia describes "the modern building like a gigantic machine. Lifts must no longer hide away like solitary worms in the stairwells, but the stairs—now useless—must be abolished, and the lifts must swarm up the façades like serpents of glass and iron."[53] This affiliation with the Futurists is probably of greater significance than is the use of glass, although admittedly that material had symbolic value for the moderns.[54] As for Piano and Rogers's use of steel, it is highly reminiscent of the upended printing-press frame imagery used by the Vesnin brothers in their Leningradskaia Pravda project of 1924.[55] The similarity is perhaps unsurprising, given that images of works by the Russian Constructivists were widely circulated both in Italy and in Britain during the 1960s.

Joseph Paxton's Crystal Palace (1851), although more admired by the engineers than by the architects, also provided a source of inspiration. The Pompidou's cross-bracing is derived from it, as is the contrast between the transparent envelope and the displays (industrial products in the one, art in the other).[56] In this respect, the Pompidou is akin to a department store, with specialties located on different floor levels.

Many Parisians have seen the Pompidou as an alien object. Yet urban considerations were certainly not lacking in the competition project, which proposed a large sunken piazza set 3.2 meters below street level, in which temporary exhibitions, plays, concerts, games, festivals, meetings, parades, and competitions might be held. Conceived as a freely accessible open space, the piazza was to be bordered by cafés, shops, and other enterprises that would act both as a filter and as a link, so far as the district's "pedestrian environment" was concerned. The freedom to wander in and out at will, which was one of the fundamental tenets of the project, was later compromised by security requirements. The accessibility envisaged by the competition scheme was both visual and physical. In addition to unfettered pedestrian access to the space below the Pompidou, the columnar structure provided clear views through the building from the rue du Renard to "all the façades in rue Saint-Martin."[57]

When analyzing the development of the megastructure in architecture, Banham described the Pompidou as "the most complete monument to the decade when the concept was born," in that it "answers the ultimate acid-test of looking like one." And indeed, Piano and Rogers's building corresponds very closely with Banham's definition of a megastructure as a

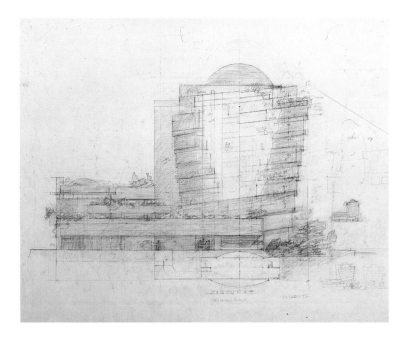

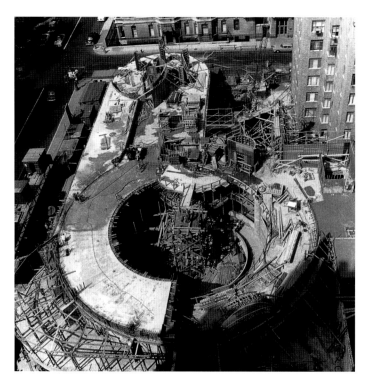

above: Frank Lloyd Wright, sectional elevation, 1943. Pencil and colored pencil on tracing paper, 66.7 × 77.2 cm (26¼ × 30⅜ inches). The Frank Lloyd Wright Archives, The Frank Lloyd Wright Foundation 4305.014.

right: Construction of the main rotunda of the Solomon R. Guggenheim Museum, ca. 1956–69.

"structural framework into which smaller structural units can be built," and which is "expected to have a useful life much longer than that of the smaller units which it may support."[58]

As befits a true megastructure, the 1971 project was intended to provide a maximum of flexibility within a rational framework. Totally unimpeded spaces were to be provided on upper floor levels, while all vertical elements—services, circulation, structural members—were to be located at the perimeter of the building, thus facilitating their replacement. In theory at least, the lifts and escalators suspended in front of the façades could be replaced or moved, to meet changing requirements—increasing visitor numbers, for example, or the relocation of a department and/or entry point within the building. These concepts are akin to those expressed by Johnson in his 1959 critique of the Guggenheim, and may explain his support for the Piano and Rogers project.[59]

The concept of total modular interchangeability was based on the use of wholly prefabricated elements. Floors and beams were "mobile elements," which could be "demounted and repositioned, to provide maximum flexibility of use."[60] The beams were to move vertically by sliding up or down the columns, and the collar clamps designed to hold them in place were presented as a formal expression of this flexibility. This notion of mobile floors within a partially open grid, pro-

posed in the competition project, recalls Price's Fun Palace.

The idea of flexibility and the technical means of achieving it were combined with a playful attitude toward the use of the building, which had resonances of Constant Neuwenhuis's *Neo-Babylone* (1958), the ideology of May 1968 (which Rogers admits he had in mind at the time), and such Archigram projects as Mike Webb's Sin Centre (1959–62), Peter Cook's Plug-in City (1962–64) and Ron Herron's Instant City (1968–70).[61] To Rogers, the notion of culture promulgated by the brief was sufficiently wide and vague for the Pompidou to be designed as an urban toy resembling "a giant Meccano set."[62] In other words, the utopian ideas already present in the programming envisaged for the Pompidou were matched by an architectural concept encapsulating many of the design fantasies formulated since the 1950s.[63]

The issue of how a museum should be used was thus handled very differently in the buildings designed for the Guggenheim and the Pompidou. As Wright had never accepted any sign of life in the houses he designed and, indeed, was often tempted to "correct" the abuses perpetrated by the inhabitants, it was unthinkable that he would allow curators or artists an inch of authority in the museum. The question of an autonomous brief simply did not arise. In contrast, Piano and Rogers sought to establish an architectural frame-

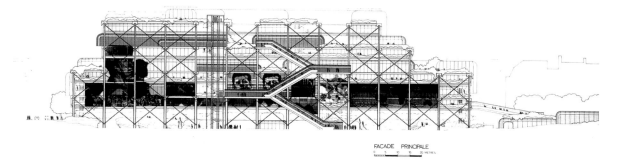

FACADE PRINCIPALE

above: Piano & Rogers, Centre Georges Pompidou, second project, elevation from the piazza, 1971.

right: Centre Georges Pompidou under construction, 1976.

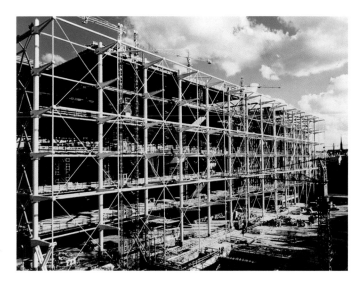

work capable of accommodating any program. Paradoxically, the project represented a response to May 1968 both for the architects and for Georges Pompidou. But if Piano and Rogers wanted to create a setting for spontaneous playful activities where people would be "free do their own thing," Pompidou, seeking to meet public demand by making French cultural policy seem less institutionalized, was nevertheless interested in pinning down the form that culture should take.

High-Profile Building Sites

The process of gestation and execution of the two projects would seem to be of unequal length. It took sixteen years to design and build the Guggenheim, while the Pompidou took only seven, if calculated from competition to opening (although if one counted earlier work on the *musée du vingtième siècle*, the total would be thirteen years). These periods of time had implications for the architects' initial plans and for the subsequent drastic cost-cutting and changes they were required to make.

Construction started on the Guggenheim in August 1956, twelve years after Wright presented the first detailed scheme for the project. By the time the building was completed, Wright had produced seven complete sets of working drawings, while continually battling to keep his practice solvent. Yet for all that, he was never forced to abandon any of the principles essential to his initial design, which he developed with increasing formal coherence, eventually achieving what Robert Venturi has described as a "geometric motival consistency that is ironically as dominating and pretty as that consistency that characterizes Rococo architecture with its rocaille all over."[64] Having moved to Paris to work on a buildable version of their competition entry, Piano and Rogers put the

finishing touches on a preliminary design in December 1971. Less angular than the initial design, the upper stories of the building now had stepped roof-terraces with planting sprouting from them and terminated more aerodynamically with curved glass. This variant was killed by cost estimates, which doubled the budget. A simplified version, which was submitted in May 1972, reverted to the rectilinearity of the competition scheme and included two escalators on the west elevation. The definitive design, complete with the escalator in its final form, was only approved in May 1973, one year after the leveling of the site had begun.

The first preliminary design following the competition (December 1971) was described by Banham as being "superficially in the style of some of Archigram's 'Instant City' drawings." In contrast, he considered that the definitive version, "in its visibly open frames, with communications etc. threaded through them, and even more so in the graphic detailing and the *ad hoc* transient-function implications of the very large presentation drawings that were made for it," had closer affiliations with the Plug-in City. The draftsmen were disciples of Archigram and the drawings did indeed depict "a world of bright colors, keen shapes, inflatables, clip-on gadgetry, giant projection screens and all the rest of the good old imagery of fun and flexibility."[65]

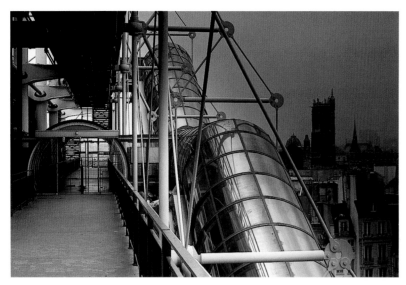

Centre Georges Pompidou, detail of the *gerberette*, fourth-floor escalator.

But the utopian charge of the initial project was whittled down during the advanced design stage. The notion of three-dimensional flexibility was confined to a series of fixed floor levels and vertical openings within the building were reduced to access wells. Although each floor level, or plateau, remained completely open, the fire brigade insisted each should be wholly self-contained to prevent the spread of fire. Even so, Piano had to fight long and hard to get the authorities to accept this principle.[66] There were political pitfalls to be sidestepped, too. When he took office in 1974, President Giscard d'Estaing tried to make his mark on the building by insisting its overall height be reduced and suggesting one of the lifts might be heightened, to create a more picturesque skyline.[67]

The design of the structure, for which Rice was responsible, was made all the more arduous by the decision to opt for methods of dynamic pretensioning, which lightened the frame but required very precise calculation. In some respects, the construction process did correspond with the Prouvé-influenced ideal cherished by Piano and Rogers of total prefabrication. Strict controls were introduced for factory-made components, especially those produced by previously untried methods. A great many elements were of cast steel (as opposed to pressed or cut steel), which meant the casting requirements had to be taken into account at a very early stage in detailing the sections. Of all these elements, the *gerberettes*, or rocker arms, best illustrate the indissoluble synthesis of technical and spatial aims. Streamline in form, they articulate the columns, beams, and cross-bracing of the façades.[68] These elements, which provide the means to assemble a range of structural members, also illustrate the extent to which the idea of a giant Meccano set was put into practice.[69]

The image of assemblage, this sense that the Pompidou was a giant kit of parts, is miles apart from the monolithic appearance of the Guggenheim, and is, of course, given added emphasis by the Brutalist handling of service ducts on the eastern façade. The powerful impact made by this lesson in architectural anatomy came home to roost when Rogers saw himself satirized as a man with his innards hanging out, on the British television show *Spitting Image*.

A period of experimentation, during which the strength of materials and methods of component production were tested, intervened between the design and construction. Fire precautions were also taken into account, notably by cooling the columns internally with water and by stepping up the number of floor-to-ceiling fire breaks on each floor level. In the end, the idea of making the ground floor completely open to pedestrians was abandoned, thereby emphasizing the institutional autonomy of the completed building. One of the greatest losses was the screenlike façade of the initial project, though in a way the animation it was to have provided has been transposed to the activity on the piazza itself.[70]

Like Wright, who had endless battles over his fees, Piano and Rogers's financial relationship with their client was far from easy, despite the fact that they managed to control overall construction costs, which only exceeded the allocated budget by twelve percent. In the end, they overturned the established conditions of payment (until then based on two separate scales, one for design, the other for execution) by arguing that more complex work was worth double the sum proposed by the French administration. Piano and Rogers also succeeded in having Ove Arup & Partners appointed as consultants, although their close involvement with the project did not correspond with the role usually ascribed to a *bureau d'études* (engineering and design department) in France. Numerous details were resolved thanks to a close working relationship with the main contractor, Grands Travaux de Marseille.

Buildings Hostile to Art

The fate allotted to the works of art in each museum reveals the underlying attitude of the architects. In their relationship to the principal circulation route—ramp or escalator—the two buildings suggest fundamentally different forms of contact with the collections, which can be better understood by analy-

sis of the circumstances surrounding the commissions and the role played by the presiding institutions. At the Guggenheim, the pictures were placed at regular intervals, as if to a set pattern, along the length of the ramp. By contrast, the hang at the Pompidou was based on a combination of movable vertical planes derived from projects by Mies, and seemed to be eminently changeable.

The question of how the works should be shown was from the start a conflictual challenge in the design of the Guggenheim. Wright declared himself to be hostile to traditional museums, especially the Louvre, in which the paintings, in his opinion, became "insignificant."[71] As early as 1943, he stated, "the building ought to show how to show a painting."[72] In 1946, he announced that "for the first time, purely imaginative paintings, regardless of the representation of any material object, will have an appropriate, congenial environment suited to their character and purpose as harmonious works of art for the eye, as music is for the ear."[73] He extolled low ceilings from the start, and in 1944 he began to think in terms of "screens" as is shown in his early sketches. Wright also wanted to control the framing of the pictures, or rather, he wanted them frameless and cited Georgia O'Keeffe on this matter.[74] He also meant to display the pictures at an angle, and even wanted to put them in place himself.[75] But it was not until 1958 that he suggested a trial hanging of work.

Guggenheim was already expressing skepticism about the presentation of the pictures in 1946, when he asked for a full-size model showing the paintings in situ. Discussion continued in 1949. For her part, Rebay was appalled by what she saw as Wright's dogmatic fanaticism. He demonstrated the validity of the lighting strip to Guggenheim in situ by presenting his Urform—the slot lighting the kitchen work space at Taliesin, Spring Green, Wisconsin. However, not everyone was in favor of lighting the museum by combining natural with artificial sources. Wright fought against Sweeney's preference for artificial light, which Harry Guggenheim shared. In 1958, Wright proposed a compromise, in which the lower floors were to have artificial light, and the upper floors natural light. In 1952, Wright had demanded "a veto power on all furnishings and the installation of pictures—this, of course, at the beginning."[76] But Sweeney would in the end have the last word: the pictures were mounted proud of the wall plane.[77]

Centre Georges Pompidou, view of the main reception hall, ca. 1990.

At the Pompidou, the design of the galleries sprang from the type of fully equipped, totally adaptable box sought by museum directors in the 1960s and later exemplified to a certain degree by Frank O. Gehry's design for the Temporary Contemporary at the Museum of Contemporary Art, Los Angeles (1982–83). The thinking hinged on the potential mobility of historical narrative and the links postulated by the exhibitions. In theory at least, space was to be available for the development of performance art and Happenings. Wright had devised an "environment" for art, a novel notion at the time. Based on the use of the color beige, which Sweeney countered with complete whiteness, it provided a neutral background for the colors in the paintings. By contrast, the color coding of service ducts and other structural elements at the Pompidou vied with the perception of the artworks inside the building.

The Ire of Artists

The subordination of artworks to an architectural aim, whether it was highly manipulative, as at the Guggenheim, or had the semblance of total freedom, as at the Pompidou, was symptomatic of an awkward relationship between the two buildings and living artists. Wright's position on the hierarchy of the arts could not be clearer. In one of the most strained of his exchanges with Rebay, he stressed the preeminence of architecture over the paintings she accused him of not liking. But Wright was attracted by abstraction, and in particular by the work of Kandinsky. In a spate of outbidding of a kind frequently indulged in by Le Corbusier, Wright claimed to be more non-objective than his client. But he was unsparing in his criticism of Moholy-Nagy, not least because Rebay had considered appointing him architect before turning to Wright

Frank O. Gehry's exhibition design for *The Art of the Motorcycle* at the Solomon R. Guggenheim Museum, 1998.

and she dared to suggest she might call him in as a consultant.

The artists' revolt broke out even before the building on Fifth Avenue was completed. In an exchange in the *New York Times*, in December 1956, Willem de Kooning, Franz Kline, Robert Motherwell, and others deemed the Guggenheim "not suitable for a sympathetic display of paintings and sculpture," and deplorable for the absence of the "rectilinear frame of reference necessary for the adequate visual contemplation of works of art." Wright defended his right to make an architectural statement that would be in dialogue with art.[78]

In the case of the Pompidou, the families of artists, rather than living artists, protested. The transfer to the Pompidou of the Musée national d'art moderne (MNAM) was opposed by the children of the sculptor Henri Laurens and by the daughters of the painter Georges Rouault, who considered the district to be unworthy and who were shocked by the building. Thanks to her high regard for Hulten, Nina Kandinsky made a donation to the Pompidou and others then followed her example. As a result, works by Constantin Brancusi, Max Ernst, and Antoine Pevsner were acquired by MNAM. A replica of Brancusi's studio was moved from the Palais de Tokyo (MNAM's previous home) to the Pompidou.[79]

Despite these initiatives, the effects of heat, light, and gadgetry at the Pompidou created the impression that it would turn into a machine for devouring works of art. Conceived in terms of a center of creativity, MNAM had precious little space for conservation and restoration; indeed, such

procedures had been deliberately excluded from the brief by the *programmation* (programming) team. In fact, complaints about the Pompidou by living artists were less virulent than was the controversy provoked by the way the permanent collections were arranged in the form of a punctuated narrative. Hulten's initial hang was intended as a rapid itinerary highlighting major works, complemented by excursions into specific themes. The idea of works from the reserves being "called up" at will by visitors, on a system of mobile screens, was deemed too risky and dangerous for the pictures and was swiftly abandoned.

The Pompidou was given a major shift in direction by Dominique Bozo. Involved at the inception of the project, he directed MNAM from 1981 to 1986 and became president of the Pompidou in 1991. In 1992, he reorganized it institutionally.[80] The Centre de création industrielle was absorbed by the museum, which was restructured spatially to designs by Gae Aulenti. The fixed arrangement of linear galleries and corridors she devised allowed for twice as many works of art to be exhibited. Bozo disliked the openness of the initial project and attempted to negate its Kunsthalle character by making the Pompidou into a *musée du vingtième siècle*, a move that implied bringing history to a standstill.[81] He modified the overall structure of the Pompidou by getting rid of the "Forum" and providing a separate entrance to the library. The Institut de recherche et de coordination acoustique-musique, which had until then been entirely confined to the basements, acquired

an above-ground identity in the form of a tower designed by Piano with brick cladding suggesting an illusive echo of neighboring Parisian buildings.

Mixed Metaphors

Few twentieth-century buildings have generated as many metaphorical allusions as the Guggenheim and the Pompidou. If natural phenomena tend to predominate discourse on the Guggenheim and analogies with machines are more often applied to the Pompidou, these categories are not mutually exclusive. The "Chambered Nautilus on Fifth Avenue" has also been dubbed "a spring," while the "Beaubourg refinery" has been described, too, as an anatomical diagram.[82] The wide variety of terms applied to the two buildings testifies both to the impact they have made as urban objects and to their popularity with the media, which followed the design and construction of both buildings with great interest. In both cases too the architects made careful use of the media. Wright had the first perspex model of his "Modern Gallery" published in *Architectural Forum* and *Magazine of Art* as early as 1946, emphasizing its affinity with a "true logarithmic spiral . . . worked out as a complete plastic building." He summarized his building as: "one single, grand, slow wide ramp—a purely plastic development of organic structure."[83]

Wright was a jump ahead of the critics, who were scathing at times. Although generally in favor of Wright's ideas and architecture, Lewis Mumford methodically demolished his concept of the museum in *The New Yorker*. While conceding the building was a work of "non-traditional, non-representational, non-historical abstract art in its own right," he described it as a "fortress" or "super pill-box" (similar to the Nazi's coastal fortification), expressing nothing except the "desire for monumental solidity" on the part of an "autocratic and exhibitionist" architect. In Mumford's view, "works of art, surely, should impose their need on the building," whereas the only message conveyed by a museum centering solely on the "exhibit Wright" was "Power." Paradoxically, Mumford argued, this approach sacrificed all the organic qualities of Wright's architecture to an inflexible form of doubtful benefit.[84] Mumford denounced the ramp as a reproduction of the "continuous corridor." So too did Nikolaus Pevsner

Claes Oldenburg, Coosje van Bruggen, and Frank O. Gehry, *Il Corso del Coltello*, 1985, at the Centre Georges Pompidou, 1987.

who, having reviewed the architecture of museums since the Renaissance, concluded that although Wright's building was "sensational," it was "also about everything a museum should not be. It is a monument, after all, and the spiral ramp which one is forced to descend makes any cross move impossible, and cross moves at will are the spice of museum visits."[85]

The external appearance of the Pompidou in relation to its Parisian surroundings has provoked still more comment. Popular skepticism about this "Notre-Dame-des-tuyaux" (Our Lady of the Pipes) was more than counterbalanced by the unexpected scale of attendance: 5,000 visitors per day had been expected, but five times that number regularly poured into the Pompidou. The building received the qualified approval of its British progenitors. While not hiding his pleasure, Cook of Archigram was of the opinion the building was too uniform from the bottom up. Peter Smithson made ironic remarks about Gallic technical rhetoric and commented that the cross-bracing was like the Crystal Palace "turned inside out like a glove." However, Georges Candilis (who, like Smithson had been a co-founder of Team Ten, the reformist group inside the International Congresses for Modern Architecture), distanced himself from this "display of guts spilling out of an immense organism with its belly slit open."[86]

Dennis Crompton, an active member of Archigram, doubted the reality of the promised "live centre of information."[87] The split between the proposed form of State culture

A corridor in the Musée national d'art moderne as redesigned by Gae Aulenti, ca. 1985.

Appropriation and Interventions

The buildings were appropriated in two ways. As a result of public pressure, they were increasingly used as *sites* by artists, whose interventions often manifested misgivings about the architecture and defiance toward the museographic institution, which had been called into question in both cases anyway in relation to the Museum of Modern Art and the Metropolitan Museum of Art in New York and to the old Musée national d'art moderne in Paris. And indeed, as central voids, the cylindrical volume at the Guggenheim and the Forum at the Pompidou were settings that continued to invite ironic or subversive interventions.

The opening of the two institutions, within some fifteen years of each other, coincided with the emergence of art forms designed to challenge the locus of the museum by invading and attacking its space. From this point of view, there is a de facto resemblance between the Guggenheim and the Pompidou, in that both have served to exhibit such works as Claes Oldenburg, Coosje van Bruggen, and Gehry's *Il Corso del Coltello* (1985). In retrospect, the apparent inflexibility of the Guggenheim building seems not to have disadvantaged manifestations of this sort. Indeed, such artists as Joseph Beuys, Jenny Holzer, and Mario Merz have all used it as a backdrop for the presentation of their work. As the central volume works like a panopticon in reverse, attention is drawn to exhibits at its center, be they historical, as in the case of the 1981 reconstruction of Liubov Popova's Constructivist machine, or contemporary.

Until partially blocked in 1992, the equivalent space at the Pompidou was the Forum. Instead of highlighting a single object, it centered on the overall topography of displays laid out on the floor below. Far from being confined to gallery-goers, this spectacle made an impact on all the visitors to the Pompidou. Jean Tinguely's machine-sculptures were joyously deployed there, as were many other things. In fact, as a place of interface between the general public and the "experiments" of artists and designers, the Forum was central to the initial conception of the project. It was probably this space that most faithfully represented the cultural and architectural aspirations of 1969 to 1971.

The changing spectacle of the Forum was supplemented by that of the escalators outside the building. Prefigured by

and the basic concept of a "well-serviced shed" was questioned by Alan Colquhoun. He was critical of the transparency of the Pompidou and above all of the way the so-called flexibility had been achieved. He suspected that, contrary to the stated aim, it would lead to a certain amount of inflexibility, and that the allocation of spaces to the various users would make the Pompidou into a "Gesamtkunstwerk of the bureaucracy." As he put it, "once these allocations have been made, there are powerful pressures to leave them unaltered, except in the case of extreme necessity, since any alterations of demarcation in one place has repercussions everywhere else." The presence of an "intermediary group of 'programmers' between the architect and the user" leads one to doubt that a "flexible space . . . is any more flexible in reality than spaces of a more conventional type."[88] The similarities between the building and a big store led intellectuals such as Jean Baudrillard to quip, "the scale of Beaubourg is to culture what the scale of a hypermarket is to merchandise."[89]

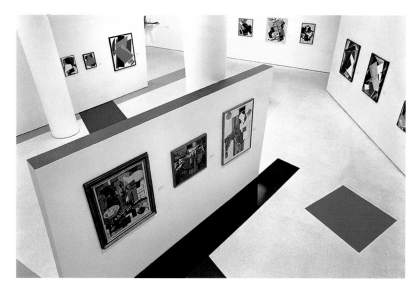

One of the Solomon R. Guggenheim Museum's new tower galleries designed by Gwathmey Siegel and Associates Architects, with installation view of *The Great Utopia: The Russian and Soviet Avant-Garde, 1915–1932,* 1992.

the fantasies of the Futurists, and also by the galleria or glazed shopping arcades and Fourierist phalansteries that had been "rediscovered" in the 1960s, the escalator provides a double source of visual enjoyment.[90] Riding the escalators adds the dimension of visual interchange to the vertical promenade, while also gradually revealing the Parisian roofscape. Watching the hidden world of chimney stacks and dormers coming into view is particularly memorable. Like the Forum, the escalator prolongs the animation of the piazza more than it suggests the contemplative ambiance of the museum or the library.

The multifarious ways the public appropriated the building were paralleled by the uses made of—or devised for—the Pompidou by its constituent departments. The fundamental role accorded to *programmation* from the inception of the project, and the part played by François Lombard and Patrick O'Byrne in compiling the brief should not be overlooked. The exhibitions and events that developed from the cultural project established in 1977 notably included Hulten's first exhibition series.[91] Yet while the built-in flexibility was exploited in the temporary exhibition spaces, such proved not to be the case in the museum. Successive attempts to transform it have more closely resembled trauma than the joyous state of confusion envisaged by the architects. If the inertia of the various departments has called into question the tool put at their disposal, its limitations should be outlined. Circulation routes were almost unavoidably restricted to the perimeter at each floor level, there was limited height available beneath the beams (3.8 meters), and the load-bearing members effectively divided the floor levels into self-contained parallel strips.

In addition to these architectural considerations, the interdisciplinary ideal has been compromised because the Pompidou derives much of its character from its specialist institutions.[92] After some fifteen years of intense activity and attempts to relate interior projects to public life, Bozo effectively put a stop to the interdisciplinarity. That it was not working well was emphasized by several surveys undertaken at the time of the Pompidou's tenth anniversary, and when consulted Michel de Certeau argued for "greater differentiation" and a "better articulation of tasks."[93] The rethinking of the relationships among the collections and the creativity conducted under Bozo's presidency coincided with the eruption

in France of postmodernist theories of design and the rising predominance of historical and heritage-based themes in architecture. In this context, it is interesting to note that an architect as opposed to nostalgic themes as Piano considered the project by Gae Aulenti for the transformation of MNAM to be the ultimate justification of his initial *parti,* as though he was relieved that this flexible space could *also* become a museum.[94]

The Pompidou and the Guggenheim are at opposite ends of the spectrum so far as the balance between conservation and living art is concerned. Fears were being vigorously expressed in Paris about the Pompidou fixing its sights on a conservation-based view of culture, a dimension that had predominated at the Guggenheim.[95] Yet relatively little space was devoted to contemporary art at the Pompidou; in contrast, although initially founded on a historic collection, the Guggenheim opened its doors to it.[96] Rather than seeking to resolve this problem by slogans or by an unattainable fusion, this question was reconsidered by the staff of the Pompidou more in terms of the planning of exhibitions and their themes—in a word, by *programmation,* in this case the coordinated planning of cultural events—an approach no longer confined to the Pompidou, if it ever had been.

Expansion and Dissemination

Given their respective ambitions and dynamics, neither of these two institutions could be contained by the finite spaces originally given them. For the Pompidou and the Guggenheim, expansion plans have encompassed both the programming of

exhibitions, often in association with numerous partners, and the buildings themselves. The complete reorganization of the Pompidou initiated by Bozo in 1992 was implemented by François Barré from 1993. The piazza was remodeled as a single plane and Brancusi's studio was rebuilt in a stone-clad concrete enclosure designed by Piano. Above all, the internal distribution of the main building is being reorganized, the administrative offices relocated elsewhere, and the program structure readjusted. The Centre de création industrielle has been absorbed by MNAM; levels three and four are being converted for use as a unique museographic unit; and level five will be used for temporary exhibitions. The library is to be relocated and reorganized in a vertical configuration, with its own internal circulation "tower" that extends from ground level to level two, using designs by Jean-François Bodin. For his part, Piano is remodeling the ground and basement levels, as the focus for events and films.

Shortly before the Guggenheim became eligible for protection as a landmark (on the termination of a statutory thirty-year period), it was substantially altered. The new tower addition was designed by Gwathmey Siegel and Associates Architects beginning in 1982 and completed in 1992. As at the Pompidou, most of the administrative offices were moved out of the main building. Loosely based on 1952 designs by Wright for studio-apartments on a neighboring lot, the new building provided that the exhibition spaces spread laterally, breaking with the linear discipline of the spiral.[97] More generally, the Guggenheim began to put down new roots, elsewhere in New York, at the Guggenheim Museum SoHo, a rehabilitation by Arata Isozaki, and then around the world to the Guggenheim Museum Bilbao, in which Gehry's architectural objectives pick up on the demonstrative energy of Wright's building. These recent projects provide an opportunity to review some of the characteristics of the Fifth Avenue building. That the notion of the "rectilinear frame" so contested by Wright should have been revived in some of the gallery spaces in the Bilbao museum is particularly striking, the more so for having been adopted by Gehry, who is engaged with contemporary art to a far greater degree than was Wright. (Even so, some artworks respond with pertinence to the spatial challenge thrown at them by Gehry.)

From the Guggenheim's two bases—the Solomon R.

Guggenheim Museum in New York and the Peggy Guggenheim Collection in Venice—a more complex system has emerged, akin to the way Greek towns were linked to a metropolis, or the capital city to its colonies. Paradoxically, it is the Guggenheim that has become the real "hub of decentralization" that President Giscard d'Estaing's culture minister, Michel Guy, wanted to see at the Pompidou. Whereas the Guggenheim has created a network of repositories for its collections and exhibitions, the effective decentralization of culture that has taken place in France since the 1970s has not been Pompidou-centered but has involved many other networks.

Return to the Monumental

The architectural force of the Guggenheim Museum Bilbao and its impact on a declining industrial city center brings into sharp focus the question of the monument in New York and Paris. Wright defended having created one from the start. He was, as he put it somewhat cryptically, creating "not so much a living memorial as a monument," although "not caring so much for monuments and preferring the more lively memorial."[98] But that did not stop him from trying to make the museum into an "Archeseum," or monument to architecture, and he only described it as a memorial when in need of Guggenheim's support for the project after Solomon Guggenheim's death. Mumford could see "only one way of fully redeeming Wright's monumental and ultimately mischievous failure—that of turning the building into a museum of architecture."[99]

As for the Pompidou, it only appears to be antimonumental, as Paul Chemetov pointed out when likening it to "that jingoistic fanfare by a Pop group at the Charles Garnier Opera House."[100] Architecturally, it is consistent in its frontal emphasis while at the same time affirming the *Neuheitswert* (novelty value) evoked by Riegl. Moreover, as Banham has pointed out, there is an inherent contradiction in making the image of change perennial and hence monumental.[101] In this respect, Banham saw the Pompidou as the realization of the program established in 1942 by Sigfried Giedion for a new monumentality incorporating movement.[102] And it is on this point that the two museums mark a break with the thinking of the first moderns, by going back to a theme they had repeatedly rejected.

If one refers to the categories Riegl established for the evaluation of a monument, it is evident that initially, both the Guggenheim and the Pompidou lacked *Erinnerungswert* (recall value), except perhaps in the sense that Wright's referred to his earlier work; that neither possessed *Alterswert* (antiquity value); and that they—especially the Pompidou—were not deemed to have *Kunstwert* (artistic value). In contrast, they had comparable *Entwicklungswert* (development value) and *Neuheitswert*, while the *historischer Wert* (historic value) they have since acquired qualifies them to be authentic monuments, even if their provocative character suggests otherwise.[103] It is, finally, as receptacles for a mass cult of culture—which put in motion vast crowds in relationship with leisure and tourism—rather than as places of experiment, that they should be recognized. As to the spectrum of sources they evoke, the contrasts they set up with their respective cities, and the instant memorability of their image-based architecture, the Pompidou and the Guggenheim testify to the institutional empowerment that brought the founding cycle of modern architecture to its conclusion.

Translated, from the French, by Charlotte Ellis and Martin Meade

Notes

1. Aloïs Riegl, *Der moderne Denkmalkultus, sein Wesen und seine Entstehung* (Vienna-Leipzig: W. Braumhuller, 1903).

2. The Solomon R. Guggenheim Museum opened to the public six months after Frank Lloyd Wright's death in 1959. At the time of the design competition, both Renzo Piano and Richard Rogers were in their thirties and had staffs of five (in Genoa) and six (in London), respectively.

3. Piano and Rogers, *Du Plateau Beaubourg au Centre Georges Pompidou* (Paris: Centre Georges Pompidou, 1987), pp. 10–11 (interview with Antoine Picon).

4. For Wright's letters about the project, see Bruce Brooks Pfeiffer, ed., *Frank Lloyd Wright: The Guggenheim Correspondence* (Fresno/Carbondale: California State University and Southern Illinois University Press, 1986). Pfeiffer is also the author of "A Temple of the Spirit," in *The Solomon R. Guggenheim Museum* (New York: Solomon R. Guggenheim Museum, 1992), pp. 3–39. For an analysis of the significance of the building in Wright's career, see Neil Levine, *The Architecture of Frank Lloyd Wright* (Princeton: Princeton University Press, 1996), pp. 299–362; William J. Hennessey, "Frank Lloyd Wright and the Guggenheim Museum: A New Perspective," *Arts* (April 1978), pp. 128–33; and Claude Massu, "Le dessein contourné de Frank Lloyd Wright; Le Solomon R. Guggenheim Museum et les artistes," *Cahiers du Musée national d'art moderne* 39 (spring 1992), pp. 80–97. On the Centre Georges Pompidou, see Nathan Silver, *The Making of Beaubourg: A Building Biography of the Centre Pompidou* (Cambridge, Mass.: MIT Press, 1994);

and Alexander Fils, *Das Centre Pompidou in Paris; Idee, Baugeschichte, Funktion* (Munich: Moos, 1980).

5. Roberto Aloi, *Musei: architettura, tecnica* (Milan: Hoepli, 1962); and Michael Brawne, *The New Museum: Architecture and Display* (London: Architectural Press, 1965).

6. The two undertakings are discussed retrospectively, in the context of numerous recent building projects, in Victoria Newhouse, *Towards a New Museum* (New York: Monacelli Press, 1998), pp. 162–68 (on the Guggenheim) and 193–98 (on the Pompidou).

7. For the origins of the Mundaneum, see Giuliano Gresleri and Dario Matteoni, *La città mondiale Andersen Hébrard Otlet Le Corbusier* (Venice: Marsilio, 1982).

8. Ludwig Mies van der Rohe, "Museum for a Small City," *Architectural Forum* 78, no. 5 (1943), pp. 84–85.

9. Wright to Hilla Rebay, March 1, 1945, in Pfeiffer, ed., *Frank Lloyd Wright: The Guggenheim Correspondence*, pp. 58–59. Wright's paternalistic attitude toward Mies was not new. When Mies took up an appointment at the Armour Institute in October 1938, Wright introduced him with the words, "I give you my Mies."

10. John Collidge discusses the two approaches in *Patrons and Architects* (Forth Worth: Amon Carter Museum of Western Art, 1989), pp. 40–48 (on the Guggenheim) and 92–109 (on the Pompidou).

11. For more on Solomon R. Guggenheim and his nephew Harry F. Guggenheim, see John H. Davis, *The Guggenheims: An American Epic* (New York: William Morrow, 1978), pp. 199–231 and 437–56;

Milton Lomask, *Seed Money: The Guggenheim Story* (New York: Farrar, Straus, 1964), pp. 164–217; and Edwin P. Hoyt, Jr., *The Guggenheims and the American Dream* (New York: Funk & Wagnalls, 1967). On Georges Pompidou, see Jean-Denis Bredin, *La République de Monsieur Pompidou* (Paris: Fayard, 1974); Eric Roussel, *Georges Pompidou* (Paris: Jean-Claude Lattes, 1984); and Pompidou, *Pour rétablir une vérité* (Paris: Flammarion, 1982).

12. Wright to Harry Guggenheim, May 14, 1952, in Pfeiffer, ed., *Frank Lloyd Wright: The Guggenheim Correspondence*, p. 170.

13. Rebay to László Moholy-Nagy, May 28, 1943, in *Hilla Rebay: In Search of the Spirit in Art* (New York: George Braziller, 1983), p. 182.

14. Wright to Rebay, October 19, 1951, in Pfeiffer, ed., *Frank Lloyd Wright: The Guggenheim Correspondence*, p. 155.

15. Conseil municipal minutes, October 24, 1968, Paris.

16. Pompidou, quoted in *Le Monde*, October 17, 1972. For the beginnings of the Pompidou, see Olivier Dufour, "L'Histoire d'une ambition," *Esprit*, no. 123 (February 1987), pp. 1–15.

17. Annette Michelson, "Beaubourg: The Museum in the Era of Late Capitalism," *Artforum* 13, no. 8 (April 1975), p. 66.

18. A former member of the Resistance and a Gaullist, Robert Bordaz had been principal private secretary to the Minister for Reconstruction and a high-ranking civil servant in Vietnam before moving to cultural affairs, in which he was responsible for directing government radio and television broadcasting and for organizing international

exhibitions. See his text on the project, "Conception et réalisation du Centre Beaubourg," *Revue des Deux Mondes* (September 1971), pp. 612–617, and his memoir, *Pour donner à voir* (Paris: Diagonales, 1987).

19. Jørn Utzon was replaced, due to illness.

20. For the competition conditions, see *Le Moniteur des travaux publics et du bâtiment*, November 28, 1970.

21. Prouvé, "La permanence d'un choix," *L'Architecture d'aujourd'hui*, no. 189 (February 1977), pp. 48–49. The fact that an entry by a team from Philadelphia was assumed to be by Robert Venturi suggests how much energy is often wasted trying to guess who designed which entry in open competitions subject to the anonymity rule. This error anticipated the jury's mistaken assumption that the winning entry in the Opéra-Bastille competition was by Richard Meier.

22. The projects are published in *Paris-Projet*, no. 7 (1st quarter 1972), pp. 15–47; *L'Architecture d'aujourd'hui*, no. 157 (August–September 1971) and no. 168 (July–August 1973).

23. The means finally adopted to calculate Piano and Rogers's fees formed the basis for the revised-fee scales introduced by law in 1973. The *établissement public autonome* set up in January 1972 was officially designated the Centre Georges Pompidou by legislation passed on January 3, 1975. The related decree of January 27, 1975 confirmed its status as an *établissement public* and defined its purpose as "to favor the creation of works of art and the spirit" (*"favoriser la création des oeuvres de l'art et de l'esprit"*).

24. Wright to Harry Guggenheim, May 1, 1952, in Pfeiffer, ed., *Frank Lloyd Wright: The Guggenheim Correspondence*, pp. 168–69.

25. Wright to James Johnson Sweeney, October 7, 1954, in Pfeiffer, ed., *Frank Lloyd Wright: The Guggenheim Correspondence*, pp. 209–10.

26. Jean Lauxerois, *L'Utopie Beaubourg, vingt ans après* (Paris: Bibliothèque publique d'information, Centre Georges Pompidou, 1996), pp. 23 ff.

27. Herbert Muschamp, *Man about Town: Frank Lloyd Wright in New York City* (Cambridge, Mass.: MIT Press, 1983).

28. Wright, *When Democracy Builds* (Chicago: University of Chicago Press, 1945), p. 28.

29. Wright to Solomon Guggenheim, July 14, 1943, in Pfeiffer, ed., *Frank Lloyd Wright: The Guggenheim Correspondence*, p. 10.

30. Wright to Rebay, December 22, 1943, in Pfeiffer, ed., *Frank Lloyd Wright: The Guggenheim Correspondence*, p. 24.

31. Wright to Harry Guggenheim, September 1, 1952, in Pfeiffer, ed., *Frank Lloyd Wright: The Guggenheim Correspondence*, p. 174. The idea of a site outside New York City was still lingering

in Wright's mind after Solomon Guggenheim died in 1949.

32. Wright to Rebay, March 13, 1944, in Pfeiffer, ed., *Frank Lloyd Wright: The Guggenheim Correspondence*, p. 45. The initial project was opposed by the highly influential Fifth Avenue Association, which had been actively involved in the control of development in Manhattan since the beginning of the century. A more positive role was played by Robert Moses who, despite his well-known aversion to modern architecture, was consistently helpful to Wright. See Hoyt, Jr., *The Guggenheims and the American Dream*, pp. 334–35.

33. Wright to Solomon Guggenheim, December 31, 1943, in Pfeiffer, ed., *Frank Lloyd Wright: The Guggenheim Correspondence*, p. 45.

34. Eugène Claudius-Petit, "LC., dernier projet pour Paris," *L'Architecture d'aujourd'hui*, no. 249, (February 1987), pp. liv-lv. For this project, see dossier 13 (18), Fondation Le Corbusier, Paris.

35. Conseil municipal minutes, November 15, 1923, Paris.

36. Georges Hartmann, "Quartier Saint-Merri, les îlots insalubres," *La Cité*, nos. 103–04 (October 1927), p. 281.

37. Bordaz, *Pour donner à voir*, p. 216.

38. Wright to Harry Guggenheim, September 1, 1952, in Pfeiffer, ed., *Frank Lloyd Wright: The Guggenheim Correspondence*, p. 174.

39. Arthur Drexler, ed., *The Architecture of the Ecole des Beaux-Arts* (London: Secker & Warburg, 1977); and Donald Drew Egbert, *The Beaux-Arts Tradition in French Architecture* (Princeton: Princeton University Press, 1980).

40. Wright to Rebay, January 26, 1944, in Pfeiffer, ed., *Frank Lloyd Wright: The Guggenheim Correspondence*, p. 42.

41. For an overview of the project developed from Wright's earlier work, see William Jordy, *American Buildings and Their Architects*, vol. 4 of *The Impact of European Modernism in the Mid-Twentieth Century* (Garden City, N.Y.: Anchor/Doubleday, 1972), pp. 281–311.

42. Reyner Banham, *Age of the Masters: A Personal View of Modern Architecture* (London: Architectural Press, 1975), p. 51.

43. Wright's comments to Ben Raeburn are quoted in Pfeiffer, ed., *Frank Lloyd Wright: The Guggenheim Correspondence*, p. 111.

44. Peter Blake sees a precedent for the interrelationship between spiral and top lighting in the Vatican museums, which Wright had visited; see Blake, "Who Really Designed the Guggenheim," *Interior Design* 63 (September 1992), pp. 242–43.

45. For the best (and perhaps only) analysis of the structure, see Jordy, *American Buildings and Their Architects*, pp. 311–59. Wesley Peters, who was appointed by Wright to supervise the structure, and the New York building contractor

George N. Cohen, made important contributions to the structural design.

46. Wright put the number at 300 and Sweeney at 350. See letters to Harry Guggenheim, January 21 and 27, 1956, in Pfeiffer, ed., *Frank Lloyd Wright: The Guggenheim Correspondence*, pp. 221–22.

47. According to Piano's account in Bordaz, *Entretiens Robert Bordaz-Renzo Piano* (Paris: Diagonales, 1997), p. 14.

48. Silver, *The Making of Beaubourg*, pp. 13–14.

49. Piano and Rogers, "Rapport de présentation pour le concours du Centre Beaubourg, 1971," in *Du Plateau Beaubourg*, p. 54.

50. François Barré, "Fascination et banalisation: le rêve et la fonction," *L'Architecture d'aujourd'hui*, no. 189 (February 1977), pp. 50–51.

51. Gus Dudley, ed., *Oscar Nitzché Architect* (New York: Cooper Union, 1985); Joseph Abram, "Oscar Nitzché, un constructivisme rationaliste et tempéré," *Architecture Mouvement Continuité* (December 1984).

52. Cedric Price, *New Scientist*, May 14, 1964, p. 433. See also Price, *Cedric Price: Works* (London: Architectural Association, 1984), pp. 56–61.

53. Antonio Sant'Elia, *L'architettura futurista, manifesto*, July 11, 1914. In French, in *Le Futurisme 1906–1916* (Paris: Editions des Musées Nationaux, 1973), p. 131; in English, in Banham, *Theory and Design in the First Machine Age* (London: Architectural Press, 1960, 1970), pp. 128–29.

54. Its importance in relation to the machine is overstated by Lauxerois in *L'Utopie Beaubourg*, pp. 28–34.

55. Alan Colquhoun, in "Critique," *Architectural Design* 47 (February 1977), p. 116, notes the resemblance, as does Barré in "Fascination et banalisation."

56. No doubt some members of the team were familar with Nikolaus Pevsner's analysis of the Crystal Palace in *High Victorian Design, A Study of the Exhibits of 1851* (London: Architectural Press, 1951).

57. Piano and Rogers, *Du Plateau Beaubourg*, p. 54.

58. Banham, *Megastructure: Urban Futures of the Recent Past* (London: Thames and Hudson, 1976), p. 12.

59. Philip Johnson, "Letter to the Museum Director," *Museum News* (January 1959), pp. 22–25.

60. Piano and Rogers, *Du Plateau Beaubourg*, p. 55.

61. Archigram was active from 1961 to 1970.

62. Piano and Rogers, *Du Plateau Beaubourg*, p. 11.

63. Lauxerois, *L'Utopie Beaubourg*, p. 14.

64. Robert Venturi, "Words on the Guggenheim Museum," *Guggenheim Magazine* (spring–summer 1994), p. 7.

65. Banham, *Megastructure*, pp. 212–14.

66. Piano and Rogers, *Du Plateau Beaubourg*, p. 12.

67. Bordaz, *Pour donner à voir*, p. 228.

68. Peter Rice, "La structure métallique," *L'Architecture d'aujourd'hui*, no. 189 (February 1977), pp. 60–65. See also Rice, *An Engineer Imagines* (London, Zurich: Artemis, 1993), pp. 25–46.

69. Because the prices quoted by French firms were twice as expensive, the Pompidou's 110-ton beams were manufactured by Krupp in Germany. Extraordinary lengths were taken to import them into France secretly by road and rail.

70. Paul Virilio, *Art Press* (special issue on architecture, summer 1983), quoted by Lauxerois in *L'Utopie Beaubourg*, p. 60.

71. Wright to Harry Guggenheim, July 15, 1958, in Pfeiffer, ed., *Frank Lloyd Wright: The Guggenheim Correspondence*, p. 270.

72. Wright to Rebay, December 18, 1943, in Pfeiffer, ed., *Frank Lloyd Wright: The Guggenheim Correspondence*.

73. Frank Lloyd Wright, "The Modern Gallery: For the Solomon Guggenheim Foundation, New York City," *Magazine of Art* (January 1946), pp. 24.

74. Wright to Harry Guggenheim, January 21, 1956, in Pfeiffer, ed., *Frank Lloyd Wright: The Guggenheim Correspondence*, p. 221.

75. Wright to Harry Guggenheim, December 27, 1958, in Pfeiffer, ed., *Frank Lloyd Wright: The Guggenheim Correspondence*, pp. 281–82.

76. Wright to Albert E. Thiele, June 18, 1952, in Pfeiffer, ed., *Frank Lloyd Wright: The Guggenheim Correspondence*, p. 171. Wright's habit of supervising everything down to the last detail, even in the smallest houses he designed, is well known.

77. For the approach adopted in the Guggenheim's lighting design, see I. D. Robbins, *The Lighting of a Great Museum* (Garfield, N.J.: American Lighting Corporation, 1960).

78. The artists' letter of protest was published in the *New York Times* on December 12, 1956. Wright composed a reponse, "Concerning the Solomon Guggenheim Museum," on December 14 and published on December 24. See Pfeiffer, ed., *Frank Lloyd Wright: The Guggenheim Correspondence*, pp. 244–45.

79. Bordaz, *Pour donner à voir*, p. 232.

80. The statutory instrument giving increased powers to the president, amalgamating Centre de création industrielle with Musée national d'art moderne (MNAM), and creating a department of cultural development for the benefit of the public was decreed on December 24, 1992. The Bibliothèque publique d'information and Institut de recherche et de coordination acoustique-musique remained associated with the Pompidou.

81. Lauxerois, *L'Utopie Beaubourg*, p. 175.

82. Sweeney, "Chambered Nautilus on Fifth Avenue," *Museum News* (January 1959), pp. 14–15; the piece is followed by articles by Blake, Alfred Frankenstein, and Lewis Mumford.

83. Wright, "The Modern Gallery," p. 24. See also "The Modern Gallery," *Architectural Forum* (January 1946), pp. 81–88.

84. Mumford, "What Wright Hath Wrought," *The New Yorker* (December 5, 1959); reprinted in *The Highway and the City* (New York: Harcourt, Brace & World, 1963), pp. 124–38. Also worth noting are Henry-Russell Hitchcock, "Notes of a Traveller, Wright and Kahn," *Zodiac*, no. 6 (1960), pp. 14–20; and Bruno Zevi, "Polemica sul Museo Guggenheim," *L'Architettura, cronache e storia* (April 1960), p. 799. Zevi zealously supported Wright's initial proposals against Sweeney.

85. Pevsner, *A History of Building Types* (Princeton: Princeton University Press, 1976), p. 138.

86. Georges Candilis's comments appear in *L'Architecture d'aujourd'hui*, no. 189 (February 1977), pp. 52–53.

87. Dennis Crompton, "Centre Pompidou, A Live Center of Information," *Architectural Design* 47 (February 1977), pp. 120–27. Crompton's entry in the 1971 competition typified Archigram's final period.

88. Colquhoun, "Critique," p. 116. Rogers later admitted how deeply this criticism affected him, in Piano and Rogers, *Du Plateau Beaubourg*, pp. 34–35.

89. Jean Baudrillard, *L'Effet Beaubourg: implosion et dissuasion* (Paris: Galilée, 1977), p. 33.

90. Johann Friedrich Geist, *Arcades: The History of a Building Type*, trans. Jane O. Newman and John H. Smith (Cambridge, Mass.: MIT Press, 1985).

91. *Paris–New York, Paris–Berlin, Paris–Moscou*, and *Paris–Paris*, followed by *Les Réalismes*, marked a radical revision in MNAM's policies, compared with such exhibitions as *Sources du XXᵉ Siècle* of 1960–61 at the Palais de Tokyo. See Paul Thibaud, "Voir et revoir les grandes expositions," *Esprit*, no. 123 (February 1987), pp. 17–22.

92. The completion and inauguration of the Pompidou was marked by a spate of publications. Some, like Claude Mollard, *L'Enjeu du Centre Pompidou* (Paris: UGE/10–18, 1976), were favorable; others, notably Francis Ponge, *L'Ecrit Beaubourg* (Paris, 1977), and Jean Clair, "Du musée comme élevage de poussière (pensées impies)," *Beaubourg et le musée demain*, *L'Arc*, no. 63 (1975), pp. 47–54, reprinted in Jean Clair, *Elevages de poussière: Beaubourg vingt ans après* (Caen: L'Echoppe, 1992), were not.

93. Michel de Certeau, "Le Sabbat encyclopédique du voir," *Esprit*, no. 123 (February 1987), p. 67. As de Certeau had access to only part of the material he required for the in-depth survey he was planning, only the preliminary report was written.

94. Bordaz thought Gae Aulenti's intervention was regrettable; see *Pour donner à voir*, p. 234.

95. Lauxerois, *L'Utopie Beaubourg*, p. 19.

96. For the development of the museum collection, see *Art of This Century: The Guggenheim Museum and Its Collection* (New York: Solomon R. Guggenheim Museum, 1993).

97. On the Gwathmey Siegel and Associates extension, see "Guggenheim Go-Around," *Architectural Record* (October 1992), pp. 102–12. In 1965, the museum took over the space linking the spiral to the Monitor to exhibit the Justin K. Thannhauser Collection. An annex had been built for conservation work on the northeast corner of the lot in 1968 and in 1974 the entrance was converted for use as the bookshop.

98. Wright to Solomon Guggenheim, July 14, 1943, in Pfeiffer, ed., *Frank Lloyd Wright: The Guggenheim Correspondence*.

99. Mumford, "What Wright Hath Wrought," p. 138. This idea is central to Blake's analysis in "The Guggenheim: Museum or Monument," *Architectural Forum* (December 1959), pp. 86–93, 180, 184.

100. Paul Chemetov, "L'Opéra Pompidou," *Techniques et architecture*, no. 317 (December 1977), pp. 62–64.

101. Banham, "Enigma of the rue du Renard," *The Architectural Review* 161, no. 963 (May 1977), p. 278.

102. José-Luis Sert, Fernand Léger, and Sigfried Giedion, "Nine Points on Monumentality" (1943), in Giedion, *Architecture, You and Me* (Cambridge, Mass.: Harvard University Press, 1958), pp. 58–60.

103. The Pompidou is already being treated as though it were an historic monument, and it may soon be given statutory protection as such.

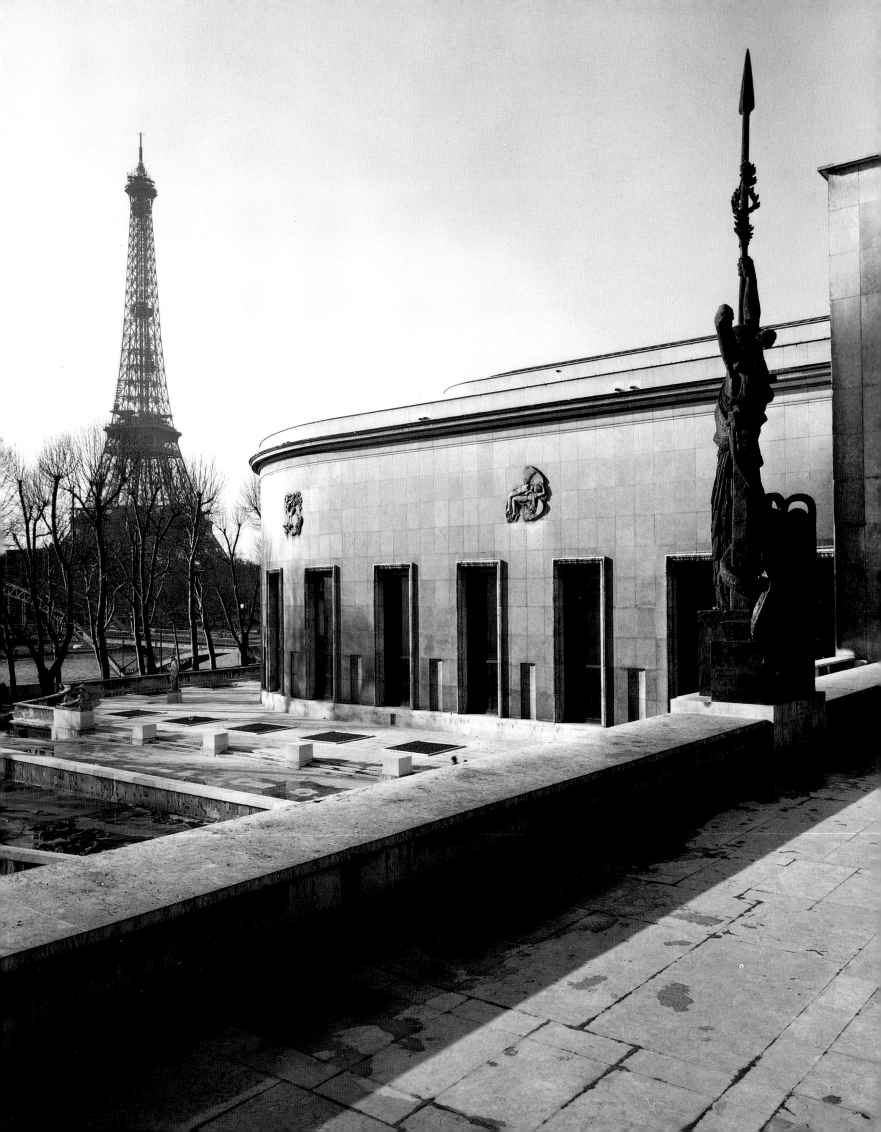

BETTER LATE THAN NEVER

There is some disagreement about when I made my first visit to the Musée national d'art moderne (MNAM). My mother thinks I was five. But given how sharply I remember certain features of the event, I find this doubtful. Perhaps I made up a composite memory, blending that visit with a later one? In my mind, the encounter took place in 1961 or 1962, shortly before I entered the *lycée*. We lived in a small southern town and once a year came to Paris to see my grandparents and to shop in the department stores. My brother and I weren't too happy about the shopping part of the trip, and to placate us, my mother would take us to the museums. Not art museums—we were undoubtedly deemed too young—but the Musée d'histoire naturelle, the Musée de l'homme, the Palais de la découverte . . . one by one these great repositories of knowledge, and many others, were meticulously attended. Assiduous, we would often beg for a second visit. On our second trip to the Musée de la marine, we unexpectedly found its doors closed. We were already quite familiar with the other non-art museums in the area, so for some reason my mother resolved to stroll down the street to MNAM (the Musée Guimet might have been another choice, and I often wonder if I would have become a historian of Khmer or Chinese art if chance had led us there instead).

Perhaps, after all, it is my second visit to MNAM that I recall, for in this memory I am alone with my mother—we are the perfect Proustian couple. My younger brother probably complained, and my mother would have agreed to return with me the next day. What I do remember with absolute precision is my exhilaration in front of: the little roped-off room in the museum's basement, which was supposedly a reconstruction of Constantin Brancusi's studio (until its transfer to the Centre Georges Pompidou, I'd return to this room, as if on a

pilgrimage, each time I'd visit the museum); a huge allover canvas by Jean-Paul Riopelle; the large Matisse cut-out *The Sorrow of the King* (1952, cat. no. 15), which then greeted visitors on the landing of a monumental staircase; the Léger room; and a small painting, saturated with ultramarine and punctuated by spots of yellow, by Gustave Singier (no doubt its title, *La Nuit de Noël* [1950], played a major role in the strong impression the work made on me).

It amuses me in retrospect to notice how much these youthful choices reflected the nature of MNAM's collection at the time. Its strongest element was the bequest from an artist (Brancusi's studio), and it was, indeed, large gifts of this kind, engineered by the director, Jean Cassou, after World War II, and inaugurated by Pablo Picasso's offering of eleven paintings in 1945, that then constituted the highlights of the museum's collection. The Léger ensemble, the cumulative result of many generous donations over the years (there were few purchases at this point), testified to the importance of a handful of benefactors without whom the historical part of the collection would have been a disgrace. Attaining the Matisse had been very difficult, involving a struggle between Georges Salles, director of Musées de France, Cassou, and the state bureaucracy; and only the support of the artist himself finally made the purchase possible. (On the whole, Henri Matisse was very poorly represented, the bulk of the museum's holdings being the seven paintings bought directly from the artist, in 1945, only nine years before his death. My childish eyes had selected a work from the end of his career, but it might have been otherwise if stronger works from the 1905–17 period had been on display.)[1]

The Singier and the Riopelle had been bought by the state, in 1951 and 1960 respectively, and were immediately

The Musée national d'art moderne at the Palais de Tokyo, avenue du Président Wilson, Paris, ca. 1950.

41

Jean-Paul Riopelle, *Chevreuse*, 1954. Oil on canvas, 3 × 3.9 m (9 feet ⅛ inch × 12 feet ½ inch). Centre Georges Pompidou, Musée national d'art moderne, Paris, Purchased by the French State in 1960, allocated 1960.

allocated to MNAM. The Singier was typical: during the 1950s and throughout the 1960s, the French state's purchase of twentieth-century art was almost entirely geared toward the production of what was then called the "Nouvelle Ecole de Paris," even though it was not so "new," as most of its practitioners had come to maturity during World War II. The large Riopelle (*Chevreuse*, 1954) was much more unexpected. But, upon reflection, it fits the chauvinistic sentiment that pervaded the French art administration at the time. The painter, though Canadian, was fully assimilated (he had been living in France since 1947 and his strongest supporter was Georges Duthuit, Matisse's son-in-law). He had participated in the famous exhibition *Véhémences confrontées* (at the Galerie Nina Dausset, in Paris, in March 1951), where he had aligned himself with the French artists in the competitive comparison with Jackson Pollock and Willem de Kooning. True, the allover conception of his work was quite foreign to the landscapist half-baked abstraction of his Informel colleagues, and it had much more to do with Abstract Expressionism, especially in scale. But purchasing Riopelle's canvas had provided the administration with a good alibi: why buy Pollock when one could obtain the "same thing" at home for less than half the price (the first Pollock did not enter the collection until 1972). I don't want to sound unfair to Riopelle—his canvas was, and remains, impressive. But the politics that presided over its acquisition had little to do with the painting's intrinsic quality. (Many works purchased at the same time are today as embarrassing as the Singier—airport art, basically—and

are now mostly confined to storage.) The structure of the institution was such then that the acquisition of a work of any importance either constituted a statistical miracle or represented the isolated victory of a persistent curator.

The seed of my interest in Modern art was sowed during those early visits, although it remained dormant until my early teens, when I educated myself as best as I could through the art books in my high school library. It is then that I began to realize the huge gaps in the collection of the Musée national d'art moderne, which I now visited alone very regularly, taking the overnight train to Paris as often as I could afford it. Seeing today what has become a spectacular collection, it may be difficult to understand how bad things were, and moreover for how long they remained so: it was only in 1974 (yes, 1974!) that the curators of MNAM were at last given the means to institute a concerted acquisitions policy. For what they have managed to accomplish over the past twenty-five years, helped by the invention of the *dation* (a remittance of artworks in lieu of inheritance taxes) in 1968, they must be commended.

During the visits of my teen years, I was particularly shocked at the absence of any work by Piet Mondrian, who had lived in Paris for more than twenty years, and whom I had discovered through Michel Seuphor's monograph. Seuphor, whom I met in 1966, fueled my anger when he told me that the donation of Neo-Plastic painting had been personally nixed by André Malraux, the Minister of Culture. According to Seuphor, Malraux had said: "Moi vivant, ça jamais!" The Caillebotte affair all over again, I thought.[2] The first Mondrian, the purchase of which Dominique Bozo fought for mightily, did not enter the collection until 1975. I was also immensely frustrated at the lack of Dadaist works, and the absence of anything American. As Bozo notes, in 1961, the collection included only a single work by an American artist, Alexander Calder (and he lived in France half the year), although, from 1947 on, the museum had acquired 1,000 paintings and 300 sculptures.[3] Basically, nothing had changed since my childhood visit—only now I was better informed, and thus disappointed. The collection was still centered on the great masters (Georges Braque, Fernand Léger, Matisse, Picasso, etc.), yet it contained few key works by them since the purchases were made so late, and the walls of the

museum had kept filling up with canvases by the now very old-looking Nouvelle École de Paris.

The year immediately after high school, 1969–1970, which I spent in the United States as an exchange student, perfected my disillusion. Visiting the galleries of the Museum of Modern Art (MOMA), New York (where I also saw Frank Stella's big retrospective in 1970), and the architecture of the Solomon R. Guggenheim Museum, New York, so opposed to that of the pompous neoclassical Palais de Tokyo, made me ashamed of my country (even if, politically—to my great astonishment, as not long before I'd been on the barricades—I felt obliged to defend Charles de Gaulle's anti-American position regarding the Vietnam War). I remember having to return to the Guggenheim several times in order to see its permanent collection, which was often whisked away to make room for temporary exhibitions. (That situation has actually gotten worse. A benefit of the current show should be the occasion it gives New Yorkers of realizing how rich the holdings of this museum actually are.) It was a fabulous time to be in America for anyone fascinated with contemporary art. Post-Minimalism and Conceptual art were at their height; the gallery scene was buoyant, with the museums trying their best to keep up. Going back to France, after such a cure, was painful. But now I wanted to understand why everything seemed so stale. In particular, I wanted to know why Paris, the birthplace of so many of this century's important works of art, had no museum that could compare with either MOMA or the Guggenheim. Why was MNAM so tragically lethargic and antiquated?

I was not yet trained as a historian, had no archival skills, and the responses to my queries—mainly from artists, but also from a few critics, who had long thought the situation hopeless—were biased by politics. The right-wing government was prima facie detested by most of the intelligentsia; and museum curators, thought guilty by association, were deemed its accomplices. I too jumped on the bandwagon, not able to recognize the paradox that, at that very moment, Georges Pompidou, who became president of France in 1969, was beginning to free MNAM from its straitjacket. Only much later, when I read Jeanne Laurent's extraordinary book, *Arts & Pouvoirs en France de 1793 à 1981: Histoire d'une démission artistique*, was I able to fully understand the situation and

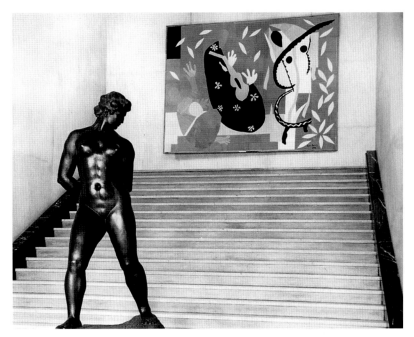

Entrance hall of the Musée national d'art moderne at the Palais de Tokyo, Paris, ca. 1954. Works shown are Aristide Maillol, *Action in Chains (L'Action enchaînée)*, 1906, and Henri Matisse, *The Sorrow of the King*, 1952.

how it had arisen.[4] Although her major argument was against the Académie des Beaux-Arts, which still had a powerful hold on the French cultural bureaucracy (it would only begin to lose it after the election of François Mitterand to the French presidency in 1981), Laurent examined in detail the circumstances behind the disastrous arts policy of the French government from the French Revolution on. And, to my surprise, she completely exonerated the museum's successive directors and curators of responsibility for the blatant inadequacies of MNAM's holdings (she is perhaps a bit too diligent in that regard, but she had a case to make).[5]

I peruse the checklist of *Rendezvous: Masterpieces from the Centre Georges Pompidou and the Guggenheim Museums*, concentrating on the works that will be exhibited in the main galleries. Interestingly, one of the effects of this parallel crash course in the history of Modernism is to make the two collections—that of the Musée national d'art moderne, and that of the Guggenheim—look oddly similar. I wonder, for a moment, whether the moral of the tale is that, in the end, there is no fundamental difference between the state museum and the capitalist, private, entrepreneurial foundation since the results they attain are the same.

Such a conclusion, however, would ignore a major historical factor inherent in the tale—the labor performed over time by works on display in a public collection. For it is not the same thing to have seen a great early Kandinsky or a classic Neo-Plastic Mondrian in the 1930s, as New York

The second reconstruction of Brancusi's studio (11 impasse Ronsin) at the Centre Georges Pompidou, Paris, ca. 1985.

museum-goers could have done on a permanent basis, and to be exposed to such works forty years later. Writing about the French government's lamentable auctioning, between 1921 and 1923, of about 1,500 works confiscated from the stock of the Kahnweiler Gallery as "enemy property" during World War I, and about Cassou's and Salles's damage-control efforts after World War II, Laurent notes that this act of deliberate sabotage prevented the French public from seeing any masterpieces of Cubism until 1947: "Such a delay is irreparable. What would have been living nourishment in 1919 belongs, in 1947, to the class of archeological treasures."[6]

More than half of the 326 paintings, drawings, and sculptures grouped together in *Rendezvous* come from MNAM. If I am not mistaken, all but two of these works, a 1972 Oldenburg received as a gift in 1975, and a 1984 Beuys bought in 1985, both from MNAM, date from before 1970. Omitting those two, a breakdown of MNAM acquisitions shows: fifty-nine works were gifts, nineteen were bought by the state (without the direct input of MNAM curators, and later allocated to the museum), fifteen were received in *dation*, and eight were bequests. Before 1974, only eighteen works in the collection were bought at the request of MNAM by the national museums. Of the works included here, sixty-five (that is, just over thirty-three percent of MNAM's contribution to *Rendezvous*) were purchases made directly by the museum after 1974. These numbers tell a story worth recounting.

The Musée national d'art moderne was created in 1945 (it officially opened in 1947), but the idea for such an entity had been in formation over a period of more than ten years.

As early as 1934, a plan had been conceived to merge two collections: that of the Musée du Luxembourg, or "Musée des artistes vivants," which had been created in 1818, and that of the Musée des Ecoles étrangères contemporaines at the Jeu de Paume, created in 1922 (but not opened until 1932). The Musée du Luxembourg had long been the stronghold of the Académie des Beaux-Arts, and in her book Laurent exposes in detail how scrupulously its curator, the conservative Léonce Bénédite, followed the orders of Paul Léon, director of the Beaux-Arts administration, who had declared a war against Modern art.[7] The museum at the Jeu de Paume, however, had an independent budget, with funding from other sources, such as the Ministry of Foreign Affairs, and it quickly became a bastion of emancipation from the very powerful yet underground domination of the Académie des Beaux-Arts. The museum's curator André Dezarrois was sensitive to Modern art and began to assemble a modest collection. It is thanks to him, for example, that the first Picasso, *Portrait of Gustave Coquiot* (1901), acquired by gift, entered the national collections. He also hosted a series of remarkable exhibitions.[8]

The two institutions could not have been more antipodal, and it is an understatement to say that the Académie des Beaux-Arts was opposed to the merger. But thanks to the Front Populaire government's support for the principle of a museum of Modern art, the Académie failed to abort the plan (although it managed to impose a conservative architect for the Palais de Tokyo, which was built in 1937). The Académie received a further blow in 1938, when Cassou was appointed assistant curator at the Musée du Luxembourg, with the mission of supervising work on the Palais de Tokyo, which had been so poorly built that it needed major reconstruction before it could house a permanent collection.

The Vichy government interrupted Cassou's work (he was sacked), and he did not really get started until 1945, with the full support of his superior Salles, who was himself a collector of Modern art (MNAM's great *Portrait of a Young Girl* [1914, cat. no. 24], by Picasso, was a personal bequest from him). For two years, the two men, as heroes of the Resistance, were unstoppable. (The Académie des Beaux-Arts, momentarily silenced for having been too ostentatiously collaborationist during the war, had to toe the line.) Managing to obtain

special credits for the occasion, Cassou and Salles launched an acquisition campaign, supplemented by donations they judiciously secured through the old technique of "I'll buy four, you give me one." The results were stupendous: seven Matisses (among them the 1941 *Still Life with a Magnolia* [*Nature morte au magnolia*]), five Braques, two Brancusis, two Bonnards, a 1915 Gris, several works given by Joan Miró, etc. The ball was rolling. Unfortunately, it soon stopped. Once the special funds had been exhausted, there was nothing to be done except go the bureaucratic route, with predictable and disappointing results. Not until the end of 1974 was MNAM detached from the overall Direction des Musées de France and, at last, given an autonomous acquisition budget by the government. Until then, if one excludes bequests, gifts, and the first *dations*, acquisitions were entirely dependent on the caprices of two external committees. The first, the Conseil artistique des musées nationaux, was involved almost exclusively with the work of dead artists. Although the director of MNAM (or a curator) regularly took part in the committee's meetings and had the support of Salles, the competition for funds involved all the national museums. It is not difficult to guess, given the conservatism of the profession in those years, where the votes would go if the purchase of a Mondrian, say, was weighed against that of a Boucher. The second committee, which dealt with living artists, was the Direction des arts plastiques (later rebaptized the Direction des arts et des lettres). Most of its members were uninformed bureaucrats easily manipulated by the Académie, whose power had been reinforced, in 1959, by Malraux, contrary to his legend as a "revolutionary."[9] MNAM had *no* direct say whatsoever in the workings of this second committee, and had to be extremely discrete when applying diplomatic pressure, in order to avoid a backlash.

Despite such unfavorable conditions, Cassou and his team were able to secure important donations during the 1950s and early 1960s, but these very successes prompted a different kind of opposition: why buy, reasoned the state, what we can get for free? In 1965, a frustrated Cassou resigned, soon followed by his brilliant second, Maurice Besset, the only curator at that time well informed in the international development of art. Besset was not replaced, and another curator, Bernard Dorival, whose views were

The Musée des Ecoles étrangères contemporaines at the Jeu de Paume, Paris, 1932–45.

ultranationalist, if not racist, and whose taste was utterly provincial, became director of MNAM.[10] His tenure represents the darkest years of the museum and its acquisitions policy: not a single work was bought for MNAM by the Conseil artistique des musées nationaux, and only a handful were purchased by the other committee.

It was only after the political seism of May 1968 that the situation began to change. At the end of that year, Jean Leymarie replaced Dorival as the head of MNAM and was given the means to assemble a new team of curators, including Bozo and Isabelle Monod-Fontaine, both well-versed in the history of twentieth-century art. Concurrently, however, the Centre national d'art contemporain was created as an organ wholly independent from MNAM, with the mission of exhibiting and purchasing contemporary work. While this entity allowed for the circumvention of some bureaucratic red tape,[11] it left MNAM even more isolated from current art, which was now entirely out of the museum's mandate. MNAM took a more aggressive stance in order to secure donations and purchases from the two committees (for example, during this period, it acquired Matisse's four *Backs* [*Nu de dos I–IV*, 1909–30] and its first Pollock [*Silver over Black, White, Yellow, and Red*, 1948] and Gorky [*Landscape-Table*, 1945, cat. no. 230]), but that was all it could do.

The departure of Malraux (with the election of President Pompidou, who was known to be deeply interested in twentieth-century art) encouraged Leymarie and his team to press their case: compared to the collections of many of its European counterparts, not to mention those of museums in

The Léger room, Musée national d'art moderne, Palais de Tokyo, 1971. Works shown from left to right: *Adieu New York*, 1976; *Leisure, Homage to Louis David* (*Les Loisirs, Homage à Louis David*), 1948–49; *Polychrome Flower* (*Fleur polychrome*), 1950; and *Composition with Two Parrots*, 1935–39.

Centre Georges Pompidou, Musée national d'art moderne, 1977. Works shown from left to right: Robert Delaunay, *The City of Paris* (*La Ville de Paris*), 1910–12; Raymond Duchamp-Villon, *The Large Horse* (*Le Cheval majeur*), 1914; and Vasily Kandinsky, *With the Black Arc*, 1912.

the United States, MNAM's was a collection of holes, a situation that might have been avoided had it been granted both financial autonomy and full independence from the politically appointed bureaucracy.

Georges Pompidou launched the idea of the center bearing his name in October 1970. It took four years to meet the conditions for the necessary aggiornamento. In 1974, Pontus Hulten, who could not be accused of French chauvinism, was appointed head of the museum, with the mission of preparing its transfer to the huge building being built on the Plateau Beaubourg. At this juncture, MNAM was finally granted the autonomy it had been requesting since 1945, and it immediately began buying aggressively: many Dadaist, Surrealist, abstract (including Abstract Expressionist), and Pop works entered the collection during these interim years, before the 1977 inauguration of the Centre Georges Pompidou. Hulten also urged the creation of a department of photography, which was established in 1975,[12] and a department of video, which was created in 1976.[13] Starting almost from scratch, these two departments have managed to acquire impressive holdings over the intervening years.

With the election of President Mitterand in 1981, MNAM saw its acquisition budget doubled and, with the help of the *dation* system and the numerous donations engineered by Bozo, who was director from 1982 to 1986, many crucial gaps in its historical holdings were filled. (For example, *Luxe, calme et volupté* [1904–05]; *French Window at Collioure* [September–October 1914, cat. no. 12]; *Portrait of Greta Prozor* [late 1916, cat. no. 14]; and *Auguste Pellerin II* [1917], four

important pre-Nice works by Matisse, were added to the collection during this period.) At the same time, conscious of its poverty in this regard, MNAM made a real effort to acquire many works of contemporary American art, while not forgetting its French and European counterparts. The year 1982 also saw the creation of the newest department in the museum, the cinema department, which, in record time, has amassed a vast collection of experimental films, from the heyday of Dada to the underground movies of the 1960s and beyond.[14]

Finally, if belatedly, institutional apparatuses were now fully in place to insure a steady increase in the museum's collection. The exhibition *Manifeste, 30 ans de création en perspective, 1960–1990*, hastily organized in 1992 at Bozo's request, revealed to the public the amplitude of the acquisitions made during the previous decade. Simultaneously, Bozo, now president of the Centre Georges Pompidou as a whole, decided that the Centre de creation industrielle, responsible for the collections of architecture and design and until then independent from MNAM, should become a department of the museum.

It had taken almost a half-century for the Musée national d'art moderne to develop the means of housing a truly multimedia collection and to be worthy of its name. The results of the delay in the formation of the collection of twentieth-century art, denounced by Laurent in her book, has not, however, been repaired. It cannot be. But perhaps, if the museum continues its good work, new generations of kids brought to the museum by their mothers will not notice its effects.

Notes

1. From those years, there were only *Le Luxe I* (summer 1907, cat. no. 11); *L'Algérienne* (1909); and *The Painter in His Studio* (1916). These are fine paintings but far from giving a sense of Matisse at his best.

2. In 1894, Gustave Caillebotte made a bequest of his collection of sixty-nine Impressionist works to the French state. The administration tried to turn down the bequest, but, after an uproar, was forced to accept part of it. In the end, twenty-nine works were refused.

3. Dominique Bozo, preface, *La Collection du Musée national d'art moderne* (Paris: Editions du Centre Georges Pompidou, 1987), p. 18.

4. Jeanne Laurent, *Arts & Pouvoirs en France de 1793 à 1981: Histoire d'une démission artistique* (Saint-Etienne: Centre interdisciplinaire d'études et de recherches sur l'expression contemporaine, 1982).

5. Bozo, who was passionate about raising the quality of the Musée national d'art moderne's collection, was very fond of Laurent's study, to which he pays due homage in his preface to *La Collection du Musée national d'art moderne*, featuring highlights from the museum's collection. Bozo is no more tender than Laurent toward the administrative system that had engendered the situation he was so instrumental in upturning.

6. Laurent, *Arts & Pouvoirs*, p. 134. In fact, the real date is not 1947 but 1952, the year of André Lefevre's donation.

7. As Laurent shows, Léon was fully responsible for, among other disasters, the Kahnweiler sales of 1921–23. In flooding the market with more than 1,500 works by, among others, Braque, Juan Gris, Léger, and Picasso, Léon's purpose was to devaluate Cubism. His plan, fortunately, failed: prices did not plummet, though they were much lower than prewar levels. Many fortunate buyers— for example, Raoul La Roche—later gave some of their purchases to MNAM. But a footnote in Laurent's text is quite telling: "Braque's *Man with a Guitar* [1914, cat. no. 23], bought for 9 million francs by the Musée national d'art moderne in 1981, was sold for 2,400 francs at the first Kahnweiler sale, on June 13, 1921" (ibid., p. 121).

8. The exhibition *Origines et développement de l'art international indépendant*, mounted on the occasion of the 1937 *Exposition Internationale*, Paris, was a notable survey of the history of art from 1900. Striking in its inclusiveness and refusal of national criteria, it included works by, among others, Brancusi, Giorgio de Chirico, Max Ernst, Julio González, Paul Klee, Joan Miró, and Mondrian, as well as Picasso's *Ma Jolie* (1911) and Matisse's *Moroccans* (1916), both now in the collection of the Museum of Modern Art, New York, and Vasily Kandinsky's *With the Black Arc* (1912, cat. no. 115), bequeathed to MNAM by the artist's widow in 1976. The French public would have to wait until 1960 and *Les Sources du XXᵉ Siècle: Les Arts en Europe de 1884 à 1914*, the landmark exhibition organized by Cassou at MNAM (but, crucially, with financial support from the Conseil de l'Europe, that is, independent of the French bureaucracy), to again see such an accumulation of key historic works.

9. As soon as he arrived in power, Malraux appointed an academician, Jacques Jaujard, to head the Direction des arts et des lettres. On Malraux's action, see Laurent, *Arts & Pouvoirs*, pp. 158–64. Laurent describes Malraux's policy toward MNAM as one of deliberate asphyxia.

10. Dorival's nationalist views are endlessly expounded in his three-volume *Les Etapes de le peinture française contemporaine* (Paris: Gallimard, 1946), as well as in numerous articles. This quotation dates from May 1945, a time when one would have expected any proponent of the racial theory of art to keep his own counsel:

Here the Slavs and the Spaniards, Juan Gris and Picasso above all, whose works unite Zurbaran's tension and the pure-bred nervousness of Velásquez with the schematic and dry elegance of the Islamic art at Cordoue. There the Frenchmen, more faithful to the real, such as Lhote and La Fresnaye, or to the "beautiful handiwork," such as Villon and Delaunay, exquisite colorists, or Léger, flawless practitioner. Between the two groups, Braque, too much Picasso's friend not to be seduced by the abstract refinements of this Oriental, and too French not to share with Villon and La Fresnaye their taste for an art all in nuances ("Le Cubisme," *Les Nouvelles Littéraires*, May 31, 1945).

I owe this reference to Gerte Utley, whom I thank for having made her Ph.D. dissertation available ("Picasso and the 'Parti de la Renaissance Française': The Artist as a Communist, 1944, 1953," New York University, Institute of Fine Arts, 1997). As Utley shows, this type of discourse, notably, the portrayal of Picasso as an "Oriental," was pervasive in contemporary right-wing journals.

11. The Centre national d'art contemporain's purchases, which also included historical works, among them a large de Kooning drawing (*Woman*, 1952) and a Rothko canvas (*Dark over Brown, No. 14*, 1963, cat. no. 277), were eventually merged with MNAM's collection with the creation of the Centre Georges Pompidou.

12. See Alain Sayag, ed., *Photographies 1905–1948: Collection de photographies du Musée national d'art moderne* (Paris: Editions du Centre Georges Pompidou, 1996). With the exception of Brancusi's photographs of his works, which were part of the artist's bequest to the French state in 1957, MNAM owned only two photographs in 1975. The published catalogue of the present photography collection is more than 500 pages long. Sayag headed the department of photography from its inception.

13. See Christine Van Assche, ed., *Vidéo et après: La collection vidéo du Musée national d'art moderne* (Paris: Editions du Centre Georges Pompidou, 1992). Van Assche has been the head of the video department from its inception.

14. See Jean-Michel Bouhours, ed., *L'Art du mouvement: Collection cinematographique du Musée national d'art moderne* (Paris: Editions du Centre Georges Pompidou, 1996). Bouhours has been the principal architect of the cinema collection, which is all the more impressive for being so recent.

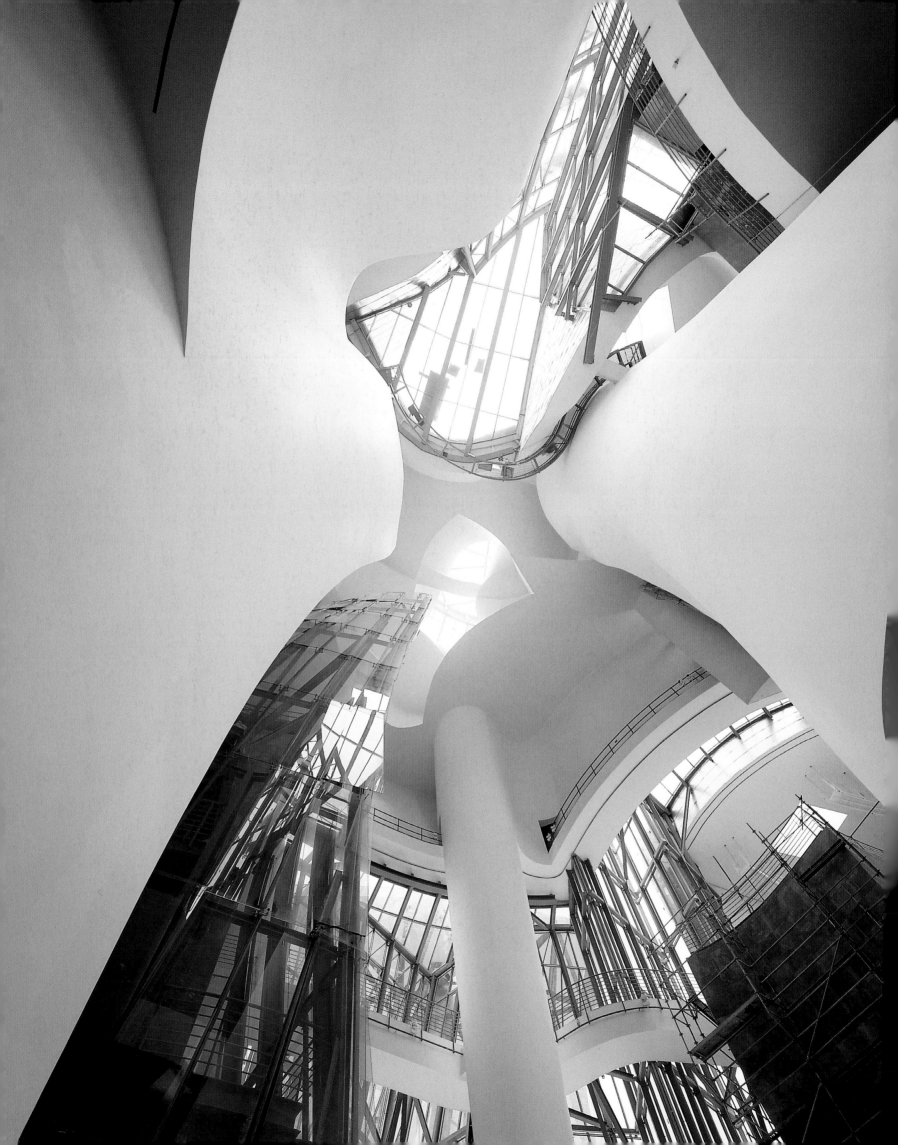

MARK C. TAYLOR

FROM SIMPLICITY TO COMPLEXITY

Changing Museum Architectures

This is, I believe, the single secret of simplicity: that we may truly regard nothing at all as simple in itself. I believe that no one thing in itself is ever so, but must achieve simplicity—as an artist should use the term—as a perfectly realized part of some organic whole.

—FRANK LLOYD WRIGHT

I believe one needs a system that is not a system—if you have several systems, no one system in particular becomes overbearing.

—FRANK O. GEHRY

My argument is that you consider the Guggenheim as an organism; these other parts of it lend strength to the overall operation.

—THOMAS KRENS

Programming Visions

No art museum is more closely associated with the architecture of its buildings than the Solomon R. Guggenheim Museum. The architectures that distinguish the Guggenheim do not merely involve concrete, limestone, steel, and glass but, more important, reflect articulations of changing visions of the mission of the museum in contemporary culture. Thomas Krens, director of the Solomon R. Guggenheim Foundation, recently observed:

The Guggenheim was founded in 1937 to realize four basic objectives: the collection, preservation, interpretation, and presentation of objects of twentieth-century visual culture. In becoming a great institution, the Guggenheim Museum grew in concert with its times. It came to embody architectural greatness and it established itself as an international presence, as the scope and quality of its collections grew dramatically.

Sixty years later, however, the Guggenheim must accommodate the future to remain a great institution. That it must vigorously pursue the conservative tendencies of scholarship and stewardship that have been the traditional hallmark of the modern museum goes without saying. But to realize the promise of its original vision and the statement of utopian optimism that is embodied in the very architecture of the buildings that house and symbolize the museum, and to confront the challenges that define the cultural field, the Guggenheim must redefine itself as a new and stimulating institution, one with the capacity and energy to shape the discussion of what museums aspire to be.[1]

From the earliest stages of their often tumultuous collaboration, it was clear that Solomon Guggenheim, Hilla Rebay, and Frank Lloyd Wright intended the architecture of their new museum to create a setting in which the spiritual vision expressed by the art they planned to exhibit would effectively

transform the awareness of museum-goers and, by extension, change society as a whole. Rather than a neutral background for pictures, the museum was supposed to be a work of art that would express and promote certain artistic, social, and spiritual values. Krens realizes that consistency, paradoxically, requires change. Standing at the threshold of the twenty-first century, he stresses that if the Guggenheim is to realize the promise of its original vision and the utopian optimism suggested in its architecture, it must redefine itself. In the world now emerging, global networks of exchange are rapidly altering the conditions of cultural production and transmission. These changes make it necessary for the museum to shift its tactics and strategies. Since structures that once were effective are no longer functional, new forms of organization must be created. Just as Guggenheim and Rebay found in Wright the architect who gave form to their vision, so Krens has found in Frank O. Gehry an architect to design a structure as complicated as Krens's vision of the twenty-first century. As Rebay's search for simplicity gives way to Krens's cultivation of complexity, Wright's harmonious spiral morphs into Gehry's distributed network.

Seeking Simplicity

In a letter to Wright dated July 1, 1943, Rebay declared: "I want a temple of spirit, a monument!"[2] Four years earlier, the Museum of Non-Objective Painting had opened with Rebay as its first director. Rebay had initially proposed to name the museum that would display Guggenheim's collection of paintings the Temple of Non-Objectivity and Devotion. When Rebay wrote to Wright, she was seeking an architect who could design a museum that would express her spiritual vision of art. This profound interest in spirituality grew out of her childhood encounter with Helena Petrovna Blavatsky's mystical Theosophy and Rudolf Steiner's visionary Anthroposophy. Though they eventually became two distinct spiritual movements, Theosophy and Anthroposophy do not differ significantly in their essential theological and philosophical principles. The most basic belief of Theosophy is, according to Blavatsky, that "all men have spiritually and physically the same origin." This origin is "The One Reality," which is the "enduring substance," "Universal Spirit," "Nature," "Absolute," "Deity," and "God."[3] Within Blavatsky's scheme,

duality, division, opposition, and fragmentation are apparent rather than real. Those who have been initiated into "the secret doctrine" realize that the human and the divine are one. Recognition of the divine identity of the self is the salvific knowledge that the great religious teachers from both Eastern and Western traditions bring to their followers. While accepting these metaphysical principles, Steiner tried to develop empirically testable strategies for inducing spiritual vision. The arts, he believed, play a critical role in spiritual education, which can overcome fragmentation and restore unity, integrity, and simplicity. Throughout the early decades of this century, the writings of Blavatsky and Steiner exercised considerable influence on many major artists and architects.

Having heard Steiner lecture in Freiburg when she was only fourteen, Rebay was prepared for her encounter with Theosophy during her student years in Paris. In a letter written to her mother from Paris in 1909, she reports:
You have undoubtedly noticed that I am again very much occupied with Theosophy. The deeper I delve into it, the happier it makes me; everything becomes clear, especially that spiritual sensitivity necessary for an artist to experience nature and to feel one with it.[4]
For Rebay, art—more specifically non-objective art—engenders the sense of unity and harmony that religion once bestowed. The modern belief that art displaces religion can

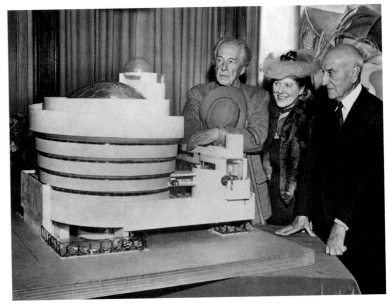

Frank Lloyd Wright, Hilla Rebay, and Solomon R. Guggenheim in 1945 with Wright's model for the museum.

Thomas Krens and Frank O. Gehry in Bilbao, 1995.

man." The course Kandinsky charts passes from "the night-mare of materialism" to "the kingdom of the abstract." *The more abstract is form, the more clear and direct is its appeal. In any composition the material side may be more or less omitted in proportion as the forms used are more or less material, and for them substituted pure abstractions, or largely dematerialized objects. The more an artist uses these abstracted forms, the deeper and more confidently will he advance into the kingdom of the abstract. And after him will follow the gazer at his pictures, who also will have gradually acquired a greater familiarity with the language of the kingdom.*[7] The goal of Kandinsky's aesthetic education is the discovery of "the 'oneness' of the 'human' and the 'divine.'"[8]

Rebay not only knew Kandinsky's art well but translated some of his most important writings. While the source of her term "non-objective" is unclear, it is most likely a translation of Kandinsky's *gegenstandslos*. In contrast to realistic paintings that re-present the world in images, non-objective art, Kandinsky maintains, allows the viewer who is attuned to it "to hear the whole world as it is without representational interpretation. Here these abstracting or abstract forms (lines, planes, dots, etc.) are not important in themselves, but only their inner sound, their life. As in realism, the object itself or its outer shell is not important, only its inner sound, its life."[9] Rebay enthusiastically embraces Kandinsky's insistence that the purpose of art is inward transformation rather than out-ward representation. Non-objective painting, she explains, *represents no object or subject known to us on earth. It is simply a beautiful organization arranged in rhythmic order of colors and forms to be enjoyed for beauty's sake. This order is dependent on the proportion of the canvas or paper itself and has law and coun-terpoint as has the musical creation. This lawfulness the layman does not realize at once; only when living with this work of art for some time will he be subconsciously influenced by the beauty and perfection of the organization and begin to realize its spiritual life and lawfulness. The non-objective painting has the ability to entertain the soul of those receptive to beauty itself and is of most practical importance.*[10] The practical importance of non-objective painting is the spiritual transformation it effects in the viewer.

The reputation of the other painter to whom Rebay was devoutly committed has not fared as well in the twentieth

be traced to post-Kantian philosophers like Georg Wilhelm Friedrich Hegel, Friedrich Wilhelm Joseph von Schelling, and Friedrich Schiller, as well as to Romantic poets like Samuel Taylor Coleridge, Friedrich Hölderlin, Novalis, and William Wordsworth. While aware of these philosophers and poets, Rebay found her spiritual vision most adequately expressed in the work of certain twentieth-century painters. Two painters were particularly important for Rebay and, consequently, were crucial for the future of the Guggenheim Museum: Vasily Kandinsky and Rudolf Bauer.

The spiritual vision informing Kandinsky's art is an idio-syncratic mixture of philosophical idealism, Theosophy, and Russian Orthodoxy. In a 1911 manuscript, Kandinsky and his co-author Franz Marc reflect the apocalyptic hopes of their time: "A great era has begun: the spiritual 'awakening,' in the increasing tendency to regain 'lost balance,' the inevitable necessity of spiritual plantings, the unfolding of the first blos-som. We are standing at the threshold of one of the greatest epochs that mankind has ever experienced, the epoch of great spirituality."[5] This rebirth of spirituality, they believe, will bring heaven to earth. Quoting Blavatsky in *Concerning the Spiritual in Art* (1911), Kandinsky observes, "The earth will be heaven in the twenty-first century in comparison to what it now is."[6] The artist-prophet leads the way to this kingdom by developing what Schiller calls "the aesthetic education of

Vasily Kandinsky, *Black Lines* (*Schwarze Linien*), December 1913. Oil on canvas, 129.4 × 131.1 cm (51 × 51⅝ inches). Solomon R. Guggenheim Museum, Gift, Solomon R. Guggenheim.

century. Convinced that Bauer was also a revolutionary artist, Rebay persuaded Guggenheim to build his collection around the work of Bauer and Kandinsky. In retrospect, it seems clear that Rebay's troubled personal and professional relation with Bauer clouded her critical vision. Far from a revolutionary, Bauer derived most of his important insights from other artists. What Bauer adds to Kandinsky's notion of non-objective art is a sense of the organic. Describing how his and Kandinsky's work differs from Cubism, Bauer writes to Rebay:

The picture must be organic. To keep the elements of such an infinite painting integrally related is very difficult. . . . The main thing is that the picture be organic. . . . A decisive factor is whether the picture is simply a plane or a shaping of space. That's why free, absolute painting is capable of so much more than Cubism. Cubism isn't free because it is bound to forms within the plane, that is, bound to the plane itself. Absolute art, on the contrary, works with space, and can thus go much further. Focusing on the surface does not demand as much intensity. When I limit myself to the plane, I see nothing but the canvas, which is not what I see when I am working in the cosmic. . . . In both cases, one is an absolute creator; this must be so, for then the one attitude couldn't lead to the creation of art. Thus it seems to me that Chagall is potentially stronger than the Cubists, even though he isn't their

equal. Leger is much more resolute than Chagall. The strongest and most advanced of all—theoretically and practically, synthetically and analytically—is Kandinsky.[11]

It is important to stress that Bauer's view of the organic is not bound to the natural world. To the contrary, the organic is a *structural* concept that characterizes abstract forms as well as natural bodies. Organic structures establish harmonious relations capable of synthesizing seemingly disparate elements in unified wholes or integrated totalities. In an essay written for the 1936 exhibition *Solomon R. Guggenheim Collection of Non-Objective Paintings*, Rebay joins Kandinsky's interpretation of abstraction with Bauer's notion of organism to form her distinctive reading of non-objective art:

The chief beauty of a non-objective masterpiece lies in the perfect rhythm with which it presents themes so combined and related that the space used is completely organized. Rhythm is created by the length of the pause in painting, as well as in music; to feel the order of this rhythm is to feel the order of the universe. The first statement of form or color commits the artist to further development in accordance with the rhythm and counterpoint of his creation; the first motif is followed by a second, which must continue the rhythm and fit in with the first theme. Having begun the picture, the creator continues until the space is completely, organically harmonized and all themes have been perfected and finished; the artist's concentration for continuity has to last until his intuition is exhausted. The finality in a great masterpiece of non-objectivity must be so convincing that it appears extremely simple to compose, yet it must be impossible to change any of its elements without disturbing the rhythm and upsetting the balance. There must be no weak, unfinished or unbalanced spot.[12]

In this revealing text, Rebay appropriates the Romantic identification of the artist and God. Just as God is an artist who creates a world that is a work of art, so "the artists of non-objectivity," who "paint with the religious spirit of intuitive creation," create works of art in which the material and spiritual are one.[13] For such spiritual works of art, no ordinary museum will do—only a "Temple of Spirit" will suffice.

In Wright, Rebay found an architect who was uniquely qualified to realize her artistic vision, and in Rebay, Wright found a client who offered him a unique opportunity to realize his architectural vision. Wright's "organic architecture" is inspired by the same foundational principles and ideals that

Rebay discerns in non-objective painting. In 1939, Wright concluded his Sir George Watson Lectures at the Royal Institute of Architects, London, by offering his most concise definition of organic architecture: "What we call organic architecture is no mere aesthetic nor cult nor fashion but an actual movement based upon a profound idea of a new integrity of human life wherein art, religion, and science are one: Form and Function seen as One, such is Democracy."[14] Wright and Rebay agree that the organic is not primarily a natural phenomenon but is a structural notion that integrates differences and mediates oppositions. In a manner reminiscent of the *Gesamtkunstwerk*, organic architecture is intended to unify science, art, and religion as well as to reconcile art and world in a democratic social community that creates the opportunity for the full self-realization of every individual. Never merely an end in itself, the purpose of architecture is to transform life.

Though their backgrounds differ significantly, Rebay and Wright's shared spiritual vision suggests common influences and sources. For Wright, as for Rebay, childhood experiences were decisive. The young Wright's early experience in the Froebel kindergarten educational system was particularly instrumental in shaping his eventual view of the world and understanding of architecture. As Robert McCarter points out: *The Froebel training emphasized learning from nature . . . and introduced him to the formative geometries that would later become the basis for his architecture. At a fundamental level, this training was directed towards the development of analytical thinking. It taught the child to see that geometric forms and patterns structured every object in nature, and to see each object as "a whole both in its organic unity and its component parts," as Friedrich Wilhelm August Froebel himself explained in the instruction manual. The training intended that the child come to understand, through his own investigations in playing, that there was an inner coherence in all things and that the material and spiritual worlds were one. The training methods, according to Froebel, were to "begin by establishing spatial relationships" and to operate through "inference from the general to the particular, from the whole to the part."[15]* Just as Rebay's youthful encounter with Steiner created an openness to the insights of Theosophy, so Wright's early Froebel training prepared him for the American Transcendental poets whose works he read religiously in later years.[16] Deeply indebted to the German Romantic tradition

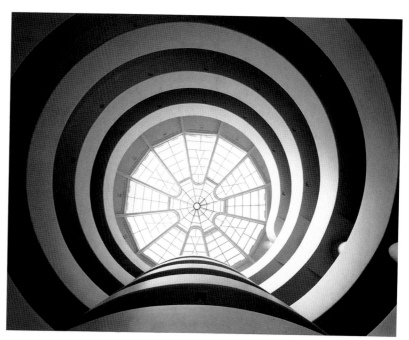

Skylight in the main rotunda of the Solomon R. Guggenheim Museum, New York.

dating back to Hegel, Schelling, and Schiller, which was mediated to the English-speaking world by Coleridge and Wordsworth, poets like Ralph Waldo Emerson and Walt Whitman cultivated the sense of simplicity and oneness that Wright sought in all of his work. Etched in stone at the entrance to Wright's Taliesin West (1937–59) were lines from Whitman's *Leaves of Grass* (1855):

> The measured faiths of other lands
> The grandeurs of the past are not for thee
> But grandeurs of Thine own
> Deific faiths and amplitudes absorbing comprehending all
> All in all to all.[17]

The task of art and architecture is to articulate the "all in all" that constitutes the organic unity of life.

For Wright, architecture is not merely a matter of materials and buildings. Indeed, every art and all of life are essentially architectural. At one point, he goes so far as to declare that Bach and Beethoven are "the two greatest architects I know anything about."[18] Like Rebay, Wright hears in the subtle rhythms of music echoes of the structures of reality that the architect is called to design and construct:
In Beethoven's music I sense the great master mind, conscious fully of the qualities of heartful soaring imagination that are godlike in man. The striving for entity, oneness in diversity, depth in design, repose in the final expression of the whole—all these essentials are there in common pattern between architect and musician. So I am going to a delightful school of architecture when I listen to Beethoven's music—music not even yet "classic"—soul language to

be classified because of soul-depth and breadth of emotional range. *Beethoven's music is in itself the greatest proof of divine harmony alive in the human spirit I know. As trees and flowering or fluttering things under the changing lights of a sun beclouded pervade all the out of doors, so Beethoven pervades the universe of the soul.*[19] In contrast to pseudo-architectures of the past, Wright insists that his "new architecture" involves "an earnest search for reality."[20] The reality Wright seeks is precisely the "oneness in diversity" he hears in Beethoven's music. This oneness is the "all in all" that extends beyond the pages of Whitman's *Leaves of Grass* to unify the material and spiritual in a world where reality is one and the one is real.

The one uniting everything constitutes what Wright describes as "organic simplicity." Rebay believes that the complexities of modern life create a longing for simplicity that art and architecture must fulfill. "As our lives become more hurried and crowded with constantly changing impressions and sensations," she avers, "our nerves require a contrast of restfulness and repose at home. People will demand ever greater simplicity of line in houses and will expect their walls to be light and soothing. The only paintings suitable to decorate these walls are those creations whose balance of form, line and color harmonize into space and refresh the soul."[21] Wright's architecture promises the simplicity Rebay is seeking. In his *Autobiography* (1943), Wright explains the significance of organic simplicity by placing it within a religious context: *This is, I believe, the single secret of simplicity: that we may truly regard nothing at all as simple in itself. I believe that no one thing in itself is ever so, but must achieve simplicity—as an artist should use the term—as a perfectly realized part of some organic whole. Only as a feature or any part becomes a harmonious element in the harmonious whole does it arrive at the state of simplicity. Any wild flower is truly simple but double the same wild flower by cultivation and it ceases to be so. The scheme of the original is no longer clear. Clarity of design and perfect significance are both first essentials of the spontaneous born simplicity of the lilies of the field. "They toil not, neither do they spin." Jesus wrote the supreme essay on simplicity in this, "Consider the lilies of the field."*[22] This text suggests why Wright qualifies simplicity as "organic." The unity Wright envisions does not exclude differences but integrates oppositions in a comprehensive whole. For this reason, simplicity and harmony are inseparable. Like

a flower whose petals, leaves, and stem are different and yet function harmoniously to produce life, organic simplicity integrates parts to form a vital whole.

The architectural expression of organic simplicity is "plasticity." "In architecture," Wright maintains, "plasticity is only the modern expression of an ancient thought. But the thought taken into structure and throughout human affairs will recreate in a badly 'disjointed,' distracted world the entire fabric of human society."[23] The integrity and continuity of the created object prefigures the unity and harmony of the recreated subject: *Plasticity is actually the normal* countenance, *the true aesthetic expression of genuine structural reality. . . . A significant outline and expressive surface, Plasticity (physical continuity) is a useful means to form the supreme physical-body of an organic, or integral American Architecture. . . . Architecture is now integral architecture only when Plasticity is a genuine expression of actual construction just as the articulate line and surface of the hand is articulate of the structure of the hand. Arriving at steel, I first used Continuity as actual stabilizing principle in concrete slab construction also and in the concrete ferro-block system I devised in Los Angeles.*[24] Wright brings together the notions of organicism, simplicity, and plasticity to form the principle of continuity, which consistently guides his architectural theory and practice.

Wright's preoccupation with the principle of continuity is most obvious in his well-known efforts to integrate buildings with their natural settings. Ever sensitive to the importance of context, Wright resists the Modernist tendency to subordinate site to structure. Rather than imposing structures on resistant sites, he tries to create a harmonious balance between the building and its setting. Wright's commitment to the principle of continuity, however, extends beyond the structure-site relation. Not only does he insist on the unity of form and function, but he also attempts to integrate the interior and exterior of all his buildings. By integrating structure and site and unifying form and function as well as inner and outer, Wright seeks to create a continuous whole through which the discontinuities of modern experience can be overcome.

While Wright's search for the continuities of organic simplicity informed all of his architecture, he was convinced that the Guggenheim Museum represented the fullest realization of his effort to achieve the harmonious integration of opposites. Indirectly recalling the architecture of Beethoven's

music, he writes to Rebay in a letter dated May 12, 1945: "This unique building is so symphonic in character that the least discord at any one point echoes throughout the entire structure. Perhaps it is folly to try to make a building live so completely as an entity, but the faith otherwise is within me and won't leave it at that. I seem compelled to perfect it and have no power to neglect a single detail if I would."[25] Wright believes the Guggenheim is an "organic building" in which there is no division of concept, purpose, and execution. From the time Rebay initially approached him, he explores the possibility of constructing the museum in the form of a ziggurat, which had long fascinated him. Rebay, however, resisted the square shape of ancient Mesopotamian, Sumerian, Assyrian, and Babylonian ziggurats and insisted on a "round" or "circular" building that would "embrace the sky as much as the earth."[26] Wright modifies the traditional ziggurat by transforming the square into a spiral and inverting the form. Growing larger and opening wider as it extends from earth to heaven, the museum, in Wright's own words, forms "an optimistic ziggurat."[27] The shape of the spiral creates a continuous space, which is appropriate for the display of non-objective art. In one of his most revealing comments on the design of the museum, Wright explains:

If non-objective painting is to have any great future it must be related to the environment in due proportion as it pretty much is already, not to the high ceiling. And to flat backgrounds of various tonalities suited to the paintings. The less the texture in the background the better. A museum should have above all a clear atmosphere of light and sympathetic surface. Frames were always an expedient that segregated and masked the paintings off from environment to its own loss of relationship and proportion, etc., etc.

A museum should be one extended expansive well-proportioned floor space from bottom to top—a wheelchair going around and up and down, throughout. No steps anywhere and such screened divisions of space gloriously lit within from above as would deal appropriately with every group of paintings or individual paintings as you might want them classified.

The atmosphere of the whole should be luminous from bright to dark—anywhere desired: a great calm and breadth pervading the whole place.[28]

From rigid frames and vertical walls to steps, doors, and separate floors, anything that interrupts the continuous flow of space is excluded. The most distinctive feature of the Guggenheim is, of course, the spiral ramp that gracefully winds its way skyward. Along this gradually sloping curve, the isolation and discontinuity of boxlike galleries give way to the uninterrupted flow of continuous space. The museum, according to Wright, is "one great space on a single continuous floor. The eye encounters no abrupt change, but is gently led and treated as if at the edge of the shore watching an unbreaking wave . . . one floor flowing into another instead of the usual superimposition of stratified layers."[29] At the top of the spiral a translucent dome joining sky and earth creates "a clear atmosphere of light" that allows the picture to be seen "more as the painter saw it himself in changing light."[30] The luminosity of the light seems to etherealize the building as well as the paintings. If one follows Rebay and Wright along the Guggenheim's ramp, spirit and matter become one.

Ever since the museum opened, Wright's design has been criticized for creating difficult spaces in which to display art. There is no denying that it is not always easy to hang flat paintings on curved walls that slant outward. Many critics charge Wright with trying to impose his architectural will on artists and curators. This criticism, however, runs exactly counter to Wright's stated intention. Extending his principle of organic plasticity from the harmonious integration of elements in the structure to the interplay between architecture and art, Wright attempts to create a "symphonic" relation between building and painting:

Painting has seldom been presented in other than incongruous rooms of the old static architecture. Here in the harmonious fluid quiet created by this building interior, the new painting will be seen for itself under favorable conditions.

It is not to subjugate the paintings to the building that I conceived this plan. On the contrary, it was to make the building and the painting an uninterrupted, beautiful symphony such as never existed in the World of Art before.[31]

The "beautiful symphony" between picture and viewer not only echoes the integral simplicity of the museum but also reflects what Rebay describes as the "organically harmonized" art it displays. By creating an "atmosphere of great harmonious simplicity wherein human proportions are maintained in relation to the picture," Wright believes he gives non-objective

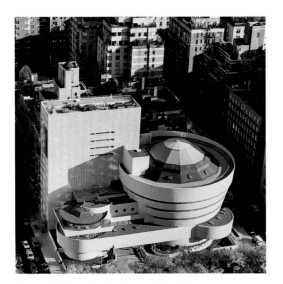

Solomon R. Guggenheim Museum, New York.

Peggy Guggenheim Collection, Venice.

Guggenheim Museum SoHo, New York.

painting the opportunity to have its maximum effect. For Wright, as for Rebay, the art that matters reveals a reality that is personally and socially transformative. "Reality," Wright insists, "is spirit—the essence brooding just behind all aspect. Seize it! And—after all you will see that the pattern of reality is supergeometric, casting a spell or a charm over any geometry, and such is a spell in itself."[32]

Emerging Complexity

Krens is as much a visionary as Rebay. Standing at the threshold of the millennium, Krens gazes back at a world he believes is passing away and anticipates an era rich with opportunity for those who are willing to think and act differently. If museums are to play a role in the world that is emerging, they must change significantly. In a recent discussion of the future of the museum, Krens writes:

That the museums of the future will no longer resemble the familiar institutional and social form that has quietly and persistently evolved over the past two hundred years is a foregone conclusion. Those institutions that move to successfully address these fundamental issues and are the first to restructure will be the ones to survive and flourish in the twenty-first century.[33]

The restructuring of the museum is necessary not only because of changes in the kind of art that has been produced in recent decades but also because of larger social, economic, and political transformations that are occurring. Krens maintains that the structure of contemporary museums of art can be traced to the model of the eighteenth-century encyclopedia.

Describing the early stages of his collaboration with Gehry, he explains:

Early on in the design process, Frank and I were able to clearly articulate these "themes," which are themselves based on two philosophical views of mine. First, art museums are an eighteenth-century idea (the encyclopedia) in a nineteenth-century box (the extended palace). The extended palace is a collection of rooms that fulfilled its structural destiny sometime toward the end of the twentieth century; that is to say, the rooms got filled—they weren't adequate to the imagination of contemporary artists who began to work with notions of scale. Second, that the experience of the museum as a treasure house with objects on display was different from the experience of the museum as a kind of narrative theater in which you organize objects to define certain intellectual moments. You make connections between these moments and present different accounts of how attitudes and ideas have evolved at this century's end.[34]

The dream of the encyclopedia is to present an all-inclusive catalogue of knowledge that is systematically organized. With the advent of what Manuel Castells aptly describes as "network society," this encyclopedic model is no longer functional. In a culture of emerging worldwide webs and global networks, different models for organizing knowledge and forming institutions must be articulated. Attempting to describe the new model of the museum he is developing, Krens invokes the metaphor of the organism, which, as we have seen, informs Rebay's spiritual vision and guides Wright's architecture:

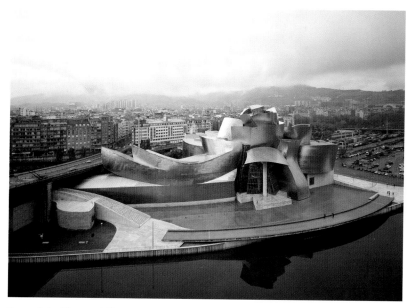

Guggenheim Museum Bilbao.

Deutsche Guggenheim Berlin.

You have to find a strategy that allows you to embrace the future. By adding Bilbao, and as we develop in SoHo, we start to become pretty formidable as an institution around the world. My argument is that you consider the Guggenheims an organism; these other parts of it lend strength to the overall operation. I see SoHo and Bilbao less as satellite museums than I see the Guggenheim as one museum with one collection—our galleries are not connected and the collections have different provenances and different ownership structures, but they are essentially unified under one curatorial organization.[35]

The ways in which Rebay and Wright's organism differ from Krens's organism represent the difference between the Guggenheim of the twentieth century and the Guggenheim of the twenty-first century, which Krens is in the process of building.

While Rebay and Wright's organism is a natural phenomenon, Krens's organism is a global informational structure that patterns network society. Far from seeking a reassuring simplicity in the midst of growing confusion, Krens not only acknowledges but actually embraces irreducible complexity as a condition of creative innovation. Where Rebay and Wright see organic simplicity, Krens sees organic complexity. Though he has not yet explicitly formulated the organizational vision shaping his restructuring of the Guggenheim, a clear logic is at work in Krens's efforts. Under his leadership, the Guggenheim is being transformed from *a* museum into a *network* of museums. Having recognized both the inevitability and the possibilities of global networking, Krens is developing

a new kind of cultural institution that simultaneously reflects and promotes the broader social, political, economic, and cultural changes now occurring. What Krens has recognized in advance of his contemporaries is that, in network society, the political and economic significance of art and culture increase considerably. The museum is no longer a treasure house for precious objects with little or no use value. To the contrary, when information is the currency of exchange, the museum becomes an institution capable of exercising enormous political and economic power. In today's world, it is impossible to determine where art ends and politics and economics begin. On the one hand, exercising political and economic power is increasingly a matter of the effective management of images, and, on the other hand, art and cultural institutions are playing a growing role in economic development.

It is important to stress that a network never stands alone but is always embedded within other networks. Global networks are neither universal nor uniform structures but are networks of more-or-less local networks. When understood as complex rather than simple, networks have a distinctive logic, which is characteristic of "any system or set of relationships using these new information technologies. The morphology of the network," Castells explains, "seems to be well adapted to increasing complexity of interaction and to unpredictable patterns of development arising from the creative power of such interaction."[36] If the organism is understood in terms of this "networking logic," it is not an equilibrium system that balances opposites and reconciles differences in a

harmonious totality. Rather, the networked organism or the organizational network is decentralized, differentiated, and distributed and always operates in conditions far from equilibrium. Webs and nets, in other words, are not all-encompassing structures but consist of associations and strategic coalitions of nodes, cells, modules, and circuits. Never permanent or fixed, flexible lines of association can constantly be redrawn to adapt to changing circumstances. Network operations involve as much competition and conflict as coordination and integration. Instead of being centralized, functions are distributed among multiple circuits that operate in parallel. The distribution of networks creates nonlinear structures in which intricate loops create the possibility for positive feedback, which promotes growth and expansion rather than restriction and limitation. The recursivity inherent in nonlinearity renders networks open rather than closed and makes it possible for seemingly simple interactions to create far-reaching results. The complexity of the structure is an emergent property that can be neither planned nor programmed. Networks, therefore, harbor a contingency that renders them both volatile and vulnerable. As interconnections grow, vulnerability and volatility increase. Disruptions create disjunctions that can be both destructive and creative.

Networks display the structure of complexity at every level of organization. Within the museum network that Krens is creating, different branches of the Guggenheim, as well as the network as a whole, display a common structure. What is at stake in this interactive decentralized structure is not merely the economy of scale but the creation of the conditions for creative innovation, which is nourished by manifold relays and intricate interrelations. Since every network is always embedded in other networks, the networked museum is entangled in social, political, and economic relations that extend far beyond what has traditionally been regarded as the domain of art. In network society, influence is always multidirectional and multidimensional. This endlessly complex web of relations is what lends art its extensive power to transform institutions by changing awareness.

Just as Wright's Guggenheim expresses Rebay's vision, so Gehry's Guggenheim is a reflection of Krens's vision of the world and interpretation of art. Gehry, like Krens, is fascinated by complexity. Unlike Rebay and Wright, Gehry rarely engages

in spiritual speculation or philosophical meditation. The one exception to his reticence on such matters is a remarkable essay entitled "Theism or Atheism?" which he wrote as a teenager but has never published. Though unaware of the theological tradition he is probing, in this essay, Gehry presents a careful analysis of two of the classical arguments for the existence of God. In the Christian theological tradition, there are three traditional arguments that are supposed to prove God's existence for any rational person: the ontological argument, which Gehry ignores, and the cosmological and teleological arguments, which he considers in some detail. The cosmological and teleological arguments both rest on the principle of causality. While the cosmological argument argues from the existence of the world to the necessity of a first cause or creator God, the teleological argument argues from the order of the world to the necessity of a purposeful God. The future architect translates these two arguments into questions of material and design. After summarizing what he takes to be the arguments in favor of theism, Gehry offers his response: *Science leans in favor of evolution. That is to say that at some early time the bodies of the inhabitants of earth were not the same as they are today, but have changed throughout the centuries. Theism leans in favor of God creating all substance and that the human body, etc. was put on the earth in the same form as it is in today. Since the possibility of God creating all substance is out, another aspect appears. It is the idea that God has been co-existent with substance watching and guiding over it. This is based on the idea that there was always substance but the greatly complex things, mentioned before, had to be formed by something because of their great degree of complexity. The credit is attributed to a thing called God because this aspect considered the substance unable to form these shapes of itself. It excludes the alternative that the forms may have always existed. The great examples previously mentioned and all the great achievements of nature are attributed to this thing called God.*

When the reasons that are responsible for the forms and shapes of present-day things and nature are called by the name of God, a characteristic of perfectness or flawlessness creeps in. These reasons responsible for shapes and forms and nature brought about some very magnificent things all right—such as our solar system running in very good order, the greatly complicated human body and also all the bodies of animals, the stars, and probably more,

but along with the good marvelous things, some very, very bad things have also resulted. By saying this, I mean the many great disharmonies of nature.[37]

Though there are many fascinating aspects of Gehry's argument, three points deserve emphasis in this context. First, Gehry rejects the classical notion of *creation ex nihilo*. The postulate of God, Gehry insists, is not necessary to account for the substance, matter, or material of the world. Since nothing comes from nothing, either nothing exists, which obviously is not true, or material has always existed. As if debating the most sophisticated medieval theologian, the young Gehry argues:

Think now and see if you can picture a time when there was nothing in existence, a time of complete nothingness. Would not nothingness then have to prevail forever before this time you are picturing it? If nothing had existed before it would it still exist at the time when you are picturing it, for it could not have been put out of existence. . . . Would not then nothingness prevail even after this time when you are picturing it? It must, because no thing could be brought into existence to change it. Therefore, if at any time there was a time of complete nothingness, it would had to have prevailed ever before and ever after, consequently no thing ever exists.

Now it seems that today there is something in existence. Because something is in existence that shows that there never must have been a time of complete nothingness for then no thing would have ever existed. If there never could have been a time of complete nothingness, there always must have been something in existence to prevent such a time.[38]

Implying the conservation of matter, Gehry concludes, since something is, something always has been, and always will be.

Second, Gehry, in contrast to Rebay and Wright, is preoccupied with the disharmony rather than the harmony of nature. To counter the suggestion that this is the best of all possible worlds, he presents a list of "disharmonies in nature" ranging from natural disasters and disease to cruelty and suffering. "It is easily seen," Gehry argues, "that nature is by no means perfect. Therefore, nature could not be the result of a perfect being. The responsible thing is not perfect and that is why I say they or it should not be called by the name God because of the perfectness and flawlessness implied. If I *were* to call it God, God to me would no longer hold that almighty, perfect being, but would become a great mute erring thing, which is capable of good and bad, right and wrong."[39]

In other words, if Gehry has a God, it is the errant God of both/and rather than the pure God of either/or.

Contrary to traditional theological wisdom, Gehry does not believe that disharmony necessarily implies disorder. The world, he argues, displays *complex* designs, which involve conflict as well as cooperation. This insight leads Gehry to his third point: order is not imposed from without by a transcendent creator but emerges from within through complex interactions and interrelations. Anticipating some of the insights of today's most sophisticated complexity theorists, Gehry maintains that life involves networks of complex emergent, self-organizing systems. Unconvinced that the complex order of the cosmos requires an all-powerful architect, he concludes by siding with the atheists against the theists.

It is, of course, easy to dismiss Gehry's juvenile theological reflections as irrelevant to his mature architectural work. Looking back over his career, however, it is instructive to see how the questions that preoccupy the teenage Gehry consistently inform his architecture. From his earliest work on his own house, Gehry has been experimenting with unconventional materials and exploring the complex interrelation of shapes and forms. Drawing on the work of artists more than architects, he designs orders of complexity never imagined by his postmodern contemporaries. It is, of course, Robert Venturi who in his influential book *Complexity and Contradiction in Architecture* (1966) attempted to shift architectural theory and practice from the simplicity of Modernism to the complexity of postmodernism.[40] For Venturi and most of the postmodernists influenced by him, complexity tends to remain superficial. Though ornamentation changes, structure remains the same. In Gehry's work, by contrast, complexity becomes radical by transforming structure as such. "The art ideas Gehry brought into architecture," Joseph Giovannini points out,

challenged a whole value system consolidated during the decades of Modernism. . . . Simplicity itself ceded to increasing degrees of complexity, which in turn eschewed the notions of repetition and industrial production on which Modernist design was predicated. Beauty was not to be found in pristine regularities accountable to Euclidean geometries and the T-square, but in combustions of form and material that produced illusions of energy. Rawness rather than polish emerged as a value, along with broken geometries,

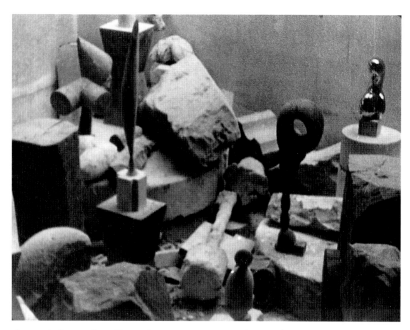

Constantin Brancusi's studio at 11 impasse Ronsin, Paris, photographed by Man Ray.

unfinished surfaces, and the yearnings of incompletion. Gehry was trying to open closed form, and doing so, he opened architecture's closed circuitry to another logic.[41]

The alternative logic that Gehry articulates is structurally similar to what I have described as networking logic. When geometries are fractured, surfaces unfinished, and forms incomplete, structures are opened in ways that allow complexity to emerge.

Reflecting on his experiences as a child, Gehry remarks: "I'm still doing the same thing with little boxes and trash and leftover pieces of wood. But the point is that if there is any thread of continuity in my view of 'the city,' it stems from the fact that I've always thought of the city in sculptural terms and been interested in how the forms of a city create patterns of living. . . . The city is itself a sculpture that can be composed and in which relationships can be established."[42] The city from which Gehry takes his inspiration is, of course, Los Angeles. Where others see confusion and conflict, Gehry discerns order emerging in the midst of complex relations. "I tried to see L.A. for what it was," Gehry remarks. "If you look out the window, you could see everything as a mess— or you could begin to compose things, find relationships between shapes."[43] The task of the architect is to create forms by finding relationships between shapes. Forms and relations, according to Gehry, are inseparable, for relations—or, more precisely, interrelations—constitute forms and forms generate relations. If Gehry's architecture is sculptural, it, like the work of his friend and colleague Richard Serra, takes sculpture off its pedestal and opens it to the complexities of context.

When forms are not isolated, they are shaped by their interconnections and create unexpected interrelations for the people who enter their space.

It is precisely this dynamic of interrelation that Gehry sees at work in his 1976 design for the Jung Institute in Los Angeles. "The individual elements," he explains, "became pieces that you would discover by walking around them and seeing them play against each other sculpturally. This very simple manipulation of a very clear and minimal set of forms—a box, a wedge, an oval—produced a very interesting and complex interplay and set of interrelationships."[44] Far from a single structure, the Jung Institute is a network of structures. The complexity of this network is a function of the intricacy of its relations. Twelve years later, Gehry realized that the interplay of forms is the source of their energy. This insight informed his design of the American Center in Paris (1988–94): "I was thinking of buildings in terms of bottles. You put them together and there's an energy that you do not get from a bottle alone. They have an effect on each other."[45] Just as networks are networks of networks, so Gehry's buildings are buildings of buildings and forms of forms. In all of his architecture, as Herbert Muschamp stresses, "Gehry's main preoccupation is with subtly adjusting the relationships among the forms he employs."[46] If things are relations and relations are always shifting, nothing is stable and everything is in motion. The most extraordinary realization of the complex dynamics of Gehry's complex architecture is the Guggenheim Museum in Bilbao.

In a 1997 interview, Krens describes his vision of the structure of the Guggenheim Museum in uncharacteristically metaphoric terms: "I conceive the Guggenheim Museum as one museum that has a constellation of spaces. . . . Some stars in the firmament might burn a little bit brighter—but that's what constellations are all about."[47] While Krens is referring to a projected network of Guggenheim museums extending from the United States to Europe and beyond, his figure of a constellation is also an apt description of the shapes and spaces in Gehry's building in Bilbao. In contrast to Wright's unified structure, which seamlessly unfolds around a central space, Gehry exposes the seams between forms to generate a complex structure whose parts interact in ever-changing ways. Implicitly suggesting Krens's vision

of the Guggenheim as a distributed network, Gehry has designed a building that is a network of structures in which the whole is more than the sum of its parts.

In some ways, Gehry's Guggenheim is more organic than Wright's. Wright's longing for the "natural" led to a lifelong aversion to cities that eventually drove him to the Arizona desert. At one point, he went so far as to declare: "History records that the civilizations that built the greatest cities invariably died with them. Did the civilizations themselves die of them? I think they did."[48] As a result of this suspicion of cities, Wright made no effort to integrate the Guggenheim with its urban context. His organic spiral is designed to envelop museum-goers in a way that allows them to leave behind the complexity and cacophony of the city and to enjoy the simplicity and harmony of the "temple of art." Gehry, by contrast, is preoccupied with the urban. Profoundly committed to the social responsibility of architecture, he constantly probes what the city is and what it might become. From his earliest appropriation of chain-link and corrugated metal, Gehry acknowledges the gritty side of twentieth-century urbanism and explores the aesthetic resources of the most unlikely materials. Faced with the challenge of building an art museum in a city better known for its industrial past than its cultural traditions, Gehry connected architecture and city by effectively folding site and structure into each other. The site he favored from the outset testifies to his abiding desire to weave his building into the urban-industrial fabric of Bilbao. Rather than removing the museum to the outskirts of town, Gehry located the Guggenheim in the heart of industrial Bilbao by placing it in the midst of a transportation network formed by roads, railroad tracks, and the Nervión River. He further underscored the integration of art and modern life by threading the museum under the Puente de la Salve bridge and wrapping his high reader around one of the main thoroughfares leading into the city. The exposed steelwork of the sculptural tower explicitly connects the museum with Bilbao's industrial infrastructure.

We have already noted that Gehry's sculptural architecture explodes the pedestal by opening inside to outside in endlessly creative ways. In the Guggenheim Museum Bilbao, he inverted the pedestal by sinking the entrance below ground level. To enter this museum one must descend rather than ascend. The sloping stairs leading to the entrance invert Wright's gently unfolding spiral, which had become the Guggenheim's trademark. Upon crossing the threshold of Gehry's building, one enters a space that is both reminiscent of and yet completely different from Wright's structure. Gehry's atrium is as complex as Wright's is simple. Rather than leaving the confusion of the city behind, one is thrust into a futuristic space as disorienting as it is inviting. Gehry admits that his inspiration for this novel space came from an unlikely combination of Brancusi's sculpture studio in Paris and Fritz Lang's 1926 film *Metropolis*. In the overwhelming vertical expanse of this city within a city, it is possible to detect traces of Wright's rotunda. But Gehry transforms the pure white curves from a harmonious whole to dispersed fragments that form irreducibly complex structures.

The steel and glass as well as the rich beige limestone of the exterior carry over into the interior to produce an interplay of interiority and exteriority. Whereas Wright opens inner to outer only at the base and top of his spiral, Gehry translates transcendence into immanence by forging lateral connections through windows, doors, balconies, and terraces. Even when inside the building, one somehow remains outside, and, of course, vice versa. The flow of spaces is as fluid as the water of the river and the movement of the traffic that frame the building.

Film still from Fritz Lang's *Metropolis* (1926).

Struggling to describe the interplay of spaces, Gehry and his associates frequently invoke the metaphor of a "metallic flower." But if the Guggenheim Museum Bilbao is a flower, it is unlike any "natural" plant. The petals of Gehry's metallic flower seem to have been genetically altered in a way that makes each of them different from the others. As Krens suggests, the Guggenheim is a constellation that functions as a whole but is not always a harmonious unit. The network of spaces that Gehry constructs brings together forms and volumes that are usually held apart to form what he describes as "a system that is not a system."[49] Surprisingly, the resulting incongruities are not incoherent. While Krens insisted on the necessity of some traditional boxlike galleries, he also realizes the importance of more innovative spaces for exhibiting art. To fulfill Krens's program, Gehry designed a variety of spaces ranging from the rectilinear to the curvilinear and from small and intimate to vast and overwhelming. What is unexpected about the galleries is the way in which individual spaces are transformed by their interrelations.

Though the petals more or less radiate from a common stem, the atrium does not exactly function as a center that integrates its parts. Rather, the atrium is a relay that serves as a circuit of circulation among different modules. In the midst of these circuits of transfer and exchange, the grid of Modernism gives way to the networks and webs of postmodernism. Ever sensitive to what has been, Gehry is, nonetheless, always intent on what might be. By interfacing grid and network, he connects Bilbao's industrial past with its postindustrial future. In this way, he effectively realizes Krens's fundamental insight: in the world that is emerging, art is increasingly becoming the currency of exchange. The power art exercises is a function of the social and political relations it faciliates and mediates.

In many ways, it seems impossible to respond to the challenge Krens issued to Gehry. How, after all, can the complex, open-ended, nonlinear, volatile structure of networks be captured in steel, glass, and stone? At the precise moment Gehry was pondering this dilemma, in the spring of 1991, he happened to see an exhibition at the Toledo Museum of Art in Ohio, which was entitled *Mirror of Empire: Dutch Marine Art of the Seventeenth Century*. In the paintings of majestic sailing

vessels, Gehry glimpsed traces of the effect he was seeking in his architecture. Commenting on his work at the time, he recalls: "I came at it differently because I sail a boat. I was trying to get a sense of movement in my buildings, a subtle kind of energy. And making a building that has a sense of movement appeals to me, because it knits into the larger fabric of movement in the city. . . . Buildings are part of living in the city and it changes; there's a transient quality."[50] The remarkable titanium-clad forms of the Guggenheim Museum Bilbao appear to be, among other things, the billowing sails, rippling in the wind, of a grand ship docked in the city's port. In this building, Gehry has achieved what seems to be impossible by simultaneously setting forms in motion and giving shape to movement by orchestrating interrelations in complex networks. Never a static structure, Gehry's building is an ongoing event. As one moves around and through the building, it constantly changes. The order of the structure is neither preprogrammed nor permanent but instead emergent and transient. This condition of emergency is created and sustained by the interconnection of forms, interaction of spaces, and interplay of circulatory circuits. Though the structure is never unified, it nonetheless functions as a whole. Since the eventuality of the structure renders it both open and incomplete, the unavoidable seams of forms leave time and space for the aleatory. The infinitely complex activities of figuring, disfiguring, and refiguring are projected on the seemingly fluid titanium surface of the building. As sails morph into screens, the façade of the Guggenheim Museum Bilbao becomes as interactive as the complex networks sustaining it. Gehry's flickering screen displays Krens's vision.

Transforming Networks

Ever since its inception, members of the avant-garde have believed in the transformative power of art and architecture. The nature of transformation and the way in which art accomplishes it, however, have been interpreted in different ways. Amid the many variations on these themes, two tendencies persistently recur. While for some, art functions to effect a personal transformation that tends to be inward, for others art brings about social change in the outer world. This is not to imply that the inward and the outward are separate or

opposed; to the contrary, they are inseparably interrelated. From one point of view, however, outer change follows inner transformation, while from another perspective, selves change only when society is transformed.

Krens and Gehry share Rebay and Wright's faith in the transformative power of art yet with a different understanding of change. For Rebay, art plays a spiritual role by altering people's vision. The task of the architect is to create a temple in which this vision can be cultivated. The utopia for which Rebay and Wright long cannot be realized until human consciousness changes. Less idealistic and utopian and more pragmatic and realistic, Krens is convinced that the power that matters is social, political, and economic. Individual selves are never isolated but are always entangled in complex webs that simultaneously encompass and surpass them. As structures change, subjects are transformed. In the emergent network society, Krens maintains, culture will play an increasingly important role. Accordingly, the responsibility of the museum is not to withdraw from the world by providing a safe sanctuary but to become ever more involved in the networks of relations through which power is distributed. To fulfill this mission, the museum must move beyond showing art and, in Krens's words, play "an active role as a generator of culture."[51] By promoting creative activity, ranging from the production of art to the creation of new institutions, the museum contributes to the transformation of the complex networks of exchange in which reality will be constituted in the twenty-first century.

Notes

1. Thomas Krens, "The Guggenheim Museums: A Vision for the Twenty-first Century," *Guggenheim Magazine* 11 (fall 1997), p. 9.
2. Bruce Brooks Pfeiffer, ed., *Frank Lloyd Wright: The Guggenheim Correspondence* (Carbondale: Southern Illinois University Press, 1986), p. 4.
3. Helena Blavatsky, *The Key to Theosophy* (Point Loma, Calif.: Aryan Theosophical Press, 1913), p. 42.
4. Hilla Rebay, quoted in John M. Lukach, *Hilla Rebay: In Search of the Spirit in Art* (New York: George Braziller, 1983), p. 4.
5. Vasily Kandinsky and Franz Marc, typescript preface, in Kandinsky and Marc, eds., *The Blaue Reiter Almanac* (1912), new documentary ed., Klaus Lankheit (New York: Viking Press, 1974), p. 250.
6. Kandinsky, *Concerning the Spiritual in Art*, trans. M. T. H. Sadler (New York: Dover, 1977; 1911), p. 14.
7. Ibid., pp. 2, 32.
8. Kandinsky, *Point and Line to Plane*, trans. Howard Dearstyne and Hilla Rebay (New York: Dover, 1979; 1926), p. 21.
9. Kandinsky, "On the Question of Form," in Kandinsky and Marc, eds., *Blaue Reiter Almanac*, pp. 164–65.
10. Pfeiffer, ed., *Frank Lloyd Wright: The Guggenheim Correspondence*, p. 28.
11. Rudolf Bauer, quoted in Lukach, *Hilla Rebay*, p. 29.
12. Rebay, "Definition of Non-Objective Painting," in *Solomon R. Guggenheim Collection of Non-Objective Paintings*, exh. cat. (Charleston, S.C.: Gibbes Memorial Art Gallery, 1936), p. 10.
13. Ibid., p. 12.
14. Frank Lloyd Wright, *An Organic Architecture: The Architecture of Democracy* (London: Lund Humphries, 1939), p. 47.

15. Robert McCarter, *Frank Lloyd Wright* (London: Phaidon Press, 1997), p. 12.
16. Wright later came to have contact with Rebay's world of spirituality through his wife, Olgivanna, a follower of G. I. Gurdjieff as well as a student and instructor at the Institute for the Harmonious Development of Man in Paris.
17. Walt Whitman, quoted in David Michael Hertz, *Angels of Reality: Emersonian Unfoldings in Wright, Stevens, and Ives* (Carbondale: Southern Illinois University Press, 1993), p. 144.
18. Wright, *Organic Architecture*, p. 24.
19. Wright, *An Autobiography* (New York: Horizon Press, 1977; 1943), p. 453.
20. Wright, *Organic Architecture*, p. 9.
21. Rebay, "Definition of Non-Objective Painting," p. 12.
22. Wright, *Autobiography*, p. 168.
23. Ibid., p. 170.
24. Ibid., pp. 366–68.
25. Pfeiffer, ed., *Frank Lloyd Wright: The Guggenheim Correspondence*, pp. 60–61.
26. Rebay, quoted in Lukach, *Hilla Rebay*, pp. 186–87.
27. Pfeiffer, ed., *Frank Lloyd Wright: The Guggenheim Correspondence*, p. 28.
28. Ibid., p. 40. Wright does not really integrate the museum into its urban setting. This is at least in part a function of his suspicions about cities.
29. Wright, quoted in McCarter, *Frank Lloyd Wright*, p. 311.
30. Pfeiffer, ed., *Frank Lloyd Wright: The Guggenheim Correspondence*, p. 296.
31. Ibid., p. 234.
32. Wright, quoted in Hertz, *Angels of Reality*, p. 261.
33. Krens, "The Guggenheim Museums," p. 8.

34. Krens, interview with Kim Bradley, *Art in America* 85 (July 1997), p. 53.
35. Ibid.
36. Manuel Castells, *The Rise of the Network Society* (Cambridge, Mass.: Blackwell, 1996), p. 61.
37. Frank Gehry, "Theism or Atheism?," unpublished manuscript.
38. Ibid.
39. Ibid.
40. Robert Venturi, *Complexity and Contradiction in Architecture*, 2d ed. (New York: Museum of Modern Art, 1977; 1966).
41. Joseph Giovannini, "Art into Architecture," *Guggenheim Magazine* 11 (fall 1997), pp. 20–21.
42. Gehry, quoted in Coosje van Bruggen, *Frank O. Gehry: Guggenheim Museum Bilbao* (New York: Solomon R. Guggenheim Museum, 1997), p. 72.
43. Gehry, quoted in Cathleen McGuigan, "A Maverick Master," *Newsweek*, June 17, 1991, p. 54.
44. Gehry, quoted in van Bruggen, *Frank O. Gehry*, p. 73.
45. Ibid., p. 60.
46. Herbert Muschamp, "The Miracle in Bilbao," *The New York Times Magazine*, September 7, 1997, p. 82.
47. Krens, quoted in van Bruggen, *Frank O. Gehry*, p. 96.
48. Wright, *Autobiography*, p. 342.
49. Gehry, "Since I'm so Democratic, I Accept Conformists," in Charles Jencks, ed., *Frank O. Gehry: Individual Imagination and Cultural Conservatism* (London: Academy Editions, 1995), p. 44.
50. Gehry, quoted in van Bruggen, *Frank O. Gehry*, p. 62.
51. Krens, quoted in ibid., p. 99.

THE WORLD AS THINGS

Collecting Thoughts on Collecting

[Fleda] took the measure of the poor lady's strange, almost maniacal disposition to thrust in everywhere the question of "things," to read all behaviour in the light of some fancied relation to them. "Things" were of course the sum of the world; only, for Mrs. Gereth, the sum of the world was rare French furniture and oriental china. She could at a stretch imagine people's not "having," but she couldn't imagine their not wanting and not missing.

——HENRY JAMES, *The Spoils of Poynton* (1897)

The world is the totality of facts, not of things.
——LUDWIG WITTGENSTEIN,
Tractatus Logico-Philosophicus (1921)

I

Not this or that collection is my assignment here, but collecting as such, or, as it was also specified to me, the philosophy of collecting. And presumably not collecting as what dust does on shelves, or rain does in pails, or as what is called a "collector" does on certain roofs, gathering particulates to monitor air pollution; but as someone collects medals, coins, stamps, books, skeletons, jewels, jewel boxes, locks, clocks, armor, vases, sarcophagi, inscriptions, paintings, curiosities of unpredictable kinds. Krzysztof Pomian, in his remarkable study *Collectors and Curiosities*, declares that every human culture has collected and that every movable thing has been collected.[1] As if collecting for possession and display is as primitive as gathering food for survival.

But while we may sensibly speculate, or ask, why certain people collect stamps, jewels, skeletons, etc., and why different things seem favored for collection by different classes or ranks of society, or different genders or ages, in different historical periods, is it sure that it makes sense to ask why people collect as such—any more than it makes obvious sense to ask what my relation to things is as such, or my relation to language, or what the point of thinking is?

Yet writers about collecting are characteristically moved precisely to advance some idea of what the point of collecting is as such, as a form of human life. For instance, Jean Baudrillard articulates collecting as an objectifying of oneself in a simulation of death which one symbolically survives within one's life; Pomian begins with the fact of collecting as removing objects from economic circulation and putting them on display, and speaks of a consequent establishment of connection between the invisible and the visible, the realm of religion, made possible (and inevitable?) by the advent of

Sigmund Freud's desk and some objects in his collection in his study, Freud Museum, London.

language; Susan Stewart combines the withdrawal of objects from use with the establishment of a commerce between death and life (as if creating a realm of mock exchange [mock religion?]); Robert Opie is one of many who see in collecting an attempt to reproduce and hence to preserve or to recapture the world; Philip Fisher, concentrating on art museums since the Enlightenment, identifying stages of a history in which an object is removed from its original setting (of use, say, in battle or in prayer), becoming a thing of memory (a souvenir or a relic), and ending up as an object for aesthetic appreciation, arrives at a definition of the museum as a place of the making of art, an institution of practices within which the function of art is operable; Michel Foucault, in the paradigmatic onslaught of his *The Order of Things*, speaks of shifts in our ways of "taming the wild profusion of things."[2] I shall not refrain from certain similar speculations in what follows.

(I should note at the outset that an important issue about collections, one that makes news, plays almost no role here, that concerning the right to exhibit, or to own, objects improperly taken from, or identified with, another culture. My excuse for silence is that such a conflict is apt to be poorly discussed apart from a patient account and interpretation of the forces in play in a concrete historical context, which is not how I have conceived the form of my contribution. James Clifford, in his deservedly admired *The Predicament of Culture*, provides such context for several cases, guided by the principle that living cultures worldwide are inherently appropriating the strange, the evidently predatory cultures no less than the obviously victimized.)[3]

II

Speculation about the role of collections in human life has been explicit since at least the problem of the One and the Many, made philosophically inescapable in Plato's Theory of Forms, or Ideas, according to which the individual things present to our senses are knowable, are indeed what they are, by virtue of their "participation" in, or "imitation" of, the realm of Forms, which provides us with our armature of classification, to put it mildly. The Platonic hierarchy disparages the things, the life, of ordinary sensuous experience, this realm of the transient and the inexact, in contrast with the perfect, permanent realm of the Ideas. To know a thing in the lower realm is to know which Ideas it imitates in common with other things of its kind: there are many chairs, but just one Idea of (the perfect, hence perfectly knowable) chair; the Form of a chair is what is common to, the common aspiration of, the collection of the things that are, and are known as, chairs. Just how the relation between the many and the one (or as it came to be called in later philosophy, the universal and the particular) is to be conceived became at once a matter of controversy in the work of Aristotle, and the problem of the status of universals has not abandoned philosophy to this day.

But a perplexity other than the relation of universal and particular, or a more specialized version of the relation of a general term to a singular object, is more pressing for us when we attempt to bring the issue of the collection into view. We have, in effect, said that every collection requires an idea (or universal, or concept). (This seems to presage the fact, testified to by many writers on collecting, that collections carry narratives with them, ones presumably telling the point of the gathering, the source and adventure of it.) But can we say the reverse, that every idea requires (posits, names) a collection? This is a form of the question: How can signs refer to what is non-existent? What do expressions such as "Pegasus," "a round square," "the present King of France," refer to, and if to nothing, what do they mean, how can they mean anything, how can anything true or false be said of them? Bertrand Russell and Edmund Husserl were both caught by the importance of such a question; it was, I suppose, the last moment at which what has come to be called analytical philosophy and what (consequently?) came to be called Continental philosophy so clearly coincided in concern. It was Russell's solution to the question of the reference of such terms, by means of his theory of descriptions (which evaluates the terms by means of modern logic to demonstrate perspicuously that it is not they that assert reference to something), that can be said to have established a preoccupation and to have determined the style of analytical philosophy, and the style appears to have outlasted that preoccupation. The preoccupation also outlasted the style. The first section of Wittgenstein's *Philosophical Investigations* announces its first interpretation of the passage from Augustine with which it opens, in which Augustine recalls his learning of language: *[Augustine's] words give us a particular picture of the essence of human language. It is this: the individual words in language*

574. A proposition, and hence in another sense a thought, can be the 'expression' of belief, hope, expectation, etc. But believing is not thinking. (A grammatical remark.) The concepts of believing, expecting, hoping are less distantly related to one another than they are to the concept of thinking.

575. When I sat down on this chair, of course I believed it would bear me. I had no thought of its possibly collapsing.
But: "In spite of everything that he did, I held fast to the belief" Here there is thought, and perhaps a constant struggle to renew an attitude.

576. I watch a slow match burning, in high excitement follow the progress of the burning and its approach to the explosive. Perhaps I don't think anything at all or have a multitude of disconnected thoughts. This is certainly a case of expecting.

577. We say "I am expecting him", when we believe that he will come, though his coming does not *occupy our thoughts*. (Here "I am expecting him" would mean "I should be surprised if he didn't come" and that will not be called the description of a state of mind.) But we also say "I am expecting him" when it is supposed to mean: I am eagerly awaiting him. We could imagine a language in which different verbs were consistently used in these cases. And similarly more than one verb where we speak of 'believing', 'hoping' and so on. Perhaps the concepts of such a language would be more suitable for understanding psychology than the concepts of our language.

578. Ask yourself: What does it mean to *believe* Goldbach's theorem? What does this belief consist in? In a feeling of certainty as we state, hear, or think the theorem? (That would not interest us.) And what are the characteristics of this feeling? Why, I don't even know how far the feeling may be caused by the proposition itself.
Am I to say that belief is a particular colouring of our thoughts? Where does this idea come from? Well, there is a tone of belief, as of doubt.
I should like to ask: how does the belief connect with this proposition? Let us look and see what are the consequences of this belief, where it takes us. "It makes me search for a proof of the proposition." —Very well; and now let us look and see what your searching really consists in. Then we shall know what belief in the proposition amounts to.

579. The feeling of confidence. How is this manifested in behaviour?

580. An 'inner process' stands in need of outward criteria.

581. An expectation is imbedded in a situation, from which it arises. The expectation of an explosion may, for example, arise from a situation in which an explosion *is to be expected*.

582. If someone whispers "It'll go off now", instead of saying "I expect the explosion any moment", still his words do not describe a feeling; although they and their tone may be a manifestation of his feeling.

583. "But you talk as if I weren't really expecting, hoping, *now*— as I thought I was. As if what were happening *now* had no deep significance."—What does it mean to say "What is happening now has significance" or "has *deep* significance"? What is a *deep* feeling? Could someone have a feeling of ardent love or hope for the space of one second—*no matter what* preceded or followed this second?— What is happening now has significance—in these surroundings. The surroundings give it its importance. And the word "hope" refers to a phenomenon of human life. (A smiling mouth *smiles* only in a human face.)

584. Now suppose I sit in my room and hope that N.N. will come and bring me some money, and suppose one minute of this state could be isolated, cut out of its context; would what happened in it then not be hope?—Think, for example, of the words which you perhaps utter in this space of time. They are no longer part of this language. And in different surroundings the institution of money doesn't exist either.
A coronation is the picture of pomp and dignity. Cut one minute of this proceeding out of its surroundings: the crown is being placed on the head of the king in his coronation robes.—But in different surroundings gold is the cheapest of metals, its gleam is thought vulgar. There the fabric of the robe is cheap to produce. A crown is a parody of a respectable hat. And so on.

585. When someone says "I hope he'll come"—is this a *report* about his state of mind, or a *manifestation* of his hope?—I can, for example, say it to myself. And surely I am not giving myself a report. It may be a sigh; but it need not. If I tell someone "I can't keep my mind on my work today; I keep on thinking of his coming"— *this* will be called a description of my state of mind.

§§ 574–85 of Ludwig Wittgenstein's *Philosophical Investigations,* 3d ed., trans. G. E. M. Anscombe (Englewood Cliffs, NJ: Prentice Hall, 1958; 1953).

*name objects—sentences are combinations of such names. —In this picture of language we find the roots of the following idea: Every word has a meaning. The meaning is correlated with the word. It is the object for which the word stands.*4

It is a picture of language from which philosophers of both the Anglo-American analytical tradition and the German-French tradition continue to perform, in their different ways, hairbreadth escapes.

Of interest here is that the first example (the first "language game" of a sort) that Wittgenstein develops in response to this picture materializes not around a single absent object but around a collection:

*I send someone shopping. I give him a slip on which stands the signs "five red apples"; he takes the slip to the shopkeeper, who opens the drawer on which stands the sign "apples"; then he looks up the word "red" in a table and finds a color sample opposite it; then he says the series of cardinal numbers.*5

Reference—if this means linking a sign to an object—is hardly the chief of the problems revealed in this curious, yet apparently comprehensible, scene. How did the shopper know to whom to present the slip? Does the sign "apple" on his slip refer to the sign "apple" on the shopkeeper's drawer? They may not at all look alike. Would it have secured the linkage to have provided the shopper with a photograph or a sketch of the drawer and its sign? How would the shopkeeper know what the point of the photograph or sign is supposed to be? (Perhaps he will hang it on his wall.) Does the sign on the slip rather refer (directly, as it were) to the items inside the closed drawer? But we are free to imagine that when the shopkeeper opens the drawer it is empty. Did the signs on the slip and on the drawer then become meaningless? And if there were only four apples then would just the word "five" have become meaningless? Do you want an explanation of how it happens that signs retain their meaning under untoward circumstances? Shouldn't you also want an explanation of the fact that the drawer was marked "apples" rather than, say, "red," whereupon the shopkeeper would be expected to look up the word "apple" on a chart of fruits and vegetables (we won't ask how he knows which of his charts to consult)?

Do we know why we classify as we do? In order to know, would we have to memorize what Foucault says about changing conditions of possibility? Wittgenstein's primitive, and studiedly strange, opening example can be taken as stirring such wisps of anxiety among the threads of our common lives that we may wonder, from the outset of thinking, how it is that philosophy, in its craving for explanation, seeks to explain so little, that is to say, how it conceives that so little is mysterious among the untold threads between us that become tangled or broken. Perhaps Wittgenstein may be taken as redressing philosophy's disparagement of the things of sense when late in the *Tractatus* he finds: "It is not *how* things are in the world that is mystical, but *that* it exists."6

III

Baudrillard declares:

*While the appropriation of a "rare" or "unique" object is obviously the perfect culmination of the impulse to possess, it has to be recognized that one can never find absolute proof in the real world that a given object is indeed unique. . . . The singular object never impedes the process of narcissistic projection, which ranges over an indefinite number of objects: on the contrary, it encourages such multiplication whereby the image of the self is extended to the very limits of the collection. Here, indeed, lies the whole miracle of collecting. For it is invariably oneself that one collects.*7

How well do we understand this final claim? Let us consider that one of the most celebrated American plays of the middle

Film still from Orson Welles's *Citizen Kane* (1941) showing Kane's collection in storage after his death.

of this century, Tennessee Williams's *The Glass Menagerie* (1944), depends upon its audience's capacity for a rapt understanding of the daughter Laura's identification with her collection of fragile glass figures. And this understanding is not broken, but is deepened, when her Gentleman Caller accidentally steps on her favorite piece, a tiny unicorn, breaking off its horn, and Laura reveals an unexpected independence of spirit, refusing the suggestion of a clumsy castration and instead observing something like, "It makes him more like other creatures," a state she also has reason to desire. Another famous work of that period, Orson Welles's *Citizen Kane* (1941), equally depends upon some identification of a person by his collection, but here some final interpretation of its meaning appears to be dictated to us by the closing revelation of the childhood sled, Rosebud. I like thinking that when Jay Gatsby is in the course of realizing his fantasy of showing Daisy his house, his showplace, and unfurls his fabulous collection of shirts before her, it is clear that the value he attaches to them, or to anything, is a function of their value to her. No other object contains him; he is great.

So let us not be hasty in arriving at very firm conclusions about what our relation to collections is, hence what relation they may propose concerning our relation to the world of things as such. It may be worth remembering further here

that two of a series of recent films breaking all attendance records, Steven Spielberg's *Raiders of the Lost Ark* (1981) and *Indiana Jones and The Last Crusade* (1989) are about the fatality of a quest for a unique object, and that the closing shot of the former, the camera floating over an unclassifiably colossal collection of crated objects among which, some unpredictable where, the unique lost object of the quest is anonymously contained, seems some kind of homage to the closing roving shot of *Citizen Kane*, where now the integrity of civilization, not merely of a single unsatisfied millionaire, is at stake.

IV

Both Wittgenstein and Martin Heidegger, in something like opposite directions, break with the ancient picture of the things of the world as intersections of universals and particulars. Wittgenstein's way is, characteristically, almost comically plain and casual.

Instead of producing something common to all that we call language, I am saying that these phenomena have no one thing in common which makes us use the same word for all. . . . Consider for example the proceedings that we call "games." I mean board-games, card-games, Olympic games, and so on. What is common to them all? Don't say: "There must be something common, or they would not be called 'games'"—but look and see whether there

is anything common to all. . . . [Y]ou will . . . see . . . similarities,
relationships, and a whole series of them at that. . . . I can think of
no better expression to characterize these similarities than "family
resemblances."[8]

This idea has had the power of conversion for some of its
readers—too precipitously to my way of thinking, since it does
not account for Wittgenstein's signature play of casualness
with profundity. He still wants to be able to articulate the
essences of things.

Heidegger's way of breaking with universals is, character-
istically, almost comically obscure and portentous. In a semi-
nal essay "The Thing," he opens with the assertion, "All dis-
tances in time and space are shrinking," surely a banality we
might expect to see in any newspaper.[9] Then he undertakes to
show us that we do not know the meaning of the banalities of
our lives.

Yet the frantic abolition of all distances brings no nearness; for
nearness does not consist in shortness of distance. . . . How can we
come to know [the nature of] nearness? . . . Near to us are what
we usually call things. But what is a thing? Man has so far given
no more thought to the thing as a thing than he has to nearness.[10]
Is Heidegger here constructing a parable of the museum, per-
haps a rebuke to those who think art brings things near in the
empirical manner of museums? He takes as his most elabo-
rated example that of the jug, which holds water or wine, and
he spells out a vision in which the water, retaining its source
in the running spring, marries earth and sky, and in which
the wine, which may be the gift of a libation, connects mortals
and gods. Heidegger concentrates these and other properties
of the jug in such words as these: "The thing things. Thinging
gathers. Appropriating the fourfold [earth, sky, mortals, gods],
it gathers the fourfold's stay, its while, into something that
stays for a while: into this thing, that thing."[11] Without giving
the German, which has caused a diligent translator recourse
to this near-English, I trust one can see the point of my saying
that Heidegger, in this text (and it variously relates to many
others), is a philosopher of collecting.

What I meant by speaking of the opposite directions
taken in Heidegger's and Wittgenstein's perspectives I might
express by saying that whereas Heidegger identifies things as
implying the setting of the world in which they are and do
what they surprisingly are and do, Wittgenstein identifies

things as differing in their positions within the system of
concepts in which their possibilities are what they surpris-
ingly are. We cannot simply say that Heidegger is concerned
with essence ("What, then, is the thing as thing, that its essen-
tial nature has never yet been able to appear?")[12] and that
Wittgenstein is not so concerned (he, in fact, announces that
grammar, which provides the medium of his philosophizing,
expresses essence).[13] Nor can we say that Wittgenstein is
concerned with language and Heidegger not, for while
Wittgenstein says, "Grammar tells what kind of object any-
thing is"[14] (or more literally, "It is essence that is articulated
in grammar"), Heidegger writes, "It is language that tells us
about the nature of a thing, provided that we respect lan-
guage's own nature."[15]

If Heidegger is a philosopher of collecting, Wittgenstein
composes his *Investigations* in such a way as to suggest that
philosophy is, or has become for him, a procedure of collect-
ing. Only the first, and longest, of its two parts was prepared
by him for publication and its 172 pages consists of 693 sec-
tions; in his Preface he calls the book "really only an album."
For some, me among them, this feature of Wittgenstein's pre-
sentation of his thoughts is essential to them and is part of
their attraction. For others it is at best a distraction. Ralph
Waldo Emerson's writing has also had a liberating effect
on my hopes for philosophical writing, and I have taken
the familiar experience of Emerson's writing as leaving the
individual sentences to shuffle for themselves to suggest
that each sentence of a paragraph of his can be taken to be
its topic sentence. I welcome the consequent suggestion that
his essays are collections of equals rather than hierarchies
of dependents.

V

I do not make the world that the thing gathers. I do not sys-
tematize the language in which the thing differs from all
other things of the world. I testify to both, acknowledge my
need of both.

The idea of a series, so essential to the late phase of
Modernist painting (epitomized, in one major form, in
Michael Fried's *Three American Painters* catalogue of 1965, on
the work of Kenneth Noland, Jules Olitzki, and Frank Stella)[16]
captures this equipollence in the relation between individual

and genus or genre. These manifestations of participation in an idea may seem excessively specialized, but the implication of their success (granted one is convinced by their success as art) seems some late justification for the existence of collections and for places in which to exhibit their items in association with one another, as if the conditions of the makeup of the world and of the knowing of the world are there put on display and find reassurance.

This is an odd point of arrival, this emphasis on knowledge as marking our relation to the world, after a bit of byplay between Heidegger and Wittgenstein, whose importance to some of us is tied to their throwing into question, in their radically different ways, philosophy's obeisance to epistemology, its development of the question of knowledge as the assessment of claims along the axis of certainty, certainty taken as its preferred relation to objects (as opposed, for example, to recognition, or intimacy, or mastery). It is in modern philosophical skepticism, in René Descartes and in David Hume, that our relation to the things of the world came to be felt to hang by a thread of sensuous immediacy, hence to be snapped by a doubt. The wish to defeat skepticism, or to disparage it, has been close to philosophy's heart ever since. To defeat skepticism need not be a declared grounding motive of a philosophical edifice, as it is in Immanuel Kant; it may simply be declared a bad dream, or bad intellectual manners, as in W. V. Quine, who finds skepticism vitiated by science, whose comprehensibility needs from experience only what Quine calls certain measured "check points."[17] Philosophers such as William James and John Dewey are forever appalled by what their fellow empiricists have been willing to settle for in the name of experience, steadfastly refusing to give our birthright in return for, it may seem, so specialized a world, the world as required by the success of modern science. (Foucault calls it the world of black and white.)

When Walter Benjamin tracks the impoverishment of our (Western, late capitalist) experience, and relates it to a distance from objects that have become commodified, hence mystified in their measurement not for use but for the signs of exchange, he does not, so far as I know, relate this experience to philosophy's preoccupation with skepticism, to an enforced distance from the things of the world and others in it by the very means of closing that distance, by the work of

my senses. But then Benjamin seems to harbor a fantasy of a future that promises a path—through collecting—to new life, a reformed practicality with, or use for, objects.

The interior was the place of refuge of Art. The collector was the true inhabitant of the interior. He made the glorification of things his concern. To him fell the task of Sisyphus which consisted of stripping things of their commodity character by means of his possession of them. But he conferred upon them only a fancier's value, rather than use-value. The collector dreamed that he was in a world which was not only far-off in distance and in time, but which was also a better one, in which to be sure people were just as poorly provided with what they needed as in the world of everyday, but in which things were freed from the bondage of being useful.

The interior was not only the private citizen's universe, it was also his casing. Living means leaving traces. In the interior, these were stressed. . . . The detective story appeared, which investigated these traces.[18]

The collector knows that our relation to things should be better, but he does not see this materialized through their more equitable redistribution, or, say, through recollection. That the interior place of Art, and the collector as its true inhabitant, is registered as past may suggest that the place of Art is altered, or that the time of Art and its private collecting is over, or that interiority is closed, or that these proprieties of experience have all vanished together.

Take the formulation, "Living means leaving traces." In conjunction with the figure of the detective, the implication is that human life, as the privileged life of the interior and its "coverings and antimacassars, boxes and casings," is a crime scene, that (presumably in this period of exclusive comfort) human plans are plans contracted by the guilty. So presumably Benjamin's writing is at once confessing in its existence as traces the guilt of its privilege and at the same time declaring that its obscurity is necessary if it is not to subserve the conditions that insure our guilt toward one another. But the direct allusion to Karl Marx ("[the collector] conferred on [things] only a fancier's value, rather than use-value"), hence to Marx's derogation of exchange value as a realm of mystery, suggests a mystery in the living of the life of traces that cannot be solved by what are called detectives.

The idea that the evidence of life produced by each of us is of the order of traces conveys a picture according to which

no concatenation of these impressions ever reaches to the origin of these signs of life, call it a self. Then the thrill of the detective story is a function of its warding off the knowledge that we do not know the origins of human plans, why things are made to happen as they do. Traces relate the human body's dinting of the world back to this particular body, but how do we relate this body to what has dinted it? If it was something inside, how do we correlate the events (how compare the sorrow with its manifestation)? If it was something outside, why is *this* the effect (why sorrow instead of contempt or rage)? The discovery of the identity of the criminal is bound to be anticlimactic, something less than we wanted to know.

It does seem brilliant of Edgar Allan Poe, in "The Murders in the Rue Morgue" (1841), to have presented the traces of a crime early in the history of the genre, so that the solution depends upon realizing that they are not effects of a human action but of those of an ape, as though we no longer have a reliable, instinctive grasp of what the human being is capable of. Was the hand of man, therefore, not traced in this crime? What brings murderousness into the world? What detective responds to this evolutionary crossroads?

Beyond this, let's call it, skepticism of traces, I take Benjamin's portrait, or function, of the collector as the true inhabitant of the interior to suggest that the collector himself is without effective or distinctive interiority, without that individuality of the sort he prides himself on. So that when Benjamin goes on to identify the *flâneur*'s search for novelty as engendered by "the collective unconscious" and its craving for fashion,[19] this can be taken to mean that what is interpreted by an individual as his uniqueness is merely an item of impulse in an unobserved collection of such impulses, hence anything but original; call it, after Emerson, the source of conformity, part of the crowd after all.

VI

How did it become fashionable for disparagers of skepticism to tell the story of Dr. Johnson, who, receiving Bishop Berkeley's "denial" of matter, kicked a stone, replying, "Thus I refute you." People who know nothing of the motives of skepticism know a version of this story. How strange a scene it offers. Why, to begin with, is kicking a hard object more a "refutation" of immateriality than, say, sipping wine, or

putting your hand on the arm of a friend, or just walking away on solid ground, or muddy for that matter? Why is a sensation in the toe taken to be closer to the things of the world than one in the throat or in the hand or on the sole of the foot? Does Samuel Johnson take himself to be closer to his foot than to his throat or his hand? Or is it the gesture that is important—the contempt in kicking? Emerson assigns to Johnson the saying, "You remember who last kicked you." Is Johnson's refutation accordingly to be understood as reminding the things of earth who is master, as an allegory of his contempt of philosophy left to its arrogance? Or is it—despite himself—a way of causing himself pain by the things of the world, implying that he knows they exist because he suffers from them? And, if so, had he then forgotten when he last kicked them, or brushed them by?

VII

Some I know, otherwise than Benjamin offended by claims to individuality, profess to understand the self—presumably of any period and locality—as some kind of collection of things, as though such a collection is less metaphysically driven on the face of it than the simple, continued self that Hume famously denies, or would deny to all save harmless metaphysicians. Leaving these self-isolating ones aside, Hume "[ventures] to affirm of the rest of mankind, that they are nothing but a bundle or collection of different perceptions."[20] This alternative picture, however, retains relations among the collection such as resemblance, causation, memory, and the incurable capacity of the whole to torment itself with "philosophical melancholy and delirium."[21] Then when Hume confesses here that "I find myself absolutely and necessarily determined to live, and talk, and act like other people, in the common affairs of life,"[22] how are we to take this assertion against his earlier, famous assurance in the section "Of Personal Identity" that "for my part, when I enter most intimately into what I call *myself*, I always stumble on some particular perception or other, of heat or cold, light or shade, love or hatred, pain or pleasure. I never can catch *myself* at any time without a perception"?[23] What idea (held or deplored) must we understand Hume to have of "entering most intimately into what I call myself"—what perception announces to him this entering? And what would count as a

pertinent perception he has stumbled on when he declares his "absolute and necessary determination" to live like other people in the common affairs of life—what perception of absoluteness or determination? And is this determination meant to assure himself that he is like other people? Do other people have such a determination to live . . . like themselves? If they do, he is not like them (does not live like them); if they do not, he is not like them (does not think like them).

Hume goes on to say, fascinatingly, that "the mind is a kind of theater," glossing this as emphasizing that "perceptions successively make their appearance, pass, re-pass, glide away, and mingle in an infinite variety of ways. There is properly no *simplicity* in it at one time, nor *identity* in different."[24] But what isn't there? What is the metaphysical proposal that must be denied? Setting aside whatever importance there is to be attached to our "natural propension" to seek some such simplicity or identity, the question Hume poses was, "From what impression could [our] idea [of the self] be deriv'd?"[25] I am, for my part, prepared to say that, if we derive from the idea of the mind as a theater the idea that what we witness there are scenes and characters—so impressions of a scene in which characters are in light and dark, expressing love or hatred, manifesting pain or pleasure—these provide precisely impressions or perceptions of myself, revelations of myself, of what I live and die for, wherein I catch myself. They are not— I am happy to report—simple and identical the way impressions of simple, stable things are. They are ones I might miss, as I might miss any other chance at self-discernment. I must discover a narrative for the scene and an identity for the characters and see how to decipher my role in the events. No impression of a thing which failed to relate that thing to itself as a witness or party to its own concerns (or to understand how it fails in a given case in this role) would be an impression of a self, of a thing to which to attribute personhood. Whether what I find is unity or division, simplicity or complicity, depends upon the individual case—both of the one under narration, the collection, or of the one doing the narration, call him or her the collector, or adaptor, or ego.

VIII

In his introduction to the *Treatise*, Hume remarks, "'Tis no astonishing reflection to consider, that the application of

experimental philosophy to moral subjects should come after that to natural at the distance of above a whole century"—he constructing his application of Newtonianism to human encounter in the century after Sir Isaac Newton's consolidation of the new (corpuscular) science, and considering how long it took Nicolaus Copernicus and the others to arrive at the new science against the reign of Aristotelianism.[26] It took another century and a half after Hume for the Freudian event to arrive, with its methodical discoveries of what the "impressions" or "perceptions" are in relation to which we catch ourselves. Call the discoveries new laws, or new ideas of laws, of attraction and repulsion and of the distance over which they act. Whether this span is astonishingly long or short depends on where you start counting from—Sophocles, Shakespeare, Schopenhauer. . . . More urgent than determining the time of the achievement is recognizing its fragility. This new knowledge of the self, as Sigmund Freud explained, perpetually calls down repression upon itself. Since it is these days again under relatively heavy cultural attack (sometimes in conjunction with philosophy, sometimes in the name of philosophy), it is worth asking what would be lost if this knowledge is lost, what aspiration of reason would be abdicated.

That aside, the idea of a self as a collection requiring a narrative locates the idea that what holds a collection together, specifically perhaps in the aspect of its exhibition, is a narrative of some kind. We might think of this idea as the issue of the catalogue, where this refers not simply to the indispensable list of objects and provenances, but to the modern catalogue produced by curators who are as responsible for circulating ideas as for acquiring and preserving objects. Mieke Bal is explicit in positing a narrative among the objects of an exhibition; Stewart more implicitly invokes narrative interaction in her perception of what she calls the animation of a collection; Fisher presents his idea of the effacing and the making of art as a sort of counternarrative, even effecting a certain counteranimation of objects.[27] The issue of the catalogue is, I think, a pertinent emphasis for Norton Batkin's proposal that an exhibition be informed by its objects' own preoccupations with their fatedness to the condition of display, for example, by their relation to the theatrical, or to the pervasiveness of the photographic, or, perhaps later, to what remains of the experience of collage, or of assemblage.[28]

IX

Batkin's concern, evidently, is that the current emphasis on the concept of collecting, on establishing a holding, not come to swamp the concept, and the practices of exhibiting the holding. A shadow of my concern here, rather, has been that the concept of a collection not swamp the concept and perception of the particulars of which it is composed. Both are concerns, I think, that the worth of certain values in the concept of art not be misplaced, that is, lost—for example, that the demand to be seen, call it the demand of experience to be satisfied, however thwarted or deferred, not be settled apart from a responsiveness to the claims of individual objects upon experience.

This says very little, but that little is incompatible with, for example, the recently fashionable tendency among aestheticians in the philosophically analytical mode to let the question of conferring or withholding the status of art upon an object be settled by whether or not someone or some place or other puts it on display (with no Duchampian taste for naughtiness and scenes). If it comes to this, I should prefer to let the status of the object be settled by the persuasiveness of the catalogue. But artists who work in series can be taken to declare that only art can determine which singularities can sustain, and be identified by, a collection of works of art.

The problem here is one already there in Kant's founding of the modern philosophy of art, in his *Critique of Judgment*.[29] His characterization of the aesthetic judgment as placing a universal demand for agreement on the basis of one's own subjectivity in assessing pleasure and purposiveness perhaps draws its extraordinary convincingness from its transfer to the act of judgment what should be understood as the work of the work of art (of, as it were, the thing itself), namely, lodging the demand to watch. It is not news that we moderns cannot do or suffer without intellectualizing our experience. Then we should at least make sure that our intellectualizing is after our own hearts. Criticism, which (drawing out the implication of Kant's findings) articulates the grounds in a thing upon which agreement is demanded, after the fact of pleasure, bears a new responsibility for the resuscitation of the world, of our aliveness to it.

It remains tricky. When Henry David Thoreau one day at Walden moved all the furniture in his cabin outside in order to clean both the cabin and the furniture, he noticed that his possessions looked much better outdoors than they ever had when in their proper place. This is an enviable experience, and valuable to hear. But it did not make his possessions works of art. Then, recently, I read of some new legislation proposed against price-fixing schemes at certain prominent auction houses, about which a lawyer remarked that the movement of works of art is now being treated to legal constraints designed for deals in milk and cement. I reported this to Bernard Blistène, my host at the Centre Georges Pompidou, as we were about to enter a splendid exhibition there devoted to structures in cement and iron. He replied that he knew a German artist who works with milk.

But in what continues here I shall remain indiscriminate in collecting thoughts of collections in the world of things, leaving the differences in the realm of art mostly to shift for themselves, and perhaps, at times, toward us.

X

The other week, I saw for the first time Chantal Akerman's breakthrough film, *Jeanne Dielman/23 quai du Commerce/1080 Bruxelles* (1975), known for the originality of its vision of film and of what film can be about, for its length (three and a half hours), for its director's age (she was twenty-four when she made it), and for the performance of Delphine Seyrig. I adduce it here because it can be taken as a study, or materialization, of the self as a collection, in the particular form in which the one who is the subject of the collection is not free (or not moved?) to supply its narrative. I sketch from memory certain events, mostly of its first hour, already knowing that while little happens that in customary terms would be called interesting, the way it is presented, in its very uneventfulness, makes it almost unthinkable to describe what happens in sufficient detail to recount all it is that you notice.

The film opens with a woman standing before a stove, putting on a large pot under which she lights a flame with a match. The camera is unmoving; it will prove never to move, but to be given different posts, always frontal and always taking in most of a person's figure and enough of the environment in which to locate them, once you are given the complete cycle of their possible locations. It is hard to know whether everything, or whether nothing, is being judged. The

camera holds long enough in its opening position that you recognize you are in a realm of time perhaps unlike any other you have experienced on film. A doorbell sounds, the woman takes off her apron, walks into the hallway to a door that she opens to a man whose face you do not see but whose hat and coat the woman takes and with whom she exchanges one-word greetings and then disappears into a room. The camera observes the closed door to the room, a change of light indicates the passage of an indefinite span of time, the door opens, the woman returns the coat and hat to the man, who now appears in full length. The man takes money out of a wallet and hands it to the woman, says something like, "Until next week," and departs. She deposits the money in a decorative vase on what proves to be the dining table, bathes herself, an evident ritual in which each part of her body is as if taken on separately, and then returns to the preparation at the stove. When she is again signaled by the doorbell she opens it to a young man, or school boy. Admitting him, she returns to the kitchen, dishes out the contents of the boiling pot into two bowls, one potato at a time, four potatoes into each bowl, and takes them to the dining room table, where the boy has already taken a seat, and we watch the two of them eat each of their respective rations of potatoes. Near the beginning of the meal the woman says, "Don't read while you eat"; nothing more is said until the close of the meal when she reports that she has received a letter from her sister in Canada, which she reads, or rather recites, aloud: it is an invitation to visit the sister, who says she has sent a present to her, and contains the suggestion that the sister wants to introduce her to a man, since it has been six years since the death of the woman's husband. She asks the boy—we suppose by now he is her son—whether they should accept the invitation. After dinner she takes out knitting; it is a sweater for the young man; she puts it away after making a few additional stitches. Her son meanwhile has been reading. She listens to him recite a poem by Charles Baudelaire, evidently in preparation for school, remarks that his accent is deteriorating, that he doesn't sound like her, and they move to the stuffed seat on which the son had been reading and unfold it into a bed. As the woman stands at the door, the boy, now in bed, announces that a friend has told him about erections, orgasm, and conception, which he declares to be disgusting, and asks how she can

have brought herself to go through it in having him. She replies that that part is not important.

The first day, the screen announces, is over. In the remaining two and a half hours the same activities are repeated, with different economies. The second day, for instance, we see the preparation of the potatoes for the soup, watching, of course, each potato being peeled. Kant says that every object which enters our world is given along with all the conditions of its appearance to us. I should like to say: Every action that we enter into our world must satisfy all the conditions of its completion, or its disruption. (Every human action is, as Kant says, handled, performed by the creature with hands, the same action in different hands as different, and alike, as different hands.) With this knife with this blade, sitting in this garment at this table, with this heap of potatoes from this bowl, within these walls under this light, at this instant . . . the woman knots herself into the world. Thoreau says the present is the meeting of two eternities, the past and the future. How does a blessing become a curse?

On this second day, certain things, or conditions, are not in order—a button is missing from the son's jacket, a wisp of the woman's hair is out of place after finishing with that day's client, she lets the potatoes burn, she cannot get the coffee to taste right, even after going through the process of beginning again, throwing out the old coffee grounds, grinding new beans, and so on. The film feels as if it is nearing its end when on the third day we are not kept outside but accompany the woman and that day's client into her bedroom. After an abstract scene of intercourse in which she is apparently brought to orgasm despite her air of indifference, she rises, moves about the room to her dressing table to freshen herself, picks up the pair of scissors we had earlier seen her find and take into the room in order to cut the wrapping of the present just arrived from her sister, walks over to the man lying on her bed, stabs him fatally in the throat, and slides the scissors back onto the dressing table as she walks out of the room. In the dining room, without turning on a light, she sits on a chair, still, eyes open, we do not know for how long.

I wish to convey in this selected table of events the sense of how little stands out until the concluding violence, and at the same time that there are so many events taking place that a wholly true account of them could never be completed,

and if not in this case, in no case. As for a narrative that amounts to an explanation of the stabbing, it would make sense to say that it was caused by any of the differences between one day and the following—by burning the potatoes or failing to get the coffee to taste right or being unable to decide whether to go to Canada or receiving the gift of a nightgown from her sister or slipping against her will into orgasm. To this equalization of her occupations a narrative feature is brought that is as pervasive and difficult to notice as the camera that never moves of itself but is from time to time displaced. Each time the woman moves from one room to another room of the apartment (kitchen, bathroom, her bedroom, the dining-sitting-sewing-reading-sleeping room, all connected by a corridor) she opens a door and turns out a light and closes the door and opens another door and turns on another light and closes that door (except after the stabbing). The spaces are kept as separate as those in a cabinet of curiosities. (What would happen if they touched? A thought would be ignited.)

But if Akerman's film may be brought together with the cabinet of curiosities—an inevitable topic in any discussion of the history of collecting since the Renaissance—it suggests that from the beginning this phenomenon signified both an interest in the variances of the world and at the same time a fear of the loss of interest in the world, a fear of boredom, as though the world might run out of difference, might exhaust its possibilities. A space I am trying to designate and leave here is for a consideration of Benjamin's perception of the era of the Baroque as characterized by melancholy, marked by acedia, or depletion of spirit. As the era arguably of Shakespearean tragedy (*Hamlet* is the implicit centerpiece, or touchstone, of Benjamin's work on the twin of tragedy he calls "the mourning play"),[30] it is marked principally for me as the advent of skepticism. This is no time to try to make this clear; I mention it to go additionally with, for example, Pomian's suggestion that funerary display marks the origin of the idea of collecting, and with Friedrich Nietzsche's suggestion that it is not God's death that causes churches to turn into mausoleums, but the other way around, that our behavior in these habitations unsuits them for divinity—precisely Emerson's point when he speaks, half a century earlier, of preachers speaking as if God is dead.

The pivotal role claimed for Akerman's films as events in the unfolding of contemporary feminism would mean, on this account, that she has found women to bear undistractibly, however attractively, the marks of supposedly interesting social partitions or dissociations. Her pivotal role in the unfolding of filmmaking is then that she has constructed new means of presenting the world in which these marks perpetuate themselves, and has thereby made them newly visible and discussable. Call this a new discovery of the violence of the ordinary. In this Akerman joins the likes of Samuel Beckett and Anton Chekhov, but also Jean-Jacques Rousseau (in his revelation of mankind so far as free and chained—the easiest thing in the world not to notice), as well as Emerson and Nietzsche (in what the former called conformity and the latter philistinism). That Akerman's camera can as if discover suspense in what is not happening, as if we no longer know what is worth showing or saying, what is remarkable, shows a faith in the sheer existence of film, the camera's unadorned capacity for absorption, that approaches the prophetic.

XI

That the occasion of the present reflections is the interaction of two great cities, Paris and New York, enacts the fact that major museums and their collections require the concentration of wealth to be found, in the modern world, in centers of population and power. In thinking of the connection between what he calls the metropolis and mental life ["Die Grosstadt und das Geistesleben"], Georg Simmel observes:

There is perhaps no psychic phenomenon which is so unconditionally reserved to the city as the blasé outlook. . . . The essence of the blasé attitude is an indifference toward the distinctions between things. Not in the sense that they are not perceived, as in the case of mental dullness, but rather that the meaning and the value of the distinction between things, and therewith the things themselves, are experienced as meaningless. . . . This psychic mood is the correct subjective reflection of a complete money economy to the extent that money takes the place of all the manifoldness of things and expresses all qualitative distinctions between them in the distinction of "how much." . . . [T]he metropolis is the seat of commerce and it is in it that the purchasability of things [this altered relation to objects; "this coloring, or rather this de-coloring of things"] appears in quite a different aspect than in simpler economies. . . .

Eugène Atget, *Rue Pigalle, à 6 h. du matin en avril, 1925*, 1925. Albumen-silver print, 18 × 24 cm (7 × 9 3/8 inches). The Museum of Modern Art, New York, Abbott-Levy Collection, Partial gift of Shirley C. Burden.

We see that the self-preservation of certain types of personalities is obtained at the cost of devaluing the entire objective world, ending inevitably in dragging the personality downward into a feeling of its own valuelessness.[31]

Simmel announces the topic of his essay by saying that "the deepest problems of modern life flow from the attempt of the individual to maintain the independence and individuality of his existence against the sovereign powers of the society, against the weight of the historical heritage and the external culture and techniques of life."[32] Call the individual's antagonist here the collective and its heritage and techniques its collections, gathered, it may be, as much like pollutants as like potsherds. Might there be some philosophical cunning that permits us to learn from collections how to oppose their conforming weight?

Benjamin evidently thinks not. From his "Eduard Fuchs, Collector and Historian": "[Culture and history] may well increase the burden of the treasures that are piled up on humanity's back. But it does not give mankind the strength to shake them off, so as to get its hands on them."[33] For whom is this said? It was such a perception that set the early Nietzsche writing against a certain form of history, monumental history

he called it; Emerson's first essay in his first series of *Essays* is "History," written against what he takes us to imagine history to be: "I am ashamed to see what a shallow village tale our so-called History is. How *many* times must we say Rome, and Paris, and Constantinople! What does Rome know of rat and lizard? What are Olympiads and Consulates to these neighboring systems of being? Nay, what food or experience or succor have they for the Esquimaux seal-hunter, for the Kanaka in his canoe, for the fisherman, the stevedore, the porter?"[34] It is part of the concept of my telling another about an event, that I (take myself to) know something about the event that the other fails to know, and might be glad to know, or that I am interested in it in a way that that other has not seen and might be interested to see. Emerson opposes a history of events that trades upon their having already received significance, so he demands a recounting of what has hitherto been taken to count.

When Freud, in *Civilization and Its Discontents*, introduces the issue of ethics—"the relations of human beings to one another"—into the problem he is bringing before us, "namely, the constitutional inclination of human beings to be aggressive toward one another," he goes on to say:
The commandment, "Love thy neighbor as thyself," is the strongest defense against human aggressiveness and an excellent example of the unpsychological proceedings of the cultural super-ego. The commandment is impossible to fulfil. . . . What a potent obstacle to civilization aggressiveness must be, if the defense against it [the unslakable super-ego] can cause as much unhappiness as aggressiveness itself! . . . [S]o long as virtue is not rewarded here on earth, ethics will, I fancy, preach in vain. I too think it quite certain that a real change in the relations of human beings to possessions would be of more help in this direction than any ethical commands; but the recognition of this fact among socialists has been obscured and made useless for practical purposes by a fresh idealistic conception of human nature [namely, that the abolition of private property will eliminate difference that causes aggressiveness].[35]

Grant that you needn't be a socialist to recognize the necessity of a real change in our relation to things. (Jacques Lacan, in effect, develops this thought of Freud's in the concluding chapters of Seminar VII, *The Ethics of Psychoanalysis*, in, for example, his assertion that the experience and goals of

psychoanalysis demand a break with what he calls "the service of goods.")[36] What change in relation to objects might Freud have had in mind? The most prominent model of his own relation to possessions is figured in his well-known collection of some 2,000 ancient Greek, Roman, and Asian objects, primarily statuettes. Putting aside psychoanalytically dependent explanations of Freud's tastes (that the statuettes of gods and heroes are father-substitutes, that archeological finds are emblematic of the finds excavated through the methods of psychoanalysis itself), we might consider certain facts of his reported behavior toward these possessions. Baudrillard, among the prominent theorists of collecting, uses Freudian concepts most explicitly, invoking relations to objects in connection with oral introjection and anal retention; yet while he concludes "The System of Collecting" by observing that "he who . . . collect[s] can never entirely shake off an air of impoverishment and depleted humanity," he does not, so far as I am aware, express interest in Freud's own collecting.[37] John Forrester's essay "Collector, Naturalist, Surrealist" is indispensable on this topic, relating Freud's psychoanalytic practices throughout as modes of collecting (dreams, slips, symptoms) and emphasizing how Freud maintained the life in his collections by adding to them and making gifts of them.[38] It is not easy, in the staid atmosphere of the so-called Freud Museum, his former residence in London, to imagine what it could be like to be alone with Freud in his apartment of study and treatment rooms, guarded or regarded by these figures. It is known that new figures, before taking their place within the collection, were initially introduced into the family setting, placed on the table at the communal meal. The suggestion has been that Freud used the collection to mark the separation of his working from his family life, but it seems more pointedly true (but then this should amount only to a redescription of the same fact) to say that it served to mark the separation of his patients' work with him from *their* everyday lives.

What could be more pertinent for a holding environment (to use an idea of British psychoanalyst D. W. Winnicott's)[39]— in which the claims of ordinary assertions are to be put in suspension (not to stop you, as in philosophical exercises, from saying more than you know, but to free you from stopping saying what you wish, from expressing your desire)—

Edward J. Steichen, *The Flatiron*, 1909 print from 1904 negative. Blue-green pigment gum-bichromate over platinum, 47.8 × 38.4 cm (18 13/16 × 15 1/8 inches). The Metropolitan Museum of Art, New York, The Alfred Stieglitz Collection, 1933.

than uncounted gods, who have seen and survived the worst and whose medium is revelation through concealment?

To imagine Freud's collecting anything different is like trying to imagine his having a different face (with apologies to Wittgenstein and his example of the ridiculous and embarrassing results of trying to imagine what Johann Wolfgang von Goethe would have looked like writing the Ninth Symphony).[40] Neither a series of objects that in themselves are more or less worthless (for example, the series of match boxes mounted in a curved line along a wall that Lacan cites as representing sheer thingness)[41] nor a collection each piece of which may suggest pricelessness (perhaps like the objects in the Frick Museum, New York) fits our idea of Freud. The random voracity of Charles Foster Kane's acquisitiveness, or (somewhat less?) of William Randolph Hearst's at San

The Garden Court of the Frick Collection, New York.

Simeon, California, on which Welles's *Citizen Kane* is based, seems to fit (indeed to have helped construct) the personas of their acquirers, and to manifest, with touching vulgarity, the proposition—established clinically and theoretically by Melanie Klein,[42] and alluded to in such Romantic narratives as Samuel Taylor Coleridge's "The Rime of the Ancient Mariner" (1798)—that the loss of our first object is never fully compensated for.

XII

Is, then, the value we attach to things ineradicably compromised in its assumption of objectivity? The issue takes on various emphases in moral philosophy. It is essential to John Rawls's *A Theory of Justice* that "as citizens we are to reject the standard of perfection as a political principle, and for the purposes of justice avoid any assessment of the relative value of one another's way of life. . . . This democracy in judging each other's aims is the foundation of self-respect in a well-ordered society."[43] How sure are we that we know what constitutes the aims of the ways of life depicted in *Jeanne Dielman* or in *The Glass Menagerie* or in F. Scott Fitzgerald's *The Great Gatsby* (1925)? A fundamental implication of the avoidance of relative

judgment—call it the rejection of snobbery, that sibling of envy—is that the bearing of another's life cannot be measured (beyond the requirements upon it of justice) without seeing it from that other's perspective. This is emphasized in Christine Korsgaard's Rawlsian/Kantian treatment of the question of the objectivity of value when she takes as an example of questionable value one in which a collection figures essentially.[44] In considering the question of whether value is subjective or objective, a Kantian is bound to measure the question by the formulation of the aesthetic judgment in Kant's *Critique of Judgment* (1790), in which the claim to beauty is both subjective and yet necessarily makes a comprehensibly universal claim—necessity and universality being the Kantian marks of the objective. So one can say the issue of conflict between the objective and the subjective (in aesthetic matters, as differently in moral) becomes a matter of how, as rational beings, we are to confront one another.

Korsgaard takes the case of someone who collects pieces of barbed wire—presumably a rarefied taste—and asks in effect where the claim, if any, upon my respect for this activity is supposed to lie, in the sincerity of the passion for the wire, or in a property of the wire itself? No one else should be counted on to share the taste, and why be interested in someone who has it? A crucial point of moral order is involved for Korsgaard: our respect for other persons must not await our respect for their ends, but on the contrary, respecting their ends must be a function of respecting them as fellow persons. This must be right. But what does "respecting their ends" come to? Given that it cannot require sharing their ends, as the case of the barbed wire is designed to show, it evidently means something like finding the alien end comprehensible, seeing *how* it may be valued. A good society cannot depend upon our approval of each other's desires but it does depend upon a certain capacity and willingness to make ourselves comprehensible to one another. Here is a place where the idea of a collection can play an essential role. What interest this piece of barbed wire has may only be communicable by associating it with other, competing pieces, to which a given piece may be taken to allude, comparing it with these others, perhaps, in its effectiveness, economy, simplicity, handling, or producibility. This may not succeed. It does seem that some imagination of the alien desire, of acting upon it, is

required for reason to prevail. But then respect, or tolerance, should have a way to prevail in the absence of offerable reasons. It seems hard to imagine members of a society flourishing in a society in which their commitments to one another are based upon sheer indifference toward their differences.

It is to show that a commitment to democracy will have to imagine the alien, and to show the room there is for responsiveness to it, that I can understand, and be grateful for, Dave Hickey's instruction, in his Overture to *Air Guitar*, in our "need [for] so many love songs"—there are so many things to learn, well within the range of justice, about satisfying desire.[45] You needn't share Hickey's taste for Las Vegas, but just a fragment of his love song to it flying back from some respectable art panel—"coming home to the only indigenous visual culture on the North American continent, a town bereft of dead white walls, gray wool carpets, ficus plants, and Barcelona chairs—where there is everything to see and not a single pretentious object demanding to be scrutinized"—and you can rejoice that Las Vegas is, at least for him, part of the union.[46]

It suggests itself that collecting may serve to allay an anxiety, not exactly that the world can lose its interest, that we may all just disinvest in its differences—but that my interests may make me incomprehensible to others, that safety lies alone in masquerading a conformity with those of others. Early in my reading of Wittgenstein's *Investigations*, I summarized my sense of what I will come to call his vision of language, and what I might now call the stake of our mutual comprehensibility, in these words:

We learn and teach words in certain contexts, and then we are expected, and expect others, to be able to project them into further contexts. Nothing insures that this projection will take place (in particular, not the grasping of universals or of books of rules), just as nothing insures that we will make, and understand, the same projections. That on the whole we do is a matter of our sharing routes of interest and feeling, modes of response, senses of humor and of significance and of fulfillment, of what is outrageous, of what is similar to what else, what a rebuke, what forgiveness, of when an utterance is an assertion, when an appeal, when an explanation—all the whirl of organism Wittgenstein calls "forms of life." Human speech and activity, sanity and community, rest upon nothing more, but nothing less, than this. It is a vision as

The Neptune Pool built by Julia Morgan, mid-1930s, at the William Randolph Hearst Estate, San Simeon, California.

simple as it is difficult, and as difficult as it is (and because it is) terrifying.[47]

Terrifying because this seems to allow that my meaning anything, my making sense, depends upon others finding me worth understanding, as if they might just *decide* that I am without sense. Childhood is lived under this threat. It is no wonder Melanie Klein describes the child's world as hedged with madness, negotiating melancholy for paranoia, reparation for destructiveness.[48]

XIII

In *Art and Money*, Marc Shell recounts through a thousand instances the millennial-long controversies in the West over the relation between the representation of value by art and by money, and relates the controversies to life and death issues of the materialization and dematerialization of God (for example, the status of the graven image, the significance of reproducibility, the definition of truth [as "adequacy" between conception and thing]), noting the issue to be alive in Minimalist and Conceptual art.[49] (Here Michael Fried's "Art and Objecthood" and Clement Greenberg's "Modernist Painting" and "After Abstract Expressionism" are pivotal texts.)[50] But the dematerialization of art and of reality are also at work from Andy Warhol's painted shoe forms to Heidegger's creepy casualness about our relation to the atom bomb, or as he puts it, "Man's staring at what the explosion of the bomb could bring with it. He does not see that the atom bomb and

Andy Warhol, *Untitled (Shoe)*, 1956–58. Tempera on wood,
12.7 × 22.5 × 7 cm (5 × 8⅞ × 2¾ inches). The Andy Warhol Foundation
for the Visual Arts, Inc./ARS, Art Resource, New York.

its explosion are the mere final emission of what has long since taken place, has already happened."[51]

What has already happened to us is the loss of distance and the ignorance of nearness—our thoughtlessness concerning the nature of the thing—that I glanced at in section IV of this essay. Even if, as I am, one is willing to go a considerable way with such signature Heideggerean soundings as "the thing things," there are junctures at the surface around which suspicion should form. What may be dismissed as, let us say, the poor taste of comparing the effects of the atom bomb with a metaphysical process barely conceals a political claim marked by the careful distinction between the bomb and its explosion. Only one nation has exploded the atom bomb in war, showing "what it could bring with it." And the implication is that there is a metaphysical condition that makes the use of the bomb possible, or thinkable, and that Heidegger's thought has been alone in its efforts to outline and counter this condition on behalf of the globe.

And then there is that matter of Heidegger's exemplary jug, in "The Thing," which is suspiciously folkish—pre-technological, pre-capitalist, pre-democratic—in its extravagant aura.[52] I do not wish here to counter a healthy impulse toward disgust with philosophy. One finds oneself recovering the good of philosophy in one's own time, or not. Yet I will say that to miss Heidegger's narration, in which the jug marries earth and sky and its contents form a gift of mortals to gods; and to miss the unfolding, in which a ring of celebration (alluding surely to Nietzsche's wedding ring of eternal recurrence) among the fourfold (earth, mortals, etc.) is the work of the thing thinging, a work accessible to us only in stepping back from our millennia of constructions and representations within a heritage of philosophical concepts and leaping free to a form of thinking that is "called by the thing as the thing," and hence to understand ourselves as "be-thinged" ("in the strict sense of the German word *bedingt*"), the conditioned ones (dictionary definitions of *bedingt* are "conditionally," "limited," "subject to"), a condition in which "we have left behind us the presumption of all unconditionedness" (unconditionedness for ourselves, as if we were the gods of creation)—to miss this narration of a new relation to things as such is to miss one of the most remarkable in the history of responses to Kant's derivation and puzzle of the thing-in-itself, and accordingly to risk slighting the distinct contribution Heidegger proposes for an understanding of gathering or collecting, namely one that affirms our finitude (the renunciation of our unconditionedness, of an identification with pure spirituality). This forms a counterweight to the impression, variously given in writing about collections, that collecting is a narcissistic, not to say imperialist, effort to incorporate the world. But would Heidegger consider an empirical collection to provide occasion for the event of entering on his new path toward a different gathering of the world? He himself suggests no exercises for this change of heart.

In the sequence of proposals I have made, leading to Heidegger's, meant to account for our valuing of collecting—that we have an interest in learning nearness, in the stability of materiality, in achieving comprehensibility to others, and an interest in the endurance of interest itself—I am continuing a line of thought in earlier moments of my writing that I ask leave to name here: In "Finding as Founding," a reading of Emerson's "Experience," I cite Emerson's search for nearness in terms of his apparent distance from the consciousness of grief over the death of his young son Waldo, which stands for all there is to be near to ("I cannot get it nearer to me"), and I observe his discovery that he must thereupon accept the world's nearing itself to him ("indirect" is his word for this direction), an acceptance of a certain revised form of life (philosophy may poorly call it animism) outside himself, outside

any human power.[53] This reading goes back to my *World Viewed*, in which I relate the automatism of Jackson Pollock, and of post-Pollock abstraction (somewhat modifying the concept of automatism as introduced by William Rubin into the discussion of Pollock's work),[54] to the achieving of a candidness, or candor, or uncanniness and incandescence (all etymological developments of the idea of glowing, or being white), from which I associate an unexpected, all but paradoxical, connection between these non-objective commitments and the power of photography and of nature's autonomy, or self-sufficiency.[55] From here I derive the idea of such paintings as facing us (an indebtedness to formative discussions with Fried), as if to perceive them is to turn to them, all at once. This line of thought extends a step further back into my *Senses of Walden* and its discussion of Thoreau's concept of our "nextness" to the world, or our neighboring of it, as the condition of ecstasy.[56] I add here that the idea of automatism in painting leads, in the section that follows in *The World Viewed*, to the invoking of work that essentially exists in series, that is, in a collection.[57] (What I referred to a moment ago as philosophy's poor concept of animism, something that dogs, or should dog, a certain intensity in accounting for the work art does, can be taken, while not named, as a subtext of Heidegger's still formidable "The Origin of the Work of Art," as when he speaks of "let[ting] things encounter us," and claims that "all art is poetry," recalling—I take it—that, as we are forever told, *poesis* means making, but then goes on with originality to ask what it is that art makes *happen*, and answers: "Art breaks open an open place . . . in such a way that only now, in the midst of beings, the Open brings beings to shine and ring out."[58] It does seem sometimes that we are in our period destined to be told things unwelcome either because they are heard too often or because they are too unheard of. As though the world has become immeasurably tactless, inadequately traditional, insufficiently original.)

This line of thought was brought to mind in attending a fine presentation, at the recent meetings of the American Society for Aesthetics in Santa Fe, by Stephen Melville, who, in taking up the ideas of a painting's candidness and its facing of the beholder, cited among many other matters some of the material I have just alluded to. He startled me (I cannot in this speak for others) with the coup of projecting in this con-

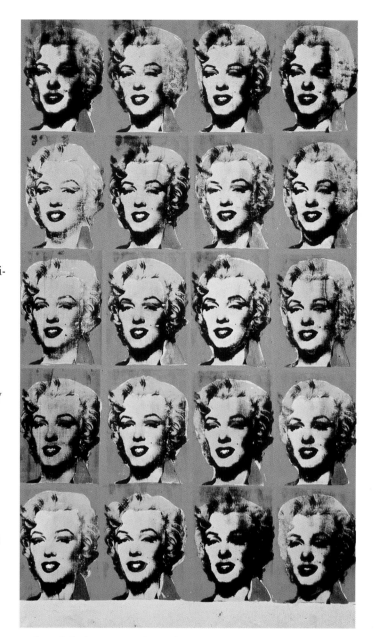

Andy Warhol, *The Twenty Marilyns*, 1962. Synthetic polymer paint and silkscreen ink on canvas, 194 × 114 cm (76 3/8 × 44 7/8 inches). The Andy Warhol Foundation for the Visual Arts, Inc./ARS, Art Resource, New York.

text an Andy Warhol multiple "portrait" of Marilyn Monroe— the image of her in ranks and files of differently tinted replications of the same frontal image.[59] It thus, I suppose, not only declares the issue of a painting's facing us but posits that the singularity of a face may be visible only in its repetition, achieving its aura precisely because of its existence as a collective property, as if the mark of the objective now, even of existence, is celebrity.

XIV

What has happened to the idea of the capacity of knowing as our fundamental relation to the world—the capacity so treasured by modern philosophy that it willingly exposed itself to

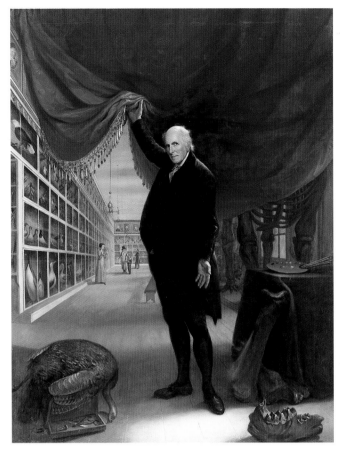

Charles Willson Peale, *The Artist in His Museum*, 1822. Oil on canvas, 263.5 × 202.9 cm (8 feet 7¾ inches × 6 feet 7⅞ inches). Museum of American Art of the Pennsylvania Academy of Fine Arts, Philadelphia, Gift, Mrs. Sarah Harrison (The Joseph Harrison, Jr. Collection).

its powers of skepticism? We have neglected here, and will mostly continue to neglect, the species of collection that may seem to have been made to inspire the response of, or motive to, knowledge, that of the natural history museum. If there is a decent justification for this neglect it is that such collections are no longer readable as the work of individuals (as, for example, in the case of the painting and collecting activities of Charles Willson Peale, given so excellent an account by Stewart in "Death and Life, in That Order"), and the interest in collecting is apt to shift from the desire of the collector to the quality of the collection, and from the matter of our relation to objects to that of a theory of the relation of objects to one another, so that classification becomes more fundamental in presenting the collection than juxtaposition and progression.

In both arenas display is essential, but with the things dear to collectors, as is characteristically emphasized (most insistently, perhaps, by Pomian), the object is taken out of circulation (or, to respect Fisher's alliance of the making and the effacing of art, the object is put into a different circulation), whereas one could say that in a natural history collection the

object (or part, or reconstruction) is put into circulation for the first time. Here the status, or life, of the work of art shifts again into view. If it is true, as said earlier, that objects of art are objects from their outset destined to be exhibited (unlike bones and stones), it might also be true that other objects share such a destiny without (quite, yet) being known as objects of art. Was it before or after cultures collected that they also decorated and selected among options, offering themselves grounds for a relation to an object of service not strictly required, or exhausted, by that service? From that moment objects could exist within intersecting circles of circulation.

We should be cautious in saying that with natural objects we know where the next specimen or part fits, whereas with the artifact we have to find where it fits best—cautious because of what we learn from work made most famous in Foucault's texts, especially *The Order of Things*, that knowledge grounded in classification is not a discovery derived from a clear accumulation of facts but itself required a set of intellectual/historical conditions in which a new conception of knowledge (or *episteme*) was possible, in which a new counting, or order, of facts was made visible. This is an insight marked as belonging to the same intellectual era in which Thomas Kuhn startled philosophers and historians with the suggestion that physical science, knowledge at its most prestigious, goes through periods of crisis in which accumulation is not driving research, and reconceptualization appears to wish to remake rather than to refine the picture of the world.[60] And, of course, it was as if we had always known that.

In both arenas of display death is invoked, even death as present in life, but in collections of art, or artifacts, it is my death that is in question as I enter into the stopped time of the objects (Pomian remarks that their display is as on an altar),[61] whereas the skeletons and parts of natural history speak of the death and the perpetuation of species, of their coexistence and succession, measured within the earth's time (one of Foucault's favorite expressions of the new *episteme* exemplified by the natural history museum is to say that it displays its items on, or in, a table).[62]

XV

But one event staged within a natural history museum is irresistibly pertinent for an American with a certain philosophical

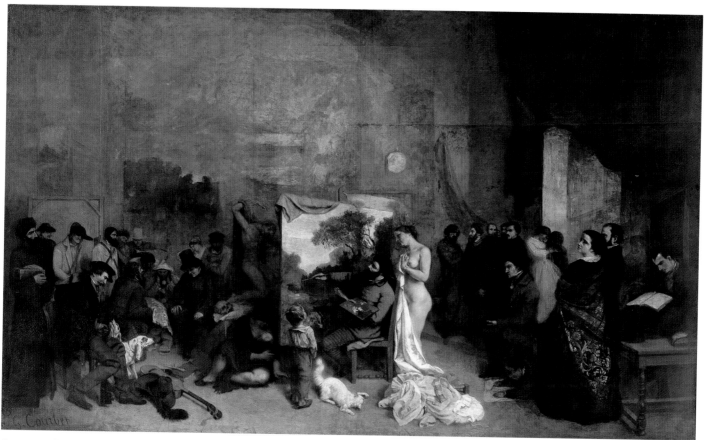

Gustave Courbet, *Studio of a Painter (Intérieur de mon atelier du peintre)*, 1854–55. Oil on canvas, 3.6 × 6 m (11 feet 10 inches × 19 feet 7 inches). Musée d'Orsay, Paris.

disposition asked to think about a collection being transported from France for a stay in the United States. I mean the declaration Emerson made to his journal at the time of his visit to Paris, in 1833, that he has had something like a revelation in his experience of the great collections in the Jardin des Plantes. In a recent study, *The Emerson Museum: Practical Romanticism and the Pursuit of the Whole*, Lee Rust Brown takes that experience, always remarked on by Emerson's biographers, as more decisively significant than has been recognized before.[63] He proposes that we understand what floored Emerson by the Paris exhibitions to be their presentation of an image of what he wanted his writing to be. I might formulate the image Brown constructs as one in which Emerson sees that his words may become specimens of a totality of significance arrived at otherwise than by a system (philosophical or scientific or narrative) of which Emerson felt incapable. *The Emerson Museum* casts a wide net of social, philosophical, and historical reference and I do not imagine my formulation to do justice to it. The formulation leaves deliberately open, for example, whether Emerson's "words" refers to single words, to sentences, to paragraphs, or to essays; and to what the idea of system is to be credited if not to laws or argument. There should be another time for that. Here I wish simply to give

credit for the insistence that Emerson's experience and vow in Paris ("I will be a naturalist") is some kind of revelation to him of his project and practice as a writer. I have myself been too long preoccupied with the sound of the Emersonian sentence not to welcome an addition to its understanding; but too long accustomed to asking how each of Emerson's essays characterizes its own writing not to be wary of a proposal of any fixed model for them.

This is too important a matter to me not to be a little more specific about it. Having indicated a connection between the concept of collecting and that of thinking (as in the history of disappointment with universals), and with the concept of the self (as in contemporary play with Humean ideas of the subject), I would not have satisfied my opening sense of my assignment to think publicly about the philosophical interest of collecting without including some speculation about its comparable connection with the concept of philosophical writing, particularly in the cases of Emerson and of Wittgenstein. An obvious cause for this inclusion at this moment is to recall Emerson's and Wittgenstein's relation, in their fashionings of discontinuity, to the medium of philosophy as aphorism, in counterpoise to its medium as system. Wittgenstein is explicit about this, but implicitly everything

The Jardin des Plantes, Paris.

about Emerson's practice as a writer bespeaks this sense of aggregation and juxtaposition—from his culling from his journals for individual essays, to the sense of his sentences as desiring to stand apart from one another, each saying everything, each starting over.

XVI

The first impulse Emerson records, on July 13, upon noting that he went "to the Cabinet of Natural History in the Garden of Plants," is "how much finer things are in composition than alone. 'Tis wise in man to make Cabinets." Here is some of what he took away with him that day.

The fancy-colored vests of these elegant beings [in the Ornithological Chambers] make me as pensive as the hues & forms of a cabinet of shells, formerly. It is a beautiful collection & makes the visiter as calm & genial as a bridegroom. The limits of the possible are enlarged, & the real is stranger than the imaginary. . . .

Ah said I this is philanthropy, wisdom, taste. . . . The Universe is a more amazing puzzle than ever as you glance along this bewildering series of animated forms . . . the hazy butterflies, the carved shells, the birds, beasts, fishes, insects, snakes, —& the upheaving principle of life everywhere incipient in the very rock aping organized forms. Not a form so grotesque, so sane, nor so beautiful but is an expression of some property inherent in man the observer, —an occult relation between the very scorpions and man. I feel the centipede in me—cayman, carp, eagle, & fox. I am moved by strange sympathies, I say continually "I will be a naturalist." . . .

Walk down the alleys of this flower garden & you come to the enclosures of the animals where almost all that Adam named or Noah preserved are represented. . . . It is very pleasant to walk in this garden.[64]

He does seem by the end of his visit to be well-recovered from signs of revelation. The scrupulous editor of this volume of Emerson's journals notes that beneath the ink entry "this is philanthropy, wisdom, taste—" is written in faint pencil: "Le moment ou je parle est deja loin de moi"—a quotation from Boileau presumably to mark that Emerson is unsure what he has learned.[65]

I think I can see that Emerson's sequence of descriptions of his state at the Jardin des Plantes—being pensive; calm and genial as a bridegroom; inspired as by a perception of philanthropy, wisdom, taste; moved by strange sympathies—produces an outburst of dedication to qualities he wants for his writing. But I am not so far able to see how Brown makes the transfer from, for example, Emerson's description of "a beautiful collection" (of elegant birds) to the way we are to see his sentences hang or perch together. An elegant bird, I should imagine, is, as Emerson says of a squirrel running over a lawn and up into trees, not made to go unobserved; linking his writing with a display of bright feathers or a casual virtuosity suggests that Emerson has his own uses for attractiveness. ("You are attracted to the standard of the true man," from the first printing of "Self-Reliance.")[66] And I think I can see, more specifically, Emerson's "Self-Reliance" as describing its own writing when it speaks of thinking as an aversion to conformity; and "The American Scholar" of its own writing when it speaks of thinking as a process of conversion going forward at every hour; and "Fate," similarly, when it describes freedom as resistance or counterstroke; and the so-called "Divinity School Address" when it speaks of communion; and "Circles" when it speaks of circular forms and seems to imply a circle as an intimate audience; and "Experience" when it speaks of "glancing blows" as opposed to direct grasps as the direction of knowing.[67] (Do we not have an internal gag when "Experience" speaks of originating from three points—as when Emerson says Sir Everard Home has discovered the embryo originates "coactively"—since three points define a circle, three gathered together in an arc?)[68] But I do not know that I have in any case made clear or concrete enough the transfer to Emerson's actual words, or made clear that the process is clear enough as it stands. Clear enough for what?

Perhaps I am too attached to Thoreau's more explicit interest in literal classification and listing as the basis for self-

A couple in *La Jetée* (made 1962, released 1964) looking at a sequoia trunk covered with dates of historical events in the Jardin des Plantes, Paris. Photo by Chris Marker, reproduced in Marker, *La Jetée: Ciné roman* (New York: Zone Books, 1993).

Film still from Chris Marker's *Sans Soleil* (1982) showing a collection of cats.

allegory, as when his series or tables of measurements or soundings in *Walden* (1854) show as emblems of the accuracy and systematicity he claims for his words.[69] Or when his tabulation of his expenditures on food, in the first chapter, "Economy," shows as "thus publishing his guilt," thus assigning to his writing the power to assess his guilt in acquiring, at who knows what expense to others, the sustenance of his existence; and the writing is the sustenance, declaring that its will is to make itself cost something to read.[70] The Emersonian sound seems different, otherwise, as in the passage cited earlier, in which Emerson expresses his shame at what we know and accept as History: "What does Rome know of rat or lizard?"—these neighboring systems of existence. There is an urgency here of the incessant bearing of unseen processes, to be registered in each sentence, that Thoreau can allow to be suspended across sentences, or chapters, or years. The idea broached earlier of every Emersonian sentence as a self-standing topic sentence of the essay in which it appears, hence of his paragraphs as bundles or collections that may be moved, is linked, in my mind, with Friedrich von Schlegel's remark that in good prose it is as if every word is stressed.

XVII

Emerson's visit to the Jardin des Plantes collects (or, more accurately, was itself collected by) a pair of visits there by another translated American, Chris Marker, first as recorded in his film *La Jetée* (made 1962, released 1964) and then quoted in his film *Sans Soleil* (1982), that endlessly instructive autobiographical/anthropological meditation on art and technology, culture and memory, past and future, space and

time, words and images, desire and death, nearness and distance. In the original scene in *La Jetée*, we see two people looking and gesturing at a cut from a giant sequoia, the rings of which are inscribed with various historical dates; in *Sans Soleil*, which quotes this scene, Marker continues by quoting the passage from Alfred Hitchcock's *Vertigo* (1958) (on which his shot is based), in which Madeleine (Kim Novak) takes Scottie (James Stewart) to the Muir Woods near San Francisco, where she shows him its sequoia cut covered with historical dates and, pointing to one of the rings, says, "There I was born, and there I died." The memory of a memory of a Hitchcock film about the fatality of memory is preserved in the collections of inscriptions on the trunks of trees that were born before either French or English were formed, surviving all they have had to forget.

Taking the Emerson/Marker/Hitchcock/California intersection with me to Paris last summer as I went to visit again, for instance, the Centre Georges Pompidou and the Jardin des Plantes (the Paris sequoia cut is still, or again, on display, but it has been moved inside, into an entrance hall of one of the museum buildings), you may imagine my momentary vertigo on being informed that Marker had accepted an invitation to make a piece to mark the very occasion of the exhibition that is the cause of these words. When returning to the Pompidou I inquired of Blistène whether there were documents recording the ideas behind the Marker commission, he replied, "There is something better. Marker is downstairs shooting." What I found him shooting, or having just ceased shooting, was a sequence in which a visitor to the museum interactively views a provisional CD-ROM that Marker had installed on a monitor. The monitor, which was mounted

on a stand with two chairs before it, stood in an otherwise empty space. Marker held up the small camera he had been using and said, "I've wanted this all my life. No more waiting for developing, adding tracks. . . . Things like *Sans Soleil* are past. It is why I tore up the poster of *Sans Soleil* before putting it up." I had noticed the collagelike shape on the wall as I entered the installation space, and looking at it again I saw that the poster appeared to have been torn, once lengthwise, once across, and then reassembled; the title was still quite legible, and the new form was no doubt more attractive than the original rectangle of the poster would have been. I felt encouraged that this master of his art, or arts, had found elation both in breaking with an old practice (that of the movie camera) and in calling upon an old practice (that of collage) in announcing the fact.

The CD-ROM turned out to be an elaboration of material pertaining to *Sans Soleil*. On one of my routes interacting with it I came upon a voice-over reference to *Vertigo* in which Marker says that he has seen the Hitchcock film—he calls it the best film ever made about time—nineteen times and that his remarks about the film are for others who also have seen it nineteen times. And, I imagined, for those who will see *Sans Soleil* with that attention. (I think here of Susan Howe's wonderful responses to Marker, and others, in her "Sorting Facts; or, Nineteen Ways of Looking at Marker.")[71] This invitation to obsession—must I decide whether it is fetishistic attachment, or honest labor?—is something I have sometimes felt I must ward off. The temptation is, I think, a reason I was struck early by Wittgenstein's self-reflection in the *Investigations*:

It is not our aim to refine or complete the system of rules for the use of our words in unheard-of ways. For the clarity that we are aiming at is indeed complete clarity. But this simply means that the philosophical problems should completely disappear. The real discovery is the one that makes me capable of breaking off philosophizing when I want to. —The one that gives philosophy peace.[72]

The issue of completeness can haunt discussions of collecting, some writers (for example, Stewart) taking it as essential to the desire in collecting, others (for example, Forrester) taking it that a collection that is no longer growing is dead.[73] Regarding Wittgenstein's *Investigations* (Part I especially) as a collection, I have described the 693 sections of this work as showing the willingness to come to an end 693 times. Since I have understood the current overinsistence (so I judge it) on the idea of meaning as the deferral of significance to be an expression of the fear of death, I find Wittgenstein's practice here a memorable realization of Montaigne's assignment of philosophy as learning how to die. Since Wittgenstein also describes his philosophical practice as "[leading] back words from their metaphysical to their everyday use," in which, or at which, philosophy brings itself to an end (momentarily?—but how can we know that there will be a further call upon it, a 694th call?), the ordinary, in Wittgenstein's philosophy of the ordinary, is the realm of death, of the life of mortality, subjection to the universal collector.[74]

Does the passion for collecting have something to say about such matters as coming to an end?

XVIII

A number of collections are depicted in the Tokyo sequences of *Sans Soleil*. One toward the beginning is of cat figurines lodged in a temple consecrated to cats; one near the middle is of dolls in a ceremony for the repose of the souls of broken dolls; one toward the end is of the debris collected from the accessories and decorations of the communal New Year ceremonies. The ceremony for the broken dolls and the one for the debris both conclude with the burning of the collections. The film does not make explicit the significance of the burnings, but the suggestion is that debris, whose burning seems fairly natural, has as much right to immortality as do the souls of broken dolls. The burning of the dolls, however, is shocking. Perhaps one thinks of Kurt Schwitters's collages incorporating debris, tracing a fitful immortality of beauty upon what others have abandoned. There is also to ponder Opie's self-described near mania for collecting and displaying wrappings or packagings, enacting the mad wittiness of retaining and reorganizing precisely what is meant—is it not?—to be discarded.[75] Many collections convey the wish to make the world immortal by, so to speak, forming a reconstruction or impression or shadowy duplicate of it (what is new about film?); but Opie's idea, in description, projects a sort of defiance of the world's availability, or deliverability.

Thoreau, the philosopher of non-collection, of the way of responsible life as one of disencumbering oneself from false

Kurt Schwitters, *Prikken paa I en*, 1939. Collage of various papers mounted on painted board, 75.5 × 91.8 cm (29¾ × 36⅛ inches). Centre Georges Pompidou, Musée national d'art moderne, Paris, Remittance in lieu of inheritance taxes to the government of France, 1988.

necessity (enacting and extending teachings from Plato and from Rousseau), is struck by a ceremony of burning what he regards as debris, late in the opening chapter of *Walden*:

Not long since I was present at the auction of a deacon's effects, for his life had not been ineffectual: "The evil that men do lives after them." As usual, a great proportion was trumpery which had begun to accumulate in his father's day. Among the rest was a dried tapeworm. And now, after lying half a century in his garret and other dust holes, these things were not burned; instead of a bonfire, or purifying destruction of them, there was an auction, or increasing of them. The neighbors eagerly collected to view them, bought them all, and carefully transported them to their garrets and dust holes, to lie there till their estates are settled, when they will start again. When a man dies he kicks the dust.[76]

Thoreau contrasts this ceremony, to its disfavor, with a certain celebration of a "busk" or "feast of first fruits," which the naturalist William Bartram describes as having been the custom of the Mucclasse Indians. Thoreau quotes Bartram:

When a town celebrates the busk, having previously provided themselves with new clothes, new pots, pans, and other household utensils and furniture, they collect all their worn out clothes and other despicable things, sweep and cleanse their houses, squares, and the whole town of their filth, which with all the remaining grain and other old provisions they cast together into one common heap, and consume it with fire.[77]

After adding several further critical details, Thoreau concludes the section by remarking: "I have scarcely heard of a truer

sacrament, that is, as the dictionary defines it, 'outward and visible sign of an inward and spiritual grace.'"[78]

This is not quite allowing the debris of life its own right to remembrance, or abandonment. That idea of right is announced by the film in connection with Sei Shonagon's *Pillow Book* and her passion for lists, lists of elegant things, of distressing things, among them a list of things not worth doing, and one—an enviable mode of composition—of things "to quicken the heart."[79] This passion has, in *Sans Soleil*, its own, to my taste, beautiful consequences, inspiring, for instance, ideas of visits to post-office boxes without expecting letters but just to honor letters unsent or unwritten; and of pauses at an empty intersection to leave space for the spirits of cars broken there. And when the voice-over adds, to the list of things to be honored in farewell, "All that I'd cut to tidy up" (that is, in completing *Sans Soleil*), I found myself attaching a small prayer for thoughts that have never come, or never been given sufficient appreciation. Priceless uncollecteds.

Thoreau joins in recognizing the air of abandonment, or farewell, in the character of what he calls an event of sacrament (as allowing divorce to the character of marriage). But Thoreau's main emphasis falls still farther, to make his leaving even of Walden unceremonious, a step on a way. As if he has so burned himself into every event of Walden's days, the aroma of which is *Walden*, that he can trust both his and its existence, entrust them to one another.

If collections can teach this, they may not exempt themselves from the knowledge they impart, that they are to be left. Some people need, or have, as luck would have it, a bequest to leave. Thoreau quite explicitly makes a bequest or deed of each form and depth and nameable object of Walden to whomever wants them properly. Thus he exhibits his obedience to St. Matthew's injunction, "Lay not up for yourself treasures upon earth where moth and rust doth corrupt." And he can say, evidently, in a worldly register, "A man is rich in proportion to the number of things he can afford to let alone,"[75] thus humoring the labor theory of possession running, in John Locke's formulation, "Whatsoever [any man] removes out of the State that Nature hath provided, and left it in, he hath mixed his Labour with, and joyned to it something that is his own, and thereby makes it his Property."[80] Locke wants something of the kind metaphysically to define ownership,

and Marx wants the denial of something of the kind to reveal itself to us in the phantasmagoria of the exchange of commodities; so it is bracing that Thoreau isolates and makes explicit the religious, or animated, bearing of the features of nature left to us, as when he characterizes a lake (in the "Ponds" chapter of *Walden*) as "earth's eye."[82]

But when Benjamin declares, "There is no document of civilization which is not at the same time a document of barbarism," the very power of the perception disguises the fact that it is as much phantasm as insight, an illumination of things indiscriminately in their aspect as spoils or booty.[83] It can be seen; in some moods it is irresistible. But in lashing together, say, the Elgin Marbles with, perhaps, a collection of old jazz records that preserve treasures of a harsh time, and these, perhaps, with a collection of silver objects of observance that Jews carried from a disguised into an undisguised exile, or with their steamer trunks desperately packed with evening gowns and court slippers for which no future life will call— here is a frenzied invitation to a madness of misanthropy as much as it is to an enlightened liberation of conduct. For what is writing responsible? Not to hearten pointlessly; but not to dishearten expansively.

I said earlier that we should encounter again the bearing of Wittgenstein's and of Heidegger's work on the task of leaving or abandonment. In our relation to the things of the world, Heidegger proposes (as he translates a phrase from Parmenides) "letting-lie-before-us" as the mode of thinking to be sought in stepping back from our fantasies of thinking as grasping the world in fixed concepts.[84] Wittgenstein explicitly mentions just once the pertinent idea of leaving, as befits his discontinuous moments of philosophizing about philosophy: "[Philosophy] leaves everything as it is."[85] Perhaps he means to attract the interpretation this has largely received, a confession of philosophy's conservatism. Then one is left with having to put this together with the radical destruction of philosophical tradition that his writing undertakes. The immediate import of the claim is that modes of thought and practice other than the philosophical—for example the political or the economic, as we know them—do *not* leave things as they are, but subject them to violence, the state in which they are given to us. "Our investigation must be turned around the fixed point of our real need."[86] Our thinking is faithless to our desire, oblivious to what it set out to express. Whatever instructs us here is to the good.

"Don't take it as a matter of course, but as a remarkable fact, that pictures and fictitious narratives give us pleasure, occupy our minds."[87] I know of no better initial tip in matters of aesthetics. You are advised to consult yourself as to whether a thing you have taken into your mind, have consented for that time to bear upon your life, gives you pleasure, or perhaps otherwise disturbs you, and if not, to demand of yourself the cause, whether the thing that solicits you is unremarkable, or whether you are coarsened in what you can remark and can allow to matter to you. Why do we put things together as we do? Why do we put ourselves together with just these things to make a world? What choices have we said farewell to? To put things together differently, so that they quicken the heart, would demand their recollecting.

Notes

Thanks are due to the following people for their contributions to this essay: Steven Affeldt, Norton Batkin, Gus Blaisdell, Arnold Davidson, Charles Warren, Bernard Blistène at the Centre Georges Pompidou, and the resourceful staff of the Publications Department at the Guggenheim Museum.

1. Krzysztof Pomian, *Collectors and Curiosities: Paris and Venice, 1500–1800*, trans. Elizabeth Wiles-Portier (Cambridge: Polity Press; Cambridge, Mass.: Blackwell, 1990).
2. See Jean Baudrillard, "The System of Collecting," in *The Cultures of Collecting*, ed. John Elsner and Roger Cardinal (Cambridge, Mass.: Harvard University Press, 1994); Pomian,

Collectors and Curiosities; Susan Stewart, "Death and Life, in That Order, in the Works of Charles Willson Peale," in *The Cultures of Collecting*; Robert Opie, "'Unless you do these crazy things' . . . : An Interview with Robert Opie," in ibid.; Philip Fisher, *Making and Effacing Art* (Cambridge, Mass.: Harvard University Press, 1997); Michel Foucault, *The Order of Things: An Archaeology of the Human Sciences* (New York: Vintage Books, 1994; 1966).
3. See James Clifford, *The Predicament of Culture* (Cambridge, Mass.: Harvard University Press, 1988).
4. Ludwig Wittgenstein, *Philosophical Investigations*, trans. Elizabeth Anscombe, 3d ed. (Oxford: Blackwell, 1958; 1953), § 1.

5. Ibid.
6. Wittgenstein, *Tractatus Logico-Philosophicus*, trans. D. F. Pears and B. F. McGuinness, 2d ed. (London: Routledge & Kegan Paul, 1961; 1921), p. 149.
7. Baudrillard, "The System of Collecting," in *The Cultures of Collecting*, p. 12.
8. Wittgenstein, *Philosophical Investigations*, §§ 65, 66, 67.
9. Martin Heidegger, "The Thing," in *Poetry, Language, Thought*, trans. Albert Hofstadter (New York: Harper & Row, 1975; 1971), p. 165.
10. Ibid., pp. 165, 166.
11. Ibid., p. 174.
12. Ibid., p. 171.
13. Wittgenstein, *Philosophical Investigations*, § 371.

14. Ibid., § 373.

15. Heidegger, "Building Dwelling Thinking," in *Poetry, Language, Thought*, p. 146.

16. Michael Fried, *Three American Painters: Kenneth Noland, Jules Olitski, Frank Stella*, exh. cat. (Cambridge, Mass.: Fogg Art Museum, 1965).

17. W. V. Quine, *Pursuit of Truth* (Cambridge, Mass.: Harvard University Press, 1990).

18. Walter Benjamin, *Charles Baudelaire: A Lyric Poet in the Era of High Capitalism*, trans. Harry Zohn (London: Verso, 1983), pp. 168–69.

19. Ibid., p. 172.

20. David Hume, *A Treatise of Human Nature*, ed. L. A. Selby-Bigge, vol. I, iv (Oxford: Oxford University Press, 1951), p. 252.

21. Ibid., p. 269.

22. Ibid.

23. Ibid., p. 252.

24. Ibid., p. 253.

25. Ibid., p. 251.

26. Ibid., p. xx.

27. See Mieke Bal, "Telling Objects: A Narrative Perspective on Collecting," in *The Cultures of Collecting*; Stewart, "Death and Life"; Fisher, *Making and Effacing Art*.

28. See Norton Batkin, "Conceptualizing the History of the Contemporary Museum: On Foucault and Benjamin," *Philosophical Topics*, vol. 25, no. 1 (spring 1997).

29. Immanuel Kant, *Critique of Judgment*, trans. J. H. Bernard (New York: Hafner Press, 1951; 1790).

30. Benjamin, *The Origin of German Tragic Drama*, trans. John Osborne (London: NLB, 1977).

31. Georg Simmel, "The Metropolis and Mental Life," in *On Individuality and Social Forms*, ed. Donald N. Levine, trans. Edward A. Shils (Chicago: University of Chicago Press, 1971), pp. 329, 330.

32. Ibid., p. 324.

33. Benjamin, "Eduard Fuchs, Collector and His-torian," in *One-Way Street and Other Writings*, trans. Edmund Jephcott and Kingsley Shorter (London and New York: Verso, 1997), sec. 3.

34. Ralph Waldo Emerson, "History," in *Essays and Lectures*, ed. Joel Porte (New York: Library of America, 1983).

35. Sigmund Freud, *Civilization and Its Discontents*, ed. and trans. James Strachey, vol. 21 (London: Hogarth Press, 1961), pp. 142–43.

36. Jacques Lacan, *The Ethics of Psychoanalysis*, Seminar VII (1959–60), trans. Dennis Porter (New York: Norton, 1992).

37. Baudrillard, "The System of Collecting," p. 24.

38. John Forrester, "Collector, Naturalist, Surrealist," in *Dispatches from the Freud Wars* (Cambridge, Mass.: Harvard University Press, 1997), pp. 107–37.

39. For a good introduction to Winnicott's work, see Adam Phillips, *Winnicott* (Cambridge, Mass.: Harvard University Press, 1988).

40. Wittgenstein, *Philosophical Investigations*, § 183.

41. Lacan, *The Ethics of Psychoanalysis*, p. 114.

42. See, for example, Melanie Klein, *Envy and Gratitude* (New York: Free Press, 1984).

43. John Rawls, *A Theory of Justice* (Cambridge, Mass.: Harvard University Press, 1971), p. 442.

44. Christine Korsgaard, "The Reasons We Can Share: An Attack on the Distinction between Agent-relative and Agent-neutral Values," in *Creating the Kingdom of Ends* (Cambridge and New York: Cambridge University Press, 1996), pp. 275–310.

45. Dave Hickey, *Air Guitar: Essays on Art and Democracy* (Los Angeles: Art Issues Press, 1997), p. 16.

46. Ibid., p. 23.

47. Stanley Cavell, *Must We Mean What We Say? A Book of Essays* (Cambridge and New York: Cambridge University Press, 1976; 1969), p. 52.

48. Klein, *Envy and Gratitude*.

49. Marc Shell, *Art and Money* (Chicago: University of Chicago Press, 1995).

50. See Fried, "Art and Objecthood" (1967), in *Art and Objecthood* (Chicago: Chicago University Press, 1998); Clement Greenberg, "Modernist Painting" (1960) and "After Abstract Expressionism" (1962), in *Modernism with a Vengeance*, vol. 4, *The Collected Essays and Criticism*, ed. John O'Brian (Chicago: University of Chicago Press, 1993).

51. Heidegger, "The Thing," p. 166.

52. Ibid., pp. 168*ff*. Subsequent quotations in this paragraph are from p. 181.

53. Cavell, "Finding as Founding," in *This New Yet Unapproachable America: Lectures after Emerson after Wittgenstein* (Albuquerque, N.M.: Living Batch Press, 1989).

54. William Rubin, *Dada, Surrealism and Their Heritage*, exh. cat. (New York: Museum of Modern Art, 1968).

55. Cavell, *The World Viewed: Reflections on the Ontology of Film* (Cambridge, Mass., and London: Harvard University Press, 1979; 1971).

56. Cavell, *The Senses of Walden* (Chicago: University of Chicago Press, 1992; 1972), pp. 100–04.

57. Cavell, *The World Viewed*, p. 115.

58. Heidegger, "The Origin of the Work of Art," pp. 25, 72.

59. See, for example, Stephen Melville, *Philosophy beside Itself: On Deconstruction and Modernism*, Theory and History of Literature, vol. 27 (Minneapolis, 1986).

60. Thomas S. Kuhn, *The Structure of Scientific Revolutions*, 3d ed. (Chicago: University of Chicago Press, 1996; 1962).

61. Pomian, *Collectors and Curiosities*, for example, p. 44.

62. Foucault, *The Order of Things*, p. 131.

63. Lee Rust Brown, *The Emerson Museum: Practical Romanticism and the Pursuit of the Whole* (Cambridge, Mass.: Harvard University Press, 1997).

64. Emerson, *The Journals and Miscellaneous Notebooks of Ralph Waldo Emerson*, vol. 4, ed. Alfred R. Ferguson (Cambridge, Mass.: Belknap Press, 1964; 1832–34), entry for July 13, 1833.

65. Ibid.

66. Emerson, "Self-Reliance," in *Essays and Essays: Second Series* (Columbus: Merritt, 1969; 1844; 1849), p. 50.

67. Emerson, "The American Scholar," "Fate," "Divinity School Address," "Circles," and "Experience," in *Essays and Lectures*.

68. Emerson, "Experience," in ibid.

69. Henry David Thoreau, *Walden*, ed. Walter Harding (New York: Washington Square Press, 1970; 1854), chap. 1, "Economy," passim.

70. Ibid., p. 43.

71. Susan Howe, "Sorting Facts; or, Nineteen Ways of Looking at Marker," in Charles Warren, ed., *Beyond Document: Essays on Non-Fiction Film* (Wesleyan University Press, 1996).

72. Wittgenstein, *Philosophical Investigations*, § 133.

73. Stewart, "Death and Life," p. 204; Forrester, "Collector, Naturalist, Surrealist," p. 107.

74. Wittgenstein, *Philosophical Investigations*, § 116.

75. Opie, "'Unless you do these crazy things'"

76. Thoreau, *Walden*, p. 49.

77. Ibid., p. 50.

78. Ibid.

79. Sei Shonagon, *The Pillow Book*, trans. Ivan Morris (New York: Columbia University Press, 1991).

80. Thoreau, *Walden*, p. 60.

81. John Locke, *The Second Treatise of Government*, in *Locke's Two Treatises of Government*, ed. Peter Laslett, 2d ed. (Cambridge: Cambridge University Press, 1967), chap. v, sec. 27, p. 306.

82. Thoreau, *Walden*, p. 141.

83. Benjamin, "Theses on the Philosophy of History," in *Illuminations: Essays and Reflections*, ed. Hannah Arendt, trans. Harry Zohn (New York: Schocken Books, 1969), p. 256.

84. Heidegger, *What Is Called Thinking?*, trans. J. Glenn Gray (New York: Harper and Row, 1968; 1951–52), pp. 200*ff*.

85. Wittgenstein, *Philosophical Investigations*, § 124.

86. Ibid., § 108.

87. Ibid., § 524.

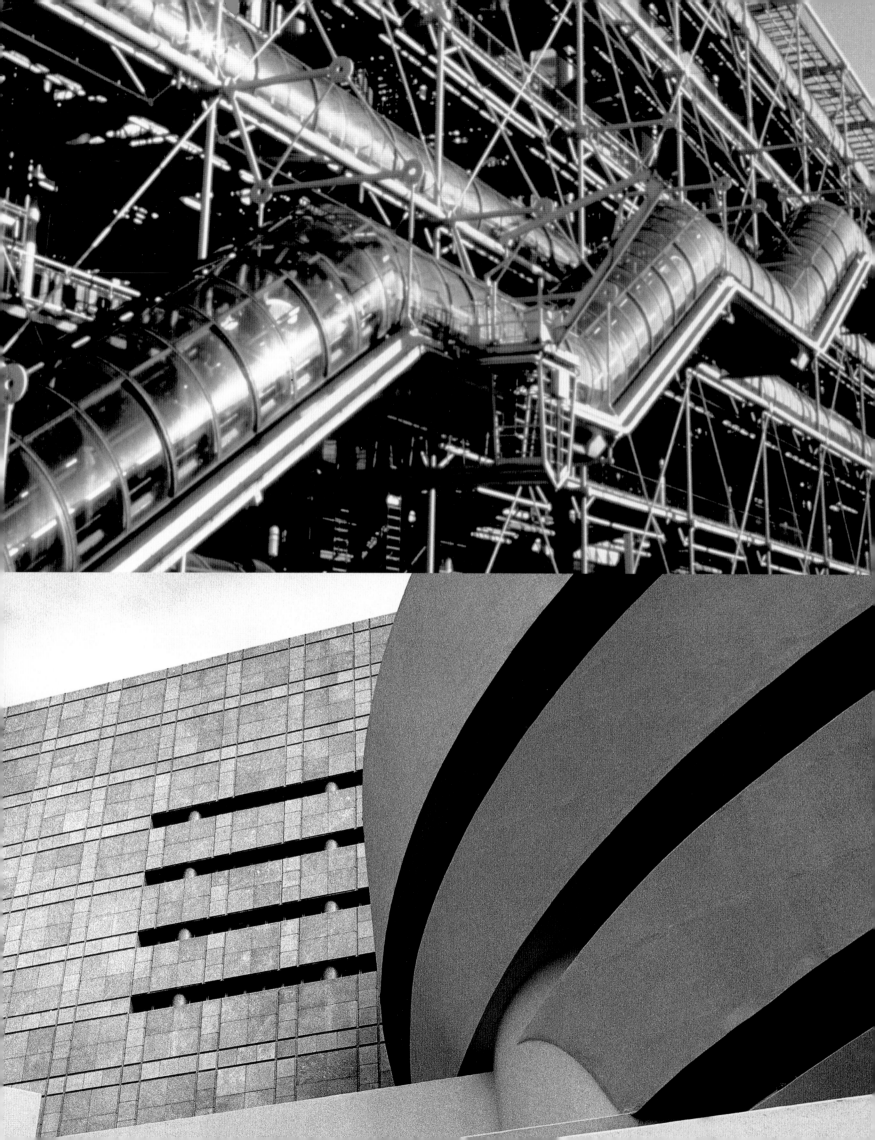

BERNARD BLISTÈNE

AND LISA DENNISON

POMPIDOU/GUGGENHEIM

A Dialogue for an Exhibition

This conversation between Bernard Blistène and Lisa Dennison, the curators of Rendezvous: Masterpieces from the Centre Georges Pompidou and the Guggenheim Museums, *took place from April to August 1998 in Paris and New York.*

LISA DENNISON: This rendezvous between the Guggenheim and the Pompidou is far from a chance encounter. We decided to collaborate for a very specific reason. After beginning a serious study of the histories of our two collections, we were convinced that the similarities and differences in their formation and composition could sustain an interesting dialogue. In addition, both institutions share a unique relation to architecture, defined as much by their avant-garde buildings as they are by their collections.

We also believed that this type of exhibition could be emblematic of a contemporary museological approach that has revalorized an intensive curatorial focus on permanent collections. These very simple but compelling reasons were the pretext for our work together over the past years.

BERNARD BLISTÈNE: I agree that we have many reasons for this rendezvous. But we should keep in mind that the constructions of our collections are parallel to a certain kind of construction of Modern art. This is why our collections, as demonstrated by the first half of the exhibition, seem so homogeneous, while in fact this historiography of Modernism that has been created by each institution is incredibly reductive and even arbitrary.

LD: In fact, we could extend our curatorial research to say that we have tried to dissect each institution's creation of a particular narrative of Modern art.

BB: We've looked at the idea of Modern art in and of itself. In fact, it's not a particular idea, but an ideology, which both our institutions have participated in constructing. This story becomes much more ambiguous later, let's say after World War II, when the relations between the two cultures become quite different. That is what Serge Guilbaut tried to explain in *How New York Stole the*

The Centre Georges Pompidou (top) and the
Solomon R. Guggenheim Museum.

Solomon R. Guggenheim (1861–1949)
Solomon R. Guggenheim was born in Philadelphia in 1861 to a mercantile family, which later made its wealth in the mining industry. Along with his wife, Irene Rothschild, he earned a reputation as a patron of the arts and a philanthropist.

Starting in the mid-1890s, Guggenheim began collecting Old Masters, American landscapes, the French Barbizon School, and primitive art. The nature of his collection, however, changed radically in 1927, when he met Hilla Rebay, who introduced him to the work of the European avant-garde. In 1929, Rebay arranged a meeting between Guggenheim and Vasily Kandinsky, whose work embodied her vision of pure nonmimetic, or non-objective, painting, and Guggenheim bought his first canvas by the artist (150 more would follow). Starting in 1930, the public was allowed to view his collection in his private apartment at the Plaza Hotel, New York. Soon the walls were covered with works by such artists as Marc Chagall, Robert Delaunay, Fernand Léger, and László Moholy-Nagy; in order to publicly exhibit the works, Guggenheim established the Solomon R. Guggenheim Foundation. This step led to the opening of the Museum of Non-Objective Painting on East Fifty-fourth Street, and eventually to the commissioning of Frank Lloyd Wright to design a new building to house the collection. Guggenheim died ten years before the completion of the museum that commemorates his name.

Idea of Modern Art [1983]. Anyway, it adds another variable to our discussion in that we can relate the ideology of Modern art and the history of the modern museum to the history of national power during the twentieth century.

LD: Well, let's start by looking at the origins of our collections. Both began as institutions before the creation of the museums that house them today. The Pompidou collection was part of a larger state collection that was eventually carved up to become new, individual institutions. This is a unique genesis, especially when we reflect upon the encyclopedic scope that the Pompidou's collection later embraced. It is far from the founding philosophy of the Guggenheim, which was based on the subjective vision of two individuals, the philanthropist Solomon R. Guggenheim and his adviser, Hilla Rebay [the Guggenheim's first director].

BB: Yes, the idea of Modern art was in contradiction with the idea of the historical museum. In France, people thought that Modern art was experimental and that this experimentation had nothing to do with the space of the museum, which was a place for celebration and recognition of historically codified artistic achievement. The French wanted to reconstruct a history of Modern art, thinking of it as a celebration of the achievement of the art of France and its seminal role in the evolution of Modernism. In the process of realizing this original scheme, most avant-garde artists of this century who were outside France were ignored or marginalized.

So the idea of the Modern art museum came late in the development of Modernism; the idea of creating the Musée national d'art moderne [MNAM], I have to say, was an idea that originated from only a few people.

LD: Wasn't the scope and character of the Musée national d'art moderne's collection somewhat predetermined?

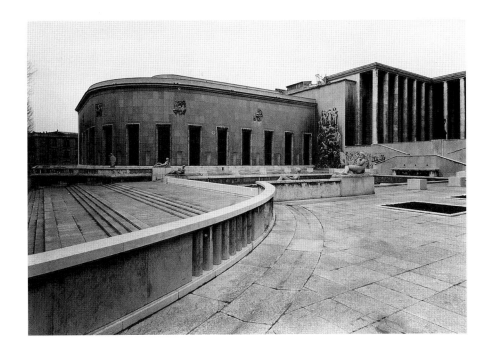

BB: The Musée national d'art moderne was the result of a merger [in 1945] of the Musée du Luxembourg and the Musée des Ecoles étrangères contemporaines. These two institutions did not have well-developed collections, nor were they comprehensive in their makeup. Jean Cassou became the first chief curator, at the recommendation of Louis Hautecoeur [chief curator of the Musée du Luxembourg from 1929 to 1941]. They insisted that the artists should be involved with the museum, and give gifts of their works to make the collection a reality. This idea was totally new for its time.

LD: That's interesting. The Guggenheim, unlike the Pompidou, is not a national museum. It began as a privately owned foundation, with strong European roots. When Rebay moved to New York in the 1920s, her dream was to help patrons assemble collections of art that she called "non-objective," an abstract art based not on nature but on pure artistic invention stemming from the inner spirit. She was commissioned to paint Solomon's portrait in 1927, and through her passionate persuasion, convinced him to build a collection of the most avant-garde art of his time. They traveled together, seeing the work of Vasily Kandinsky, Piet Mondrian, Albert Gleizes, Robert Delaunay, and László Moholy-Nagy, for example. There was never a will to form an encyclopedic collection, but the idea of building a museum to house this growing collection was there, certainly in Rebay's mind, if not Solomon's, from the very beginning. I must stress that Rebay was not just building a collection with the idea of establishing a museum—she was constructing a *temple* to the spiritual in art. There is a strong contrast between the private, one might even say sacred vision of Rebay, and the more "secular" model of your state-run institution.

BB: Over the past forty years, both museums' structures and collections evolved considerably, as subsequent museum directors and their curators

Jean Cassou (1897–1986)
Born in Bilbao in 1897, Jean Cassou moved to Paris in 1910. After studying Spanish literature at the Sorbonne, he worked as a commissioner and a counselor for the Bureau des arts plastiques, and later as an assistant curator at the Musée du Luxembourg. Dismissed by the Vichy Government in 1940, he was reinstated in 1945 as the chief curator in charge of creating the Musée national d'art moderne at the Palais de Tokyo. He began to strengthen the museum's collection through purchases and donations of works by Constantin Brancusi, Georges Braque, Fernand Léger, Henri Matisse, and Pablo Picasso, among others. Cassou also organized numerous wide-ranging exhibitions, including presentations of Fauvism and Cubism, as well as works from the collection of the Museum of Modern Art, New York, and by Jackson Pollock and other young American painters. Cassou retired from the Musée national d'art moderne in 1965. Two years later, he issued two seminal studies that addressed the museography and the mission of modern museums, prefiguring the Centre Georges Pompidou project. Cassou was also an art critic, a historian, an essayist, a writer, a translator of Hispanic literature, a poet, and a political activist.

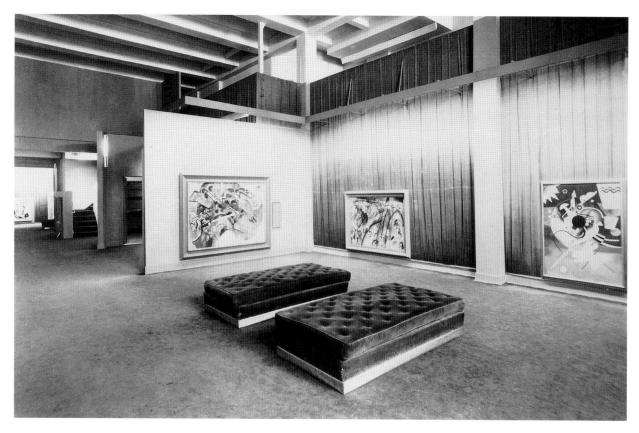

Installation view of *In Memory of Vasily Kandinsky*, at the Museum of Non-Objective Painting, New York, 1945.

The Solomon R. Guggenheim Foundation

Two years after the Solomon R. Guggenheim Foundation was established in 1937, the Museum of Non-Objective Painting opened on East Fifty-fourth Street in New York to showcase Solomon R. Guggenheim's collection of non-objective art. The commissioning, in 1943, of Frank Lloyd Wright to design a permanent museum was followed by the foundation's announcement that the exhibition programming was expanding to represent the full scope of Modern art from the late nineteenth century to the present.

The Solomon R. Guggenheim Museum, as it was renamed, opened on Fifth Avenue in 1959. In 1963, the foundation received a portion of Justin K. Thannhauser's collection of French Impressionist, Post-Impressionist, and Modern masterpieces, for which a new gallery was established. Later improvements included the construction of an annex, a restaurant, a bookstore, and the Richard Meier–designed Aye Simon Reading Room.

In 1976, Peggy Guggenheim's art collection and Venetian palazzo were transferred to the foundation, adding more than 300 works and a new museum site. From 1989 to 1992, the Fifth Avenue museum underwent extensive restoration and expansion, including a nine-story tower addition by Gwathmey Siegel and Associates Architects. The opening of the Guggenheim Museum SoHo in 1992 was followed by the opening of the Guggenheim Museum Bilbao and of the Deutsche Guggenheim Berlin in 1997.

The collection, which was significantly enhanced by the acquisition of the Panza Collection in 1990, has recently expanded to include photography and media arts.

re-evaluated and redefined the missions of their institutions. Obviously the Musée national d'art moderne has gone through many transformations since its origins, most significantly in that it became part of the Centre Georges Pompidou, which was in a way the realization of André Malraux's "*maisons de la culture*" in the late 1950s. His dream was to create a multidisciplinary institution that would serve as the ultimate form of pedagogy. This desire was melded into President Georges Pompidou's initiative [in 1969] to create a large cultural institution that would later bear his name.

LD: In the process of deciding how the Musée national d'art moderne's collection would reflect the story of Modernism, why did your institution begin this history in 1905 with Fauvism?

BB: There is now a division between the three state-run museums in Paris: the Musée du Louvre, the Musée d'Orsay, and the Musée national d'art moderne. It's interesting to see that many Modern art museums in the United States include Impressionism and Post-Impressionism to explain and give meaning to what is recognized as Modern art. The Musée national d'art moderne at one time also held this kind of work in its collection, but in the 1980s, the Impressionist, Post-Impressionist, and Nabis works—everything pre-Fauve—was removed in order to found the core collection of the Musée d'Orsay.

LD: That's the advantage and the disadvantage of being part of a network of national museums. While your historical divisions are clear, and you can provide a more exhaustive examination of stylistic periods, you have said that the

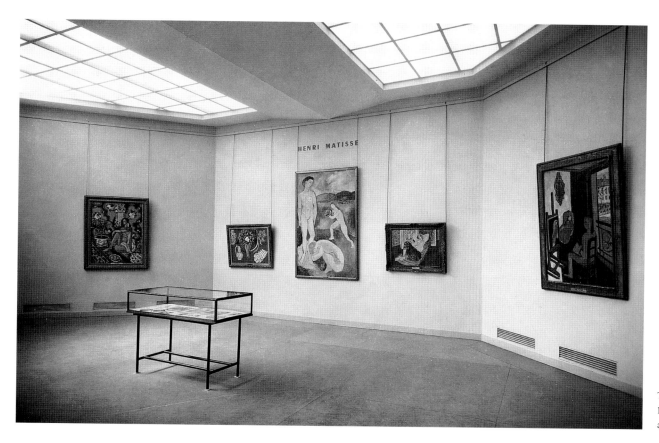

The Matisse room in the
Musée national d'art moderne
at the Palais de Tokyo, ca. 1950.

cultural structures that house this Modernist patrimony have also created a
mammoth bureaucracy to support those divisions.

BB: Yes, even if these divisions are somewhat arbitrary and subjective, they
reflect not only art-historical events but also the cultural politics of the French
state. As you know, unlike the United States, France has a strong governmen-
tal infrastructure to support all forms of culture. The Louvre is meant to
represent the traditions of art history and the Orsay the break from this past
and the beginning of Modernism. These distinctions are somewhat arbitrary
given the fact that the Orsay houses Gustave Courbet's *Studio of a Painter*
[*Intérieur de mon atelier du peintre*, 1854–55] as well as his *Burial at Ornans*
[*L'Enterrement à Ornans*, 1849–50]. *Burial at Ornans* represents Realism, the
first stage of Modernism, if we follow a traditional, teleological version of the
story, and therefore belongs in the Orsay, but *Studio* could arguably be part
of the collection of the Louvre because it is an allegory and a mid-nineteenth-
century masterpiece.

LD: This is an essential point in our juxtaposition: all of the museums in
France involved with various strains of Modernism are national institutions.
They are owned by the state, and their administrators are functionaries of the
state. This is unlike the American model, in which cultural institutions, such
as the Guggenheim, have a private and independent administration.

BB: But isn't your National Gallery of Art in Washington, D.C., the exception
to this rule?

Musée national d'art moderne

In 1945, the holdings of the Musée du Luxembourg
(dedicated to living French artists) and the Galerie du
Jeu de Paume (designated for living foreign artists),
were amalgamated to form the basis of the Musée
national d'art moderne (MNAM), which opened to the
public at the Palais de Tokyo in 1947. In 1969, French
President Georges Pompidou, introduced the idea of a
cultural center, the Centre Beaubourg, which now bears
his name. A reconfiguration of the state-run museums
in Paris merged the holdings of the Centre national
d'art contemporain and MNAM, forming a strong collec-
tion of contemporary art, while pre-Fauve works were
relocated to the Musée d'Orsay. In 1974, MNAM officially
became part of the Centre Georges Pompidou, the
world's first interdisciplinary museum facility. Designed
by Renzo Piano and Richard Rogers, the institution
houses a public library, an institute for musical research,
a center for graphic and industrial design, as well as
theaters and galleries. As part of the Pompidou, MNAM
acquired the administrative and financial autonomy
to dramatically increase its collection. In 1977, the
Pompidou opened to the public. In 1982, the state's
decision to more than double the budget of MNAM sig-
nificantly enhanced the collection, as have the generous
gifts of the Kahnweiler-Leiris and Daniel Cordier collec-
tions and of artists' estates. From 1984 to 1985, the
museum's interior was renovated and redesigned by
Gae Aulenti and Piano. In 1992, the Centre de création
industrielle's collection of design merged with MNAM's
collection, and the holdings now number more than
40,000 objects. In 1997, the Pompidou closed for
extensive renovation and expansion, and is scheduled
to reopen on December 31, 1999.

Hilla Rebay

Hilla Rebay (1890–1967)
Born in Strasbourg, in 1890, Hilla Rebay (born
Baroness Hilla Rebay von Ehrenwiesen) studied art
in Cologne, Paris, Munich, and Berlin, and was inter-
ested in the teachings of Rudolf Steiner. A member
of the Dada group in Switzerland and part of the artistic
circle associated with Der Sturm gallery in Berlin, she
was acutely aware of the groundbreaking work being
produced by the avant-garde.

 In 1927, she moved to the United States and met
Solomon R. Guggenheim, becoming his artistic ad-
viser. She influenced him to purchase "non-objective"
art, which she defined as pure abstraction and believed
to be infused with a mystical essence. She served as
the first director of the Museum of Non-Objective
Painting and instituted a series of traveling exhibitions
devoted to Guggenheim's collection. In 1943, her
vision of a "museum-temple" led her to choose
Frank Lloyd Wright to design a permanent museum
for the collection.

 In 1952, due to philosophical differences with
Solomon Guggenheim's nephew, Harry F.
Guggenheim, the president of the Solomon R.
Guggenheim Foundation, Rebay resigned as director
of the museum but continued her relationship with
the institution in the role of director emeritus. Part of
her estate, which included works by Vasily Kandinsky,
Paul Klee, and Kurt Schwitters, was given to the
Solomon R. Guggenheim Museum four years after
her death.

LD: Not really. The National Gallery was in fact founded on the tastes and con-
noisseurship of individual collectors, in particular Andrew W. Mellon, who,
having served as Secretary of the Treasury, wanted to created a collection in the
nation's capital. In 1937, he donated his art collection to form its core, and also
provided funds for the erection of the building. Congress passed an official
act to perpetuate the museum's operation. While it is true that the operating
budget is largely funded by the federal government, and the staff is comprised
of governmental employees, its collecting initiative remains largely private,
depending on the generosity of donors to enhance the holdings. And unlike
the French model, there is not a prioritization given to American art, nor does
the collection as a whole form an encyclopedia.

BB: How can we have the same expectations of a privately founded institution
as a publicly founded one? A private institution is, as we know, one of specific
taste and personal ambition, and this is true of the Solomon R. Guggenheim
Museum and the Peggy Guggenheim Collection in Venice. We could also cite
another kind of passion, for the influences that have been brought to bear by
husbands and lovers have also shaped these collections. But still, these individ-
ual collections reflect a distinct aestheticism that is obvious when looking at
them, even with just a cursory glance. Just in comparing Solomon's collection
with that of Peggy, we see that they're almost completely in contradiction—one
believes in Modernism through abstract art, the other is skeptical of this model
and embraces Dada and Surrealism. How can we compare Kandinsky's spiritu-
alist abstraction or Fernand Léger's and Delaunay's Modernist credo with
Marcel Duchamp's ironic wit? Your collection does not aspire to be anthological
in scope, while national museums, by their very definition, do strive for a
broader overview. Obviously, it is impossible to achieve any kind of encyclopedia
of art: all collections, by their nature, are partial. This partiality reflects their
purpose to engage in a debate of ideas and the fiction of history.

LD: In that sense, the Guggenheim collection stated its *parti pris* specifically
in the beginning with the very name of the first Guggenheim gallery to open
to the public: the Museum of Non-Objective Painting. The Guggenheim
Foundation had a detailed mission and charter in order to maintain that focus;
as it changed and expanded, the name of the museum changed. Over time,
that orientation has not been lost completely because its strong core of non-
objective art is still quite present. Yet the imprint of subsequent museum
directors James Johnson Sweeney, Thomas Messer, and Thomas Krens—
each of whom strengthened the collection by broadening its scope and filling

in some of the gaps—is dramatically visible when examining the evolution of the collection.

Sweeney added sculpture to the collection, including ten Brancusis, as well as seminal works of Abstract Expressionism; Messer brought the Thannhauser and Peggy Guggenheim collections under the umbrella of the Guggenheim Foundation; and Krens added photography, media arts, and a sensitivity to the spatial requirements of contemporary art that the Frank Lloyd Wright building couldn't anticipate, forming part of the rationale for the new Gwathmey Siegel tower uptown, the loft spaces of the Guggenheim Museum SoHo, as well as the Guggenheim Museum Bilbao.

It is important to mention that the Peggy Guggenheim Collection brought the New York–based foundation physically onto European territory. With the absorption of the Peggy Guggenheim Collection in 1976, the Guggenheim became simultaneously an American and a European institution. The location in Venice is also quite fortuitous because it has allowed us to have a hand in one of most influential events in the contemporary art world: the Venice *Biennale*. In fact, the Guggenheim owns the American pavilion itself. We have taken the opportunity to straddle both continents and have pushed this globalism even further with Bilbao, and more recently, with the Deutsche Guggenheim Berlin. In this respect, our position is unique in the museum world.

B B: It seems to me, however, that the Thannhauser Collection, with its Impressionist and Post-Impressionist paintings, and its strong holdings of early Picassos, brought your institution to another level. For the first time in its history it could display the entire view of Modernism that we call without any subtlety "high art." In a way, the Guggenheim Museum became then a kind of anthology of Modern art in spite of itself. When you try, as you do now, to put all your museums together into a network, doesn't it seem in contradiction to the original ambitions of each individual collection?

L D: Even with our global network, we still do not come close to the anthology that your network of national museums achieves. But it is true that our collections have diversified greatly through our program of international expansion, and will continue to do so. The Guggenheim Museum Bilbao, for example, is essentially a museum of postwar art, and through its acquisition program has purchased singular masterpieces of Abstract Expressionist and Pop art, but also continues the New York museum's strategy of collecting fewer artists in depth. Also, in response to the changing character of art in the last decades of

François Mathey

François Mathey (1917–1993)
François Mathey was born in Ronchamp in 1917. He became general inspector of Historic Monuments in 1942, curator in 1953, and served as chief curator of the Musée des arts décoratifs de Paris from 1966 to 1985. As early as the 1950s, he initiated a series of retrospectives for such living artists as Balthus, Jean Dubuffet, Yves Klein, and Roy Lichtenstein, as well as architects, designers, and graphic artists. His most notable and controversial show was *72-72* (1972), a large survey of French contemporary art commissioned by French President Georges Pompidou. In 1969, he created the Centre de création industrielle according to a program that equalized and integrated the arts without establishing a hierarchy among the different forms. In 1974, during Mathey's directorship (1972–76), the Centre de création industrielle became one of the departments of the Centre Georges Pompidou; it has generated many exhibitions, including *Paul Virilio-Bunker archéologie* (1975–76), *Ettore Sottsass* (1994), and *Gaetano Pesce* (1996).

Peggy Guggenheim

Peggy Guggenheim (1898–1979)
Peggy Guggenheim, a niece of Solomon R.
Guggenheim, was born in New York in 1898. In 1920,
she settled in Europe and became acquainted with
artists and writers. In 1938, Peggy, who rapidly estab-
lished herself as a supporter and patron of the arts,
opened the Guggenheim Jeune gallery in London,
exhibiting the works of Jean Cocteau, Vasily Kandinsky,
and Yves Tanguy. In March 1939, Peggy decided to
found a museum of contemporary art, but her plan was
interrupted by World War II. Peggy, who lived by the
motto "buy an artwork a day," assembled a private col-
lection of Cubist, abstract, and Surrealist art. She fled a
war-torn Europe, and arrived in New York in July 1941.
The following year, she opened the gallery/museum
Art of This Century, which was designed by Frederick
Kiesler. She gave William Baziotes, Jackson Pollock,
Mark Rothko, Clyfford Still, and others their first solo
exhibitions. After the war, she took up residence in
Venice, where her collection was shown at the 1948
Biennale, and where she purchased the eighteenth-
century Palazzo Venier dei Leoni, in which she lived for
the rest of her life. The palazzo enabled her to realize
her dream of opening an art museum. Peggy donated
numerous works to museums around the world, and
in 1976 transferred her collection and palazzo to the
Solomon R. Guggenheim Foundation, which now
operates the Peggy Guggenheim Collection, Venice.

the twentieth century, we have opened our doors to photography and the media
arts, previously ignored in our collecting history. Yet if you look back to the
charter of the Guggenheim Museum, you would be surprised to see how
diverse the founding collection actually was. Rebay and Solomon Guggenheim
collected Marc Chagall and Amedeo Modigliani, for example, as well as
Expressionist and Surrealist works when the Karl Nierendorf estate was pur-
chased in 1948. Keeping with our comparison, it seems to me that MNAM was
slower to fill the gaps in its own collection, especially in regard to such non-
French based movements as Italian and Russian Futurism, German Dada and
Expressionism, and even American art.

BB: In contrast to those in the United States, French institutions have never
been involved with the Futurists, Expressionists, or Dadaists, except, for
obvious reasons, with Paris Dada. And in that rare case, it is because we were
reading Dada from a Surrealist perspective. Despite the wide-ranging roots of
Modernism, the collection stayed very modest until it was amalgamated into
the larger structure of the Centre Georges Pompidou. All the same, MNAM
was not too simple in its showing of Modern art, for it had received several
artist's estates, including those of Brancusi, Henri Laurens, Robert and Sonia
Delaunay, Georges Rouault, Germaine Richier, and Victor Brauner. The visitor
had the impression that the history of Modernism was inextricably linked to
the history of France. Until the opening of the Pompidou [in 1977], the history
of MNAM's collections is the history of one culture that refused to recognize
anything that was outside itself.

LD: This is surprising because French culture has always been a culture of
assimilation, a home for exiles. If you look at Kees van Dongen in Paris; Pablo
Picasso and Juan Gris at the Bâteau-Lavoir; Chagall at La Ruche; Modigliani
and Chaim Soutine in Montparnasse; as well as Max Beckmann, Mondrian,
and Kandinsky, working in Paris for so many years, how can you explain that
a French museum could refuse to pay attention to their work?

BB: As Jean-Luc Godard would quip, *"La culture, c'est la règle, et l'art c'est
l'exception"* (Culture is the rule, and art is the exception). I would add that the
administration is more concerned with rules than exceptions!

So as you keenly point out, this lacuna is the fault of the French adminis-
tration's active forgetting of these artists. Likewise, most French Modern art
historians and curators also refused to consider art that was outside the con-
struction of this modern French history, beginning with Impressionism as its
foundation. They ignored the Italian Futurists even though Filippo Tommaso

Marinetti published his first manifesto in *Le Figaro* [in 1909]. They only started to pay attention to Cubism in the 1920s, when it was becoming an academicism easy to inscribe in *l'histoire de France*. In addition, who can forget that France was part of a dialogue with Germany through the Flechtheim or Der Sturm galleries, which gave many French artists their first recognition? After World War II and the return of so many artists who had lived in exile during the war, France was obsessed with celebrating its past and reconstructing its roots, more than with reconsidering other territories of Modern art.

L D : That explains the difficulties encountered at the beginning of MNAM. However, it's impressive to see what Cassou accomplished with the complicity of the Modern masters who were still alive after the war, given the fact that he was interested in reconstructing the history of pre–World War II art rather than engaging the very young generation of art of that time.

More significant is what happened later in the 1950s, when France missed some opportunities to collect new American painting, such as the work of Jackson Pollock, although it was being shown in Paris. It is somewhat ironic that you did not acquire works presented in the groundbreaking exhibition organized by Cassou, *Pollock et la jeune peinture américaine* [in 1959]. It seems to me that while the geography of the art scene expanded, France became even more nostalgic in reaction, insisting on its supremacy as the artistic center in the first half of the century. But despite the difference in our histories, we can say retroactively that both of our collections are indeed quite similar in composition until the seminal date of 1945.

B B : On the first hand, in response to your rather critical assessment, we must give recognition to those figures who quickly perceived this shortsightedness in French cultural politics. Without someone like Pontus Hulten or Dominique Bozo [subsequent directors of MNAM], not to mention the substantial public monies that they had at their disposal, we would never have been able to catch up with the time and opportunities we lost after Cassou's early efforts.

With respect to your later statement, we could attribute the similarity of our current collections to a historiographic construction of the avant-garde that has been completely idealized and codified. It is true that we can compare the holdings of MNAM and the Guggenheim museums, as we could do with those of many other great institutions. In fact, the collection of the Museum of Modern Art in New York adheres to the same historical trajectory of Modernism that the MNAM collection promotes, reflecting the francophile attitudes of Alfred H. Barr, Jr., and Clement Greenberg.

Daniel-Henri Kahnweiler

Daniel-Henri Kahnweiler (1884–1979)
Born in Mannheim to a wealthy family, Daniel-Henri Kahnweiler lived in Stuttgart, where he developed a taste for art by visiting the city's museums. In 1907, he opened his first gallery, the Kahnweiler gallery in Paris, and became a friend and dealer of Cubists, exhibiting the work of Georges Braque, Juan Gris, Fernand Léger, and Pablo Picasso. He was also an editor and critic, and published the first works of Antonin Artaud, Georges Bataille, and Michel Leiris, among others.

Kahnweiler went into exile to Switzerland during World War I, and his assets were subsequently seized and later sold by the French state. In 1920, he opened another gallery in Paris, and from 1921 onward he worked closely with his sister-in-law, Louise Leiris. In 1937, he became a French citizen, and although he was Jewish, he was able to maintain his gallery during World War II with the help of Leiris. The gallery still exists, and is known as the Louise Leiris Gallery. Through their close relationships with many painters, poets, and philosophers, Kahnweiler and Leiris and her husband, Michel, were able to shape an exceptional collection of art from the first half of this century, including masterpieces by André Masson, Joan Miró, and Picasso, as well as by postwar artist Francis Bacon. In 1967, Kahnweiler donated his collection to the French state. In 1985, the Leirises gave 200 works to the state; these two donations, which became known as the Kahnweiler-Leiris collection, became integrated into the holdings of the Musée national d'art moderne.

Frank Lloyd Wright

Frank Lloyd Wright (1869–1959)
Born in Richland Center, Wisconsin, in 1869, Frank Lloyd Wright studied engineering before working for the architectural firm of Dankmar Adler and Louis Sullivan in Chicago. During Wright's early career, he challenged nineteenth-century conventions in his designs for a series of Prairie Houses, his earliest major contribution to modern architecture, which emphasize flowing open spaces in the principal living areas and the integration of the structure's interior and exterior with the natural surroundings.

In 1943, the Solomon R. Guggenheim Foundation commissioned Wright to design a permanent structure for the Museum of Non-Objective Painting, New York; the project occupied him for the next sixteen years. In accordance with Hilla Rebay's desire for a "museum-temple," Wright developed a structure reminiscent of ancient Mesopotamian ziggurats. In spite of many revisions made over the next decade, the basic design remained: a poured-concrete ramp, spiraling outward while rising around an open central well almost one hundred feet high to a large skylight. Wright died six months before the museum opened.

Major projects of Wright's substantial oeuvre include the Unity Church (1904), Oak Park, Illinois; the Imperial Hotel (1915, demolished 1968), Tokyo; Fallingwater (1935), Mill Run, Pennsylvania; the Johnson Wax Building (1936), Racine; and Taliesin West (1937), Scottsdale.

So although our "rendezvous" is by definition artificial, it does give us the opportunity to put together many works that have a strong relationship to one another and that have been separated for a multiplicity of reasons. I would venture that it is interesting in art-historical terms, but it is also necessary to use the opportunity of this exhibition to consider how these collections have been constituted, almost in the spirit of Stanley Cavell's essay [see "The World as Things: Collecting Thoughts on Collecting," pp. 64–89, in this catalogue]. Otherwise stated, our dialogue must touch upon the philosophical and ethical implications of the act of collecting.

L D : Beginning purely in terms of historical events, the similarities of our two collections until World War II have to do with the fact that Rebay and Peggy Guggenheim were always involved with Europe. There is little of the early American avant-garde in their collections, although Rebay did support and collect a number of American artists working with "non-objectivity," such as Rolph Scarlett and Irene Rice Pereira. Rebay was friends with Moholy-Nagy and through him visited Mondrian in Paris. She also brought Solomon directly to Kandinsky's studio in Dessau. So the collection is the result of her direct engagement with Modern artists themselves on a firsthand basis, as it was for Peggy, and later in a way for Messer with artists such as Jean Dubuffet. I don't think that you can build a collection in any other way.

B B : This is the same with Cassou, but unfortunately he had to play catch-up. This is a strong difference between Europe and United States. For better or worse, the greatest American collections are of their time. Americans don't deal with history in the same way that the French do. In addition to this game of catch-up, Hulten and Bozo tried through their own convictions to convert their institution to be also an international reflection of their time.

L D : Despite this recent transformation, your collection doesn't deal with many movements during the first part of the twentieth century, and its perspective is constantly referring to the celebration of its own territory. Do you feel that the immediate postwar collection of the museum engages international art in a much more open way, or is it still the preservation of the French Modern tradition, which is often referred to as the Ecole de Paris?

B B : Don't forget that the Ecole de Paris is only a phantasm. It was invented after the war as a counterpoint to the New York School. These names are simply an expression of power, an expression of cultural imperialism. Dubuffet would find his placement in the Ecole de Paris ridiculous and "asphyxiating";

so much of his work escapes this definition: the notion of being part of a group, the constant reference to historical models such as Impressionism, and craftsmanship. There is a deliberate confusion in trying to assimilate all the art in Paris in the century under the banner of the Ecole de Paris. This terminology is in fact more indeterminate than the New York School and cannot be seen as an equivalent.

Nevertheless, it is true that the constitution of the Musée national d'art moderne, as well as its programming, was deeply involved in this celebration. We can also say that in the 1950s MNAM refused to purchase works that were outside its cultural makeup. This is because the French institutions refused to consider the French art scene as part of an international dialogue, and accordingly most French artists were seen in isolation.

LD: Despite what we say, one interesting part of the dialogue between our collections is that the Guggenheim, especially through the activities of Messer, who is himself European, strove to keep a balance between American and European postwar art, especially this so-called Ecole de Paris, perhaps even to the detriment of our own Abstract Expressionist holdings. The result is that we do have a strong and rather unique collection of French art of that generation, including such artists as Maria Helena Vieira da Silva, Alfred Manessier, Hans Hartung, Pierre Soulages, and of the later Kineticists Jesus Rafael Soto and Victor Vasarely. In a way, the Guggenheim is a counterexample of most American museums, which decided to consider postwar American art as a normal extension of prewar European art.

BB: Given that Messer was so interested in the work of Dubuffet, can you explain to me why you didn't acquire such masters as Nicolas de Staël, Jean Fautrier, Bram Van Velde, and Wols? I should, however, be careful in my interrogation of your institution because MNAM did not pay close attention to these artists until the early 1980s, and instead preferred in the 1960s to exhibit certain artists considered to be part of the Ecole de Paris.

LD: Well, let's not forget that all acquisition monies for the Guggenheim collection must be privately raised. In the case of de Staël, there was a keen desire to purchase his work, but the funds were not there. But we did present an exhibition of de Staël in 1966, which was the only museum show he ever had in New York, and one of the very few that he had in the United States.

American critics and curators have treated artists like Wols and Fautrier poorly in comparison to the Abstract Expressionists, and they never even looked at Van Velde. Maybe it is because their art was antiheroic in nature

Renzo Piano (b. 1937) and **Richard Rogers** (b. 1933) Renzo Piano was born in Genes, Italy, in 1937. After earning an architectural diploma at the polytechnic school of Milan in 1964, his apprenticeships included one with Louis I. Kahn in Philadelphia. His projects include the Menil Collection (1987), Houston; Kansaï Airport (1994), Osaka; the reconstruction of Brancusi's studio at the Pompidou (1997); and the Centre culturel Jean-Marie Tjibaou (1994), Nouméa, New Caledonia. He was honored with the 1978 Architects International Union Prize and received the 1998 Pritzker Prize.

Born in Florence in 1933, Sir Richard Rogers is an British citizen. He earned a diploma from the Architectural Association, London, in 1963. Rogers's major projects include the Lloyd's of London headquarters (1978–83); the redevelopment of the London Billingstate Fish Market (1985–88); and the European Court of Human Rights, Strasbourg (1989–95). His firm is well known for constructing energy-conserving buildings. Rogers was named president of the Tate Gallery Board, London, in 1984, and Honorary Doctor of the Royal College of Art, London, in 1986.

In 1971, Piano and Rogers won an international architectural competition for the design of the Centre Georges Pompidou. Both architects recently participated in the reconstruction of the Potsdamerplatz, Berlin (1996–).

Born in Bratislava, Czechoslovakia, in 1920, Thomas M.
Messer was raised in Prague. He studied art history at
the Sorbonne, Paris, and then at Harvard University,
Cambridge, Massachusetts, where he earned an M.A.
in 1951. After graduating, he worked at the Roswell
Museum in New Mexico, the American Federation for
the Arts in New York, and the Institute of Contemporary
Art in Boston.

In 1961, Messer became the third director of the
Solomon R. Guggenheim Museum. During his tenure,
the curatorial and technical staff expanded to meet the
needs of the museum's rapidly growing exhibition
and publishing activities. Messer originated various
exhibitions, including three shows on Jean Dubuffet
and four on Vasily Kandinsky. His accomplishments
included securing a portion of the acquisition of Justin
K. Thannhauser's collection, part of the Hilla Rebay
estate, and the Peggy Guggenheim Collection. Messer,
who was intent upon filling the gaps within the
Guggenheim collection, made acquisitions ranging
from *The Italian Woman* (1916) by Henri Matisse to
Soft Pay-Telephone (1963) by Claes Oldenburg. In addi-
tion, he opened the collection up to new geographical
dimensions, including Latin American and Eastern
European art.

Along with the growth of the collection, Messer
oversaw the expansion of the museum with the Justin
K. Thannhauser wing, the annex, and the Aye Simon
Reading Room. In 1982, Gwathmey Siegel and
Associates Architects were contracted to implement
a plan for major development and restoration of
the museum. Messer retired in 1988 just before the
commencement of construction.

Thomas M. Messer

and in contrast to an American teleological perspective. That we reconsider
the events of postwar European and American art is one of the strengths of
Rendezvous. It is a difficult task to perform on American soil as these artists
remain underappreciated in the United States.

BB: In our assessment of these artists, it has been important not to create
simple formal comparisons between American and European art of this genera-
tion for each has its different concerns. What does it mean to juxtapose Van
Velde with Mark Rothko, or Franz Kline with Soulages, except for the fact that
they share superficial visual similarities? In the 1950s and 1960s there were
many exhibitions that compared these artists' works and even set them up in a
kind of competition, particularly at the Betty Parsons and Sidney Janis galleries
in New York. These juxtapositions, which were simply an outgrowth of cultural
bias, did not allow for the viewer to see the individual artist's concerns.

LD: However, in its exhibition *Paris–New York* [in 1977], the Centre Georges
Pompidou forced comparisons between European and American artists by
placing works by Pollock and Georges Mathieu, Dubuffet and Willem de Kooning,
as well as Robert Rauschenberg and Jean Tinguely, in the same rooms. We are
taking a slightly different tack, giving these artists their separate spaces, or "bays"
as we call them, rather than directly juxtaposing their works. We reconsider
their works as part of the same time period but not the same "frame." It is our
objective here to address the problem in the reception of European and American
art during the postwar period.

BB: No one can deny that Paris and New York were the two centers of art directly
after the war, even if New York has tried to proclaim itself the sole art capital of

that time. Most artists who had been living in exile during the war returned to Paris, and new salons, such as the Salon des Réalités Nouvelles, started to have a real influence on the generation emerging after the war. Many foreign artists, such as those in the CoBrA group, had to come to, or pass through, Paris to feel a part of the intellectual activity of art in Europe, even though they had previously received international recognition. New York became a center of art through strategies of domination and the creation of an American myth, which was developed by the influential critic Clement Greenberg and his formalist perspective. In a way, New York became a paragon of postwar Modern art.

So, the choice of some key works by Antonin Artaud, Henri Michaux, Fautrier, Wols—without speaking, of course, of a younger generation—must now be considered by the American audience in a discussion of postwar art. In a way this is also what Rosalind Krauss and Yve-Alain Bois were exploring in their recent exhibition at the Pompidou, *l'Informe* [in 1996].

LD: Skipping forward to the generation of artists working in the 1960s, when the supposedly separate poles of Paris and New York converged, I consider the list of European artists, such as Arman, Martial Raysse, and Tinguely, who decided to let go of their European roots and sample American soil, not unlike Francis Picabia and Duchamp fifty years before. The international dialogue became different. A very concrete example that corroborates this claim would be the collaborative artworks executed by the couplings of Jasper Johns, Rauschenberg, Tinguely, Yves Klein, and Niki de Saint-Phalle. We should also not disregard the importance of a site such as the Chelsea Hotel, where these artists lived and intermingled. There were also the first exhibitions of New Realism at Sidney Janis Gallery, Klein's first American show at the Leo Castelli Gallery in 1961, and *The Art of Assemblage* at the Museum of Modern Art [in 1961]. On the other side of the ocean, Americans Sam Francis and Ellsworth Kelly, who lived in Paris in the late 1940s and early 1950s, were singular figures. They were never part of a collective strategy or a group such as the Nouveaux Réalistes or Pop art.

All of this being said, we have not been able to exhaustively treat the question of international dialogues after the war. To point out a major gap in both collections—the absence of significant pieces by Richard Hamilton—explains why we do not have the opportunity to present Pop art as a British invention, and underscores that *Rendezvous* is far from definitive. We can only go as far as our collections allow us to go. In fact, this confrontation between the collections must also be considered as a space in which to ask questions about just these kind of lapses or gaps.

Pontus Hulten

Pontus Hulten (b. 1924)
Pontus Hulten was born in Stockholm in 1924. After studying art and ethnography, he traveled to Paris, where he made experimental films and helped organize a pioneering exhibition of Kinetic art in 1955 at the Galerie Denise René. His museum career began the following year at the Moderna Museet, Stockholm, of which he became the director in 1959. In 1973, he became the director of the Musée national d'art moderne. As a result of a change in the museum's legal status, Hulten was able to increase its acquisitions and expand the scope of its collection, securing many donations such as the Nina Kandinsky estate. His contributions to the museum also include the curating of a landmark exhibition series: *Paris–New York* (1977), *Paris–Berlin* (1978), and *Paris–Moscou* (1979). Hulten left the Musée national d'art moderne in 1980 to create and successively direct several museums, among them the Museum of Contemporary Art, Los Angeles; the Palazzo Grassi, Venice; the Kunst und Austellungshalle der Bundesrepublik Deutschland, Bonn; and the Jean Tinguely Museum, Basel. From 1984 to 1996, he continued to serve as the director of the Institut des Hautes études en Art Plastiques, Paris, a fine-arts study center he had founded.

Thomas Krens

Thomas Krens (b. 1946)
Born in New York, Thomas Krens holds a B.A. from
Williams College, Williamstown, Massachusetts, an
M.A. from the State University of New York at Albany,
and a Masters in Public and Private Management from
Yale University, New Haven. From 1971 to 1991, Krens
was a member of the art-department faculty at Williams
College, and in 1981, became director of the Williams
College Museum of Art.

In 1988, Krens was named the fourth director of the
Solomon R. Guggenheim Foundation, which at the
time included the Solomon R. Guggenheim Museum
in New York and the Peggy Guggenheim Collection in
Venice. Among his accomplishments, Krens managed
the restoration of and addition to the Frank Lloyd
Wright building, as well as the realization of the
Guggenheim Museum SoHo. In 1997, he expanded the
audiences for the museum's collection and program-
ming by establishing two more sites for the network of
Guggenheim museums: the Guggenheim Museum
Bilbao and Deutche Guggenheim Berlin.

Under Krens's leadership, the museum acquired the
Hilde Thannhauser Bequest and the Panza Collection,
as well as a substantial gift from the Mapplethorpe
Foundation. He has also enhanced the museum's pro-
gramming with such landmark exhibitions as *The Great
Utopia: The Russian and Soviet Avant-Garde, 1915–1932*
(1992) and *China: 5,000 Years* (1998). He has also
curated exhibitions of contemporary art and design
such as *Robert Morris: The Mind/Body Problem* (1994)
and *The Art of the Motorcycle* (1998).

BB: This is exactly why I'd like to rhetorically ask, Why do we persist in posing
these questions about equivalence? Are these divisions still defined between
Europe and America, or is it more appropriate to speak about a larger global
configuration? I would say that, at least in speaking about contemporary art,
these divisions are very porous. Nationalist agendas as well as Europe- and
America-centricisms are thinly veiled; their transparency impedes us from con-
tinuing collection strategies that perpetuate along these poles. Unfortunately,
we are unable to explore this issue here, as the last work presented in
Rendezvous was created in 1970.

It was not an arbitrary decision to stop at this date. I have to say that a
book such as Lucy Lippard's *Six Years: The Dematerialization of the Art Object*
[1973], a study that focuses on the works that we just begin to explore at the
end of *Rendezvous* (by Buren, Toroni, Weiner, Morris, etc.), continues to influ-
ence on my thinking about this period. The year 1970 is an important marker
because the art of this time begins to actively engage with a critique of the
institution; questions circulate around the limits of the museum, its ideological
structures, and the role of the artist as a figure who should bring these ques-
tions to the forefront. Even if we could have prolonged our dialogue to engage
this period, especially since both of our museums possess important holdings
of Post-Minimalism, Conceptual Art, and Arte Povera, we could never have been
able to resolve or codify works falling into the category of Earth Art, and even
certain examples of Process Art. Some things escape the museographic frame.

LD: If we wanted to ask the questions you have started to raise here, we would
have to dedicate an entire exhibition to these issues. We could not have done
any justice to them on the final ramps of the spiral in this context. Not to men-
tion that we would also have had to expand our scope to deal with questions of
multidisciplinarity that would have brought us very far away from the dialogue
we carefully balance between the paintings and sculptures presented in
Rendezvous, even if there are brief installations of photography and design in
the exhibition. In a certain way, *Rendezvous* is a testimony to the Modernist
exploration and interrogation of sculptural and pictorial models. That being
said, it is true that we could create another entire exhibition by putting our
Panza Collection in dialogue with your holdings of Conceptual and Post-
Minimalist works.

BB: If we could criticize MNAM for being slow to create a contemporary collec-
tion, we should recognize the way that it eventually made a commitment to
aggressively acquiring contemporary work, as well as making the decision to

Dominique Bozo

Dominique Bozo (1935–1993)
Dominique Bozo studied in Paris at the Ecole du
Louvre, the Institute of Art and Archeology, and the
Ecole Pratique des Hautes Etudes. After working as a
teacher, he joined the French cultural ministry. In
1969, he was assigned to oversee the relocation of the
Musée national d'art moderne to the forthcoming
Centre Georges Pompidou. In 1976, Bozo supervised
the creation of the Musée Picasso in the Hotel Salé,
Paris, and handled the artist's *dation*. In 1981, he
became director of the Musée national d'art moderne,
acquiring such masterpieces as *New York City I* (1942)
by Piet Mondrian, works by Henri Matisse, Alberto
Giacometti, and Joan Miró, a major ensemble of ready-
mades by Marcel Duchamp, and the Kahnweiler-Leiris
Collection, and implemented the renovation of the
museum's interior spaces in 1982. In 1984, he became
the first director of the Musée Picasso, and in 1986
he became president of the Centre national des arts
plastiques and initiated a project to turn the Galerie du
Jeu de Paume in Paris into a contemporary-art exhibi-
tion center. In 1990, he resumed his directorship at
the Musée national d'art moderne-Centre de création
industrielle, and the following year became the presi-
dent of the Pompidou to oversee administrative reform.
He also created a collection of design and architecture
for the Pompidou.

build strong architecture and design collections. Because of this decision, we
have built an in-depth collection of contemporary art from Conceptualism
through to works of the 1980s and 1990s. This is our unique position in a
country that has other official structures—such as Fonds national d'art con-
temporain and Fonds régional d'art contemporain—to support the diversity of
contemporary art practices. I am convinced that those who critique our active
engagement with contemporary art today are analogous to the detractors of
Cassou's engagement with living artists in order to transform MNAM during
the 1950s into *"un musée vivant."*

LD: The Guggenheim has also been the object of criticism vis-à-vis our collec-
tion strategies even if our means and methods of collecting are different. As we
are not beneficiaries of the *dation* system [a remittance of artworks in lieu
of inheritance taxes established in 1968] as you are, we must engage in
relationships with artists and collectors in order to enrich our holdings. We
must continue to find "pillars," just as the collections of Solomon, of Hilla, of
Peggy, of Justin Thannhauser, and most recently of Count Panza's holdings
of Minimalist works are the foundations upon which our collection has been
built. The decision to acquire the Panza Collection, which was criticized
because works from the Modern collection were sold to fund this purchase,
has turned out to be a very important cornerstone of the contemporary
collections. And, once again, contemporary foresight recalls the principles of
non-objectivity, which the Guggenheim has not forgotten.

LE MUSÉE IMAGINAIRE

If one were to embark on a grand tour of Modern art today, two essential stops on the excursion would be the Solomon R. Guggenheim Museum and the Musée national d'art moderne of the Centre Georges Pompidou. *Rendezvous*, as a meeting between these two collections, creates what André Malraux described as a *"musée imaginaire,"* or "museum without walls." Through the invention of photography, photographic reproduction, and the rise in number of museums, Malraux argues, the twentieth-century viewer is able to analyze and compare artworks from different locations and periods in a way that was not previously possible.[1] Traditionally, such study would have required the scholar not only to travel long distances through Europe or across the Atlantic but also to rely upon a keen, vivid memory. *Rendezvous* itself is thus unique; it literally combines two venues on the grand tour in one location, placing works side by side that would not otherwise be seen together.

Presenting the dialogue between the two museums, the following pages are divided into sections, organized in a loose chronological order from the turn of the century to approximately 1970. Some sections explore significant art movements and artists' relationships to one another, while others serve as artists' monographs, which take advantage of the two collections' holdings to bring together works from the same series as well as studies and final paintings. In some instances, face-to-face oppositions occur to highlight institutional and national differences. In this way, the history of Modern art and the histories of the two museums have been woven together.

The first section begins with Paul Cézanne's *Man with Crossed Arms* (*Homme aux bras croisés*, ca. 1899, cat. no. 1) from the Solomon R. Guggenheim Museum. Cézanne's great influence can be seen in much twentieth-century artwork, including André Derain's *Portrait of Iturrino* (*Portrait d'Iturrino*, 1914, cat. no. 3) from the Musée national d'art moderne. More than a decade separates the two artists' portraits, yet the similarities between them are strong. After seeing Cézanne's 1906 retrospective at the Salon d'automne, Derain abandoned Fauvism and began to explore his interest in Cézanne's work and classical techniques of painting.

Just as each of these portraits gives an idea of the individual artist's work, the works in *Rendezvous* provide a portrait of each institution. Although the two collections are merged, the identity of each is discernible. Structurally, the Musée national d'art moderne and the Guggenheim represent two distinct kinds of museums: the public, government-run institution and a public museum founded on the private collections of several individuals. The former is one institution within a multidisciplinary cultural center, and the latter is one in a network of international museums. One originally celebrated the Modern art produced in France, the other non-objective painting. Despite such fundamental differences, however, the collections, particularly in the area of pre–World War II art, are remarkably similar.

Rendezvous, in uniting the collections of two museums, moves beyond Malraux's idea of the *musée imaginaire*. The viewer is invited to examine not only the artworks from these institutions but also to consider the institutions themselves and the relations between them. More important, the catalogue documents European and American approaches to collecting and explores the relationship between two of the dominant art capitals of the twentieth century, Paris and New York.

1. André Malraux, "Museum Without Walls," pt. 1 of *The Voices of Silence*, trans. Stuart Gilbert, Bollingen Series xxiv-a (Princeton, N.J.: Princeton University Press, 1978), pp. 13–130.

Paul Cézanne in his studio.

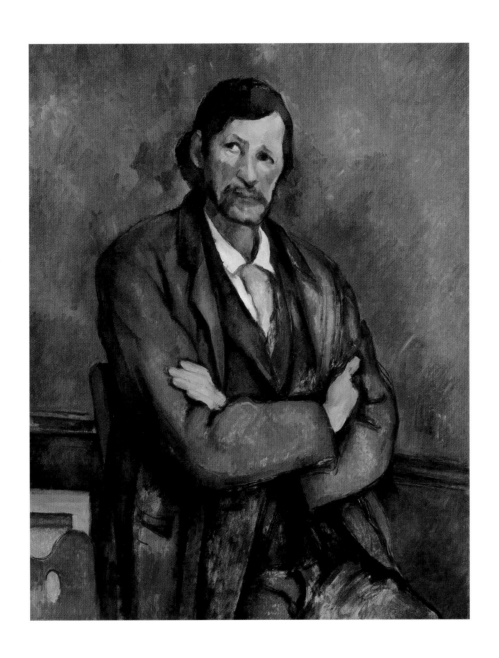

1

Paul Cézanne

Man with Crossed Arms (Homme aux bras croisés), ca. 1899
Oil on canvas
92 × 72.7 cm (36¼ × 28⅝ inches)

Solomon R. Guggenheim Museum, New York 54.1387

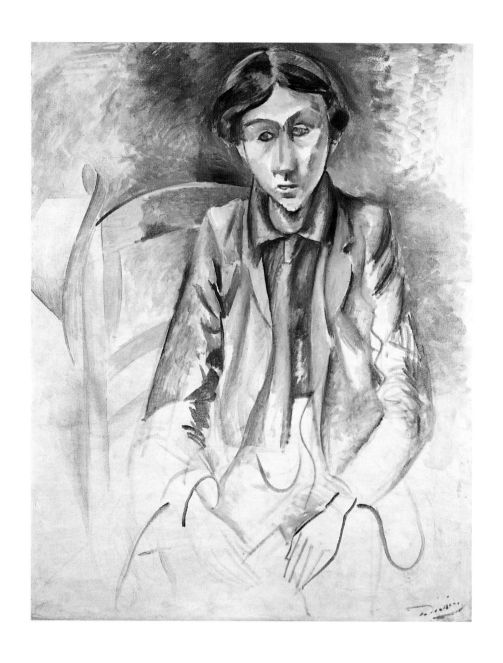

2

André Derain

Portrait of a Young Man (Portrait de jeune homme), ca. 1913–14
Oil on canvas with pencil underdrawing
91.8 × 73.6 cm (36⅛ × 29 inches)

Solomon R. Guggenheim Museum, New York 59.1548

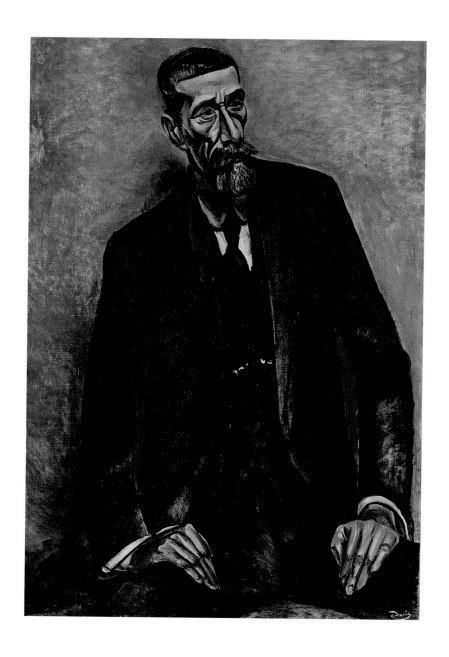

3
André Derain
Portrait of Iturrino (Portrait d'Iturrino), 1914
Oil on canvas
92 × 65 cm (36 1/4 × 25 9/16 inches)

Centre Georges Pompidou, Musée national d'art moderne, Paris,
Gift, Geneviève Gallibert, 1969 AM 4575 P

FAUVISM AND HENRI MATISSE

Fauvism, which marks the first avant-garde art movement of the twentieth century, was influenced by the Impressionist's love of nature and contemporary life, as well as the Neo-Impressionists' strong sense of emotive color. In particular, the Fauves (wild beasts), including Georges Braque, André Derain, Maurice de Vlaminck, and Henri Matisse, wanted to free color from its traditionally descriptive role, creating an art that expressed an emotional, subjective experience through the pure optical sensation of brushwork and color.

The Musée national d'art moderne has developed a substantial collection of Fauvist paintings and a strong selection from Matisse's oeuvre. The Guggenheim, in contrast, has collected very few Fauvist works because its original mission was focused on non-objective, or purely abstract, painting. It was not until 1982 that the Guggenheim acquired, through an exchange with the Museum of Modern Art, New York, its only major Matisse, *The Italian Woman* (*L'Italienne*, 1916, cat. no. 13), a painting complemented, in particular, by Matisse's *Portrait of Greta Prozor* (*Portrait de Greta Prozor*, late 1916, cat. no. 14), which, like *The Italian Woman*, Matisse painted in the austere style characteristic of his World War I portraiture.

Henri Matisse at his Quai Saint-Michel studio, autumn or winter 1916. Left to right: *Portrait of Michael Stein* (1916), *Portrait of Sarah Stein* (1916), an early state of *Portrait of Greta Prozor* (late 1916), an early state of *The Italian Woman* (1916). On the wall: *Marguerite in a Leather Hat* (1914).

113

4
Maurice de Vlaminck
The Hills around Rueil (*Les Coteaux de Rueil*), 1906
Oil on canvas
48 × 56 cm (18⁷⁄₈ × 22¹⁄₁₆ inches)

Centre Georges Pompidou, Musée national d'art moderne, Paris,
Purchased 1947 ᴀᴍ 2675 ᴘ

5
André Derain
The Banks of the Thames (The Bridge at Chatou)
(*Les Bords de la Tamise [Le Pont de Chatou]*), 1905–06
Oil on canvas
81 × 100 cm (31⅞ × 39⅜ inches)

Centre Georges Pompidou, Musée national d'art moderne, Paris,
Gift, Marcelle Bourdon, 1990 AM 1990-202

6
André Derain
Two Barges (Les Deux Péniches), 1906
Oil on canvas
80 × 97.5 cm (31¹⁄₂ × 38³⁄₈ inches)

Centre Georges Pompidou, Musée national d'art moderne, Paris,
Purchased 1972 AM 1972-1

7
Georges Braque
L'Estaque, 1906
Oil on canvas
60 × 73.5 cm (23 5/8 × 28 15/16 inches)

Centre Georges Pompidou, Musée national d'art moderne, Paris,
Remittance in lieu of inheritance taxes to the government of France,
1982 AM 1982-98

8

Georges Braque
Landscape near Antwerp (Paysage près d'Anvers), 1906
Oil on canvas
60 × 81 cm (23 5/8 × 31 7/8 inches)

Solomon R. Guggenheim Museum, New York,
Thannhauser Collection, Gift, Justin K. Thannhauser
78.2514 TI

9
Georges Braque
The Little Bay at La Ciotat (*Petite baie de La Ciotat*), 1907
Oil on canvas
36 × 48 cm (14 ³/₁₆ × 18 ⁷/₈ inches)

Centre Georges Pompidou, Musée national d'art moderne, Paris,
Gift, Mrs. Georges Braque, 1963 AM 4298 P

10

Henri Matisse
Study for *Le Luxe I*, 1907
Charcoal on paper
2.3 × 1.4 m (7 feet 4⅝ inches × 4 feet 5⅞ inches)

Centre Georges Pompidou, Musée national d'art moderne, Paris,
Gift, Mrs. Marguerite Duthuit, 1975 AM 1976-279

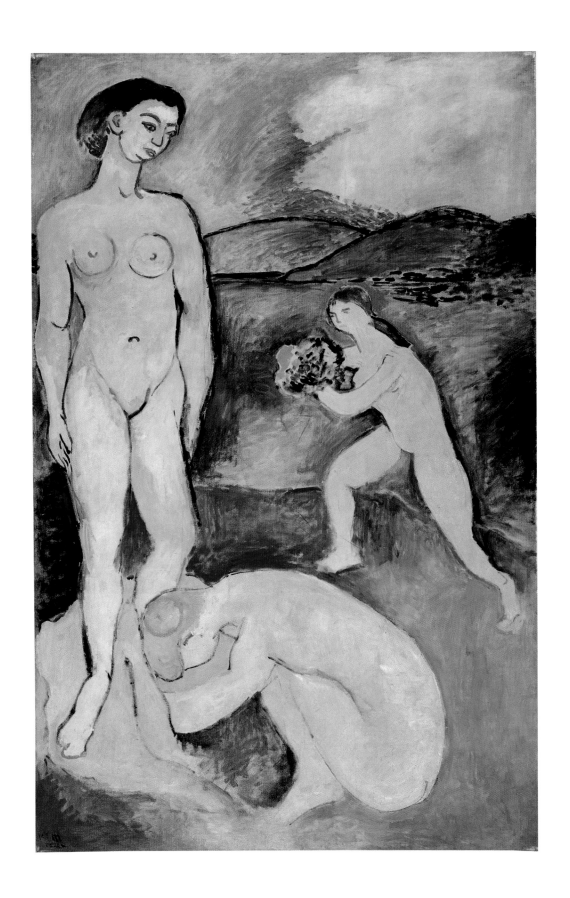

11

Henri Matisse

Le Luxe I, summer 1907

Oil on canvas

2.1 × 1.4 m (6 feet 10 11/16 inches × 4 feet 6 5/16 inches)

Centre Georges Pompidou, Musée national d'art moderne, Paris,
Purchased 1945 AM 2586 P

12
Henri Matisse
French Window at Collioure (Porte-fenêtre à Collioure),
September–October 1914
Oil on canvas
116.5 × 89 cm (45 7/8 × 36 1/16 inches)

Centre Georges Pompidou, Musée national d'art moderne, Paris,
Remittance in lieu of inheritance taxes to the government of France,
1983 AM 1983-508

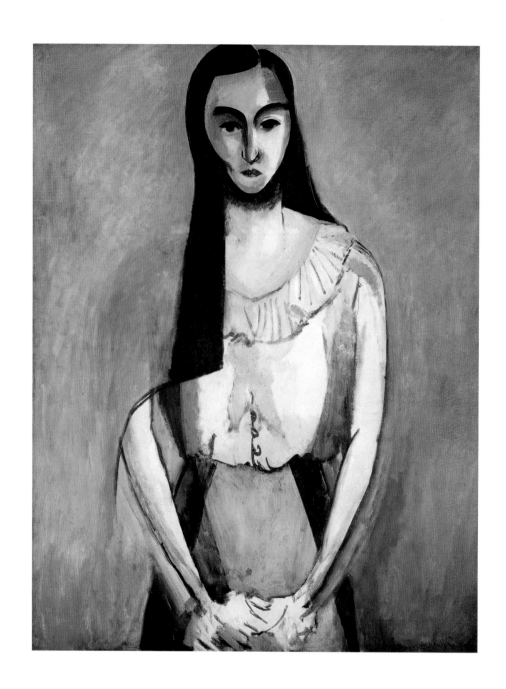

13
Henri Matisse

The Italian Woman (L'Italienne), 1916
Oil on canvas
116.7 × 89.5 cm (45^{15}/$_{16}$ × 35^{1}/$_{4}$ inches)

Solomon R. Guggenheim Museum, New York, By exchange 82.2946

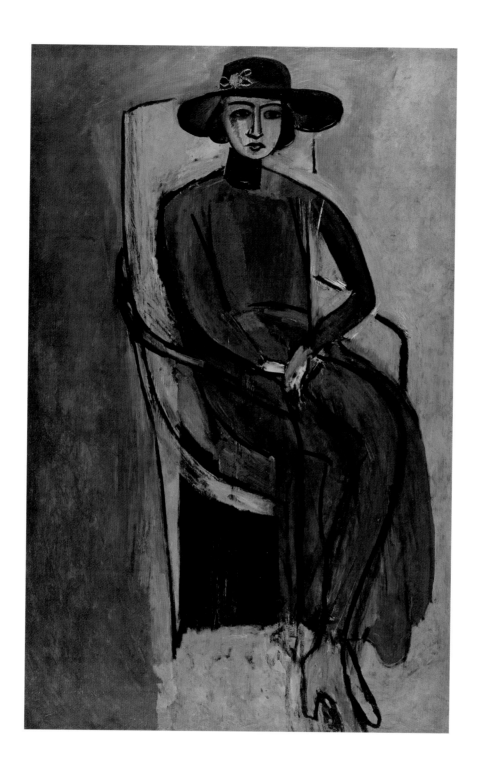

14
Henri Matisse
Portrait of Greta Prozor (*Portrait de Greta Prozor*), late 1916
Oil on canvas
146 × 96 cm (57¹/₂ × 37¹³/₁₆ inches)

Centre Georges Pompidou, Musée national d'art moderne, Paris,
Gift, the Scaler Foundation with the assistance of an anonymous
donor, 1982 AM 1982-426

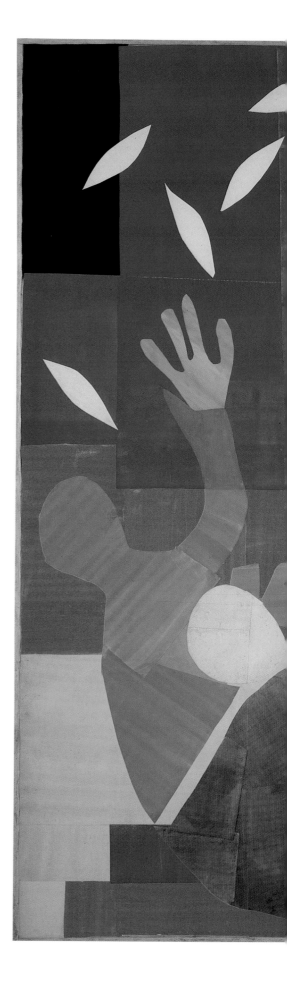

15
Henri Matisse
The Sorrow of the King (*La Tristesse du roi*), 1952
Gouache on paper, cut and pasted, on canvas
2.9 × 3.9 m (9 feet 6^{15}/$_{16}$ inches × 12 feet 7^{15}/$_{16}$ inches)

Centre Georges Pompidou, Musée national d'art moderne, Paris,
Purchased by the French State from the artist in 1954, allocated 1954
AM 3279 P

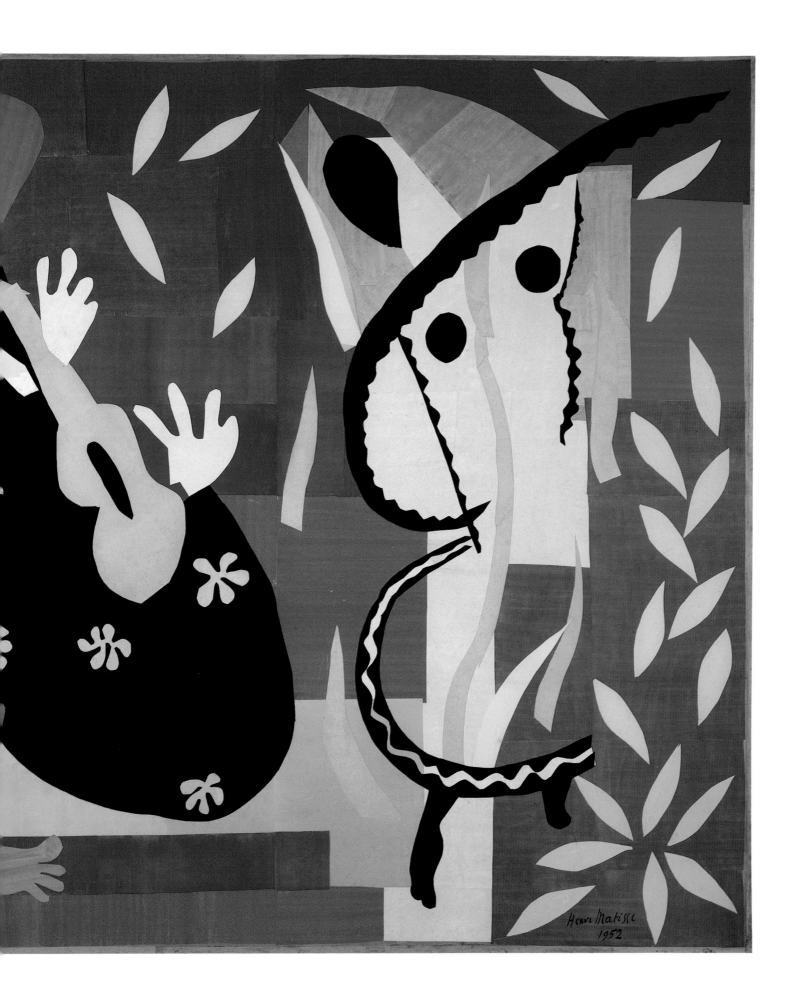

THE DIALOGUES OF CUBISM

Both the Guggenheim, with its major gifts from Justin K. Thannhauser and Hilde Thannhauser, and the Musée national d'art moderne, with its purchase of *Seated Nude* (*Nu assis*, 1905, cat. no. 17), feature important examples of Pablo Picasso's early work. The two collections also display the well-known interchange between Picasso and Georges Braque as "pioneers of Cubism." Two examples of Analytical Cubism, Picasso's *Accordionist* (*L'Accordéoniste*, summer 1911, cat. no. 21) and Braque's *Still Life with Violin* (*Nature morte au violon*, 1911, cat. no. 22), reveal the intimate relationship between the artists. The subsequent development of Synthetic Cubism, characterized by the addition of color, stenciling, and the collaging of newspaper and objects to the painting's surface, can be seen in Picasso's *Pipe, Glass, Bottle of Vieux Marc* (*Pipe, verre, bouteille de Vieux Marc*, spring 1914, cat. no. 25), as well as in the work of Juan Gris.

A major group of works by Robert Delaunay and Sonia Delaunay, along with Franz Marc's *Stables* (*Stallungen*, 1913, cat. no. 34), interpret Cubism with an emphasis on color. These paintings also demonstrate the relationship between French art and the avant-garde Blaue Reiter group in Germany. Marc, who visited Robert Delaunay's studio in France, invited him, as well as Picasso and Braque, to present their works in the 1912 Blaue Reiter exhibition in Munich.

Pablo Picasso's studio on Boulevard Raspail, 1913.

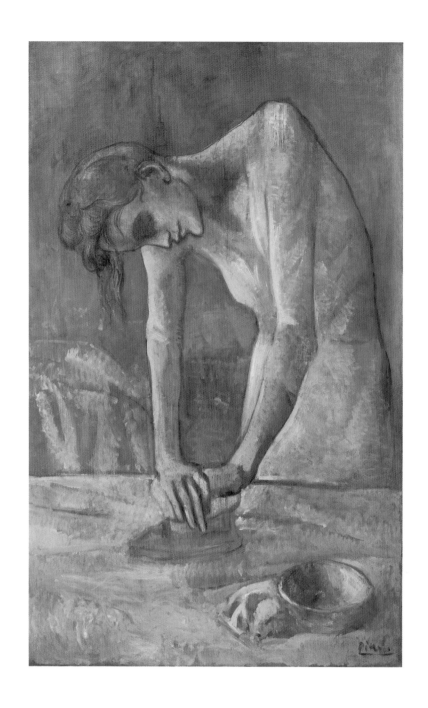

16
Pablo Picasso
Woman Ironing (*La Repasseuse*), 1904
Oil on canvas
116.2 × 73 cm (45 ¾ × 28 ¾ inches)

Solomon R. Guggenheim Museum, New York,
Thannhauser Collection, Gift, Justin K. Thannhauser
78.2514 T41

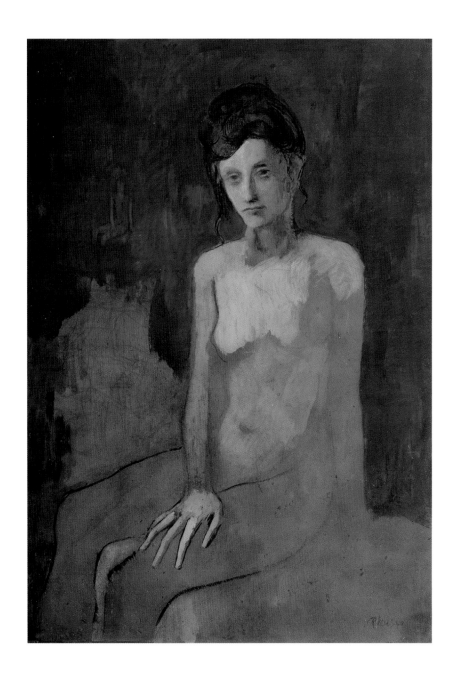

17
Pablo Picasso

Seated Nude (Nu assis), 1905
Oil on cardboard, mounted on panel
106 × 76 cm (41 3/4 × 29 15/16 inches)

Centre Georges Pompidou, Musée national d'art moderne, Paris,
Purchased 1954 AM 3306 P

18
Pablo Picasso
Fernande with a Black Mantilla (Fernande Olivier), 1905/1906
Oil on canvas
100 × 81 cm (39 ³⁄₈ × 31 ⁷⁄₈ inches)

Solomon R. Guggenheim Museum, New York,
Thannhauser Collection, Bequest, Hilde Thannhauser
91.3914

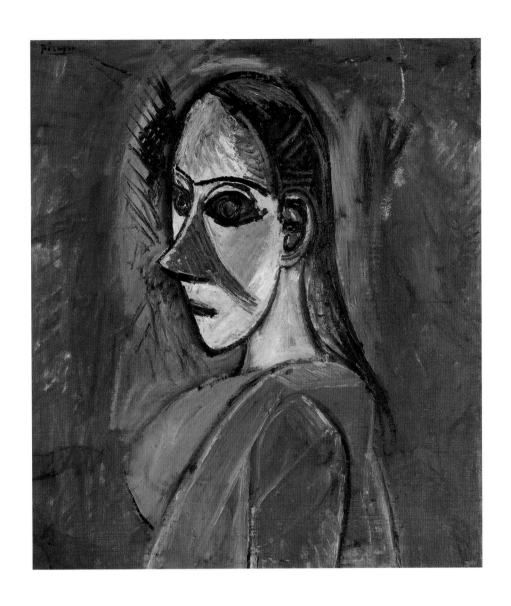

19
Pablo Picasso
Bust of a Woman (Buste de femme), 1907
Oil on canvas
66 × 59 cm (26 × 23¼ inches)

Centre Georges Pompidou, Musée national d'art moderne, Paris,
Purchased 1965 ᴀᴍ 4320 ᴘ

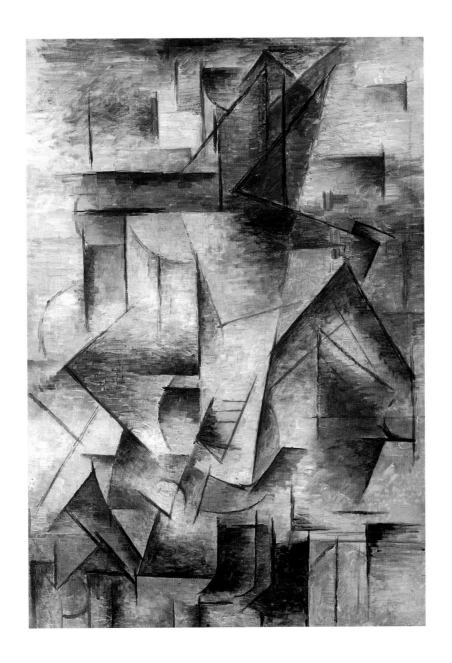

20

Pablo Picasso

The Guitarist (*Le Guitariste*), summer 1910
Oil on canvas
100 × 73 cm (39 ⅜ × 28 ¾ inches)

Centre Georges Pompidou, Musée national d'art moderne, Paris,
Gift, Mr. and Mrs. André Lefèvre, 1952 AM 3970 P

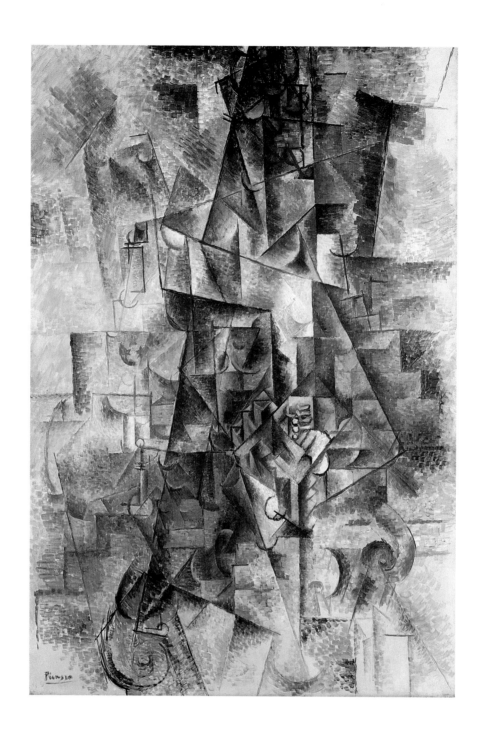

21
Pablo Picasso
Accordionist (*L'Accordéoniste*), summer 1911
Oil on canvas
130.2 × 89.5 cm (51¼ × 35¼ inches)

Solomon R. Guggenheim, New York, Gift, Solomon R. Guggenheim
37.537

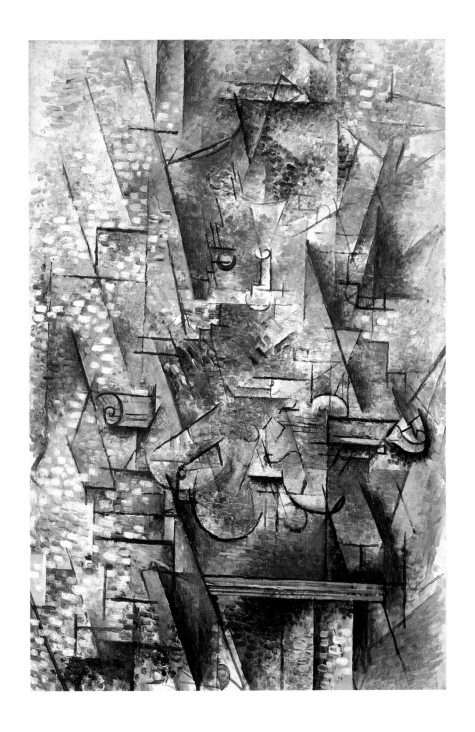

22

Georges Braque

Still Life with Violin (Nature morte au violon), 1911
Oil on canvas
130 × 89 cm (51 3/16 × 35 1/16 inches)

Centre Georges Pompidou, Musée national d'art moderne, Paris,
Gift, Mrs. Georges Braque, 1963 AM 4299 P

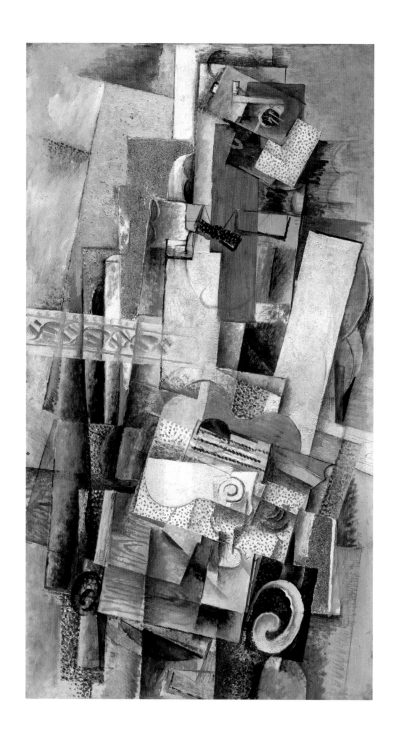

23
Georges Braque
Man with a Guitar (L'Homme à la guitare), 1914
Oil and sawdust on canvas
130 × 72.5 cm (51 ³/₁₆ × 28 ⁹/₁₆ inches)

Centre Georges Pompidou, Musée national d'art moderne, Paris,
Purchased with generous contribution from the French State and
with the aid of the Scaler Foundation in 1981 AM 1981-540

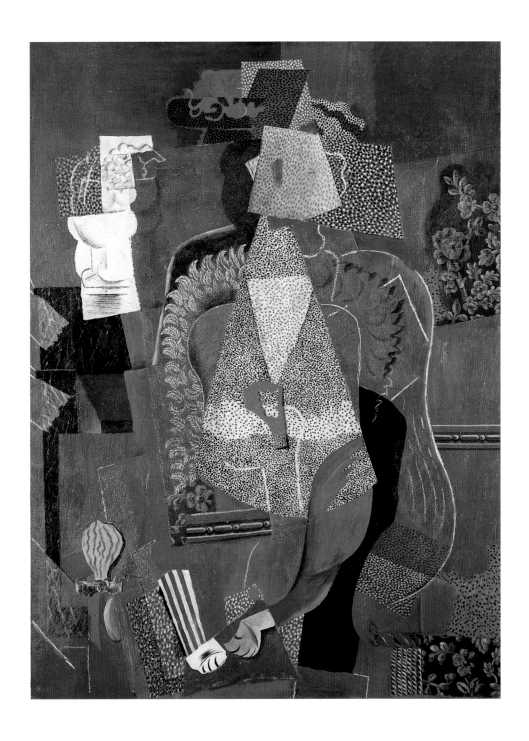

24
Pablo Picasso
Portrait of a Young Girl (Portrait de jeune fille), 1914
Oil on canvas
130 × 96.5 cm (51 3/16 × 38 inches)

Centre Georges Pompidou, Musée national d'art moderne, Paris,
Bequest, Georges Salles, 1967 AM 4390 P

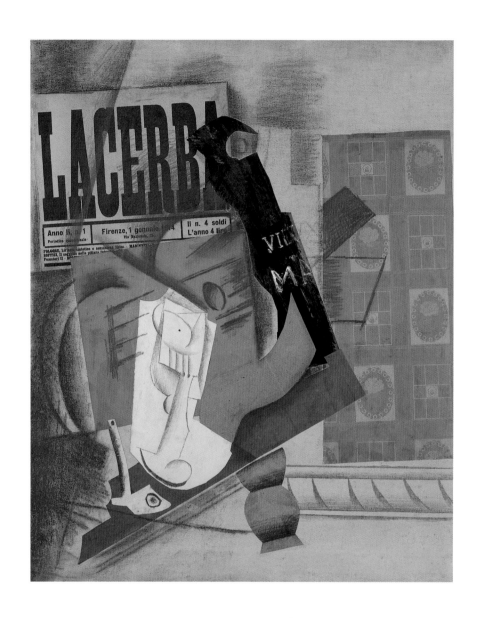

25
Pablo Picasso
Pipe, Glass, Bottle of Vieux Marc
(*Pipe, verre, bouteille de Vieux Marc*), spring 1914
Paper collage, charcoal, india ink, printer's ink,
graphite, and gouache on canvas
73.2 × 59.4 cm (28 13/16 × 23 3/8 inches)

Peggy Guggenheim Collection, Venice 76.2553 PG2

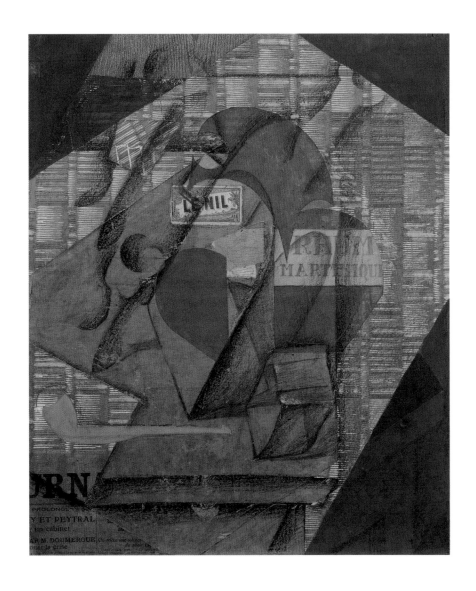

26
Juan Gris
Bottle of Rum and Newspaper (*Bouteille de rhum et journal*), June 1914
Paper collage, gouache, conté crayon, and
pencil on newspaper, mounted on canvas
54.8 × 46.2 cm (21⅝ × 18¼ inches)

Peggy Guggenheim Collection, Venice 76.2553 PGII

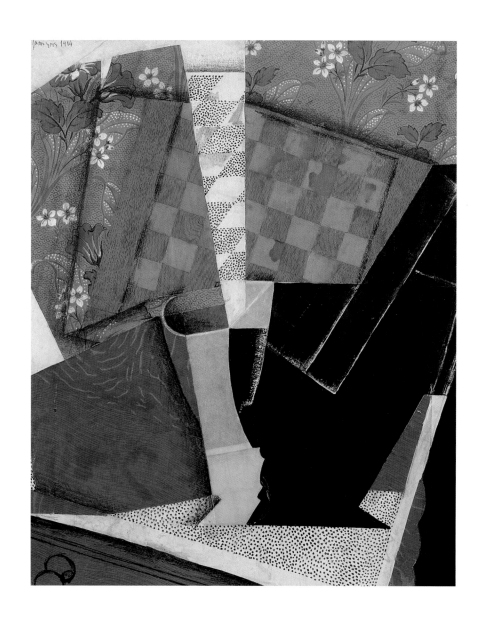

27
Juan Gris
Glass and Checkerboard (*Verre et damier*), 1914
Paper, gouache, watercolor, and charcoal on canvas
73 × 60 cm (28 3/4 × 23 5/8 inches)

Centre Georges Pompidou, Musée national d'art moderne, Paris,
Purchased 1980 AM 1980-440

28
Juan Gris
The Breakfast Table (*Le Petit Déjeuner*), 1915
Oil and charcoal on canvas
92 × 73 cm (36 ¼ × 28 ¾ inches)

Centre Georges Pompidou, Musée national d'art moderne, Paris,
Purchased 1947 AM 2678 P

29
Robert Delaunay
Eiffel Tower (*Tour Eiffel*), 1911
Oil on canvas
202 × 138.4 cm (79 1/2 × 54 1/2 inches)

Solomon R. Guggenheim Museum, New York,
Gift, Solomon R. Guggenheim 37.463

30
Robert Delaunay
Simultaneous Windows (2nd Motif, 1st Part)
(*Les Fenêtres simultanées [2e motif, 1ère partie]*), 1912
Oil on canvas
55.2 × 46.3 cm (21⅝ × 18¼ inches)

Solomon R. Guggenheim Museum, New York,
Gift, Solomon R. Guggenheim 41.464 A

31
Robert Delaunay
A Window (Une Fenêtre), 1912–13
Oil on canvas
111 × 90 cm (43¹¹⁄₁₆ × 35⁷⁄₁₆ inches)

Centre Georges Pompidou, Musée national d'art moderne, Paris,
Purchased 1950 AM 2975 P

32
Robert Delaunay
Windows Open Simultaneously (1st Part, 3rd Motif)
(Fenêtres ouvertes simultanément [1ère partie, 3e motif]), 1912
Oil on oval canvas
57 × 123 cm (22 ³⁄₈ × 48 ³⁄₈ inches)

Peggy Guggenheim Collection, Venice 76.2553 PG36

33
Sonia Delaunay
The Bullier Ball (Le Bal Bullier), 1913
Oil on canvas
97 × 390 cm (38 3/16 × 153 9/16 inches)

Centre Georges Pompidou, Musée national d'art moderne, Paris,
Purchased by the French State in 1954, allocated 1954 AM 3307 P

34
Franz Marc
Stables (Stallungen), 1913
Oil on canvas
73.6 × 157.5 cm (29 × 62 inches)

Solomon R. Guggenheim Museum, New York 46.1037

35
Robert Delaunay
The Tower (*La Tour*), 1910
India ink on paper
63 × 47 cm (24 13/$_{16}$ × 18 1/$_{2}$ inches)

Centre Georges Pompidou, Musée national d'art moderne, Paris,
Gift, Sonia and Charles Delaunay, 1963 AM 2575 D

36
Robert Delaunay
The Woman and the Tower (*La Femme et la tour*), ca. 1925
Pencil on paper
27.5 × 21.3 cm (10 13/$_{16}$ × 8 3/$_{8}$ inches)

Centre Georges Pompidou, Musée national d'art moderne, Paris,
Gift, Sonia and Charles Delaunay, 1963 AM 2582 D

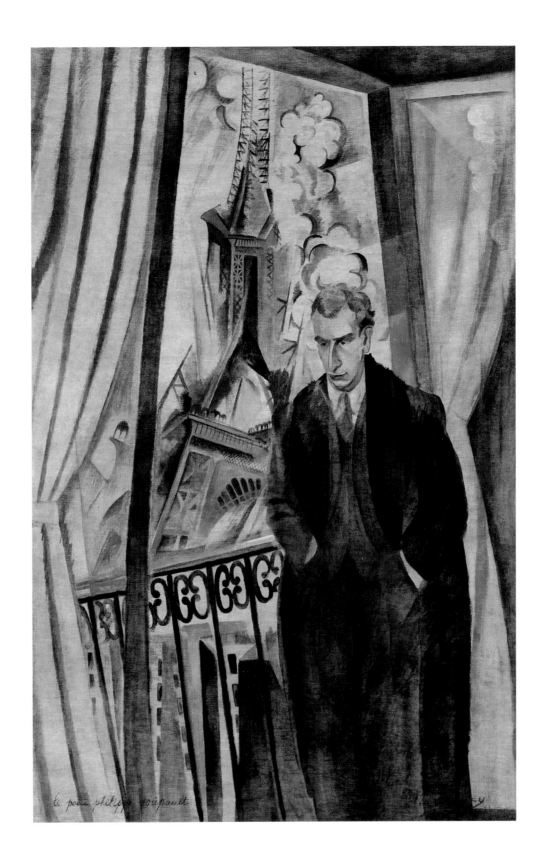

37
Robert Delaunay
The Poet Philippe Soupault (*Le Poète Philippe Soupault*), 1922
Oil on canvas
197 × 130 cm (77 9/16 × 51 3/16 inches)

Centre Georges Pompidou, Musée national d'art moderne, Paris,
Purchased 1978 AM 1978-323

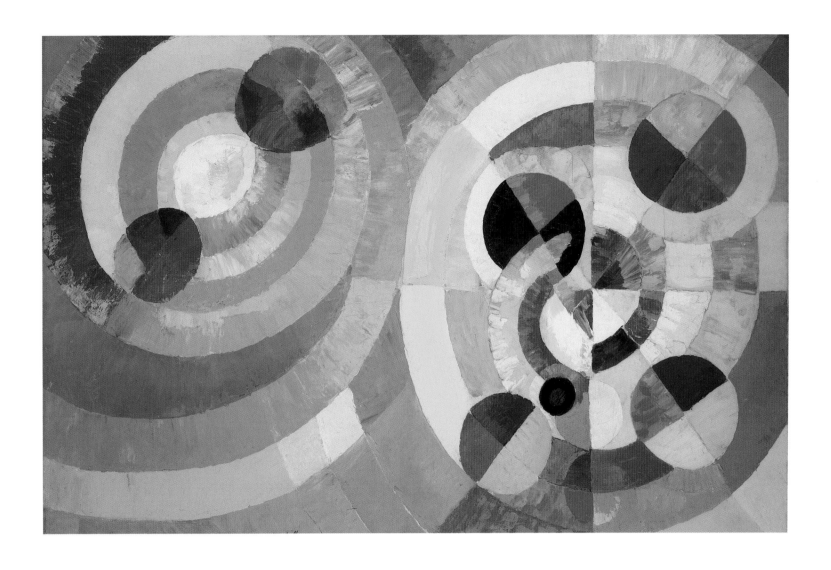

38

Robert Delaunay

Circular Forms (*Formes circulaires*), 1930

Oil on canvas

128.9 × 194.9 cm (50¾ × 76¾ inches)

Solomon R. Guggenheim Museum, New York 49.1184

FRANTIŠEK KUPKA

František Kupka is credited as being one of the first twentieth-century artists to make abstract paintings, yet he never achieved the recognition of his contemporaries, such as Robert Delaunay. After Kupka's death in 1957, the Solomon R. Guggenheim Museum and the Musée national d'art moderne were the only two institutions to accord him retrospectives, until an international traveling retrospective finally took place in 1997. This group of works by Kupka shows his development from figuration to abstraction. Together, this union of experimental studies and finished works from both collections reveals his process of simplifying organic forms into vibrating, geometric compositions.

František Kupka in his studio, ca. 1956.

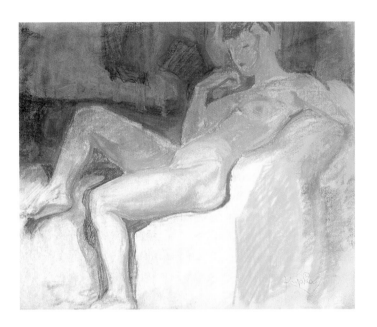

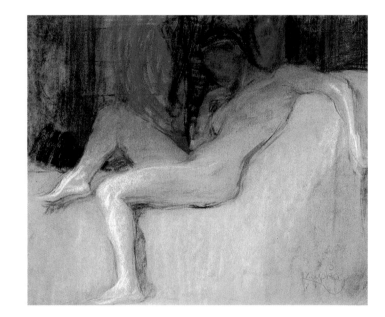

39
František Kupka
Study for *Planes by Colors, Large Nude*
(*Plans par couleurs, grand nu*), ca. 1909
Pastel on Ingres paper
48 × 60 cm (18⅞ × 23⅝ inches)

Centre Georges Pompidou, Musée national d'art moderne, Paris,
Gift, Mrs. Eugénie Kupka, 1963 AM 2759 D

40
František Kupka
Study for *Planes by Colors, Large Nude*
(*Plans par couleurs, grand nu*), ca. 1906–08
Pastel on Ingres paper
45 × 56 cm (17¾ × 22 inches)

Centre Georges Pompidou, Musée national d'art moderne, Paris,
Gift, Mrs. Eugénie Kupka, 1963 AM 2774 D

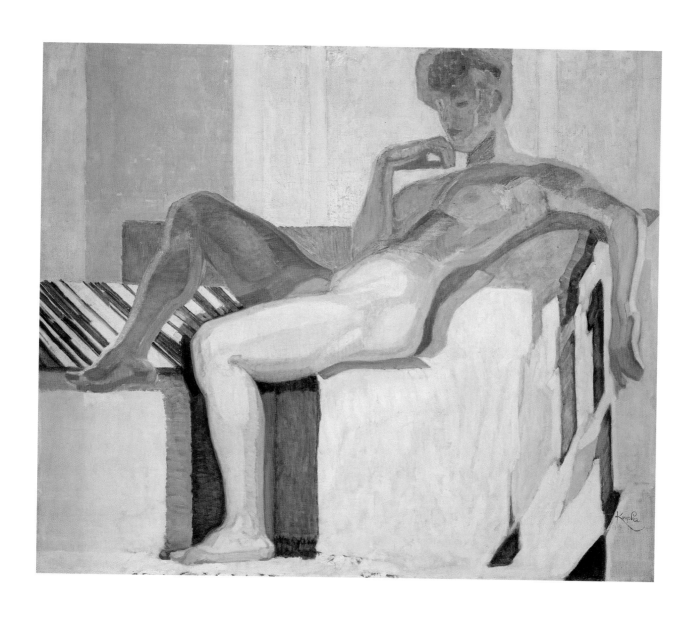

41
František Kupka
Planes by Colors, Large Nude (Plans par couleurs, grand nu), 1909–10
Oil on canvas
150.1 × 180.8 cm (59⅛ × 71⅛ inches)

Solomon R. Guggenheim Museum, New York,
Gift, Mrs. Andrew P. Fuller 68.1860

42
František Kupka
Study for *Vertical Planes III* (*Plans verticaux III*), 1912–13
Gouache on paper
50 × 34.8 cm (19 ¹¹/₁₆ × 13 ¹¹/₁₆ inches)

Centre Georges Pompidou, Musée national d'art moderne, Paris,
Gift, Mrs. Eugénie Kupka, 1963 ᴀᴍ 2788 ᴅ

43
František Kupka
Study for *Vertical Planes* (*Plans verticaux*), 1911–13
Pencil on paper
21 × 14 cm (8 ¹/₄ × 5 ¹/₂ inches)

Centre Georges Pompidou, Musée national d'art moderne, Paris,
Gift, Mrs. Eugénie Kupka, 1963 ᴀᴍ 2794 ᴅ

44
František Kupka
Vertical Planes [I] (Plans verticaux [I]), 1912–13
Oil on canvas
150 × 94 cm (59 1/16 × 37 inches)

Centre Georges Pompidou, Musée national d'art moderne, Paris,
Purchased 1936 JP 807 P

45
František Kupka
The Colored One (La Colorée), ca. 1919–20
Oil on canvas
65 × 54 cm (25⅝ × 21¼ inches)

Solomon R. Guggenheim Museum, New York,
Gift, Mrs. Andrew P. Fuller 66.1810

46
František Kupka

Tale of Pistils and Stamens No. II
(*Conte de pistils et d'étamines nº II*), 1919–20
Oil on canvas
85 × 73 cm (33½ × 28¾ inches)

Centre Georges Pompidou, Musée national d'art moderne, Paris,
Gift, Mrs. Eugénie Kupka, 1963 AM 4181 P

47
František Kupka
Study for *Around a Point* (*Autour d'un point*), 1918–20
Watercolor on paper
11 × 11 cm (4 5/16 × 4 5/16 inches)

Centre Georges Pompidou, Musée national d'art moderne, Paris,
Gift, Mrs. Eugénie Kupka, 1963 AM 2750 D

48
František Kupka
Study for *Around a Point* (*Autour d'un point*), 1919–20
Pencil on paper
27.5 × 20 cm (10 13/16 × 7 7/8 inches)

Centre Georges Pompidou, Musée national d'art moderne, Paris,
Gift, Mrs. Eugénie Kupka, 1963 AM 2719 D

49
František Kupka
Study for *Around a Point* (*Autour d'un point*), ca. 1920–25
Watercolor, gouache, and graphite on paper
20.1 × 23.8 cm (7 7/8 × 9 3/8 inches)

Peggy Guggenheim Collection, Venice 76.2553 PG16

50
František Kupka
Study for *Around a Point* (*Autour d'un point*), 1919–20
Pencil on paper
15 × 13 cm (5 7/8 × 5 1/8 inches)

Centre Georges Pompidou, Musée national d'art moderne, Paris,
Gift, Mrs. Eugénie Kupka, 1963 AM 2718 D

51
František Kupka

Around a Point (*Autour d'un point*), ca. 1925–30/1934
Oil on canvas
2 × 2 m (6 feet 4 9/16 inches × 6 feet 6 3/4 inches)

Centre Georges Pompidou, Musée national d'art moderne, Paris,
Purchased by the French State in 1947, allocated 1953 AM 3213 P

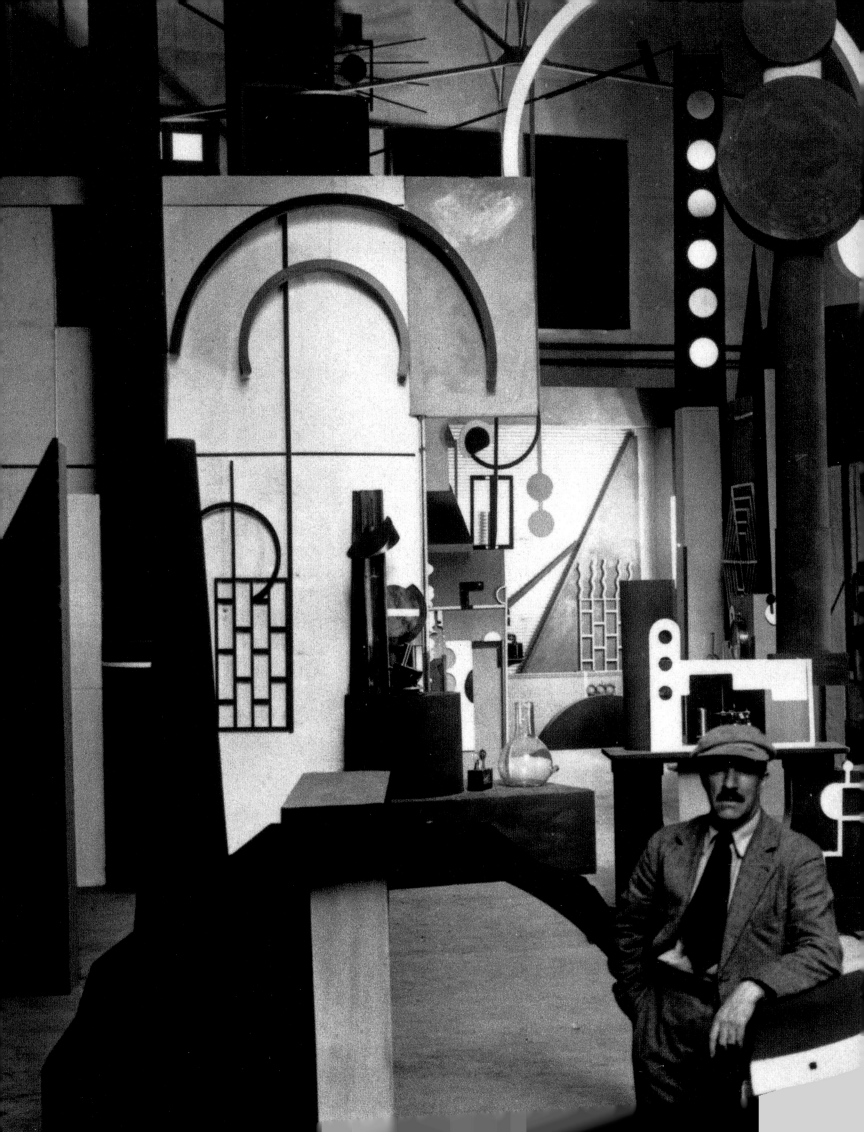

FERNAND LÉGER

The Musée national d'art moderne, which organized a Fernand Léger retrospective in 1997, has demonstrated a strong commitment to the artist's work, acquiring more than one hundred of his paintings and drawings. Hilla Rebay, the Guggenheim's founding director, was particularly interested in Léger's early abstract work and supported Léger by purchasing his paintings while he sought to escape Nazi persecution during World War II.

The combination of the two collections presents a representative view of the artist's work from all decades of his career. Léger considered his massive *Composition with Two Parrots* (*Composition aux deux perroquets*, 1935–39, cat. no. 58) to be one of his most successful paintings. After exhibiting it in New York to considerable praise, Léger asked that the painting be returned to Paris in 1949 for a retrospective organized by Jean Cassou, then director of the Musée national d'art moderne. One year later, Léger donated the painting, along with *Adieu New York* (1946, cat. no. 59), to the museum.

Begun in the United States and finished in France, the latter painting exemplifies his method of freeing color from form, which he developed as a result of seeing the bright lights of Broadway. This technique is also seen in the Guggenheim's *The Great Parade* (definitive state) (*La Grande Parade* [état définitif], 1954, cat. no. 60), perhaps the quintessential work of Léger's career, embodying the many themes he developed over the last fifteen years of his life.

Fernand Léger on the set he created for the film *L'Inhumaine* (Marcel l'Herbier, 1923).

52
Fernand Léger
Nude in the Studio (Nu dans l'atelier), 1912
Ink and gouache on paper
61 × 50 cm (24 × 19 $^{11}/_{16}$ inches)

Centre Georges Pompidou, Musée national d'art moderne, Paris,
Gift, Louise and Michel Leiris, 1984 AM 1984-579

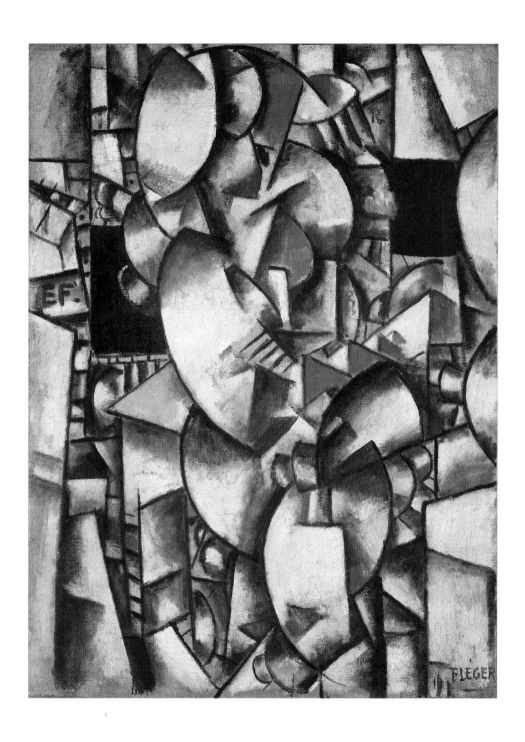

53
Fernand Léger
Nude Model in the Studio (*Le Modèle nu dans l'atelier*), 1912–13
Oil on burlap
127.8 × 95.7 cm (50 3/8 × 37 5/8 inches)

Solomon R. Guggenheim Museum, New York 49.1193

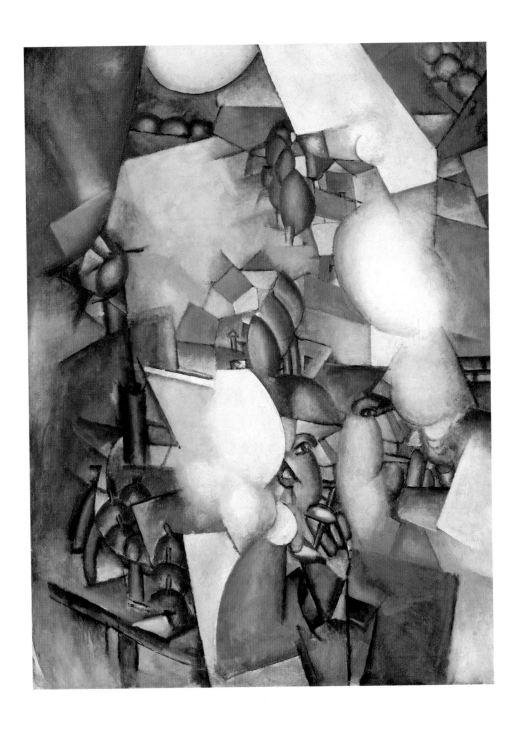

54
Fernand Léger
The Smokers (*Les Fumeurs*), December 1911–January 1912
Oil on canvas
129.2 × 96.5 cm (50⅞ × 38 inches)

Solomon R. Guggenheim Museum, New York,
Gift, Solomon R. Guggenheim 38.521

55
Fernand Léger
The Wedding (*La Noce*), 1911
Oil on canvas
2.8 × 2.1 m (8 feet 5³⁄₁₆ inches × 6 feet 9⅛ inches)

Centre Georges Pompidou, Musée national d'art moderne, Paris,
Gift, Mr. Alfred Flechtheim, 1937 AM 2146 P

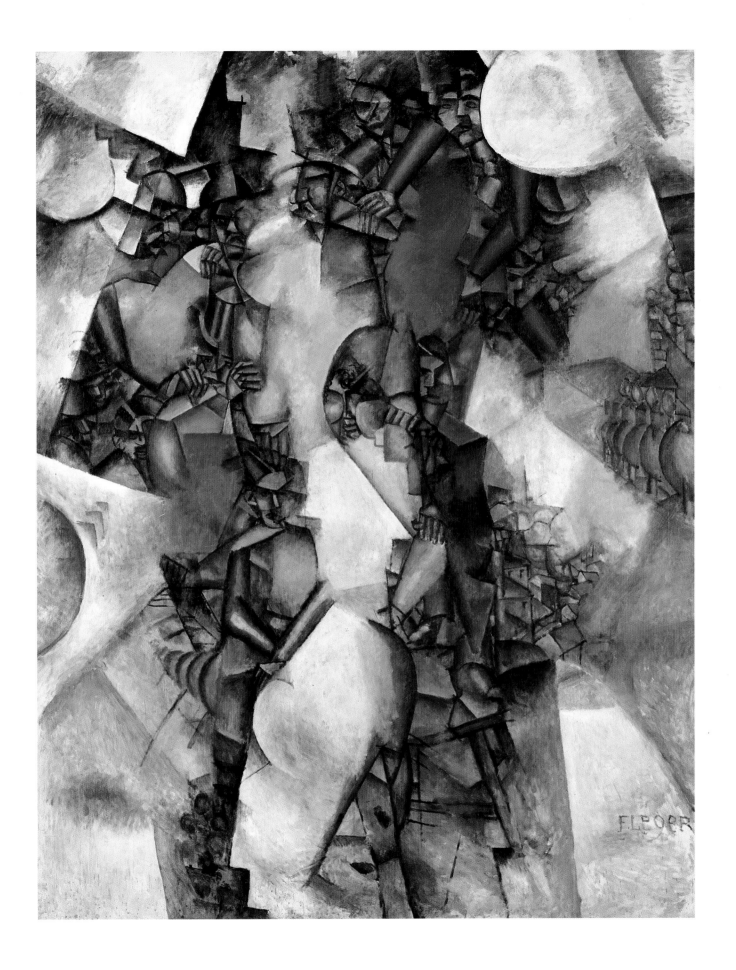

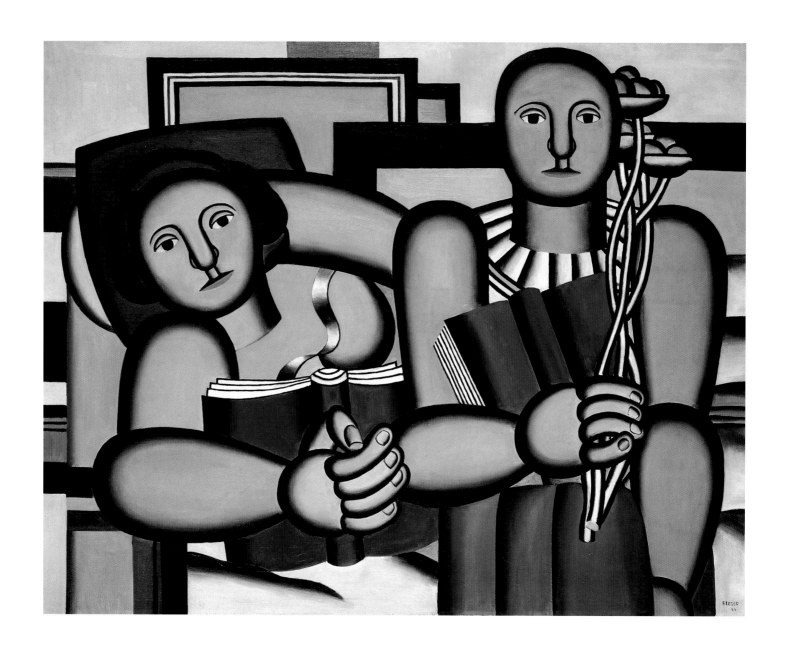

56
Fernand Léger
Reading (La Lecture), 1924
Oil on canvas
113.5 × 146 cm (44 11/$_{16}$ × 57 1/$_{2}$ inches)

Centre Georges Pompidou, Musée national d'art moderne, Paris,
Gift, the Baroness Gourgaud, 1965 AM 3718 P

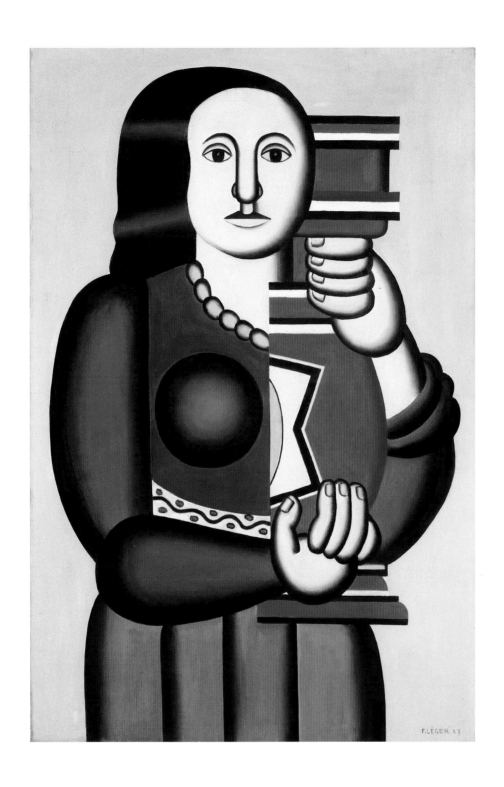

57
Fernand Léger
Woman Holding a Vase (definitive state)
(*Femme tenant un vase* [état définitif]), 1927
Oil on canvas
146.3 × 97.5 cm (57⅝ × 38⅜ inches)

Solomon R. Guggenheim Museum, New York 58.1508

58
Fernand Léger

Composition with Two Parrots
(*Composition aux deux perroquets*), 1935–39
Oil on canvas
4 × 4.8 m (13 feet 1½ inches × 15 feet 9 inches)

Centre Georges Pompidou, Musée national d'art moderne, Paris,
Gift of the artist, 1950 AM 3026 P

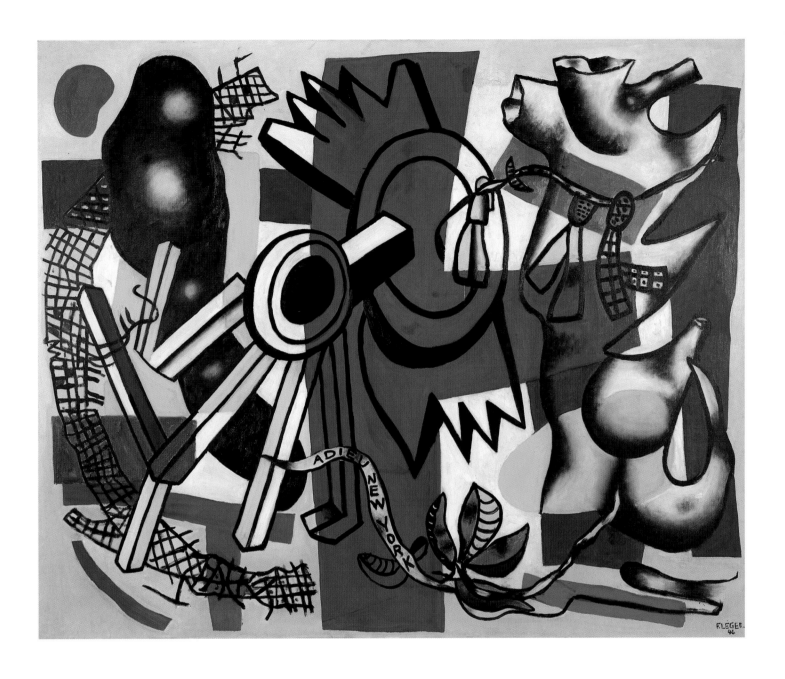

59
Fernand Léger
Adieu New York, 1946
Oil on canvas
130 × 162 cm (51 3/16 × 63 3/4 inches)

Centre Georges Pompidou, Musée national d'art moderne, Paris,
Gift of the artist, 1950 AM 3025 P

60
Fernand Léger
The Great Parade (definitive state)
(*La Grande Parade* [état définitif]), 1954
Oil on canvas
3 × 4 m (9 feet 9¾ inches × 13 feet 1½ inches)

Solomon R. Guggenheim Museum, New York 62.1619

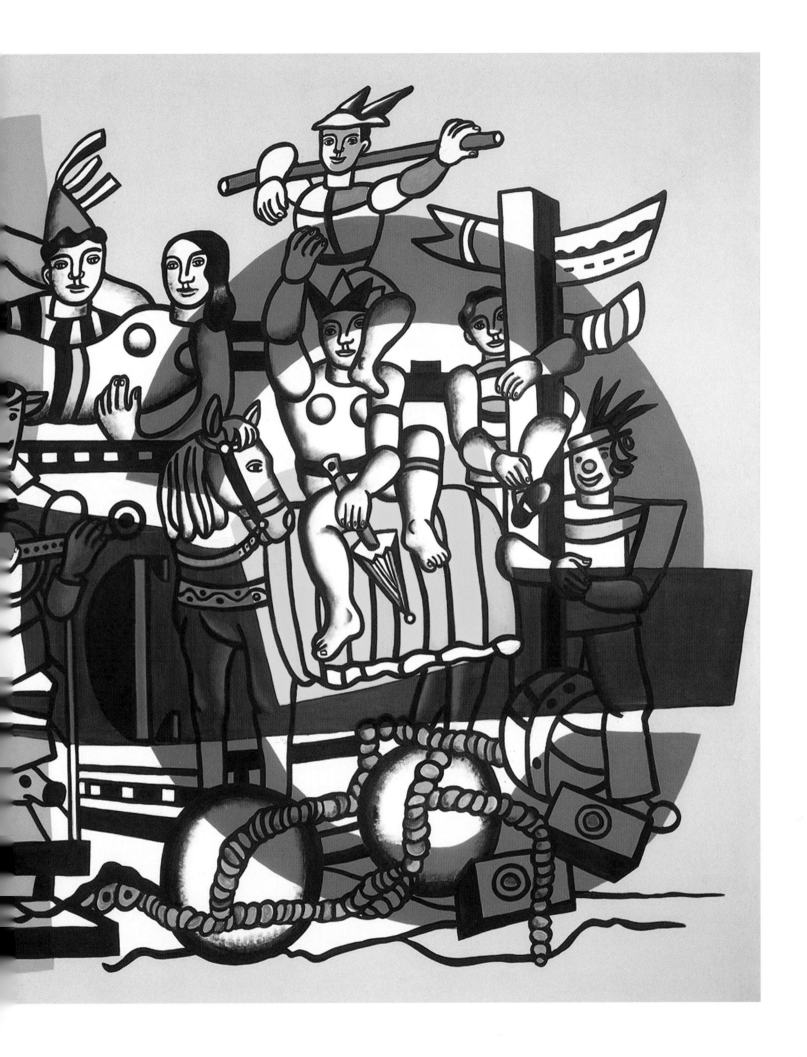

EARLY TWENTIETH-CENTURY SCULPTURE

The inventions of Fauvist and Cubist painting were matched by comparable achievements in sculpture during the early twentieth century. That Pablo Picasso created sculpture is well recognized, but André Derain's forays into the medium are less known. His proto-Cubist work *Standing Nude* (*Nu debout*, winter 1907, cat. no. 61), from the Musée national d'art moderne, breaks free from the canons of nineteenth-century figurative sculpture and exemplifies the characteristic blocky, frontal forms of "primitive" sculpture from Africa and Asia. The spatial breakdown of forms in Cubist painting lent itself readily to the medium of sculpture, as seen in the works by Alexander Archipenko, Umberto Boccioni, Raymond Duchamp-Villon, Henri Laurens, and Jacques Lipchitz selected from both collections.

André Derain seated in his studio beside *Standing Nude* (winter 1907).

61
André Derain

Standing Nude (*Nu debout*), winter 1907
Stone
95 × 33 × 17 cm (37 3/8 × 13 × 6 11/16 inches)

Centre Georges Pompidou, Musée national d'art moderne, Paris,
Remittance in lieu of inheritance taxes to the government of France,
1994 AM 1994-76

62
Pablo Picasso

Glass of Absinthe (*Le Verre d'absinthe*), spring 1914
Painted and sanded bronze and silver absinthe spoon
21.5 × 16.5 × 6.5 cm (8 7/16 × 6 1/2 × 2 9/16 inches)

Centre Georges Pompidou, Musée national d'art moderne, Paris,
Gift, Louise and Michel Leiris, 1984 AM 1984-629

63

Umberto Boccioni

Dynamism of a Speeding Horse + Houses
(*Dinamismo di un cavallo in corsa + case*), 1914–15
Gouache, oil, paper collage, wood, cardboard, copper, and coated iron
112.9 × 115 × 57 cm (44⁷⁄₁₆ × 45¼ × 22½ inches)

Peggy Guggenheim Collection, Venice 76.2553 PG30

64
Raymond Duchamp-Villon

Head of a Horse (Tête de cheval), 1914 (cast 1976)
Bronze
48 × 49 × 39.5 cm (18⁷⁄₈ × 19⁵⁄₁₆ × 15⁹⁄₁₆ inches)

Centre Georges Pompidou, Musée national d'art moderne, Paris,
Purchased with the assistance of Mrs. Marcel Duchamp and
Mr. Louis Carré in 1976 ᴀᴍ 1976-257

65
Raymond Duchamp-Villon
The Horse (*Le Cheval*), 1914 (cast ca. 1930)
Bronze
43.6 × 41 × 30 cm (17 3/16 × 16 1/8 × 11 13/16 inches)

Peggy Guggenheim Collection, Venice 76.2553 PG24

66
Alexander Archipenko
Carrousel Pierrot, 1913
Painted plaster
61 × 48.6 × 34 cm (24 × 19 × 13 ⅜ inches)

Solomon R. Guggenheim Museum, New York 57.1483

67
Alexander Archipenko
Boxing (La Boxe), 1913–14
Painted plaster
61 × 46 × 46 cm (24 × 18⅛ × 18⅛ inches)

Solomon R. Guggenheim Museum, New York 55.1436

68
Alexander Archipenko
Médrano II, 1913–14?
Painted tin, wood, glass, and painted oilcloth
126.6 × 51.5 × 31.7 cm (49⅞ × 20¼ × 12½ inches)

Solomon R. Guggenheim Museum, New York 56.1445

69
Alexander Archipenko
Two Glasses on a Table (*Deux verres sur une table*), 1919–20
Painted papier-mâché on wood
56 × 46 × 4.5 cm (22 ¹/₁₆ × 18 ¹/₈ × 1 ³/₄ inches)

Centre Georges Pompidou, Musée national d'art moderne, Paris,
Purchased 1964 AM 1428 s

70
Jacques Lipchitz
Standing Personage (Personnage debout), 1916
Limestone
108 × 23.2 × 20.3 cm (42 1/2 × 9 1/8 × 8 inches)

Solomon R. Guggenheim Museum, New York 58.1526

71
Jacques Lipchitz
Sailor with Guitar (*Marin à la guitare*), 1917–18
Limestone
90 × 38 × 34 cm (35⁷/₁₆ × 14¹⁵/₁₆ × 13³/₈ inches)

Centre Georges Pompidou, Musée national d'art moderne, Paris,
Purchased 1979 AM 1978-736

72
Henri Laurens
Bottle of Beaune (*La Bouteille de Beaune*), 1918
Painted wood and steel
66.8 × 27 × 24 cm (26 5/16 × 10 5/8 × 9 7/16 inches)

Centre Georges Pompidou, Musée national d'art moderne, Paris,
Purchased 1978 AM 1978-22

73
Henri Laurens

Head (Tête), 1918–19
Painted stone
60 × 40 × 30 cm (23 ⅝ × 15 ¾ × 11 ¹³/₁₆ inches)

Centre Georges Pompidou, Musée national d'art moderne, Paris,
Remittance in lieu of inheritance taxes to the government of France,
1997 AM 1997-236

AMEDEO MODIGLIANI

In Montparnasse in the 1910s, Amedeo Modigliani stood out among the crowd of bohemians and artists, developing a style of art that combined the archaic with the Modern. These three works emphasize the strong relationship between Modigliani's painting and his sculpture, which shares an emphasis on monumental and simplified forms. The Guggenheim's *Head* (*Tête*, 1911–13, cat. no. 74) explicitly recalls the elongated forms of African masks and the smooth, polished surfaces of Constantin Brancusi's sculptures. In contrast, the Musée national d'art moderne's *Woman's Head* (*Tête de femme*, ca. 1912–13, cat. no. 75) is rounder in form and rougher in texture; the features of the head appear to be drawn into the raw, unmodulated stone. Although the works differ stylistically, both heads display an impassive demeanor and, with their stoic expressions and vacant eyes, echo the figure in the painting *Red Head* (*Tête rouge*, 1915, cat. no. 76).

Amedeo Modigliani in his Paris studio,
winter 1915–16.

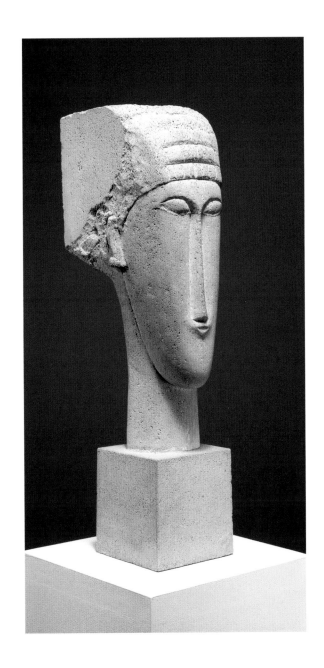

74
Amedeo Modigliani
Head (Tête), 1911–13
Limestone
63.5 × 15.2 × 21 cm (25 × 6 × 8 ½ inches)

Solomon R. Guggenheim Museum, New York 55.1421

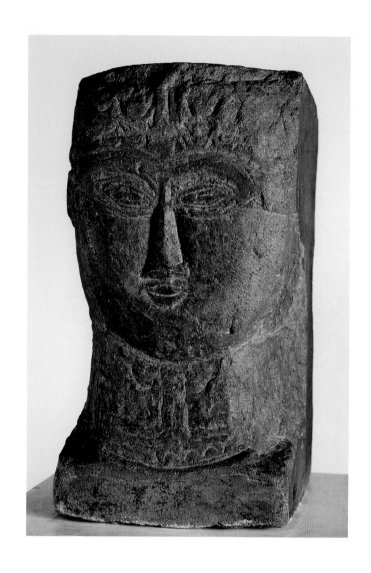

75
Amedeo Modigliani
Woman's Head (Tête de femme), ca. 1912–13
Limestone
47 × 25 × 30 cm (18 1/2 × 9 7/8 × 11 13/16 inches)

Centre Georges Pompidou, Musée national d'art moderne, Paris,
Purchased 1950 AM 903 s

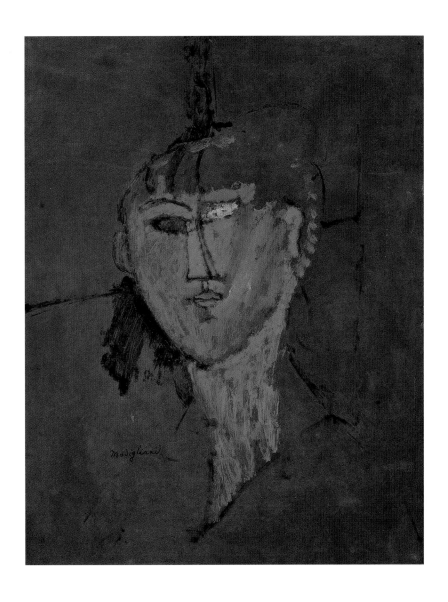

76
Amedeo Modigliani
Red Head (*Tête rouge*), 1915
Oil on cardboard
54 × 42.5 cm (21 1/4 × 16 3/4 inches)

Centre Georges Pompidou, Musée national d'art moderne, Paris,
Purchased 1964 AM 4286 P

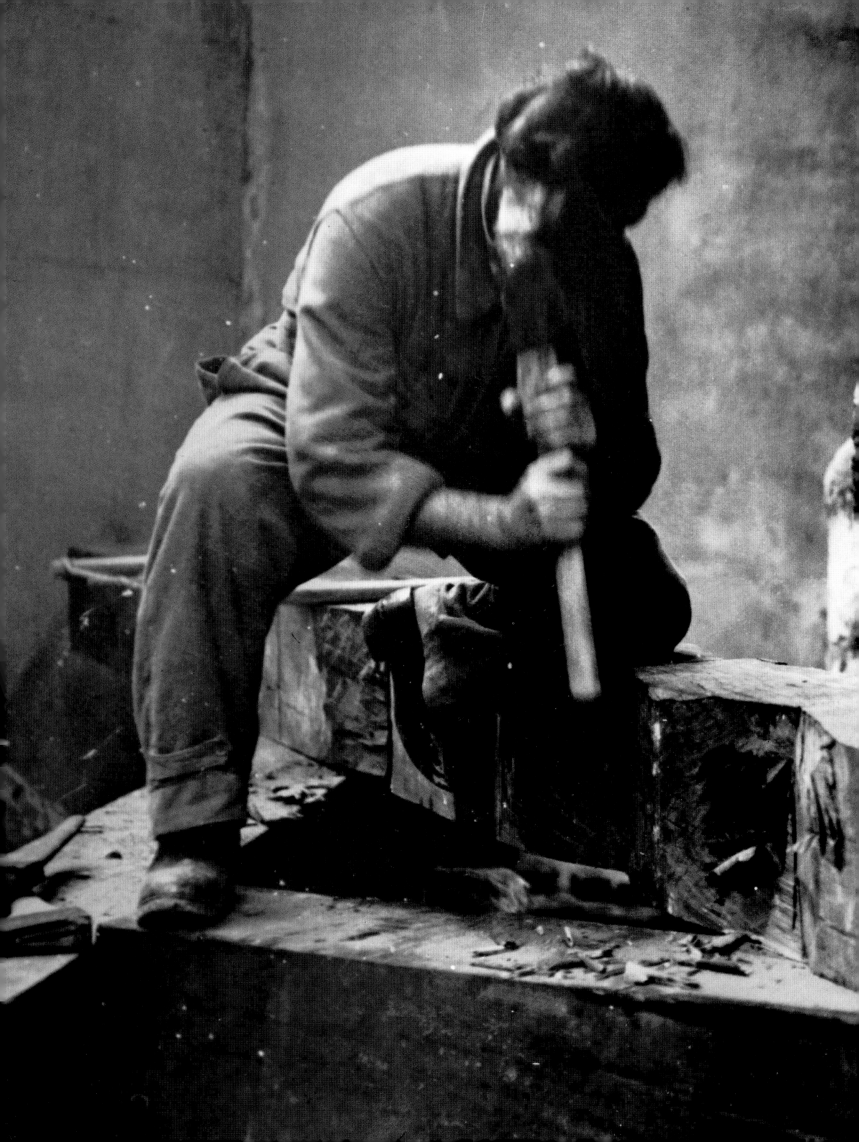

CONSTANTIN BRANCUSI

When Constantin Brancusi died in 1957, the Musée national d'art moderne received from his estate the contents of his studio, which included his tools and many of his most important sculptures. In accordance with his will, the studio was reconstructed in its entirety on the site of the museum and placed on view to the public. In 1997, the studio was rebuilt by the architect Renzo Piano.

The Guggenheim's significant collection of Brancusi's work began with the efforts of James Johnson Sweeney, who succeeded Hilla Rebay as director of the museum in 1952. Sweeney broadened the scope of the collection to include sculpture. By the time Sweeney resigned in 1960, the museum had acquired ten Brancusis, and, with subsequent acquisitions, now owns thirteen works. The works from both collections illustrate many of the motifs—muses and animals, ovoids and columns—that Brancusi employed in various mediums throughout his career.

Constantin Brancusi working on an *Endless Column* at his studio, 11 impasse Ronsin, Paris, ca. 1924.

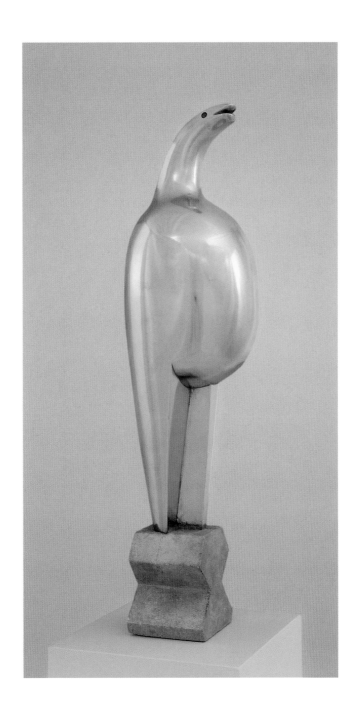

77
Constantin Brancusi
Maiastra, 1912?
Polished brass on stone base
61.5 × 19.3 × 21.4 cm (24 × 7¹/₂ × 8¹/₂ inches);
base: 14.8 × 13 × 12 cm (5³/₄ × 5¹/₄ × 4³/₄ inches)

Peggy Guggenheim Collection, Venice 76.2553 PG50

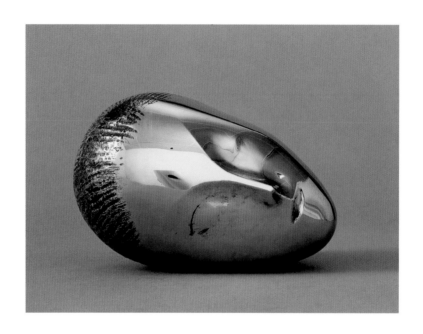

78
Constantin Brancusi
The Sleeping Muse (*La Muse endormie*), after 1910
Polished bronze
16 × 25 × 18 cm (6 5/16 × 9 13/16 × 7 1/16 inches)

Centre Georges Pompidou, Musée national d'art moderne, Paris,
Gift, the Baroness Renée Irana Frachon, 1963 AM 1374 s

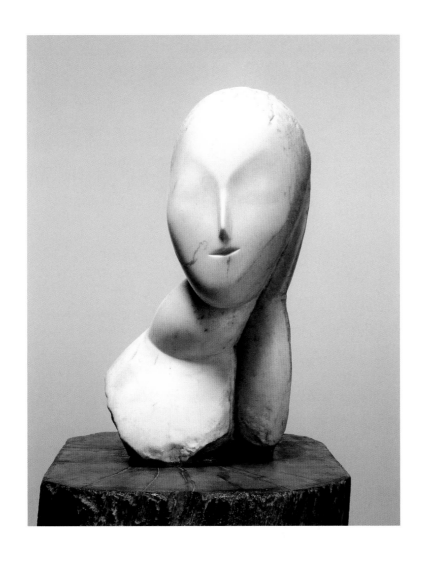

79
Constantin Brancusi
The Muse (La Muse), 1912
Marble
44.5 × 24.1 × 20.3 cm (17½ × 9½ × 8 inches)

Solomon R. Guggenheim Museum, New York 85.3317

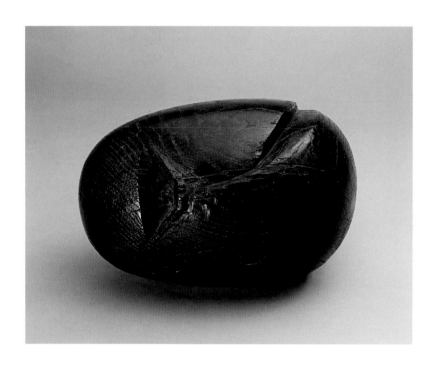

80
Constantin Brancusi
Head of a Child (Head from The First Step*)*
(*Tête d'enfant [Tête du* Premier pas]*),* 1913–15
Oak
16.5 × 25.6 × 18.4 cm (6 1/2 × 10 1/16 × 7 1/4 inches)

Centre Georges Pompidou, Musée national d'art moderne, Paris,
Bequest, Constantin Brancusi, 1957 AM 4002-24

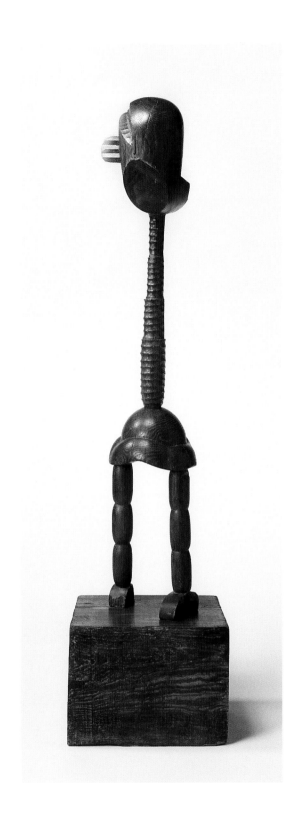

81
Constantin Brancusi
Little French Girl (*La Jeune Fille française*), ca. 1914–18
Oak
152.4 × 33 × 36.8 cm (60 × 13 × 14 ½ inches), including base

Solomon R. Guggenheim Museum, New York,
Gift, Estate of Katherine S. Dreier 53.1332

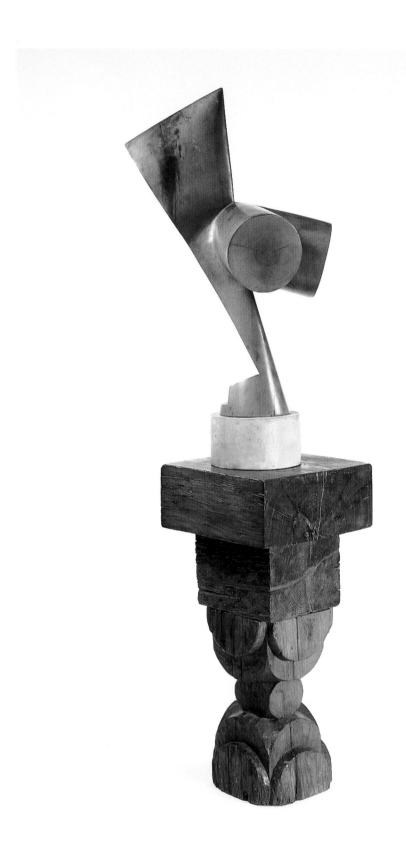

82

Constantin Brancusi

The Sorceress (*La Sorcière*), 1916–24
Walnut on limestone base
100 × 63.5 × 48.3 cm (39 3/8 × 25 × 19 inches);
base: 5 cm (5 7/8 inches) high, 27.6 cm (10 7/8 inches) diameter

Solomon R. Guggenheim Museum, New York 56.1448

Shown on *Oak Base*, 1920
Oak
97.5 cm (38 3/8 inches) high

Solomon R. Guggenheim Museum, New York 56.1516

83
Constantin Brancusi
Adam and Eve (Adam et Eve), 1916–24
Oak and chestnut on limestone base
227 × 48.2 × 44 cm (89 ³/₈ × 19 × 17 ³/₈ inches);
base: 13.3 × 46.4 × 46.4 cm (5 ¹/₄ × 18 ¹/₄ × 18 ¹/₄ inches)

Solomon R. Guggenheim Museum, New York 53.1329.a-.d

84
Constantin Brancusi
King of Kings (*Le Roi des rois*), early 1930s
Oak
300 × 46.4 × 47.6 cm (118 1/8 × 18 1/4 × 18 3/4 inches)

Solomon R. Guggenheim Museum, New York 56.1449

85
Constantin Brancusi
The Cock (Le Coq), 1935
Polished bronze
103.4 × 12.1 × 29.9 cm (40 11/16 × 4 3/4 × 11 3/4 inches);
on wood and stone base

Centre Georges Pompidou, Musée national d'art moderne, Paris,
Purchased 1947 AM 817 s

86
Constantin Brancusi
Flying Turtle (Tortue volante), 1940–45
Marble on marble base
31.8 × 93 × 69 cm (12 1/2 × 36 5/8 × 27 1/8 inches);
base: 28.3 cm (11 1/8 inches) high, 41 cm (16 1/8 inches) diameter

Solomon R. Guggenheim Museum, New York 55.1451

87
Constantin Brancusi
The Seal [I] (Miracle) (Le Phoque [I] [Le Miracle]), 1924–36
Marble
108.6 × 114 × 33 cm (42 3/4 × 44 7/8 × 13 inches)

Solomon R. Guggenheim Museum, New York 56.1450

88
Constantin Brancusi
The Seal [II] (Miracle) (Le Phoque [II] [Le Miracle]), 1943
Marble
110.5 × 121.5 × 34 cm (43 1/2 × 47 13/16 × 13 3/8 inches)

Centre Georges Pompidou, Musée national d'art moderne, Paris,
Purchased by the French State in 1946, allocated 1947 AM 816 s

BETWEEN THE WARS
DIALOGUES WITH PICASSO

The extraordinarily inventive oeuvre of Pablo Picasso was enriched through his collaborations and dialogues with other artists. By the mid-1920s, he and Georges Braque had followed divergent paths for some time. Braque's *The Bowl of Grapes* (*Le Compotier de raisins*, 1926, cat. no. 91) is essentially a continuation of his prewar practice of Synthetic Cubism, while Picasso's *Still Life with Classical Bust* (*Nature morte à la tête antique*, 1925, cat. no. 90), with its biomorphic forms, marks his turn to Surrealism. Around 1930, Picasso and Julio González both created welded-iron sculptures that related to Picasso's paintings of this time. González's *Woman Combing Her Hair I* (*Femme se coiffant I*, ca. 1931, cat. no. 93) is a linear sculpture in which solids are depicted by contour rather than mass, as in Picasso's earlier painting *The Studio* (*L'Atelier*, 1928, cat. no. 92). Picasso's *Woman with Yellow Hair* (*Femme aux cheveux jaunes*, December 1931, cat. no. 95) in the collection of the Guggenheim and Henri Matisse's *The Dream* (*Le Rêve*, 1935, cat. no. 94) in that of the Musée national d'art moderne explore the intimate theme of sleeping beauties. The exchange between the two artists is most evident in the way Matisse posed his model to mirror the figure in Picasso's work. Their dialogue continued until Matisse's death in 1954.

Pablo Picasso's self-portrait in his studio, Royan, Villa Les Voiliers, France, 1940.

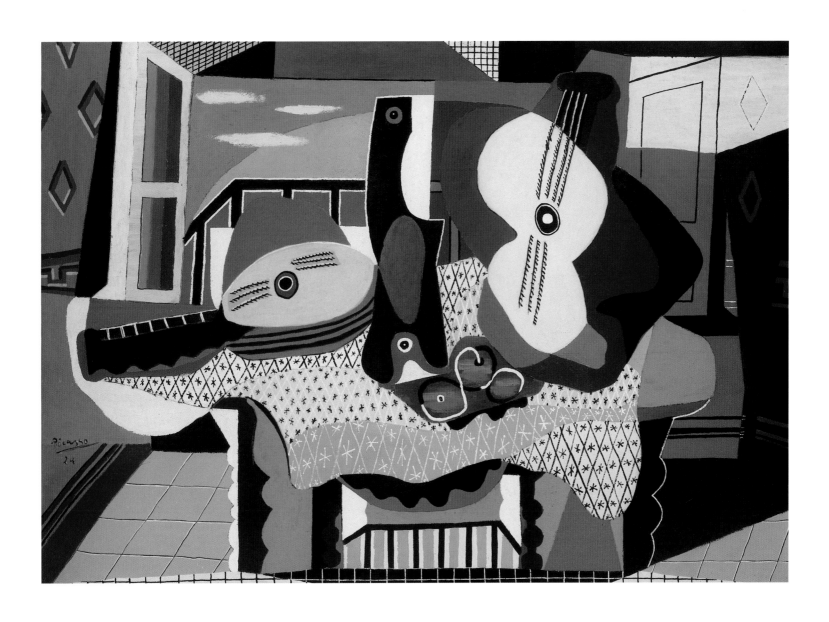

89
Pablo Picasso
Mandolin and Guitar (Mandoline et guitare), 1924
Oil with sand on canvas
140.6 × 200.4 cm (55 3/8 × 78 7/8 inches)

Solomon R. Guggenheim Museum, New York 55.1358

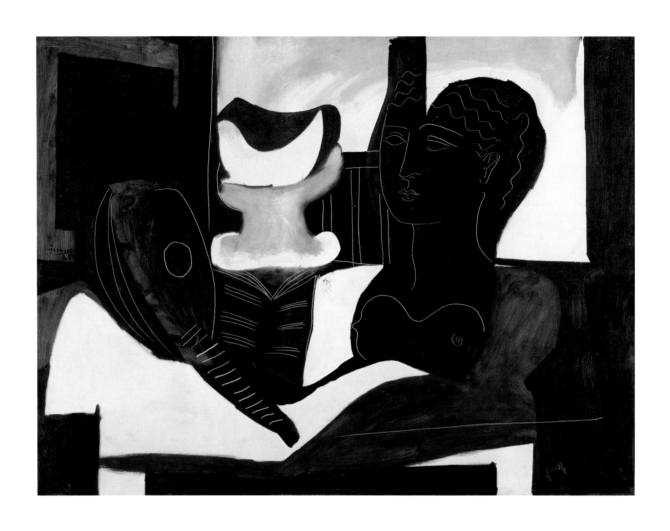

90
Pablo Picasso

Still Life with Classical Bust (Nature morte à la tête antique), 1925
Oil on canvas
97 × 130 cm (38 ³/₁₆ × 51 ³/₁₆ inches)

Centre Georges Pompidou, Musée national d'art moderne, Paris,
Gift, Galerie Paul Rosenberg, 1946 AM 2596 P

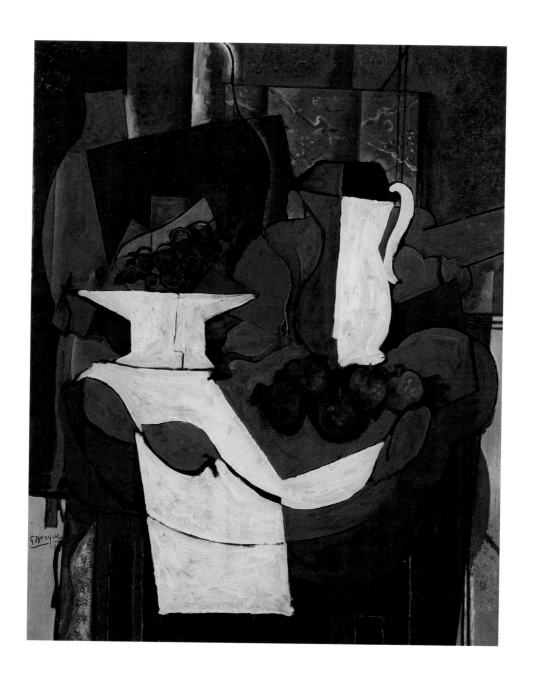

91
Georges Braque

The Bowl of Grapes (*Le Compotier de raisins*), 1926
Oil with pebbles and sand on linen
100 × 80.8 cm (39 3/8 × 31 3/4 inches)

Peggy Guggenheim Collection, Venice 76.2553 PG8

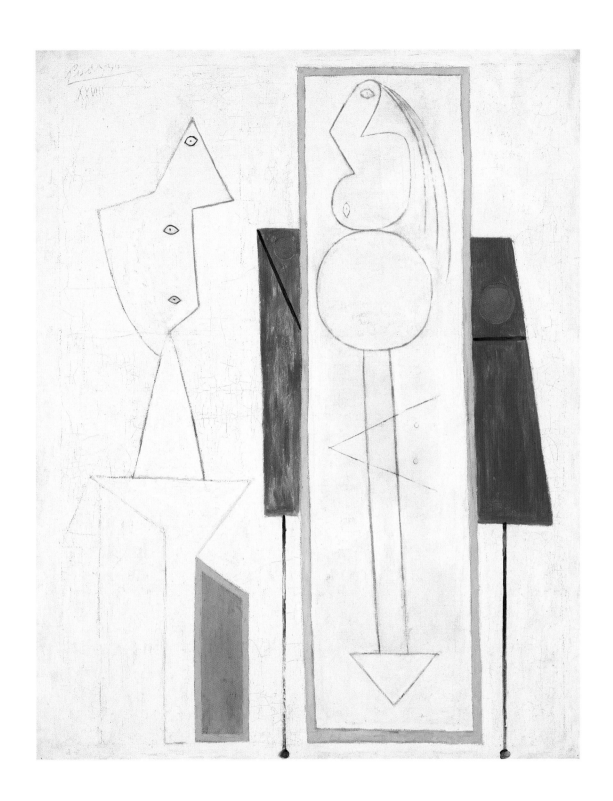

92
Pablo Picasso
The Studio (L'Atelier), 1928
Oil and black crayon on canvas
161.6 × 129.9 cm (63 5/8 × 51 1/8 inches)

Peggy Guggenheim Collection, Venice 76.2553 PG3

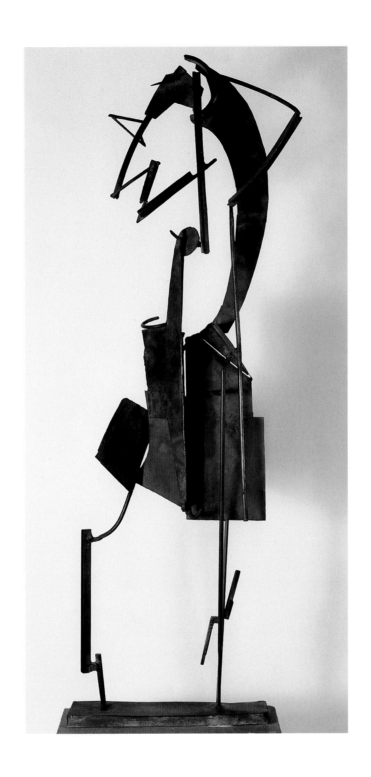

93
Julio González
Woman Combing Her Hair I (*Femme se coiffant I*), ca. 1931
Welded wrought iron
168.5 × 54 × 27 cm (66 $^{5}/_{16}$ × 21 $^{1}/_{4}$ × 10 $^{5}/_{8}$ inches)

Centre Georges Pompidou, Musée national d'art moderne, Paris,
Gift, Mrs. Robertá González, 1953 AM 951 s

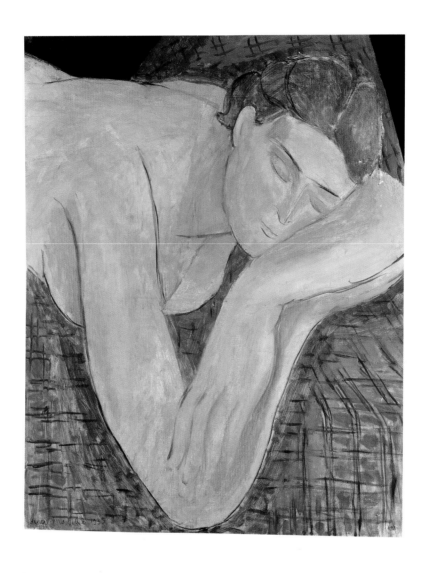

94
Henri Matisse
The Dream (Le Rêve), 1935
Oil on canvas
81 × 65 cm (31 7/8 × 25 5/8 inches)

Centre Georges Pompidou, Musée national d'art moderne, Paris,
Purchased 1979 AM 1979-106

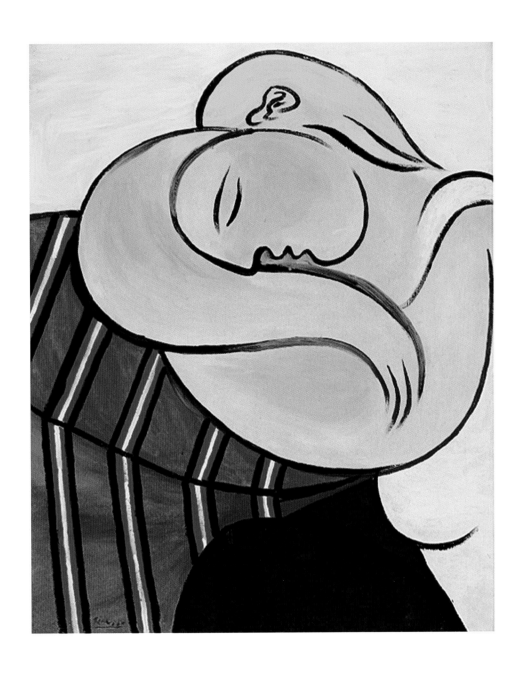

95
Pablo Picasso
Woman with Yellow Hair (Femme aux cheveux jaunes), December 1931
Oil on canvas
100 × 81 cm (39 3/8 × 31 7/8 inches)

Solomon R. Guggenheim Museum, New York,
Thannhauser Collection, Gift, Justin K. Thannhauser
78.2514 T59

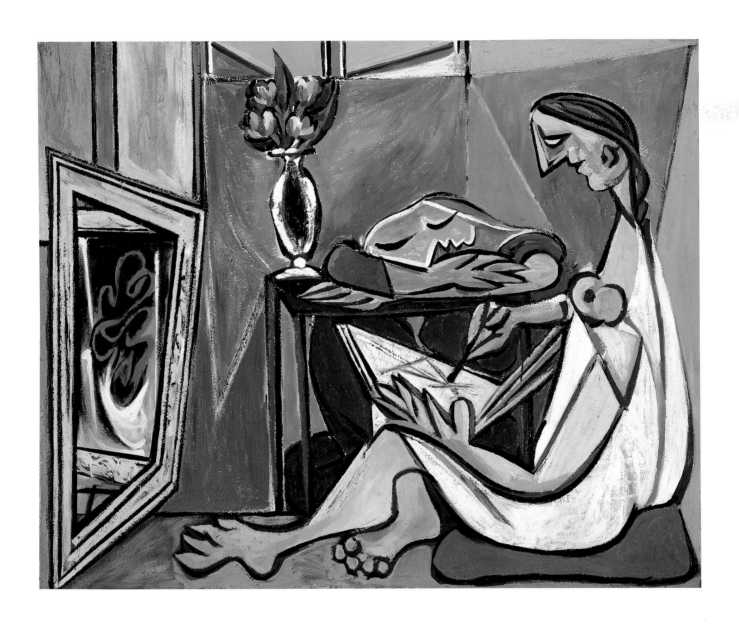

96
Pablo Picasso

The Muse (*La Muse*), 1935
Oil on canvas
130 × 162 cm (51 3/16 × 63 3/4 inches)

Centre Georges Pompidou, Musée national d'art moderne, Paris,
Gift of the artist, 1947 AM 2726 P

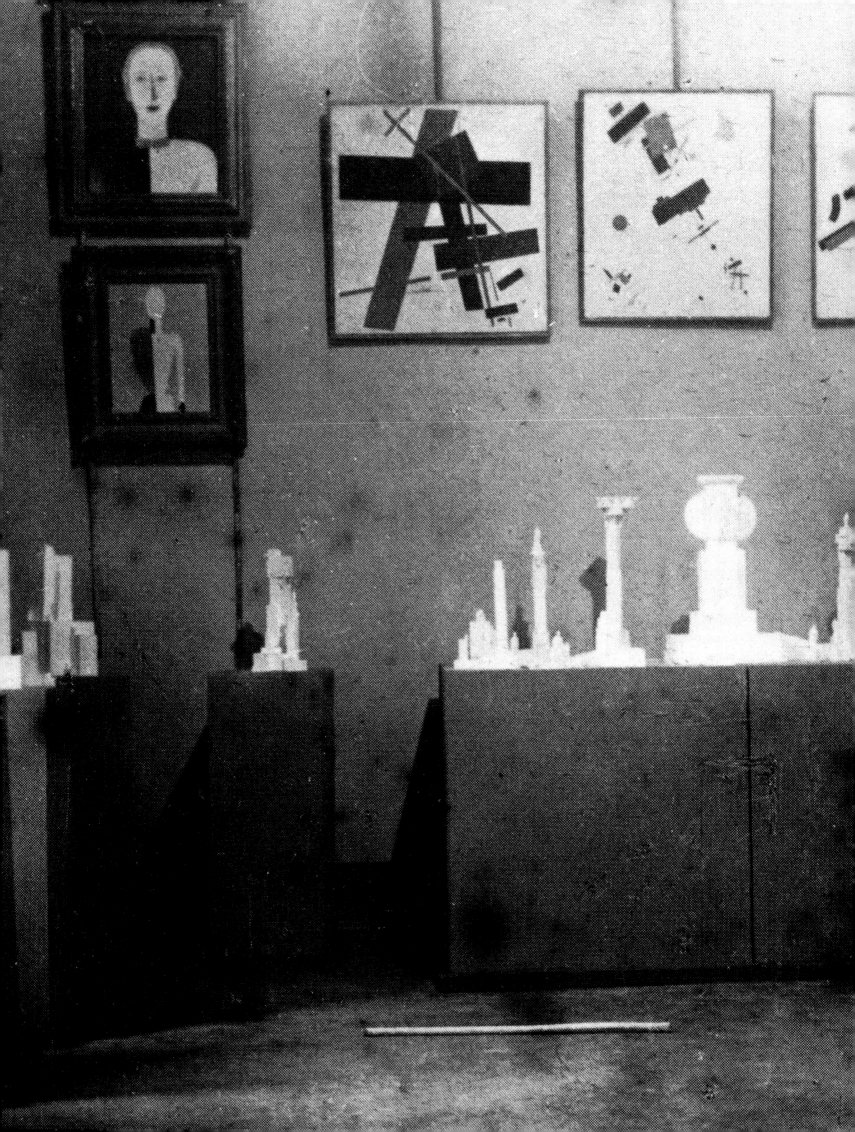

THE RUSSIAN AVANT-GARDE AND CHAGALL

The collections of the Guggenheim and the Musée national d'art moderne bring together the work of the Russian avant-garde and Marc Chagall, including major examples of studies and final paintings, such as Kazimir Malevich's *Peasant Women* (*Krestianka*, ca. 1910–12, cat. no. 100) and *Morning in the Village after Snowstorm* (*Utro posle v'iugi v derevne*, 1912, cat. no. 101) and Chagall's *Green Violinist* (Study for *Music*, 1918, cat. no. 108) and *Green Violinist* (*Violoniste*, 1923–24, cat. no. 109). From 1919 to 1920, the work of these two artists, who were both faculty members of the Vitebsk Academy, differed to such an extent that a conflict between them ensued. Malevich's emphasis on pure abstraction versus Chagall's embrace of the figure resulted in the latter's resignation from the school in 1919. Chagall then moved to Moscow, where he created set designs for Kamerny State Jewish Theater; his later *Green Violinist* is based on the mural *Music* that he painted for the theater.

Although Malevich was highly critical of Chagall, his own work shifted in the 1930s toward more representational imagery, as seen in the Musée national d'art moderne's *Man and Horse* (1933, cat. no. 105). However, the artist's synthesis of figurative imagery and abstract form creates an idiomatic rather than a natural representation of the subject.

Kazimir Malevich at the time of the installation of the exhibition *The Artists of the RSFSR over the Last Fifteen Years* (1932–33), Leningrad.

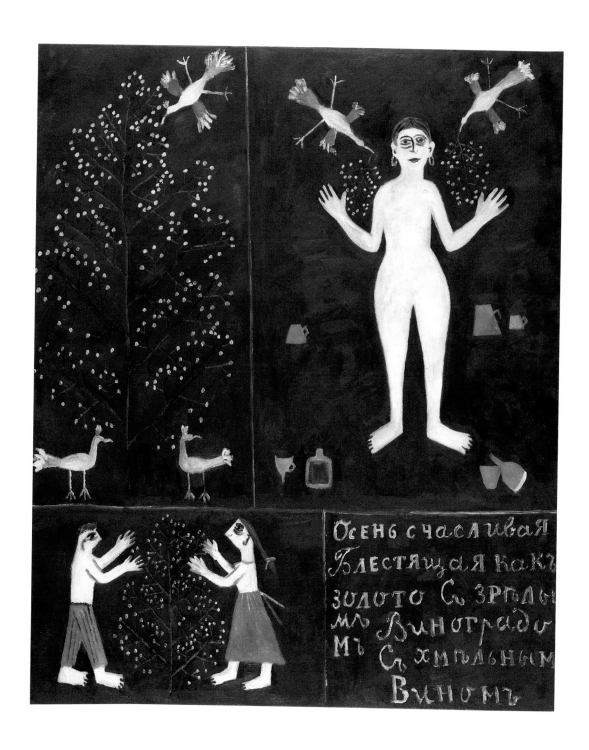

97
Mikhail Larionov
Autumn (Osen'), 1912
Oil on canvas
136 × 115 cm (53⁹/₁₆ × 45¹/₄ inches)

Centre Georges Pompidou, Musée national d'art moderne, Paris,
Purchased 1970 AM 4513 P

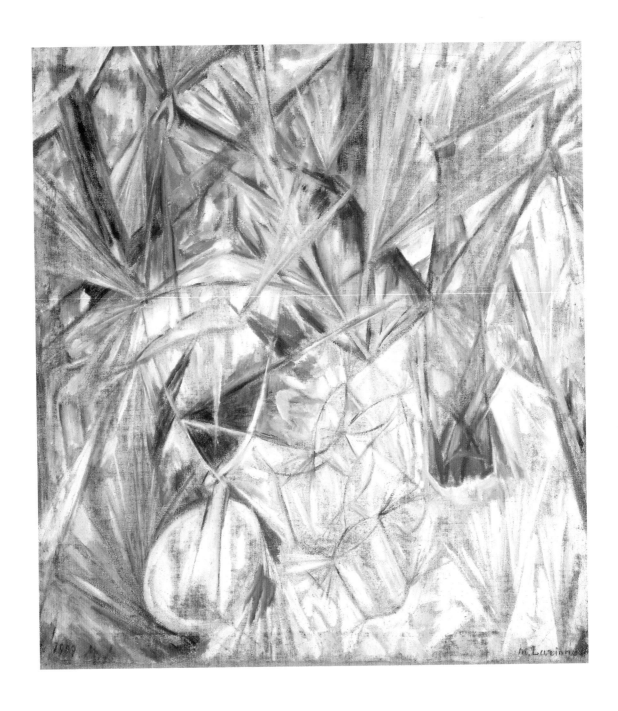

98

Mikhail Larionov

Glass (Steklo), 1912

Oil on canvas

104.1 × 97.1 cm (41 × 38¼ inches)

Solomon R. Guggenheim Museum, New York 53.1362

99
Mikhail Larionov
Sunny Day (*Journée ensoleillée*), 1913–14
Oil, paper paste, and glue on canvas
89 × 106.5 cm (35 1/16 × 41 15/16 inches)

Centre Georges Pompidou, Musée national d'art moderne, Paris,
Purchased 1986 AM 1986-80

100
Kazimir Malevich
Peasant Women (*Krestianka*), ca. 1910–12
Pencil on paper
13 × 13.5 cm (5 1/8 × 5 5/16 inches)

Centre Georges Pompidou, Musée national d'art moderne, Paris,
Purchased 1986 AM 1986-280

101
Kazimir Malevich
Morning in the Village after Snowstorm (*Utro posle v'iugi v derevne*), 1912
Oil on canvas
80.8 × 80.7 cm (31¾ × 31⅞ inches)

Solomon R. Guggenheim Museum, New York 52.1327

102
Liubov Popova
Birsk, 1916
Oil on canvas
106 × 69.5 cm (41 ¾ × 27 ⅜ inches)

Solomon R. Guggenheim Museum, New York,
Gift, George Costakis 81.2822.1

103
Kazimir Malevich
Black Cross (Čërnyj krest'), 1915
Oil on canvas
80 × 79.5 cm (31 1/2 × 31 5/16 inches)

Centre Georges Pompidou, Musée national d'art moderne, Paris,
Gift, the Scaler Foundation and the Beaubourg Foundation, 1979
AM 1980-1

104
Kazimir Malevich
Untitled, ca. 1916
Oil on canvas
53 × 53 cm (20⁷/₈ × 20⁷/₈ inches)

Peggy Guggenheim Collection, Venice 76.2553 PG42

105
Kazimir Malevich

Man and Horse, 1933
Oil on canvas
66.5 × 51.5 cm (26 ³⁄₁₆ × 20 ¼ inches)

Centre Georges Pompidou, Musée national d'art moderne, Paris,
Anonymous gift, 1978 AM 1978-629

106
Marc Chagall
To Russia, Asses and Others (A la Russie, aux ânes et aux autres), 1911–12
Oil on canvas
157 × 122 cm (61 13/16 × 48 1/16 inches)

Centre Georges Pompidou, Musée national d'art moderne, Paris,
Gift of the artist, 1949 AM 2925 P

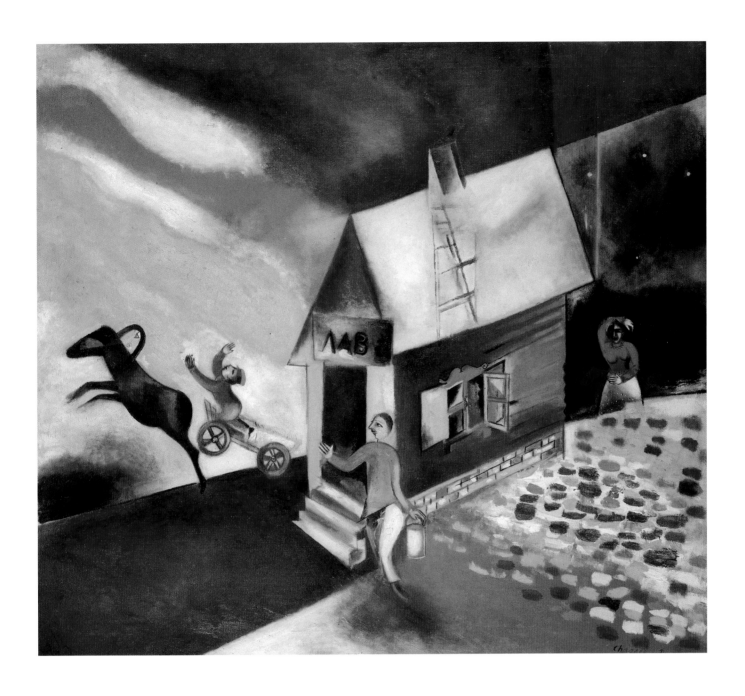

107
Marc Chagall
The Flying Carriage (La Calèche volante), 1913
Oil on canvas
106.7 × 120.1 cm (42 × 47¼ inches)

Solomon R. Guggenheim Museum, New York 49.1212

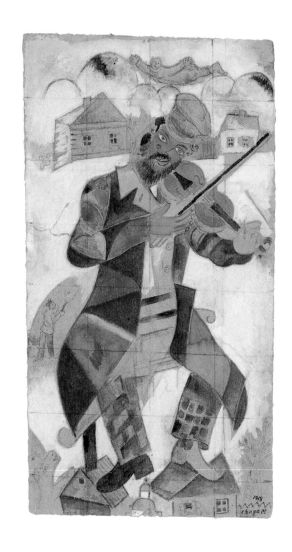

108
Marc Chagall
Green Violinist (Study for *Music*), 1918
Pencil, gouache, and watercolor on paper, mounted on paper
31.2 × 18.4 cm (12 5/16 × 7 1/4 inches)

Centre Georges Pompidou, Musée national d'art moderne, Paris,
Remittance in lieu of inheritance taxes to the government of France,
1988 AM 1988-221

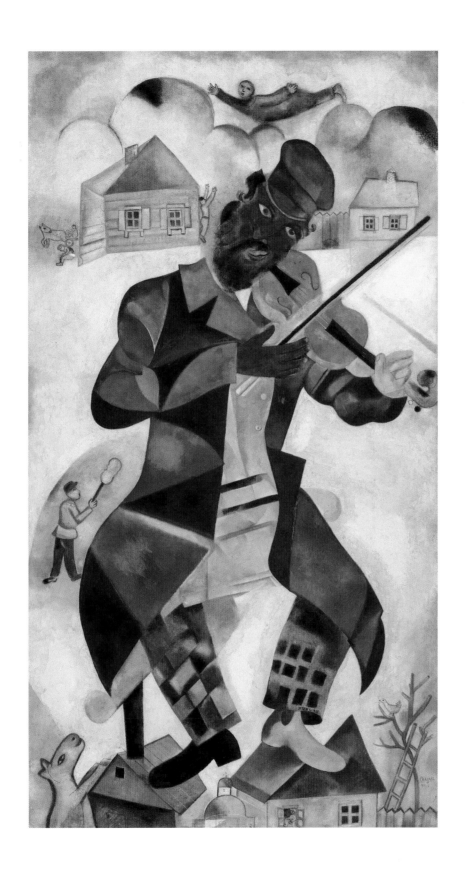

109
Marc Chagall
Green Violinist (Violoniste), 1923–24
Oil on canvas
198 × 108.6 cm (78 × 42 ¾ inches)

Solomon R. Guggenheim Museum, New York,
Gift, Solomon R. Guggenheim 37.446

VASILY KANDINSKY

Vasily Kandinsky's paintings, writings, and teachings were groundbreaking in the development of Expressionism, abstraction, and the role of the spiritual in twentieth-century art. Of the three periods of his exceptional career represented here—the Munich years, the Bauhaus period, and the artist's final years in Paris—the collections overlap most during Kandinsky's two German phases.

Each institution has developed a strong collection of the artist's work through close ties with him and his family. The holdings of the Musée national d'art moderne were enhanced by a substantial donation and bequest from the artist's widow, Nina Kandinsky, and the Guggenheim's acquisition of more than one hundred fifty works by the artist remains the cornerstone of its collection. In fact, the original mission of the Guggenheim, in its incarnation as the Museum of Non-Objective Painting, comes from Kandinsky's work. "Non-objective" is Hilla Rebay's translation of the German word "*gegenstandslos*," which Kandinsky used in his seminal writing and means literally "without object." As Rebay defined it, non-objective art is based not on forms in the physical world but on pure abstraction, which she believed was infused with mystical essence and spirituality.

Vasily Kandinsky in front of *Composition IV* (1911) at his studio, Paris, June 1934.

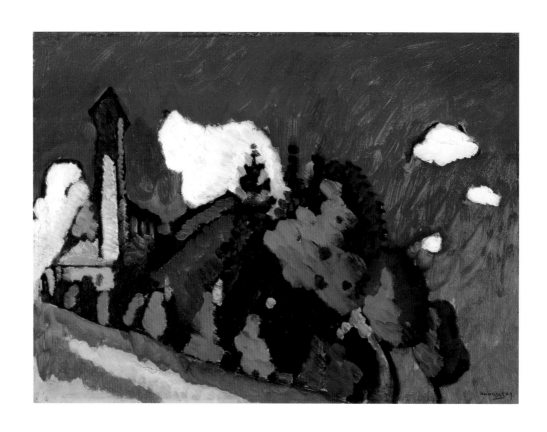

110
Vasily Kandinsky
Study for *Landscape with Tower* (*Landschaft mit Turm*), 1908
Oil on board
33 × 44.5 cm (13 × 17 1/2 inches)

Solomon R. Guggenheim Museum, New York,
Gift, Solomon R. Guggenheim 38.501

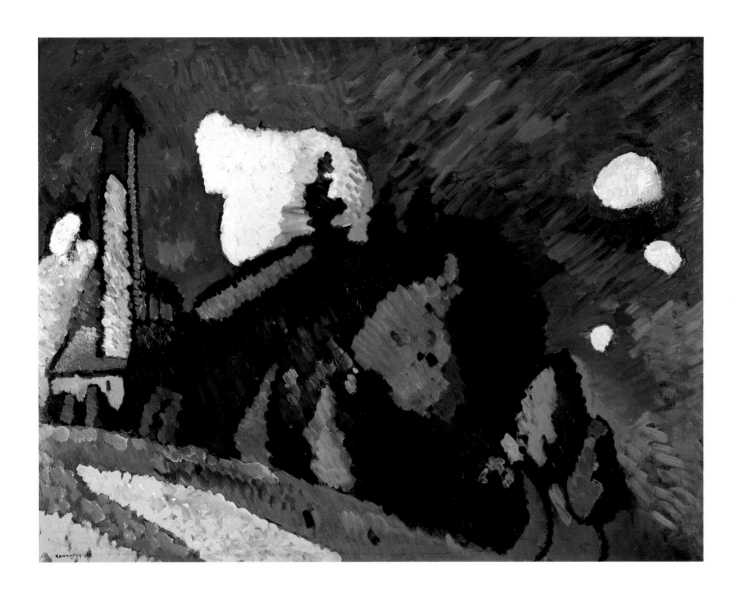

III
Vasily Kandinsky
Landscape with Tower (Landschaft mit Turm), 1908
Oil on cardboard
74 × 98.5 cm (29 1/8 × 38 3/4 inches)

Centre Georges Pompidou, Musée national d'art moderne, Paris,
Gift, Mrs. Nina Kandinsky, 1976 AM 1976-849

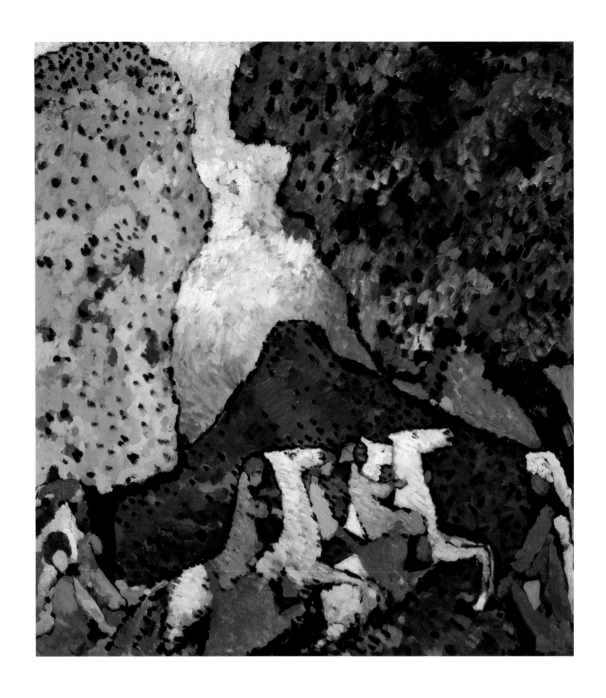

112
Vasily Kandinsky
Blue Mountain (*Der blaue Berg*), 1908–09
Oil on canvas
106 × 96.6 cm (41¾ × 38 inches)

Solomon R. Guggenheim Museum, New York,
Gift, Solomon R. Guggenheim 41.505

113
Vasily Kandinsky
Landscape with Factory Chimney (Landschaft mit Fabrikschornstein), 1910
Oil on canvas
66.2 × 82 cm (26 × 32 ¼ inches)

Solomon R. Guggenheim Museum, New York,
Gift, Solomon R. Guggenheim 41.504

114
Vasily Kandinsky
Impression V (Park), 1911
Oil on canvas
106 × 157.5 cm (41¾ × 62 inches)

Centre Georges Pompidou, Musée national d'art moderne, Paris,
Gift, Mrs. Nina Kandinsky, 1976 AM 1976-851

115
Vasily Kandinsky
With the Black Arc (Mit dem schwarzen Bogen), 1912
Oil on canvas
189 × 198 cm (74 7/16 × 77 15/16 inches)

Centre Georges Pompidou, Musée national d'art moderne, Paris,
Gift, Mrs. Nina Kandinsky, 1976 AM 1976-852

116
Vasily Kandinsky
Study for *Improvisation 28* (second version), 1912
Watercolor, india ink, and pencil on paper
39 × 56.1 cm (15 3/8 × 22 1/8 inches)

Solomon R. Guggenheim Museum, New York,
The Hilla von Rebay Foundation 1970.127

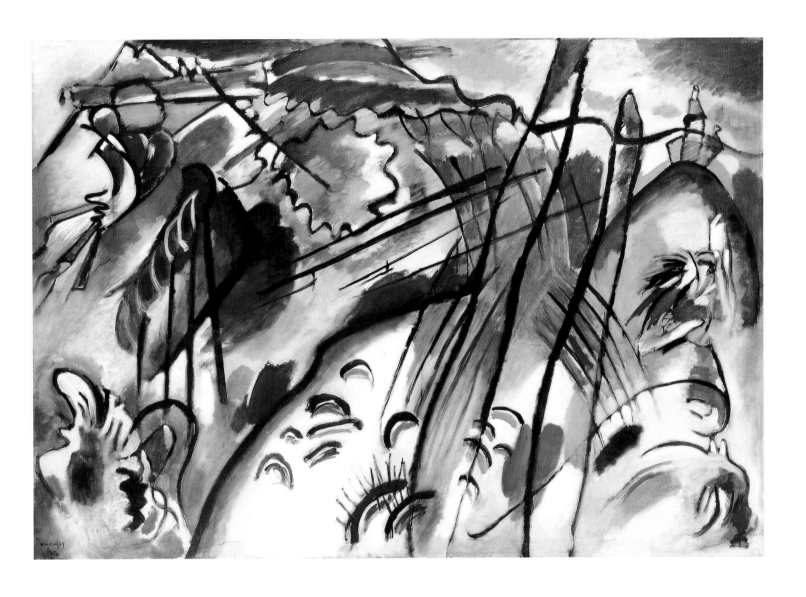

117
Vasily Kandinsky
Improvisation 28 (second version), 1912
Oil on canvas
111.4 × 162.1 cm (43⅞ × 63⅞ inches)

Solomon R. Guggenheim Museum, New York,
Gift, Solomon R. Guggenheim 37.239

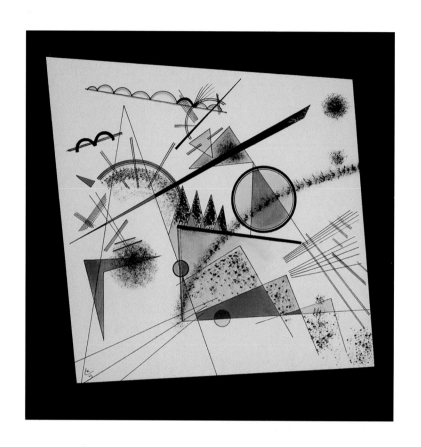

118
Vasily Kandinsky
Study for *In the Black Square* (*Im schwarzen Viereck*), 1923
Watercolor, gouache, and india ink on paper
36 × 36 cm (14 3/16 × 14 3/16 inches)

Centre Georges Pompidou, Musée national d'art moderne, Paris,
Remittance in lieu of inheritance taxes to the government of France,
1994 AM 1994-72

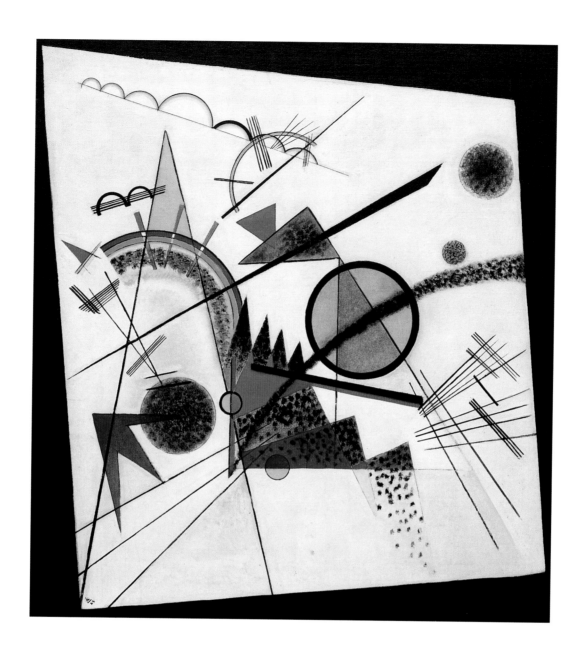

119
Vasily Kandinsky
In the Black Square (*Im schwarzen Viereck*), June 1923
Oil on canvas
97.5 × 93 cm (38 3/8 × 36 5/8 inches)

Solomon R. Guggenheim Museum, New York,
Gift, Solomon R. Guggenheim 37.254

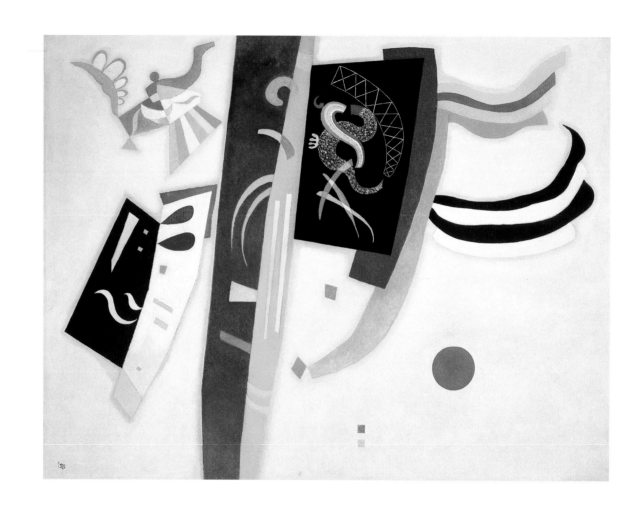

120
Vasily Kandinsky
Violet-Orange, October 1935
Oil on canvas
88.9 × 116.2 cm (35 × 45¾ inches)

Solomon R. Guggenheim Museum, New York,
Gift, Solomon R. Guggenheim 37.334

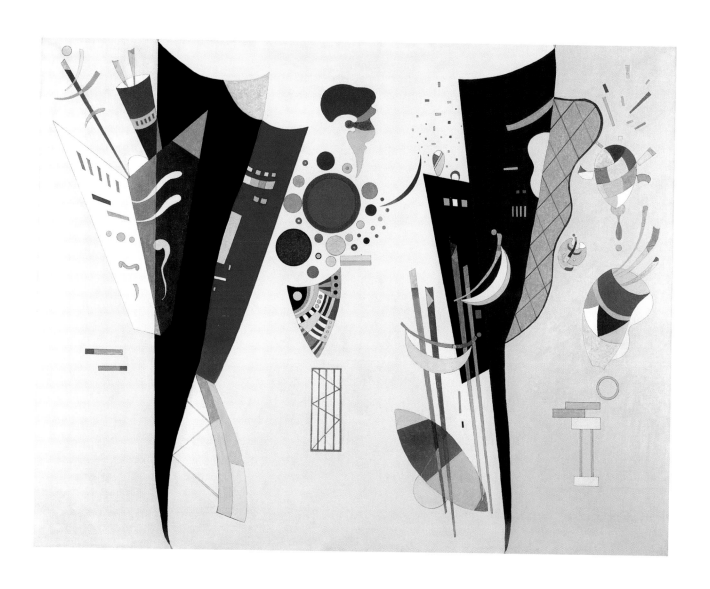

121
Vasily Kandinsky
Reciprocal Accord (*Accord réciproque*), 1942
Oil and Ripolin enamel on canvas
114 × 146 cm (44⅞ × 57½ inches)

Centre Georges Pompidou, Musée national d'art moderne, Paris,
Gift, Mrs. Nina Kandinsky, 1976 AM 1976-863

PAUL KLEE

In 1947, the Guggenheim acquired 121 works by
Paul Klee with the purchase of the entire estate
of Karl Nierendorf, a New York art dealer and art
adviser to the United States government. The Musée
national d'art moderne, through substantial gifts
from Heinz Berggruen, Nina Kandinsky, and Louise
and Michel Leiris, and others, now has more than
fifty Klees in its collection. Klee's art, ever-varied
in subject matter, style, and technique, resists easy
categorization, as these eight works selected from
various moments in his career attest. Yet his work
is readily recognizable for its exploration of the fan-
tastic and the unique combination of poetry and
music in its visual imagery.

Paul Klee in his studio, Weimar, 1925.

122
Paul Klee
Dance You Monster to My Soft Song!
(*Tanze Du Ungeheuer zu meinem sanften Lied*), 1922
Watercolor and oil transfer drawing on plaster-primed gauze,
bordered with watercolor on the paper mount
Gauze: approximately 35.2 × 29.2 cm (13⅞ × 11½ inches);
gauze and border: 40 × 29.2 cm (15¾ × 11½ inches);
paper: 44.9 × 32.6 cm (17¾ × 12⅞ inches)

Solomon R. Guggenheim Museum, New York,
Gift, Solomon R. Guggenheim 38.508

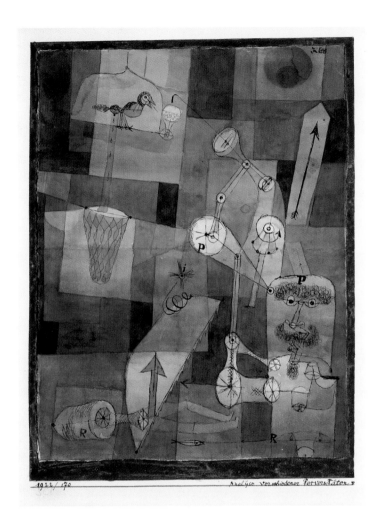

123
Paul Klee

Analysis of Diverse Perversities
(*Analyse Verschiedener Perversitaeten*), 1922
India ink and watercolor on paper, mounted on cardboard
47 × 31.4 cm (18½ × 12⅜ inches)

Centre Georges Pompidou, Musée national d'art moderne, Paris,
Gift, Mr. Heinz Berggruen, 1972 AM 1972-9

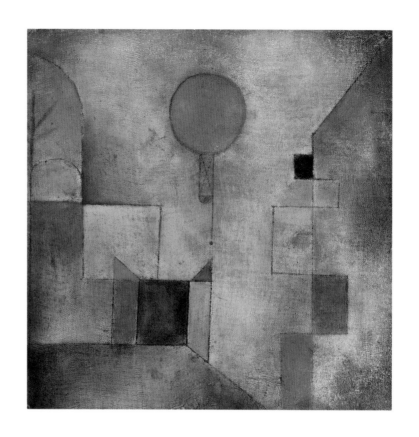

124
Paul Klee

Red Balloon (*Roter Ballon*), 1922
Oil (and oil transfer drawing?) on chalk-primed gauze,
mounted on board
31.7 × 31.1 cm (12 ¹/₂ × 12 ¹/₄ inches)

Solomon R. Guggenheim Museum, New York 48.1172x524

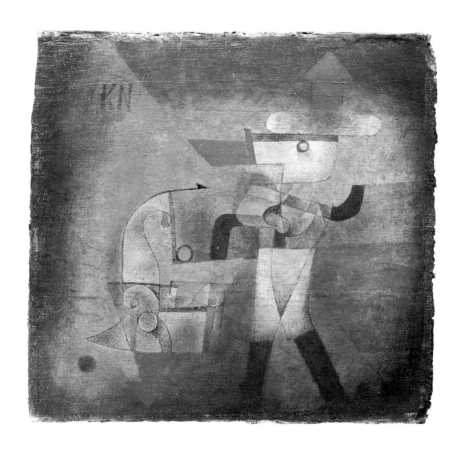

125
Paul Klee
KN the Smith (KN der Schmied), 1922
Oil on gauze, mounted on cardboard
32.8 × 35.6 cm (12 ¹⁵/₁₆ × 14 inches)

Centre Georges Pompidou, Musée national d'art moderne, Paris,
Bequest of Mrs. Nina Kandinsky, 1981 AM 81-65-881

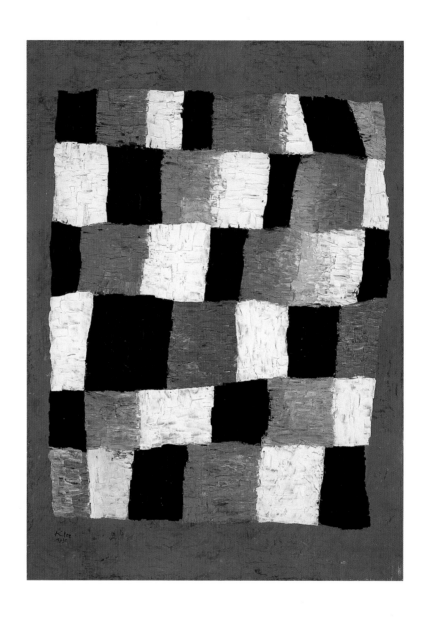

126
Paul Klee
Rhythmical (*Rhythmisches*), 1930
Oil on jute
69.6 × 50.5 cm (27 3/8 × 19 7/8 inches)

Centre Georges Pompidou, Musée national d'art moderne, Paris,
Purchased 1984 AM 1984-356

127
Paul Klee
New Harmony (*Neue Harmonie*), 1936
Oil on canvas
93.6 × 66.3 cm (36⅞ × 26⅛ inches)

Solomon R. Guggenheim Museum, New York 71.1960

128
Paul Klee
Boy with Toys (*Knabe mit Spielsachen*), 1940
Colored paste on paper, mounted on paper
Paper support: 29.2 × 20.6 cm (11 1/2 × 8 1/4 inches);
paper mount: 40.4 × 31.2 cm (15 7/8 × 12 1/4 inches)

Solomon R. Guggenheim Museum, New York 48.1172x70

129
Paul Klee

Hardship by Drought (Not durch Dürre), 1940
Watercolor and gouache on notebook paper, mounted on paper
33.5 × 43.5 cm (13 3/16 × 17 1/8 inches)

Centre Georges Pompidou, Musée national d'art moderne, Paris,
Gift, Mr. Heinz Berggruen, 1972 AM 1972-17

GEOMETRIC ABSTRACTION

During World War I and the period between the wars, several artists living in France, Germany, the Netherlands, and Russia created abstract paintings and constructions based on the language of geometry. Among them, the most important to the Guggenheim's collection were László Moholy-Nagy, who often acted as an adviser to Hilla Rebay, and Piet Mondrian, whose work Rebay purchased for her own collection during her first meeting with the artist in 1930.

Until the mid-1970s, the Musée national d'art moderne virtually ignored foreign artists who had worked—many at least partially in France—in this style of geometric abstraction. When Pontus Hulten, a Swedish museum director and curator, became director in 1974, he sought to fill these gaps. By that time, however, it was difficult to purchase significant examples of the artists' works, and it was not until 1984, under the directorship of Dominique Bozo, that Mondrian's *New York City I* (1942, cat. no. 144) was acquired, thanks to a special credit allocated by the government of France and the help of the American-based Scaler Foundation.

Piet Mondrian in his studio, New York, 1943.

130
László Moholy-Nagy
Untitled, 1922
Photogram on contact paper
14 × 9 cm (5½ × 3⁹⁄₁₆ inches)

Centre Georges Pompidou, Musée national d'art moderne, Paris,
Purchased 1994 AM 1994-179

131
László Moholy-Nagy
Untitled, 1922
Photogram on contact paper
13.8 × 8.8 cm (5⁷⁄₁₆ × 3⁷⁄₁₆ inches)

Centre Georges Pompidou, Musée national d'art moderne, Paris,
Purchased 1994 AM 1994-177

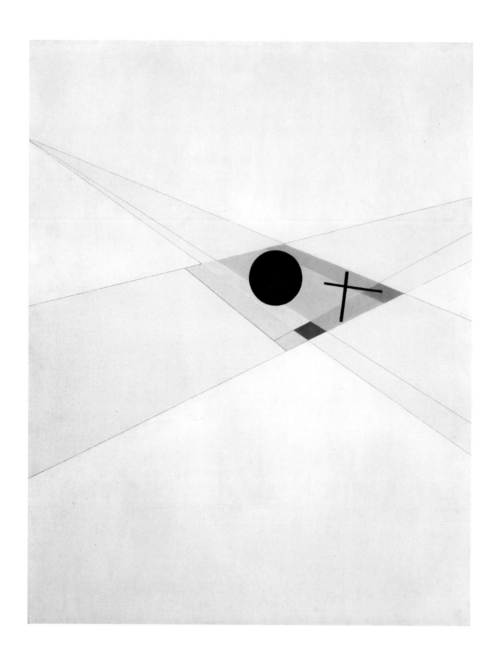

132
László Moholy-Nagy
AXL II, 1927
Oil on canvas
94.1 × 73.9 cm (37 × 29 ⅛ inches)

Solomon R. Guggenheim Museum, New York,
Gift, Mrs. Andrew P. Fuller 64.1754

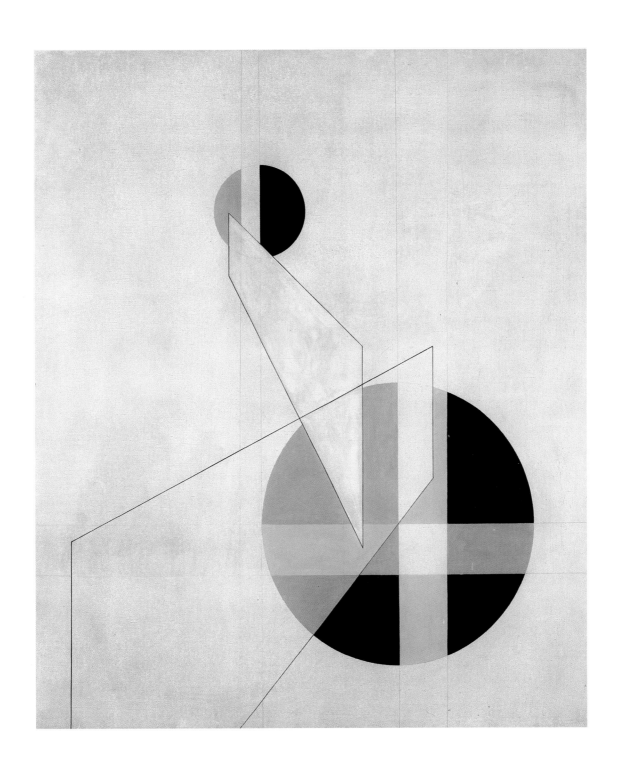

133
László Moholy-Nagy
A XX, 1924
Oil on canvas
135.5 × 115 cm (53 ³⁄₈ × 45 ¹⁄₄ inches)

Centre Georges Pompidou, Musée national d'art moderne, Paris,
Gift, the Société des amis du Musée national d'art moderne, Paris, 1962
AM 4025 P

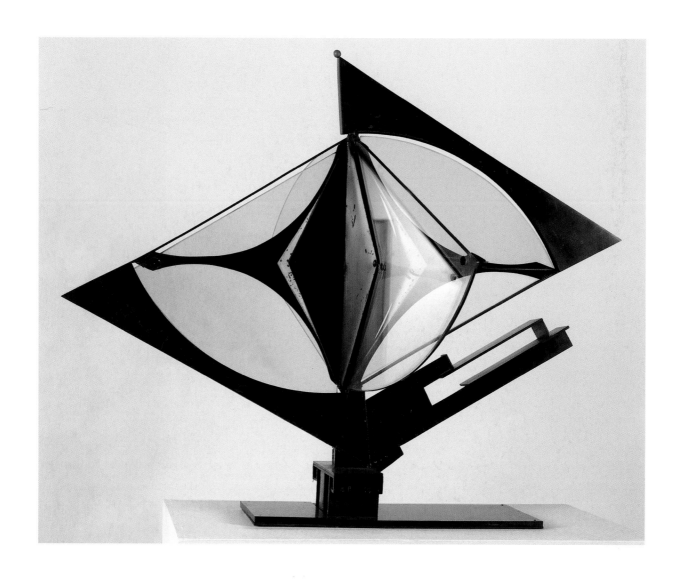

134
Antoine Pevsner
Construction in Space (Construction dans l'espace), 1923–25
Bronze and Baccarat crystal
64 × 84 × 70 cm (25 3/16 × 33 1/16 × 27 9/16 inches)

Centre Georges Pompidou, Musée national d'art moderne, Paris,
Gift, Mrs. Virginie Pevsner, 1962 AM 1346 s

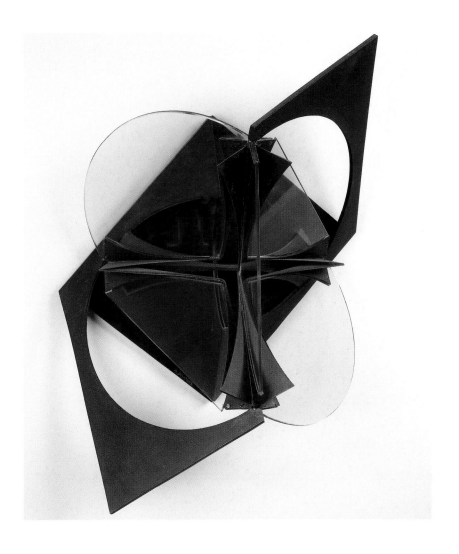

135
Antoine Pevsner
Anchored Cross (La Croix ancrée), 1933
Marble, painted brass, and crystal
68.5 × 55 × 35.5 cm (27 × 21 ⁵/₈ × 14 inches)

Peggy Guggenheim Collection, Venice 76.2553 PG60

136
Jean Hélion
Equilibrium (*Equilibre*), 1933–34
Oil on canvas
97.4 × 131.2 cm (38 3/8 × 51 5/8 inches)

Peggy Guggenheim Collection, Venice 76.2553 PG44

137
Theo van Doesburg
Composition XI (*Kompositie 11*), 1918
Oil on canvas
64.8 × 109.2 × 1.1 cm (25 ½ × 43 × ⁷⁄₁₆ inches),
including artist's painted frame

Solomon R. Guggenheim Museum, New York 54.1360

138
Theo van Doesburg
Pure Painting, 1920
Oil on canvas
130 × 80.5 cm (51 3/16 × 31 11/16 inches)

Centre Georges Pompidou, Musée national d'art moderne, Paris,
Purchased 1964 AM 4281 P

139
Theo van Doesburg
Counter-Composition XIII (Contra-Compositie XIII), 1925–26
Oil on canvas
49.9 × 50 cm (19 ⅝ × 19 ⅝ inches)

Peggy Guggenheim Collection, Venice 76.2553 PG41

140
Georges Vantongerloo
*Construction of Volumetric Interrelationships Derived from the
Inscribed Square and the Square Circumscribed by a Circle
(Construction des rapports des volumes émanant du carré inscrit
et du carré circonscrit d'un cercle)*, 1924
Painted cast cement
30 × 25.5 × 25 cm (11 ¹³/₁₆ × 10 ¹/₁₆ × 9 ¹³/₁₆ inches)

Peggy Guggenheim Collection, Venice 76.2553 PG59

141
Georges Vantongerloo
Volumetric Interrelationships Derived from the Cone
(*Rapport des volumes émanant du cône*), 1927
Painted plaster
32.5 × 27.5 × 27.2 cm (12 ¾ × 10 ¹³/₁₆ × 10 ¹¹/₁₆ inches)

Centre Georges Pompidou, Musée national d'art moderne, Paris,
Gift, Max Bill, 1980 AM 1980-354

142
Piet Mondrian

Composition No. I; Composition 1A, 1930
Oil on canvas
75.2 × 75.2 cm (29 ⅝ × 29 ⅝ inches);
lozenge, vertical axis 105 cm (41 ⅜ inches)

Solomon R. Guggenheim Museum, New York, Hilla Rebay Collection
71.1936 R96

143
Piet Mondrian
Composition II, 1937
Oil on canvas
75 × 60.5 cm (29 1/2 × 23 13/16 inches)

Centre Georges Pompidou, Musée national d'art moderne, Paris,
Purchased 1975 AM 1975-53

144
Piet Mondrian
New York City I, 1942
Oil on canvas
119.3 × 114.2 cm (46 ¹⁵/₁₆ × 44 ¹⁵/₁₆ inches)

Centre Georges Pompidou, Musée national d'art moderne, Paris,
Purchased with a generous contribution by and the assistance of
the Scaler Foundation in 1984 AM 1984-352

MARCEL DUCHAMP, FRANCIS PICABIA, AND MAN RAY

In 1915, Marcel Duchamp and Francis Picabia left war-torn Europe and moved to New York, where they met Man Ray. The three artists, who had each been painting in styles related to Cubism, developed a style called New York Dada. Along with the larger European Dada movement, they produced some of the most antirational, anarchic, and humorous work of the twentieth century, mocking the bourgeois values thought to be responsible for the horrors of war. From 1916 to 1917, Picabia traveled between Europe and New York and later became involved with the Dadaists in Zurich and Paris. Duchamp and Man Ray engaged in a trans-Atlantic dialogue with the Paris Dadaists until the early 1920s, when the Paris group disbanded.

Francis Picabia in front of *Udnie* (1913) and *Edtaonisl* (1913) in the Château de Mai, Mougins, France, 1935.

145
Marcel Duchamp
Apropos of Little Sister (*A propos de jeune soeur*), October 1911
Oil on canvas
73 × 60 cm (28 3/4 × 23 5/8 inches)

Solomon R. Guggenheim Museum, New York 71.1944

146
Marcel Duchamp
Study for *Chess Players* (*Les Joueurs d'échecs*), late 1911
India ink and watercolor on lined wove paper
21.2 × 18.4 cm (8 ³⁄₈ × 7 ¹⁄₄ inches)

Solomon R. Guggenheim Museum, New York,
Gift, Estate of Katherine S. Dreier 53.1339

147

Marcel Duchamp

The Chess Players (*Les Joueurs d'échecs*), December 1911
Oil on canvas
50 × 61 cm (19 11/16 × 24 inches)

Centre Georges Pompidou, Musée national d'art moderne, Paris,
Purchased 1954 AM 3329 P

148
Marcel Duchamp
First study for *The Bride Stripped Bare by the Bachelors*
(*La Mariée mise à nu par les célibataires*), 1912
Pencil and ink on cardboard
24 × 32.1 cm (9⁷/₁₆ × 12⁵/₈ inches)

Centre Georges Pompidou, Musée national d'art moderne, Paris,
Purchased 1979 AM 1978-747

149
Marcel Duchamp
Nude (Study), Sad Young Man on a Train
(*Nu [esquisse], jeune homme triste dans un train*), 1911–12
Oil on cardboard, mounted on Masonite
100 × 73 cm (39 3/8 × 28 3/4 inches)

Peggy Guggenheim Collection, Venice 76.2553 PG9

150
Francis Picabia
Udnie, 1913
Oil on canvas
2.9 × 3 m (9 feet 6 3/16 inches × 9 feet 10 1/8 inches)

Centre Georges Pompidou, Musée national d'art moderne, Paris,
Purchased by the French State in 1949, allocated 1949 AM 2874 P

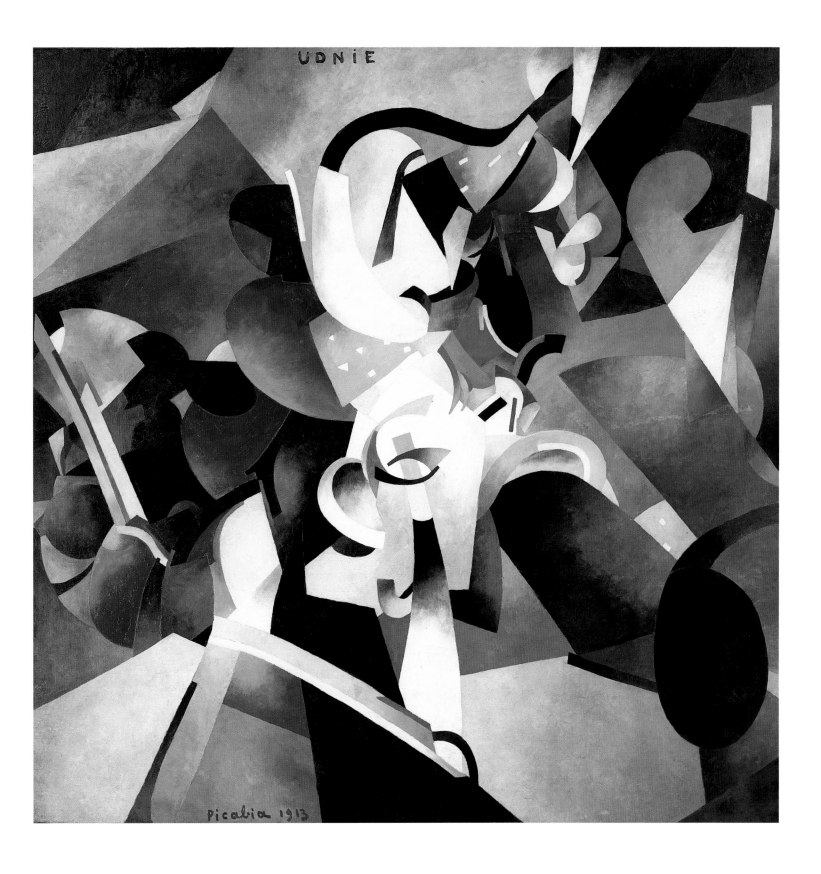

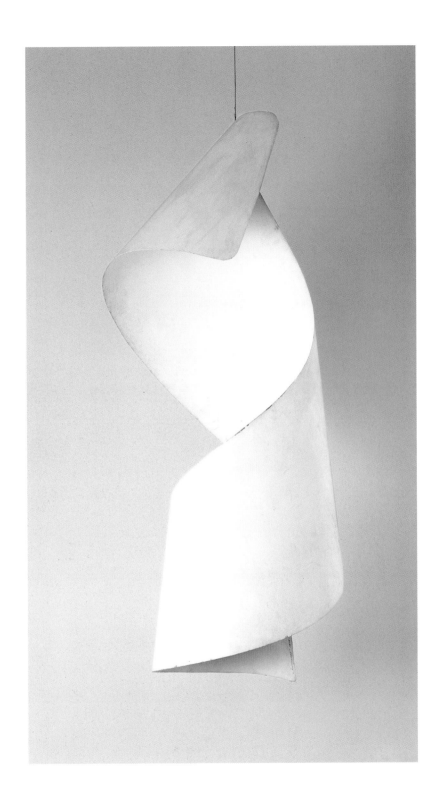

151
Man Ray
Lampshade, 1919/1954
Painted aluminum
152.5 × 63.5 cm (60¹/₁₆ × 25 inches)

Centre Georges Pompidou, Musée national d'art moderne, Paris,
Remittance in lieu of inheritance taxes to the government of France,
1994 AM 1994-300

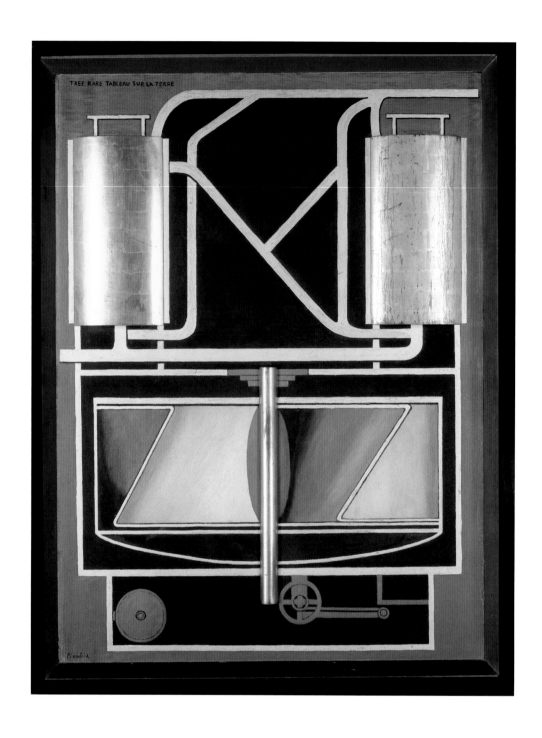

152

Francis Picabia

Very Rare Picture on the Earth (*Très rare tableau sur la terre*), 1915
Oil and metallic paint on board, and silver and gold leaf on wood
125.7 × 97.8 × 7 cm (49 1/2 × 38 1/2 × 2 3/4 inches),
including artist's painted frame

Peggy Guggenheim Collection, Venice 76.2553 PG67

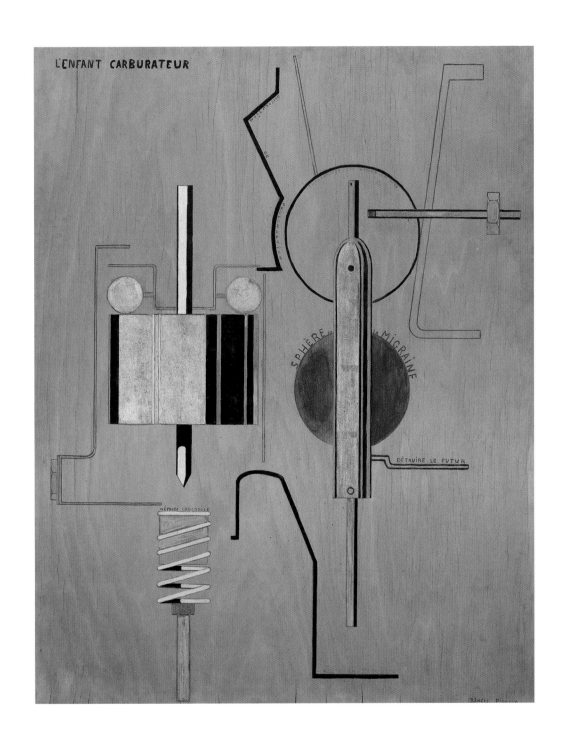

153
Francis Picabia
The Child Carburetor (*L'Enfant carburateur*), 1919
Oil, enamel, metallic paint, gold leaf, pencil,
and crayon on stained plywood
126.3 × 101.3 cm (49 ¾ × 39 ⅞ inches)

Solomon R. Guggenheim Museum, New York 55.1426

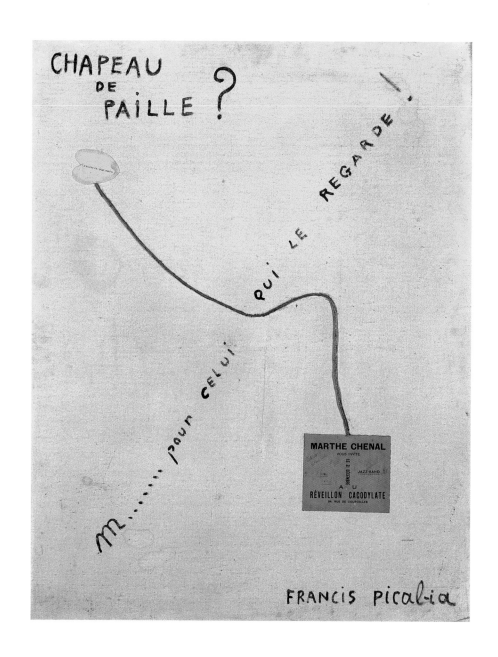

154
Francis Picabia
Straw Hat? (*Chapeau de paille?*), ca. 1921
Oil, string, and printed invitation on canvas
92.3 × 73.5 cm (36 3/8 × 28 15/16 inches)

Centre Georges Pompidou, Musée national d'art moderne, Paris,
Bequest, R. Lemasle, 1974 AM 1974-110

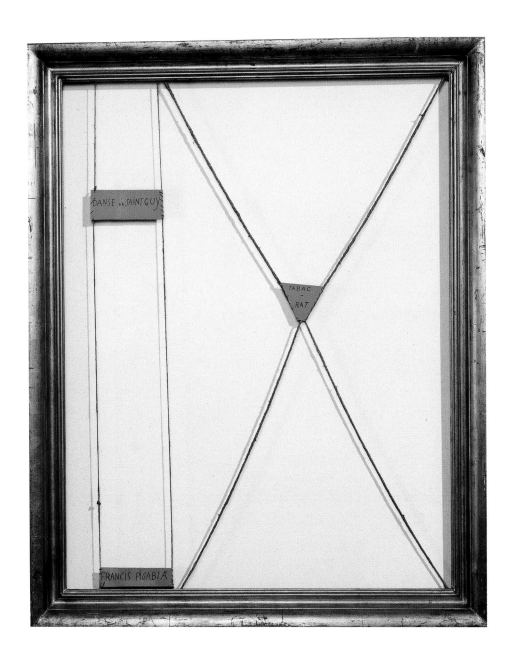

155
Francis Picabia
Tobacco-Rat (Tabac-Rat), ca. 1919–20 (destroyed),
refabricated ca. 1946–49
Cardboard, ink, and twine in wood frame
104.4 × 84.7 cm (41 1/8 × 33 3/8 inches)

Centre Georges Pompidou, Musée national d'art moderne, Paris,
Purchased 1988 AM 1988-40

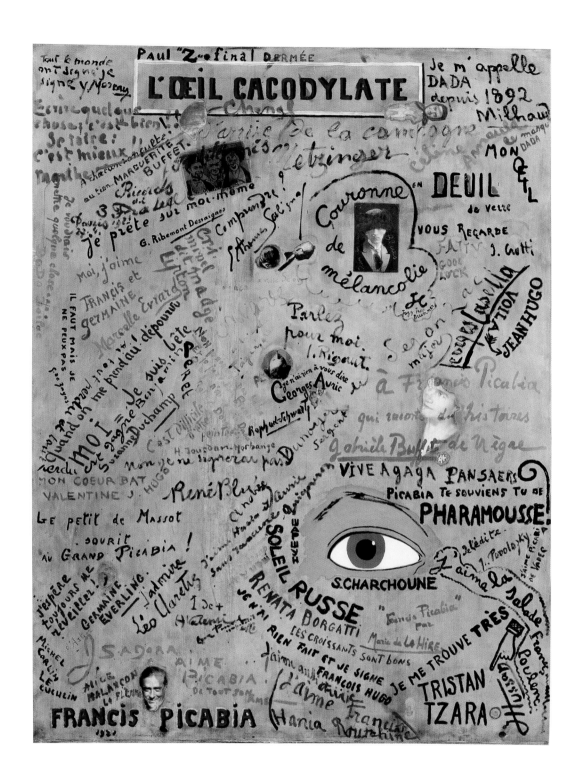

156

Francis Picabia

The Cacodylic Eye (*L'Oeil cacodylate*), 1921
Oil, photographs, postcards, and paper on canvas
148.6 × 117.4 cm (58¹⁄₂ × 46¹⁄₄ inches)

Centre Georges Pompidou, Musée national d'art moderne, Paris,
Purchased 1967 AM 4408 P

FROM DADA TO SURREALISM

Surrealism, which was both a literary and an artistic movement led by the writer André Breton, advocated an art of pure imagination, drawing upon Sigmund Freud's ideas of dream analysis, the uncanny, and the unconscious. The Surrealists employed inventive artistic techniques in order to stress the breakdown of conscious thought. Like the Dadaists, these artists, all of whom had lived through World War I, emphasized the idea of revolt against social tradition. Their work often relies on disturbing images and juxtapositions that disrupt stable, conventional notions of form through their practice of free association, chance, and accident.

Peggy Guggenheim, Solomon R. Guggenheim's niece, was an intimate part of this artistic circle as well as a collector and promoter of Surrealist work. Max Ernst, who belonged first to the Berlin Dada group, then to the Surrealists, acted as an adviser to Peggy Guggenheim, and the two were married from 1941 to 1943.

Perhaps because Ernst left Europe for New York during World War II, his work was not acquired by the Musée national d'art moderne until the 1950s. A 1959 Ernst show resulted in the purchase of one work and gifts from the artist himself. In 1985, the Musée national d'art moderne received several paintings, including *Garden Airplane Trap* (*Jardin gobe-avions*, 1935, cat. no. 176), from the artist's estate as a result of the government's introduction of a policy, *dation*, which allows gifts of art to serve as payment of inheritance tax.

Salvador Dalí during a lecture given at the *International Surrealist Exhibition*, London, June 1936.

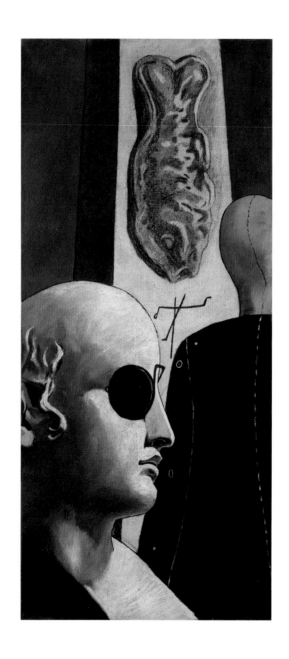

157
Giorgio de Chirico
The Nostalgia of the Poet (La Nostalgie du poète), 1914
Oil and charcoal on canvas
89.7 × 40.7 cm (35 5/16 × 16 inches)

Peggy Guggenheim Collection, Venice 76.2553 PG65

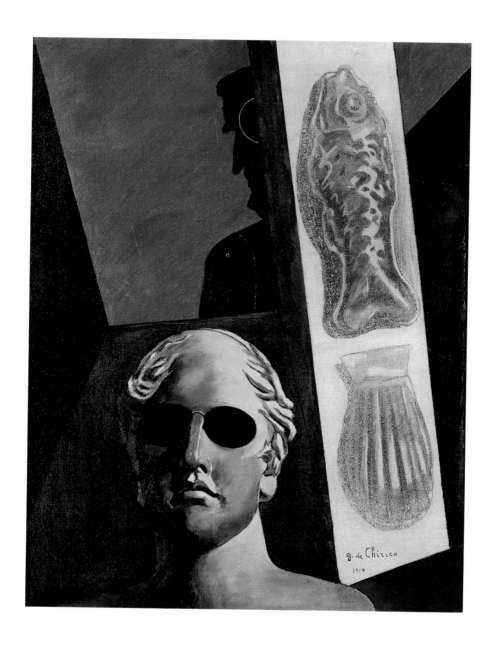

158
Giorgio de Chirico
Premonitory Portrait of Guillaume Apollinaire
(*Portrait prémonitoire de Guillaume Apollinaire*), 1914
Oil on canvas
81.5 × 65 cm (32 1/16 × 25 9/16 inches)

Centre Georges Pompidou, Musée national d'art moderne, Paris,
Purchased 1975 AM 1975-52

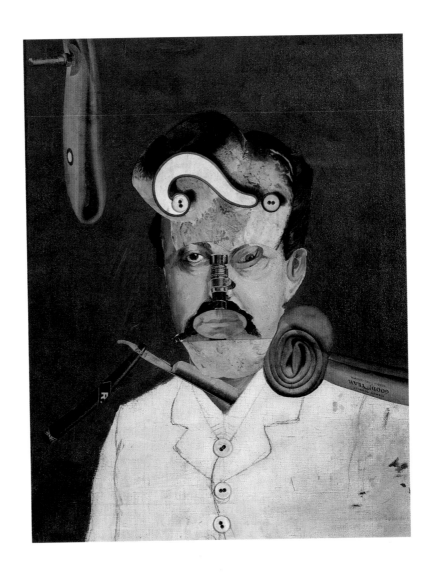

159
George Grosz
Remember Uncle August, the Unhappy Inventor, 1919
Oil, pencil, paper, and buttons on canvas
49 × 39.5 cm (19 5/16 × 15 9/16 inches)

Centre Georges Pompidou, Musée national d'art moderne, Paris,
Purchased 1977 AM 1977-562

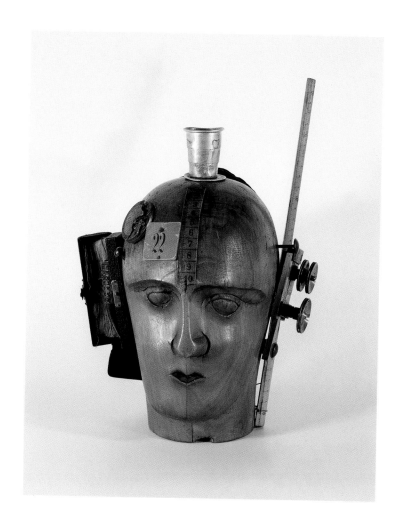

160

Raoul Hausmann

The Spirit of Our Time (Mechanical Head)
(Der Geist unserer Zeit [Mechanischer Kopf]), 1919
Wood mannequin's head, collapsible cup, purse,
pipe cleaner, printed cardboard, ruler, and clock mechanism
32.5 × 21 × 20 cm (12 ¹³⁄₁₆ × 8 ¼ × 7 ⁷⁄₈ inches)

Centre Georges Pompidou, Musée national d'art moderne, Paris,
Purchased 1974 AM 1974-6

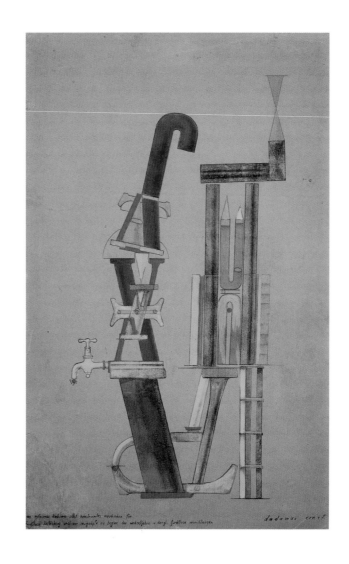

161

Max Ernst

Little Machine Constructed by Minimax Dadamax in Person
(*Von minimax dadamax selbst konstruirtes maschinchen*), 1919–20
Hand printing (?), pencil and ink frottage, watercolor,
and gouache on paper
49.4 × 31.5 cm (19 1/2 × 12 3/8 inches)

Peggy Guggenheim Collection, Venice 76.2553 PG70

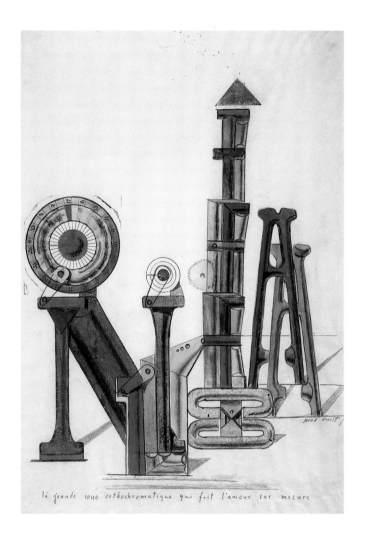

la grande roue orthochromatique qui fait l'amour sur mesure

162
Max Ernst
The Great Orthochromatic Wheel that Makes Love to Measure
(*La Grande Roue orthochromatique qui fait l'amour sur mesure*), 1920
Pencil, india ink, and watercolor on paper, mounted on cardboard
40.8 × 27.4 cm (16 1/16 × 10 13/16 inches)

Centre Georges Pompidou, Musée national d'art moderne, Paris,
Gift, Louise and Michel Leiris, 1984 AM 1984-513

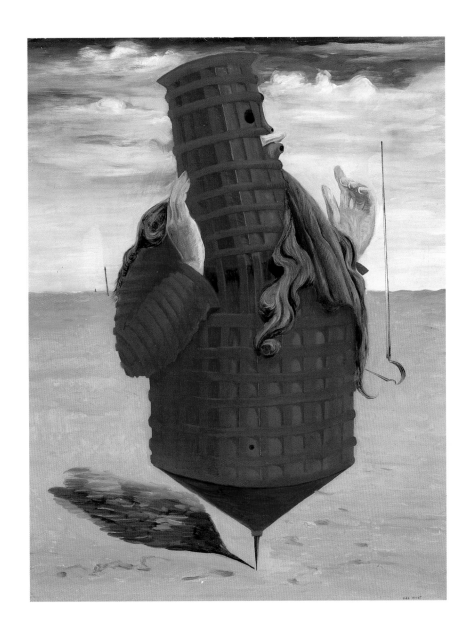

163
Max Ernst
Ubu Imperator, 1923
Oil on canvas
81 × 65 cm (31⅞ × 25⁹⁄₁₆ inches)

Centre Georges Pompidou, Musée national d'art moderne, Paris,
Gift, the Fondation pour la recherche médicale in memory of
Mrs. Hélène Anavi, 1984 AM 1984-281

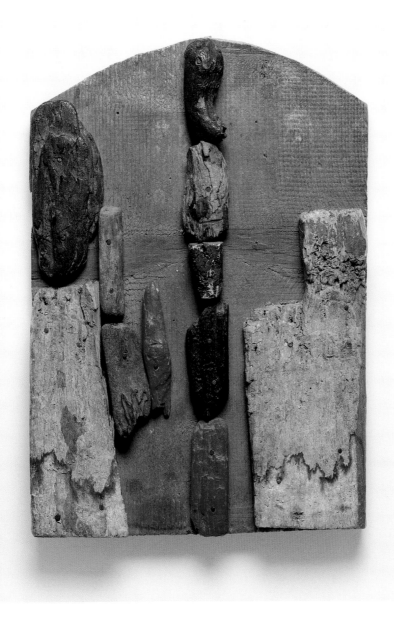

164
Jean Arp
Trousse d'un Da, 1920–21
Driftwood nailed on wood, painted
38.7 × 27 × 4.5 cm (15 1/4 × 10 5/8 × 1 3/4 inches)

Centre Georges Pompidou, Musée national d'art moderne, Paris,
Gift, Mr. and Mrs. Christophe Tzara, 1989 AM 1989-195

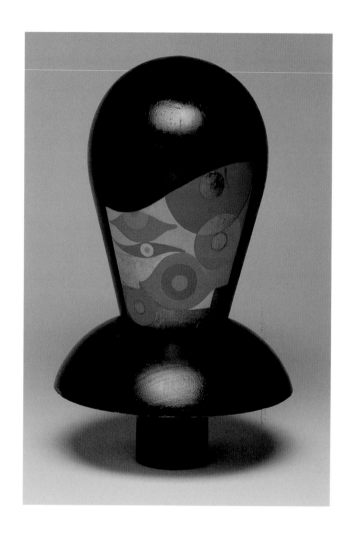

165
Sophie Taeuber-Arp
Dada Head (*Dada Kopf*), ca. 1918–19
Painted wood
34 × 20 × 20 cm (13 3/8 × 7 7/8 × 7 7/8 inches)

Centre Georges Pompidou, Musée national d'art moderne, Paris,
Gift, Marguerite Arp-Hagenbach, 1967 AM 1692 s

166
Jean Arp
Dancer (*Danseuse*), 1925
Oil on wood collage
149 × 112.5 cm (58^{11}/$_{16}$ × 44^{5}/$_{16}$ inches)

Centre Georges Pompidou, Musée national d'art moderne, Paris,
Purchased 1976 AM 1976-247

167
Max Ernst
The Kiss (Le Baiser), 1927
Oil on canvas
129 × 161.2 cm (50¾ × 63½ inches)

Peggy Guggenheim Collection, Venice 76.2553 PG71

168

Max Ernst

Chimera (Chimère), 1928
Oil on canvas
114 × 145.8 cm (44 7/8 × 57 3/8 inches)

Centre Georges Pompidou, Musée national d'art moderne, Paris,
Purchased 1983 AM 1983-47

169
René Magritte
The Secret Double (*Le Double secret*), 1927
Oil on canvas
114 × 162 cm (44⅞ × 63¾ inches)

Centre Georges Pompidou, Musée national d'art moderne, Paris,
Purchased 1980 AM 1980-2

170
René Magritte
Voice of Space (*La Voix des airs*), 1931
Oil on canvas
72.7 × 54.2 cm (28 5/8 × 21 3/8 inches)

Peggy Guggenheim Collection, Venice 76.2553 PG101

171
Salvador Dalí
The Spectral Cow (La Vache spectrale), 1928
Oil on plywood
50 × 64.5 cm (19 11/16 × 25 3/8 inches)

Centre Georges Pompidou, Musée national d'art moderne, Paris,
Purchased by the French State in 1974, allocated 1974 AM 1974-14

172
Salvador Dalí
Invisible Sleeping Woman, Horse, Lion
(*Lion, cheval, dormeuse invisibles*), 1930
Oil on canvas
50.2 × 65.2 cm (19 3/4 × 25 11/16 inches)

Centre Georges Pompidou, Musée national d'art moderne, Paris,
Gift, the Bourdon Association, 1993 AM 1993-26

173
Salvador Dalí
Untitled, 1931
Oil on canvas
27.2 × 35 cm (10 11/16 × 13 3/4 inches)

Peggy Guggenheim Collection, Venice 76.2553 PG99

174
Salvador Dalí
Birth of Liquid Desires (*La Naissance des désirs liquides*), 1931–32
Oil and collage on canvas
96.1 × 112.3 cm (37⅞ × 44¼ inches)

Peggy Guggenheim Collection, Venice 76.2553 PG100

175
Yves Tanguy

Promontory Palace (*Palais promontoire*), 1931
Oil on canvas
73 × 60 cm (28 ¾ × 23 ⅜ inches)

Peggy Guggenheim Collection, Venice 76.2553 PG94

176
Max Ernst

Garden Airplane Trap (Jardin gobe-avions), 1935
Oil on canvas
54 × 74 cm (21¼ × 29⅛ inches)

Centre Georges Pompidou, Musée national d'art moderne, Paris,
Remittance in lieu of inheritance taxes to the government of France,
1985 AM 1982-188

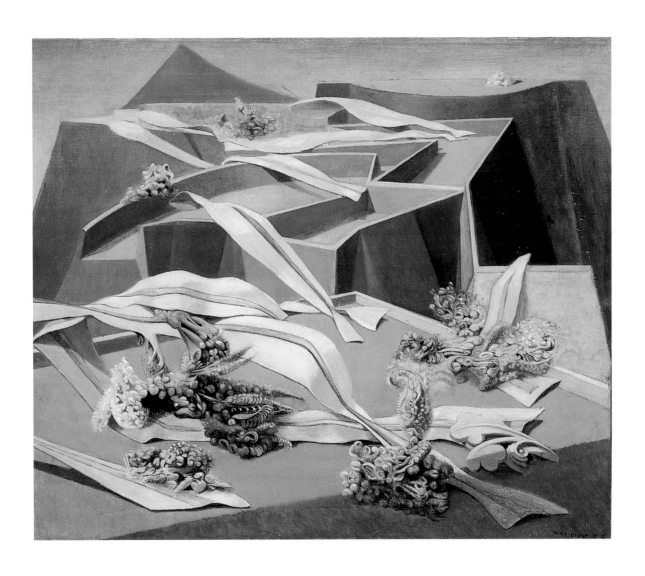

177
Max Ernst
Garden Airplane Trap (Jardin gobe-avions), 1935–36
Oil on canvas
54 × 64.7 cm (21 1/4 × 25 1/2 inches)

Peggy Guggenheim Collection, Venice 76.2553 PG76

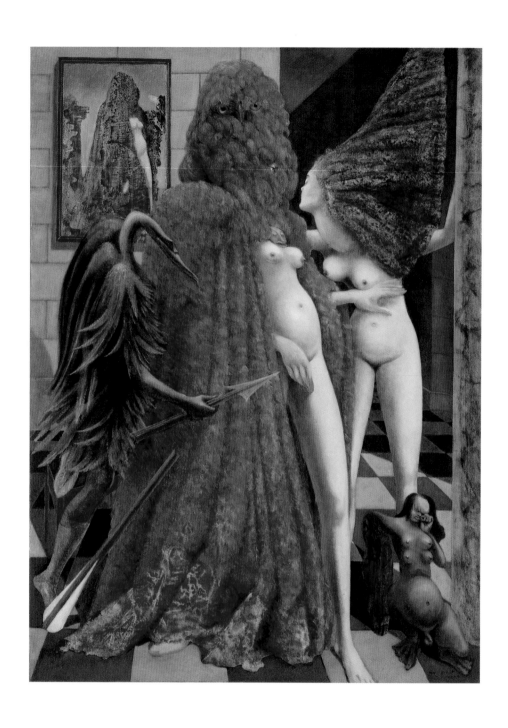

178
Max Ernst
Attirement of the Bride (La Toilette de la mariée), 1940
Oil on canvas
129.6 × 96.3 cm (51 × 37⅞ inches)

Peggy Guggenheim Collection, Venice 76.2553 PG78

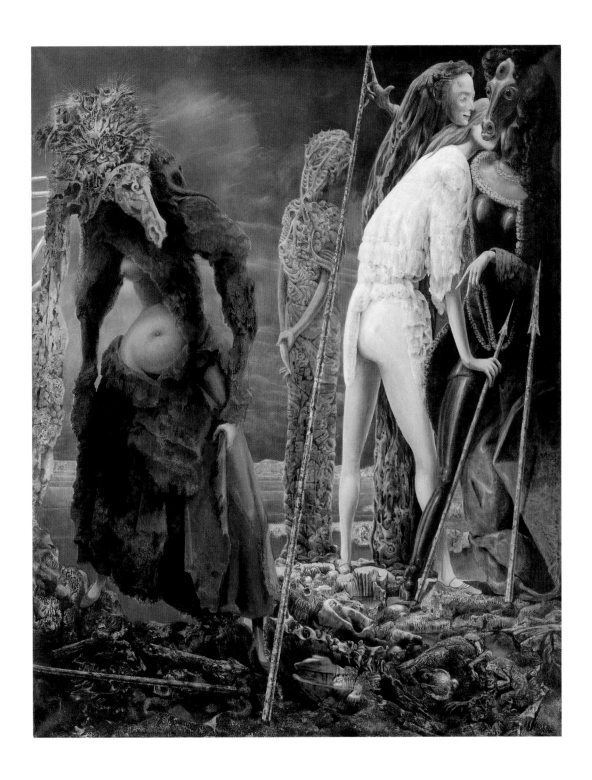

179
Max Ernst
The Antipope, December 1941–March 1942
Oil on canvas
160.8 × 127.1 cm (63¼ × 50 inches)

Peggy Guggenheim Collection, Venice 76.2553 PG80

MAX BECKMANN

Depicting an outdoor woodsman, a depressed social elite, and a masked yet exposed woman, these three works by Max Beckmann express the troubled human condition and social unrest in Europe between the wars.

The French government originally acquired Beckmann's *Forest Landscape with Lumberjacks* (*Waldlandschaft mit Holzfäller*, June 18–September 10, 1927, cat. no. 180) in 1931 for the Musée des Ecoles étrangères contemporaines, the museum for contemporary foreign artists. The holdings of this museum and the Musée du Luxembourg, the museum for contemporary French artists, were amalgamated in 1945 to form the basis of the collection of the Musée national d'art moderne. After this merger, however, many foreign artists were neglected by the institution. Although Pontus Hulten and other directors have actively acquired the art of nonnationals since the 1970s, the museum's collection of Beckmann and other great German artists remains small in comparison to its representation of other western European countries.

Max Beckmann in his studio, Amsterdam, 1938.

180

Max Beckmann

Forest Landscape with Lumberjacks (*Waldlandschaft mit Holzfäller*),
June 18–September 10, 1927
Oil on canvas
101 × 61 cm (39 ¾ × 24 inches)

Centre Georges Pompidou, Musée national d'art moderne, Paris,
Purchased by the French State in 1931, allocated 1931 JP 540 P

181
Max Beckmann
Paris Society (*Gesellschaft Paris*), 1931
Oil on canvas
109.3 × 175.6 cm (43 × 69 ⅛ inches)

Solomon R. Guggenheim Museum, New York 70.1927

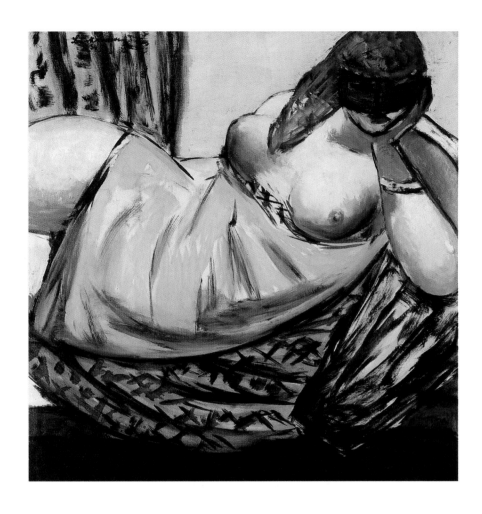

182
Max Beckmann
Alfi with Mask (Alfi mit Maske), 1934
Oil on canvas
78.4 × 75.5 cm (30⅞ × 29¾ inches)

Solomon R. Guggenheim Museum, New York,
Partial gift, Georgia van der Rohe 76.2202

BALTHUS AND THE SURREAL FIGURE

The human body in fragmented or eroticized states was of strong interest to Balthus and several Surrealist artists, including Hans Bellmer, Victor Brauner, and René Magritte. The rise in popularity of this type of work created various difficulties for both the Solomon R. Guggenheim Museum and the Musée national d'art moderne.

As the influence of Surrealism increased in the 1930s, Kandinsky and other abstract artists felt threatened by its success, referring to the Surrealists as their "contemporary enemies." In an effort to promote non-objective art, Hilla Rebay and Solomon R. Guggenheim decided to create an outpost of Guggenheim's collection in Paris called the Centre Guggenheim. They were concerned, however, not only with the rising fame of the Surrealists but with Peggy Guggenheim herself, who also planned to open an institution in Paris and whose name and strong interest in Surrealism could confuse the public perception of the Solomon R. Guggenheim collection. Their anxieties were most

likely not misplaced, given the fact that Peggy's advisers were Marcel Duchamp and Max Ernst, two Dadaists whose embrace of playful disorder might well have been satisfied by creating a feud within the Guggenheim family. In the end, however, World War II intervened, preventing either institution from being realized.

The work of Balthus created a conflict between the Musée national d'art moderne and the Conseil artistiques des musées. For a short time after the war, the curators of the French museum were allowed to propose the works by living artists they wished the institution to purchase. The curators' presentation to the council of three or four paintings by Balthus was rejected and, further, the museum's authority to propose works of living artists for purchase was revoked. It was not until 1974, when the museum became part of the Centre Georges Pompidou, that it was given a budget to purchase art directly and the work of Balthus and the Surrealists began to be seriously collected.

Hans Bellmer with one of his dolls.

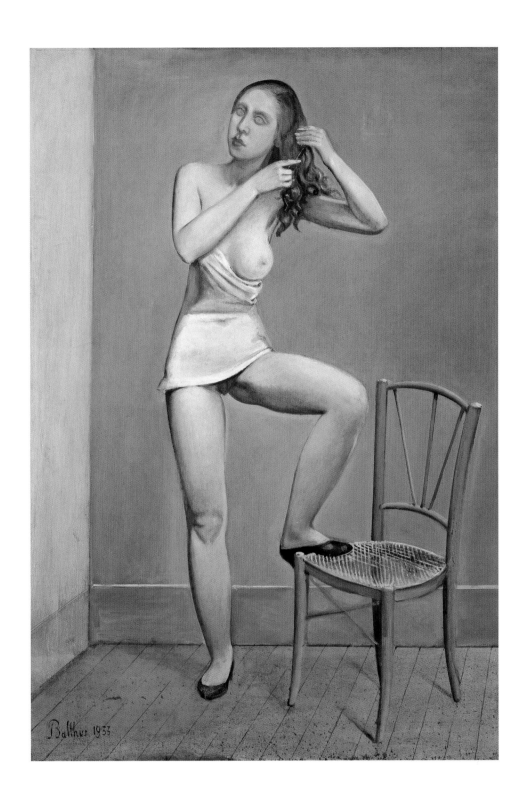

183
Balthus
Alice, 1933
Oil on canvas
162.3 × 112 cm (63⅞ × 44⅛ inches)

Centre Georges Pompidou, Musée national d'art moderne, Paris,
Purchased with the aid of the Fonds du patrimoine in 1995
AM 1995-205

184
Hans Bellmer
The Games of the Doll (*Les Jeux de la poupée*), 1938–49
Gelatin-silver print, colored with aniline
14.2 × 14 cm (5⁹⁄₁₆ × 5½ inches)

Centre Georges Pompidou, Musée national d'art moderne, Paris,
Purchased 1995 AM 1995-289

185
Hans Bellmer
The Doll (*La Poupée*), 1932–45
Painted wood, hair, socks, and shoes
61 × 170 × 51 cm (24 × 66 $^{15}/_{16}$ × 20 $^{1}/_{16}$ inches)

Centre Georges Pompidou, Musée national d'art moderne, Paris,
Gift of the artist to the French State in 1972, allocated 1976
AM 1976-927

186
René Magritte
The Red Model (*Le Modèle rouge*), 1935
Oil on canvas, mounted on cardboard
56 × 46 cm (22 1/16 × 18 1/8 inches)

Centre Georges Pompidou, Musée national d'art moderne, Paris,
Purchased 1975 AM 1975-216

187

Victor Brauner

Force of Concentration of Mr. K (Force de concentration de M. K.), 1934
Oil, plastic dolls, artificial plant pieces,
and metal wire on canvas, on paper
148.5 × 295 cm (58⁷/₁₆ × 116 ¹/₈ inches)

Centre Georges Pompidou, Musée national d'art moderne, Paris,
Purchased 1991 AM 1991-47

188
Victor Brauner
Wolf-Table (*Loup-table*), 1939–47
Wood and parts of a stuffed fox
54 × 57 × 28.5 cm (21 1/4 × 22 7/16 × 11 1/4 inches)

Centre Georges Pompidou, Musée national d'art moderne, Paris,
Gift, Mrs. Jacqueline Victor Brauner, 1974 AM 1974-27

189

Victor Brauner

The Lovers (Messengers of the Number)
(*Les Amoureux [Messagers du nombre]*), 1947
Oil on canvas
92 × 73 cm (36¼ × 28¾ inches)

Centre Georges Pompidou, Musée national d'art moderne, Paris,
Bequest, Mrs. Jacqueline Victor Brauner, 1987 AM 1987-1204

190
Victor Brauner
The Surrealist (*Le Surréaliste*), January 1947
Oil on canvas
60 × 45 cm (23 ⅝ × 17 ¾ inches)

Peggy Guggenheim Collection, Venice 76.2553 PGIII

ALBERTO GIACOMETTI
AND ANTONIN ARTAUD

Before Peggy Guggenheim fled Paris in fear of the
approaching Nazis, her goal was to buy an artwork
a day. One of the works she purchased at this time
was Alberto Giacometti's *Woman with Her Throat Cut*
(*Femme égorgée*, 1932 [cast 1940], cat. no. 195), a
cast of which also belongs to the Musée national
d'art moderne, as does a preparatory drawing for
the sculpture. Other similar works from the two
collections include Giacometti's *Nose* (*Le Nez*, 1947,
cat. nos. 196–97), the plaster-cast version of which
is in Paris and the bronze in New York.

Before the war, both Giacometti and Antonin
Artaud—a writer, director, actor, and artist—had
been affiliated with the Surrealist group for periods
of time. Yet each subsequently broke with the group.
Giacometti's portraits, often of members of his family,
show his concern with rendering figures in space,
their images appearing isolated in the network of
lines. Artaud's drawing was more personally thera-
peutic than aesthetic; his figures emerge out of
scumbled markings and hang suspended in space.
Both artists' works speak to the postwar condition
in Europe, evoking a sense of alienation and the
need to rebuild that which has been lost.

Alberto Giacometti in his studio, rue Hippolyte
Madron, Paris, ca. 1946.

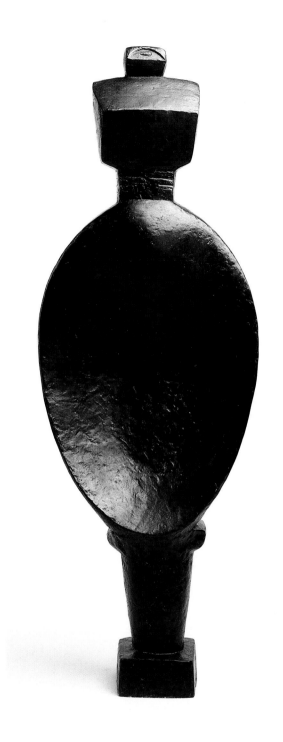

191
Alberto Giacometti
Spoon Woman (Femme-cuiller), 1926
Bronze
143.8 × 51.4 × 21.6 cm (56 ⅝ × 20 ¼ × 8 ½ inches)

Solomon R. Guggenheim Museum, New York 55.1414

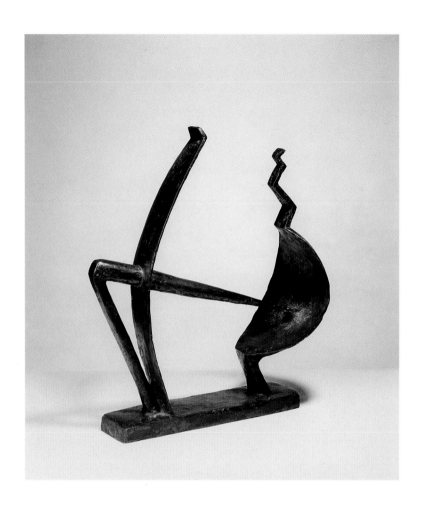

192
Alberto Giacometti
Man and Woman (Homme et femme), 1928–29
Bronze
40 × 40 × 16.5 cm (15 ¾ × 15 ¾ × 6 ½ inches)

Centre Georges Pompidou, Musée national d'art moderne, Paris,
Remittance in lieu of inheritance taxes to the government of France,
1984 AM 1984-355

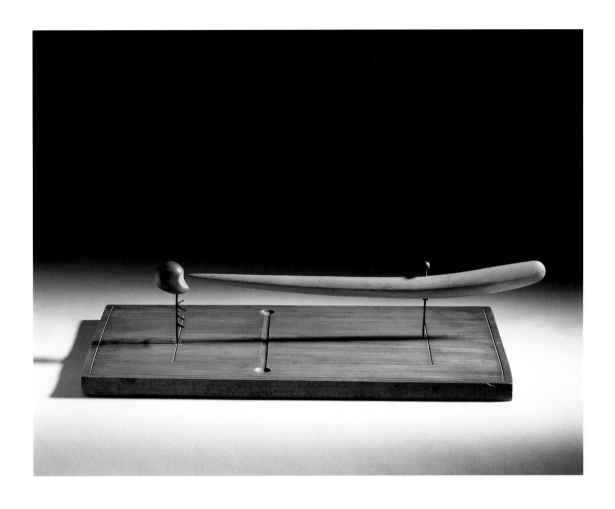

193
Alberto Giacometti
Point to the Eye (*La Pointe à l'oeil*), 1932
Wood and iron
12.5 × 53.2 × 29.5 cm (4 ¹⁵/₁₆ × 20 ¹⁵/₁₆ × 11 ⁵/₈ inches)

Centre Georges Pompidou, Musée national d'art moderne, Paris,
Purchased 1981 AM 1981-251

194
Alberto Giacometti
Women with Their Throats Cut (Femmes égorgées), 1932
Pencil and ink on cardboard
33.4 × 22 cm (13 ⅛ × 8 ¹¹⁄₁₆ inches)

Centre Georges Pompidou, Musée national d'art moderne, Paris,
Purchased 1975 AM 1975-92

195
Alberto Giacometti
Woman with Her Throat Cut (Femme égorgée), 1932 (cast 1940)
Bronze
23.2 × 57 × 89 cm (9 1/8 × 22 1/2 × 35 1/16 inches)

Peggy Guggenheim Collection, Venice 76.2553 PG131

196
Alberto Giacometti
Nose (*Le Nez*), 1947
Painted plaster, synthetic cord, and iron
81.5 × 66 × 36.7 cm (32 1/16 × 26 × 14 7/16 inches)

Centre Georges Pompidou, Musée national d'art moderne, Paris,
Gift, Aimé Maeght and his children, 1992 AM 1992-358

197
Alberto Giacometti
Nose (*Le Nez*), 1947
Bronze, wire, rope, and steel
Cage: 81 × 39.1 × 48.3 cm (31⁷⁄₈ × 15³⁄₈ × 19 inches);
head: 43.2 × 8.1 × 69.2 cm (17 × 3³⁄₁₆ × 27¹⁄₄ inches)

Solomon R. Guggenheim Museum, New York 66.1807

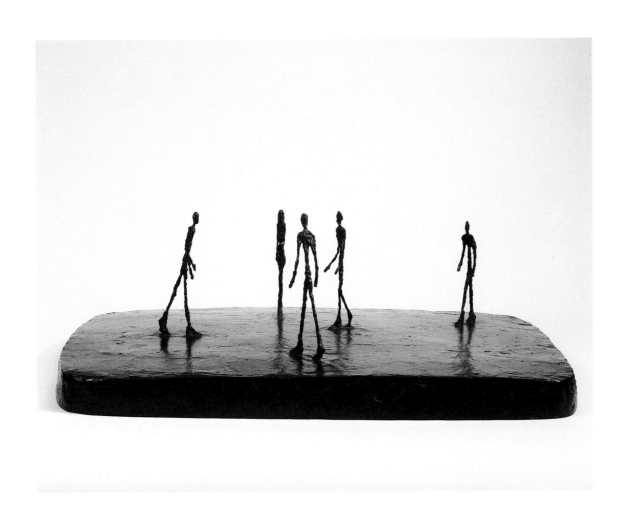

198
Alberto Giacometti
Piazza, 1947–48 (cast 1948–49)
Bronze
21 × 62.5 × 42.8 cm (8¹⁄₄ × 24⁵⁄₈ × 16⁷⁄₈ inches)

Peggy Guggenheim Collection, Venice 76.2553 PG135

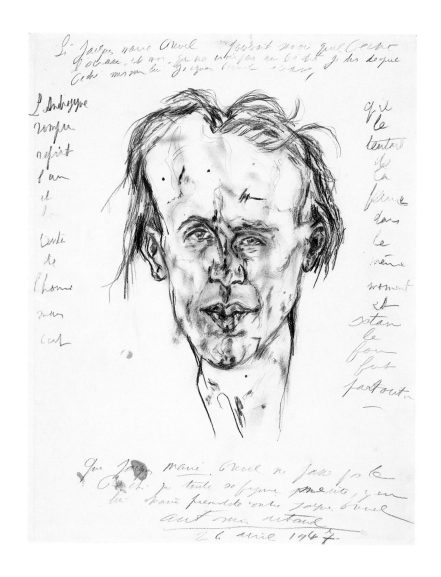

199
Antonin Artaud
Portrait of Jacques Marie Prevel (Portrait de Jacques Marie Prevel), 1947
Pencil on paper
57.4 × 45.6 cm (22⅝ × 17¹⁵/₁₆ inches)

Centre Georges Pompidou, Musée national d'art moderne, Paris,
Purchased 1987 AM 1987-555

200
Antonin Artaud
Untitled, ca. 1948
Pencil on paper
64 × 49 cm (25 ³/₁₆ × 19 ⁵/₁₆ inches)

Centre Georges Pompidou, Musée national d'art moderne, Paris,
Bequest, Paule Thévenin, 1993 AM 1994-135

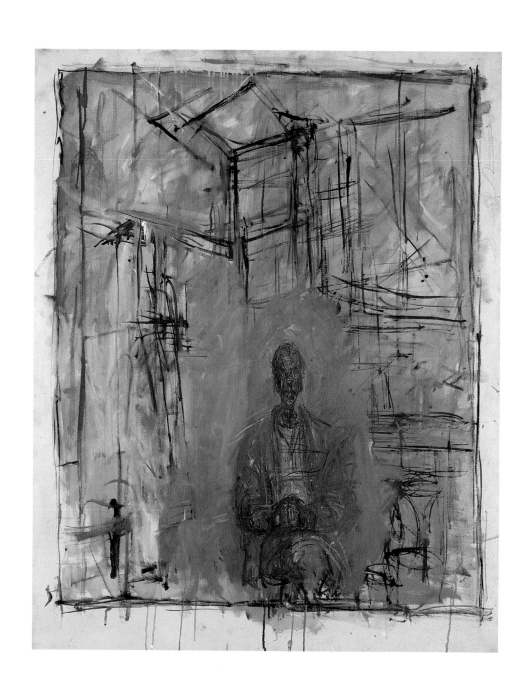

201

Alberto Giacometti

Diego, 1953
Oil on canvas
100.5 × 80.5 cm (39½ × 31¾ inches)

Solomon R. Guggenheim Museum, New York 55.1431

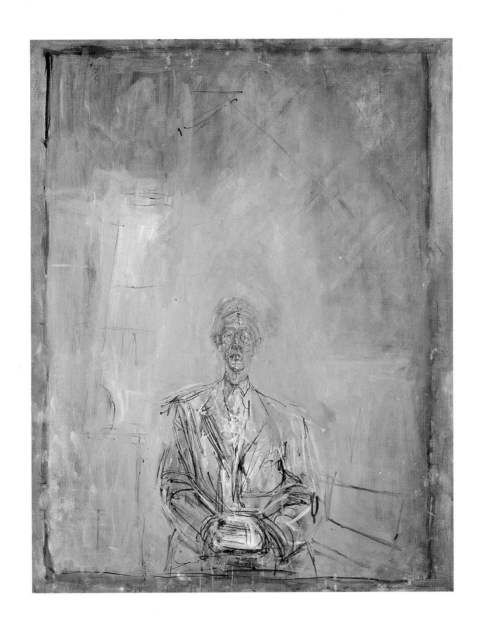

202

Alberto Giacometti

Portrait of Isaku Yanaihara (*Portrait d'Isaku Yanaihara*), 1956
Oil on canvas
80.7 × 64.8 cm (31¾ × 25½ inches)

Centre Georges Pompidou, Musée national d'art moderne, Paris,
Purchased by the French State in 1965, allocated 1970 AM 4573 P

JOSEPH CORNELL

In the early 1930s, the American Joseph Cornell met European Surrealist writers and artists and became familiar with their work through the Julien Levy Gallery in New York. Cornell focused on collage and filmmaking, but he is best known for the reliquaries in which he placed various ordinary objects in sometimes bizarre arrangements. He used the reliquaries to explore motifs including the pharmacy, the aviary, the celestial, and the terrestrial. His work was eventually exhibited alongside the European Surrealists, whom he admired, and his mixed-medium box constructions were influential to many assemblage artists working after World War II.

Joseph Cornell in his garden, Utopia Parkway, Flushing, New York, 1969.

203
Joseph Cornell
Untitled (Pharmacy), ca. 1942
Box construction
35.5 × 30.6 × 11.1 cm (14 × 12 1/16 × 4 3/8 inches)

Peggy Guggenheim Collection, Venice 76.253 PG128

204
Joseph Cornell
Fortune Telling Parrot (Parrot Music Box), ca. 1937–38
Box construction
40.8 × 22.2 × 17 cm (16 1/8 × 8 3/4 × 6 3/4 inches)

Peggy Guggenheim Collection, Venice 76.2553 PG126

205
Joseph Cornell
Owl Box, 1945–46
Box construction
63.5 × 36 × 16 cm (25 × 14 3/16 × 6 5/16 inches)

Centre Georges Pompidou, Musée national d'art moderne, Paris,
Gift, François de Menil in memory of Jean de Menil, 1977
AM 1977-211

206
Joseph Cornell
Soap Bubble Set, 1948–49
Box construction
26 × 38 × 8 cm (10 1/4 × 14 15/16 × 3 1/8 inches)

Centre Georges Pompidou, Musée national d'art moderne, Paris,
Purchased by the French State in 1971, allocated 1976 AM 1976-941

207
Joseph Cornell
Space Object Box: "Little Bear, etc." motif, mid 1950s–early 1960s
Box construction
28 × 44.5 × 13.3 cm (11 × 17½ × 5¼ inches)

Solomon R. Guggenheim Museum, New York 68.1878

JOAN MIRÓ AND ALEXANDER CALDER

Catalan painter Joan Miró and American sculptor Alexander Calder met in Paris in 1928 and became lifelong friends. Although Calder embraced the abstract and Miró the surreal, their friendship proved influential: a few years after their meeting, Calder's forms became more biomorphic, like those in Miró's paintings, and in the 1940s both artists made series entitled *Constellations* (see cat. nos. 218–19).

Calder's work was collected by both institutions even though it did not neatly fit the mission of either. Hilla Rebay disdained the purchase of sculpture for the Museum of Non-Objective Painting, but she and Solomon R. Guggenheim were nevertheless fond of Calder's work, which she eventually purchased for the museum. In 1950, Calder's sculptures became the first American works to enter the Musée national d'art moderne—a logical distinction, given that he divided his time between the United States and France and exhibited his work frequently in Paris.

Although Peggy Guggenheim was a strong supporter of Surrealism and had acquired Miró's *Painting* (*Peinture*, 1925, cat. no. 211), Rebay rejected the artist's work for Solomon R. Guggenheim's collection. Miró's *Personage* (*Personnage*, summer 1925, cat. no. 210) entered the collection only through the 1948 purchase of Karl Nierendorf's estate. Under the subsequent direction of James Johnson Sweeney, the Guggenheim's collection was enriched with Surrealist work.

It was not until the 1970s that the Musée national d'art moderne began to collect Miró's work in depth. In the 1980s, through a gift from the American-based Menil Foundation and an increased budget, the museum acquired Miró's *Blue* series (*Bleu I–III*, March 1961, cat. nos. 221–23), some of the most impressive works of his late career.

Alexander Calder and Joan Miró.

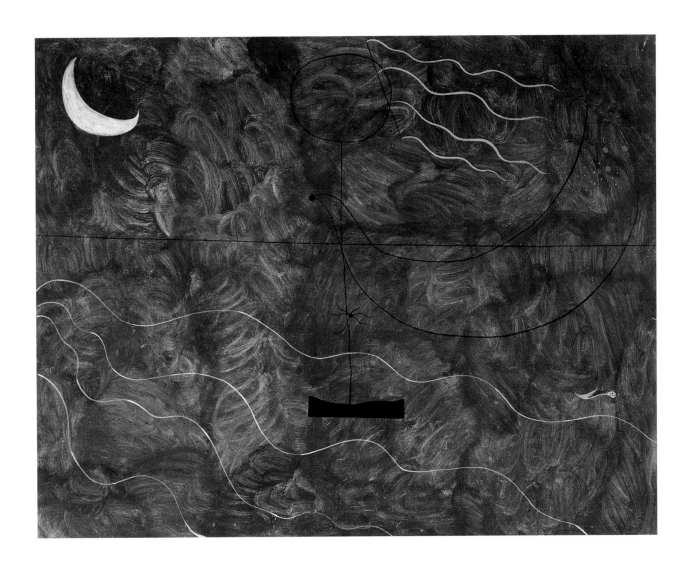

208
Joan Miró
Bather (Baigneuse), winter 1924
Oil on canvas
72.5 × 92 cm (28⁹/₁₆ × 36¹/₄ inches)

Centre Georges Pompidou, Musée national d'art moderne, Paris,
Gift, Louise and Michel Leiris, 1984 AM 1984-618

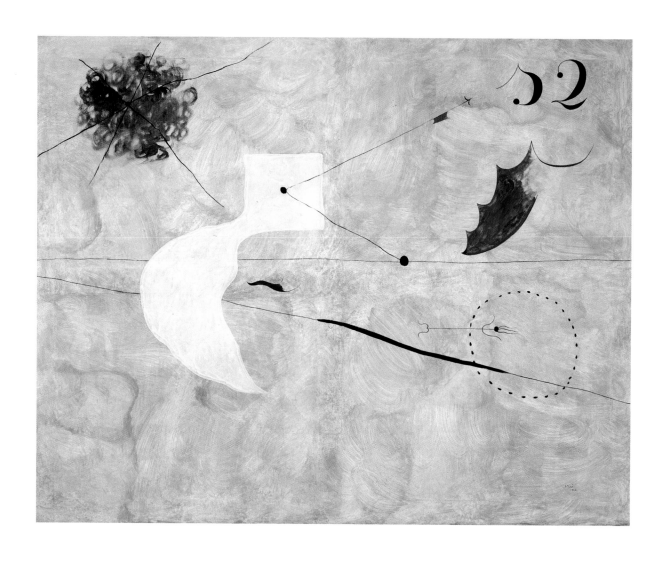

209
Joan Miró
The Siesta (*La Sieste*), 1925
Oil on canvas
113 × 146 cm (44 1/2 × 57 1/2 inches)

Centre Georges Pompidou, Musée national d'art moderne, Paris,
Purchased 1977 AM 1977-203

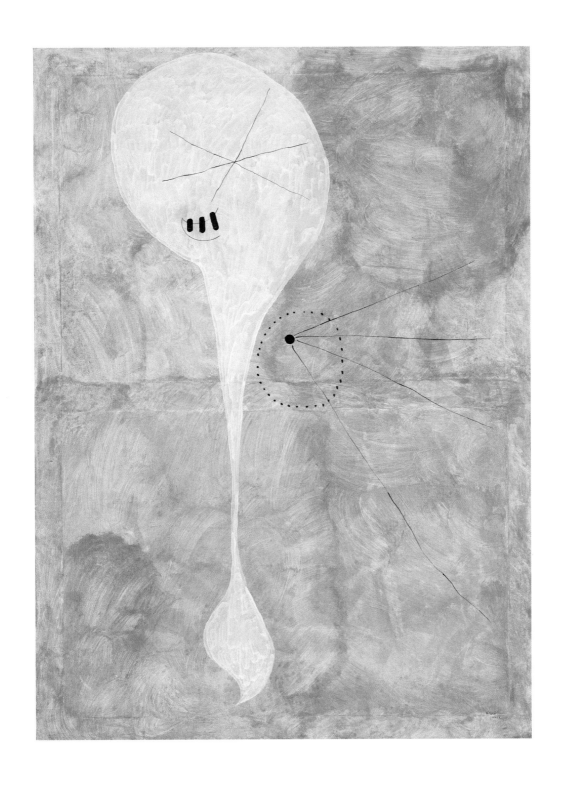

210
Joan Miró

Personage (*Personnage*), summer 1925
Oil and egg tempera (?) on canvas
130 × 96.2 cm (51¼ × 37⅞ inches)

Solomon R. Guggenheim Museum, New York 48.1172x504

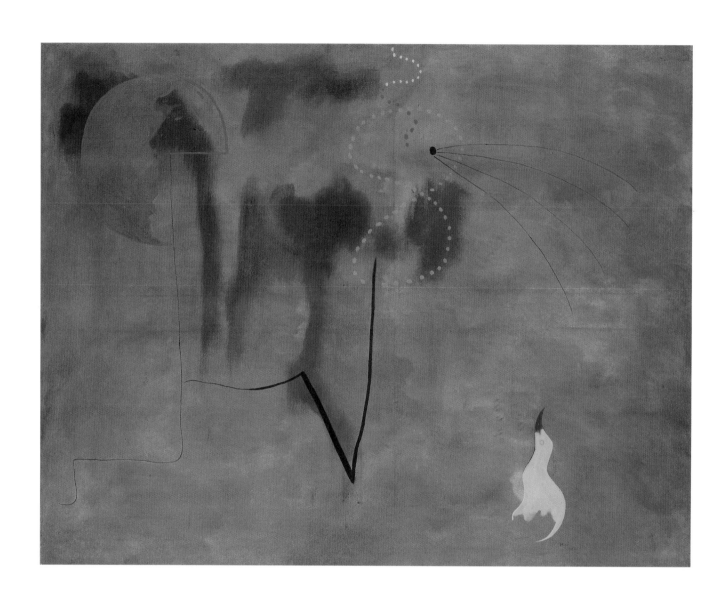

211
Joan Miró
Painting (Peinture), 1925
Oil on canvas
114.5 × 145.7 cm (45⅛ × 57⅜ inches)

Peggy Guggenheim Collection, Venice 76.2553 PG91

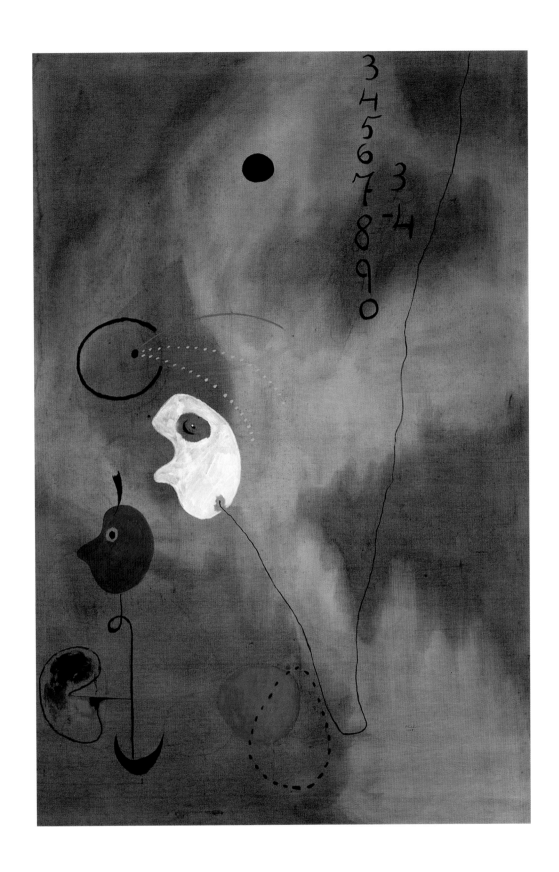

212
Joan Miró
The Check (*L'Addition*), 1925
Oil on canvas
195 × 129.2 cm (76 ¾ × 50 ⅞ inches)

Centre Georges Pompidou, Musée national d'art moderne, Paris,
Purchased 1983 AM 1983-92

213
Joan Miró
Object of Sunset (*L'Objet du couchant*), summer 1935–March 1936
Painted carob wood, metal bedspring, gas burner,
twine, metal chain, and metal link
68 × 44 × 26 cm (26 ¾ × 17 ⁵⁄₁₆ × 10 ¼ inches)

Centre Georges Pompidou, Musée national d'art moderne, Paris,
Purchased 1975 AM 1975-56

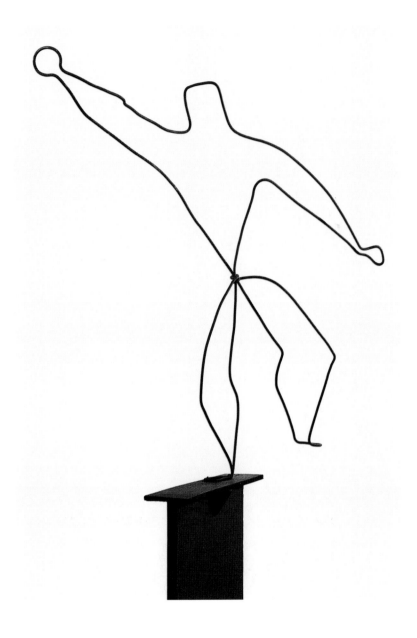

214
Alexander Calder
Shot-Putter (Le Lanceur de poids), 1929
Iron wire
82 × 73 × 13.3 cm (32 5/16 × 28 3/4 × 5 1/4 inches);
on detachable iron base

Centre Georges Pompidou, Musée national d'art moderne, Paris,
Gift of the artist, 1966 AM 1515 S

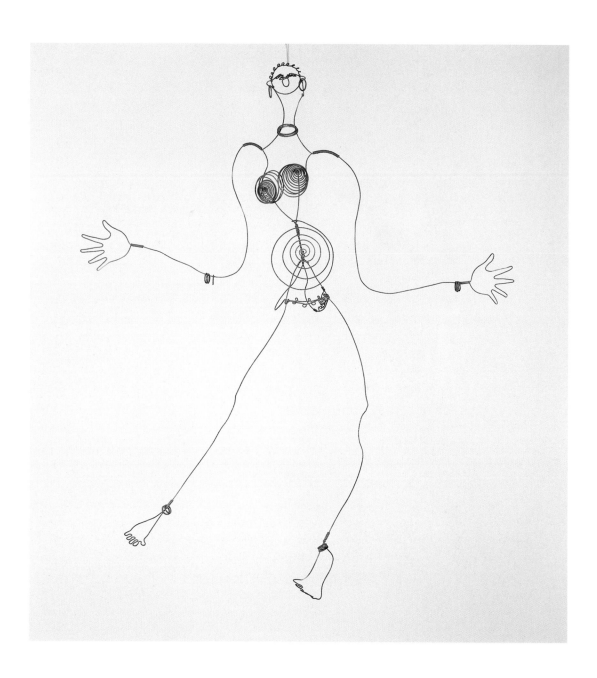

215
Alexander Calder
Josephine Baker I, 1926
Iron wire
101 × 95 × 25 cm (39 3/4 × 37 3/8 × 9 7/8 inches)

Centre Georges Pompidou, Musée national d'art moderne, Paris,
Gift of the artist, 1966 AM 1518 s

216
Alexander Calder
Spring (*Printemps*), 1928
Wire and wood
240 × 91.4 × 49.5 cm (94 1/2 × 36 × 19 1/2 inches)

Solomon R. Guggenheim Museum, New York,
Gift of the artist 65.1739

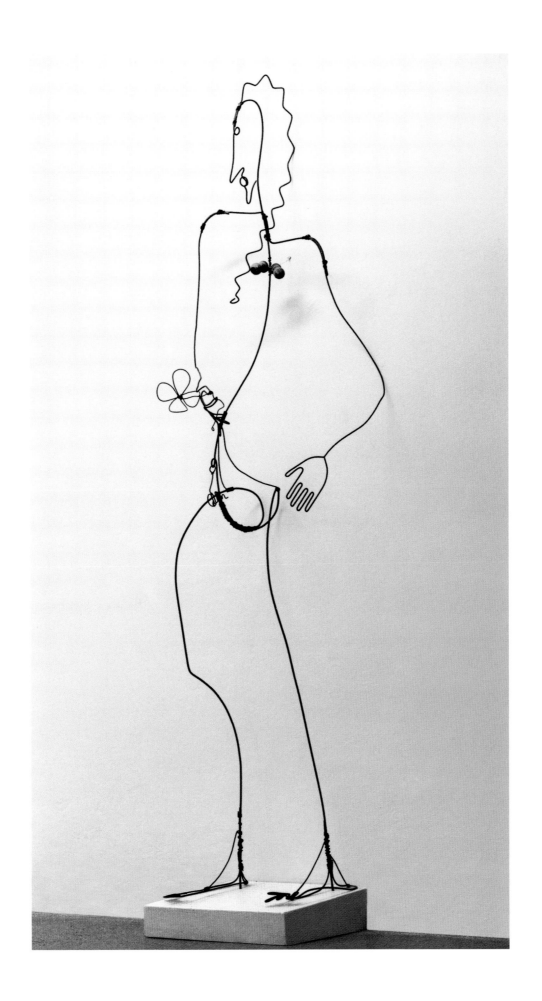

217
Alexander Calder
Shark and Whale (Requin et baleine), 1933
Various woods
86.5 × 102 × 16 cm (34 $^1/_{16}$ × 40 $^3/_{16}$ × 6 $^5/_{16}$ inches)

Centre Georges Pompidou, Musée national d'art moderne, Paris,
Remittance in lieu of inheritance taxes to the government of France,
1983 AM 1983-54

218
Alexander Calder
Constellation, 1943
Wood and metal rods
55.9 × 113 × 35.6 cm (22 × 44½ × 14 inches)

Solomon R. Guggenheim Museum, New York,
Collection of Mary Reynolds, Gift of her brother 54.1393

219
Alexander Calder
Constellation, 1943
Painted wood and metal rods
61 × 72 × 53 cm (24 × 28 3/8 × 20 7/8 inches)

Centre Georges Pompidou, Musée national d'art moderne, Paris,
Gift of the artist, 1966 AM 1530 s

220

Alexander Calder

Red Lily Pads (*Nénuphars rouges*), 1956
Painted sheet metal, metal rods, and wire
1.1 × 5.1 × 2.8 m (3 feet 6 inches × 16 feet 9 inches × 9 feet 1 inch)

Solomon R. Guggenheim Museum, New York 65.1737

221
Joan Miró
Blue I (Bleu I), March 1961
Oil on canvas
2.7 × 3.6 m (8 feet 10 5/16 inches × 11 feet 7 3/4 inches)

Centre Georges Pompidou, Musée national d'art moderne, Paris,
Purchased with the assistance of the Fonds du patrimoine, the
support of numerous subscribers, and the generous aid of Sylvie and
Eric Boissonnas, Jacques Boissonnas, Hélène and Michel David-Weill,
and the Société des amis du Musée national d'art moderne, Paris,
in 1993 AM 1993-119

222
Joan Miró
Blue II (Bleu II), March 1961
Oil on canvas
2.7 × 3.6 m (8 feet 10 5/16 inches × 11 feet 7 3/4 inches)

Centre Georges Pompidou, Musée national d'art moderne, Paris,
Gift, the Menil Foundation in memory of Jean de Menil, 1984
AM 1984-357

223
Joan Miró
Blue III (Bleu III), March 1961
Oil on canvas
2.7 × 3.5 m (8 feet 9 ½ inches × 11 feet 5 ⅜ inches)

Centre Georges Pompidou, Musée national d'art moderne, Paris,
Purchased 1988 AM 1988-569

FROM AUTOMATISM TO
ABSTRACT EXPRESSIONISM

With the onset of World War II, many Surrealists
fled Paris and moved to the United States and Latin
America; André Masson and Matta settled in New
York and Wifredo Lam returned to his native Cuba.
These three artists and other Surrealists had a
tremendous impact on the New York art scene,
contributing significantly to the development of
American art.

Arshile Gorky, an Armenian-born artist who had
been living in the United States since 1920, became
friends with André Breton during Breton's New York
exile and fell under the influence of Masson and
Matta. Gorky's style of painting serves as the
link between European Surrealism and American
Abstract Expressionism. Its biomorphic, curvilinear
shapes, based on nature and memory, recall the for-
mer while the strong interconnecting line among
these forms—which create an allover composition
free from complete representation—anticipate
the latter.

Peggy Guggenheim was the first to appreciate
the most well-known Abstract Expressionist,
Jackson Pollock, and gave him his first solo exhibi-
tion at Art of This Century, her gallery in New York,
in 1943. Among the following works, the Musée
national d'art moderne and the Peggy Guggenheim
Collection each owns paintings from the same
series: *The Moon Woman* (1942, cat. no. 225) and
The Moon Woman Cuts the Circle (ca. 1943,
cat. no. 226).

Peggy Guggenheim and Jackson Pollock
in front of Pollock's *Mural* (December 1943),
which she commissioned for her New York
apartment, 1943.

224
André Masson
Pythia (La Pythie), 1943
Oil and tempera on canvas
130.5 × 106.5 cm (51 ³/₈ × 41 ¹⁵/₁₆ inches)

Centre Georges Pompidou, Musée national d'art moderne, Paris,
Purchased 1981 AM 1981-21

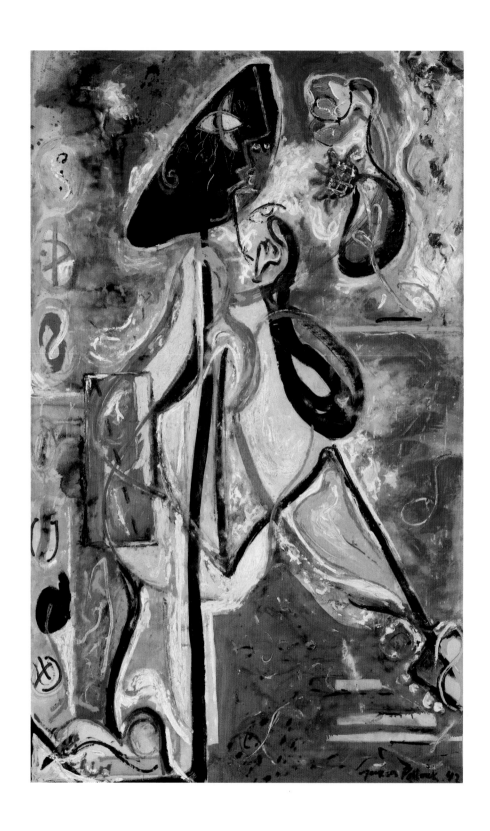

225
Jackson Pollock
The Moon Woman, 1942
Oil on canvas
175.2 × 109.3 cm (69 × 43 1/16 inches)

Peggy Guggenheim Collection, Venice 76.2553 PG141

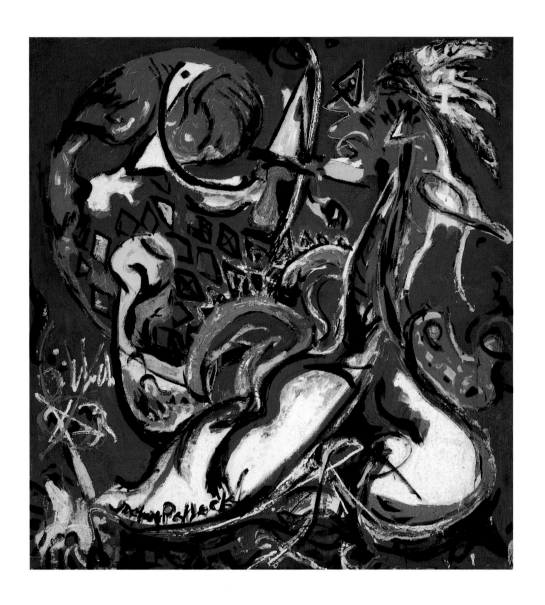

226
Jackson Pollock
The Moon Woman Cuts the Circle, ca. 1943
Oil on canvas
109.5 × 104 cm (47 1/8 × 40 15/16 inches)

Centre Georges Pompidou, Musée national d'art moderne, Paris,
Gift, Frank K. Lloyd, 1979 AM 1980-66

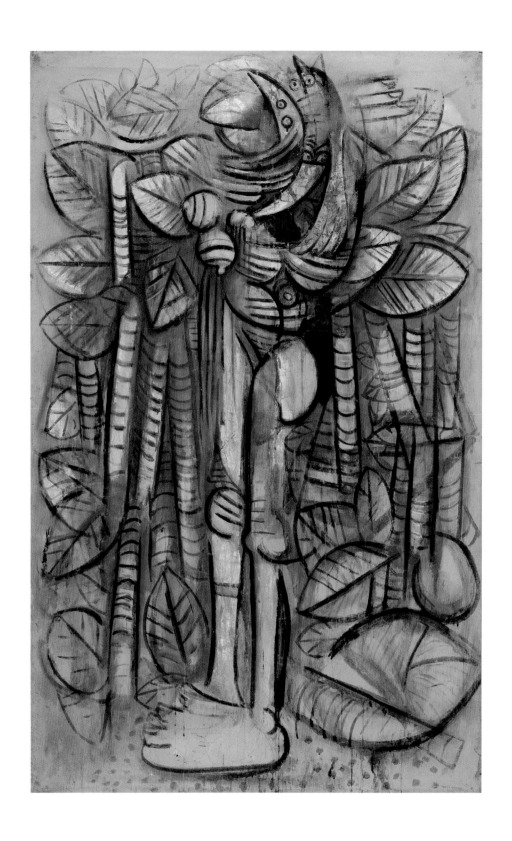

227
Wifredo Lam
Light in the Forest (Lumière dans la forêt), 1942
Gouache on paper, mounted on canvas
192 × 123.5 cm (75 ⁹/₁₆ × 48 ⁵/₈ inches)

Centre Georges Pompidou, Musée national d'art moderne, Paris,
Purchased by the French State from the artist in 1974, allocated 1974
AM 1974-23

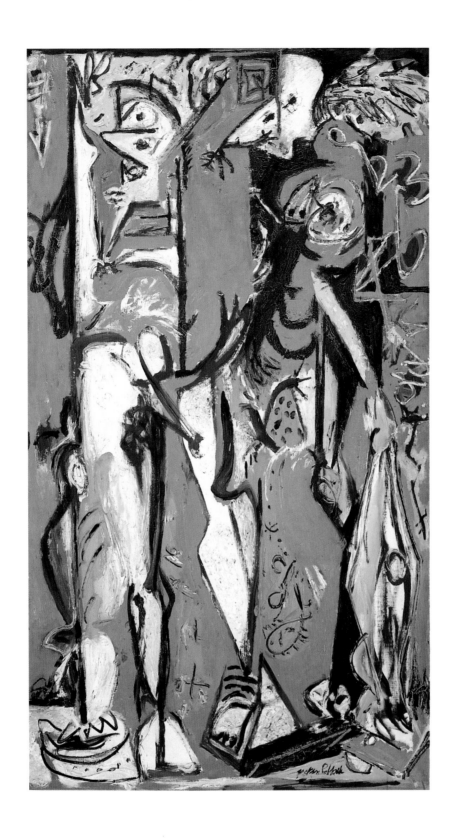

228
Jackson Pollock
Two, 1943–45
Oil on canvas
193 × 110 cm (76 × 43 5/16 inches)

Peggy Guggenheim Collection, Venice 76.2553 PG143

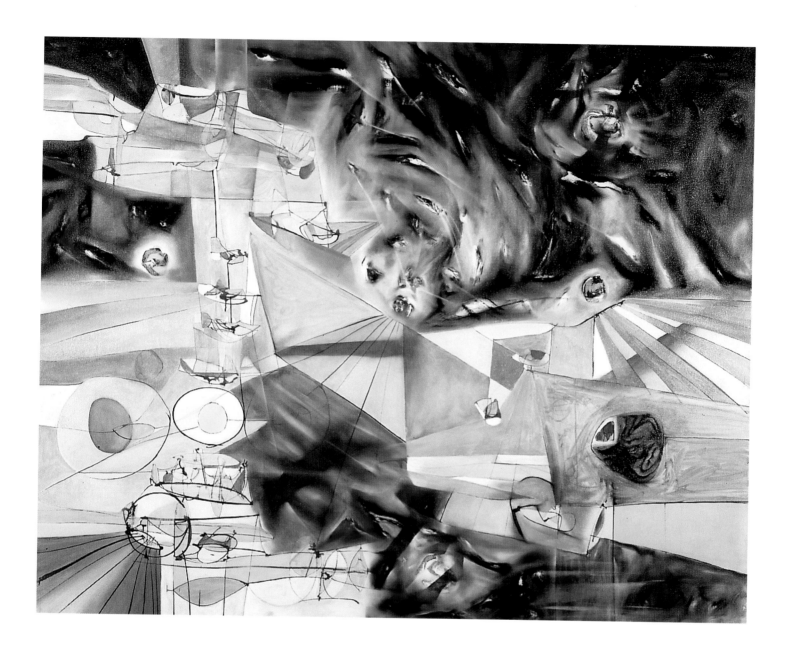

229
Roberto Matta
Years of Fear, 1941
Oil on canvas
111.8 × 142.2 cm (44 × 56 inches)

Solomon R. Guggenheim Museum, New York 72.1991

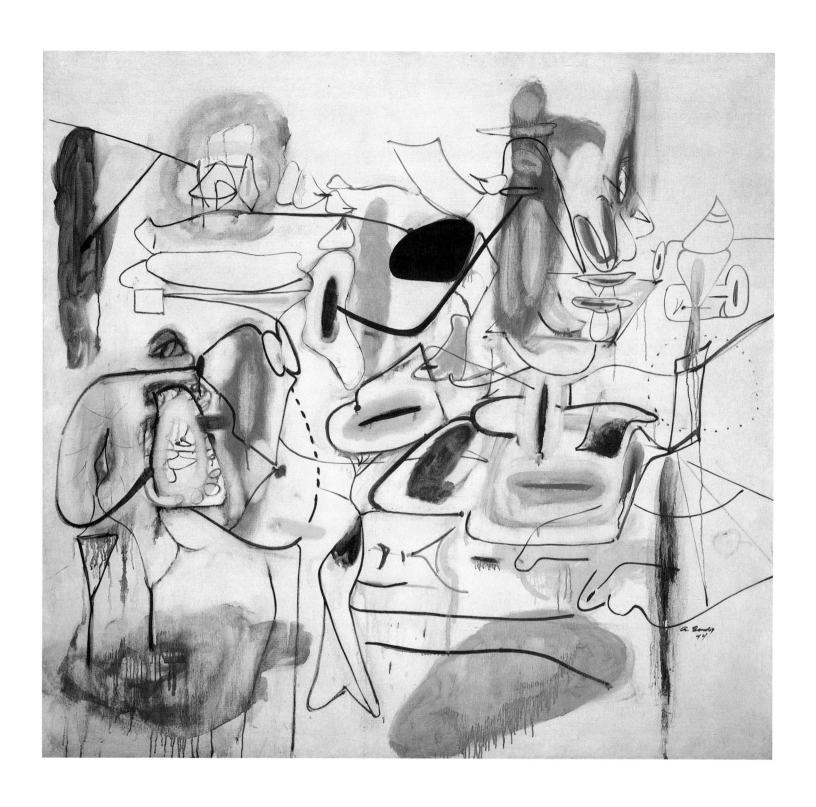

230
Arshile Gorky
Untitled, summer 1944
Oil on canvas
167 × 178.2 cm (65 ¾ × 70 ³/₁₆ inches)

Peggy Guggenheim Collection, Venice 76.2553 PG152

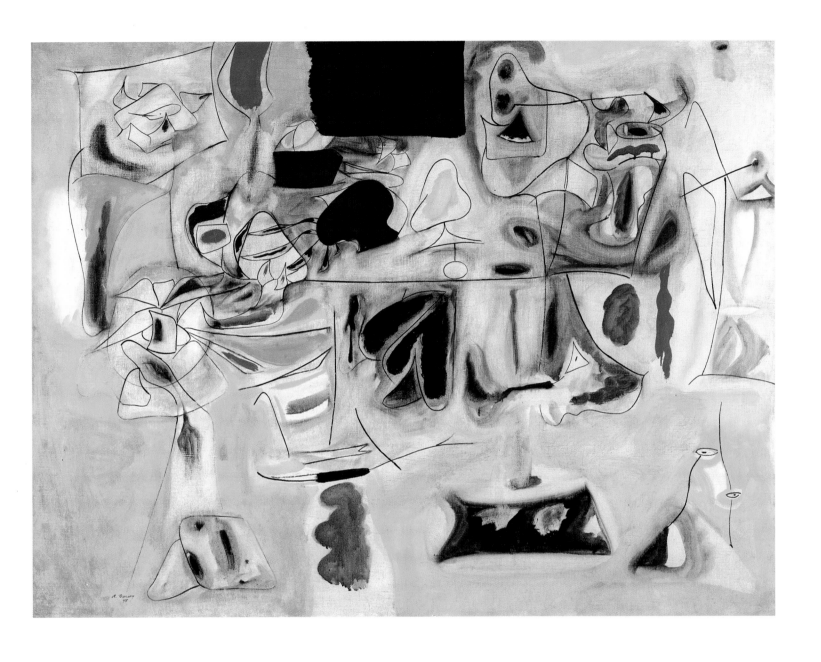

231
Arshile Gorky
Landscape-Table, 1945
Oil on canvas
92 × 121 cm (36 1/4 × 47 5/8 inches)

Centre Georges Pompidou, Musée national d'art moderne, Paris,
Purchased 1971 AM 1971-151

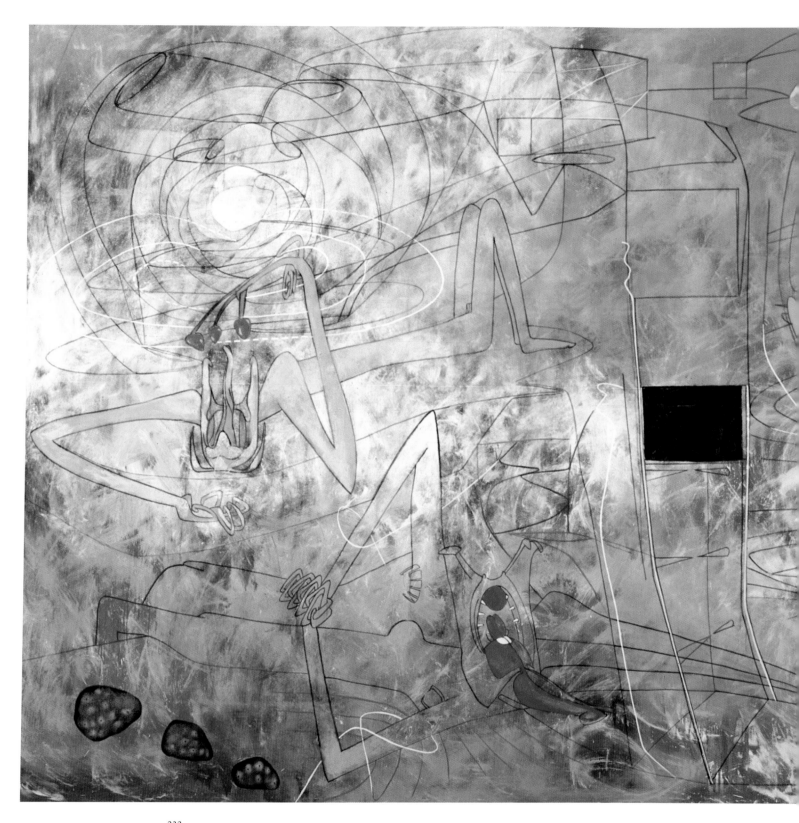

232
Roberto Matta
Xpace and the Ego, 1945
Oil on canvas
2 × 4.6 m (6 feet 7 1/4 inches × 14 feet 11 15/16 inches)

Centre Georges Pompidou, Musée national d'art moderne, Paris,
Purchased 1983 AM 1983-94

233
André Masson
Entanglement (*Enchevêtrement*), 1941
Distempered paint and gouache on cardboard
41 × 33 cm (16 1/8 × 13 inches)

Centre Georges Pompidou, Musée national d'art moderne, Paris,
Gift, Mrs. Rose Masson, 1982 AM 1982-194

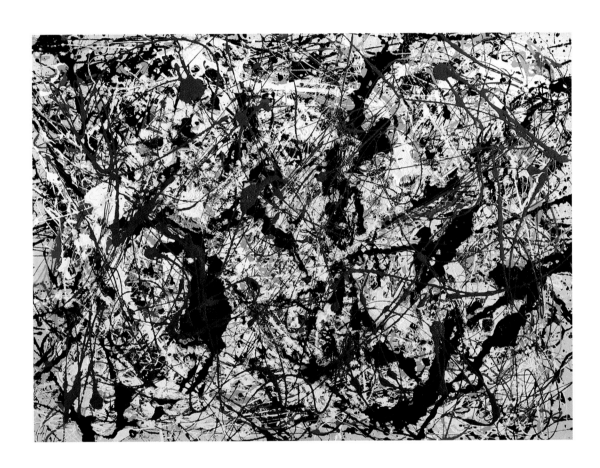

234
Jackson Pollock
Enchanted Forest, 1947
Oil on canvas
221.3 × 114.6 cm (87 1/8 × 45 1/8 inches)

Peggy Guggenheim Collection, Venice 76.2553 PG151

235
Jackson Pollock
Painting, 1948
Enamel on paper, mounted on canvas
61 × 80 cm (24 × 31 1/2 inches)

Centre Georges Pompidou, Musée national d'art moderne, Paris,
Purchased 1972 AM 1972-29

236
Jackson Pollock
The Deep, 1953
Oil and enamel on canvas
220.4 × 150.2 cm (86 ¾ × 59 ⅛ inches)

Centre Georges Pompidou, Musée national d'art moderne, Paris,
Gift, In memory of Jean de Menil by his children and
the Menil Foundation, 1975 AM 1976-1230

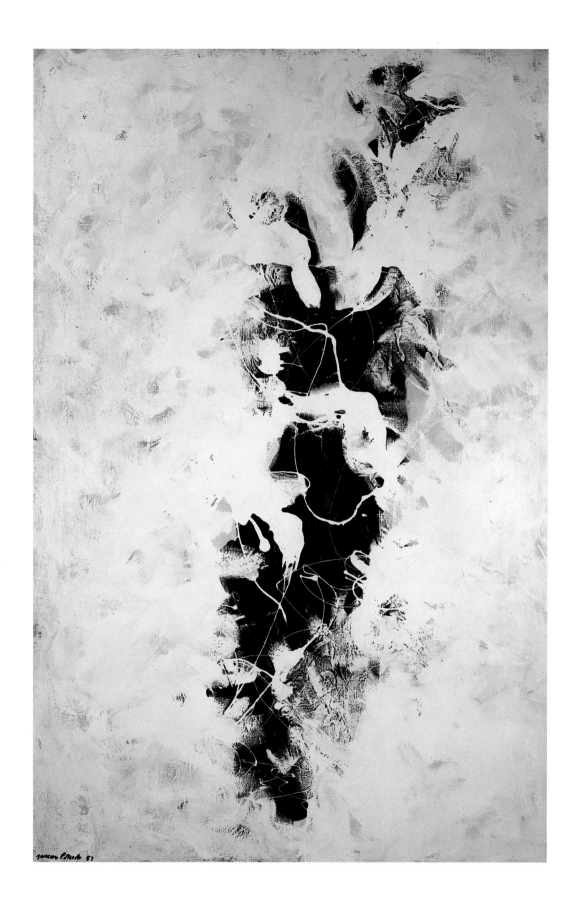

433

HENRI MICHAUX

In his drawings and writings, Henri Michaux sought to free himself from his conscious mind. To this end he experimented with hallucinogenic drugs such as mescaline and recorded his reactions. He also worked with great speed and agility, bringing himself into the hypnotic, trancelike state evinced by his work.

In 1978, the Musée national d'art moderne organized an exhibition of Michaux's work, which traveled in part to the Solomon R. Guggenheim Museum. Through a significant gift from art dealer Daniel Cordier, the Musée national d'art moderne received several drawings by Michaux (see cat. nos. 237, 239–240, 242), as well as other works. Five years after the artist's death in 1984, the Guggenheim received substantial gifts from the Henri Michaux Estate, which also gave works to the Musée national d'art moderne.

Henri Michaux

237
Henri Michaux
Prince of the Night (*Le Prince de la nuit*), 1937
Gouache on paper
32.3 × 24.5 cm (12 ¹¹/₁₆ × 9 ⅝ inches)

Centre Georges Pompidou, Musée national d'art moderne, Paris,
Gift, Daniel Cordier, 1976 AM 1976-1171

238
Henri Michaux
Untitled, 1965
Watercolor on paper
38.1 × 28.6 cm (15 × 11¼ inches)

Solomon R. Guggenheim Museum, New York 65.1775

239
Henri Michaux
Untitled, 1949
Gouache and watercolor on paper
38.7 × 54 cm (15¼ × 21¼ inches)

Centre Georges Pompidou, Musée national d'art moderne, Paris,
Gift, Daniel Cordier, 1976 AM 1976-1177

240
Henri Michaux
Mescaline Drawing (Dessin mescalinien), 1958–59
Red chalk on paper
40.3 × 30 cm (15 7/8 × 11 13/16 inches)

Centre Georges Pompidou, Musée national d'art moderne, Paris,
Gift, Daniel Cordier, 1976 AM 1976-1181

241
Henri Michaux
Mescaline Drawing (*Dessin mescalinien*), 1958
India ink on wove paper
26.4 × 17.9 cm (10 ³⁄₈ × 7 ¹⁄₁₆ inches)

Solomon R Guggenheim Museum, New York, By exchange 85.3288

242
Henri Michaux
Untitled, 1959
India ink on paper
74 × 105 cm (29⅛ × 41⁵⁄₁₆ inches)

Centre Georges Pompidou, Musée national d'art moderne, Paris,
Gift, Daniel Cordier, 1976 AM 1976-1184

243
Henri Michaux
Untitled, 1970?
Ink and acrylic on paper
37.7 × 53.8 cm (14 7/8 × 21 3/16 inches)

Solomon R. Guggenheim Museum, New York,
Gift, Henri Michaux Estate 89.3644

DUCHAMP AND PICABIA
LATER WORK

The Guggenheim owns only one late work by Marcel Duchamp, a standard version of his famous *Box in a Valise* (*Boîte-en-valise*, 1941/1961, cat. no. 250), which serves as a summary or retrospective of the artist's career until 1941. Inside this work are miniature replicas and reproductions of his early works, including *The Chess Players* (*Les Joueurs d'échecs*, December 1911, cat. no. 147) and the first study for *The Bride Stripped Bare by the Bachelors* (*La Mariée mise à nu par les célibataires*, 1912, cat. no. 148) from the Musée national d'art moderne. Favoring the pre–World War I, Cubist-based work by Duchamp and Francis Picabia, the Musée national d'art moderne's acquisition of their postwar works did not begin until long after the artists' deaths.

Picabia's postwar painting embraces abstract geometric patterns with hints of representational imagery, as in his *Widow* (*Veuve*, 1948, cat. no. 244). Duchamp's work from this period is represented by two erotic plaster casts, a relief self-portrait, and two assemblages that mock the traditional still life in sculpture form.

Marcel Duchamp playing chess with Eve Babitz at the exhibition *By or of Marcel Duchamp or Rrose Sélavy*, the Pasadena Art Museum, 1963.

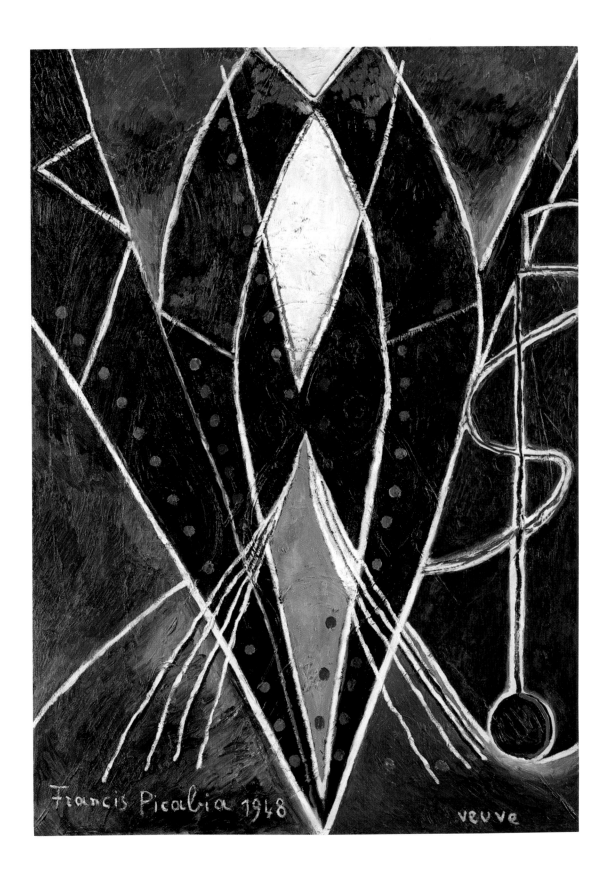

244
Francis Picabia
Widow (Veuve), 1948
Oil on wood
153.2 × 116 cm (60 5/16 × 45 11/16 inches)

Centre Georges Pompidou, Musée national d'art moderne, Paris,
Gift, Mrs. Olga Picabia, 1986 AM 1986-170

245
Marcel Duchamp
Not a Shoe, 1950
Galvanized plaster
7 × 5.1 × 2.5 cm (2¾ × 2 × 1 inches)

Centre Georges Pompidou, Musée national d'art moderne, Paris,
Purchased 1995 AM 1995-261

246
Marcel Duchamp
Female Fig Leaf (Feuille de vigne femelle), 1950–51
Painted plaster
8.5 × 13 × 11.5 cm (3 ³/₈ × 5 ¹/₈ × 4 ¹/₂ inches)

Centre Georges Pompidou, Musée national d'art moderne, Paris,
Purchased 1990 AM 1990-104(1)

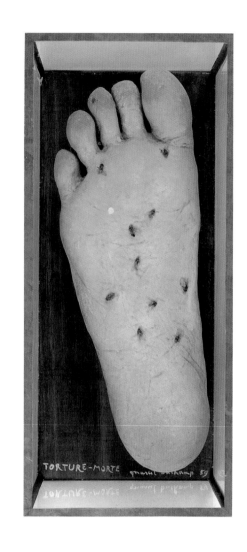

247
Marcel Duchamp

Still Torture (*Torture-morte*), summer 1959
Painted plaster, artificial houseflies, and paper,
mounted on wood, in a glass box
29.5 × 13.4 × 10.3 cm (11 5/8 × 5 1/4 × 4 1/16 inches)

Centre Georges Pompidou, Musée national d'art moderne, Paris,
Remittance in lieu of inheritance taxes to the government of France,
1993 AM 1993-122

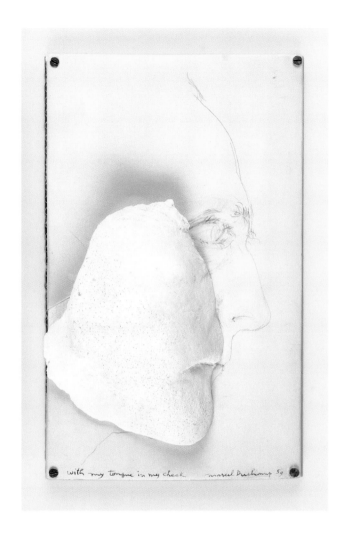

248
Marcel Duchamp
With My Tongue in My Cheek, summer 1959
Plaster and pencil on paper, mounted on wood
25 × 15 × 5.1 cm (9 ¹³⁄₁₆ × 5 ⁷⁄₈ × 2 inches)

Centre Georges Pompidou, Musée national d'art moderne, Paris,
Remittance in lieu of inheritance taxes to the government of France,
1993 AM 1993-123

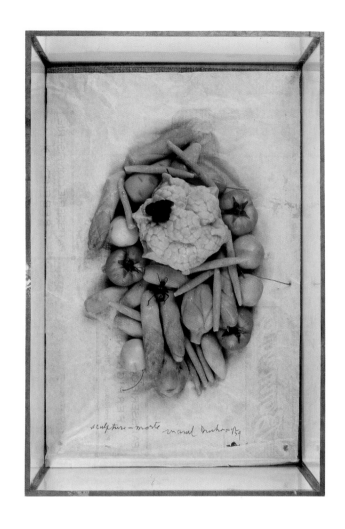

249
Marcel Duchamp

Still Sculpture (*Sculpture-morte*), summer 1959
Marzipan fruit and vegetables, insects, and paper,
mounted on wood, in a glass box
33.8 × 22.5 × 9.9 cm (13 5/16 × 8 7/8 × 3 7/8 inches)

Centre Georges Pompidou, Musée national d'art moderne, Paris,
Remittance in lieu of inheritance taxes to the government of France,
1993 AM 1993-121

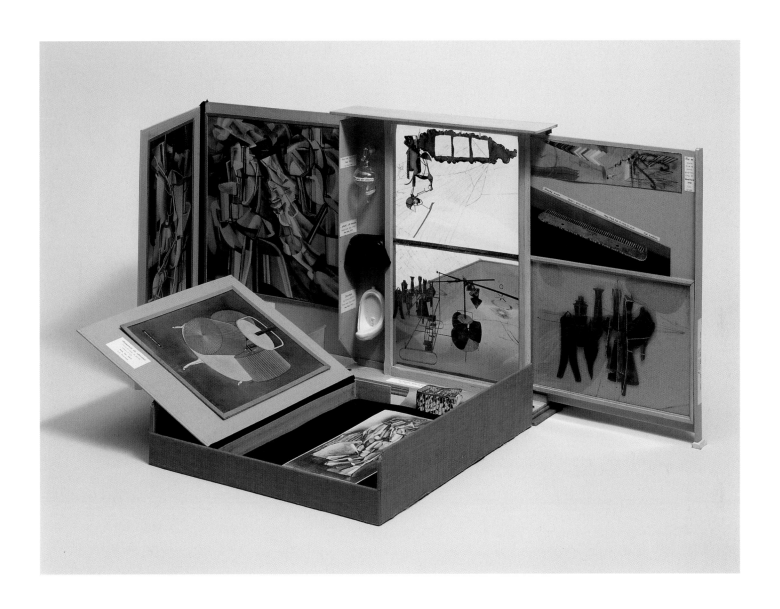

250
Marcel Duchamp
Box in a Valise (Boîte-en-valise), 1941/1961
Cloth-covered cardboard-and-wood box containing
miniature replicas and printed reproductions of works
by Duchamp, with paint and ink additions
Box closed: 40.6 × 35.5 × 9 cm (16 × 14 × 3½ inches)

Solomon R. Guggenheim Museum, New York 62.1623

POSTWAR FIGURATIVE PAINTING

The art that emerged in Europe directly after World War II spoke to the despair of the human condition. Karl Appel, Francis Bacon, Jean Dubuffet, Jean Fautrier, Asger Jorn, and Wols, who had all experienced the devastation caused by the war, drew upon such diverse sources as the art of children, the primitive, the prehistoric, the art of the insane, and folk art. The work of artist Georg Baselitz, which represents a later generation with its loose, gestural brushstroke, is a reinvestigation of his predecessors' techniques and a counterexample to the abstract art dominant in the 1960s.

Among these artists, Dubuffet enjoyed success in both Europe and the United States. Thomas Messer, director of the Guggenheim from 1961 to 1988, was responsible for the museum's many acquisitions of Dubuffet's paintings. The Musée national d'art moderne developed a rich collection of Dubuffet's work through allocations from the French state in the 1960s and its own purchases in the 1970s and 1980s. A 1991 *dation* brought to the museum *Pierre Matisse, portrait obscur* (August 1947, cat. no. 254), Dubuffet's depiction of his art dealer in the United States.

Jean Dubuffet in his studio, Paris, 1951.

251
Wols
Blue Pomegranate (*Grenade bleue*), 1946
Oil on canvas
46 × 33 cm (18⅛ × 13 inches)

Centre Georges Pompidou, Musée national d'art moderne, Paris,
Purchased 1971 AM 1971-4

252
Jean Fautrier
Femme douce, 1946
Spanish white, glue, pigment, and oil on canvas
97 × 145 cm (38 ³/₁₆ × 57 ¹/₁₆ inches)

Centre Georges Pompidou, Musée national d'art moderne, Paris,
Purchased 1982 AM 1982-12

253
Jean Fautrier
L'Ecorché, 1944
Oil on paper, mounted on canvas
80 × 115 cm (31 1/2 × 45 1/4 inches)

Centre Georges Pompidou, Musée national d'art moderne, Paris,
Remittance in lieu of inheritance taxes to the government of France,
1997 AM 1997-93

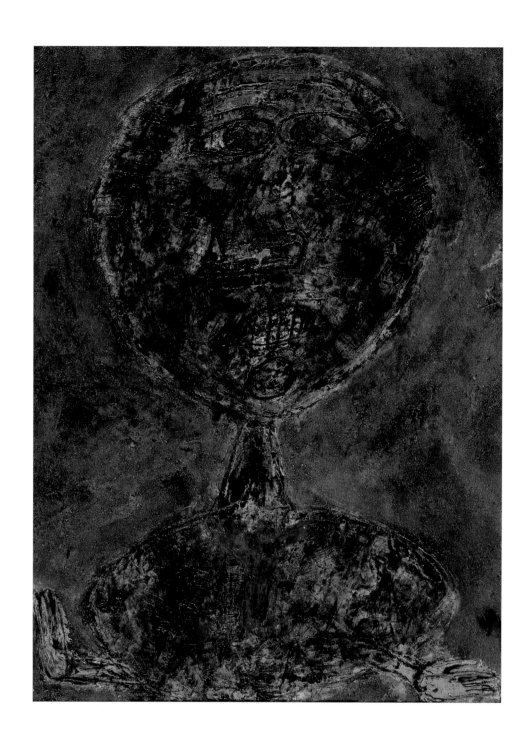

254
Jean Dubuffet
Pierre Matisse, portrait obscur, August 1947
Oil, sand, and gravel on canvas
130 × 97.3 cm (51³/₁₆ × 38⁵/₁₆ inches)

Centre Georges Pompidou, Musée national d'art moderne, Paris,
Remittance in lieu of inheritance taxes to the government of France,
1991 AM 1991-296

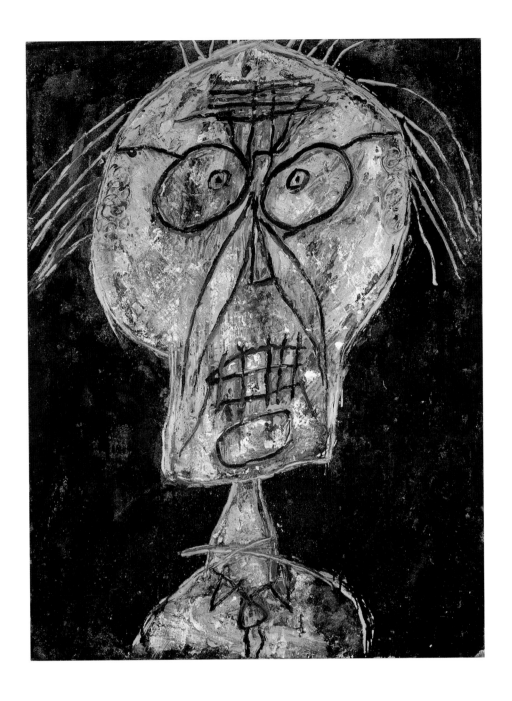

255
Jean Dubuffet
Dhôtel nuancé d'abricot, 1947
Oil on canvas
116 × 89 cm (45 11/16 × 35 1/16 inches)

Centre Georges Pompidou, Musée national d'art moderne, Paris,
Purchased with the assistance of the Scaler Foundation in 1981
AM 1981-501

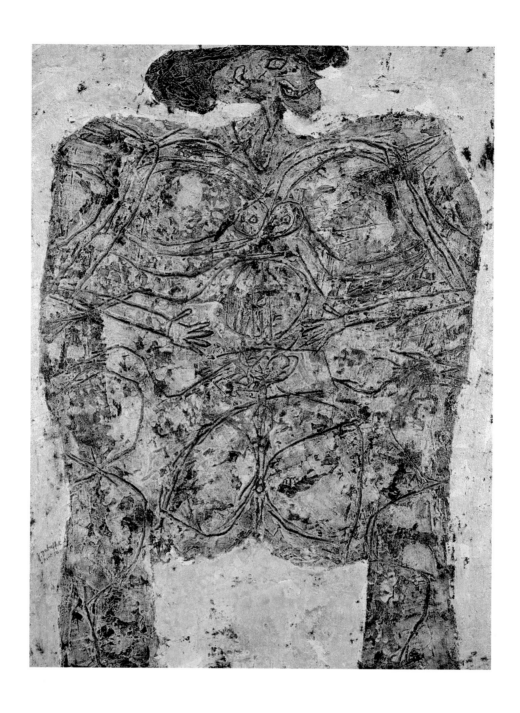

256
Jean Dubuffet
Le Métafisyx, 1950
Oil on canvas
116 × 89.5 cm (45 $^{11}/_{16}$ × 35 $^{1}/_{4}$ inches)

Centre Georges Pompidou, Musée national d'art moderne, Paris,
Purchased 1976 AM 1976-12

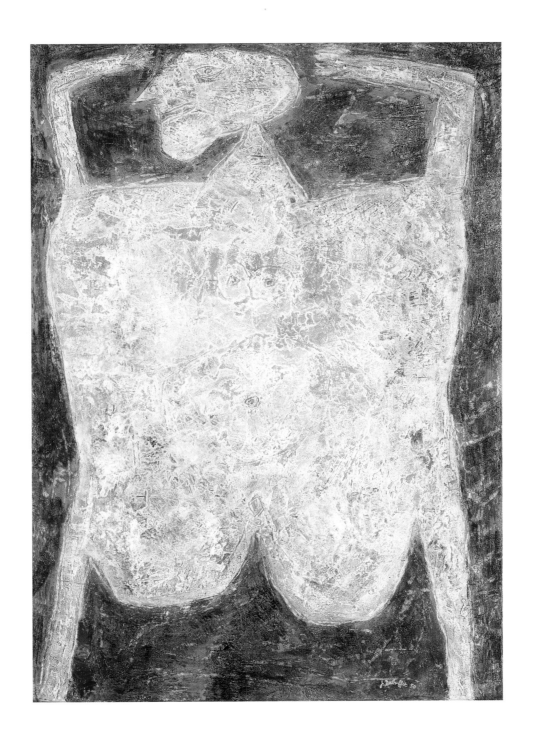

257
Jean Dubuffet
Triumph and Glory (Triomphe et gloire), December 1950
Oil on canvas
129.5 × 96.5 cm (51 × 38 inches)

Solomon R. Guggenheim Museum, New York 71.1973

258
Jean Dubuffet
The Traveler without a Compass, July 8, 1952
(*Le Voyageur sans boussole, 8 juillet 1952*), 1952
Oil on Masonite
118.5 × 155 cm (46 ⅝ × 61 inches)

Centre Georges Pompidou, Musée national d'art moderne, Paris,
Purchased 1976 AM 1976-11

259
Jean Dubuffet
Knoll of Visions (*La Butte aux visions*), August 23, 1952
Oil on Masonite
150 × 195 cm (59 × 76 ¾ inches)

Solomon R. Guggenheim Museum, New York 74.2077

260
Karel Appel
Questioning Children (Vragende Kinderen), 1948
Oil and wood on wood panel
85 × 56 cm (33 1/2 × 22 inches)

Centre Georges Pompidou, Musée national d'art moderne, Paris,
Purchased 1985 AM 1985-128

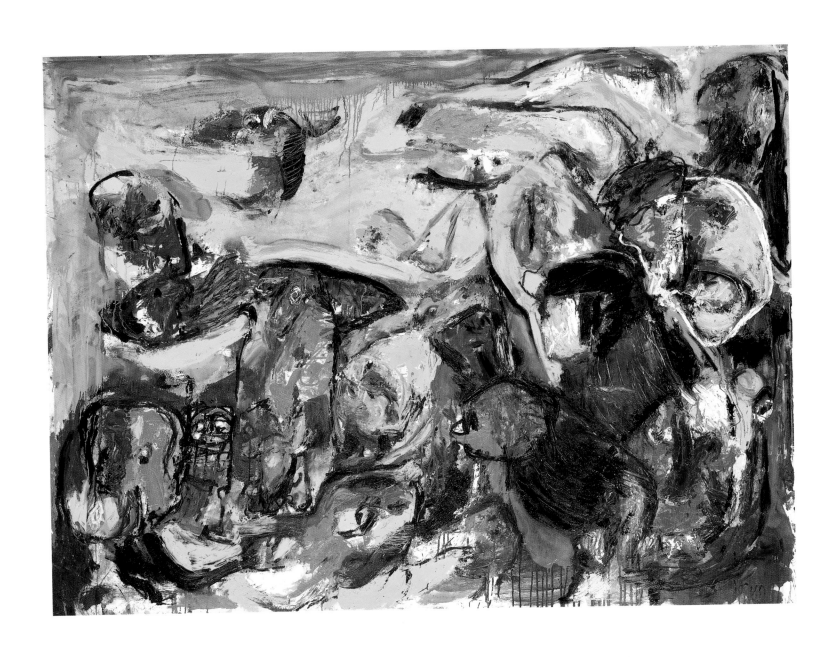

261
Asger Jorn
Green Ballet (Il balletto verde), 1960
Oil on canvas
145 × 200 cm (57⅛ × 78¾ inches)

Solomon R. Guggenheim Museum, New York 62.1608

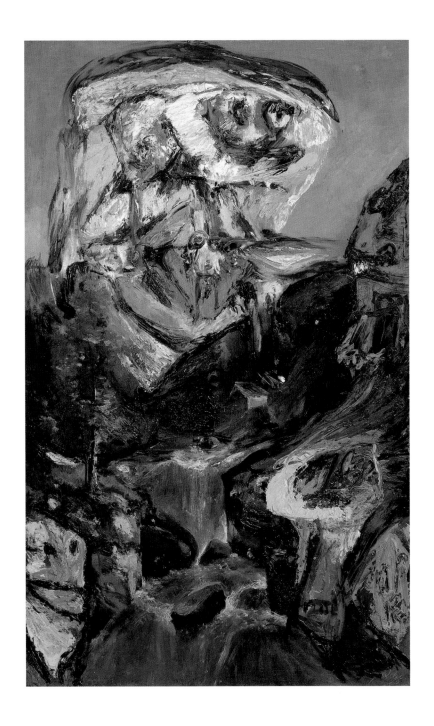

262
Asger Jorn
Lord of the Mountain Trolls (Dovre gubben), 1959
Oil on canvas
129 × 80 cm (50 ¹³/₁₆ × 31 ½ inches)

Centre Georges Pompidou, Musée national d'art moderne, Paris,
Purchased 1981 AM 1981-19

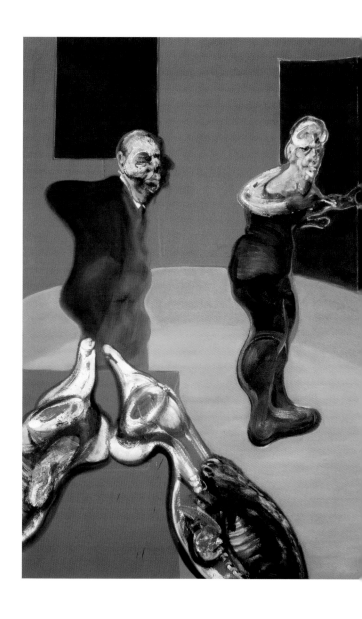

263
Francis Bacon
Three Studies for a Crucifixion, March 1962
Oil with sand on canvas
Three panels, 198.2 × 144.8 cm (78 × 57 inches) each

Solomon R. Guggenheim Museum, New York 64.1700.a-.c

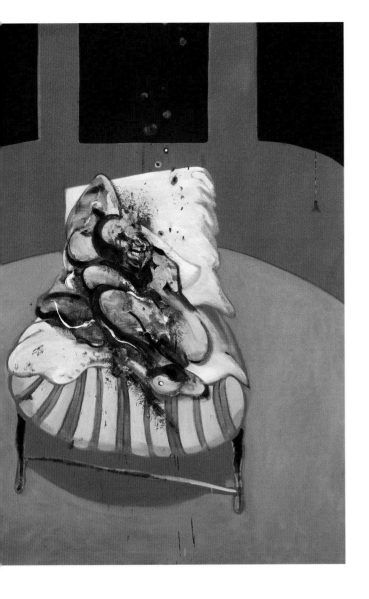

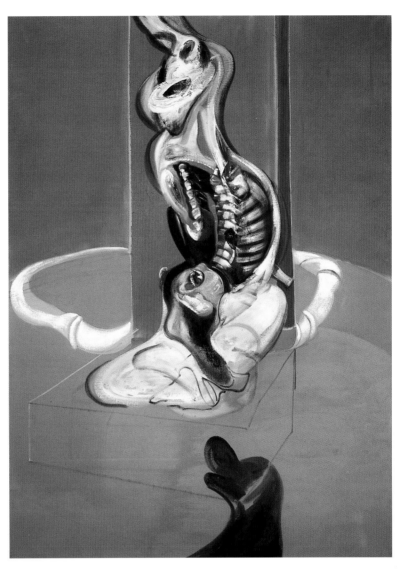

264
Georg Baselitz
Ralf III, 1965
Oil on canvas
100.5 × 80 cm (39 9/16 × 31 1/2 inches)

Centre Georges Pompidou, Musée national d'art moderne, Paris,
Purchased 1994 AM 1994-103

ABSTRACTION IN EUROPE
AND THE UNITED STATES

The term "Art Informel," coined by the French critic
Michel Tapié in 1952, refers to the tendency in
postwar European art to reject traditional forms of
composition and order in favor of a more gestural
and expressive kind of painting, embracing the anti-
naturalistic, the antigeometric, and the nonfigurative.
Tapié used the word *informe* (formless) to describe
this work, which broke with the prewar geometric-
based, cerebral art in Europe.

Abstract Expressionism, the American equiva-
lent of Art Informel, grew out of the influences of
European artists, particularly the Surrealists, living
in the United States during World War II. The term
"Abstract Expressionism," like Art Informel, repre-
sents an attitude more than a single style of art, and
within this broad category critics developed their own
preferences. Clement Greenberg was interested in
abstract painting for its celebration of its own inher-
ent properties—the two-dimensional support of the
canvas—whereas Harold Rosenberg was intrigued
by the dramatic gesturalism, which he saw as an
expression of the inner consciousness of the artist.

While on the surface Abstract Expressionist
and Art Informel artists appear to share common
concerns, their underlying motivations were often
quite different. Although Frenchman Pierre Soulages
and the American Franz Kline both painted in a
predominantly black and white palette, Soulages's
painting expresses a sense of solidity, monumentality,
and control, in contrast to the spontaneous, energetic,
dynamic gesture in Kline's work.

Left to right: Franz Kline, Howard Kanovitz,
and Willem de Kooning playing softball in East
Hampton, New York, at Wilfred Zogbaum's
house, summer 1954.

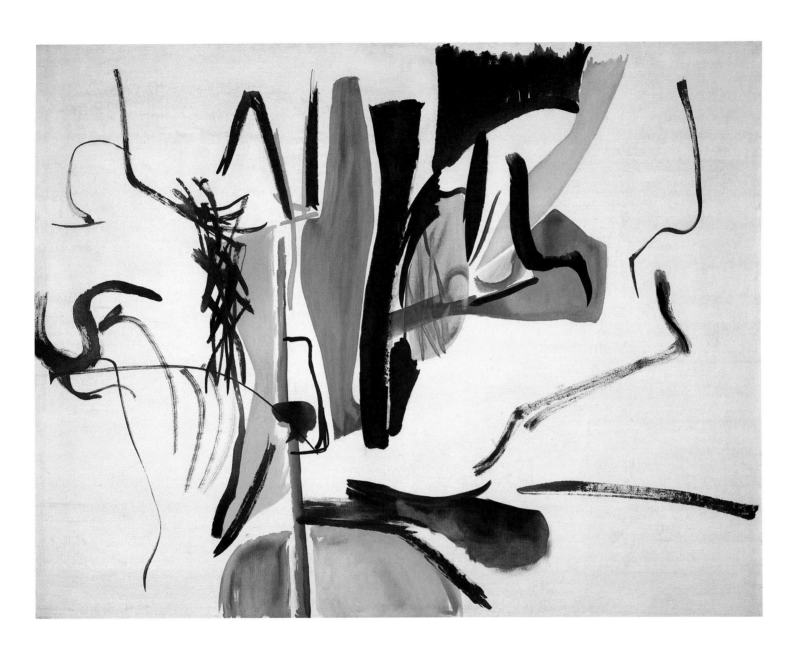

265
Hans Hartung
T. 1935-1, 1935
Oil on canvas
142 × 186 cm (55^{15}/$_{16}$ × 73^{1}/$_{4}$ inches)

Centre Georges Pompidou, Musée national d'art moderne, Paris,
Purchased 1976 AM 1977-2

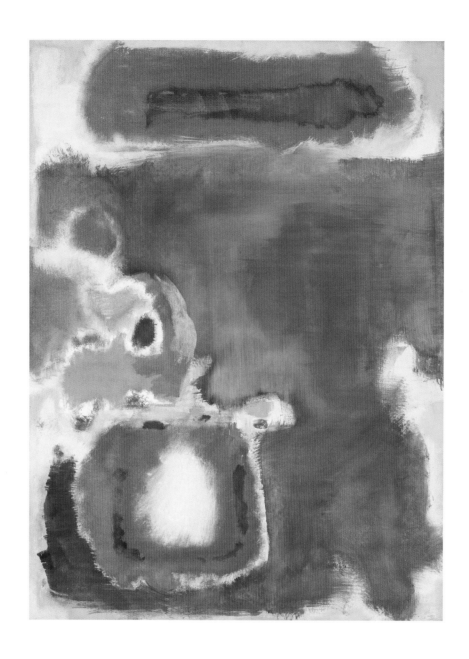

266
Mark Rothko
Number 17, 1947
Oil on canvas
121 × 90.1 cm (47⅝ × 35½ inches)

Solomon R. Guggenheim Museum, New York,
Gift, The Mark Rothko Foundation, Inc. 86.3420

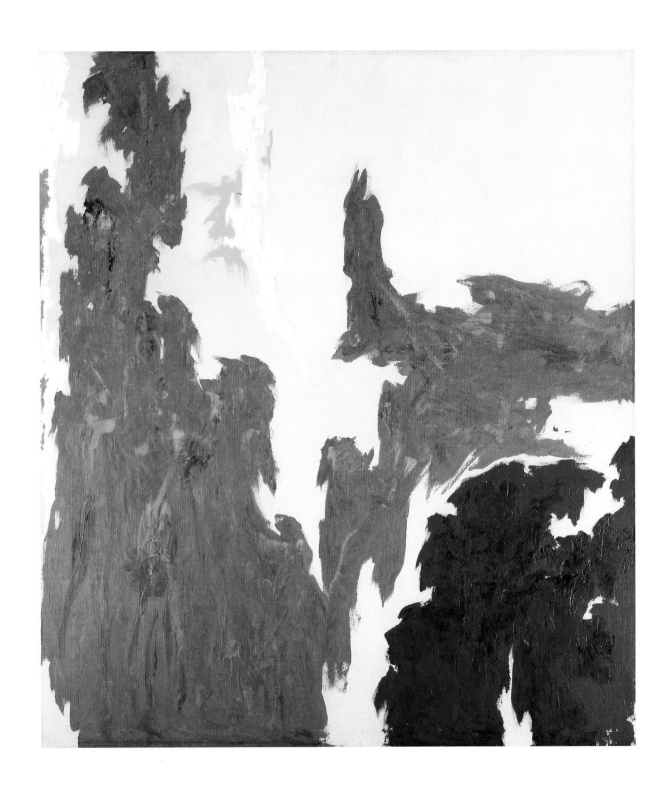

267
Clyfford Still
1948, 1948
Oil on canvas
175.3 × 155 cm (69 × 61 inches)

Solomon R. Guggenheim Museum, New York,
Fractional gift, Barbara and Donald Jonas 92.3986

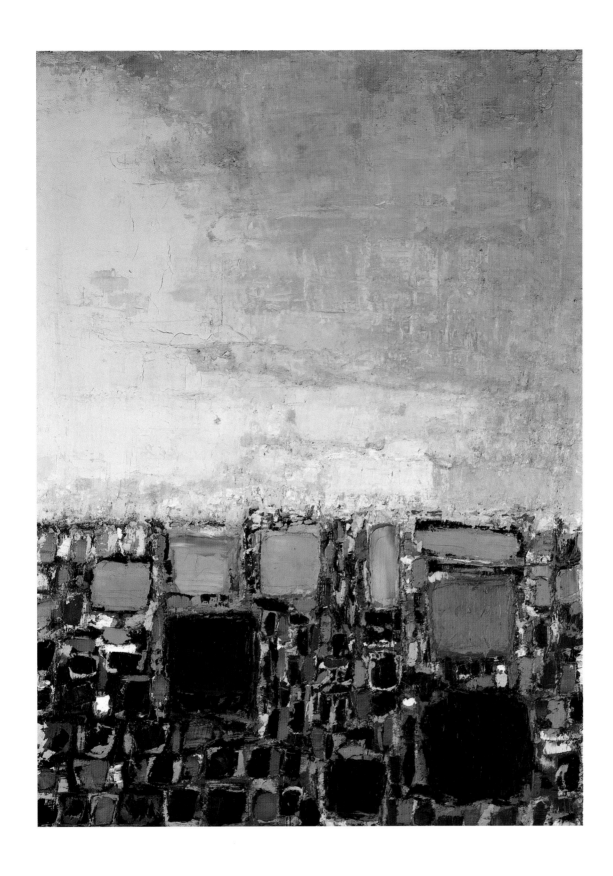

268
Nicolas de Staël
The Roofs (Les Toits), 1952
Oil on Masonite
200 × 150 cm (78 ³/₄ × 59 ¹/₁₆ inches)

Centre Georges Pompidou, Musée national d'art moderne, Paris,
Gift of the artist to the French State in 1952, allocated 1952 AM 3159 P

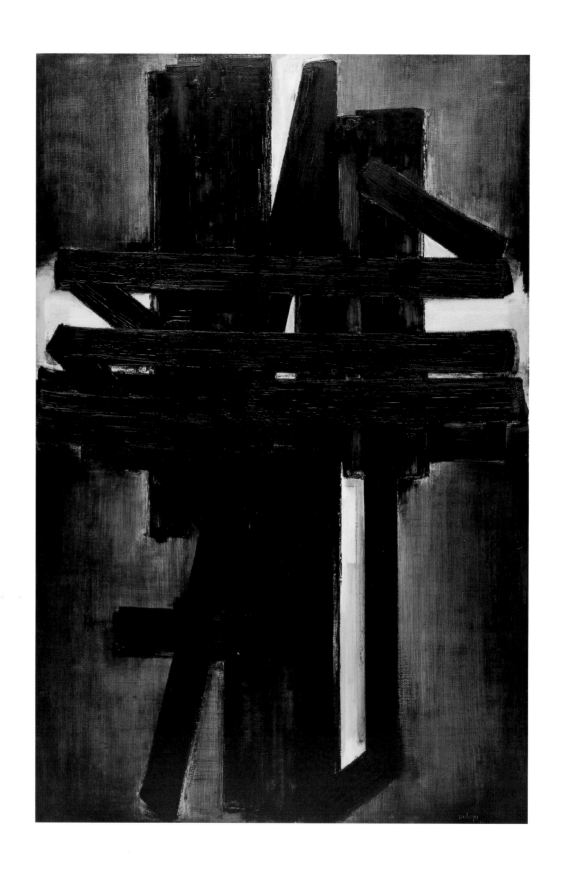

269
Pierre Soulages
Painting, 195 × 130 cm, May 1953
(*Peinture, 195 × 130 cm, mai 1953*), May 1953
Oil on canvas
196.5 × 129.9 cm (77 3/8 × 51 1/8 inches)

Solomon R. Guggenheim Museum, New York 53.1381

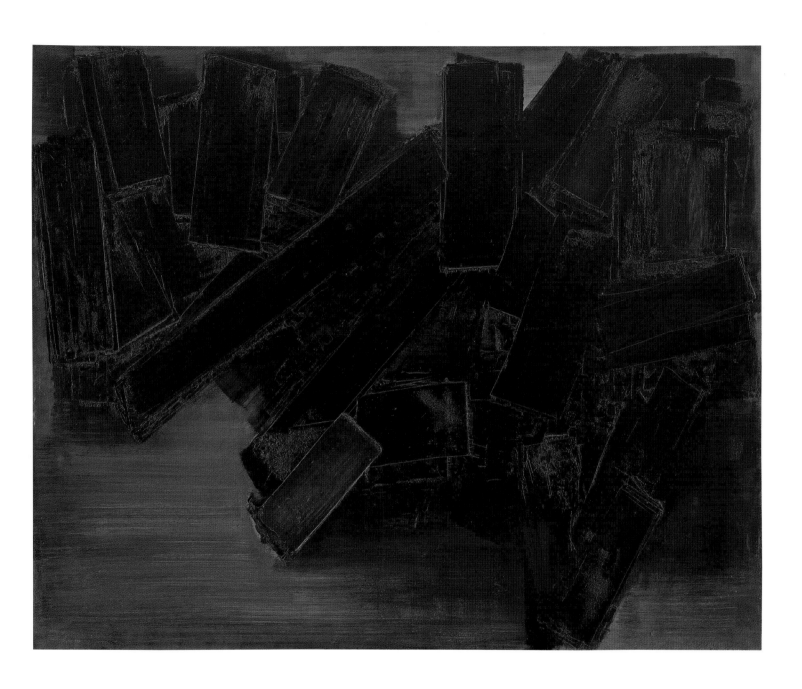

270
Pierre Soulages
Painting, 131 × 162 cm, August 14, 1956
(*Peinture, 131 × 162 cm, 14 août 1956*), 1956
Oil on canvas
131 × 162 cm (51 9/16 × 63 3/4 inches)

Centre Georges Pompidou, Musée national d'art moderne, Paris,
Purchased by the French State in 1961, allocated 1961 AM 3937 P

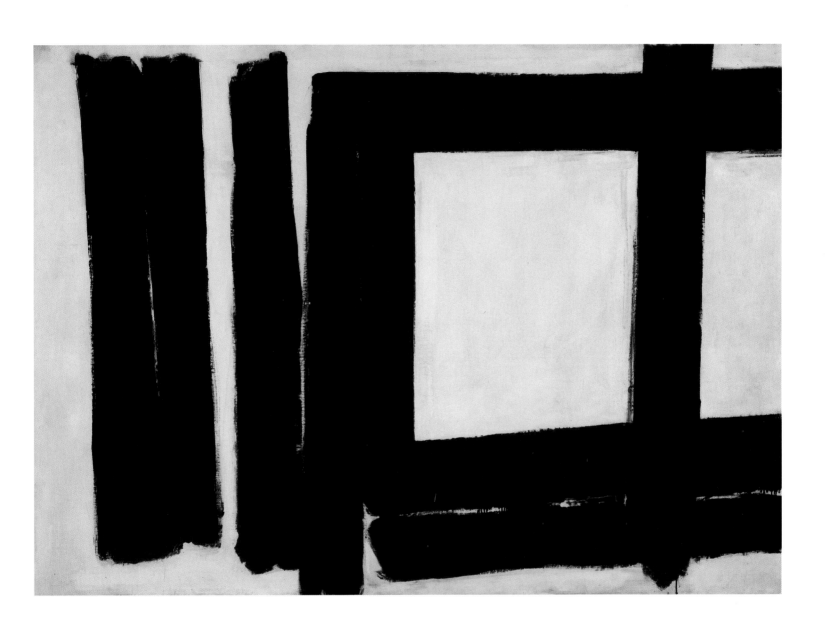

271
Franz Kline
Painting No. 7, 1952
Oil on canvas
146 × 207.6 cm (57¹/₂ × 81³/₄ inches)

Solomon R. Guggenheim Museum, New York 54.1403

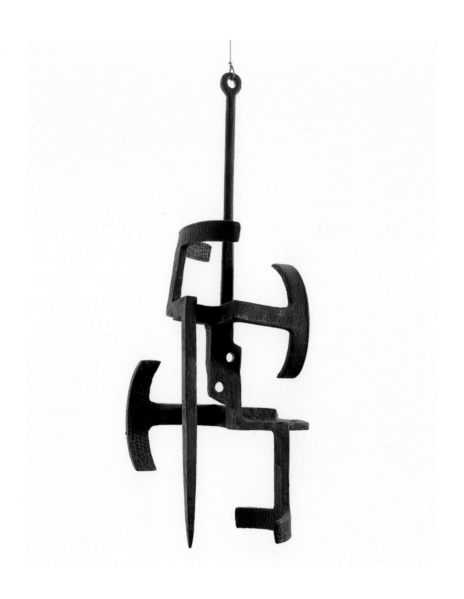

272
Eduardo Chillida
From Within (*Desde dentro*), March 1953
Iron
98.4 × 27.9 × 40 cm (38¾ × 11 × 15¾ inches)

Solomon R. Guggenheim Museum, New York 58.1504

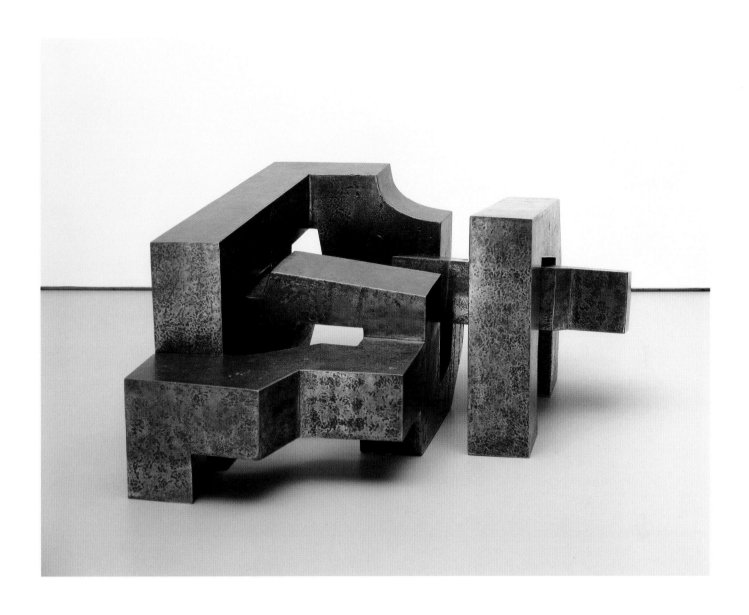

273
Eduardo Chillida
Three Irons (Iru burni), 1966
Steel
57.5 × 146 × 89.8 cm (22 ⁵⁄₈ × 57 ¹⁄₂ × 35 ³⁄₈ inches)

Solomon R. Guggenheim Museum, New York,
Gift, The Merrill G. and Emita E. Hastings Foundation,
Elizabeth Hastings Peterfreund, Trustee, In honor of
Thomas M. Messer 85.3257.a-.c

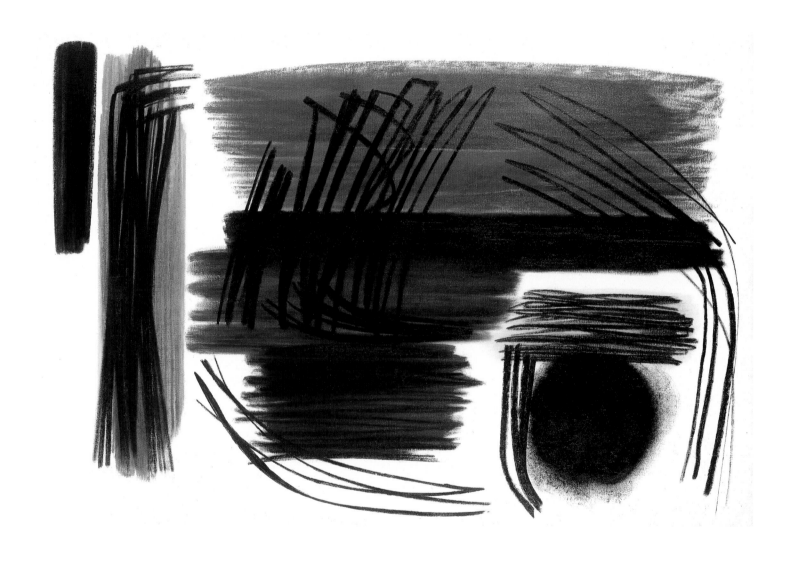

274
Hans Hartung
T-50 Painting 8 (T-50 peinture 8), 1950
Oil on canvas
96.8 × 146 cm (38 1/8 × 57 1/2 inches)

Solomon R. Guggenheim Museum, New York 54.1367

275
Hans Hofmann
The Gate, 1959–60
Oil on canvas
190.7 × 123.2 cm (75 1/8 × 48 1/2 inches)

Solomon R. Guggenheim Museum, New York 62.1620

276
Mark Rothko
Number 18, 1963
Oil on canvas
175.6 × 163.5 cm (69 1/8 × 64 3/8 inches)

Solomon R. Guggenheim Museum, New York,
Gift, The Mark Rothko Foundation, Inc. 86.3421

277
Mark Rothko
Dark over Brown No. 14, 1963
Oil on canvas
225 × 172 cm (88 9/16 × 67 3/4 inches)

Centre Georges Pompidou, Musée national d'art moderne, Paris,
Purchased by the French State in 1968, allocated 1976
AM 1976-1015

278
Richard Stankiewicz
Europe on a Cycle, 1953
Found metal objects
202 × 94 × 91 cm (79 1/2 × 37 × 35 7/8 inches)

Centre Georges Pompidou, Musée national d'art moderne, Paris,
Gift, Daniel Cordier, 1976 AM 1977-551

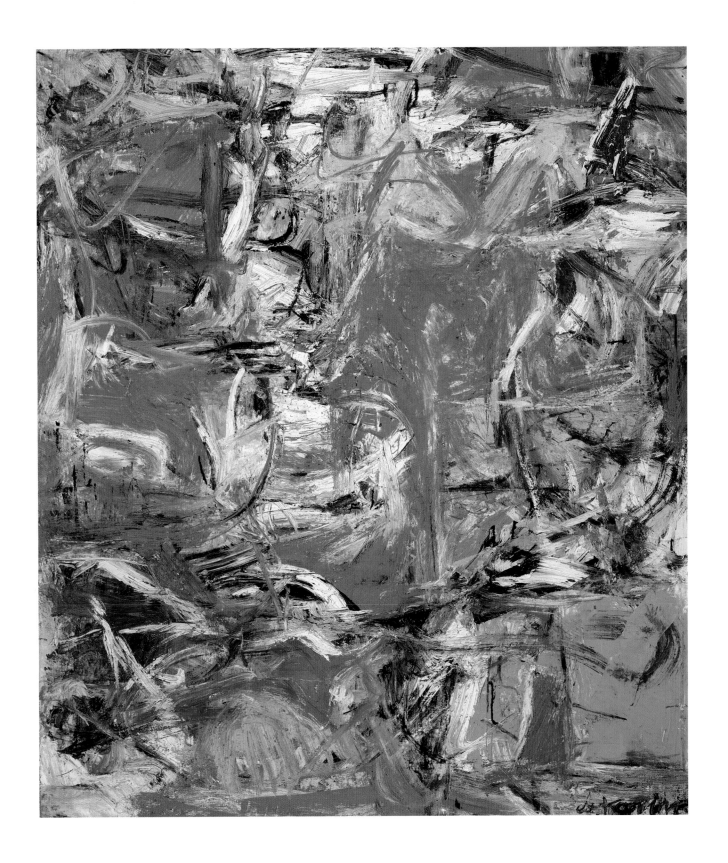

279
Willem de Kooning

Composition, 1955
Oil, enamel, and charcoal on canvas
201 × 175.6 cm (79 ⅛ × 69 ⅛ inches)

Solomon R. Guggenheim Museum, New York 55.1419

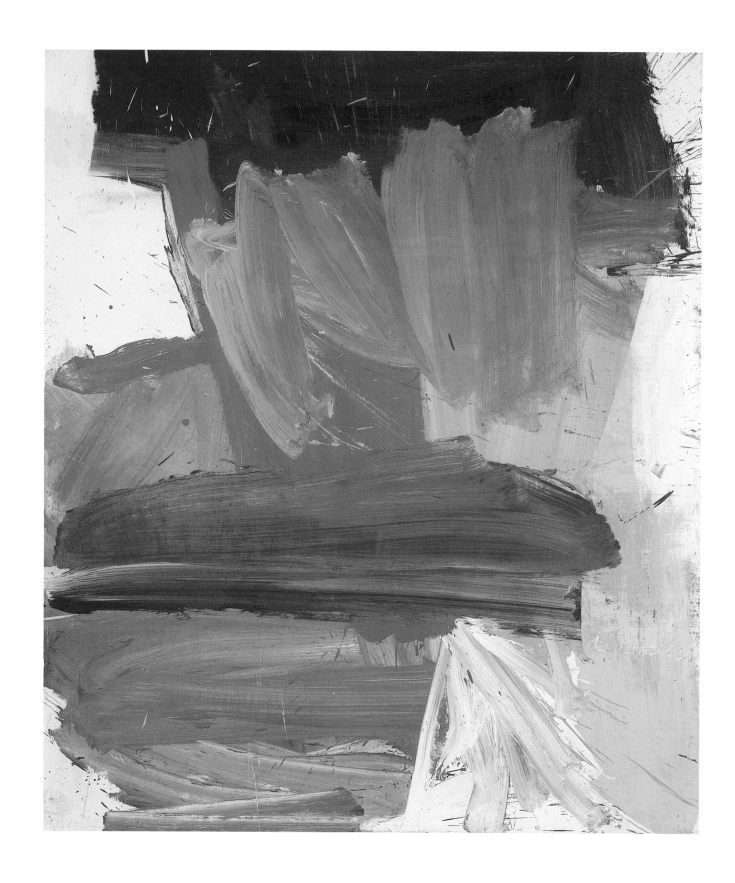

280
Willem de Kooning
Villa Borghese, 1960
Oil on canvas
203 × 178 cm (79 $^{15}/_{16}$ × 70 $^{1}/_{16}$ inches)

Guggenheim Bilbao Museoa 96.1

281
Cy Twombly
Untitled (Rome, June 1960), June 1960
Oil, pencil, and oil stick on canvas
95.7 × 101.8 cm (37 5/8 × 40 1/16 inches)

Solomon R. Guggenheim Museum, New York,
Gift, Michael and Elizabeth Rea 91.3975

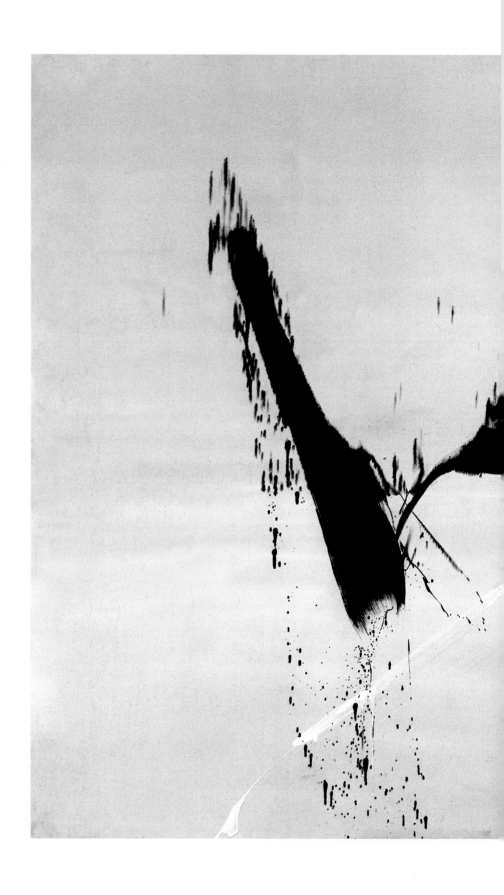

282
Jean Degottex
Aware II, 1961
Oil on canvas
2 × 3.5 m (6 feet 7 1/2 inches × 11 feet 5 13/16 inches)

Centre Georges Pompidou, Musée national d'art moderne, Paris,
Purchased by the French State in 1972, allocated 1975 AM 1975-262

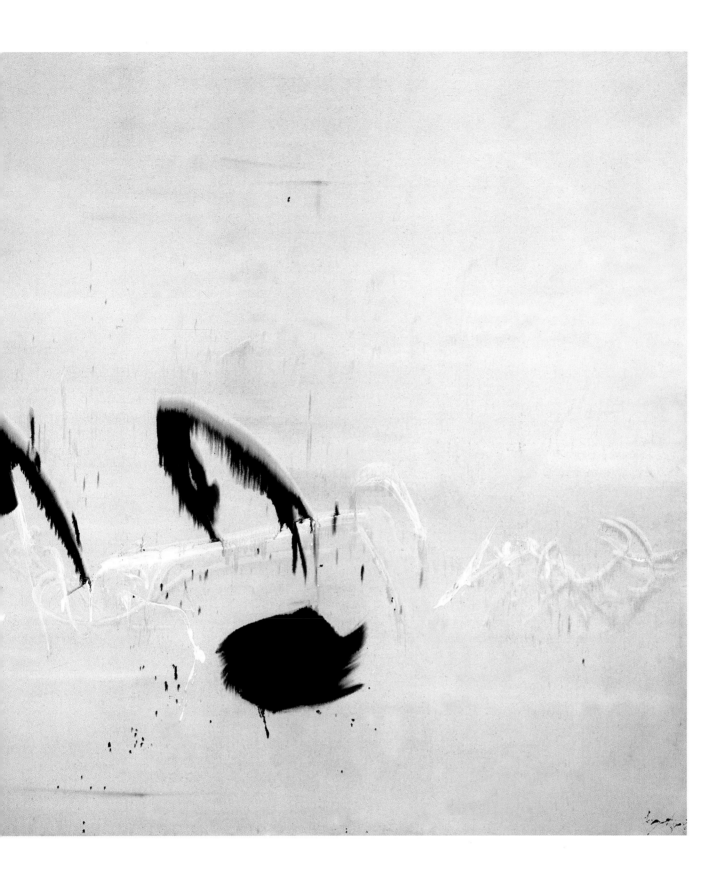

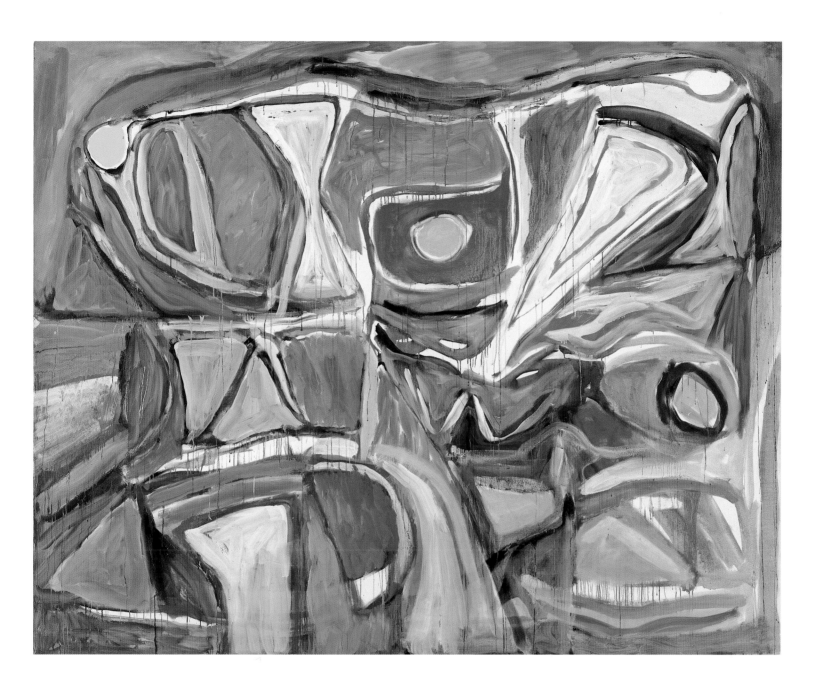

283
Bram Van Velde
Untitled, 1965
Oil on canvas
2 × 2.5 m (6 feet 6 9/16 inches × 8 feet 2 5/8 inches)

Centre Georges Pompidou, Musée national d'art moderne, Paris,
Purchased 1982 AM 1982-139

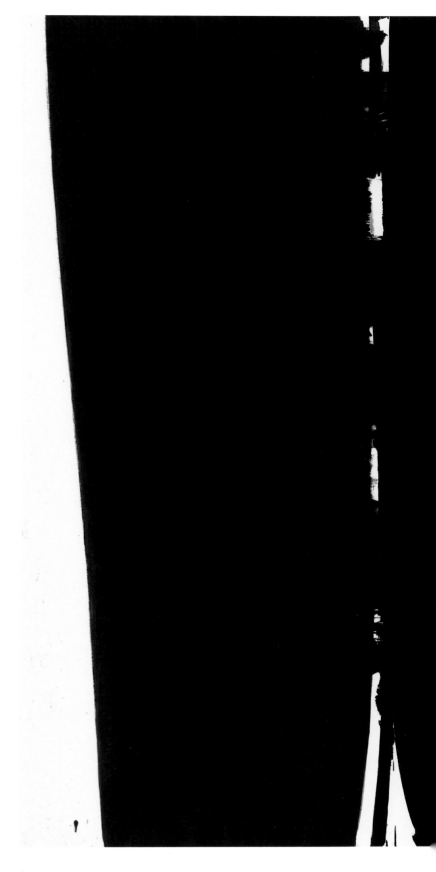

284
Pierre Soulages
Painting, 220 × 366 cm, May 14, 1968
(*Peinture, 220 × 366 cm, 14 mai 1968*), 1968
Oil and acrylic on canvas
2.2 × 3.7 m (7 feet 2 ⅝ inches × 12 feet ¹⁄₁₆ inch)

Centre Georges Pompidou, Musée national d'art moderne, Paris,
Purchased by the French State in 1969, allocated 1976 AM 1976-1021

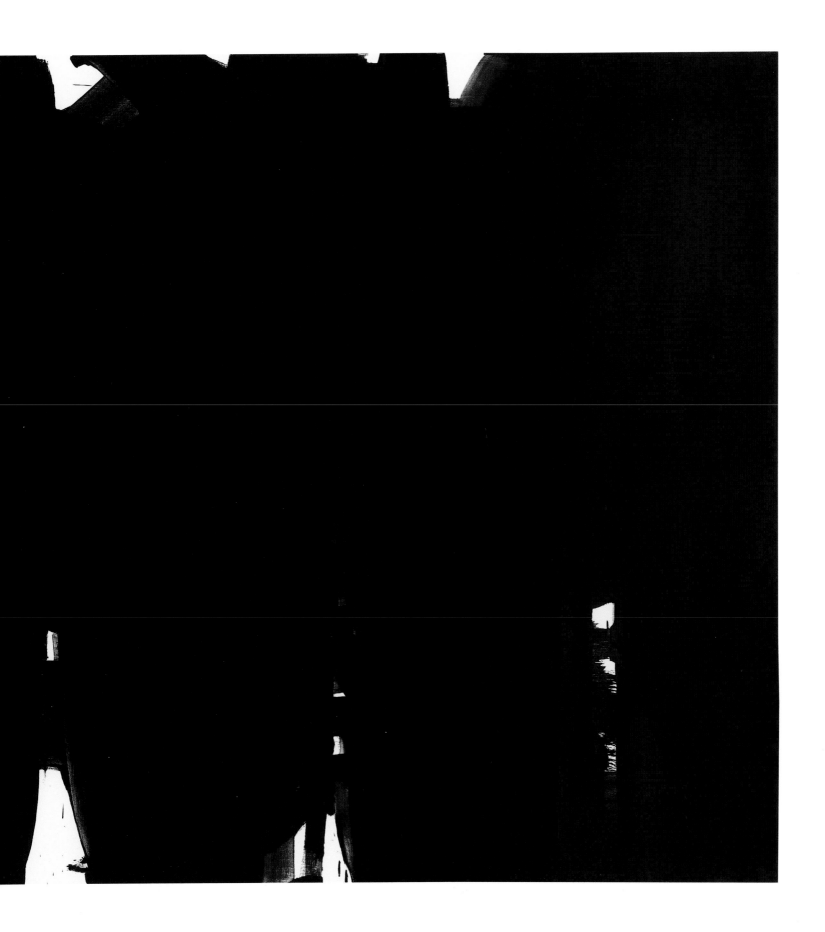

POSTWAR MATERIALITY

Within postwar abstraction, there emerged in
western Europe and the United States an art
that transfigured the materials of painting and
sculpture and suggested the presence of the body.
Lucio Fontana's *Black Sculpture—Spatial Concept*
(*Scultura nera—Concetto spaziale*, 1947, cat. no. 285)
is a cubelike form, suggesting the scatological: it
appears to have been ingested or even digested.
Alberto Burri, Robert Rauschenberg, and Antoni
Tàpies built up the surfaces of their canvases with
nontraditional materials such as cloth, newspaper,
sand, and burlap bags, recalling prewar Dada practice.
With their allusions to bandages, scraped wall-like
surfaces, and blood, some of these canvases suggest
the violence of warfare. Fontana's puncturing and
slashing of the canvas skin in his *Tagli* and *Bucchi*
series also suggest violence, though he executed
these gestures with great control. Fontana's painting
and sculpture influenced Piero Manzoni, whose work
acknowledged the body literally, particularly in his
series *Living Sculpture* (*Scultura vivente*), in which
he wrote his signature on live models, and his series
of canned *Artist's Shit* (for example, *Artist's Shit
No. 031* [*Merda d'artista n. 031*, 1961], cat. no. 315).

Lucio Fontana, ca. 1957.

503

285
Lucio Fontana
Black Sculpture—Spatial Concept
(*Scultura nera—Concetto spaziale*), 1947
Patinated bronze
56.5 × 50.5 × 24.5 cm (22 ¼ × 19 ⅞ × 9 ⅝ inches)

Centre Georges Pompidou, Musée national d'art moderne, Paris,
Gift, Mrs. Teresita Fontana, 1979 AM 1979-31

286
Lucio Fontana
Spatial Concept (Concetto spaziale), 1949
Ceramic
60 × 64 × 60 cm (23 ⅝ × 25 ³⁄₁₆ × 23 ⅝ inches)

Centre Georges Pompidou, Musée national d'art moderne, Paris,
Purchased 1994 AM 1994-256

287
Lucio Fontana
Spatial Concept (*Concetto spaziale*), 1960
Oil on canvas
150 × 150 cm (59 1/16 × 59 1/16 inches)

Centre Georges Pompidou, Musée national d'art moderne, Paris,
Purchased 1977 AM 1977-197

288
Robert Rauschenberg
Untitled (Red Painting), ca. 1953
Oil, fabric, and newspaper on canvas with wood
200.7 × 84.1 cm (79 × 33⅛ inches)

Solomon R. Guggenheim Museum, New York,
Gift, Walter K. Gutman 63.1688

289
Alberto Burri
Composition (Composizione), 1953
Oil, gold paint, and glue on burlap and canvas
86 × 100.4 cm (33⅞ × 39½ inches)

Solomon R. Guggenheim Museum, New York 53.1364

290
Alberto Burri
Plastic Combustion (Combustione plastica), 1964
Burnt polyvinyl plastic
150.5 × 251 cm (59 ¼ × 98 ¹³⁄₁₆ inches)

Centre Georges Pompidou, Musée national d'art moderne, Paris,
Gift of the artist, 1977 AM 1977-555

291
Antoni Tàpies
Large Brown Triangle (Gran triangle marró), 1963
Oil and sand on canvas, mounted on plywood
195 × 170 cm (76 ¾ × 66 ¹⁵/₁₆ inches)

Centre Georges Pompidou, Musée national d'art moderne, Paris,
Purchased by the French State in 1968, allocated 1980 AM 1980-425

292
Lucio Fontana
Spatial Concept, Expectations (Concetto spaziale, Attese), 1959
Water-based paint on canvas
126 × 251 cm (49 5/8 inches × 98 3/4 inches)

Solomon R. Guggenheim Museum, New York,
Gift, Mrs. Teresita Fontana, Milan 77.2322

293
Lucio Fontana
Spatial Concept, Expectations (Concetto spaziale, Attese), 1965
Water-based paint on canvas
130 × 97 cm (51 3/16 × 38 3/16 inches)

Peggy Guggenheim Collection, Venice,
Gift, Fondazione Lucio Fontana 88.3590

NOUVEAU RÉALISME AND POP ART

The well-known critic Pierre Restany first used the term "Nouveau Réalisme" in 1960 to describe an eclectic body of work by such artists as César, Jacques de la Villeglé, Raymond Hains, Yves Klein, Martial Raysse, and Jean Tinguely. Their work ranges from lacerated posters and assemblages of junk materials to monochrome painting and images of popular culture. Nouveau Réalisme does not represent a specific style, nor does it describe a timely trend, for Hains had been working with torn posters since the late 1940s. These artists were reacting against the introspective abstraction of Art Informel, Tachisme, and Abstract Expressionism in favor of exploring the gritty culture of everyday life. For these reasons, Nouveau Réalisme is often compared with its American counterparts, such as Neo-Dadaism and Pop art.

In comparison, Pop art, which was named by the critic and curator Lawrence Alloway in 1958, refers to a more narrowly defined movement that focused specifically on popular culture and that emerged in Great Britain and flourished in the United States. James Rosenquist and Andy Warhol, for example, appropriated images from advertising and the mass media, and Roy Lichtenstein adapted the look of comic strips for his paintings. In addition, Claes Oldenburg transformed everyday objects into crudely plastered wall pieces or soft sculptural masses. While Pop art has roots in the Neo-Dada art of Jasper Johns and others, Nouveau Réalisme is also sometimes considered its precursor. Through irony and wit, works from both movements simultaneously celebrate and critique popular culture. In addition to these artists, such German artists as Sigmar Polke employed a Pop-related style that also referred to the Socialist Realist painting of Eastern Europe. His work, unlike that of the French and the Americans, is a more sardonic critique of capitalist culture.

In 1983, the Musée national d'art moderne and the Solomon R. Guggenheim Museum each served as venues for a major Klein traveling retrospective. Since then, the Paris museum has purchased the artist's work in depth, including such significant acquisitions as *Anthropometry of the Blue Period (ANT 82)* (*Anthropométrie de l'époque bleue [ANT 82]*, 1960, cat. no. 299). Although the New York museum owns only one sculpture by Klein, his *Large Blue Anthropometry (ANT 105)* (*La Grande Anthropométrie bleue [ANT 105]*, ca. 1960, cat. no. 301) was one of the major purchases by the Guggenheim Museum Bilbao, which opened in 1997.

Jean Tinguely, *Homage to New York*, The Museum of Modern Art Sculpture Garden, New York, March 17, 1960.

294
Raymond Hains and Jacques de la Villeglé
Ach Alma Manetro, 1949
Lacerated posters on paper, mounted on canvas
58 × 256 cm (22⅞ × 100¾ inches)

Centre Georges Pompidou, Musée national d'art moderne, Paris,
Purchased 1987 AM 1987-938

295
Jacques de la Villeglé
Tapis Maillot, 1959
Lacerated posters on canvas
118 × 490 cm (46 1/2 × 192 15/16 inches)

Centre Georges Pompidou, Musée national d'art moderne, Paris,
Purchased by the French State in 1974, allocated 1980 AM 1980-428

296
Jasper Johns
Figure 5, 1960
Encaustic and newspaper on canvas
183 × 137.5 cm (72 1/16 × 54 1/8 inches)

Centre Georges Pompidou, Musée national d'art moderne, Paris,
Gift, the Scaler Foundation, 1975 AM 1976-2

297
Jean Tinguely
Méta-matic n° 1, 1959
Metal, paper, felt-tipped pens, and motor
96 × 85 × 44 cm (37 ¹³/₁₆ × 33 ¹/₂ × 17 ⁵/₁₆ inches)

Centre Georges Pompidou, Musée national d'art moderne, Paris,
Purchased 1976 AM 1976-544

298
Jean Tinguely
Baluba, 1961–62
Metal, iron wire, electrical wire, plastic objects, and feathers on
Shell gasoline can, with motor
187 × 56.5 × 45 cm (73 ⁵/₈ × 22 ¹/₄ × 17 ³/₄ inches)

Centre Georges Pompidou, Musée national d'art moderne, Paris,
Purchased 1982 AM-1981-851

299
Yves Klein

Anthropometry of the Blue Period (ANT 82)
(Anthropométrie de l'époque bleue [ANT 82]), 1960
Dry pigment and synthetic resin on paper, mounted on canvas
156.5 × 282.5 cm (61⅝ × 111¼ inches)

Centre Georges Pompidou, Musée national d'art moderne, Paris,
Purchased 1984 AM 1984-279

300
Yves Klein

Monochrome IKB 3, 1960
Dry pigment and synthetic resin on canvas, mounted on wood panel
199 × 153 cm (78⁵/₁₆ × 60¼ inches)

Centre Georges Pompidou, Musée national d'art moderne, Paris,
Purchased by the French State in 1974, allocated 1975 AM 1975-6

301
Yves Klein

Large Blue Anthropometry (ANT 105)
(*La Grande Anthropométrie bleue* [ANT 105]), ca. 1960
Dry pigment and synthetic resin on paper, mounted on canvas
2.8 × 4.3 m (9 feet 2¼ inches × 14 feet ½ inch)

Guggenheim Bilbao Museoa 97.26

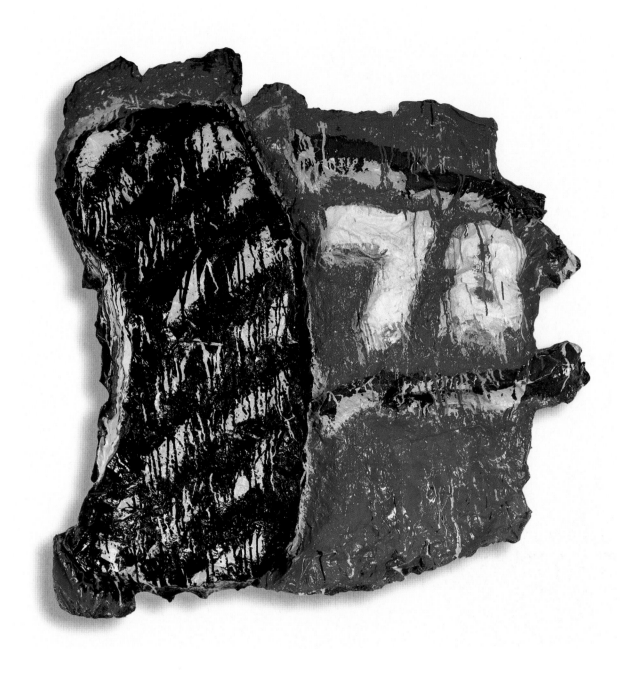

302
Claes Oldenburg
Auto Tire with Fragment of Price, 1961
Muslin soaked in plaster over wire frame, painted with enamel
124.5 × 121.9 × 17.8 cm (49 × 48 × 7 inches)

Centre Georges Pompidou, Musée national d'art moderne, Paris,
Gift, Leo and Jean-Christophe Castelli in memory of Toiny Castelli
by the intermediary of The French Museum Corporation, Inc., 1991
AM 1991-213

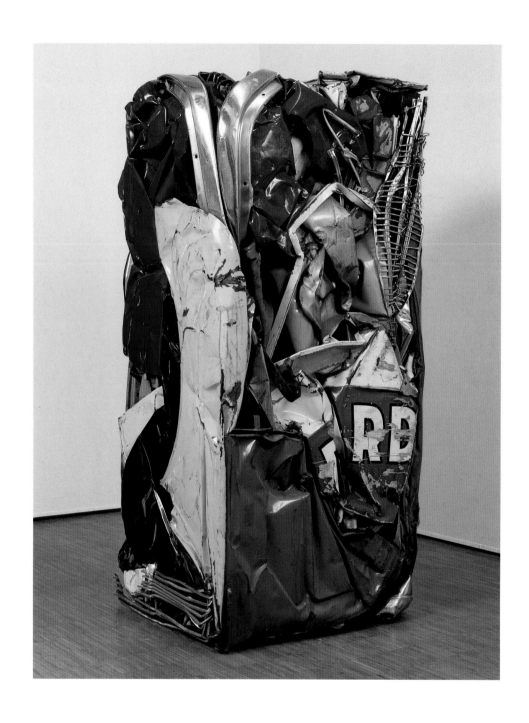

303
César
Ricard, 1962
Compacted automobile
153 × 73 × 65 cm (60¼ × 28¾ × 25⅝ inches)

Centre Georges Pompidou, Musée national d'art moderne, Paris,
Gift, Pierre Restany, 1968 AM 1698 s

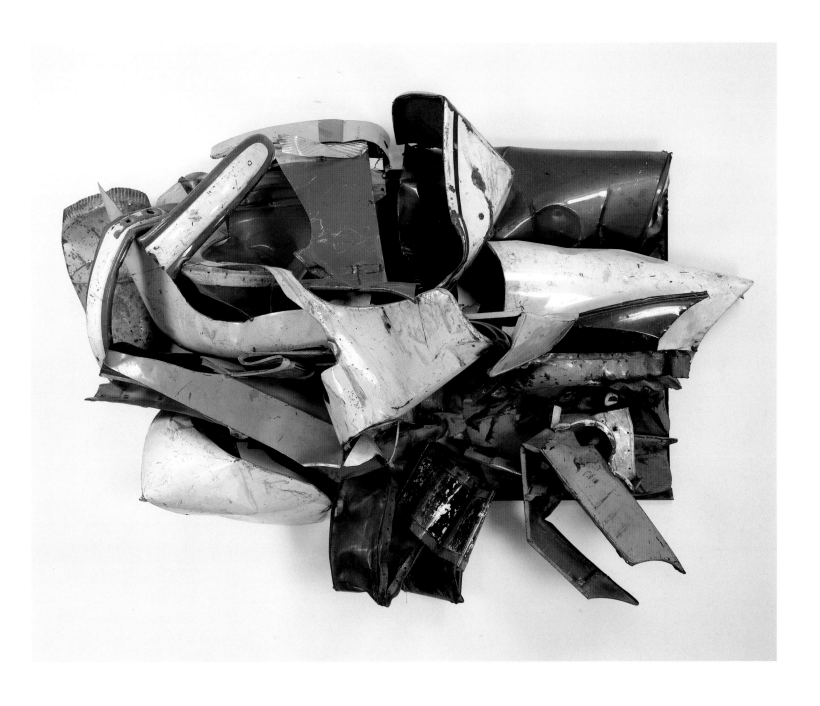

304
John Chamberlain

Dolores James, 1962
Welded and painted automobile parts
193 × 246.4 × 99.1 cm (76 × 97 × 39 inches)

Solomon R. Guggenheim Museum, New York 70.1925

305
Andy Warhol
Orange Disaster, 1963
Acrylic and silkscreen enamel on canvas
269.2 × 207 cm (106 × 81½ inches)

Solomon R. Guggenheim Museum, New York,
Gift, Harry N. Abrams Family Collection 74.2118

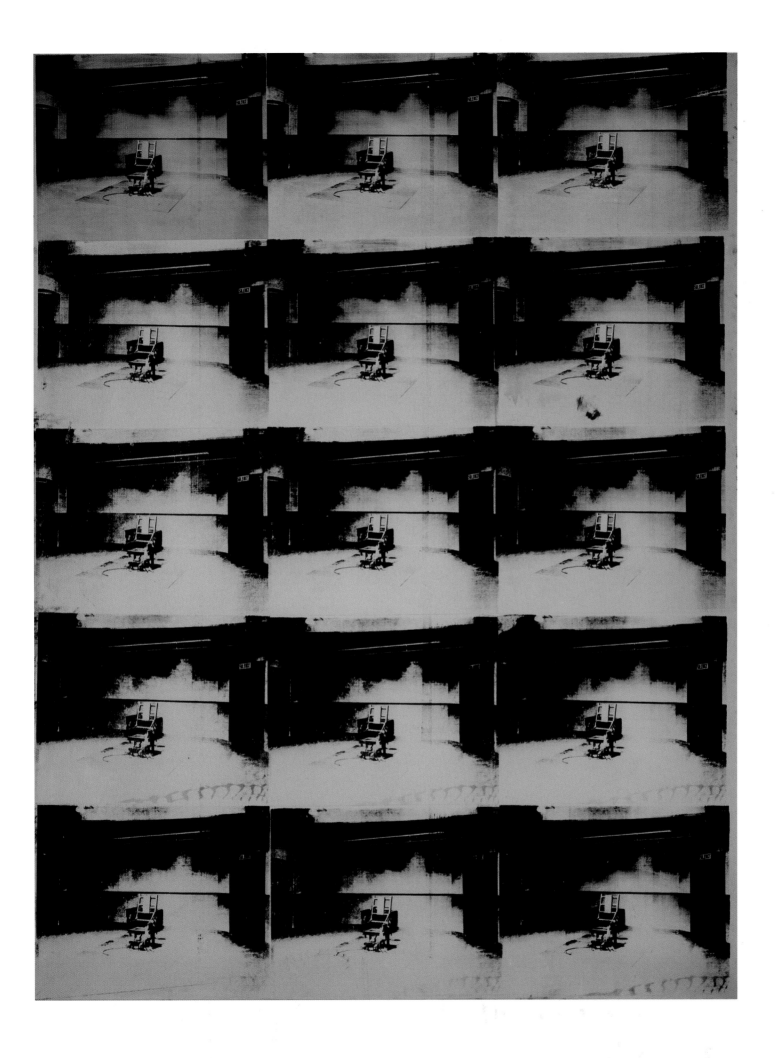

306

James Rosenquist

President Elect, 1960–61

Oil on Masonite

2.3 × 3.7 m (7 feet 5¾ inches × 12 feet ⅛ inch)

Centre Georges Pompidou, Musée national d'art moderne, Paris,
Purchased by the French State from the artist in 1973, allocated 1976
AM 1976-1014

307
Martial Raysse
Suddenly Last Summer (*Soudain l'été dernier*), 1963
Acrylic on canvas, with photograph, straw hat, and towel
100 × 225 cm (39 3/8 × 88 9/16 inches)

Centre Georges Pompidou, Musée national d'art moderne, Paris,
Purchased by the French State in 1968, allocated 1976 AM 1976-1010

308
Andy Warhol
Ten Lizes, 1963
Oil and lacquer silkscreened onto canvas
2 × 5.6 m (6 feet 7⅛ inches × 18 feet 6¼ inches)

Centre Georges Pompidou, Musée national d'art moderne, Paris,
Purchased 1986 AM 1986-82

309
Alain Jacquet
Luncheon on the Grass (*Le Déjeuner sur l'herbe*), 1964
Acrylic and serigraph on canvas
Two panels, 172.5 × 196 cm (67 ¹⁵/₁₆ × 77 ³/₁₆ inches) overall

Centre Georges Pompidou, Musée national d'art moderne, Paris,
Purchased 1996 AM 1996-428

310
Roy Lichtenstein
Grrrrrrrrrrr!!, 1965
Oil and Magna on canvas
172.7 × 142.5 cm (68 × 56⅛ inches)

Solomon R. Guggenheim Museum, New York,
Bequest of the artist 97.4565

Das zehnte Foto, das in Pasadena aufgezeichnet wurde. Es zeigt die Mond–oberfläche am Landeplatz von „Surveyor–1". Der Stein im Bild links vorne ist 15,0 cm hoch und 30,8 cm lang. Die hellen Punkte sind Sonnenreflexe.

311
Sigmar Polke
Pasadena, 1968
Oil and synthetic paint on canvas, mounted on jute
190 × 150.5 cm (74 $^{13}/_{16}$ × 59 $^{1}/_{4}$ inches)

Centre Georges Pompidou, Musée national d'art moderne, Paris,
Purchased 1987 AM 1987-559

312
Claes Oldenburg
Soft Pay-Telephone, 1963
Vinyl filled with kapok, mounted on painted wood panel
118.2 × 48.3 × 22.8 cm (46½ × 19 × 9 inches)

Solomon R. Guggenheim Museum, New York,
Gift, Ruth and Philip Zierler in memory of their
dear departed son, William S. Zierler 80.2747

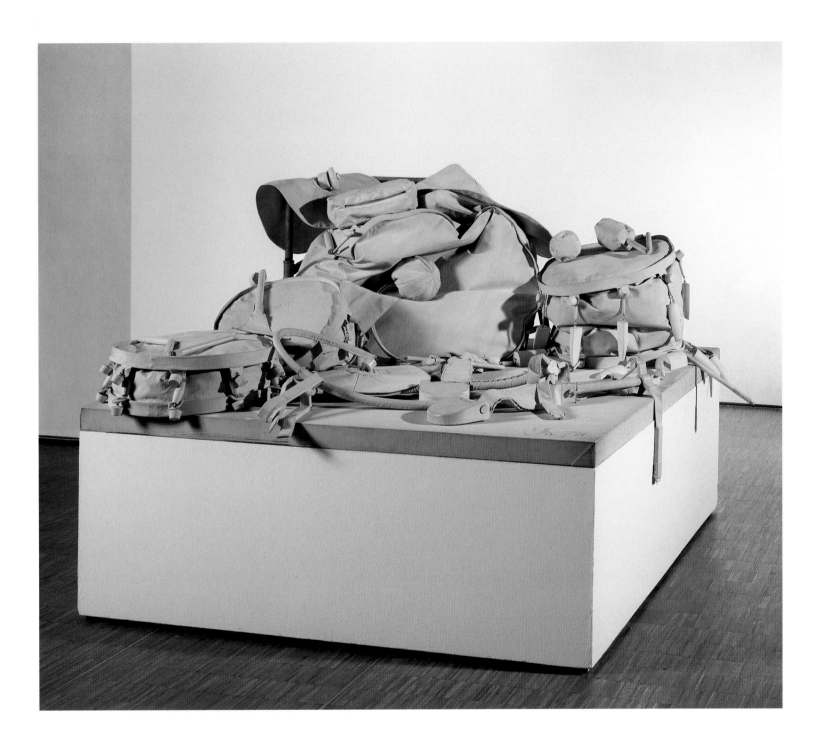

313
Claes Oldenburg

Soft Drum Set—Ghost Version, 1972
Canvas filled with expanded polystyrene chips, painted
with acrylic; metal and painted wood parts; and wood base
1.2 × 1.8 × 2.1 m (4 feet × 6 feet × 7 feet)

Centre Georges Pompidou, Musée national d'art moderne, Paris,
Gift, the Menil Foundation in memory of Jean de Menil, 1975
AM 1975-64

ARTE POVERA AND PROCESS ART

The art of Piero Manzoni was influential to artists of the 1960s who rejected both the traditional conventions of painting and sculpture and the impersonal character of Minimalist and Conceptual art. In their works, these artists used such non-art materials as feathers, rubber hosing, neon, lettuce, and felt. To manipulate these mediums, they combined them with other materials and objects, placed them in unusual arrangements, or broke them into pieces. In general, their works emphasize the temporality, rather than the presumed permanence, of the art object and draw attention to the process of construction more than the final result, which can sometimes change according to installation or the effects of time.

This 1960s phenomenon of using nontraditional materials in art practice was international in scope. The term "Arte Povera," introduced by art critic and curator Germano Celant, refers to mostly Italian art of this type, including the work of Giovanni Anselmo, Jannis Kounellis, Mario Merz, Pino Pascali, and Gilberto Zorio. The Musée national d'art moderne has acquired significant examples of this art. The label "Process Art" is used for this kind of art outside Italy, in western Europe primarily for the work of German artist Joseph Beuys, and in the United States for the art of, among others, Eva Hesse, Bruce Nauman, and Richard Serra.

Both the Solomon R. Guggenheim Museum and Musée national d'art moderne have made strong commitments to Beuys. In 1979, the Guggenheim mounted a large-scale retrospective, and in 1994 the Musée national d'art moderne served as a venue for an important Beuys exhibition in Europe. Each institution has acquired the artist's work in depth, with the Guggenheim amassing a comprehensive collection of scuptures, drawings, and installations, and the Musée national d'art moderne focusing on his environments.

Joseph Beuys, *Vitex Agnus Castus*, Modern Art Agency, Naples, 1972.

545

314
Piero Manzoni

Achrome, 1959
Kaolin on canvas
140 × 120.5 cm (55⅛ × 47⁷/₁₆ inches)

Centre Georges Pompidou, Musée national d'art moderne, Paris,
Purchased 1981 AM 1981-36

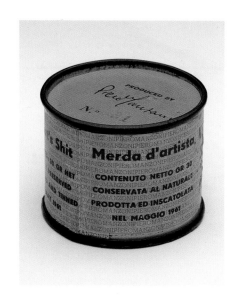

315
Piero Manzoni
Artist's Shit No. 031 (*Merda d'artista n. 031*), 1961
Metal can
5 cm (1¹⁵/₁₆ inches) high, 6.5 cm (2⁹/₁₆ inches) diameter

Centre Georges Pompidou, Musée national d'art moderne, Paris,
Gift, Liliane and Michel Durand-Dessert, 1994 AM 1994-100

316
Robert Morris
Card File, 1962
Metal and plastic wall file mounted on wood,
containing forty-four index cards
68.6 × 27.7 × 5.1 cm (27 × 10½ × 2 inches)

Centre Georges Pompidou, Musée national d'art moderne,
Purchased 1992 AM 1992-32

317
Joseph Beuys

Braunkreuz House (*Braunkreuz Haus*), ca. 1962–64
Vitrine containing *Untitled*, early 1960s (1962?): cardboard box
with metal hardware, skulls, jaws, and teeth of mice and rats,
needle, and carbon sticks; and *Braunkreuz House* (*Braunkreuz Haus*),
ca. 1962–64?: wood, wood chipboard, and cardboard painted
with Braunkreuz (brown oil paint), joined with metal and wire,
with electrical wire
Vitrine: 2.1 × 2.2 × .5 m (6 feet 9 inches × 7 feet 2½ inches ×
1 foot 7½ inches)

Solomon R. Guggenheim Museum, New York 91.3942.a,.b

318

Joseph Beuys

Sledge with Fat Filter, 1964–69
Vitrine containing *Fat Filter*, 1964: linen bag with fat,
beeswax, canoba wax, and bark; and *Sledge* (*Schlitten*), 1969:
wood sledge with Braunkreuz (brown oil paint), wax, tape,
webbing bands with tin finishings and felt buckles, felt blanket,
flashlight, and rope
Vitrine: 2.1 × 2.2 × .5 m (6 feet 9 inches × 7 feet 2¹/₂ inches ×
1 foot 7¹/₂ inches)

Solomon R. Guggenheim Museum, New York 91.3950.a,.b

319
Joseph Beuys
Infiltration-Homogen for Grand Piano
(*Infiltration homogen für Konzertflügel*), 1966
Grand piano covered in felt with fabric cross
100 × 152 × 240 cm (39 3/8 × 59 7/8 × 94 1/2 inches)

Centre Georges Pompidou, Musée national d'art moderne, Paris,
Purchased 1975 AM 1976-7

320
Joseph Beuys
The Skin (*La Peau*), 1984
Felt and fabric cross
100 × 152 × 240 cm (39 3/8 × 59 7/8 × 94 1/2 inches)

Centre Georges Pompidou, Musée national d'art moderne, Paris,
Purchased 1985 AM 1985-23

321
Bruce Nauman
My Last Name Extended Fourteen Times Vertically, 1967
Neon tubing with glass-tubing suspension frame
160 × 84 × 5 cm (63 × 33 × 2 inches)

Solomon R. Guggenheim Museum, New York,
Panza Collection, Extended loan LN266.93

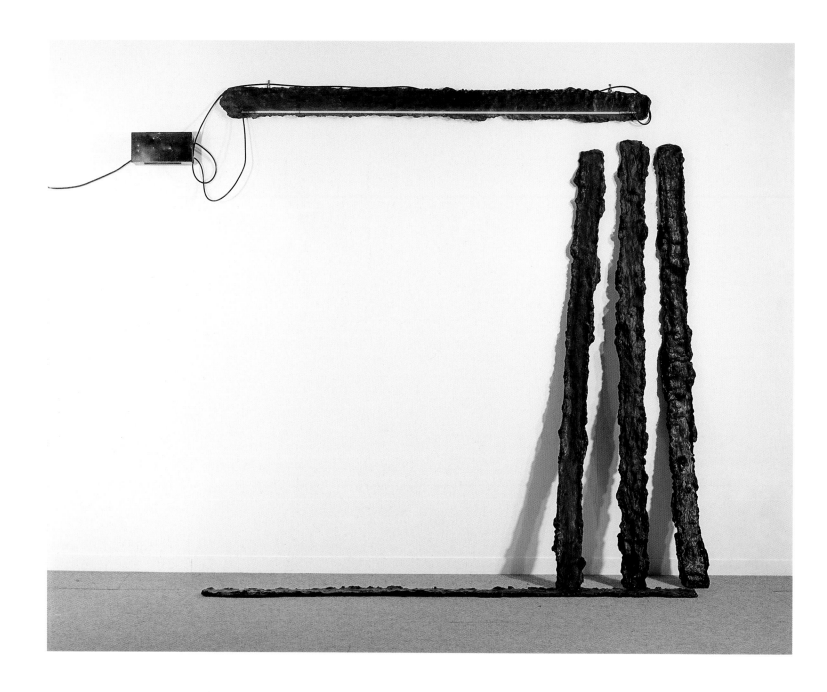

322
Richard Serra
Plinths, 1967
Rubber and fiberglass elements, neon tubing,
electrical wire, and transformer
Five elements, 220 × 18 cm (86 5/8 × 7 1/16 inches) each;
variable dimensions overall

Centre Georges Pompidou, Musée national d'art moderne, Paris,
Purchased 1984 AM 1984-278

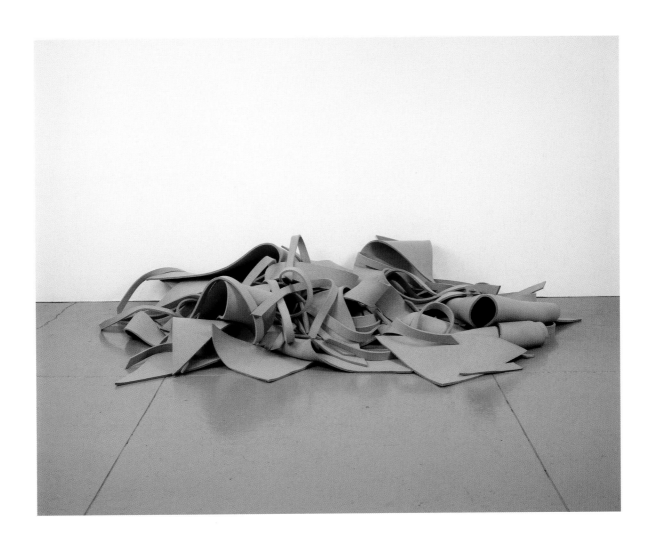

323
Robert Morris
Untitled, 1970
Felt
Variable dimensions

Solomon R. Guggenheim Museum, New York,
Panza Collection 91.3804

324
Eva Hesse
Untitled (Seven Poles), 1970
Aluminum wire, polyethylene resin, and fiberglass
2.7 × 2.4 m (8 feet 11¹/₁₆ inches × 7 feet 10¹/₂ inches)

Centre Georges Pompidou, Musée national d'art moderne,
Paris, Purchased 1986 AM 1986-248

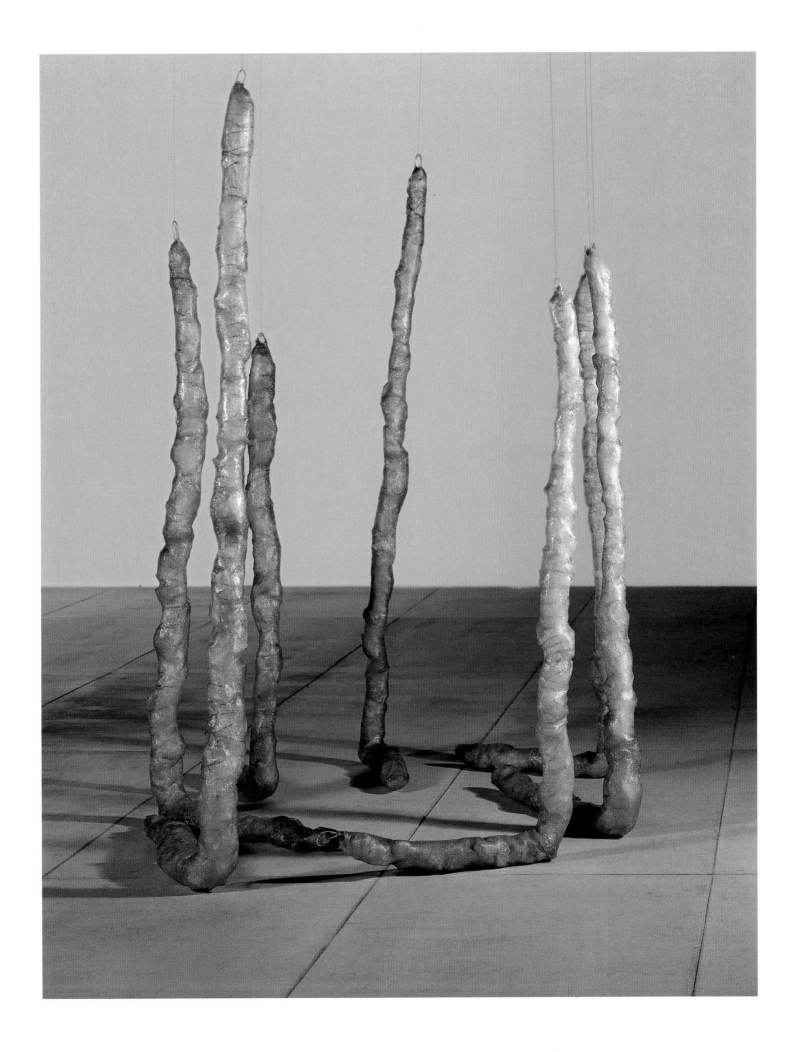

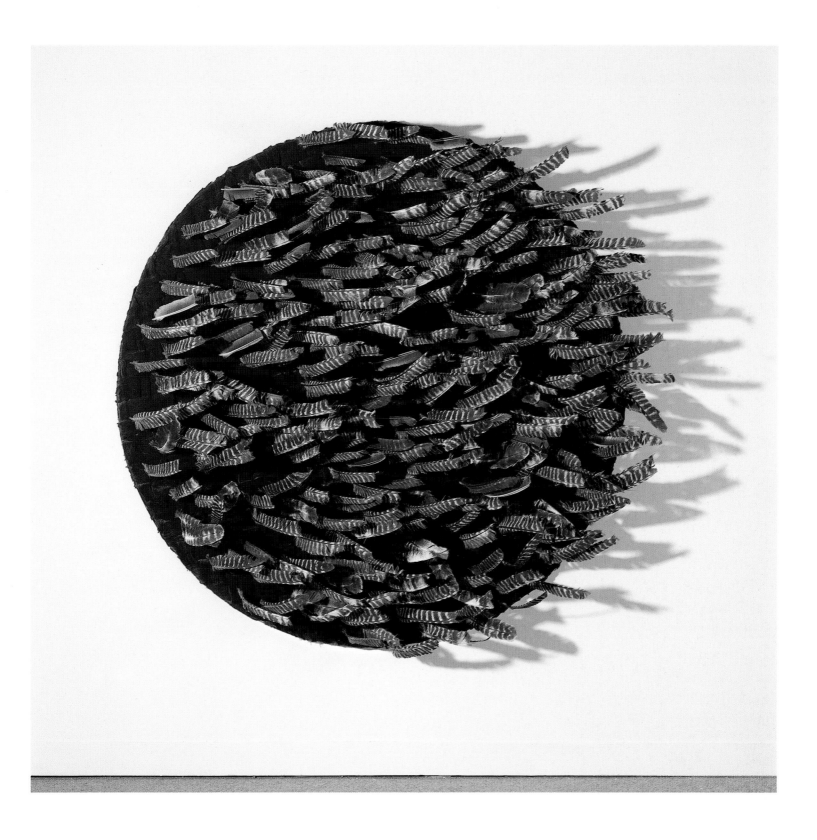

325
Pino Pascali

Aesop's Quills (*Le Penne di Esopo*), 1968
Wood armature, fiberglass, and feathers
150 cm (59 1/16 inches) diameter

Centre Georges Pompidou, Musée national d'art moderne, Paris,
Purchased 1991 AM 1991-98

326
Giovanni Anselmo
Untitled (Structure That Eats) (*Senza titolo [Struttura che mangia]*), 1968
Granite, copper wire, sawdust, and fresh lettuce
70 × 23 × 37 cm (27 9/16 × 9 1/16 × 14 9/16 inches)

Centre Georges Pompidou, Musée national d'art moderne, Paris,
Purchased 1985 AM 1985-177

327
Jannis Kounellis
Untitled, 1969
Steel beam, spring balances, and ground coffee
253 × 12 × 37 cm (99 ⁵/₈ × 4 ³/₄ × 14 ⁹/₁₆ inches)

Centre Georges Pompidou, Musée national d'art moderne, Paris,
Purchased 1985 AM 1985-178

328
Jannis Kounellis
Untitled, 1969
Sheet metal and braided hair
100.5 × 70.5 × 5 cm (39 ⁹/₁₆ × 27 ³/₄ × 1 ¹⁵/₁₆ inches)

Centre Georges Pompidou, Musée national d'art moderne, Paris,
Purchased 1981 AM 1981-1

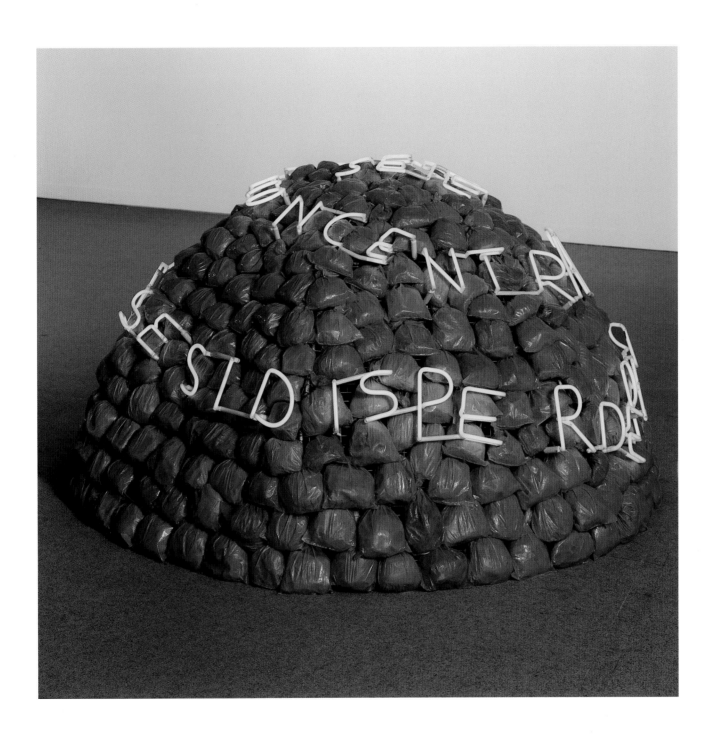

329
Gilberto Zorio

To Purify Words (*Per purificare le parole*), 1969
Rubber fire hose covered in canvas with zinc fittings,
iron tubes, and alcohol
170 cm (66 15/16 inches) high, 300 cm (118 1/8 inches) diameter

Centre Georges Pompidou, Musée national d'art moderne, Paris,
Purchased 1983 AM 1983-379

330
Mario Merz

Giap Igloo (*Igloo di Giap*), 1968
Wire mesh, earth-filled plastic bags, neon tubes, and batteries
120 cm (47 1/4 inches) high, 200 cm (78 3/4 inches) diameter

Centre Georges Pompidou, Musée national d'art moderne, Paris,
Purchased 1982 AM 1982-334

BETWEEN FRANCE AND THE UNITED STATES: ABSTRACTION AND CONCEPTUAL ART

In the 1950s, the American Ellsworth Kelly and Frenchman François Morellet were among the first post–World War II artists to initiate the reductive principle found in the artwork of 1960s America and France.

Minimalism, which flourished largely in the United States, is characterized by serial repetition, geometric forms, and the use of industrial materials and techniques. The term applies to the work of such artists as Carl Andre, Donald Judd, Brice Marden, and Robert Ryman. Rejecting the heroic gesture of Abstract Expressionism, Minimalist work, pared to essentials, is self-referential and emphasizes the viewer's phenomenological experience. By the late 1960s, the reductive impulse led such artists as Lawrence Weiner to abandon the art object altogether, embracing language as a medium and examining the philosophical underpinnings of representation.

French art of the period shared some of the same critical strategies. Martin Barré focused on simple, sometimes repeated movements to record directly the artist's gesture. In the mid 1960s, Daniel Buren and Niele Toroni extrapolated from this idea to systematize the gesture as motif and use it as signature. In addition, Buren and Toroni questioned art's institutional frame by exhibiting both within and outside of galleries and museums. In the late 1960s, Daniel Dezeuze and Claude Viallat, members of the art movement Supports-Surfaces, engaged in a radical critique of the fundamental elements of pictorial art. The antitraditional practices of the period were related to the concurrent sociopolitical events that disrupted both France and the United States in the late 1960s.

François Morellet with Ellsworth Kelly, New York, 1960.

331
Ellsworth Kelly
Eleven Panels, Kite II, 1952
Oil on canvas
Eleven joined panels, 80 × 280 cm (31 ½ × 110 ¼ inches) overall

Centre Georges Pompidou, Musée national d'art moderne, Paris,
Purchased 1987 ᴀᴍ 1987-560

332
François Morellet
3 x 3, 1954
Oil on joined wood panels
134.3 × 134 cm (52 7/8 × 52 3/4 inches)

Centre Georges Pompidou, Musée national d'art moderne, Paris,
Purchased from the artist in 1985 AM 1985-496

333
François Morellet
6 Random Distributions of 4 Black and White Squares Using
the Even and Odd Numbers of π
(*6 Répartitions aléatoires de 4 carrés noirs et blancs d'après*
les chiffres pairs et impairs du nombre π), 1958
Oil on wood
Six panels, 80 × 80 cm (31¹/₂ × 31¹/₂ inches) each;
variable dimensions overall

Centre Georges Pompidou, Musée national d'art moderne, Paris,
Purchased 1982 AM 1982-16

334
Martin Barré
"60-T-45", 1960
Oil on canvas
Four panels: 90 × 96.5 cm (35⁷/₁₆ × 38 inches), 102 × 110 cm
(40¹/₈ × 43¹/₄ inches), 80 × 86 cm (31¹/₂ × 33⁷/₈ inches), 80.5 ×
86 cm (31¹¹/₁₆ × 33⁷/₈ inches); 1.9 × 2.5 m (6 feet 3⁵/₈ inches ×
8 feet 3⁵/₈ inches) overall

Centre Georges Pompidou, Musée national d'art moderne, Paris,
Purchased by the French State in 1981, allocated 1981 AM 1982-82

335
Martin Barré
"67-2-26-70 x 53", 1967
Enamel and acrylic on canvas
69.1 × 52.7 cm (27 ³/₁₆ × 20 ³/₄ inches)

Centre Georges Pompidou, Musée national d'art moderne, Paris,
Purchased 1990 AM 1990-96

336
Brice Marden
Private Title, 1966
Oil and wax on canvas
121.3 × 243.2 cm (47 ¾ × 95 ¾ inches)

Solomon R. Guggenheim Museum, New York,
Panza Collection 91.3782

337
Robert Ryman
Classico 2, 1968
Acrylic on paper, mounted on foamcore
Six units, 157.5 × 170.2 cm (62 × 67 inches) overall

Solomon R. Guggenheim Museum, New York,
Panza Collection 91.3844.a-.f

338
Donald Judd
Untitled, 1965
Plexiglas, stainless steel, wire, and metal turnbuckles
51 × 122 × 86.2 cm (20 $^{1}/_{16}$ × 48 $^{1}/_{16}$ × 33 $^{15}/_{16}$ inches)

Centre Georges Pompidou, Musée national d'art moderne, Paris,
Purchased 1987 AM 1987-939

339
Carl Andre
10 x 10 Altstadt Copper Square, 1967
Copper
One hundred units, .5 × 50 × 50 cm ($^3/_{16}$ × 19$^{11}/_{16}$ ×
19$^{11}/_{16}$ inches) each

Solomon R. Guggenheim Museum, New York,
Panza Collection 91.3673

340
Donald Judd
Untitled, 1970
Aluminum and anodized aluminum
20.3 × 642.6 × 20.3 cm (8 × 253 × 8 inches)

Solomon R. Guggenheim Museum, New York,
Panza Collection 91.3715

341
Lawrence Weiner
*Cat. #029 (1969) THE RESIDUE OF A FLARE IGNITED
UPON A BOUNDARY,* 1969
Language + the materials referred to
Variable dimensions

Solomon R. Guggenheim Museum, New York,
Panza Collection 91.3715

A FLARE IGNITED UPON A BOUNDARY

342
Niele Toroni
Imprints of a No. 50 Brush Repeated at Regular Intervals of 30 cm
(*Empreintes de pinceau nº 50 répétées à intervalles réguliers de 30 cm*), 1967
Acrylic on oilcloth
475 × 140 cm (187 × 55 ⅛ inches)

Centre Georges Pompidou, Musée national d'art moderne, Paris,
Purchased by the French State in 1975, allocated 1976 AM 1976-1028

343
Daniel Buren
Painting, Manifestation III (Peinture, Manifestation III), May 1967
Acrylic on striped cotton fabric
2.5 × 2.5 m (8 feet 2 ¹³/₁₆ inches × 8 feet 2 ⅝ inches)

Centre Georges Pompidou, Musée national d'art moderne, Paris,
Purchased from the artist in 1986 AM 1986-254

344
Daniel Dezeuze
Stretched Plastic on Chassis (Châssis plastic tendu), 1967
Plastic sheet on wood frame
194.5 × 130 × 2 cm (76 9/16 × 51 3/16 × 13/16 inches)

Centre Georges Pompidou, Musée national d'art moderne, Paris, Purchased 1985 AM 1985-173

345
Claude Viallat
Net (Filet), 1970
Coconut-fiber cord coated in tar
3.42 × 4.17 m (11 feet 2 5/8 inches × 13 feet 8 3/16 inches)

Centre Georges Pompidou, Musée national d'art moderne, Paris, Purchased by the French State in 1971, allocated 1976
AM 1976-1032

ARTISTS

Carl Andre
Giovanni Anselmo
Karel Appel
Alexander Archipenko
Jean Arp
Antonin Artaud
Francis Bacon
Balthus
Martin Barré
Georg Baselitz
Max Beckmann
Hans Bellmer
Joseph Beuys
Umberto Boccioni
Constantin Brancusi
Georges Braque
Victor Brauner
Daniel Buren
Alberto Burri
Alexander Calder
César
Paul Cézanne
Marc Chagall
John Chamberlain
Eduardo Chillida
Joseph Cornell
Salvador Dalí
Giorgio de Chirico
Jean Degottex
Willem de Kooning
Robert Delaunay
Sonia Delaunay
André Derain
Nicolas de Staël
Daniel Dezeuze
Jean Dubuffet
Marcel Duchamp
Raymond Duchamp-Villon
Max Ernst
Jean Fautrier

Lucio Fontana
Alberto Giacometti
Julio González
Arshile Gorky
Juan Gris
George Grosz
Raymond Hains
Hans Hartung
Raoul Hausmann
Jean Hélion
Eva Hesse
Hans Hofmann
Alain Jacquet
Jasper Johns
Asger Jorn
Donald Judd
Vasily Kandinsky
Ellsworth Kelly
Paul Klee
Yves Klein
Franz Kline
Jannis Kounellis
František Kupka
Wifredo Lam
Mikhail Larionov
Henri Laurens
Fernand Léger
Roy Lichtenstein
Jacques Lipchitz
René Magritte
Kazimir Malevich
Man Ray
Piero Manzoni
Franz Marc
Brice Marden
André Masson
Henri Matisse
Roberto Matta
Mario Merz
Henri Michaux

Joan Miró
Amedeo Modigliani
László Moholy-Nagy
Piet Mondrian
François Morellet
Robert Morris
Bruce Nauman
Claes Oldenburg
Pino Pascali
Antoine Pevsner
Francis Picabia
Pablo Picasso
Sigmar Polke
Jackson Pollock
Liubov Popova
Robert Rauschenberg
Martial Raysse
James Rosenquist
Mark Rothko
Robert Ryman
Richard Serra
Pierre Soulages
Richard Stankiewicz
Clyfford Still
Sophie Taeuber-Arp
Yves Tanguy
Antoni Tàpies
Jean Tinguely
Niele Toroni
Cy Twombly
Theo van Doesburg
Georges Vantongerloo
Bram Van Velde
Claude Viallat
Jacques de la Villeglé
Maurice de Vlaminck
Andy Warhol
Lawrence Weiner
Wols
Gilberto Zorio

ARTIST BIOGRAPHIES AND CATALOGUE ENTRIES

These biographies and catalogue entries have been adapted by Susan Hapgood from numerous sources. Entries for works in the collection of the Musée national d'art moderne have been translated from the French by Stephen Sartarelli and Sophie Hawkes, with the exception of Daniel Abadie's entries, which have been translated by Brian Holmes. Many entries for works in the collection of the Solomon R. Guggenheim Museum have been adapted from catalogues published by the museum since 1980, including Vivian Endicott Barnett, ed., *Handbook: The Guggenheim Museum Collection, 1900–1980* (1980); *From van Gogh to Picasso, From Kandinsky to Pollock: Masterpieces of Modern Art* (1990); *Berriaren Tradizioa: Guggenheim Bildumako, Maisu–Lanak, 1945–1990/La Tradición de lo Nuevo: Obras Maestras de la Colección Guggenheim, 1945–1990* (1995); *Masterpieces from the Peggy Guggenheim Collection* (1996); *Masterpieces from the Guggenheim Museum* (1996); Nancy Spector, ed., *Guggenheim Museum: A to Z* (1996). Entries for works in the collection of the the Musée national d'art moderne have been adapted from the two catalogues dedicated to the collection: *La Collection du Musée national d'art moderne*, under the editorial direction of Agnès de la Beaumelle and Nadine Pouillon (ed. du Centre Pompidou, 1987), and *La Collection du Musée national d'art moderne, acquisitions 1986–1996*, under the editorial direction of Agnès de la Beaumelle and Nadine Pouillon (ed. du Centre Pompidou, 1997), and from the following publications: Werner Spies, *Les Sculptures de Picasso* (Lausanne: ed. La Guilde du Livre et Clairefontaine, 1971); Françoise Cachin-Nora, *Klee au MNAM* (Editions des Musées nationaux, 1972); *Soulages, peintures récentes, 17 oct.–31 déc. 1979* (Musée national d'art moderne, Centre Pompidou, 1979); Jean-Hubert Martin, *Malévitch, oeuvres de Casimir Severinovitch Malévitch (1878–1935)*, Collections du Musée national d'art moderne (ed. du Centre Pompidou, 1980); *100 oeuvres nouvelles 1977–1981*, Musée national d'art moderne, Centre national d'art et de culture Georges Pompidou (ed. du Centre Pompidou, 1981); Claude Laugier et Michèle Richet, *Oeuvres de Fernand Léger (1881–1995)* (ed. du Centre Pompidou, 1981); Nadine Pouillon with Isabelle Monod-Fontaine, *Braque, oeuvres de Georges Braque (1882–1963)*, Collections du Musée national d'art moderne (ed. du Centre Pompidou, 1982); *Chefs d'oeuvre du Musée national d'art moderne*, Centre national d'art et de culture Georges Pompidou (ed. du Centre Pompidou, 1982); Alfred Pacquement et Joëlle Pijaudier Cabot, *Daniel Dezeuze* (Paris: Editions Flammarion, 1989); *Joseph Beuys*, Musée national d'art moderne (ed. du Centre Pompidou, 1994); *Victor Brauner dans les collections du MNAM-CCI*,

Musée national d'art moderne (ed. du Centre Pompidou, 1996); Georges Didi-Huberman et Didier Semin, *L'Empreinte* (ed. du Centre Pompidou, 1997).

The authors of the original entries are

Musée national d'art moderne (MNAM)

(curators)
Jean-Paul Ameline (J.-P. A.)
Agnès de la Beaumelle (A. L. B.)
Edina Bernard (E. B.)
Bernard Blistène (B. B.)
Jean-Pierre Bordaz (J.-P. B.)
Marc Bormand (M. B.)
Christian Derouet (Ch. D.)
Fabrice Hergott (F. H.)
Claude Laugier (C. L.)
Isabelle Monod-Fontaine (I. M.-F.)
Nadine Pouillon (N. P.)
Claude Schweisguth (Cl. S.)
Didier Semin (D. S.)
Werner Spies (W. S.)
Jonas Storsve (J. S.)
Marielle Tabart (M. T.)

(outside contributors)
Daniel Abadie (D. A.)
Anne Baldassari (A. B.)
Marie-Laure Bernadac (M.-L. B.)
Françoise Cachin (F. C.)
Henri de Cazals (H. C.)
Catherine David (C. D.)
Georges Didi-Huberman (G. D.-H.)
Nathalie Filser (N. F.)
Verena Kuni (V. K.)
Luc Lang (L. L.)
Hélène Lassalle (H. L.)
Brigitte Léal (B. L.)
Françoise Levaillant (F. L.)
Christophe Magal (C. M.)
Florence Malet (F. M.)
Jean-Hubert Martin (J.-H. M.)
Alfred Pacquement (A. P.)
Barbara Stehlé-Akhtar (B. S.-A.)
Claire Stoullig (C. S.)
Florence Thévenon (F. Th.)
Germain Viatte (G. V.)
Véronique Wiesinger (V. W.)

Solomon R. Guggenheim Museum (SRGM)

Jan Avgikos (J. A.)
Vivian Endicott Barnett (V. E. B.)
Tracey Bashkoff (T. B.)
Jennifer Blessing (J. B.)
Elizabeth C. Childs (E. C. C.)
Robin Clark (R. C.)
Sara Cochran (J. S. C.)
Susan Cross (S. C.)
Matthew Drutt (M. D.)
Lucy Flint (L. F.)
Vivien Greene (V. G.)
Susan B. Hirschfeld (S. B. H.)
Cornelia Lauf (C. L.)
Melanie Marino (M. M.)
Sophie Prieto (S. P.)
J. Fiona Ragheb (J. F. R.)
Suzanne Ramljak (S. R.)
Vanessa Rocco (V. R.)
Ingrid Schaffner (I. S.)
Claudia Schmuckli (C. R. S.)
Nancy Spector (N. S.)
Joseph R. Wolin (J. R. W.)

Carl Andre

b. 1935

Carl Andre was born September 16, 1935, in Quincy, Massachusetts. From 1951 to 1953, he attended the Phillips Academy, Andover, where he studied art under Patrick Morgan. After a brief enrollment in Kenyon College, Gambier, Ohio, Andre earned enough money working at Boston Gear Works to travel to England and France in 1954. The following year, he joined United States Army Intelligence in North Carolina. In 1957, he settled in New York and worked as an editorial assistant for a publishing house. Shortly thereafter he began executing wood sculptures influenced by Constantin Brancusi and by the black paintings of his friend Frank Stella.

He was a leading member of the Minimalist movement, which coalesced during the early and middle 1960s. In addition to making sculpture, he also began to write poems in the tradition of Concrete Poetry, displaying the words on the page as if they were drawings. From 1960 to 1964, he was a freight brakeman and conductor for the Pennsylvania Railroad in New Jersey. Andre's first one-person show was held in 1965 at the Tibor de Nagy Gallery, New York. In the 1970s, the artist prepared numerous large installations, such as *Blocks and Stones* for the Portland Center for the Visual Arts, Oregon, in 1973, and he made many more outdoor works, such as *Stone Field Sculpture* in 1977 in Hartford. In his work to date, he continues to emphasize material and spatial specificity.

Notable among the many retrospectives of his work are those held at the Solomon R. Guggenheim Museum, New York, in 1970; the Laguna Gloria Art Museum, Austin, Texas, in 1978; the Stedelijk Van Abbemuseum, Eindhoven, in 1987; the Museum of Modern Art, Oxford, England, in 1996; and the Musée Cantini, Marseilles, in 1997. Andre lives and works in New York.

10 x 10 Altstadt Copper Square, 1967 (cat. no. 339)

In *10 x 10 Altstadt Copper Square*, space is defined by both the work and the spectator who is free to walk across it. This sculpture embodies the characteristic features of Andre's art, such as the use of ready-made materials, the employment of interchangeable modular units, and the articulation of three-dimensionality through a consideration of its negative as well as positive space. Andre began to create floor pieces in 1965 when he shifted from stacking units up to spreading them over the floor. Occupying horizontal space, these works were laid out in simple configurations that could be easily gathered for storage or transportation. In 1966, he began to make them out of industrial metal plates, which have changed over time, showing the incidental effects of pedestrian contact and atmospheric conditions.

Andre has sought to reduce the vocabulary of twentieth-century sculpture to basic phonemes such as squares, cubes, lines, and diagrams. In his avowed transition from the exploration of form to that of structure and place, he has placed significant emphasis on the relation between site and viewer. His pseudoindustrial, untheatrical arrangements hover between being ideas and testing the limits of physical presence. Andre's consistent search for the simplest, most rational models embodies a moral philosophy as well as an artistic practice. —C. L.

Giovanni Anselmo

b. 1934

Giovanni Anselmo was born August 5, 1934, in Borgofranco d'Ivrea, Italy. Anselmo's first

acknowledged artwork is a photograph of himself experiencing the sunrise at the summit of a volcano. Titled *My shadow projected toward infinity at the peak of Stromboli during the dawn of August 16, 1965*, this nascent work signals Anselmo's interest in time, nature, and the human's relations to these elements. Anselmo was one of the artists identified with the Arte Povera movement in Italy. In 1968, he was included in two early Arte Povera shows (both titled *Arte Povera*, one at the Galleria de' Foscherari, Bologna, and the other at the Centro Arte Viva Feltrinelli, Trieste), and in the same year his first solo exhibition was held at the Galleria Sperone, Turin.

Anselmo's mixed-medium work is concerned primarily with the phenomenology of perception. In many of his sculptures the artist manipulates elemental materials to underline systems in nature, from magnetic fields to centripetal propulsion, as well as to denote the atemporality inherent in these forces. Among the pieces that investigate these issues are the rough-hewn slabs of granite in which a compass needle is embedded and the tightly wound bands of fabric twisted by means of an iron rod, both series dating from 1968 to 1969. Anselmo also created installations employing conceptual photography and, by 1970, had begun to work with projectors. In 1974, he orchestrated the installation *Particular (Particolare)*, projecting a single word, *particolare*, a set number of times around the walls of the gallery space; he published a related book in 1975 and realized variations of this project through 1979. In the 1980s, Anselmo returned to the use of stones, this time hanging arrangements of stone blocks with steel cable along a vertical wall, again stressing the physical and visual tensions created by a natural force, that of gravity.

In 1979, a traveling exhibition of Anselmo's work opened at the Kunsthalle Basel and proceeded to the Stedelijk Van Abbemuseum. The artist has had a number of significant exhibitions in France, including one-person shows at the Musée de Grenoble in 1980 and at the Musée d'art moderne de la Ville de Paris in 1985. Retrospectives have been held at the Musée d'art contemporain, Lyon, in 1989, and most recently, at the Musée d'art moderne et d'art contemporain de la Ville de Nice in 1996. Anselmo lives and works in Turin.

Untitled (Structure That Eats)(Senza titolo [Struttura che mangia]), 1968 (cat. no. 326)

The notion of temporality is an essential component of this work, which the artist calls *Structure That Eats* to describe its manner of functioning. As in fact is often the case in the work of this Italian artist, the initial absence of a title makes the viewer more carefully observant and understanding of the processes that are being suggested. The supplemental description is added to give the appearance of intentional information, and suggests that Anselmo likes to formalize his experimentations with the fundamental laws governing

the universe, while rejecting all oneiric or fictional modes of representation.

Untitled (Structure That Eats) is in fact subjected to a simple evolutionary process: a small block of granite is suspended by a copper wire attached to a column made of the same stone. Between the block and the column, acting as a paradoxical sort of stay, is a head of lettuce that must be watered to prevent it from wilting too fast and causing the block to fall.

Between the juxtaposed materials and densities, the cut forms and free forms, the vegetable and mineral realms, the work stands as a moment of precarious equilibrium that one must maintain, in both the figurative and literal senses. The lettuce will absorb the water sprinkled on it, and the sawdust at the base of the granite shaft will absorb it as well. This process, kept alive like a precarious, fragile organism, thus asserts its integration into the realm of real time.

Once the metaphor has been described, one notes how every one of Anselmo's works offers a contingent, philosophical reflection on the very nature of artistic activity and its integration into the world. Combining the inexpressible and the sensate, at the confines of a phenomenology and a poetics of perception, the artistic gesture reveals itself in all its humility. It manifests Anselmo's concern for being at once a witness and revealer of fundamental universal laws. As material becomes symbol and the work becomes metaphor, Anselmo's work affirms that necessary moment of "possession of reality" that art historian Germano Celant recognized as being at the core of this artist's activity. — B.B.

Karel Appel

b. 1921

Karel Appel was born April 25, 1921, in Amsterdam. From 1940 to 1943, he studied at the Rijksakademie van Beeldende Kunsten, Amsterdam. In 1946, his first solo show was held at the Het Beerenhuis, Groningen, and he participated in the *Jonge Schilders* exhibition at the Stedelijk Museum, Amsterdam. About this time, Appel was influenced by Henri Matisse and Pablo Picasso; however, the most visible connection to his work is Jean Dubuffet's naive style. Appel was a member of the Nederlandse Experimentele

Groep and established the CoBrA movement in 1948 with George Constant, Corneille, and Asger Jorn, among others. Named after the cities Copenhagen, Brussels, and Amsterdam, the CoBrA group advocated a childlike spontaneity and a raw expressivity of gesture in art.

Appel's large-scale canvases, with their thick applications of vibrant color, have been honored and exhibited in numerous international contexts. In 1949, Appel completed a fresco for the cafeteria of the Amsterdam city hall, which initially created such controversy that it was kept covered for ten years. In 1950, the artist moved to Paris; there the writer Hugo Claus introduced him to Michel Tapié, who organized various exhibitions of his work. Appel was the subject of a solo show at the Palais des Beaux-Arts, Brussels, in 1953. He received the UNESCO Prize at the Venice *Biennale* in 1954 and was commissioned to execute a mural for the restaurant of the Stedelijk Museum in 1956. The following year, Appel traveled to Mexico and the United States and won a graphics prize at the Ljubljana *Biennial*. He was awarded international prizes for painting at the São Paulo *Bienal* in 1959 and the *Guggenheim International Exhibition* at the Solomon R. Guggenheim Museum, New York, in 1960. The first major monograph on Appel, written by Claus, was published in 1962. In the late 1960s, the artist moved to the Château de Molesmes, near Auxerre, southeast of Paris. Solo exhibitions of his work were held at the Centre national d'art contemporain, Paris, and the Stedelijk Museum in 1968 and the Kunsthalle Basel and the Palais des Beaux-Arts in 1969. During the 1950s and 1960s, he executed numerous murals for public buildings. An Appel show opened at the Centraal Museum, Utrecht, in 1970, and a retrospective of his work toured Canada and the United States in 1972. Additional retrospectives were organized in the United States in 1974 and South America in 1978.

Exhibitions in the 1980s included *Karel Appel: Works on Paper*, which opened at the Haags Gemeentemuseum in 1982 and traveled throughout Europe. This decade also marked the beginning of the artist's major theater work. In 1987, the Paris Opera commissioned Appel to conceive and design a ballet, *Can We Dance a Landscape?*, which was also performed at the Brooklyn Academy of Music, New York, in 1989 and the Het Musiek Theater, Amsterdam, in 1994. The National Museum of Contemporary Art, Seoul, organized *Karel Appel Retrospective*, which traveled to the Kaohsiung Museum of Fine Arts in 1994, and a catalogue raisonné of his sculpture written by Donald Kuspit was published that same year. Appel lives and works in New York and Italy.

Questioning Children (Vragende Kinderen), 1948 (cat. no. 260)

The great number of reliefs, wood-panel paintings, mural paintings, gouaches, and studies produced by Appel from 1946 to 1951 with titles such as *Inquiring Children, Interrogative Children,* or

Questioning Children, well attests to the "totemic" power the artist invested in this subject. This wood-panel painting is similar to those in the Stedelijk Museum, to the wall decorations of the Eryk Nyholm house in Silkeborg, and to the frescoes in the cafeteria of the Amsterdam Town Hall (both of which are for the most part destroyed). As early as 1946, he described this work to Corneille as "now potent, primitive, stronger than *art nègre* and Picasso." By 1948, the paintings marked his full adherence to the CoBrA group of artists.

These works are emblematic of Appel's "liberation" from all aesthetics. Through the frontal effigies—crudely cut into rough wood and painted in elementary fashion, like dolls made by children—he rediscovers, in fact, the childhood of art. And the pleasure of simply cutting wood and nailing and coloring is the same as that of the instinctual free play that is preliminary and necessary (perhaps more so for Appel than for Corneille and Constant) to every creative act. (The notion of play launched by Johan Huizinga's work in 1939 had resonance among Dutch artists.)

The theme of the child, so dear to the CoBrA group, here becomes magnified, moreover, by Appel's characteristic violence and material immediacy, emblematic of revolt and truth—*Innocence Accuses* was the title of another work exhibited in 1949. The primary, frontal figures of *Questioning Children*, with only the eyes and mouth indicated, look like the clairvoyant witnesses of an intolerable sociopolitical situation; the derisory, defenseless actors of an impotent rebellion or a disturbing demand. The bourgeoisie of Amsterdam knew what they were doing when they insisted that the large frieze of *Questioning Children*, executed by Appel at the Town Hall, be covered up. The CoBrA group quickly mobilized, with a tract by Aldo van Eyck, "An Appeal to the Imagination," and the intervention of Christian Dotremont, who wrote, "Appel made something violent, but of a proper, popular violence: Appel is a man of the people; he does not have the old surrealist sense of scandal." The scandal created by *Questioning Children* was comparable to that triggered by the CoBrA exhibition at the Stedelijk Museum, and was certainly a contributing factor in Appel's decision to leave Amsterdam (with Constant and Corneille) late in 1950. — A. L. B.

Alexander Archipenko
1887–1964

Alexander Archipenko was born May 30, 1887, in Kiev. In 1902, he entered the Kiev Art School, where he studied painting and sculpture until 1905. During this time, he was impressed by the Byzantine icons, frescoes, and mosaics of Kiev. After a sojourn in Moscow, Archipenko moved to Paris in 1908. He attended the Ecole des Beaux-Arts for a brief period and then continued to study independently at the Musée du Louvre, where he was drawn to Egyptian, Assyrian, archaic Greek, and early Gothic sculpture. In 1910, he began exhibiting at the Salon des Indépendants, Paris, and the following year showed for the first time at the Salon d'Automne.

In 1912, Archipenko was given his first solo show in Germany at the Folkwang Museum, Hagen. That same year, in Paris, he opened the first of his many art schools, joined the Section d'Or group, which included Georges Braque, Marcel Duchamp, Fernand Léger, and Pablo Picasso, among others, and produced his first painted reliefs, the *Sculpto-Peintures*. In 1913, Archipenko exhibited at the Armory Show in New York and made his first prints, which were reproduced in the Italian Futurist publication *Lacerba* in 1914. He participated in the Salon des Indépendants in 1914 and the Venice *Biennale* in 1920. During the war years, the artist resided in Cimiez, a suburb of Nice. From 1919 to 1921, he traveled to Geneva, Zurich, Paris, London, Brussels, Athens, and other European cities to exhibit his work. Archipenko's first solo show in the United States was held at the Société Anonyme, New York, in 1921.

In 1923, he moved from Berlin to the United States, where over the years he opened art schools in New York City; Woodstock, New York; Los Angeles; and Chicago. In 1924, Archipenko invented his first kinetic work, *Archipentura*. For the next thirty years, he taught throughout the United States at art schools and universities, including the short-lived New Bauhaus. He became a United States citizen in 1928. Most of Archipenko's work in German museums was confiscated by the Nazis in their purge of "degenerate art." In 1947, he produced the first of his sculptures that are illuminated from within. He accom-

panied an exhibition of his work throughout Germany in 1955, and at this time began his book *Archipenko: Fifty Creative Years 1908–1958*, published in 1960. Archipenko died February 25, 1964, in New York.

Carrousel Pierrot, 1913 (cat. no. 66)

Carrousel Pierrot fits into Archipenko's lifelong fascination with the possibilities of polychromy and the abstract figure in the round. It was made during a period when sculptural representations of dynamism and movement interested Archipenko and others, including his colleague Raymond Duchamp-Villon; both of their works on such themes show the influence of Italian Futurist sculptures with their complex integrations of forceful volumes.

Reminiscing about the origin of this particular work, Archipenko later recalled that he was inspired by a festival in which "dozens of carousels with horses, swings, gondolas and airplanes imitate the rotation of the earth." Indeed, the dynamic arcs and spheres of this sculpture conjure sensations of a spinning carousel and of planetary movement, encouraging viewers to walk full circle around the piece to take in all of its volumetric play. The inscription, "venez rire," invites us to "come laugh," to revel in the festivities, or perhaps to laugh at the antics of the figure that is simultaneously represented by this sculpture. Pierrot, the popular clownlike character from commedia dell'arte, may be recognized here by his tight-fitting cap and broad ruffed collar. Like his Cubist colleagues, Archipenko was drawn to themes of harlequins, acrobats, and jesters, which were seen as stand-ins for the artistic persona; they also offered a unique package of shapes and colors for formal resolution. — SRGM

Boxing (*La Boxe*), 1913–14 (cat. no. 67)

Two plaster versions of *Boxing* were made from the same mold in 1913–14. Informally known as *Struggle*, these early versions are in the collection of the Solomon R. Guggenheim Museum and at the Saarland Museum, Saarbrücken; a third version at the Peggy Guggenheim Collection, Venice, made from terra-cotta, is slightly larger and later, dating from 1935. The artist explains the choice of subject for these works in a poetic inscription at the base of the 1935 work: "'la boxe'—C'est la musique monumental [sic] des volumes d'éspace [sic] et de la matière" ("boxing"—it is the monumental music of volumes of space and of material). The thrusting figures of the two contenders are joined inextricably in opposition, forming an aggressively charged sculptural whole. Apart from the work of the Italian Futurists, few sculptures of this period combine such a radical essentialization of form with virile, assertive dynamism in the manner of *Boxing*. — L. F.

Médrano II, 1913–14? (cat. no. 68)

No doubt it was a sense of pride and more than an inkling of historical place that prompted the young Archipenko to inscribe this work with his name and "1913 Paris." Soon after arriving in Paris at the age of twenty, the Ukrainian artist could claim membership in the prestigious Section d'Or group, putting him in the company of Guillaume Apollinaire, the Duchamp brothers (Marcel Duchamp, Raymond Duchamp-Villon, and Jacques Villon), and Picasso. *Médrano II* is a souvenir of this heady time.

It is probably the only remaining work from his pioneering experiments with diverse, incongruous materials in 1912 and 1913. To create *Médrano I* (1912; now destroyed), he combined wood, glass, sheet metal, and found objects to represent an abstracted juggler; *Médrano II*, made of similar components, instead represents a female figure, perhaps a dancer. The volumes are organized along a slightly tipped, vertical axis, defining the figure by means of projecting planes. Archipenko has placed her, theatrically, in front of a flat background, thereby controlling the spectator's vantage point of the sculpture. While this highly experimental assemblage bears comparison to Cubist works of the same period, it also relates to Archipenko's native traditions—to his interest in the integrated materials of icons, and to his knowledge of the concept of *Faktura* (a Russian term meaning "materials" or "texture"), which focused on the ways in which specific materials generate specific kinds of form. Accordingly, and perhaps with *Médrano I* and *II* in mind, Archipenko later wrote, "a sheet of bent metal has only two possible geometric bendings—cylindrical or conical."

None of Archipenko's colleagues could have missed the allusions in these works to the vogue for puppetry, to the jesters in Picasso's paintings, or to the Cirque Médrano, the famous Parisian circus frequented by many artists. — SRGM

Two Glasses on a Table (*Deux verres sur une table*), 1919–20 (cat. no. 69)

Begun in 1912, Archipenko's assembled and painted reliefs, which he called "sculpto-paintings," include a small group of still lifes the artist created out of papier-mâché and wood between 1916 and 1921. As Archipenko described, "the sculpto-painting is not only a renaissance of the now forgotten tendency to combine form and color; it is rather a new means of expression in art, born of a union and a specific amalgamation of materials, shapes and colors." He further specified, "The unification of color and shape does not hinder spiritualization; on the contrary, it facilitates the expression of the abstract in this means of expression." His small still lifes of 1916–21 are characterized by somber ranges of color, akin to the Cubist constructions of Braque, Juan Gris, Henri Laurens, Jacques Lipchitz, and Picasso. Certain motifs—a pitcher of water, the tabletop inclined at a precarious angle and supported by a turned wooden leg, a dotted or checked tablecloth

or napkins, stemmed glasses seen from above or in profile—are found again and again, arranged different ways, in Archipenko's lithographs, drawings, and paintings from these years. We note, however, that unlike the other Cubist artists, Archipenko introduced a more systematic, at times gratuitous, decorative fantasy that caused him ceaselessly to vacillate in his compositions between naturalist illusions and geometricized abstractions.

In *Two Glasses on a Table*, the tabletop is reduced to a few sharp angles brutally tilted up to the vertical plane, the tablecloth is suggested by a wavy line, and the stemmed glasses are two hourglass forms. Using a great economy of means and somber elegance, Archipenko reaches the most extreme point of abstract simplification in these still lifes. — J. P. A.

Jean Arp
1886–1966

Jean (Hans) Arp was born September 16, 1886, in Strasbourg. In 1904, after leaving the Ecole des arts et métiers, Strasbourg, he visited Paris and published his poetry for the first time. From 1905 to 1907, Arp studied at the Kunstschule, Weimar, and in 1908 went to Paris, where he attended the Académie Julian. In 1909, he moved to Switzerland and in 1911 was a founder of the Moderner Bund group there. The following year, he met Robert and Sonia Delaunay in Paris and Vasily Kandinsky in Munich. Arp participated in the *Erste deutsche Herbstsalon* in 1913 at the gallery Der Sturm, Berlin. After returning to Paris in 1914, he became acquainted with Guillaume Apollinaire, Max Jacob, and Pablo Picasso. In 1915, he moved to Zurich, where he executed collages and tapestries, often in collaboration with his future wife Sophie Taeuber (who became known as Sophie Taeuber-Arp after they married in 1922).

In 1916, Hugo Ball opened the Cabaret Voltaire, which was to become the center of Dada activities in Zurich for a group that included Arp, Marcel Janco, Tristan Tzara, and others. Arp continued his involvement with Dada after moving to

Cologne in 1919. In 1922, he participated in the *Kongress der Konstruktivisten* in Weimar. Soon thereafter he began contributing to magazines such as *Merz*, *Mécano*, *De Stijl*, and in 1925 *La Révolution surréaliste*. Arp's work appeared in the first exhibition of the Surrealist group at the Galerie Pierre, Paris, in 1925. In 1926, he settled in Meudon, France.

In 1931, Arp was associated with the Paris-based group Abstraction-Création and the periodical *Transition*. Throughout the 1930s and until the end of his life, he continued to write and publish poetry and essays. In 1942, he fled Meudon for Zurich; he was to make Meudon his primary residence again in 1946. The artist visited New York in 1949 on the occasion of his solo show at Curt Valentin's Buchholz Gallery. In 1950, he was invited to execute a relief for the Harvard Graduate Center in Cambridge, Massachusetts. In 1954, Arp received the International Prize for Sculpture at the Venice *Biennale*. A retrospective of his work was held at the Museum of Modern Art, New York, in 1958, followed by another at the Musée national d'art moderne, Paris, in 1962. Arp died June 7, 1966, in Basel.

Trousse d'un Da, 1920–21 (cat. no. 164)

Immediately after the end of World War I, Arp, who had signed the first manifesto of German Dadaists in April 1918, made contact with the movement's members in Berlin. During this time, Arp became friends with one of the group's "outsiders," Kurt Schwitters, whom he described as the man who "took part in the Dada campaign against the armies of the 'Golden Section' and challenged all professors of art history to a duel." Many of Arp's works were published thanks to Schwitters's intervention, and the two even began to write a novel together. Their collaboration extended into the realm of the plastic arts, as well; Arp apparently worked on Schwitters's gigantic undertaking in Hannover, the *Merzbau* (1920–35).

Two unusual objects that defy classification clearly belong to this period: *Trousse d'un Da* (formerly in Tzara's collection) and *Travel Kit of a Castaway*, both of which have been regularly exhibited since 1936 in shows devoted to Dada and Surrealism. Both are made from pieces of driftwood nailed to a wooden plank, with a few of the pieces summarily coated with paint. These assemblages are usually considered to date from the summer of 1920, a period that Arp and Taeuber spent on the island of Sylt. Yet their resemblance to an assemblage by Schwitters, *Die breite Schnurchel*, that is similarly composed from fragments of found wood, raises the possibility that they were made during the summer of 1923, when Schwitters and Arp (accompanied by their families and Hannah Höch) were together on the island of Rugen, working on their unfinished novel. — MNAM

Dancer (Danseuse), 1925 (cat. no. 166)

Arp rejected the hegemony of easel painting in 1915 and began exhibiting embroideries executed, from his preparatory drawings, first by Madame Van Rees and later by Taeuber. With the first reliefs of 1916–17, Arp discovered the properties of unadorned or painted wood, the beauty of a simple, thick, cut-out form standing out against a background of the same wood or against the wall. His *Forests*, the first *Dada Reliefs*, with rather crude edges and obvious faces, and the exceptional constructions of found wood, commonly called "driftwoods," such as *Trousse d'un Da*, were small in size. Sometimes the artist worked not by addition but by cutting out an empty space in the support, as seen in the hollowed-out left leg of the well-known *Dancer*, which bears comparison to his wood reliefs but would actually be a large painted wooden panel, so slightly are the elements raised in relief, if it were not for the unexpected void yawning in the background. The dancer has only one leg, but the missing leg, thanks to Arp's artifice, is what commands all our attention. Following this period, Arp gradually renounced harsh colors and, even while experimenting with free-floating forms, attempted to fix them in a tight framework, marking the boundary of his miniature theater. — Ch. D.

Antonin Artaud
1896–1948

Antonin Artaud was born September 4, 1896, in Marseilles. He suffered early childhood illnesses that induced a lifelong drug addiction. In 1920, he moved to Paris determined to become a writer. He soon became involved with the Surrealists, forming friendships with Balthus, André Breton, André Masson, Joan Miró, and others. His wide range of interests led him to perform in theater and films and to publish prose poems, art criticism, and film scenarios.

During the early 1930s, he wrote his two seminal and influential manifestos on the "theater of cruelty." He traveled to Mexico in 1936 and then to Ireland, where he experienced periods of creative output as well as psychological instability. He

consequently drew his first "Spells," torn and stained missives in which he insulted and cast spells on his correspondents. From that time on, his graphic production paralleled his writings, both of which defied all cultural and social values.

Upon his return to France in 1937, Artaud was interned in many psychiatric hospitals, including one in Rodez, where he was confined from 1943 to 1946. There, he overcame the devastating experience of electroshock therapy by writing and by drawing with graphite and wax crayons. *The Rodez Drawings* (1945–46) are violent, scattered images that mirrored the artist's hallucinatory visions as well as the acute psychological and physical pain he was suffering.

In June 1946, Artaud took up residence at a less restrictive clinic in Ivry, near Paris. He produced a series of intense portraits and self-portraits, some of which were exhibited at the Galerie Pierre Loeb in July 1947. He died of cancer in March 1948 in Ivry.

Portrait of Jacques Marie Prevel (*Portrait de Jacques Marie Prevel*), 1947 (cat. no. 199)

During the same period Artaud was writing the *Notebooks*—squared pages invaded by an uninterrupted flow of a gestured, voiceless writing, made up of words, cabalistic signs, marks, figures, and what he termed "human architectures"—begun in 1945, he tried his hand, on separate sheets of paper, at making large drawings, which he called his "documents." The commanding presence here is that of Artaud's ordinary graphite pencil, at times sharp and vibrant, at times crushed into black clots on the paper, or blurring into waves, shadows, and lights. He sometimes used colored pencils and chalks too—mostly blazing ochre and blue—to illuminate the "totems of being" of this impossible theater of cruelty. In the drawings made when Artaud was preparing to leave Rodez, the human face—either his alone or those of his loved ones and friends—began to emerge from the middle of the page.

Placed on the neck of what Artaud called the "ball of cries," the head of the poet Jacques Marie Prevel looks as if it is screaming: the overly sensual mouth, the large, lumpy forehead, and most important, the eyes, with their veiled, pained, gaze, reveal the secret of an inner torment from which Artaud may be protecting his friend, or to which he may, in fact, be condemning him. He inscribes Prevel's face within a space charged by words that hammer out a dramatic incantation: "If Jacques Marie Prevel could only know what Sin squashes him, and I who do not believe in Sin, I tell of what / Sin put upon him Jacques Prevel squashes, that Jacques Prevel not leave the / Sin that his whole face meditates, that in him Marie premeditates against Jacques Prevel. / The broken Androgyne picked the one back up and tempted the man with it but / in fact he was tempting the woman with it at the same time and Satan the madman was everywhere."

Artaud attempts through drawing and writing, to nail down, to confront what human existence has become—what he calls in other writings from this period, "an empty force, a field of death." He forces us to stare at the unbearable gazing face, where all the energy of the absent body has been burned to a devastated ball of ashes. —A. L. B.

Untitled, ca. 1948 (cat. no. 200)

The body, described by Artaud as an inorganic and fleshless "gangly jumping-jack," an architecturally impossible "machine of being," vanishes from the large drawings he made after going to Ivry. Now, instead, heads have been brutally severed at the neck: a necessary mutilation, a vital separation from what Artaud saw as a formless, painful mass, an accumulation without organs.

Not until Artaud's last drawings from December 1947 to February 1948, the period preceding his death, does a bodily structure reappear on the page, though here it is essentially comprised of an accumulation of heads. These heads, which include Artaud's own face, are those of the "daughters of the heart yet to be born," as Artaud's poet friends Paule Thévenin and Minouche Pastier have called them. The heads multiply, pile up, become superimposed; they constitute human poles, "piers" according to Artaud, reminiscent of protective fetishes, or the totems of the island of New Ireland. In *Untitled*, a late drawing probably made a month before his death, Artaud attempts the impossible task of erecting fragments of bodies already ravaged by death. The pencil traces a network of lines that sweep across space in every direction, interlacing and encircling the vertical pseudofigures, as if through such a "corpus" of outlines he might effect a transubstantiation of the exploded, residual debris of his own body "yet to be born." The customary severed head—or rather, the grotesque mask, which is already the death-mask of the poet with oddly skewed gaze—juts out three times over the three columns made up of heads, hands, breasts, and totems: motley, derisory trophies, *disjuncta membra* that have always constituted the "beingness" of Artaud. The sharp-edged scratches of the lead pencil, like knife blades with metallic sheen, etch the page with strokes by turns tight and loose, light and crushed into dense punctuations. There is a sonorous energy—here grating, there modulated—that emanates from this graphic orchestration as if from a jousting duel; gesture and breath, shouts and whistlings can almost be heard. The sketched marks are Artaud's defense against the invading forces of the formless, inert "support" of the paper itself, which he never ceased to combat. —A. L. B.

Francis Bacon

1909–1992

Francis Bacon was born October 28, 1909, in Dublin. At the age of sixteen, he moved to London and subsequently lived for about two years in Berlin and Paris. Although Bacon never attended art school he began to draw and work in watercolor about 1926–27. Pablo Picasso's work decisively influenced his painting until the mid-1940s. Upon his return to London in 1929, he established himself as a furniture designer and interior designer. He began to use oils in the fall of that year and exhibited a few paintings as well as furniture and rugs in his studio. His work was included in a group exhibition in London at the Mayor Gallery in 1933. In 1934, the artist organized his own first solo show at Sunderland House, London, which he called Transition Gallery for the occasion. He participated in a group show at Thomas Agnew and Sons, London, in 1937.

Bacon painted relatively little after his solo show and in the 1930s and early 1940s destroyed many of his works. He began to paint intensively again in 1944. His first major solo show took place at the Hanover Gallery, London, in 1949. From the mid-1940s to the 1950s, Bacon's work reflected the influence of Surrealism. In the 1950s, Bacon drew on such sources as Velázquez's *Portrait of Pope Innocent X* (1649–50), Vincent van Gogh's *The Painter on the Road to Tarascon* (1888), and Eadweard Muybridge's photographs. His first solo exhibition outside England was held in 1953 at Durlacher Brothers, New York. In 1950–51 and 1952, the artist traveled to South Africa. He visited Italy in 1954 when his work was featured in the British Pavilion at the Venice *Biennale*. His first retrospective was held at the Institute of Contemporary Art, London, in 1955. Bacon was given a solo show at the São Paulo *Bienal* in 1959. In 1962, the Tate Gallery, London, organized a Bacon retrospective, a modified version of which

traveled to Mannheim, Turin, Zurich, and Amsterdam. Other important exhibitions of his work were held at the Solomon R. Guggenheim Museum, New York, in 1963 and the Grand Palais in Paris in 1971; paintings from 1968 to 1974 were exhibited at the Metropolitan Museum of Art, New York, in 1975. He was honored with two retrospectives of his work, one at the Museum of Modern Art, New York, in 1989 and another at the Musée national d'art moderne, Paris, in 1996. The artist died April 28, 1992, in Madrid.

Three Studies for a Crucifixion, March 1962 (cat. no. 263)

In 1944, one of the most devastating years of World War II, Bacon painted *Three Studies for Figures at the Base of a Crucifixion*. With this horrific triptych depicting vaguely anthropomorphic creatures writhing in anguish, Bacon established his reputation as one of England's foremost figurative painters and a ruthless chronicler of the human condition. During the ensuing years, certain disturbing subjects recurred in Bacon's oeuvre: disembodied, almost faceless portraits; mangled bodies resembling animal carcasses; images of screaming figures; and idiosyncratic versions of the Crucifixion.

One of the most frequently represented subjects in Western art, the Crucifixion has come to symbolize far more than the historical and religious event itself. Rendered in modern times by such artists as Paul Gauguin, Pablo Picasso, and Barnett Newman, this theme bespeaks human suffering on a universal scale while also addressing individual pain. The Crucifixion appeared in Bacon's work as early as 1933. Even though he was an avowedly irreligious man, Bacon viewed the Crucifixion as a "magnificent armature" from which to suspend "all types of feeling and sensation." It provided the artist with a predetermined format on which to inscribe his own interpretive renderings, allowing him to evade narrative content—he disdained painting as illustration—and to concentrate, instead, on emotional and perceptual evocation. His persistent use of the triptych format (also traditionally associated with religious painting) furthered the narrative disjunction in the works through the physical separation of the elements that comprise them.

That Bacon saw a connection between the brutality of slaughterhouses and the Crucifixion is particularly evident in the 1962 *Three Studies for a Crucifixion*. The crucified figure slithering down the cross in the right panel, a form derived from the sinuous body of Christ in Cimabue's renowned thirteenth-century *Crucifixion*, is splayed open like the butchered carcass of an animal. Slabs of meat in the left panel corroborate this reading. Bacon believed that animals in slaughterhouses suspect their ultimate fate. Seeing a parallel current in the human experience—as symbolized by the Crucifixion in that it represents the inevitability of death—he explained, "we are meat, we are potential carcasses." The bul-

bous, bloodied man lying on the divan in the center further expresses this notion by embodying human mortality. — N. S.

Balthus
b. 1908

Count Balthazar Klossowski de Rola was born February 29, 1908, in Paris, to Polish parents. He later adopted the pseudonym Balthus, an abbreviated version of his given name. As a young man he lived in Switzerland and Berlin. Because his parents frequented a largely artistic international milieu, Balthus was exposed to contemporary art and literature as a child. At the age of twelve, he published a book of drawings with a preface by Rainer Maria Rilke. Balthus settled in Paris in 1924 and had his first solo show there at the Galerie Druet. Although he briefly studied art during that year, Balthus was largely a self-taught painter. He learned from the old master paintings in the Musée du Louvre, and traveled to Italy where he viewed the work of the Italian Primitives and Piero della Francesca. In 1929, Balthus was conscripted into the French army and stationed in Morocco, serving until 1933.

Upon leaving the military, Balthus had a solo exhibition in 1934 at the Galerie Pierre, Paris. This exhibition provoked a scandal due to his predilection for painting pubescent girls in suggestive poses, a theme to which he has adhered throughout his career. Balthus frequently imbued these paintings with erotic overtones by providing a voyeuristic glimpse of a girl's breast or undergarments. At this time, Balthus also made forays into the Parisian theater, creating the sets and costumes for a production of William Shakespeare's *As You Like It* in 1934 and for Antonin Artaud's *Les Cenci* in 1935.

Balthus's paintings, whether of young girls, portraits, or landscapes, are executed in a "naive" style. Though he matured in an era when European art was shifting toward more abstracted compositions dominated by formal concerns, he

rejected Modernist styles, opting to practice his own individualized method of figurative painting. His works are characterized by flattened forms, a muted palette, and stiff figures awkwardly posed in static arrangements that are influenced more by the Italian Primitives than by contemporaneous artistic trends. Balthus returned to theatrical endeavors, designing the sets and costumes for Albert Camus's *L'Etat de siège* in 1948 and for the Mozart opera *Così fan tutte* in 1950. In 1954, Balthus moved to Morvan, France.

Balthus became the director of the French Academy in Rome in 1961, remaining in charge of this institution until 1977. In 1966, the Musée des arts decoratifs, Paris, presented an exhibition on Balthus. Two years later, the Tate Gallery, London, had a show. The painter was recognized with an exhibition at the Venice *Biennale* as well as one at the Museum of Contemporary Art, Chicago, in 1980. In 1983, he received the Premio Via Condotti prize in Rome. In that same year, a retrospective was organized by the Musée national d'art moderne, Paris, in collaboration with the Metropolitan Museum of Art, New York, where the show was presented in 1984. An exhibition of Balthus's works on paper was held at the Kunstmuseum, Bern, in 1994, and a retrospective of his work was shown at the Centro de Arte Reina Sofía, Madrid, in 1996. Balthus currently lives in Vaud, Switzerland.

Alice, 1933 (cat. no. 183)

Together with three other large paintings of 1933—*The Street*, *La Toilette de Cathy* (Musée national d'art moderne, Paris), and *The Guitar Lesson*—*Alice* can be considered an inauguration of Balthus's unique, marginal oeuvre. This painting shows remnants of his early work, characterized by an attraction to fables—as in the forty images he drew for *Mitsou*, published in 1921— or to popular novels, as when he later illustrated Emily Brontë's *Wuthering Heights* in 1934. At the same time, this painting already establishes itself as a major work, violent and unusual in its inspiration. Confronted with the "facilities" of Surrealism denounced by the poet Pierre Jean Jouve and the nostalgic call for a "return to order" of Balthus's friend André Derain, as well as others, Balthus asserted a painting style from 1934 onward that is characterized at once by a brutal realism and a quasi-hallucinatory unreality.

Alice is surprised half-naked in her daily ritual of dressing, exposed to the viewer's gaze, but she is strangely indifferent, unaware. She is situated in her familiar context (with the chair and walls reflecting a drab, banal interior), but captured, "set" in an angular, consciously restricted, almost empty space, mounted like a gem. Her body is solid, precise, with living, present flesh, but her gaze is transparent, pallid, almost dead or blind. The whole scene is bathed in amber light, perhaps from the morning sun, but its incandescence and artificiality have the blinding brightness of a dream. One is struck not by the violent, acidic

"realism" of the image (reminiscent of Neue Sachlichkeit painters Otto Dix, as in his 1932 painting *Venus with Black Gloves*, and Christian Schad, as in his *Two Girls*, 1928), but rather by the feeling of some secret that promises to be unveiled, the grave splendor of a silent mystery. There is the overwhelming impression of a *tableau vivant*. In fact, it is hardly surprising that the first person to write about this painting was Artaud, who conceived his mise-en-scène for the Théâtre Alfred Jarry with nine "tableaux vivants" in 1930, and whose definition of the "theater of cruelty" dates precisely from 1932.

The almost austere sobriety of the painting, unified by its color, magnifies the vibration of the whole space, caused by the oblique poses of the arm and the leg, and the slightly arched, vertical tension of the body. Balthus demonstrates a particularly theatrical grasp of the space and subject: this "real allegory" indeed possesses a turbid power of revelation, intensified by the allure of the girl's hair, falling in flamelike coils, by that of her pubescent sex, and by the more somber, harder allure of her blue leather ballerina shoes (reminiscent of those in Gustave Courbet's portrait *Béatrice Bouvet*, 1864). The painting's pearl-like radiance has an extraordinary intensity, like that of a true icon, of a vertical majestic image. —A. L. B.

Martin Barré

1924–1993

Martin Barré was born September 22, 1924, in Nantes. His early interest in Kazimir Malevich and Piet Mondrian was at odds with the Parisian artistic scene of the mid-1950s. Although Art Informel painters like Pierre Soulages were exploring the notion of spontaneity through gestural brushwork, Barré started a lifelong commitment to conceptual work and dealt with questions of time and space through rigorous, analytical abstract paintings.

His first exhibition took place at the Galerie La Roue, Paris, in 1954. In this period, Barré painted with a knife and started to reduce his pictorial means to a minimum. His technique of painting straight from the tube of paint during the 1960s developed this idea further. The works were made up of black lines highlighted sporadically with color. During this decade, he also started to name his paintings by their sizes, pushing the Modernist logic of reducing a picture to its intrinsic elements.

From 1963 to 1967, Barré became fascinated with the spray-painted graffiti he saw in the subway system. He subsequently produced a series of sprayed black lines on a white background and in another series stenciled graffiti-like arrows onto canvases. To remove himself completely from the act of painting, he eventually began to experiment with photography. In 1969, at the Galerie Daniel Templon, Paris, he exhibited photographs of his paintings next to his final paintings in order to enhance the spectators' awareness of how a work is perceived and experienced.

He returned to painting by creating a series of twenty-four works in 1972. Until the end of the 1970s, his work was characterized by the repetition of parallel lines that filled spaces within grids and that sometimes caused a vibrating effect on the viewer's retina. In addition, the artist sometimes overlapped these grids and hatch marks, emphasizing the elements of time and process.

In a large series of works from the 1980s, Barré submitted color itself to serial rules. His late works are characterized by an extreme austerity. In 1988, he received the Grand Prix national des arts from the French government. He was honored with many solo exhibitions throughout his lifetime. In 1993, the Galerie nationale du Jeu de Paume, Paris, organized a retrospective of his latest work. Barré died in July 1993.

"60-T-45", 1960 (cat. no. 334)

Continuing his tendency toward the extreme reduction of pictorial means in order to achieve greater concentration, Barré explored in 1960 the possibilities of line as a progression of the hand, as the gesture of appropriating perceptual space. In *"60-T-45"*, the artist's first quadriptych, a graphic sign, utterly naked, is marked directly from the tube onto four adjoining canvas panels that have been left white. The tube is used only because it allows a direct connection between the body and the pigment. There is more than one gesture, however: the first black outline is as though reevaluated and strengthened in spots by another color. Also noticeable are some widely spaced "hatchings," which later become the object of more involved investigation. The artist's initial intention, the dispersion of the four elements in space, is hinted at by a slight deviation that introduces a kind of tension between the different panels. This intervention shatters the preestablished coherence of the outline and suggests the bursting apart of the picture. It highlights the temporal and spatial fragmentation of the subject, but at the same time it also calls attention to the bond that each work—and each element of this quadriptych—maintains with other works present and absent. —MNAM

"67-2-26-70 x 53", 1967 (cat. no. 335)

"I do not paint Venuses or apples or my most recent dreams. I paint paintings, pictorial propositions, questions on or addressed to painting." These few words sum up the plastic concerns of Barré, who always preferred to consider painting a method of construction rather than a means of expression. This position "between affirmation and questioning" immediately set him off from the artists of the Ecole de Paris of the same epoch, whether they are called abstract, lyrical, gestural, or informal, and it explains the incomprehension with which his work was met for a long time.

He patiently and systematically asked these questions since the beginning of the 1950s, through, notably, his paintings with small regularly spaced self-contained strokes that clash with the white of the canvas. However, he did maintain one certitude, upon which he based his entire work, which is that of painting seen as a flat surface "torn from the wall," upon which the artist circumscribed the field by exploring its limits. The first point was to "suppress all tops and bottoms," reducing color and shape to their simplest expression, in order to allow the gesture alone to speak. "All painting is the product of gestures, even if they are slow, even in a painting by Ingres," he insisted.

The paintings created directly from the tube in the early 1960s, which depict a single line winding across the picture plane, bear witness to the extreme nature of Barré's economy of means and rejection of composition. "I always paint on the uppermost surface of the canvas," he later said. With his discovery of spray paint in 1963, Barré arrived at the neutrality, reduction, and concentration he had long been seeking.

Indeed, there was no longer any need for containers, tools, or paints; a spray of matte black was enough to imbue the canvas in a few seconds. Sometimes the stroke is a knot, sometimes a short dash, sometimes a slight curve; sometimes the black occupies only a small fraction of the canvas, sometimes, as in *"67-2-26-70 x 53"*, it is streaked across the whole of it. The attack always originates at the edges, the gesture often brutally interrupts itself, the better to demonstrate the vibration between wall and sign inscribed on the canvas, which Barré never frames. It is the dynamism of the stroke that counts, reinforced by the permanent struggle between black and white. Between

1963 and 1967, the artist created more than a hundred works with this process. In them, as art historian Yve-Alain Bois has so aptly written, "the gesture retains something of its virtuality even after having been made." The series is thus theoretically inexhaustible.

How to preserve the appearance of unpredictability in a rigorously serial work (which would become even more rigorous in the 1970s)? How to depict the time "of emergence," of the production of the work, up to the moment of "crystallization" to which it leads? How to show the field and what lies outside it? These are the questions Barré continued to ask himself until his death, always insisting on his attempt "to show the work as a small part of a whole." — Cl. S.

Georg Baselitz

b. 1938

Georg Baselitz was born January 23, 1938, as Hans-Georg Kern, in Deutschbaselitz, in what is later East Germany. In 1956, Baselitz moved to East Berlin, where he studied painting at the Hochschule für bildende und angewandte Kunst. After being expelled, he studied from 1957 to 1962 at the Hochschule der bildenden Künste, West Berlin. During this period, he adopted the surname Baselitz, taken from the name of his birthplace. In searching for alternatives to Socialist Realism and Art Informel, he became interested in anamorphosis and in the art of the mentally ill. With fellow student Eugen Schönebeck, Baselitz staged an exhibition in an abandoned house, accompanied by the *Pandämonisches Manifest I, 1. Version, 1961*, which was published, together with a second version, as a poster announcing the exhibition.

In 1963, Baselitz's first solo exhibition at Galerie Werner & Katz, Berlin, caused a public scandal; several paintings were confiscated for public indecency. In 1965, he spent six months in the Villa Romana, Florence, the first of his yearly visits to Italy. Baselitz moved to Osthofen, near Worms, in 1966, and he began to make woodcuts and started a series of fracture paintings of rural motifs. During this time, he also painted his first pictures in which the subject is upside down, in an effort to overcome the representational, content-driven character of his earlier work. In 1975,

Baselitz moved to Derneburg, near Hildesheim, and also traveled for the first time to New York and to Brazil for the São Paulo *Bienal*. In 1976, a retrospective of his work was organized by the Staatsgalerie Moderner Kunst, Munich. He established a studio in Florence, which he used until 1981. Baselitz was appointed instructor in 1977 and professor the following year at the Staatliche Akademie der Bildenden Künste, Karlsruhe.

In 1980, his reputation established, Baselitz was chosen to represent Germany at the 1980 Venice *Biennale*. During the 1980s and into the 1990s, his work was frequently exhibited at the Michael Werner Galleries, Cologne and New York. In 1980, he left the academy in Karlsruhe to assume a professorship at the Hochschule der Künste, Berlin, which he gave up in 1988 but returned to in the early 1990s. The first volume of the catalogue raisonné of his graphic work was published in 1983 by Galerie Jahn, Munich. In 1987, Baselitz established a studio in Imperia, Italy.

Among the numerous institutions that have presented solo exhibitions and retrospectives of Baselitz's work since the late 1980s are the Sala d'Arme di Palazzo Vecchio, Florence, in 1988 (show traveled to the Hamburger Kunsthalle); the Berlin Nationalgalerie in 1990; the Kunsthaus Zurich in 1990 (show traveled to the Städtische Kunsthalle Düsseldorf); the Kunsthalle der Hypo-Kulturstiftung, Munich, in 1992 (show traveled to the Scottish National Gallery of Modern Art, Edinburgh, and the Museum Moderner Kunst, Vienna); and the Solomon R. Guggenheim Museum, New York, in 1995 (show traveled to Los Angeles, Washington, D.C., and Berlin). The artist exhibits regularly with Michael Werner, Cologne and New York, and PaceWildenstein, New York. He lives and works in Derneburg and Imperia.

Ralf III, 1965 (cat. no. 264)

The first ten years of Baselitz's career are marked by depictions of people afflicted by the weight and size of their own organs, the head and genitals in particular. The feet and ears do not escape this inflation either; they are also features that, according to the artist, are eminently sexual. These hypertrophies force the subjects to live lives of tragic and grotesque immobility. In *Ralf III*, the condition is underscored by the absence of body, as incongruous as the absence of pants would be in a classical portrait. The ear becomes a second head; open, its insides made visible, this Janus head looks forward and listens to the side.

Ralf is the given name of the painter Ralf Winkler, the artist and friend of Baselitz who is better known by his pseudonym, A. R. Penck. The portrait is the third and final state of a series of *Heads* in which a hypertrophied ear is a constant element. In painting his friend's severed head, Baselitz treats the image violently without destroying the friend; he has created a painting that is like a new formulation of the severed head of Saint John the Baptist. — F. H.

Max Beckmann

1884–1950

Max Beckmann was born February 12, 1884, in Leipzig. He began to study art with Carl Frithjof Smith at the Grossherzogliche Kunstschule, Weimar, in 1900 and made his first visit to Paris in 1903–04. During this period, Beckmann began his lifelong practice of keeping a diary, or *Tagebuch*. In the fall of 1904, he settled in Berlin.

In 1913, the artist's first solo show took place at the Galerie Paul Cassirer, Berlin. He was discharged for reasons of health from the medical corps of the German army in 1915 and settled in Frankfurt. In 1925, Beckmann's work was included in the exhibition *New Objectivity* (*Die neue Sachlichkeit*) in Mannheim, and he was appointed professor at the Städelsches Kunstinstitut, Frankfurt. His first show in the United States took place at J. B. Neumann's New Art Circle, New York, in 1926. A large retrospective of his work was held at the Kunsthalle Mannheim in 1928. From 1929 to 1932, he continued to teach in Frankfurt but spent time in Paris during the winters. It was in these years that Beckmann began to use the triptych format. When the Nazis came to power in 1933, Beckmann lost his teaching position and moved to Berlin. In 1937, his work was included in the Nazis' exhibition *Degenerate Art* (*Entartete Kunst*). The day after the show opened in July in Munich, the artist left Germany for Amsterdam, where he remained until 1947. In 1938, he had the first of numerous exhibitions at Curt Valentin's Buchholz Gallery, New York.

Beckmann traveled to Paris and the south of France in 1947 and later that year went to the United States to teach at the School of Fine Arts at Washington University, Saint Louis. The first Beckmann retrospective in the United States took place in 1948 at the City Art Museum, Saint Louis. The artist taught at the University of Colorado, Boulder, during the summer of 1949 and the following fall at the Brooklyn Museum Art School. That year, the artist was awarded first

prize in the exhibition *Painting in the United States, 1949* at the Carnegie Institute, Pittsburgh. He died December 27, 1950, in New York.

Forest Landscape with Lumberjacks (*Waldlandschaft mit Holzfäller*), June 18–September 10, 1927 (cat. no. 180)

The simplicity of the scene depicted in *Forest Landscape with Lumberjacks* reflects the influence of Henri Rousseau: a forest in the background, the cover of trees forming a raised arc, and closer to us, a cabin, a few fallen trees, and lastly in the foreground the woodcutters and a ladder. The painting is precise, without black outlines and strong contrasts; it is stripped down, even naive, with soft, deep shades of green. The space is open, mysterious, and unthreatening, with the noticeable absence of any industrial modernity. In this environment, man is humbled in the face of nature. There is harmonious order in the depiction of the forest landscape, the ladder, and the people; a bucolic quality and natural grandeur tell a fable of mankind's relationship with the environment. The high, vaulted forest resembles the forms of a cathedral, recalling Beckmann's proclamation that "Space, and Space again, is the infinite deity which surrounds us and in which we are ourselves contained."

Forest Landscape with Lumberjacks has none of the cold and jarring aspects of Beckmann's best-known works associated with the Neue Sachlichkeit painters. The softness evident here is a peculiarity he developed in the second half of the 1920s, which usually remains in the shadows. — B. S. A.

Paris Society (*Gesellschaft Paris*), 1931 (cat. no. 181)

Paris Society is Beckmann's portrait of émigrés, aristocrats, businessmen, and intellectuals engaged in disjointed festivity on the eve of the Third Reich. Beckmann was invited to paint this work by the German embassy in Paris. A series of sketches shows that Beckmann had conceived of the composition as early as 1925. By 1931, when he completed it, accusations and slander against the freethinking artist had begun to mount in Germany, and the somber character of *Paris Society* seems to reflect his sense of foreboding. Beckmann spent much time in Paris, but financial hardship stemming from his persecution led him to give up his studio there.

Paris Society is rife with ambiguities. The event depicted is a black-tie party, although the socialites gathered there seem strangely depressed. Some of the figures in the composition were identified by the artist's widow, Mathilde Beckmann. They include the central figure, Beckmann's friend Prince Karl Anton Rohan; the Frankfurt banker Albert Hahn at the far right; the music historian Paul Hirsch seated at the left; the German ambassador Leopold von Hoesch at the lower right, with his head in his hands; and possibly Paul Poiret, the French couturier, standing at the left. But why they are together in this scene and what their

peculiar postures denote remain a matter of speculation.

In café, hotel, and beach scenes, Beckmann had proven himself to be a mordant painter of modern life, and some German critics counted him among the artists of the Neue Sachlichkeit. The universalizing tendency of his moral allegories, however, diverged from the political satire of his colleagues. Beckmann's paintings do not succumb to precise interpretation. In spite of their period detail, they seem to represent a condition rather than a historical moment. — C. L.

Alfi with Mask (*Alfi mit Maske*), 1934 (cat. no. 182)

Like the classical Greek mythologists, Beckmann expressed the human condition through man's confrontations with social upheaval, spiritual intervention, and sexuality. He emerged along with George Grosz and Otto Dix in the late 1910s and early 1920s as a principal voice of Neue Sachlichkeit, a German movement defined less by a specific style than by its orientation toward biting critique.

Beckmann frequently employed subjects whose identity is masked, such as carnival figures, clowns, and actors, as allegories of human endeavor and conduct. Disguise serves as a reminder that reality is a thinly constructed veneer and that the paradox of fantasy is its ability to express truth. *Alfi with Mask* rejoices in the interplay between disclosure and secrecy. Her breasts and upper thighs fully exposed, the reclining model is the epitome of lurid sexuality and confronts the viewer with a direct and determined gaze. Yet the most common and revealing of her features—her face—remains hidden behind a black mask, empowering her with the secret of her identity and disrupting the intimacy established with the viewer. — M. D.

Hans Bellmer

1902–1975

Hans Bellmer was born March 13, 1902, in Kattowitz, Germany. Between 1920 and 1923, he worked in a steel mill and coal mine until he enrolled in the Berlin Technische Hochschule. There he met the artists Otto Dix, George Grosz

(who was his professor), and John Heartfield. After only one year, Bellmer ended his engineering studies and turned to more creative pursuits. In the tradition of Dix and Grosz, he transformed the streets, subways, and cafes into his classroom, learning to critique society through drawing. To support himself, he found employment as a typographer for the publishing firm Malik-Verlag, and worked as a freelance illustrator for other publishers. Bellmer spent the winter of 1924–25 in Paris, where he was influenced by the work of Jules Pascin and Georges Seurat. In 1927, Bellmer opened his own advertising design studio in Berlin.

Between 1931 and 1933 Bellmer traveled to the Mediterranean, including Italy and Tunisia. He gave up his advertising business by the end of 1933 and began to make sculptures out of doll parts, partly inspired by the character of the doll Olympia in Jacques Offenbach's opera *The Tales of Hoffmann*. In their many future incarnations, Bellmer's creations translated Sigmund Freud's theories of the subconscious mind into the subconscious body, bespeaking a childlike innocence, sexuality, and desire, unaware of social regulation.

In the mid-1930s, Bellmer began a series of drawings that would be exhibited at the *International Surrealist Exhibitions* in London and Paris in 1936, and in New York and Tokyo in 1937. Over the course of his career, Bellmer worked in a range of diverse mediums including drawing, printmaking, photography, painting, collage, and sculpture. In 1938, Bellmer left Germany for Paris. There he formed friendships with Paul Eluard and Yves Tanguy and was in contact with Jean Arp, André Breton, Marcel Duchamp, Max Ernst, and Man Ray. In 1943, Bellmer had his first solo show at the Galerie Trentin, Toulouse. Between 1944 and 1948, Bellmer traveled to Albi, Carcassonne, Toulouse, and Revel, developing a passion for engraving during this time. In the late 1940s, Bellmer returned to Paris, where he became involved with poet Nora Mitrani. In 1953, he met Unica Zurn, a young writer who would become his longtime collaborator and muse. The two lived together until Zurn's suicide in 1970. In 1957, *L'Anatomie de l'Image*, a book he had begun during World War II, was published. The following year, Bellmer was awarded a prize from the William and Noma Copley Foundation.

In 1964, Bellmer exhibited at *Documenta* in Kassel. In 1967, the Kestner-Gesellschaft Hannover organized a retrospective exhibition that traveled throughout West Germany. In the decade before his death, Bellmer's work was finally being discovered by the Parisian public, and in 1971 the Centre national d'art contemporain, Paris, gave Bellmer a retrospective exhibition. The artist died February 23, 1975, in Paris.

The Doll (*La Poupée*), 1932–45 (cat. no. 185)

The Doll is the pivotal work in Bellmer's oeuvre, the object that articulates all of the artist's reflections, whether they take the form of drawing,

painting, or theoretical texts. The work also reconciles the opposing aspects of his personality: the engineer's cool gaze and the romantic imagination.

Bellmer's invention of *The Doll* took place in the Germany of the early 1930s, at a time when he earned his living by doing industrial drawings and publicity brochures in an aesthetic similar to that of the Bauhaus. *The Doll* allowed him to assert a social revolt, an extension of his refusal of paternal authority, as well as a violent eroticism, which would remain the chief characteristic of his work.

At a performance of Offenbach's *The Tales of Hoffmann* in Berlin in the winter of 1931–32 (this date and that of the initial work on the doll were supplied by the artist's brother, Fritz Bellmer), Bellmer became fascinated with the figure of the doll Olympia and began to dream in his turn of creating an "artificial girl with anatomical possibilities capable of re-physiologizing the whirlwinds of passion, to the point of inventing new desires." The discovery of Hoffmann's character coincided with a double emotional shock: the sudden resurgence of his childhood world, provoked by the receipt of a box of toys sent by his mother during a change of residence, including disguises, a broken doll, and glass marbles; and the troubling presence in his own home of his cousin Ursula, whose perverse adolescence fascinated him. The realization of *The Doll*, undertaken in January 1932 with the help of Fritz Bellmer, an engineer, who saw to the execution of the mechanical parts, provided the outlet for these different yet simultaneous tensions.

The Doll was created life-size on the basis of a wooden skeleton covered in a layer of furniture stuffing hardened with glue, then painted. It would undergo numerous transformations in the course of the 1930s. Early on, Bellmer eliminated the photographic mechanism that was initially integrated to the stomach, revealing his intimate dreams in the form of six photographs seen through a peephole. Later, the fabrication of a second pair of legs was provoked by the discovery of the ball joint in 1937. This principle of articulation, which Bellmer came across in a group of sixteenth-century wooden mannequins attributed to Albrecht Dürer's school and preserved in the Berlin Museum, allowed him to fix a central ball in place of the pelvis, rendering his "articulated minor" pliable to every fantasy. Bellmer gradually created a panoply of members that could be assembled at will, making *The Doll*, as Patrick Waldberg has noted, "a forever unfinished, infinitely modifiable work."

A text, *Die Puppe*, was published at the author's expense in Karlsruhe in 1934. Accompanied by ten photographs showing certain elements of *The Doll* and various stages of its fabrication, it was the first sign of the work's existence. These photographs, reproduced in the December 1934 issue of *Minotaure*, testify to the Parisian Surrealists' interest in Bellmer's work. Ignorant of the links already established between Bellmer and certain German Dadaists, such as Grosz and Heartfield,

the Surrealists could only see *The Doll* as an echo of their own concerns and as an incarnation of "that modern mannequin fit to stir up human sensibility" of which Breton had written in the *First Manifesto of Surrealism*.

It was only upon his arrival in Paris during the winter of 1938 that Bellmer entered directly into contact with the Surrealist group. He brought with him a new set of photographs of *The Doll*, equipped with its stomach ball and staged in positions that accentuated its erotic character and sexual ambiguity. Immediately won over, Eluard took his inspiration from these new prints, which were often touched up by hand in acid colors like those used in the pornographic photography of the time. In December 1938, Eluard wrote fourteen poems initially published in an offprint of the journal *Messages* in 1939 and later brought together in the 1949 volume entitled *Jeux de la Poupée*. Henceforth, *The Doll* would undergo no major modifications, although it was exhibited several times in new configurations (notably at the *Exposition internationale du surréalisme* at Galerie Daniel Cordier, Paris, in 1959). Despite the wandering imposed by the war, Bellmer never parted with his creation; for beyond its own existence, *The Doll* informed the entirety of his drawn and engraved work, from the admirable drawings executed in 1934, in silverpoint highlighted in white gouache in the manner of the German Renaissance masters, all the way to the X-rayed bodies that he would draw in the early 1960s. *The Doll* offered familiarity with a body at once childish and mature, malleable at will, like the long series of anagrams—written by Bellmer together with Mitrani—which remain the emblematic model of his oeuvre. — D. A.

Joseph Beuys
1921–1986

Joseph Beuys was born May 12, 1921, in Krefeld. During his school years in Kleve, Beuys was exposed to the work of Achilles Moortgat, whose studio he often visited, and was inspired by the sculptures of Wilhelm Lehmbruck. Beuys began to study medicine in 1940, but his studies were interrupted when he joined the army and served as a fighter pilot. During a mission in 1943, he was badly injured when his plane crashed in a desolate region of south Russia. This experience would resonate in all of his later work.

After the war, he decided to dedicate his life to art. In 1947, he registered at the Düsseldorf Academy of Art, where he studied under Joseph Enseling and Ewald Mataré. After Beuys graduated in 1951, the brothers Franz Joseph and Hans van der Grinten began to collect his work; they would eventually become his most important patrons. The artist was appointed professor of monumental sculpture at the Düsseldorf Academy of Art in 1961. The year after, he began to associate with Fluxus artists, principally Nam June Paik and George Maciunas, and later he met Minimalist artist Robert Morris. His first one-person exhibition was held at the Haus van der Grinten, Kranenburg, in 1963, and he participated for the first time in *Documenta* in Kassel in 1964.

In 1967, Beuys founded the German Student party, one of the numerous political groups that he organized during the next decade. In 1972, he was dismissed from the Düsseldorf Academy of Art amid great controversy for admitting to his class over fifty students who previously had been rejected. The following year, he founded the Free International College for Creativity and Interdisciplinary Research. He increasingly became involved in political activities and in 1976 ran for the German Bundestag. In 1978, he was made a member of the Berlin Arts Academy. The

1970s were also marked by numerous exhibitions throughout Europe and the United States; Beuys represented Germany at the Venice *Biennale* in 1976 and 1980. A retrospective of his work was held at the Solomon R. Guggenheim Museum, New York, in 1979. He was made a member of the Royal Art Academy, Stockholm, in 1980. During the inauguration of the 1982 *Documenta* in Kassel, Beuys planted the first of 7,000 oak trees; in other cities, he repeated this tree-planting action several times in the following years. In January 1986, the artist received the Wilhelm Lehmbruck Prize in Duisburg. On January 23, 1986, Beuys died in Düsseldorf.

Braunkreuz House (*Braunkreuz Haus*), ca. 1962–64 (cat. no. 317), vitrine containing *Untitled*, early 1960s (1962?), and *Braunkreuz House* (*Braunkreuz Haus*), ca. 1962–64?

Beuys made a practice of fetishizing the objects that he made, as well as curios from his everyday life, by self-consciously placing them in vitrines, as if they were objects in an ethnographic museum. Beuys further disseminated his work through a didactic discourse, giving lectures and performing public actions. He viewed these activities as "social sculpture," in which individuals "mold and shape the world in which we live" in a socially responsible manner.

The vitrine *Braunkreuz House* contains two objects, each of which has its own history. As Beuys recounted to his dealer, Anthony d'Offay, the prefabricated file box came from the Düsseldorf Academy of Art, and the rodent bones inside signify a mastodon and a mammoth. Thus, *Untitled* becomes a tiny archaeological site complete with an Iron Age tool and fire-pit remains, as the box's needle and carbon sticks might be seen to represent.

Beuys said he originally made the other object, which, like the vitrine, is titled *Braunkreuz House*, for his children. He emphasized, however, its connection to his art through its wires and terminals, which represent electrification. During the early 1960s, at the time the vitrine was assembled, Beuys was affiliated with Fluxus, whose participants expounded art as a communicative exchange of energies, both as conduit and spark. Energy and heat—along with a reverence for life-sustaining warmth that goes back to his wartime experience of being rescued by the Tartars and wrapped in felt and fat—are important themes in Beuys's work. In addition, he was profoundly influenced by Rudolf Steiner's writings on Anthroposophy, which seated spirituality in human beings rather than deities. Beuys envisioned the artist as a spiritual guide who leads society to recognize its own potential for goodness. The smaller *Braunkreuz House*, he suggested, might be seen as some kind of shaman's house, or spiritual dwelling. Beuys assigned the name "Braunkreuz" (meaning "brown-cross") to a mixture of brown industrial paint, oil, and sometimes other substances, including rust and blood. The term is also related

to the way he signed and stamped his work with a cruciform mark. — I. S.

Sledge with Fat Filter, 1964–69 (cat. no. 318), vitrine containing *Fat Filter*, 1964, and *Sledge* (*Schlitten*), 1969,

Every sound, every action, every material, and every object in Beuys's work is drenched with mythic and symbolic meaning and serves as a vehicle for a complex all-encompassing personal iconography that connects his early actions, drawings, and sculptures, with his later environments, installations, and vitrines. Each of Beuys's vitrines, with their careful arrangements of simple everyday objects and sculptures made of refuse materials like fat and felt, sometimes relics from earlier actions, offers only a small glimpse into this meaningful artistic world-vision.

The vitrine *Sledge with Fat Filter* contains *Sledge*, a wooden sledge with a folded felt blanket, a flashlight, and a lump of wax strapped on its seat, and it carries Beuys's stamped signature and a brown cross. The sledge is placed neatly in one corner, and *Fat Filter*, a cotton filter containing a mixture of wax and fat, is suspended by a thin, unraveled and irregularly knotted thread from the back board of the vitrine. The sledge is part of an edition of fifty that Beuys created in conjunction with the environment *The Pack* in 1969. In *The Pack*, twenty sledges, each one carrying "its own survival kit," seemed to fall or crawl out of the back of a Volkswagen bus on a mission, according to Beuys, "to ensure survival." What is at stake is the human condition. Yet implicitly and more precisely, perhaps Beuys was alluding to the postwar German condition, a state of illness inflicted by the guilt and burden of the Nazi history of the recent past. It was a wounded condition, which was symbolized by the existence of the Berlin Wall. In Beuys's expanded conception of human creativity, art can be a healing force, a means to create redemption for the individual as well as for society as a whole.

The sledge multiples imply the dispersal of *The Pack*, their separation from a specific environment, and thus an imminent emergency. Despite its modern equipment and appearance, it is the archaic and primitive quality of the sledge Beuys is most interested in, as for him "the sliding of the iron runners of the sledges [is] the most direct kind of movement over the earth." With its vehicular quality, the sledge is the most concrete formulation of a key concept of Beuys's sculptural theory: movement. The sledge carries the potential for movement, and therefore for change and, in other terms, for healing.

The principle of movement is also graspable in *Fat Filter*, an object related to Beuys's filter fat bags, fat corners, and filter fat corners of the early 1960s. The fine wax and fat threads protruding out of the bottom of the filter point to the fact that the substance in the filter has changed its state. Originally liquid, the wax and fat mixture has dripped through the filter. Subject to a slow process of solidification, it left visible traces of its

transition from a chaotic, liquid, and warm state to an ordered, hard, and cold state. Because of its mutability, fat best incorporates this potential of change and metamorphosis into Beuys's sculptural theory, which, at the same time, is also social theory. The infiltrating quality of fat, its absorption through other materials, is countered here by filtration, a process of purification, resulting in "a new refined essence," according to the artist. Beuys, following the example of Steiner, believed that this new essence of mankind lay in the evolutionary movement toward a threefold structure of state, economy, and intellectual life, with the geometrical shape of the triangle as its symbol. The multiplicity of triangular shapes determines the formal structure of the fat filter, as well as its installation within the vitrine. The sledge is directed toward the fat filter; once its starts moving, a healing process is set in motion, and hope reigns. — C. R. S.

Infiltration-Homogen for Grand Piano (*Infiltration homogen für Konzertflügel*), 1966 (cat. no. 319), and *The Skin* (*La Peau*), 1984 (cat. no. 320)

Infiltration-Homogen for Grand Piano—consisting of a grand piano covered with felt hugging its form like a skin, with two red crosses in cloth sewed on each side—originated in the action *Infiltration-Homogen for Grand Piano, the Greatest Contemporary Composer is the Thalidomide Baby*, which Beuys created at the Düsseldorf Academy of Art on July 28, 1966. The work has been subject to several changes since it was purchased by the Musée national d'art moderne, Paris, in 1976: the felt cover wore out, requiring two interventions by the artist in 1976 and 1985, the second resulting in the hanging of *The Skin*—the earlier, worn-out skin—close to the covered piano. While the evolution of the work is linked with its museum life, questioning its capacity for "conservation," its origin is at the crossroads of the artist's childhood and his beginnings in the Fluxus movement. Beuys had also subjected a cello to the same treatment; he had learned to play the cello and the piano as a child.

It was on the occasion of a Fluxus Festival that Beuys planned to complete his first work using a piano: *The Ground Piano*. Never realized, it established a relationship between the ground and the piano, thereby suggesting an analogy between a piano and a coffin, and also introducing the ideas of conduction and insulation that are crucial to the present work. By using a piano, Beuys demonstrated his connection to Fluxus, yet he also distinguished himself by venturing beyond the typical Fluxus provocation caused by the destruction or misuse of the instrument. Instead, he showed a desire to make the piano into a "sculpture," which implies the passing of its conventional use.

It is perhaps necessary to forget the presence of the piano to grasp the fullness of the work. The filter, in the form of felt, evokes the action of the healing of a wound; the oozing through the bandage is a minimal form of expression like the

movement from idea to substance. *Infiltration-Homogen for Grand Piano* is designed, according to Beuys, "with the intention of stimulating discussion"; it "describes the character and the structure of felt, thus, the piano becomes the repository for sound, homogeneous, whose potential is filtered through the felt. . . . The relationship to the human situation is indicated by the two red crosses symbolizing the urgency, the danger that threatens if we remain silent and fail to take the next evolutionary step."

The strange character of the object is largely due to its deformity. In transforming an instrument of harmonious shapes, both visible and invisible, into a sort of monster, clumsy and tangled, Beuys makes it an illustration of the disastrous effect of thalidomide, a medication that caused spectacular birth defects in the early 1960s. The wrapped piano constitutes a sort of enigmatic spatial knot; it becomes a question of judging the form, of seeing the poetic exchange between balance and three-leggedness or the tension between the body and the weakness of the legs. One imagines the lightness of music and the heaviness of the object, the juxtaposition of gentility with urgency. There is a semblance of nature too in the allusion to animals and their skin or to the remains of a monster that finds its body hanging vertically within the framework of a museum. — F. M. and F. H.

Umberto Boccioni

1882–1916

Umberto Boccioni was born October 19, 1882, in Reggio Calabria, Italy. In 1901, he went to Rome, where he studied design with a sign painter and attended the Scuola Libera del Nudo at the Accademia di Belle Arti. In Rome, he and Gino Severini learned the techniques of Divisionist painting from Giacomo Balla. Boccioni traveled in 1902 to Paris, where he studied Impressionist and Post-Impressionist painting. He participated in the *Mostra dei rifiutati* in 1905 and in the *Esposizione di belle arti* in 1906, both in Rome.

Following a trip to Russia in 1906, Boccioni visited Padua and then moved to Venice, where he spent the winter of 1906–07 taking life-drawing classes at the Accademia di Belle Arti. In 1907, he settled in Milan. In 1909–10, Boccioni began to frequent the Famiglia Artistica, a Milanese artists' society that sponsored annual exhibitions. During this period, he associated with Carlo Carrà and Luigi Russolo and met the poet Filippo Tommaso Marinetti, who had published the first Futurist manifesto in February 1909. In 1910, Boccioni participated in the formulation of the two Futurist manifestos *Manifesto dei pittori futuristi* and *Manifesto tecnico della pittura futurista*. He, Carrà, Russolo, and Severini signed the first, and were joined by Balla in signing the second. That same year, Boccioni's first solo exhibition was held at the Galleria Ca' Pesaro, Venice.

In the fall of 1911, the artist went to Paris, where he met Pablo Picasso and Guillaume Apollinaire through Severini. Boccioni's paintings were shown with those of Carrà, Russolo, and Severini in the first Futurist show in Paris, at the Galerie Bernheim-Jeune in 1912. The exhibition then traveled to London, Berlin, and Brussels. In 1912, Boccioni began concentrating on sculpture, and his *Manifesto tecnico della scultura futurista* was published. From 1912 to 1914, he contributed articles to the Futurist publication *Lacerba*. In 1913, the artist exhibited sculpture and paintings in a solo show at the Galerie de la Boétie, Paris, and his sculpture was included in the inaugural exhibition of the Galleria Futurista Permanente, Rome. His book *Pittura e scultura futuriste (dinamismo plastico)* appeared in 1914. In July 1915, Boccioni enlisted in the army with Marinetti, Russolo, and Antonio Sant'Elia. He suffered an accident during cavalry exercises in Sorte, near Verona, and died August 17, 1916.

Dynamism of a Speeding Horse + Houses
(Dinamismo di un cavallo in corsa + case), 1914–15
(cat. no. 63)

Boccioni turned to sculpture in 1912 after publishing his manifesto on the subject on April 11 of that year. The Futurist aesthetic platform as articulated in this document advocates the use of various materials in a single work, the rejection of closed form, and the suggestion of the interpenetration of form and the environment through the device of intersecting planes. In *Dynamism of a Speeding Horse + Houses*, Boccioni assembled wood, cardboard, and metal, with painted areas showing a Futurist handling of planes influenced by the Cubism of Georges Braque and Picasso. Ironically, his intention of preserving "unique forms" caught in space and time is mocked by the perishability of his materials—the work has been considerably restored and continues to present conservation problems.

Boccioni, like Raymond Duchamp-Villon, made studies of horses from nature before developing the motif into a nonspecific symbol of the modern age. This fully evolved symbol appears in Boccioni's painting *The City Rises* of 1910. In *Dynamism of a Speeding Horse + Houses*, he used the horse to demonstrate his observation that the nature of vision produces the illusion of a fusing of forms. When the distance between a galloping horse and a stationary house is visually imperceptible, horse and house appear to merge into a single changing form. Such sculptures as the present example are concerned with the apparent compression of space as an object traverses it, and with the nature of the object's redefinition by that space.

In 1913 and 1914, Boccioni made many drawings and watercolors related to *Dynamism of a Speeding Horse + Houses* that explore the relationship between a galloping horse and a group of houses in close proximity; these are now in the Civica Raccolta Bertarelli, Milan. In some of these studies, the speed of the horse's motion serves to dissolve the legs below the muscles of the shanks. Boccioni's original conception of the sculpture gave forceful expression to this concept. — L. F.

Constantin Brancusi

1876–1957

Constantin Brancusi was born February 19, 1876, in Hobitza, Romania. He studied art at the Craiova School of Arts and Crafts from 1894 to 1898 and at the Bucharest School of Fine Arts from 1898 to 1901. Eager to continue his education in Paris, Brancusi arrived there in 1904 and enrolled in the Ecole des Beaux-Arts in 1905. The following year his sculpture was shown at the Salon d'Automne, where he met Auguste Rodin.

Soon after 1907, Brancusi's mature period began. The sculptor had settled in Paris but throughout these years returned frequently to Bucharest and exhibited there almost every year. In Paris, his friends included Marcel Duchamp, Fernand Léger, Henri Matisse, Amedeo Modigliani, and Henri Rousseau. In 1913, five of

Brancusi's sculptures were included in the Armory Show in New York. Alfred Stieglitz presented the first solo show of Brancusi's work at his gallery "291," New York, in 1914. Brancusi was never a member of any organized artistic movement, although he associated with Francis Picabia, Tristan Tzara, and many other Dadaists in the early 1920s. In 1921, he was honored with a special issue of *The Little Review*. He traveled to the United States twice in 1926 to attend his solo shows at Wildenstein and at the Brummer Gallery in New York. The following year, a historic trial was initiated in the United States to determine whether Brancusi's *Bird in Space* was liable for duty as a manufactured object or as a work of art. The court decided in 1928 that the sculpture was a work of art.

Brancusi traveled extensively in the 1930s, visiting India and Egypt as well as European countries. He was commissioned to create a war memorial for a park in Turgu Jiu, Romania, in 1935, and designed a complex that included gates, tables, stools, and an *Endless Column*. After 1939, Brancusi continued to work in Paris. His last sculpture, a plaster *Grand Coq*, was completed in 1949. In 1952, Brancusi became a French citizen. He died March 16, 1957, in Paris.

The Sleeping Muse (*La Muse endormie*), after 1910 (cat. no. 78)

Preceded in 1908 by preparatory, terra-cotta studies (destroyed) in which the face of the model, Baroness Frachon, is captured in lively relief, and then in 1909 by a stone portrait with more generalized features, the first version of *The Sleeping Muse* in 1909–10 transposes the organic qualities of the face onto the perfection and transparency of marble. Between the marble version and the six bronze editions (two of which are in the Musée national d'art moderne, Paris), Brancusi introduced slight differences of dimension and surface and varied degrees of polish and patination.

In *The Sleeping Muse* here, the softly ribbed hair is patinated, in contrast with the brilliance of the polished face, which resembles that of the marble version. The closed eyes are part of a smooth, continuous surface, while the slightly open, asymmetrical mouth, suggests an elusive presence, an element of indecision. The fine ridge of the nose rises up in pronounced relief from the oval of the whole and delimits the two slopes that slide along the eyebrows and under the hair without changing plane. Brancusi has replaced the traditional bust with a recumbent head, deprived of its natural link to the body—the neck—and set down like a mask; by effacing the facial features in order to concentrate on the ovoid form, he has "abstracted" an object that still resonates with human presence. — M. T.

The Muse (*La Muse*), 1912 (cat. no. 79)

Though initially drawn to Rodin's sculptural transgressions of nineteenth-century aesthetic convention, Brancusi eventually rejected the French master's emphasis on theatricality and accumulation of detail in favor of radical simplification and abbreviation. Brancusi felt he was vindicated in his pursuit of sculptural immediacy when he saw Paul Gauguin's primitivist carvings at the Salon d'Automne in 1906. The practice of *taille directe*, or direct carving, adopted by Brancusi—as well as by Georges Braque, André Derain, and Pablo Picasso—after Gauguin's example, fostered an engagement with the material, eliminated working from a model, and promoted an abstract sensibility. In early sculptures executed through direct carving—such as *The Kiss*—Brancusi suppressed all decorative detail in an effort to create pure and resonant forms. His goal was to capture the essence of his subject and to render it visible with minimal formal means.

While Brancusi's sculptures reflect empirical reality, they also explore inner states of being. The human head, one of his favorite motifs, is often depicted separate from the body, as a unitary ovoid shape. When placed on its side, it evokes images of sleep. Other streamlined oval heads such as *Prometheus* and *The Newborn* (Musée national d'art moderne)—whose shapes recall Indian fertility sculptures—suggest the miracle of creation.

Brancusi's marble *The Muse* is a subtle monument to the aesthetic act and to the myth of Woman as its inspiration. The finely chiseled head—executed in a highly refined version of Brancusi's direct carving technique—is poised atop a sinuous neck, the rightward curve of which is counterbalanced by a fragmentary arm pressed against the cheek. The facial features, although barely articulated, embody classical beauty. As in the sculptor's *Mlle Pogany*, also of 1912, the subject's hair is coiffed in a bun at the base of the neck. While *Mlle Pogany* is the image of a particular woman, *The Muse*, although linked to portraiture, is the embodiment of an idea. — N. S.

Maiastra, 1912? (cat. no. 77)

According to Brancusi's own testimony, his preoccupation with the image of the bird as a plastic form began as early as 1910. Based on the theme of the *Maiastra* in the early 1910s, he initiated a series of about thirty sculptures of birds.

The word "*maïastra*" means "master," or "chief," in Brancusi's native Romanian, but the title refers specifically to a magically beneficent, dazzlingly plumed bird in Romanian folklore. Brancusi's mystical inclinations and his deeply rooted interest in peasant superstition make the motif an apt one. The golden plumage of the *Maiastra* is expressed in the reflective surface of the bronze; the bird's restorative song seems to issue from within the monumental puffed chest, through the arched neck, out of the open beak. The heraldic, geometric aspect of the figure contrasts with details such as the inconsistent size of the eyes, the distortion of the beak aperture, and the cocking of the head slightly to one side. The elevation of the bird on a saw-toothed base lends it the illusion of perching. The subtle tapering of

form, the relationship of curved to hard-edged surfaces, and the changes of axis tune the sculpture so finely that the slightest alteration from version to version reflects a crucial decision in Brancusi's development of the theme.

Seven other versions of *Maiastra* have been identified and located: three are marble and four bronze. This example from the Peggy Guggenheim Collection, Venice, apparently was cast from a reworked plaster (now lost but visible in a 1955 photograph of Brancusi's studio). This was probably also the source for the almost identical cast in the collection of the Des Moines Art Center. — L. F.

Head of a Child (*Head from* The First Step) (*Tête d'enfant [Tête du* Premier pas*]*), 1913–15 (cat. no. 80)

Only the head of *The First Step*, which Brancusi detached after its 1914 exhibition and showed at the Brummer Gallery under the title of *Head of a Child* in 1926, was preserved in the artist's studio. Indeed, Brancusi had at times wished to distance himself from these superimpositions of enigmatic forms in wood—the "darker" side of an oeuvre so often associated with light—by dislocating them or transforming them into more harmless objects, such as pedestals or stools. Following the same process that led to the evolution of *The Sleeping Muse*, the head of *The First Step* has come to form part of the theme of sleeping children's heads, separated from their bodies. This face, whose features are suggested in the manner of African masks through a translation into volumes and voids, thus constitutes an early version of Brancusi's series of sculptures of the *Newborn*. The crease of the eye/eyebrow, extended by the prominence of the nose, and the indentation of the mouth were later repeated in a play of curves and planes in space (the sphere broken by the planes of the nose and chin). — M. T.

Little French Girl (*La Jeune Fille française*), ca. 1914–18 (cat. no. 81)

From 1914 through 1925, Brancusi created several wood sculptures that translated the human figure by using a combinatorial idiom. Departing from traditional figurative sculpture, the addition of discrete, articulated masses in these works has been linked to sources in African sculpture, Romanian vernacular architecture, Cubism, and Dada. While *The First Step* of 1913–14 is generally cited as the first work by the artist to show the influence of African art, *Little French Girl*, also sometimes known as *The First Step [III]*, is sometimes identified as a later version. It has been compared specifically to Bidjogo and Senufo figures by the art historian Sidney Geist.

Positioned at an eccentric angle, the form of the girl is built up with volumes that alternate fluidly between symmetry and irregularity. Its central core is articulated by a narrow spinal shaft whose cylindrical grooves echo the stacked ellipsoids of the two legs standing awkwardly on a square base.

Rotated away from this axis, the head crowns this sculpture with its erratic contours. Rather than anatomical knowledge, Brancusi relied on the rhythm of abstract patterns to regulate its wide clefts and to create a balance between the ridged left-hand protrusion and the smooth volume which hangs subtly on the lower right side.

Since *Little French Girl* bears a clear morphological resemblance to African wooden sculpture, it is difficult to understand the artist's repudiation of such influence in a remark he was reported to have made to Jacob Epstein in 1932. It is perhaps not the arbitrary syntax of African sculpture alone that is significant but also the rich perceptual ambiguities it allowed the artist to cultivate. The additive formal dynamic of this work eschews ideal geometry in order to show aspects of the object otherwise invisible to the viewer who stands directly in front of it. By putting us in contact with these different sides, Brancusi sought to redefine Modern sculpture contextually, in terms of the body's movement through the space around it. — M. M.

Adam and Eve (Adam et Eve), 1916–24 (cat. no. 83)

The wooden components of *Adam* and *Eve* were conceived separately over a number of years, evolving into their final format after numerous changes. *Eve* was carved as early as 1916 but was reworked in 1920–21. Adam was originally part of another sculpture that was later cut in half. By 1922, when it was referred to as "Adambase" and "Adam," it was seen in relation to *Eve*. Although they were listed and illustrated separately in the catalogue for the Brummer Gallery's exhibition in 1926, installation shots of the same exhibition when it traveled to Chicago the next year showed *Eve* placed on *Adam*.

The sculpture's meaning is determined by the way Brancusi assembled *Adam and Eve*. While the male form seems to forcibly thrust up, compressed between two neutral blocks, the top-heavy female part, with its lip forms above and breasts/testicles below, seems to enjoy a position of unrestricted freedom. In *Adam*, the angularity and sturdiness of forms express an essential masculinity conveying a sense of the physical process of hewing the block. The rounded, more overtly erotic forms of *Eve* rely upon Brancusi's knowledge of African art. Likewise, the placement of *Eve* on top of *Adam* owes a debt to "primitive" art in its vertical articulation. In its more rough-hewn passages, this sculpture recalls the influence of Gauguin's carved wood pieces. — SRGM

The Sorceress (La Sorcière), 1916–24 (cat. no. 82)

Although *The Sorceress* bears the date 1916, it appears unfinished in photographs of Brancusi's studio for several years thereafter. Brancusi typically worked on his sculptures for extended periods of time, often for five years or more. As the face emerges from the grain of the wood, the pointed headdress and clothing are seen flying behind the sorceress—perhaps Brancusi had

Romanian and French folktales about witches in mind as he created this form

The Sorceress retains the integrity of the piece of wood that Brancusi selected and carved to exploit the way the branches grew from the tree trunk. The complex, asymmetrical arrangement of masses stands on a slender leg and maintains perfect equilibrium. This light form above is directly opposed by its massive rusticated support. The base is made of blocks of wood stacked on top of an hourglass shape made of symmetrical decorative motifs. As is often the case with Brancusi's sculpture, the upper "figure" and lower "base" complement each other through their contrasting textures, materials, and massing. — SRGM

The Seal [I] (Miracle) (Le Phoque [I] [Le Miracle]), 1924–36 (cat. no. 87), and The Seal [II] (Miracle) (Le Phoque [II] [Le Miracle]), 1943 (cat. no. 88)

The Seal [I] (Miracle), the earlier of two smooth, elegant forms, was carved from a piece of white marble over a period of twelve years, and was originally titled *Miracle*. According to art historian Carola Giedion-Welcker, Brancusi said these forms were inspired by a particular action of a woman—the liberating upward movement of her neck—and by the physical gesture of a gleaming aquatic animal. The later work, *The Seal [II] (Miracle)*, initially titled *Seal*, was carved from a bluish veined marble that more closely approximates the smooth wet coat of a seal; it leans at a lower, more realistic angle than the white sculpture, which appears idealized in comparison. Each of the sleek marble forms cantilevers out in graceful defiance of gravitational pull and tapers up to an end that is terminated by a flat plane representing a face. The sculptures' uplifted positions, with their abrupt planar tips, epitomize a condition of alertness and connection to the outside world.

As with most of Brancusi's sculptures, his bases are integral to the overall effect. To emphasize their changing appearances from all perspectives, and perhaps to invert the customary viewing of sculpture in the round, the artist intended these works to be viewed on bases that could be turned. According to several Brancusi catalogues and unpublished archives, a concealed motor for the former sculpture and a ball-bearing mechanism for the latter were discussed but apparently never installed. — MNAM and SRGM

King of Kings (Le Roi des rois), early 1930s (cat. no. 84)

The monumental oak *King of Kings* was originally intended to stand in Brancusi's *Temple of Meditation*, a private sanctuary commissioned in 1933 by the Maharaja Yeshwant Rao Holkar of Indore. Although never realized, the temple—conceived as a windowless chamber (save for a ceiling aperture) with interior reflecting pool, frescoes of birds, and an underground entrance—would have embodied the concerns most essential to Brancusi's art: the idealization of aesthetic form; the integration of architecture, sculpture,

and furniture; and the poetic evocation of spiritual thought.

Wood elicited from Brancusi a tendency toward expressionism, resulting in unique carved objects. *King of Kings* may be interpreted as Brancusi's attempt to translate the power of Eastern religion into sculptural form. The work's original title was *Spirit of Buddha*, and Brancusi is known to have been familiar with Buddhism through the writings of the Tibetan philosopher Milarepa.

Although the extent to which Brancusi's work was inspired by African sculpture and Romanian folk carvings has been widely debated among scholars, it is clear that he was acutely responsive to "primitivizing" influences early in his career. Gauguin's technique of direct carving to emulate the raw quality of native Tahitian art inspired Brancusi to experiment with more daring approaches to sculpture than his academic training had previously allowed.

Sculptural sources from Brancusi's native country are also abundant: prototypes for the sequential designs of *King of Kings* have been found in Romanian vernacular architecture, such as wooden gate posts and chiseled ornamental pillars. Brancusi never clarified the visual sources for his designs, preferring that an air of mystery surround the origins of his vision. — N. S.

The Cock (Le Coq), 1935 (cat. no. 85)

Many of Brancusi's works, and *The Cock* in particular, evolved from one form to another, sometimes over a span of twenty years or more, as he developed the material and formal properties of his subjects. Multiplied in many versions—in wood, white plaster, and luminous bronze—the form of the *Cock* raises its angular profile to the sky, crossed by a symbolic zigzag shape. Of all these singular specimens, only the polished bronze of 1935 was cast from a plaster model kept in the studio. This work was preceded by two wooden *Cocks* on an identical scale: one, *Coq Gallois* (1922; now lost) was more massive and awkward, and the only one with four serrated edges instead of three; the other, made in walnut in 1924, has an elongated tail that accentuates the slant of the back by extending the body backward along the axis of the beak. Resting on a base that repeats the zigzag form of the neck, this bronze *Cock* has a shorter tail and rises up above a taller, more slender footing, defining a more pronounced verticality in space. The impression of straight lines is further accentuated by the right-angle transition between the footing and the tail; in fact the bronze component seems to be inscribed within a perfect triangle. The axis from the head passes in front of the saw-toothed edges, which recede stairlike as they gain in volume. The polished bronze material further highlights the perfection of the diagonal and horizontal lines, the roundness of the transitions, and the sharp design of the profile.

Starting in 1923, Brancusi developed another, parallel cycle of *Cocks*, which are monumental,

directly modeled in plaster, and of varying degrees of sculptural definition. This series differs from the first in its more pronounced verticality, which links it to Brancusi's series of *Birds*: the axis of the beak, moving inward through the projecting profile, has the effect of lessening the slope of the back and lifting the body skyward, while the lowering of the tail toward the ground negates the angular appearance of the subject. — M. T.

Flying Turtle (*Tortue volante*), 1940–45 (cat. no. 86)

The highly abstracted *Flying Turtle* is a unified form carved from a single block of veined white marble. The body comprises a roughly hemispherical mass with two wedge-shaped sections removed. The pointed extremities, slightly asymmetrical, suggest two outstretched front legs, and between them the long tapering neck strains forward from the shell. The streamlined whole, at a dynamic angle on its low pedestal, looks poised for takeoff, or as if it were already skimming over ocean waves. Brancusi may have considered exhibiting the sculpture with the rounded dome of the shell on top and the neck projecting downward, the reverse of its present orientation. By the simple act of turning the figure upside down, Brancusi transformed an earth-hugging, tortoise-like form into an aerodynamic one.

Brancusi wanted to create absolute forms that revealed the essences of his materials as well as of the subjects represented. Despite the extreme simplification of its form, Brancusi would never consider this work to be abstract. In 1957, he wrote, "they are imbeciles who call my work abstract; that which they call abstract is the most realist, because what is real is not the exterior form but the idea, the essence of things." — SRGM

Georges Braque
1882–1963

Georges Braque was born May 13, 1882, in Argenteuil. He grew up in Le Havre and studied evenings at the Ecole des Beaux-Arts there from about 1897 to 1899. He left for Paris to study under a master decorator to receive his craftsman certificate in 1901. From 1902 to 1904, he painted at the Académie Humbert in Paris, where he met Marie Laurencin and Francis Picabia. By 1906, Braque's work was no longer Impressionist but Fauve in style; after spending that summer in Antwerp with Othon Friesz, he showed his Fauve work the following year in the Salon des Indépendants in Paris. His first solo show was at Daniel-Henri Kahnweiler's gallery in 1908. From 1909, Pablo Picasso and Braque worked together in developing Cubism; by 1911, their styles were extremely similar. In 1912, they started to incorporate collage elements into their paintings and to experiment with the papier collé (pasted paper) technique. Their artistic collaboration lasted until 1914. Braque served in the French army during World War I and was wounded; upon his recovery in 1917, he began a close friendship with Juan Gris.

After World War I, Braque's work became freer and less schematic. His fame grew in 1922 as a result of an exhibition at the Salon d'Automne in Paris. In the mid-1920s, Braque designed the decor for two Sergei Diaghilev ballets. By the end of the decade, he had returned to a more realistic interpretation of nature, although certain aspects of Cubism always remained present in his work. In 1931, Braque made his first engraved plasters and began to portray mythological subjects. His first important retrospective took place in 1933 at the Kunsthalle Basel. He won First Prize at the *Carnegie International*, Pittsburgh, in 1937.

During World War II, Braque remained in Paris. His paintings at that time, primarily still lifes and interiors, became more somber. In addition to paintings, Braque also made lithographs, engravings, and sculpture. From the late 1940s, Braque treated various recurring themes such as birds, ateliers, landscapes, and seascapes. In 1953, he designed stained-glass windows for the church of Varengeville. During the last few years of his life, Braque's ill health prevented him from undertaking further large-scale commissions, but he continued to paint, make lithographs, and design jewelry. He died August 31, 1963, in Paris.

L'Estaque, 1906 (cat. no. 7), and *Landscape near Antwerp* (*Paysage près d'Anvers*), 1906 (cat. no. 8)

At the height of Fauvism, at the 1905 Salon d'Automne, Braque discovered the paintings of André Derain and Henri Matisse: "I was struck by what was new in Fauvist painting, and this suited me well. . . . It was a very enthusiastic kind of painting. . . . I liked this physical painting." The prominent, stylized brushstrokes and choice of surprisingly unnatural colors in *L'Estaque* and *Landscape near Antwerp* show how Braque experimented with the Fauves' techniques during the year following his discovery of their work. In the former painting, exaggerated shapes and inventive coloration permeate a cloudy, gray day, enlivening the wan northern atmosphere. It was made near Antwerp during the summer of 1906, when Braque was beginning to paint in a Fauvist style. He continued this approach after moving in October to L'Estaque, a small port near Marseilles, where he was a boarder in the Hotel Maurin.

At the same time, his work from the south of France shows Braque well under the influence of Paul Cézanne, whose retrospectives he had seen at the earlier Salons d'Automne of 1904 and 1905. He confided as much in an interview with Jacques Lassaigne. In answer to the question, "When you left for L'Estaque, was it because of Cézanne?" Braque answered, "Yes, and with a clearly formed idea already in my mind. I can say that my first paintings at L'Estaque were already conceived before my departure. I nevertheless still made an effort to subject them to the influences of the light, the atmosphere, and the effect of rainfall, which heightened colors."

L'Estaque, a rare nonmaritime view (of a road and pine trees overhanging the sea), was made at the start of his sojourn in October 1906. If we compare this painting and *Landscape near Antwerp*, it becomes clear that the bold primary colors in the later painting result from the brilliant light conditions in L'Estaque as well as the influence of Cézanne's landscape paintings of southern France. Above all, however, the rigor of the construction, the refinement of the juxtaposition of colors, and the use of a broad, free stroke (in the foreground), show Braque's originality with respect to Fauvism. — N. P.

The Little Bay at La Ciotat (*Petite baie de La Ciotat*), 1907 (cat. no. 9)

During the summer of 1907, Braque made some fifteen landscapes in La Ciotat before returning to L'Estaque in September. As Braque would later inform the writer and art critic Jean Paulhan, "The first year [in 1906] it was pure enthusiasm, the surprise of a Parisian discovering the South. The following year, that had already changed. I would have had to go all the way to Senegal. One can't count on enthusiasm for more than ten months." In September 1907, at L'Estaque, Braque's work began to take a new path.

This is why the landscapes of La Ciotat, Braque's last truly Fauvist forays, are of particular interest. *The Little Bay at La Ciotat* was important enough to Braque for him to buy it back in 1959: "I bought the painting back. After first selling it I felt very sad, very regretful. I was bored with it; I sometimes thought of it the way one thinks of a loved one who is far away." Art critic Jean-Paul Crespelle writes of a visit to Braque in 1961: "On a wall, across from the window, are two Fauvist paintings: one of L'Estaque, the other of La Ciotat. The latter was bought back two years ago. See that? he said, that hasn't changed in 50 years. People used to yell at me: You'll see what your paintings are like in 20 years, with all the chemical colors you use. Well! It's as fresh as it was the first days." A good deal of this painting's charm and lightness comes from the heterogeneous brushstrokes, which are broken up and applied sparingly in spots, like bursts, to let the white background of the finely woven prepared canvas show through. There is a generalized rosy half-tone and a discreet attempt, through color variation, to avoid the appearance of a continuously painted surface. Braque once described this work as "very atmospheric, with a supple elegance of harmony. It's a Fauvist painting that does not roar. The violence of the colors is restrained in precious harmonies. I had to go further, to find essential tones, natural as opposed to decorative tones." — N. P.

Still Life with Violin (*Nature morte au violon*), 1911 (cat. no. 22)

In August 1911, Braque joined Picasso at Céret, where they spent the summer together. This was the period when the two artists felt as close to each other "as mountain climbing partners," according to Braque. Working with a "new hope," Braque and Picasso had begun to define a very structured, elaborate visual language; as Braque wrote, "fragmentation helped me to establish space and movement in space, and I could not introduce the object until I had created the space." In the paintings of this period, the period of Analytic Cubism, forms disintegrate into a multitude of luminous facets. There is tension between abstraction and representation at work in *Still Life with Violin*: the objects making up this still life elude us at the very moment we think we recognize them. The light is mentally recreated, while the palette is reduced almost exclusively to shades of gray, ochre, and brown. As Braque explained, "It's . . . very difficult to explain the austerity of color. I felt that color might create sensations that would disturb the space somewhat, and so I abandoned it. . . . Cubism tackled the problem of space, and so naturally all the other elements of painting were made to serve this end." Braque kept this *Still Life with Violin* in his own collection before donating it to the Musée national d'art moderne, Paris. — N. P.

Man with a Guitar (*L'Homme à la guitare*), 1914 (cat. no. 23)

Man with a Guitar belongs to a series of figures with musical instruments, begun—in emulation of Picasso's work—during the summer of 1911 at Céret. Rectangular in format and monumental, these paintings represent fundamental milestones in Braque's work with space, light, and color between 1911 and 1918. *Woman with a Guitar* (1913), from the same series, summarizes the Cubist discoveries, especially the color effects of the papier collés. *Man with a Guitar*, made the following season in early 1914, is a kind of counterpart: it has the same format, symmetrical subjects, and placement of the guitar in relation to the figures, who are situated on the same inclined axis in both paintings. Here, however, the color appears to be a separate consideration; it is definitively brought into focus. *Man with a Guitar* is constructed from two rectangles, one of which is positioned diagonally inside the other, which is frontal. This work was finished before the outbreak of World War I in August 1914, which caused Braque's abrupt abandonment of painting until January 1917. — N. P.

The Bowl of Grapes (*Le Compotier de raisins*), 1926 (cat. no. 91)

After his return from military service in 1917, Braque, working independently of Picasso, developed the subjects and style he had been working on before the war. His use of collage in the 1910s led to formal innovations in his paintings of the 1920s. In still lifes, such as *The Bowl of Grapes*, he constructed objects with broad, frontal planes that remain discrete and are often vividly colored or decoratively patterned.

In subject matter, *The Bowl of Grapes* belongs to Braque's table and mantelpiece series dating from about 1918 to 1929. It displays a rigorous and complex organization of shapes and lines combined with the sensuous appeal of rich color (three greens contrasted with chalky white and tan) and a masterful handling of paint. The structuring grid is softened by broad curves and clusters of circular forms, and peripheral areas are enriched by the textural variation provided by the addition of sand to the pigment.

Formal rather than illusionistic needs govern the treatment of objects. The white drapery does not cascade down from the tabletop in foreshortened, shadowed folds, but rigidly asserts itself parallel to the picture plane. The distinction between lit and shadowed sides of the pitcher is artificially sharp. Numerous attributes are reminiscent of Cézanne's still lifes: heavy contours and voluminous presence of objects; tilted planes; inconsistent perspective; and discontinuous background lines. — L. F.

Victor Brauner
1903–1966

Victor Brauner was born June 15, 1903, in Piatra-Neamt, Romania. His father was involved in spiritualism and sent Brauner to evangelical school in Braila from 1916 to 1918. In 1921, he briefly attended the School of Fine Arts, Bucharest, where he painted Cézannesque landscapes. He exhibited paintings in his subsequent expressionist style at his first solo show at the Galerie Mozart, Bucharest, in 1924. Brauner helped found the Dadaist review *75 HP* in Bucharest. He went to Paris in 1925 but returned to Bucharest approximately a year later. In Bucharest in 1929 Brauner was associated with the Dadist and Surrealist review *UNU*.

Brauner settled in Paris in 1930 and became a friend of his compatriot Constantin Brancusi. Then he met Yves Tanguy, who introduced him to the Surrealists by 1933. André Breton wrote an enthusiastic introduction to the catalogue for Brauner's first Parisian solo show at the Galerie Pierre in 1934. The exhibition was not well-received, and in 1935 Brauner returned to Bucharest, where he remained until 1938. That year, he moved to Paris, lived briefly with Tanguy, and painted a number of works featuring distorted human figures with mutilated eyes. Some of these paintings, dated as early as 1931, proved gruesomely prophetic when he lost one of his own eyes as the result of a fight in 1938. At the outset of World War II, Brauner fled to the south of France, where he maintained contact with other Surrealists in Marseilles. Later, he sought refuge in Switzerland; unable to obtain suitable materials there, he improvised an encaustic from candle wax and developed a graffito technique.

Brauner returned to Paris in 1945. He was included in the *Exposition internationale du surréalisme* at the Galerie Maeght, Paris, in 1947. His postwar painting incorporated forms and symbols based on Tarot cards, Egyptian hieroglyphics, and antique Mexican codices. In the 1950s, Brauner traveled to Normandy and Italy, and his work was shown at the Venice *Biennale* in 1954 and in 1966. He died March 12, 1966, in Paris.

Force of Concentration of Mr. K (*Force de concentration de M. K.*), 1934 (cat. no. 187)

Made during the artist's stay in Paris from 1930 to 1934, *Force of Concentration of Mr. K* is part of a series that was exhibited in Brauner's show at the Galerie Pierre in 1934. The size of the canvas, which is unusually large for Brauner's production at this time, and the curious collage of strange objects such as celluloid dolls and other souvenirs, which prefigure aspects of Nouveau Réalisme, give this work an unusual and fascinating quality.

Mr. K appears as a favorite subject in Brauner's personal mythology. The main thrust of Brauner's caricature seems to be political. Mr. K is an allegorical figure of reigning stupidity, reminiscent of Alfred Jarry's character Ubu Roi, with whom he is in fact identified in another painting of this series. Breton underscored the derisive force of Brauner's work and its seriousness in the face of the rising fascisms, when he wrote in 1934, in *Botte rose blanche*, "this image, in taking shape, long ago ceased to make us laugh." Mr. K is more than a caricature; he is emblematic of a universal *jeu de massacre*, the popular game of throwing balls to knock down dolls or figurines.

Art historian William Rubin made a striking comparison between *Force of Concentration of Mr. K* and a famous Polynesian statue (from the Tubuai archipelago) that is in the Museum of Mankind, London. While it is not out of the question that Brauner might have had a reproduction of the Polynesian figure in front of him, the confusing similarity of the swarming figurines is not necessarily due to direct inspiration; in looking for archetypes, an artist inevitably comes across forms that have their equivalent in other times and places, and this may be one of many that informed Brauner's imagery.

Force of Concentration of Mr. K puts another of Brauner's favorite principles into play, a dual organization of male/female and positive/negative. The painting is a sort of fake diptych: to the left the reddened, cannibalistic silhouette of Mr. K is seen against a white ground; to the right the same monster is set off against a black ground. This idea of the double, like the hybridization of influences and the involvement with archetypal imagery, are sources for Brauner's entire oeuvre. — D. S.

Wolf-Table (*Loup-table*), 1939–47 (cat. no. 188)

Between 1939 and 1947, the dates marking the beginning and the completion of *Wolf-Table*, there was war—there was "the reign . . . of beasts

emboldened to the point of following our scent," according to André Breton. The war for Brauner was the time when his fears took shape; the fictions of his prior paintings became manifest in everyday life. A former militant of the Romanian Communist party and a dissident during the Moscow trials, Brauner illustrates here the catastrophe of conscience in the jaws of History. The table, locus of food, turns against the eater, with opened mouth. It is death suffered and death inflicted, instinctual violence besetting the individual from within and from without. The table, a familiar object resembling the body, is likened to man. It mimics the drama of war by a convulsion of shape; it becomes the forest again, the space of an inhabited wildness, expressing the instability of being. As Breton wrote of this sculpture, "There is wildness in the air, it emanates from nudity, slyly creeping from life indoors, becoming incensed all around us: in our own homes, these pocket flashes in the thickets, are the baring of its teeth." — A. B.

The Lovers (Messengers of the Number) (*Les Amoureux [Messagers du nombre]*), 1947 (cat. no. 189)

Brauner very likely created *The Lovers* expressly for an exhibition conceived by Breton, *Le surréalisme en 1947*, in which it formed the center of Brauner's *Secretary or Serpentary Bird*, an altar dedicated to Max Ernst.

Both figures of this canvas are taken from classical tarot imagery. On the left, the Juggler, or Magician, is equipped with his characteristic attributes—cups, coins, swords, and wands. In place of his usual hat, his hair becomes a volcano, many snakes cover his chest, and one snake above his brow twines into a form that is reminiscent of both the sign of infinity and an Ouroboros, the ancient tail-devouring snake who symbolizes completion, totality, and perfection.

In the classical symbolism of the tarot, the Juggler corresponds to the male principle, active and creative. Through symbols such as the snake and the volcano—which are images familiar to his personal mythology—Brauner concretizes the principle of creativity with the emblem of the artist-magician, with whom he identifies. Whereas in many of Brauner's paintings of the early 1940s, the snake appears as the artist's totem, the volcano here becomes the symbol not only of a total freedom of thought but also of an odd coincidence that confers a sort of magic quality on the painting: an inscription on the back reveals that this painting was painted just as Mount Aetna was erupting.

Brauner transforms the Juggler's magic wand into a lunar-solar scepter to symbolize the reunion of opposites, to set up a confrontation of masculine and feminine principles, and to announce their alchemical fusion. The High Priestess on the right is the feminine counterpart to the Juggler. Her attributes—crown, pontifical garb, book, and throne—also belong to the classical iconography

of the tarot. But inside the veil that surrounds the High Priestess's bird's head like a headdress, Brauner inscribed the characters of the moon in accordance with the symbolism of the planets. The head of a bird of prey itself refers to the title of "altarpiece," and should, according to Brauner, underscore the figure's diametrical opposition to the Juggler. The striking association of the book and the scissors on her knees no doubt alludes to the High Priestess's divine power over fate. Finally, on the base of the throne, between the planetary signs of the sun and the moon, the numbers 1, 7, 1, 3 are written to suggest the letters A, B (Breton's initials), thus referring to the "patron" of the "altarpiece."

As a whole, the couple in *The Lovers* still depends on the *conjunctio oppositorum*, or joining of opposites, which is a basic principle of hermetic writings. The artist himself made the following comment: "The two characters, the universal Man and Woman, are depicted in this painting with the symbols of their attributes and polarizing currents. . . . In order to find equilibrium, the Lover waves his magic wand through space . . . and offers a conciliatory conclusion to the two principles that retain their specific autonomy, the male and female principles. This painting represents the equality of the two principles, Patriarchate and Matriarchate, culminating in their coming together and in the freedom of beings, through unification in love."

The inscriptions to the left and right of the Juggler and the High Priestess order this symbol-laden image into a tripartite schema often used by the artist during the 1940s. Here the past is tied to destiny; the future—after the years of persecution and danger—allows a glimpse of freedom; while the present is placed entirely under the sign of magic, embodied by the figure of the Juggler.

Brauner's vision of himself as an artist-magician and alchemist, and his juxtaposition of conjoined opposites may also be found in the work of Ernst as well as in the theoretical and poetical writings of Breton. — V. K.

The Surrealist (*Le Surréaliste*), January 1947 (cat. no. 190)

In *The Surrealist*, Brauner borrows motifs from the tarot to create a portrait of himself as a young man. The tarot, a set of seventy-eight illustrated cards used in fortune-telling, was a subject of widespread interest to Brauner and other Surrealists. Four of these cards, for example, appear on André Derain's cover for the December 1933 issue of *Minotaure*, and a group of artists, including Brauner, even produced a deck of cards in Marseilles in 1940–41 that was probably a tarot. As art historian Cynthia Goodman has noted, one tarot card, the Juggler (the first card in the Marseilles tarot deck), was the key to Brauner's self-portrait: the Surrealist's large hat, medieval costume, and the position of his arms all derive from this figure who stands behind a table displaying a knife, a goblet, and

coins. The tarot Juggler appropriately symbolizes the creativity of the Surrealist poet, for it refers to the capacity of each individual to create his own personality through intelligence, wit, and initiative, and thus to play with his own future, as the Juggler manipulates his baton.

In another tarot deck, known as the Waite tarot, the first card is the Magician rather than the Juggler, although both share many attributes. The sign of infinity, the symbol of life, that appears above the Magician's head is also depicted on the hat of Brauner's Surrealist. Drawing on the Juggler-Magician prototype, Brauner illustrates the traditional signs of the four suits in the tarot deck: wands, cups, swords, and coins, which are symbols of the elements of natural life — fire, water, air, and earth, respectively. These objects and all natural life are controlled by the Juggler, just as all creative life is at the disposal of the Surrealist poet, who wields his pen as the Juggler brandishes his wand.

Brauner depicts the Juggler and a High Priestess in another painting of 1947, *Les Amoureux* (*Messager de Nombre*) (Musée national d'art moderne, Paris). The inscriptions at either side of that work, "Past—Present—Future" and "Fate/Necessity—Will/Magic—Surreality/ Liberty," are written in Brauner's hand on the back of this canvas. These inscriptions convey the artist's belief that Surrealism could be a path to artistic freedom. — E. C. C.

Daniel Buren

b. 1938

Daniel Buren was born March 25, 1938, in Boulogne-Billancourt. He studied briefly at the Ecole des métiers d'art but little else is known about the artist's training and early career. In keeping with his philosophy and his radical opposition to romantic notions of the "artist as hero," Buren has systematically refused to provide further biographical details about himself.

Buren started studying painting in the late 1950s but soon became frustrated with the insularity of art schools in France. Since 1965, he has explored a single theme: the vertical stripe. Based on the ideas of repetitive motifs and neutral

forms, his work is intentionally impersonal. He chose the stripe precisely because it is so ordinary and devoid of illusion, mystery, and content. Varying the color of the stripes but not the width, he has consistently worked with this motif in situ. In 1966, with Olivier Mosset, Michel Parmentier, and Niele Toroni, he formed the brief-lived group known as BMPT; derived from the initials of the group's members, the acronym was invented by art historians.

In an open rebellion against the museum's monopoly over art, Buren began his artistic career by pasting up anonymous striped panels in various urban spaces in different cities around the world. These actions were obvious attempts to exhibit his work outside traditional art venues, and they defined his work in the 1960s. While Buren did create pieces to be shown in art institutions during the next decade, he has always looked for ways to subvert the traditional relationship between the buildings and the art. In 1972, his two large poster pieces at the gallery Incontri Internazionali d'Arte, Rome, looked like a temporary barrier outside the gallery and fused almost completely with the walls inside. His 1973 exhibition at the John Weber Gallery, New York, used banners of striped material that extended out of the gallery and across the street. Repeatedly, his work in art institutions has challenged the idea of these contexts by transcending their closed exclusivity, ignoring their physical boundaries, and placing equal importance on the inside and outside walls of the structure. Paralleling his work with art institutions and wanting to bring art into the public domain, he has used his white and colored cloth and paper in diverse ways: as wallpaper on the inside or outside of buildings (Düsseldorf in 1968 and Avignon in 1989), banners (New York in 1971 and Vienna in 1988), flags (Paris in 1975–77), and nautical sails (Ghent in 1979 and Thun in 1983). Buren's work has been compared to that of Conceptual artists of the 1960s and 1970s, but he refuses to align himself with an individual school.

In 1986, Buren executed a site-specific work for the French Pavilion at the Venice *Biennale* and that same year, he designed a controversial installation of columns and fountains for the courtyard of the Palais Royal, Paris. He continues to show his work internationally, and he lives and works in Paris and Berlin.

Painting, Manifestation III (*Peinture, Manifestation III*), May 1967 (cat. no. 343)

Painting, Manifestation III was exhibited for the first time on June 2, 1967, in the conference hall of the Musée des arts décoratifs, Paris, at a show entitled *Manifestation 3*, whose participants were the members of BMPT. This "spectacle" consisted of four paintings to be looked at on a stage, followed by a tract, *Il s'agissait evidemment de voir* (The point was obviously to see), presented at the end of the show. Almost square, Buren's painting is made of cotton fabric and alternating white and

red stripes 8.7 centimeters in width. At each end, the white stripes were re-covered in white paint to assert the work's pictorial character. And according to the certificate/notice (which the buyer was obligated to sign) accompanying each work by Buren, this canvas on stretcher must rest directly on the ground and lean against a wall.

Only four such "manifestations in four" took place, all in 1967. In January, when *Manifestation I* was presented at the Salon de la Jeune Peinture in Paris, a loudspeaker shouted out during the entire opening: "BMPT advises you to become intelligent." (*Manifestation 2* was also held at the Salon de la Jeune Peinture.) *Manifestation 4* took place in September at the Paris *Biennale*, in the cafeteria of the Musée d'art moderne de la Ville de Paris. There, four large canvases were exhibited together with a didactic sound-text, *L'art est illusion de liberté*, and the projection, on the ceiling, of some fifty color slides, synchronized with the text and illuminations of the works exhibited. In regard to BMPT, Buren speaks more readily of an association than of a group, as much to preserve the individuality of each member as to point out that their collaboration in the end only lasted nine months. For Buren, "the conflictual relationships with artists having to do with Minimal Art, Conceptual Art, Arte Povera and Body Art were, on the contrary, much more decisive for my work." — N. P.

Alberto Burri

1915–1995

Alberto Burri was born March 12, 1915, in Città di Castello, Italy. Burri began not as an artist but as a doctor, earning his medical degree in 1940 from the University of Perugia, and serving as a physician during World War II. Following his unit's capture in northern Africa, he was interned in a prisoner-of-war camp in Hereford, Texas, in 1944, where he started to paint on the burlap that was at hand. After his release in 1946, Burri moved to Rome, where his first solo show was held at the Galleria La Margherita the following year.

Like many Italian artists of his generation who reacted against the politicized realism popular in the late 1940s, Burri soon turned to abstraction, becoming a proponent of Art Informel. Around 1949–50, Burri experimented with various

unorthodox materials, fabricating tactile collages with pumice, tar, and burlap. At this time, he also commenced the "mold" series and the "hunchback" series; the latter were humped canvases that broke with the traditional two-dimensional plane. This preoccupation with the ambiguity of the pictorial surface and with non-art materials led Burri to help start Gruppo Origine, founded by Italian artists in 1950 in opposition to the increasingly decorative nature of abstraction. The artists in Gruppo Origine exhibited their work together in 1951 at the Galleria dell'Obelisco, Rome.

In 1953, Burri garnered attention in the United States: his work was included in the group exhibition *Younger European Painters* at the Solomon R. Guggenheim Museum, New York, and was shown as well at the Frumkin Gallery, Chicago, and the Stable Gallery, New York. In the mid-1950s, Burri began burning his mediums, a technique he termed *combustione*. These charred wood and burlap works were first exhibited in 1957 at the Galleria dell'Obelisco. In 1958, his welded iron sheets were shown at the Galleria Blu, Milan. In this same year, Burri was awarded third prize in the *Carnegie International*, Pittsburgh. In 1959, he won the Premio dell'Ariete in Milan and the UNESCO Prize at the São Paulo *Bienal*. There was a one-person show of Burri's art in 1960 at the Venice *Biennale*, where he was awarded the Critics' Prize.

Persevering with the *combustione* technique, Burri started to burn plastic in the early 1960s. These works were exhibited in 1962 at the Marlborough Galleria, Rome. Burri's first retrospective in the United States was presented by the Museum of Fine Arts, Houston. His art was selected for the traveling *Premio Marzotto* exhibition of 1964–65, for which he won the prize in 1965, the same year in which he was awarded the Grand Prize at the São Paulo *Bienal*. The art historian Maurizio Calvesi wrote a monograph on Burri in 1971. The subsequent year, the Musée national d'art moderne, Paris, dedicated a retrospective to Burri. In the early 1970s, Burri embarked upon the "cracked" paintings series, creviced earthlike surfaces that play with notions of trompe l'oeil. A retrospective of Burri's work was inaugurated at the University of California's Frederick S. Wight Gallery, Los Angeles, in 1977; it traveled to the Marion Koogler McNay Art Institute, San Antonio, and the Solomon R. Guggenheim Museum in 1978.

Burri turned to another industrial material, Cellotex, in 1979, and continued to use it throughout the 1980s and 1990s. In 1994, the Italian Order of Merit was bestowed upon Burri. The artist died February 15, 1995, in Nice.

Composition (*Composizione*), 1953 (cat. no. 289)

Composition is one of Burri's *Sacchi* (sacks), a group of collage constructions made from burlap bags mounted on stretchers. One of Burri's first series employing nontraditional mediums, the *Sacchi* were initially considered assaults against

the established aesthetic canon. His use of the humble bags may be seen as a declaration of the inherent beauty of natural, ephemeral materials, in contradistinction to traditional "high art" mediums, which are respected for their ostentation and permanence. Early commentators suggested that the patchwork surfaces of the *Sacchi* metaphorically signified living flesh violated during warfare; the stitching was linked to the artist's practice as a physician. Others suggested that the hardships of life in postwar Italy predicated the artist's redeployment of the sacks in which relief supplies were sent to the country.

Yet Burri maintained that his use of materials was determined purely by the formal demands of his constructions. "If I don't have one material, I use another. It is all the same," he said in 1976. "I choose to use poor materials to prove that they could still be useful. The poorness of a medium is not a symbol: it is a device for painting." The title *Composition* emphasizes the artist's professed concern with issues of construction, not metaphor. Underlying the work is a rigorous compositional structure that belies the mundane impermanence of his chosen mediums and points to art-historical influences. While the *Sacchi* rely on lessons learned from the Cubist- and Dada-inspired constructions of Paul Klee and Kurt Schwitters, they are primary examples of the expressionism widely practiced in postwar Europe. — J. B.

Plastic Combustion (*Combustione plastica*), 1964 (cat. no. 290)

Burri's *Sacchi*, with their use of junk, of cast-off trash, prefigure the return of the object in painting and marks the first step on the path to Robert Rauschenberg's Combine paintings. The series testifies to the double character of Burri's art, at once profoundly classical in spirit and adventurous in means, reconciling the teachings of tradition and the explorations of the avant-gardes.

The *Plastic Combustions* partake of the latter. In 1955, with his series of *Legni* (Woods), Burri began working with fire. The burning produces traces on the wood that can evoke the ripping of the *Sacchi*, whose development continued at the same time. The first combustion on a plastic support was carried out in 1958, but it was in 1962 that what had been an initial experiment became a major chapter in Burri's work. With his use of fire, Burri anticipated Yves Klein's explorations by several years, manifesting a similar desire to go beyond the traditional problematics of painting and to integrate an elemental dimension into the work. But where Klein's vision sought to be cosmic, Burri's is painterly above all. Just as the *Sacchi* represent an overcoming of the concept of collage, the *Plastic Combustions* question the very notion of painting. Their transparency banishes any idea of front or back, returning to the insoluble question of Marcel Duchamp's *The Large Glass* (1915–23) and offering the gaze a surface all the more ambiguous in that, like the 1964 *Plastic Combustion* here, they are made up of several lay-

ers of burnt or crumpled vinyl, translucent or smoke-blackened, enclosed as though within a double glazing by a last sheet that wraps around the stretcher. Since the *Sacchi*, Burri had made occasional use of plastic, most often to cover a burst of red and to lend it an ambiguous spatiality; but it was through combustion that he discovered the full potential of this material, as poor in appearance as the sacks were seductive. He made it a new and modern form of pictorial expression, intimately connected to his time. — D. A.

Alexander Calder
1898–1976

Alexander Calder was born July 22, 1898, in Lawnton, Pennsylvania, into a family of artists. In 1919, he received an engineering degree from Stevens Institute of Technology, Hoboken. Calder attended the Art Students League, New York, from 1923 to 1926, studying briefly with Thomas Hart Benton and John Sloan, among others. As a freelance artist for the *National Police Gazette* in 1925 he spent two weeks sketching at the circus; his fascination with the subject dates from this time. He also made his first sculpture in 1925; the following year he made several constructions of animals and figures with wire and wood. Calder's first exhibition of paintings took place in 1926 at the Artist's Gallery, New York. Later that year, he went to Paris and attended the Académie de la Grande Chaumière. In Paris, he met Stanley William Hayter, exhibited at the 1926 Salon des Indépendants, and in 1927 began giving performances of his miniature circus. The first show of his wire animals and caricature portraits was held at the Weyhe Gallery, New York, in 1928. That same year, he met Joan Miró, who became his lifelong friend. Subsequently, Calder divided his time between France and the United States. In 1929, the Galerie Billiet gave him his first solo show in Paris. He met Frederick Kiesler, Fernand Léger, and Theo van Doesburg and visited Piet Mondrian's studio in 1930. Calder began to experiment with abstract sculpture at this time and in 1931 and 1932 introduced moving parts into his work. These moving sculptures were called "mobiles"; the stationary constructions were to be named "stabiles." He exhibited with the

Abstraction-Création group in Paris in 1933. In 1943, the Museum of Modern Art, New York, gave him a solo exhibition.

During the 1950s, Calder traveled widely and executed *Towers* (wall mobiles) and *Gongs* (sound mobiles). He won First Prize for Sculpture at the 1952 Venice *Biennale*. Late in the decade, the artist worked extensively with gouache; from this period, he executed numerous major public commissions. In 1964–65, the Solomon R. Guggenheim Museum, New York, presented a Calder retrospective. He began the *Totems* in 1966 and the *Animobiles* in 1971; both are variations on the standing mobile. A Calder exhibition was held at the Whitney Museum of American Art, New York, in 1976. Calder died November 11, 1976, in New York.

Josephine Baker I, 1926 (cat. no. 215), and *Spring* (*Printemps*), 1928 (cat. no. 216)

Josephine Baker I and *Spring* are among Calder's first wire sculptures; both are characteristically witty, comprised of a few essential curves and attributes to suggest female bodies. In the earlier of the two sculptures, Calder represents Josephine Baker, the American-born singer and performer, who was a charismatic star of the Paris jazz scene during the roaring twenties. Her exoticism, irreverence, and magnetic stage presence captivated audiences of La Revue Nègre, where she introduced the wild new dance called the Charleston in 1925. In 1926, she opened her own jazz club, Chez Josephine, the same year that Calder created this dynamic figure, which conveys the energy and form of her lithe, long-limbed body in action.

Two years later, he produced *Spring*, a work that was exhibited twice and then packed away. He did not retrieve this sculpture until thirty-five years later, when he was preparing for a retrospective at the Solomon R. Guggenheim Museum in 1964–65. A single piece of wire outlines the contour of the figure's arm and shoulder, while another conveys the distinctive stance of her legs and hips; complex twisted wire details contrast with the long, sweeping outlines of her body. As in the earlier sculpture, the artist has emphasized the figure's sexuality: wooden doorstops symbolize her breasts; her lower torso is represented by a series of lines that trace her genitals and gyrate around her hips back to the front of her thighs; and she holds a flower over her abdomen—all suggesting the natural renewal of life cycles in spring. — MNAM and SRGM

Shot-Putter (*Le Lanceur de poids*), 1929 (cat. no. 214)

In making humorous drawings for a newspaper in 1924 and 1925, where quickness of gesture and lightness of stroke were indispensable, Calder learned how to capture the incisive, ephemeral essence of an event. It was his vision and technique as a draftsman that would serve as the foundation for his work in sculpture. During a first trip to Paris in 1926–27, he began to fashion charac-

ters (still humorous, in his eyes) out of iron wire, sometimes adding bits of wood or leather. His favorite subjects of inspiration came from the world of performance: there was the circus, of course, especially the Médrano circus; there was Josephine Baker, who at the time was appearing on stage in Paris; and there were also sculptures of friends, gymnasts, and laborers. What captured his eye in these prototypes taken from everyday life were obviously the qualities of vitality, expressiveness, and movement. All the works of this period express a concretized tension and precarious imbalance that find their proper formal expression in this veritable "writing in space." In this respect, *Shot-Putter*, in the stability and sobriety of its design, stands out as one of a kind. All the tension and concentration of the athlete's strength is suggested merely in the play of two diagonals that link up at the center of the body, while the shot, about to be thrown, finds its formal counterbalance, a perfect equilibrium, in the figure's raised foot. — MNAM

Shark and Whale (*Requin et baleine*), 1933 (cat. no. 217)

A prime example of the imbalanced balance developed by Calder, this mobile sculpture nevertheless displays a relatively unusual concept in the artist's oeuvre. Calder started to work with wood during the years from 1926 to 1930; during this first period, the static, rough, and figurative sculptures he produced in wood were somewhat reminiscent of American folk art. Between 1930 and 1933, in his first abstract drawings, some of which are slightly Surrealistic, Calder continued his exploration of relief through the use of forms at once ambiguous and abstract, organic, and even oneiric. In *Shark and Whale*, which follows those works, something else is introduced: the piece, in fact, is an assemblage of two barely altered "found objects"—two different, crude pieces of wood, either root or vine—which perhaps again show the influence of the Parisian Surrealist milieu. These two wood elements are held together by a point pivoting inside a hole made at the top of the support shaft, in an apparently aleatory equilibrium so precarious that the slightest vibration makes the upper piece teeter, and yet it is obviously the result of very skillful calculation. The allure of the object, which is at once playful and mysterious, charged with the primitive forces of nature, makes the work truly unique. — MNAM

Constellation, 1943 (cat. no. 218), and *Constellation*, 1943 (cat. no. 219)

Constellations are a special variety of Calder's stabiles dating from the time of World War II and constructed from pieces of wood and thin metal rods. The stabiles originated in the early 1930s, the same period as the mobiles, and were named by Jean Arp. It is no coincidence that Arp had created his own *Constellations* in the 1930s, as had Miró, another of Calder's friends, around 1940–41; to varying degrees, all three artists

were involved in creating fields of individually abstracted forms. In particular, the linear circuitry, and the way the hourglass and dumbbell forms are rhythmically interspersed throughout Calder's *Constellations*, closely resemble Miró's gouache series of the same title from several years earlier.

Some of Calder's *Constellations* were meant for horizontal placement, while others were designed as wall pieces. The wooden elements contrast in color, shape, and texture with the spiky rods: their configurations fix precise points in space, nodes in a three-dimensional network. Both of these *Constellations* jut out from a planar surface, gently charging their spatial environment as they temporarily occupy open territory. — MNAM and SRGM

Red Lily Pads (*Nénuphars rouges*), 1956 (cat. no. 220)

While the extraordinary breadth of Calder's production makes it impossible to characterize his work according to any particular style or technique, he is perhaps best known as the inventor of the mobile. It was Marcel Duchamp who devised the term for these suspended sculptures; as Calder recalled, "I asked him what sort of a name I could give these things and he at once produced 'mobile.' In addition to something that moves, in French it also means motive."

Red Lily Pads is at first a hanging abstract composition of red-painted discs, rods, and wires. Like many of Calder's complex mobiles, with their widespread distributions of cantilevered weight, this sculpture maintains a continually changing equilibrium according to the laws of physics. Yet with its lazy drift through space and subtle evocation of organic form, *Red Lily Pads* also suggests the gentle motion of leaves floating on a pond.

As Jean-Paul Sartre declared, the mobile "captures genuine living movements and shapes them." In the 1940s, he wrote, "Mobiles have no meaning. . . . They are, that is all; they are absolutes. There is more of the unpredictable about them than in any other human creation." — SRGM

César

b. 1921

César Baldaccini was born January 1, 1921, in Marseilles. Although he left school when he was twelve, he enrolled two years later in 1935 in drawing and sculpture classes at the Ecole des Beaux-Arts in Marseilles and graduated in 1939. In 1943, he was admitted to Ecole des Beaux-Arts in Paris, where he studied sculpture intermittently until 1947. He soon grew impatient with traditional materials and began to experiment with ceramics, plaster, and iron. In 1952, he tried welding with scrap iron, creating figurative works that portrayed animals, as well as a large female nude inspired by the petrified bodies discovered in Pompeii. These works, which are related to the work of Germaine Richier, were shown in César's first gallery exhibition in 1954 at the Galerie Lucien Durand, Paris. His first museum acquisition occurred the following year when the Musée national d'art moderne, Paris, bought one of these sculptures.

Throughout his life, César has experimented with nontraditional mediums and techniques, creating abstract compositions out of industrial materials. In the late 1950s, he started to make a series of sculptures called *Compressions*, working with the industrial machines that crush and compact old automobiles and other waste metals. Impressed by the violence and devastation of this process, he quickly discovered how to manipulate the equipment to achieve different compositions of form and color. Toward the end of 1960, César was affiliated briefly with the Nouveaux Réalistes, yet he has always refused labels for himself and his work, maintaining that his interest in junk material is purely personal, without any underlying political or sociological connotations.

In 1967, César discovered polyurethane and began a new phase in his career. Combining two liquefied chemicals that solidify in less than a minute, he created his series of *Expansions*. This technique gave him just enough time to manipulate the polyurethane before it set. Sometimes, these sculptures would be simple ovals, showing how the liquid radiated out. Other times, César molded his works into specific shapes, using different objects like barrels or architectural spaces, such as staircases or room corners. He thought of these works as "controlled happenings" or "action

sculptures" and often turned the act of creating them into public performances.

César taught sculpture at the Ecole National Supérieure des Beaux-Arts, Paris, from 1968 to 1986. His first retrospective was held in 1966 at the Musée Cantini, Marseilles. This was followed by a large international show in 1976 that opened at the Musée Rath, Geneva, and traveled to Grenoble, Knokke, Rotterdam, and Paris. He has received numerous honors in France, including the Chevalier de la Légion d'Honneur in 1976 and Commandeur de l'Ordre des Arts et Lettres in 1984. In 1995, a broad selection of César's work was shown in the French Pavilion at the Venice *Biennale*. He lives and works in Nice and Paris.

Ricard, 1962 (cat. no. 303)

César's *Compressions* remain one of the most radical artistic achievements of the second half of this century. César, who simultaneously developed a classical body of work based on anthropomorphic and animal themes, punctuated the process of his work with ruptures as significant as they were decisive. The principle of "compression," born in the late 1950s and presented to the public for the first time at the Salon de Mai in 1960, appeared at once as the emblem of a rich and readily protean oeuvre and as the idiom the artist does not hesitate to use in different forms even today.

During the late 1940s, when he was working with a technique of soldering iron, César discovered an automobile press at the scrap merchant's shop. Thereafter, he would use and index this tool, which became indispensable to the realization of his oeuvre. The idea of "compression" was guided at once by the principle of the machine and by a recognition of the specificity of the material. The artist would henceforth command a process the results of which were dependent upon the aleatory amassment and jumbling of the pieces that make it up.

To gain further mastery of the results, César decided to intervene in the process of creation by adding or removing colored fragments of scrap iron or metal. He thus developed in 1961 the principle of "directed compression," of which *Ricard* is an example. The systematic principle is thus thwarted by the incursion of a gesture that interrupts the process in course and modifies its appearance.

Part *homo faber*, part *homo ludens*—to use the apt expression of the artist's first exegete, Pierre Restany—César does not stray from a principle that he sees as dialectical and constant; he counters an acceptance of the logic of all the materials he puts to the test with the principle of a manual gesture.

Ricard, moreover, does not fail to remind us just how much César's *Compressions*, those modern megaliths, celebrate in commemorative and ironic fashion the industrial as well as the urban nature of our society in all its vanity. In particular, the vehicle in question here carries the fragmented logo of the famous French brand of alcohol, which

created a race-car team bearing its name that has been competing for over forty years.

It is just as apparent today as during the period of formation of the Nouveau Réalisme movement, which César joined in 1960, that the artist's gesture embodies a synthetic expression of modern man's conflict with the machine, taking its place in the logic of an intellectual current founded on a renovation of expressiveness born of a direct appropriation of reality. — B. B.

Paul Cézanne

1839–1906

Paul Cézanne was born January 19, 1839, in Aix-en-Provence. In 1854, he enrolled in the free drawing academy there, which he attended intermittently for several years. In 1858, he graduated from the Collège Bourbon, where he had become an intimate friend of his fellow student Emile Zola. Cézanne entered the law school of the University of Aix in 1859 to placate his father but abandoned his studies to join Zola in Paris in 1861. For the next twenty years, Cézanne divided his time between the Midi and Paris. In the capital, he briefly attended the Atelier Suisse with Camille Pissarro, whose art later came to influence his own. In 1862, Cézanne began long friendships with Claude Monet and Pierre-Auguste Renoir. His paintings were included in the 1863 Salon des Refusés, which displayed works not accepted by the jury of the official Paris Salon. The Salon itself rejected Cézanne's submissions each year from 1864 to 1869.

In 1870, following the declaration of the Franco-Prussian War, Cézanne left Paris for Aix-en-Provence and then nearby L'Estaque, where he continued to paint. He made the first of several visits to Pontoise in 1872; there, he worked alongside Pissarro. He participated in the first Impressionist exhibition of 1874. From 1876 to 1879, his works were again rejected for the Salon.

Cézanne showed again with the Impressionists in 1877 in their third exhibition. At that time, Georges Rivière was one of the few critics to support his art. In 1882, the Salon accepted his work for the first and only time. Beginning in 1883, Cézanne resided in the south of France, returning to Paris occasionally.

In 1890, Cézanne exhibited with the group Les XX in Brussels and spent five months in Switzerland. He traveled to Giverny in 1894 to visit Monet, who introduced him to Auguste Rodin and the critic Gustave Geffroy. Cézanne's first solo show was held at Ambroise Vollard's gallery in Paris in 1895. From this time, he received increasing recognition. In 1899, he participated in the Salon des Indépendants in Paris for the first time. The following year, he took part in the *Centennial Exhibition* in Paris. In 1903, the Berlin and Vienna Secessions included Cézanne's work, and in 1904 he exhibited at the Salon d'Automne, Paris. That same year, he was given a solo exhibition at the Galerie Cassirer, Berlin. Cézanne died October 22, 1906, in Aix-en-Provence.

Man with Crossed Arms (*Homme aux bras croisés*), ca. 1899 (cat. no. 1)

Cézanne's shimmering landscapes, searching portraits, and complex still lifes may be viewed as the culmination of Impressionism's quest for empirical truth in painting. His work was motivated by a desire to give sculptural weight and volume to the instantaneity of vision achieved by the Impressionists, who painted from nature. Relying on his perception of objects in space as visually interrelated entities—as forms locked into a greater compositional structure—Cézanne developed a style premised on the oscillation of surface and depth. Each tiny dab of color indicates a spatial shift while simultaneously calling attention to the two-dimensional canvas on which it rests. This play of illusion, along with the conceptual fusion of time and space, has led Cézanne to be considered the foremost precursor of Cubism.

Cézanne's late work, created in relative isolation in the south of France, is marked by an intensification of his perceptual analysis coupled with an increasingly introspective sensibility. In *Man with Crossed Arms*, the strangely distorted, proto-Cubist view of the sitter—his right eye is depicted as if glimpsed from below and the left as if seen from above—contributes an enigmatic, contemplative air to the painting. This portrait of an anonymous sitter has come to be seen as a study of quiet resignation and reserve—characteristics often attributed to Cézanne during the last decade of his life. —N. S.

Marc Chagall
1887–1985

Marc Chagall was born July 7, 1887, in Vitebsk. From 1906 to 1909, he studied in Saint Petersburg, Russia, at the Imperial School for the Protection of the Arts and with Léon Bakst. In 1910, he moved to Paris, where he associated with Guillaume Apollinaire and Robert Delaunay and encountered Fauvism and Cubism. He participated in the Salon des Indépendants and the Salon d'Automne in 1912. His first solo show was held in 1914 at Der Sturm gallery in Berlin.

Chagall returned to Russia during the war, settling in Vitebsk, where he was appointed Commissar for Art. He founded the Vitebsk Popular Art School and directed it until disagreements with the Suprematists resulted in his resignation in 1920. He moved to Moscow and executed his first stage designs for the Jewish Art Theater there. After a sojourn in Berlin, Chagall returned to Paris in 1923 and met Ambroise Vollard. His first retrospective took place in 1924 at the Galerie Barbazanges-Hodebert, Paris. During the 1930s, he traveled to Palestine, the Netherlands, Spain, Poland, and Italy. In 1933, the Kunsthalle Basel held a major retrospective of his work.

During World War II, Chagall fled to the United States. The Museum of Modern Art, New York, gave him a retrospective in 1946. He settled permanently in France in 1948 and exhibited in Paris, Amsterdam, and London. During 1951, he visited Israel and executed his first sculptures. The following year, the artist traveled in Greece and Italy. In 1962, he designed windows for the synagogue of the Hadassah Medical Center, near Jerusalem, and the cathedral at Metz. He designed a ceiling for the Opéra, Paris, in 1964 and murals for the Metropolitan Opera House, New York, in 1965. An exhibition of the artist's work from 1967 to 1977 was held at the Musée du Louvre, Paris, in 1977–78. Chagall died March 28, 1985, in Saint Paul de Vence, France.

To Russia, Asses and Others (*A la Russie, aux ânes et aux autres*), 1911–12 (cat. no. 106)

There exist two preparatory studies for *To Russia, Asses and Others*, which is one of Chagall's first large Parisian compositions executed in late 1911 and 1912. One of these recently discovered studies shows the original subject, roughly sketched in black ink on white paper, of the milkmaid following behind a cow; in the other one, a much more finished gouache dated 1911, one already sees the spectacular inversion of black and white fields, the decapitation of the milkmaid, and the development of the theme of nourishment. The studies thus make it possible to follow the process of the image's formation—to grasp, at once, the poetic power of the definitive oil painting and the shock potential of this "total lyric explosion," to use André Breton's expression. Having started from a spontaneous observation of everyday reality—here the "forbidden," mysterious world of Vitebsk peasant chores, whose memory haunted him in Paris—Chagall quickly arrives at the "revelation" of a mystical symbol, that of celestial nourishment, the keys to whose interpretation can be found likewise in ancient mythology, according to H. Demisch, as well as in Hasidic culture, and in the framework of a psychoanalytic reading.

It is indeed a strange, nocturnal image, an exemplary indication of the painterly mastery at Chagall's command as early as 1911, as well as an early testimony to what might be considered the very foundation of Chagall's mystical philosophy: the feeling of the multivalence of everything, the certainty of a "supernatural" unity. There is a complex, perfectly controlled exchange of contrary, simultaneous forces animating *To Russia, Asses and Others*. Ghostly silhouettes devoid of coloration, almost white, float through a dark space swept with rays of incandescent color; it is a negative image of a lost reality, a positive image of a conquered surreality. Set against the strong geometric construction in diagonals, showing Cubist origins, is the "primitivist" schematization of figures drawn from Russian folk imagery. And superimposed on the humorous burst of elements with morphological equivalences (e.g., animal equals human being, tail equals head, bucket equals dome) is the grave, poetic unity of the image, metaphor of divine presence.

Particularly meaningful in the painter's solitary quest in 1911, as he broke free of the Parisian avant-garde and invoked his Russian roots, *To Russia, Asses and Others* was visually quoted by the artist in his *Self-Portrait with Seven Fingers* (1912) to express his own marginality. The importance he accorded the painting is likewise evident in the fact that he chose to send it to the Salon des Indépendants of 1912 together with two other major works: *The Drunk* and *Dedicated to my Fiancée*. The success it subsequently enjoyed is well known: upon Guillaume Apollinaire's intervention, it was presented in Berlin at the first German Salon d'Automne, at Der Sturm gallery in 1914; hailed by Breton, it later appeared in the *First Papers of Surrealism* show in New York in 1942; and it has been seen in many retrospectives of this artist's work. It is one of the richest, most accomplished of Chagall's early works. —A. L. B.

The Flying Carriage (*La Calèche volante*), 1913
(cat. no. 107)

Painted during Chagall's first sojourn in Paris, *The Flying Carriage* demonstrates the artist's adoption of a more expressionistic palette and dynamic forms, influenced to some extent by the avant-garde idioms he had encountered in the French capital. Like many of his works, the scene depicted takes place in Chagall's native town of Vitebsk. A man, with his arms flung into the air, is swept up toward the heavens in a cart drawn by an unbridled horse that wears the traditional Russian harness and bell. The other two figures within the image observe the magical event in awe and wonder. The house itself, a typical Vitebsk timber construction, has the word "*LAV*" written in Cyrillic letters above the door, short for *lavka* meaning "shop."

Identified for a period as *The Burning House*, this work represents not a home on fire nor an omen of apocalypse, as previously posited, but a moment of spiritual ecstasy as a man is born aloft by his flying vehicle. In this composition, Chagall employs glowing hues of red, orange, and yellow, which contrast with the cool blue night sky behind the woman, visually and symbolically expressing the joy within this fantastical scene.

As with much of the imagery in Chagall's oeuvre, no individual tale can be correlated with this painting. The motif of flying does recall similar themes in Jewish and Russian folklore. Another possible source that has been cited for the flying carriage is the Old Testament story of Elijah's ascension to heaven; specifically, this Biblical narrative appears in the bas-relief of Byzantine and medieval churches of the area. Flying is often a metaphor for liberation or transformation of a mystical sort. Ultimately, Chagall's iconography allows for a broad interpretation and, as the artist himself later noted, the image is meant to evoke not a particular event, but the exalted emotion of this cosmic ascension. —V. G.

Green Violinist (Study for *Music*), 1918
(cat. no. 108), and *Green Violinist* (*Violoniste*),
1923–24 (cat. no. 109)

Chagall spent the years 1914–22 in Russia, caught there when World War I broke out while he was on a visit home from Paris. Although Chagall was isolated from the European cultural milieu in which he had experienced increasing international recognition, this Russian period was a fruitful one for him personally and professionally. During this time, he created stage designs and murals for the Jewish Art Theater, Moscow, including individual panels devoted to the arts of music, dance, drama, and literature.

The theme of the violinist is a recurring one in Chagall's work, and *Green Violinist* is based on several earlier versions of the subject, including the study from 1918. Painted almost immediately upon his return to Paris in 1923, when the artist's nostalgia for his own work led him to recreate many paintings he had left behind, the composi-

tion closely parallels Chagall's *Music* mural for the Jewish Art Theater. Chagall had brought several preparatory drawings for the murals back with him to Paris and drew upon them for this painting. Yet, according to the artist, the significance of the violinist went beyond a simple personification of music, for in Russian villages deprived of cultural resources the violinist came to personify all the arts.

Green Violinist evokes Chagall's Russian homeland. The ladder propped against a tree is an allusion both to memories from the artist's childhood, when he aspired to rise above the ground to take in the surrounding view and to the biblical Jacob's ladder. It has been suggested that this violinist dancing in a rustic setting has religious significance. The Hasidim—to whom Chagall's uncle (who was also his violin teacher) belonged—sought communion with God through dance and music. The fiddler was thus a vital presence in ceremonies and festivals. Throughout his career, Chagall drew upon his heritage to create works that illuminate his cultural and religious legacy. —J. F. R.

John Chamberlain

b. 1927

John Angus Chamberlain was born April 16, 1927, in Rochester, Indiana. He grew up in Chicago and, after serving in the Navy from 1943 to 1946, attended the Art Institute of Chicago from 1951 to 1952. At that time he began making flat, welded sculpture, influenced by the work of David Smith. In 1955 and 1956, Chamberlain studied and taught sculpture at Black Mountain College, North Carolina, where most of his friends were poets, among them Robert Creeley, Robert Duncan, and Charles Olson. By 1957, he began to include scrap metal from cars in his work, and from 1959 onward he concentrated on sculpture built entirely of crushed automobile parts welded together. Chamberlain's first major solo show was held at the Martha Jackson Gallery, New York, in 1960.

Chamberlain's work was widely acclaimed in the early 1960s. His sculpture was included in *The Art of Assemblage* at the Museum of Modern Art, New York, in 1961, and the same year he participated in the São Paulo *Bienal*. From 1962 , Chamberlain showed frequently at the Leo Castelli

Gallery, New York, and in 1964 his work was exhibited at the Venice *Biennale*. While he continued to make sculpture from auto parts, Chamberlain also experimented with other mediums. From 1963 to 1965, he made geometric paintings with sprayed automobile paint. In 1966, the same year he received the first of two Guggenheim fellowships, he began a series of sculptures of rolled, folded, and tied urethane foam. These were followed in 1970 by sculptures of melted or crushed metal and heat-crumpled Plexiglas. Chamberlain's work was presented in a retrospective at the Solomon R. Guggenheim Museum, New York, in 1971.

In the early 1970s, Chamberlain began once more to make large works from automobile parts. Until the mid-1970s, the artist assembled these auto sculptures on the ranch of collector Stanley Marsh in Amarillo. These works were shown in the sculpture garden at the Dag Hammarskjöld Plaza, New York, in 1973 and at the Contemporary Arts Museum, Houston, in 1975. In 1977, Chamberlain began experimenting with photography taken with a panoramic wide-lux camera. His next major retrospective was held at the Museum of Contemporary Art, Los Angeles, in 1986; the museum simultaneously copublished *John Chamberlain: A Catalogue Raisonné of the Sculpture 1954–1985*, authored by Julie Sylvester. In 1993, Chamberlain received both the Skowhegan Medal for Sculpture and the Lifetime Achievement Award in Contemporary Sculpture from the International Sculpture Center, Washington, D.C. The artist has lived and worked in Sarasota since 1980.

Dolores James, 1962 (cat. no. 304)

Chamberlain's dynamic agglomerations of scrap metal and used automobile bodies have been admired for translating the achievements of Abstract Expressionist painting into three-dimensional form. The whirling arabesques of color in wall reliefs such as *Dolores James* echo the energy and expressive power of paintings by Willem de Kooning; the heroic scale and animated diagonals suggest the canvases of Franz Kline. Like the Abstract Expressionists before him, Chamberlain revels in the potential of his mediums. In a 1972 interview with critic Phyllis Tuchman, he remarked, "I'm sort of intrigued with the idea of what I can do with material and I work *with* the material as opposed to enforcing some kind of will upon it." Chamberlain emphasizes the importance of "fit," or the marriage of parts, in his sculpture. As in other early works, the various elements of *Dolores James* stayed in place by virtue of careful balances when the sculpture was first assembled; later, the work was spot-welded to insure its preservation.

Chamberlain's oeuvre appeared in the context of late-1950s assemblage or Junk art, in which the detritus of our culture was critiqued and revitalized as fine art. On some level, his conglomerations of automobile carcasses must inevitably be

perceived as witnesses of the car culture from which they were born, and for which they serve as memorials. There is a threatening air about the jagged-edged protuberances in Chamberlain's sculptures, and the dirty, dented automobile components suggest car crashes; the artist, however, prefers to focus on the poetic evocations that his sculptures elicit. — J. B.

Eduardo Chillida

b. 1924

Eduardo Chillida was born January 10, 1924, in San Sebastián. From 1943 to 1947, he studied architecture at the University of Madrid while dedicating the rest of his time to drawing and sculpture. In 1948, he went to Paris, and exhibited at the Salon de Mai the following year.

In 1951, Chillida returned to Spain and lived in Hernani until 1958. His first solo exhibition opened in 1954 at the Galeria Clan, Madrid. In 1955, the city of San Sebastián commissioned his first monumental outdoor sculpture, *Alexander Fleming*; many others followed from *Comb of the Wind IV* (1969) for the UNESCO building in Paris to *Gure Aitaren Etxea* (1988) in Guernica. Chillida's sculptures are characterized by their geometric and organic shapes made of stone, steel, or fired clay; his open-air work often occupies key public spaces and dramatizes the relation between people and nature.

In 1956, the Galerie Maeght, Paris, organized the first of many solo exhibitions. He traveled to the United States in 1958, returning in 1959 to settle permanently in San Sebastián. In 1966, the Museum of Fine Arts, Houston, mounted his first retrospective. Chillida's encounter with Martin Heidegger in 1968 resulted in his illustrating the philosopher's book *Die Kunst und der Raum*.

He was invited by the Carpenter Center, Harvard University, Cambridge, Massachusetts, to be a visiting professor in 1971. In 1984, the artist created the Chillida Foundation in Hernani to house his work. For the last several years, the artist has been working on a controversial project on Fuerteventura, one of the Canary Islands; the idea is to produce a colossal artwork that will restore the Tindaya mountain, which has been endangered by previous excessive digging in a stone quarry.

Notable among the many prizes the artist has received are the Sculpture Prize of the 1958 Venice *Biennale*, the 1960 Kandinsky award, and the Andrew W. Mellon Prize shared in 1978 with Willem de Kooning. During the 1980s and 1990s, Chillida has also been honored with the highest distinctions from England, France, Germany, Japan, and Spain.

Retrospectives of his work were organized in 1980 by the Solomon R. Guggenheim Museum, New York, in 1990 by the Venice *Biennale*, in 1991 by the Martin-Gropius-Bau, Berlin, and in 1992 by the Royal Palace of Miramar, San Sebastián. Chillida lives and works in San Sebastián.

From Within (*Desde dentro*), March 1953 (cat. no. 272)

Fine craftsmanship in general, and wrought ironwork in particular, are indigenous to the Basque region where Chillida was born. Iron is a native element there, and a material he began to forge in 1951, making sculptures that manifested the metal's innate properties of extreme hardness, sharp edges, density, mass, and weight. *From Within* distills these qualities in its intricate interplay of solids and voids. As Chillida recently said of his work in general, "a dialectic exists between the empty and full space . . . the relation is produced by the communication between these two spaces." In this particular work there seem to be psychological and anthropomorphic implications as well, which are suggested by its title, by the rounded, bracelike forms rotating around and protecting a central core, and particularly by the threatening daggerlike form stabbing down from above as the work hangs precariously from the ceiling. — SRGM

Three Irons (*Iru burni*), 1966 (cat. no. 273)

Prior to the twentieth century, artists did not work directly in metal as a sculptural medium. Rather, they carved plaster and molded clay originals that were subsequently cast at a foundry by expert craftsmen. Thus, the sculpture of Chillida, comprised of abstract forms created through pounding and bending steel, represents a quintessentially modern approach. Chillida considers his materials not as a vehicle for representation but as an inherent part of the work's total conception and form. His way of working is characteristic of his native region, but it also has roots in the art of Julio González, who is generally regarded as having made the initial breakthrough to direct metal sculpture in the late 1920s.

Executed with a heroic sense of scale and a tremendous sensitivity for mass, space, and materials, Chillida's abstract sculpture is well in keeping with the Tachiste sensibility of late 1940s and 1950s art. Accentuating the work's physical properties, the surface of *Three Irons* is raw and pitted by acid. As the viewer considers the work from various angles, the interrelationships of the interlocking steel limbs in space seem to change. Chillida's interest in volumetric forms may stem, in part, from his early training in architecture. His first welded metal sculptures were relatively delicate and in keeping with a Cubist language of linear forms. But he soon developed a technique that seems to reference the Spanish tradition of forged ironwork, which had been particularly strong in the Basque Provinces and Catalonia. During the 1960s, Chillida boosted the scale of his work and executed a series of public commissions. This experience of working monumentally informs his works in all scales, so that even the relatively small *Three Irons* possesses a majestic sense of structure. — I. S.

Joseph Cornell

1903–1972

Joseph Cornell was born December 24, 1903, in Nyack, New York. From 1917 to 1921, he attended Phillips Academy, Andover. He was an avid collector of memorabilia and, while working as a woolen-goods salesman in New York for the next ten years, developed his interests in ballet, literature, and opera. He lived with his mother and brother, Robert, at their home in the Flushing section of Queens.

In the early 1930s, Cornell met Surrealist writers and artists at the Julien Levy Gallery, New York, and saw Max Ernst's collage-novel *La Femme 100 têtes*. Cornell's early constructions of found objects were first shown in the group exhibition *Surréalisme* at Levy's gallery in 1932. From 1934 to 1940, Cornell supported himself by working as a textile designer at the Traphagen studio in New York. During these years, he became familiar with Marcel Duchamp's readymades and Kurt Schwitters's box constructions. Cornell was included in the 1936 exhibition *Fantastic Art, Dada, Surrealism* at the Museum of Modern Art, New York. Always interested in film and cinematic techniques, he made a number of movies, including the collage film *Rose Hobart* (ca. 1936) and wrote two film scenarios. One of these, *Monsieur Phot* (1933), was published in 1936 in Levy's book *Surrealism*.

Cornell's first two solo exhibitions took place at the Julien Levy Gallery in 1932 and 1939, and they

included an array of objects, a number of them in shadow boxes. During the 1940s and 1950s, he made *Aviary*, *Hotel*, *Observatory*, and *Medici* boxes, among other series, as well as boxes devoted to stage and screen personalities. In the early 1960s, Cornell stopped making new boxes and began to reconstruct old ones and to work intensively in collage. Cornell retrospectives were held in 1967 at the Pasadena Art Museum and the Solomon R. Guggenheim Museum, New York. In 1971, the Metropolitan Museum of Art in New York mounted an exhibition of his collages. Cornell died December 29, 1972, at his home in Flushing.

Fortune Telling Parrot (Parrot Music Box), ca. 1937–38 (cat. no. 204)

Cornell made frequent excursions into Manhattan to gather objects for his constructions. His diaries record his alternating feelings of being trapped at home, and then of release when he escaped to Manhattan. Working on his boxes at home in his cellar became a substitute for traveling, the arrangement of imaginary souvenirs inducing the excitement of voyages.

Fortune Telling Parrot (Parrot Music Box) offers many associations with exotic travels. First, the box construction itself resembles the apparatus of a hurdy-gurdy, invoking the bohemian world of the traveling gypsy musician. The crank on the right exterior of the construction turns a broken music box, hidden in the lower-right corner of the sculpture. The music box in turn is attached by a thin rod to the cylinder above it, which is intended to revolve while music plays.

The cylinder is covered with decorations, some of which suggest the paraphernalia and practices of the fortune-teller: playing cards such as the King of Hearts and the Jack of Clubs; the numbers one through nine; a picture of two hands playing cat's cradle, recalling the entertainments of the gypsy; and the picture of a gypsy woman in elaborate costume. Small stars on the cylinder and a map of the constellation of Ursa Minor, in the lower-left corner of the box, also allude to astrology and divination. The parrot itself is a common attribute of the itinerant fortune-teller. Facing the revolving canister, this bird assumes the role of a soothsayer's assistant. Exotic birds, including parrots, parakeets, and cockatoos, appear in some eighteen boxes by Cornell, *Fortune Telling Parrot (Parrot Music Box)* being the earliest and the others dating from the 1940s and 1950s. In his diary, the artist recalled some of the experiences that contributed to his obsession with parrots: "magic windows of yesterday . . . pet shop windows splashed with white tropical plumage / the kind of revelation symptomatic of city wanderings in another era. . . . scintillating songs of Rossini and Bellini and the whole golden age of the bel canto . . . indelible childhood memory of an old German woman a neighbor's pet parrot may have added to the obsession of these . . . feathered friends." — E. C. C.

Untitled (Pharmacy), ca. 1942 (cat. no. 203)

Cornell's obsession with the collection, isolation, combination, and preservation of found objects is revealed in a fastidiously compartmentalized form in the *Pharmacy* boxes of the 1940s and 1950s. Like Marcel Duchamp's *Box in a Valise* (1941), *Untitled (Pharmacy)* is a miniature museum dedicated to the protection and presentation of its contents. The care with which the collection has been selected and displayed invests it with a potency the individual objects do not ordinarily convey.

Each apothecary jar presents a diorama of poetically allusive natural or man-made forms. The natural world is present in sand, stones, shells, plant and insect parts, feathers, and wood; the constructed world appears in mechanisms, toys, maps, and prints. The environments invoked range from the seashore, where mankind's importance is negligible, to the Renaissance palace, one of the most sophisticated expressions of humanity's material and intellectual achievement. Like the alchemist, Cornell transforms ordinary objects into precious things; in one jar he even seems to have fulfilled the ultimate alchemical aspiration of transmuting base metal into gold. By presenting these inviolable jars in a pharmaceutical context, he may also allude to the universal restorative powers that alchemists hoped to discover. The mirroring of the back wall of the box, typical of apothecaries' cabinets, multiplies the contents and reflects the viewer, whom it affords the unexpected opportunity to study the reverse of objects without moving around them. — L. F.

Owl Box, 1945–46 (cat. no. 205)

The work of Cornell may be organized around themes, the aviary appearing quite frequently among them. He addressed this theme in numerous works—for example, in his films from *Rose Hobart* to *Aviary* (1954). In December 1949, Cornell exhibited twenty-six assemblages on the theme of birds at the Egan Gallery, New York. He called his boxes "habitats" for the images of birds they contained. In the films, the birds, often doves and pigeons, are poetic, cooing, and in flight, whereas in the boxes, the birds are children's cutouts, their surfaces polished, some exotic, such as parrots, cockatoos, parakeets, some comical, like the woodpecker.

The owl is a relatively rare subject for Cornell; it appears for the first time in the mid-1940s, in *Owl Box* and in such works as *Habitat for Owl* and *Grand Owl Habitat*, both 1946. Some critics, especially in the beginning, had a tendency to consider these objects as amusements—toy boxes—designed for Robert, the mentally handicapped brother to whom Cornell devoted a great part of his life. The artist himself never accepted this interpretation, and the care that he brought to the creation of these pieces is proof. He was preoccupied by the aesthetic effects produced by the materials used, artificially aged and patinated, and by the positioning of the elements. When a montage did not satisfy him, he did not hesitate to redo it

long after it was first made. Thus *Owl Box* was reworked twenty years later. This interval reveals a surprising characteristic of Cornell's work: it shows no evolution. The objects were perfect from the beginning, and they never changed in style, process, or theme. — H.L.

Soap Bubble Set, 1948–49 (cat. no. 206)

Cornell exhibited his first *Bubble Set* in 1936, at the *Fantastic Art, Dada, Surrealism* exhibition. Continuing this fantastic theme, Cornell created a dreamy, luminous universe in this *Soap Bubble Set*, in distinct contrast to the dark, naturalistic space of *Owl Box*. The white and blue tones, celestial colors dear to Cornell, suggest a subtly resonant harmony that is found even on the glass of the box. Cracked with age, no doubt intentionally, the painting on the back wall of the box contributes to the immaterial atmosphere and magnifies the space. Constant in the other *Bubble Sets* are the clay pipe; the magical instrument; the glass, here broken; the blue powder, symbol of the constellations; and the ball, a miniature terrestrial sphere. By the gentle sounds of their movement in the box, all of these objects evoke Cornell's vital taste for music.

The work of Cornell, with its transparent and inexhaustible universe, evokes the poetry of St. John Perse and Victor Segalen and, through the enumeration of objects, shares the same incantatory power. — E. B.

Space Object Box: "Little Bear, etc." motif, mid-1950s–early 1960s (cat. no. 207)

As part of Cornell's *Winter Night Skies* series, *Space Object Box: "Little Bear, etc." motif* includes fragments of celestial maps of the northern sky. The focus of this map section is the constellation Ursa Minor, the "Little Bear" of the title. The "etc." refers to the other personifications of stars that the artist has colored in this work, including Cameleopardalis, the giraffe, and Draco, the dragon. The blue cork ball and the ring suggest the moon and its orbit; their movement along the two metal rods alludes to the unending cycle of celestial change. The toy block with a horse on its face is probably a punning reference to Pegasus, a square constellation. The *Winter Night Skies* series may recall a passage by Mary Baker Eddy, the founder of Christian Science, who believed that modern scientific theory holds a key to understanding our world. In a book that Cornell, himself a Christian Scientist, claimed was the most important to him after the Bible, she wrote, "The astronomer will no longer look up to the stars—he will look out from them upon the universe." — SRGM

Salvador Dalí

1904–1989

Salvador Dalí was born May 11, 1904, as Salvador Felipe Jacinto Dalí y Domenech, in Figueras, Spain. In 1921, he enrolled in the Real Academia de Bellas Artes de San Fernando in Madrid, where he became a friend of Luis Buñuel and Federico García Lorca. His first solo show was held in 1925 at the Galeries Dalmau, Barcelona. In 1926, Dalí was expelled from the Academia. During the following two years, he visited Paris and met Paul Eluard, Pablo Picasso, and Tristan Tzara. About this time, Dalí produced his first Surrealist publications and illustrated the works of Surrealist writers and poets. His first solo show in the United States took place at the Julien Levy Gallery, New York, in 1933.

Dalí was censured by the Surrealists in 1934. Toward the end of the decade he made several trips to Italy to study the art of the sixteenth and seventeenth centuries. In 1940, Dalí fled to the United States, where he worked on theatrical productions, wrote, illustrated books, and painted. A retrospective of his work opened in 1941 at the Museum of Modern Art, New York, and traveled throughout the United States. In 1942, Dalí published his autobiography and began exhibiting at M. Knoedler and Co., New York. He returned to Europe in 1948, settling in Port Lligat, Spain. His first paintings with religious subjects date from 1948–49. In 1954, a Dalí retrospective was held at the Palazzo Pallavicini, Rome, and in 1964 an important retrospective of his work was shown in Tokyo, Nagoya, and Kyoto. He continued painting, writing, and illustrating during the 1960s. The Salvador Dalí Museum, Cleveland, was inaugurated in 1971 (it is now located in Saint Petersburg, Florida), and the Dalinian Holographic Room opened at M. Knoedler and Co., New York, in 1973. In 1980, a Dalí retrospective was held at the Musée national d'art moderne, Paris, and his work was exhibited at the Tate Gallery, London. The artist died January 23, 1989, in Figueras.

The Spectral Cow (La Vache spectrale), 1928 (cat. no. 171)

"One of the veins of my work consists of rendering the sentiment of death colloidal, of extending it, of milking it like a cow's udder, to extract from it the milk of resurrection," Dalí wrote in 1929. As demonstrated by *The Spectral Cow*, Dalí's formal repertoire of morbidity was already in place by 1928, the year in which he met André Breton and worked with Buñuel on the screenplay of *Un Chien andalou*. Against the background of what Dalí called the "holy" sea of Cadaqués appear the constituent elements of a menacing, disturbing "natural history": the flaccid, sterile morphology of the nourishing cow, the phallus extended over a crutch, the hairs, grasses, thorns, residual grains of sand, and voracious flies, and, above all, the stinking ass, which had been Dalí's obsessive theme of the previous year, and which was a derisory symbol of grotesque virility, like the cock. Fascinated by putrefaction and the deliquescence of matter, Dalí here effectively renders instead its "spectral" aspect, which he described in 1934 as a "luminous, bristling, iridescent anguish." The pearly image of this twilight beach, like a soft but incandescent, fleshy blue- and red-colored ear, displays a bursting network of metamorphic configurations that are difficult to identify, juxtaposed without any apparent logical connection, as in works by Joan Miró from 1924 and 1925. *The Spectral Cow* also relates to "Mon amie la plage," a text of Dalí's from 1927: "Today . . . we are going to the beach to explode the most painful fibres of our physiologies and to rend the weakest pulse of our membranes with the contorted surface of little cutting devices and corals. Contracting our nerves and taking out our eyeballs with the tips of our fingers, we experience the guttural joy of exploding veins and the thousand sounds of our blood bursting under pressure." A phantasmic site of morbidity and the sexual impulse, this beach appears again in Dalí's painting *The Great Masturbator* (1929). —A. L. B.

Invisible Sleeping Woman, Horse, Lion (Lion, cheval, dormeuse invisibles), 1930 (cat. no. 172)

Invisible Sleeping Woman, Horse, Lion is one of the first canvases to show Dalí's development of double and triple images with multiple possible readings, a process stemming from the "paranoid-critical" activity that Dalí had just formulated. As he stated at the time in a lecture at the Ateneo in Barcelona: "Recently, through a clearly paranoid process, I obtained the image of a woman whose pose, shadows and morphology were simultaneously, with no alteration or deformation of her real appearance, those of a horse. One may infer that only by means of a more violent paranoiac intensity might one provoke the appearance of a third image, or a fourth, or of thirty images. In that case, it would be interesting to know what the image in question actually represents, what its reality is; eventually one begins to doubt mentally if the images of reality themselves are not perhaps just a product of our paranoid faculty."

Dalí creates this "mental doubt" masterfully in the hallucinatory, dreamlike vision that unfolds from the frontal view of a boat docked on the beach of Port Lligat. To the metamorphic progression of objects and bodies (boat, woman's body, horse; hair, mane, lion's head), to the shifting meanders of wet sand blending into the volutes of modern-style architecture so loved by Dalí, or the curls of a "sleeping" woman, Dalí adds the enigmatic ambiguity of a stagelike space reminiscent of Giorgio de Chirico. Its shadows, broken column, balls, and accelerated perspectives of tilting planes, which develop a play of reflections to infinity, likewise recall the pictorial devices of de Chirico. Half-solid, half-liquid, half-nocturnal, half-diurnal, this morbid, bloody, yellowish vision presents an unidentifiable, decomposing reality. Included with three other works by Dalí in the exhibition organized in the hall of Studio 28 on the occasion of the screening of Buñuel's *L'Age d'or*, this painting was among those most damaged during the vandalization of the premises on December 3, 1930, by the Ligue des Patriotes and the Ligue Anti-Juive. It was attacked with a cane and torn in two perpendicular lines. Despite the restoration, the lacerations remain visible, like historic stigmata on a work highly emblematic of the climate of provocation and scandal created by Dalí in the early 1930s. —A. L. B.

Untitled, 1931 (cat. no. 173)

Dalí's Surrealist landscapes combine meticulous optical realism with an elaboration of irrational detail in enigmatic contexts, a style he justified as follows: "My whole ambition . . . is to materialize the images of concrete irrationality with the most imperialist fury of precision. —In order that the world of the imagination and of concrete irrationality may be as objectively evident, of the same consistency, of the same durability, of the same persuasive cognoscitive and communicable thickness as that of the exterior world of phenomenal reality."

Untitled relates to a series of paintings from 1930–31 of nude or draped figures, whose bodies are often partially composed of shells and pebbles. These figures appear on rocky, desolate beaches, which may have been inspired by Dalí's native Cadaqués. The high horizon lines, broad expanses of empty space, precisely rendered detail, and palettes of restricted tonalities in these pictures all reveal the influence of Yves Tanguy's style on Dalí. Unlike Tanguy's abstract biomorphic forms, however, Dalí's imagery is identifiable. In *Untitled*, the woman, whose body is cropped at the hips, cryptically turns away from the viewer, offering only a view of her back and of her head, which is hollowed into a concavity that overflows with seashells and rocks. Her ribcage serves as a platform for a collection of small pebbles, and the remnants of her hair have congealed into a solid, undulating mass. Dalí charges the scene with erotic implications: the nude's wrist is tied to a feeble branch by a thin dangling rope; on the horizon a faceless white figure peeps tentatively from a hiding place among the rocks.

Dalí's substitution of shells for the woman's head and hair may relate to personal experience. According to his autobiography, when his father banished him from the family, Dalí shaved his head, buried the hair with empty sea-urchin shells, and climbed into the nearby hills of Cadaqués to meditate on the landscape of his youth. The distant figure's contemplation of the beach from a rocky viewpoint may resonate with Dalí's memories of emotional trauma. But such imagery is, at most, only partly autobiographical, and carries the broader themes of isolation, unfulfillment, sexual longing, and metamorphosis through imagination found in Dalí's other landscapes of this period. — E. C. C.

Birth of Liquid Desires (*La Naissance des désirs liquides*), 1931–32 (cat. no. 174)

One of Dalí's hallucinatory obsessions was the legend of William Tell, which represented for him the archetypal theme of paternal assault. The subject occurs frequently in his paintings from 1929, when he entered into a liaison with Gala Eluard, later his wife but then married to Paul Eluard, against his father's wishes. Dalí felt an acute sense of rejection during the early 1930s because of his father's attitude toward him.

Here father, son, and perhaps mother seem to be fused in the grotesque dream-image of the hermaphroditic creature at center. William Tell's apple is replaced by a loaf of bread, with attendant castration symbolism. (Elsewhere, Dalí uses a lamb chop to suggest his father's cannibalistic impulses.) Out of the bread arises a lugubrious cloud vision inspired by the imagery of Arnold Böcklin. In one of the recesses of this cloud is an enigmatic inscription in French: "Consigne: gâcher l'ardoise totale?"

Reference to the remote past seems to be made in the two forlorn figures shown in the distant left background, which may convey Dalí's memory of the fond communion of father and child. The infinite expanse of landscape recalls Tanguy's work of the 1920s. The biomorphic structure dominating the composition suggests at once a violin, the weathered rock formations of Port Lligat on the eastern coast of Spain, the architecture of the Catalan visionary Antoni Gaudí, the sculpture of Jean Arp, a prehistoric monster, and an artist's palette. The form has an antecedent in Dalí's own work in the gigantic vision of his mother in *The Enigma of Desire* of 1929. The repressed, guilty desire of the central figure is indicated by its attitude of both protestation and arousal toward the forbidden flower-headed woman (presumably Gala). The shadow darkening the scene is cast by an object outside the picture and may represent the father's threatening presence, or a more general prescience of doom, the advance of age, or the extinction of life. — L. F.

Giorgio de Chirico
1888–1978

Giorgio de Chirico was born July 10, 1888, in Vólos, Greece, to Italian parents. In 1900, he began studies at the Athens Polytechnic Institute and attended evening classes in drawing from the nude. About 1906, he moved to Munich, where he attended the Akademie der Bildenden Künste. At this time he became interested in the art of Arnold Böcklin and Max Klinger and the writings of Friedrich Nietzsche and Arthur Schopenhauer. De Chirico moved to Milan in 1909, to Florence in 1910, and to Paris in 1911. In Paris, he was included in the Salon d'Automne in 1912 and 1913 and in the Salon des Indépendants in 1913 and 1914. As a frequent visitor to Guillaume Apollinaire's weekly gatherings, he met Constantin Brancusi, André Derain, Max Jacob, and others. Because of the war, in 1915 de Chirico returned to Italy, where he met Filippo de Pisis in 1916 and Carlo Carrà in 1917; they formed the group that was later called the Scuola Metafisica.

The artist moved to Rome in 1918, and was given his first solo exhibition at the Casa d'Arte Bragaglia in the winter of 1918–19. In this period, he was one of the leaders of the Gruppo Valori Plastici, with which he showed at the Nationalgalerie, Berlin. From 1920 to 1924, he divided his time between Rome and Florence. A solo exhibition of de Chirico's work was held at the Galleria Arte, Milan, in 1921, and he participated in the Venice *Biennale* for the first time in 1924. In 1925, the artist returned to Paris, where he exhibited that year at Léonce Rosenberg's Galerie l'effort moderne. In Paris, his work was shown at the Galerie Paul Guillaume in 1926 and 1927 and at the Galerie Jeanne Bucher in 1927. In 1928, he was given solo shows at the Arthur Tooth Gallery, London, and the Valentine Gallery, New York. In 1929, de Chirico designed scenery and costumes for Sergei Diaghilev's production of the ballet *Le Bal*, and his book *Hebdomeros* was published. The artist designed for the ballet and opera in subsequent years, and continued to exhibit in Europe, the United States, Canada, and Japan. In 1945, the first part of his book *Memorie della mia vita* appeared. De Chirico died November 20, 1978, in Rome, his residence for over thirty years.

The Nostalgia of the Poet (*La Nostalgie du poète*), 1914 (cat. no. 157)

The Nostalgia of the Poet belongs to a series of paintings of 1914 on the subject of the poet, the best known of which is the *Premonitory Portrait of Guillaume Apollinaire* (Musée national d'art moderne, Paris). Recurrent motifs in the sequence are the plaster bust with dark glasses, the mannequin, and the fish mold on an obelisk. These objects, bearing no evident relationships to one another, are compressed here into a narrow vertical format that creates a claustrophobic and enigmatic space. De Chirico's use of inanimate forms that imitate or allude to human beings has complex ramifications. The sculpture at the lower left is a painted representation of a bust by an imaginary, or at present unidentified, sculptor. The character portrayed could be mythological, historical, symbolical, or fictional. The fish is a charcoal drawing of a metal mold that could produce a baked "cast" of a fish made with an actual fish. The fish has additional connotations as a religious symbol, and the graphic sign toward which its gaping mouth is directed has its own cryptic allusiveness. The mannequin is a simplified cloth cast of a human figure—a mold on which clothing is shaped to conform to the contours of a person. Each object, though treated as solid and static, dissolves in multiple significations and paradoxes. Such amalgams of elusive meaning in de Chirico's strangely intense objects compelled the attention of the Surrealists. — L. F.

Premonitory Portrait of Guillaume Apollinaire (*Portrait prémonitoire de Guillaume Apollinaire*), 1914 (cat. no. 158)

Premonitory Portrait of Guillaume Apollinaire was admired very early by the Surrealists and seen as an exercise of de Chirico's "premonitory" faculties: it shows Apollinaire's silhouette, with a targetlike semicircle on his head, but was painted two years before Apollinaire was wounded by shrapnel in a temple in March 1916 while serving in the military. The painting was jealously protected in the collection of the heirs of Apollinaire, to whom the artist gave it as a gift in 1915 to his "poet-friend," who was also a great champion of avant-garde art. In two consecutive letters written in 1915 to de Chirico's dealer, Paul Guillaume, Apollinaire claimed to need this *Man-Target* (or *Homme-cible*, which must have been its original title) in his apartment, for he considered it an "unusual, profound work" and already saw it as his "self-portrait." The poetic affinities between his own work and de Chirico's must have seemed rather significant to him, for in the September 1914 advance edition of his poetry collection *Calligrammes: Et moi aussi je suis peintre*, he planned to have a frontispiece with the woodcut made by Pierre Roy from this painting. In 1934, Roy's print would reappear in an issue of *Minotaure* to accompany de Chirico's text "Sur le silence," which evoked the earthenware pipe used as a target in shooting gal-

leries and gave rise to the analogy of the poet as "man-target."

The apparition of Apollinaire in the background of the painting, on that "fateful rectangle of Veronese sky," as de Chirico described it, gives the work a complexity of meaning that makes it one of his strongest paintings of 1914. The economy of form in this work diverges from the spacious, static perspectives of de Chirico's earlier painting series, the *Piazzas of Italy*. The restricted space forms a veritable "dark box"; it is closed in by violently inclined perspective planes, some of which have multiple vanishing points. In the background, the recognizable portrait of the modern poet, whose "medallion" profile was the subject of a preparatory 1914 drawing dedicated to Paul Guillaume, rises up as a fleeting shadow, like the mannequin-automaton of a shooting range, and finds itself behind an ancient Classical bust of a figure apparently blinded by chance yet seeing. In addition to mythological references to the poet of the *Odyssey*, or the seer Tiresias, which allude to the supremacy of "inner vision," one can also see an evocation of the god Orpheus, a reading supported by the fish and shell molds. De Chirico associated Apollinaire, inspired poet and Parisian champion of Orphism, with the poet-god and musician Orpheus, messenger "of light and truth," who accompanied the ship of the Argonauts. In fact, de Chirico and his brother, Alberto Savinio, had elsewhere likened their own destiny to that of the Argonauts. The learned play of allusions and the juxtaposition of avatars for the "double"—cast, silhouette, shadow—make *Premonitory Portrait of Guillaume Apollinaire* the high point of de Chirico's investigation of the enigma and absence that constitute the foundations of metaphysical poetics. —A. L. B.

Jean Degottex
1918–1988

Jean Degottex was born February 25, 1918, in Sathonay, France. He moved to Paris in 1933. A self-taught artist, he started painting in the early 1940s after a long sojourn in Tunisia and Algeria. His first one-person show was held at the Galerie de Beaune, Paris, in 1950, and the next year he won the Prix Kandinsky. In 1952, he and Charles

Estienne founded the annual art fair called the Salon d'Octobre with the goal of promoting lyrical abstraction, the French manifestation of a tendency in postwar European painting to break with all traditional notions of order and composition. Gestural and expressive, it was antigeometric, antinaturalistic and nonfigurative.

In 1953, Degottex's work was shown for the first time in the United States when he took part in *Younger European Painters*, a group show at the Solomon R. Guggenheim Museum, New York. Influenced by Zen philosophy and interested in the ways that the very act of painting could effect a composition, Degottex experimented with automatism. He interpreted the signs on a canvas as traces of the painter's unconscious and saw painting as a perpetual play between the painter's conscious and unconscious. These ideas led the Surrealist André Breton to take an interest in his art, and in 1955 Breton wrote the preface for the catalogue of Degottex's show at the Galerie l'Etoile Scellée, Paris. Despite his rapprochement with Surrealist techniques, however, Degottex's lyrical compositions, with their simple geometric shapes and primary colors, differed greatly from the Surrealist model of dreamlike figuration.

After 1955, there was a significant change in Degottex's painting style; he simplified his compositions and reduced his palette, playing with themes of space and emptiness. Interested in the history of writing, he tried to find a new approach to Western art by using written script. His works from this period are animated by bold brush strokes on neutral backgrounds. Over the next decade, while showing his work at home and abroad, he continued his research with various series that were organized according to the dominant colors of their compositions. In the middle of the 1960s, Degottex's emphasis shifted again. Taking a new interest in the materiality of his work and straying from a strict painterly focus, he started experimenting with burnt and woven paper, block prints, unstructured canvases, and hammered sheet-iron. He further simplified and radicalized his compositions, often repeating circular forms and single colors. In the 1970s, he began to include torn, overlapping, and folded elements in his compositions.

In 1981, he was awarded the prestigious Grand Prix national de peinture for his life's work. He continued painting until his death in 1988 in Paris.

Aware II, 1961 (cat. no. 282)

Aware I and *Aware II* are the first large-format paintings that Degottex made. During the early and mid-1950s, he had pursued themes of automatism and the history of writing in his art; later in the decade, he became deeply involved in Eastern spiritualism. The title is a reference to Eastern philosophy; according to Alan Watts, "Aware" represents one of the four fundamental, progressive states of "Furyu"—Sabi, Wabi, Aware, and Yugen—the state of the Zen spirit in art.

Degottex spoke of his attempts, during the time of this work, to override his deepest impulses, and of his interest in the instantaneousness, rather than speed or rapidity, as it relates to both spiritual and physical technique.

The great gesture of *Aware II* is a spontaneous writing that, neither composed nor held back, is controlled and executed at great risk because it will not bear retouching. The rejection of color implies a painting given entirely over to the stroke: "the stroke signifies space." "I would like," said Degottex, "my painting to be a greater breath." Beyond mere reference to a philosophy, what is born in Degottex is another conception of painting, a painting of the instant that, once made material, can only exist in a state of fragility. —A. P.

Willem de Kooning
1904–1997

Willem de Kooning was born April 24, 1904, in Rotterdam. From 1916 to 1925, he studied at night at the Academie voor Beeldende Kunsten en Technische Wetenschappen, Rotterdam, while apprenticed to a commercial art and decorating firm and later working for an art director. In 1924, he visited museums in Belgium and studied further in Brussels and Antwerp. De Kooning came to the United States in 1926 and settled briefly in Hoboken. He worked as a house painter before moving to New York in 1927, where he met Stuart Davis, Arshile Gorky, and John Graham. He took various commercial art and odd jobs until 1935–36, when he was employed in the mural and easel divisions of the WPA Federal Art Project. Thereafter he painted full-time. In the late 1930s, his abstract as well as figurative work was primarily influenced by the Cubism and Surrealism of Pablo Picasso and also by Gorky, with whom he shared a studio.

In 1938, de Kooning started his first series of *Women*, which would become a major recurrent theme. During the 1940s, he participated in group shows with other artists who would form the New York School and become known as Abstract Expressionists. De Kooning's first solo show,

which took place at the Egan Gallery, New York, in 1948, established his reputation as a major artist; it included a number of the allover black-and-white abstractions he had initiated in 1946. The *Women* of the early 1950s were followed by abstract urban landscapes, *Parkways*, rural landscapes, and, in the 1960s, a new group of *Women*.

In 1968, de Kooning visited the Netherlands for the first time since 1926, for the opening of his retrospective at the Stedelijk Museum, Amsterdam. In Rome in 1969, he executed his first sculptures—figures modeled in clay and later cast in bronze—and in 1970–71 he began a series of life-size figures. In 1974, the Walker Art Center, Minneapolis, organized a show of de Kooning's drawings and sculpture that traveled throughout the United States, and in 1978 the Solomon R. Guggenheim Museum, New York, mounted an exhibition of his recent work. In 1979, de Kooning and Eduardo Chillida received the Andrew W. Mellon Prize, which was accompanied by an exhibition at the Museum of Art, Carnegie Institute, Pittsburgh. De Kooning settled in the Springs, East Hampton, Long Island, in 1963. He was honored with a retrospective at the Museum of Modern Art, New York, in 1997. The artist died March 19, 1997, on Long Island.

Composition, 1955 (cat. no. 279)

In 1948, in response to de Kooning's first solo exhibition, the art critic Clement Greenberg acclaimed him "an outright 'abstract' painter"; of the gestural black-and-white paintings on display, he noted that "there does not seem to be an identifiable image in any of the ten pictures in his show." However, in 1950 de Kooning began a series of gruesomely expressive paintings of women that, when they were exhibited in 1953, brought accusations of betrayal by advocates of pure abstraction and stirred a major controversy: in which style did de Kooning intend to paint, figurative or nonrepresentational? A fusion of the two, it seemed at the time, was untenable.

Composition exemplifies the issues at the heart of this controversy. In *Composition*—like his other contemporaneous works that blend aspects of figurative, landscape, and abstract painting—various components that characterized the *Women* can be detected, such as fragmented and scrambled references to female anatomy; a palette of florid reds, pinks, turquoise blue, and rancid yellow; and de Kooning's signature agitated brushstrokes. Although it shares these elements with the *Women* series, *Composition* is far more abstract. Its underlying structure is composed of side-by-side rectangles, obscured by a thick, active paint surface characterized by its slashing gestures, heavy, rasping textures, and a proliferation of suggestive images, such as the red-and-yellow bralike form at the upper right. Ambiguities abound in the painting, brought about by its multiple focuses, visual rhythms, and abrupt breaks and discontinuities. *Composition* can be said to lack a final incisiveness, and that is its strength. In reference

to the critical debate surrounding abstract and figurative painting—a debate that still surrounds Abstract Expressionism—de Kooning once remarked, "What's the problem? This is all about freedom." — J. A.

Villa Borghese, 1960 (cat. no. 280)

Between 1958 and 1963, de Kooning painted a number of canvases recording the sensations he felt for certain places. *Villa Borghese* is part of this loosely constructed series, which includes *Suburb in Havana* (1958), *Souvenir of Toulouse* (1958), and *Rosy-Fingered Dawn at Louse Point* (1963). Despite these magical titles with their references to exotic, historical places, the paintings are rigorously abstract, evoking the mood rather than the characteristics of these locations. At first, this opposition can be jarring, but the carefully chosen palettes do much to suggest the sensual nature of their namesakes and the effects these places had on de Kooning himself.

After spending the winter in Rome, he painted *Villa Borghese* upon his return to New York. Named for the Italian mansion that houses a famous collection of old master paintings and sculptures, it is clearly part of the continuing series. However, its composition is much closer to two seminal paintings he created in 1960: *Door to the River* and *Spike's Folly II*. All three large paintings are characterized by a luminous palette that includes pinks and yellows, broad brushstrokes, and compositions that are solidly constructed through the interplay of the horizontal and vertical groupings of darker colors on lighter ones. Allowing the dominant colors of blue and green to break into and over each other, de Kooning created an animated composition that emphasizes the gestures of his hand and brush. Using his decidedly personal and very physical painting technique, the paint is heavily worked, laid thickly in some places and strapped thin in others. Unlike *Door to the River*, in which de Kooning imposed a real sense of depth, the brushstrokes of *Villa Borghese* float near the picture plane, focusing the viewer's attention on the surface of the canvas. De Kooning, rather than describing the famous Baroque architecture connected to the title, is constructing his own highly structured composition, or façade, in paint. —J. S. C.

Robert Delaunay
1885–1941

Robert-Victor-Félix Delaunay was born April 12, 1885, in Paris. In 1902, after secondary education, he apprenticed in a studio for theater sets in Belleville. In 1903, he started painting and by 1904 was exhibiting, that year and in 1906 at the Salon d'Automne and from 1904 until World War I at the Salon des Indépendants. Between 1905 and 1907, Delaunay became friendly with Henri Rousseau and Jean Metzinger and studied the color theories of Michel-Eugène Chevreul; he was then painting in a Neo-Impressionist manner. Paul Cézanne's work also influenced Delaunay around this time. From 1907–08, he served in the military in Laon, and upon returning to Paris he had contact with the Cubists. The period 1909–10 saw the emergence of Delaunay's personal style; he painted his first Eiffel Tower in 1909. In 1910, Delaunay married the painter Sonia Terk, who became his collaborator on many projects.

Delaunay's participation in exhibitions in Germany and association with advanced artists working there began in 1911, the year Vasily Kandinsky invited him to participate in the first Blaue Reiter exhibition in Munich. At this time, he became friendly with Guillaume Apollinaire, Albert Gleizes, and Henri Le Fauconnier. In 1912, Delaunay's first solo show took place at the Galerie Barbazanges, Paris, and he began his *Windows* pictures. Inspired by the *Windows'* lyricism of color, Apollinaire invented the term "Orphism," or "Orphic Cubism," to describe Delaunay's work. In 1913, Delaunay painted his *Circular Form*, or *Disc*, pictures.

From 1914 to 1920, Delaunay lived in Spain and Portugal and became friends with Sergei Diaghilev, Leonide Massine, Diego Rivera, and Igor Stravinsky. He designed decor for the Ballets Russes in 1918. By 1920, he had returned to Paris, where in 1922 an exhibition of his work was held at Galerie Paul Guillaume, and he began his second *Eiffel Tower* series. In 1924, he undertook his

Runner paintings and in 1925 executed frescoes for the Palais de l'Ambassade de France at the *Exposition internationale des arts décoratifs* in Paris. In 1937, he completed murals for the Palais des Chemins de Fer and Palais de l'Air at the Paris World's Fair. His last works were decorations for the sculpture hall of the Salon des Tuileries in 1938. In 1939, he helped organize the exhibition *Réalités nouvelles*. Delaunay died October 25, 1941, in Montpellier.

The Tower (La Tour), 1910 (cat. no. 35)

The Tower is a direct preparatory study for the important 1910–11 series of *Towers*, masterpieces of Delaunay's "destructive" period. During this time, Delaunay chose the Eiffel Tower as the object of experimentation in the breakdown, or "destruction," of forms by light and by the viewer's shifting point of view; he cast the monument in the same role as that played by the fruit dish for the orthodox Cubists, thereby revealing his taste for modern structures and for the monumental.

The first study based on the Eiffel Tower is from 1909, and there are several known studies from 1910; the one closest to the present drawing belongs to the Museum of Modern Art, New York. — M. H.

Eiffel Tower (Tour Eiffel), 1911 (cat. no. 29)

Constructed in 1889 as a symbol of technological advancement, the Eiffel Tower captured the attention of painters and poets attempting to define the essence of modernity in their work. Delaunay's obsession with the tower resulted in at least thirty completed paintings representing the radical yet graceful iron edifice. According to the poet Blaise Cendrars, Delaunay made fifty-one attempts to depict the tower in 1911 before arriving at an acceptable solution. "Delaunay," explained Cendrars, "wanted to interpret [the tower] plastically. He succeeded at last with his world-famous picture. He disarticulated the tower in order to get inside its structure. He truncated it and tilted it in order to disclose all of its three hundred dizzying meters of height."

The pictorial vocabulary with which Delaunay rendered the Eiffel Tower from several simultaneous perspectives is essentially Cubist. In *Eiffel Tower*, the shifting, fragmented forms of the tower and the buildings surrounding it implode, as it were, to create an allover pattern of interconnected planes. However, the emphasis in this painting is not entirely on the interplay of various architectural constructions viewed from multiple vantage points but also on the effect of atmospheric light upon the city of Paris. Delaunay's *Eiffel Tower* series marks the beginning of a transition from his semimimetic representations of the urban environment to abstractions based on color-spectrum analysis. According to Apollinaire, these latter works belonged to a new aesthetic category, which he called Orphism. — N. S.

Simultaneous Windows (2nd Motif, 1st Part) (*Les Fenêtres simultanées [2ᵉ motif, 1ᵉʳᵉ partie]*), 1912 (cat. no. 30), and *Windows Open Simultaneously (1st Part, 3rd Motif)* (*Fenêtres ouvertes simultanément [1ᵉʳᵉ partie, 3ᵉ motif]*), 1912 (cat. no. 32)

Though Delaunay had virtually discarded representational imagery by the spring of 1912 when he embarked on the *Windows* theme, vestigial objects endure in this series. In *Simultaneous Windows (2nd Motif, 1st Part)* (*Les Fenêtres simultanées [2ᵉ motif, 1ᵉʳᵉ partie]*) and *Windows Open Simultaneously (1st Part, 3rd Motif)*, the centralized ghost of a green Eiffel Tower alludes to his enthusiasm for modern life, while parted curtains repeatedly refer to a window motif. Some *Windows* paintings, like the two here, derive their name from Michel-Eugène Chevreul's theory of simultaneous contrasts of color, which explores how divergent hues are perceived at once.

While Analytic Cubism inspired Delaunay's fragmentation of form, oval format, and organization of the picture's space as a grid supporting intersecting planes, these Delaunay compositions are defined by the application of diaphanous, prismatic color, rather than the line and modeling seen in the monochromatic, tactile planes of Cubism. Delaunay wrote in 1913: "Line is limitation. Color gives depth—not perspectival, not successive, but simultaneous depth—as well as form and movement." As in visual perception of the real world, perceptions of these paintings is initially fragmentary, the eye continually moving from one form to others related by hue, value, tone, shape, or direction. In both canvases, Delaunay suggests glass that, like his chromatic planes, is at once transparent, reflective, insubstantial, and solid. Glass alludes as well to the Symbolists' use of window panes as metaphors for the transition from internal to external states. — MNAM and SRGM

A Window (Une Fenêtre), 1912–13 (cat. no. 31)

"Around 1912–13, I got the idea for a painting that would technically retain only color, contrasts of color, while unfolding in time and being perceived simultaneously, at a single glance. I used the scientific term of Chevreul: simultaneous contrasts. I was playing with color, as one might express oneself in music through a fugue of colored, fugal phrases." Thus, Delaunay described his "Simultaneous Contrast" paintings. *A Window* is an elaborate study for *Three-Part Windows* (1912–13). While these two paintings are sometimes associated with the great Ferris wheel, a symbol of modern Paris celebrated by Cendrars, the silhouette of the Eiffel Tower is also present here, serving as an emblem of Paris's modernity. Poised at the center of the composition, though fading into the variegated patterns of the prism, like the façade of the house at the bottom of the canvas, the tower guarantees stability and legibility. The color planes—applied in bright, flat hues, dense and scraped—look, in Delaunay's words, like "cadenced measures, one following the other,

one overtaking the other." At once the form and the subject of the composition, color thus replaces drawing and volume, precluding any recourse to chiaroscuro; it annuls perspective by bringing the depth of field up to the canvas plane itself. Delaunay's windows open onto a new reality and definitively close the Albertian window of Renaissance perspective. Although Delaunay made them out, after the fact, to be manifesto-paintings ("I laid the foundations for a new painting"), the windows also assert themselves as marvelous pieces of pure visual poetry. While the artist may have been influenced by the writings of Stéphane Mallarmé, one of whose poems is *Les Fenêtres*, his paintings are known to have inspired in 1912 one Apollinaire's most celebrated poems, also entitled *Les Fenêtres*: "From red to green the yellow all fades / . . . / The window opens like an orange / Fine fruit of the light." — B. L.

The Poet Philippe Soupault (Le Poète Philippe Soupault), 1922 (cat. no. 37)

The Poet Philippe Soupault belongs to the series of portraits of Dada and Surrealist poets—Soupault, Tristan Tzara, André Breton, Louis Aragon, and Iliazd and Ivan Goll—who were friends of the artist and visited him in the 1920s. First studied in a preparatory work of the same size, this painting is clearly the most monumental and complex of the series. Covering the themes closest to Delaunay's heart—the city, the window, the Eiffel Tower, poetry—it presents itself as a dazzling metaphor for painting, an odd combination of modernity and artistic conventions. Art historian André Chastel has compared the refined complexity of its spatial organization to "the universe of mirrors and illusory relations" of Velázquez's *Las Meninas* (1656)

Framed by Delaunay's traditional curtain motif, the bay window opens onto the space of the painting; there, a copy of a 1910–11 *Eiffel Tower* painting is suspended in the center, its light-shattered mass powerfully projected onto the picture plane. The imperious barrier of the balustrade, echoing Edouard Manet's *The Balcony* (1868), marks a boundary between inside and outside and underscores the "artifact" quality of the image of the tower. The portrait of the poet, wearing a gloomy expression, hands in his pockets, so forcefully asserts the presence of humanity that it pushes the tower motif into the background. These games of iconography (reminiscent of Manet's *Portrait of Emile Zola*, 1868) and plasticity draw one's attention to the painting's materiality, its relationship to the real and the imaginary. They call into question reality and its representation and finally assert the sovereignty of painting. — B. L.

The Woman and the Tower (La Femme et la tour), ca. 1925 (cat. no. 36)

A very fine drawing that is unfortunately faded and torn, *The Woman and the Tower* is a study for Delaunay's large composition for the entrance hall of a French embassy, which created a scandal

when it was presented by the Société des Artistes Décorateurs at the Decorative Arts exhibition in 1925. Delaunay executed two more versions of it.

In the drawing, Delaunay associates the Eiffel Tower with the feminine nude, a combination on which he based the *City of Paris* (1910–12, Musée national d'art moderne, Paris), but here the spirit is different. The tower rises up unbroken, its dry, mechanical forms consciously contrasted with the forms of the nude, which are very delicately modeled and more dislocated than those of the tower. In the final version, the woman's head is raised. —M. H.

Circular Forms (Formes circulaires), 1930
(cat. no. 38)

Around 1930, Delaunay returned to the abstract circular forms so prevalent in his work of 1913. He first represented the disc in the sky of a 1906 landscape, and by 1913 this shape had become the subject of canvases titled *Sun* and *Moon*. Apparently, some of his early interests, as stated in a letter to August Macke in 1912, continued to provide sources of inspiration for his later work. He wrote: "First of all, I always see the sun! The way I want to identify myself and others is with halos here and there—halos, movements of color. And that, I believe, is rhythm. Seeing is in itself a movement."

Circular Forms presents two distinct foci with overlapping circular bands of color, primarily red, blue, and yellow. Where the bands intersect, the color changes. The right half of the canvas, showing concentric circles divided into eight segments on which discs are superimposed, is a kaleidoscopic fragmentation of the left half. Delaunay's investigation of schematic concentric circles continued in the 1930s with relief sculpture and paintings of the *Rhythm* series. —SRGM

Sonia Delaunay

1885–1979

Sonia Delaunay was born November 14, 1885, as Sonia Terk, in Gradizhsk, Ukraine. Raised in Saint Petersburg, Russia, from the age of five, she spent her childhood there, then left to study draw-

ing in Karlsruhe, under the direction of Schmidy Reuter. In 1905, she moved to Paris, and studied painting at the Académie de la palette. Her early paintings reflect the influence of Paul Gauguin and Vincent van Gogh. In 1909, she married the art critic and collector Wilhelm Uhde, with whom she exhibited in 1908. The same year, she met Robert Delaunay, whom she married in 1910.

In 1912, she created her first Orphic works—collages, book covers, pastels, and canvases—exhibiting her fidelity to pure color, enhanced by the law of simultaneous contrasts. From her meeting with Blaise Cendrars in 1913 came the book *The Prose of the Trans-Siberian Railway (La prose du transsibérien)*, a passionate essay on the synthesis of poetry and painting.

In 1914, while staying in Spain, the Delaunays learned of the outbreak of war and decided to settle in Madrid. Since Robert Delaunay had been discharged from military service in 1908 and exempted from active duty, the couple had gone to Portugal, where they stayed around Porto, in Valencia do Minho. Just before the Russian revolution broke out, she met the ballet producer Sergei Diaghilev in Madrid, and he commissioned the sets and costumes for *Cleopatra* from her.

In 1920, the Delaunays left Madrid definitively for Paris. They became friends with the poets Louis Aragon, René Crevel, Vladimir Mayakovski, and Philippe Soupault. At the same time, Solomon R. Guggenheim began his many visits to their studio.

In 1923, Sonia Delaunay created her first simultaneous fabrics for the silk industry in Lyons, then undertook the creation of coats in woolen tapestry for such celebrities as Nancy Cunard and Gloria Swanson. In 1925, she participated in the *Exposition des arts décoratifs* and exhibited simultaneously in a boutique with the couturier Jacques Heim, on the Alexander III bridge.

During the 1930s, she temporarily abandoned the decorative arts and devoted herself completely to painting within the Abstraction-Création group. She received the gold medal at the 1937 *Exposition internationale*, for which the Delaunays executed enormous frescoes in the railroad and aeronautic pavilions.

After Robert Delaunay died in 1941, Sonia was invited by Jean Arp and Sophie Taueber-Arp to Grasse, where she remained until 1944. After the war, she rejoined the Art Concret circle, while pursuing her abstract and decorative work.

The first large retrospective of the works of Sonia and Robert Delaunay took place in the Musée des Beaux-Arts, Lyons, in 1959, as well as in the Turin museum, the same year. In 1965, the first large retrospective of Sonia Delaunay's work traveled to Toronto, Montreal, Quebec, Winnipeg, and Ottawa, followed by an exhibition at the Musée national d'art moderne, Paris, in 1967. During the 1970s and until her death, she pursued the application of her simultaneous principles in the creation of posters, tapestries, and stained glass, developing her graphic work in par-

ticular by illustrating many collections of poetry. She died in 1979 in Paris.

The Bullier Ball (Le Bal Bullier), 1913 (cat. no. 33)

Delaunay was a great lover of the theater and ballet, for which she would later design costumes, and of popular and folk dances. She and Robert Delaunay, liked to meet their friends at the Bullier Ball in Montparnasse, where she would wear her stunning "simultaneous" dresses.

The Bullier Ball shows the effects of her earlier series dedicated to the study of light and crowds on the boulevard Saint-Michel, and specifically, the glow of the first electric streetlamps. *The Bullier Ball*, also called *Tango at the Bullier Ball*, was exhibited in 1913 at Der Sturm gallery, Berlin, under the title *Movement, Color, Depth, Dance, Bullier*, which better captures the painter's intentions: by dispensing with the stroke, color becomes form, rhythm, and movement. On a vast screen on which brightly colored, simultaneous surfaces open out horizontally, the bodies surrender to the music. Their intimate harmony with sounds is rendered by the silky plaiting of lights and colors appearing and disappearing, transforming into one another in unison. Circles, arabesques, and flat geometric patches of color unfold in a cinematic flow, expressing the luminous swirls, the languorous, syncopated rhythms of the tango. At the center of the frieze, dark, gracefully curved areas suggest dancing couples, mimetic reference points that disappear in parallel paintings from this period. "The theatre of color should be composed like a line of Mallarmé or a page of Joyce: perfect juxtaposition, precise concatenations, each element endowed with its own weight by an absolute rigor. The beauty lies in the power of suggestion that lets the spectator participate." This statement by Sonia Delaunay about her painting, *Woman Dancing to a Record* (1923), could equally serve as commentary on *The Bullier Ball*, a Modernist bacchanalia that conveys the pleasure of the last Parisian ballrooms. — B. L.

André Derain

1880–1954

André Derain was born June 10, 1880, in Chatou, France. In 1898–99, he attended the Académie Camillo, studied with Eugène Carrière, and met Henri Matisse. In 1900, he met and shared a studio with Maurice de Vlaminck and painted his first landscapes. In 1905, the dealer Ambroise Vollard purchased all the works of art from his studio. In the same year, Derain exhibited at the Salon des Indépendants, worked with Matisse in Collioure during July and August, painted in L'Estaque and Marseilles, exhibited alongside the other Fauve artists in the Salon d'Automne, and made his first trip to London. Daniel-Henri Kahnweiler became Derain's dealer in 1907. During that year, the artist experimented with stone sculpture and moved to Montmartre, where he associated with Pablo Picasso and other artists and poets at the Bâteau-Lavoir. Derain's work of this period manifested an increasingly restrained palette and more tightly woven brushwork in a movement away from his well-known Fauve style of 1905–07.

Derain spent the spring of 1909 painting in Carrières-Saint-Denis, where Georges Braque visited him frequently. The following year, he and Picasso painted together in Cadaqués, Spain. In 1912, Derain developed an interest in the nude and in the following years produced many still lifes. In 1913, Derain's work gained international exposure through his participation in the Armory Show, New York, and the *Erste deutsche Herbstsalon*, Berlin. He exhibited widely in Germany in 1914. During World War I, Derain served in the military, producing a variety of works at the front, including inventive masks made from shell cases. In 1916, his first solo exhibition was held at the Galerie Paul Guillaume, Paris, for which Guillaume Apollinaire wrote the introduction to the catalogue. Kahnweiler purchased Derain's artistic output from 1920 through 1922, and Paul Guillaume served as his dealer from 1923 until 1934. His work was informed by a

wide variety of stylistic precursors, including Florentine painting and the frescoes of Pompeii.

During World War II, Derain went to Berlin with a group of French artists to attend the exhibition of Nazi sculptor Arno Brecker. This visit, for which he was strongly criticized, reflects the culmination of Derain's radical departure from the stylistic and conceptual concerns of the avantgarde in France. In September 1954, Derain died after being hit by a car.

The Banks of the Thames (*The Bridge at Chatou*) (*Les Bords de la Tamise [Le Pont de Chatou]*), 1905–06 (cat. no. 5)

Previously known as *The Bridge at Chatou*, or *Le Pecq*, and dated 1904 or 1905, *The Banks of the Thames* was recently reattributed to the artist's famous London sojourns in late 1905 and early 1906 and reintegrated into the series of some thirty views of London painted at that time on commission for Ambroise Vollard. Parisian suburb or the banks of the Thames? Autumn 1905 or winter 1906? In the end, the geographic source, like the exact dating within a few weeks, is of little importance. It is certainly more interesting that in his London, as in his suburban landscapes, Derain favors waterfronts and the scenography of clouds, sun, and reflections, without shunning the depiction of teeming human activity on the river. In fact, this latter detail argues in favor of the port district of London, punctuated as it is with industrial cranes and carts.

Painted a short time after the intense, studious summer of 1905, which the artist spent with Matisse, the London paintings represent the stunning blossoming of that summer gestation, achieved apparently without effort. In *The Banks of the Thames*, Derain plays with "Fauvist" color without compunction. He also uses a small, divided stroke inherited from the Impressionists, oriented according to whether it is representing sky, water, or riverbank; flat surfaces of color for the factories and port; and a nervous shorthand of blue spots and circles for the silhouettes of people and horses. The water, his main subject, passes through all the shades of the rainbow over the course of his London series: sometimes white as milk, sometimes tinted emerald-green, orange, or even yellow. Painted rapidly, with stunning brio, *The Banks of the Thames* looks deceptively like a realistic snapshot, though this impression is immediately contradicted by the phantasmagoria of exquisite colors (pink sky, blue factory with its plume of Nile-green smoke, and orange horses) inspired by Joseph Mallord William Turner. "Turner allows us to create forms beyond the objects considered real," wrote Derain to Matisse on March 8, 1906. The compositional mastery, based on a classical diagonal, is perfect. And each of the little energetically sketched figures (those rapid, almost caricatural strokes are the personal domain of Derain and Albert Marquet) lends vivacity to this moment of riverside grand opera. —I. M. F.

Two Barges (*Les Deux Péniches*), 1906 (cat. no. 6)

The conspicuous violence of colors, their arbitrariness (yellow and green water), and the freedom of treatment, with strokes only partially covering the canvas, letting the gray prepared surface show through—these are all particular characteristics of Derain during his full-blown Fauvist period. The similarities between *Two Barges* and the works of Vlaminck in 1905 seem evident, especially in view of the common subject of the *péniche* boats, a familar sight to the residents of Chatou and flaneurs of the banks of the Seine, such as these two painters and their friends. It is nevertheless difficult to give this painting a precise date. The angle adopted (an overhead view from a bridge) is also found in Derain's views of the port of London, painted after the winter of 1905–06. A number of historians, however, think this view was painted at Le Pecq, near Paris, in 1904. There are no irrefutable arguments to confirm or deny this hypothesis, except perhaps that the few paintings that can be attributed to 1904 with any certainty are much less bold and decisive than *Two Barges*.

The composition in *Two Barges* reveals an elaborate concern for the organization of the pictorial space, perhaps inspired by Vincent van Gogh's *The Two Boats* (1888) and indirectly by Japanese ukiyo-e woodblock prints. There is no sky; there is the invasive, horizontally unfolding presence of the water, the parallel diagonals of the boats (sole indications of depth of field), the staggering of the boats (calculated to reinforce the effect of movement), and finally the very specific choice of tones and the contrasts between them (blue/red sails, yellow/green water, red/orange boats, the absence of black). There is nothing gratuitous in any of this, no expression of instinctual effusion, as is often associated with Fauvism—this was an aspect Derain rejected and mistrusted, as he implied in a letter to Vlaminck in 1905: "I have abandoned myself to color for color's sake. I have lost my former qualities." There are, moreover, some preparatory sketches drawn by the artist before this work was painted, prior to his reinvention of the subject through his experimentation with the effects of contrasting colors. In an album of sketches dating from 1904–06, owned by the Musée national d'art moderne, Paris, there is a very fine study, in brush and india ink highlighted with watercolor, of a docked barge viewed from above that is very similar to the subject of this painting. —I. M. F.

Standing Nude (*Nu debout*), winter 1907 (cat. no. 61)

Standing Nude, a large figure cut directly into stone, is an important historic milestone in Derain's oeuvre and more generally in the crucial transition period between Fauvism and Cubism. It was documented in a photograph that was taken in April 1908 by the American journalist Gelitt Burgess and published in the May 1910 issue of *Architectural Record* as an illustration accompany-

ing his feature article on some of the Fauves and their studios.

In Derain's studio, Burgess noticed some "horrible little black gods and frightful goddesses with conical breasts, misshapen and hideous," as well as their "imitations in wood and plaster made by Derain." Another photograph of the studio makes it possible to inventory a total of seven pieces of sculpture, three of which are identifiable and traceable today. According to Alice Derain, all of them were completed in October 1907. These are the *Crouching Man* and *Man and Woman*, two small sandstone sculptures, cut into a rectangular block in accordance with the tradition of cathedral stonecutters, and *Standing Nude*, which is more ambitious in size. In a preparatory drawing for the latter sculpture, it is clear that Derain was striving for a synthesis of all the concerns of the moment—his own, but also, indirectly, those of his friends Braque, Matisse, and Picasso. In addition, *Standing Nude* reflects Paul Cézanne's oeuvre (at the time, a reproduction of *Five Women Bathing*, 1885–87, occupied a conspicuous place on the wall of his studio) and Paul Gauguin's as well (in particular, it is reminiscent of *Te Nave Fenua*, 1892). A desire for archaism, prevalent among the Fauves and burgeoning Cubists, is visible here in the accentuated geometrizing, the respect for the wholeness of the block, and the deliberate highlighting of the unfinished look. Finally, *Standing Nude* is yet another of Derain's responses to Matisse, whose painting *Blue Nude* (1907), featured at the Salon des Indépendants in spring 1907, was the result of a comparable study of modeling, three-dimensionality, and expressive distortion of form. *Standing Nude* shows Derain's integration of many simultaneous influences during an extremely fertile and transitional period. — I. M. F.

Portrait of a Young Man (*Portrait de jeune homme*), ca. 1913–14 (cat. no. 2)

In his works from the years immediately preceding World War I, Derain synthesized a diverse group of artistic influences to forge a unique style. Chief among the artistic innovations current in prewar Paris was the Analytic Cubism of Braque and Picasso. Derain's awareness of Cubism is evinced in *Portrait of a Young Man* in its subdued palette of grays, greens, and golden browns, and by the rendering of forms in terms of groupings of flat planes. As Picasso had done earlier, Derain also became interested in the appropriation of formal qualities of African sculpture. *Portrait of a Young Man* bears a striking resemblance—discernable in the shape of the face, the close-set almond-shaped eyes and brows, the long wedge-like nose, the small mouth, and the sharply pointed chin—to the wooden West African Fang mask (Musée national d'art moderne, Paris) that Derain purchased from Vlaminck in 1906. The artist's prewar style, sometimes called "medieval" or "Gothic," was marked as well by his preference for angular, attenuated figures; the graceful

elongation of the arms and torso and the chiseled contours of his jacket that create pockets of light and shade may be seen as indications of the painter's interest in the art of the later Middle Ages, such as figures from the portals of French Gothic cathedrals.

Regardless of their origins, the stylistic means Derain used to depict his unidentified sitter produce a portrayal of melancholic introspection and a certain anxiety. The young man's emotional state is the subject of the portrait, not his outward appearance. Derain left *Portrait of a Young Man* unfinished. Traces of the adjustment of composition and pose remain visible, as does the artist's underlying pencil drawing. The more heavily worked head and shoulders are surrounded by progressively less finished areas; the net impression of a painting coalescing out of emptiness brings to mind similar effects in the art of Cézanne, which had interested Derain for many years. The way in which, with a few strokes of thin paint, Derain described the volume and curve of the hat hanging on the back of the young man's chair demonstrates the artist's reliance on his own facility and his concern with the purely formal and material means of making a painting. — J. R. W.

Portrait of Iturrino (*Portrait d'Iturrino*), 1914 (cat. no. 3)

The same year Derain painted this portrait of the Spanish artist Francisco de Iturrino, Gustave Coquiot described Iturrino in *Cubistes, Futuristes, Passéistes*: "In his physical aspect, his asceticism, he fully recalls one of [Francisco] Zurbarán's monks." This is proof that the painter did not distort his model but willingly chose a figure that could just as well have come out of an El Greco painting, if not from a Byzantine icon. The work illustrates Derain's need for realism and his obsession with art in museums.

Though he was keenly aware of developments in Cubist painting, he never fully embraced the movement. In his 1912 paintings (landscapes with references to Giotto and the Italian primitives) and in his 1913–14 works (synthetic views of Martiques or figures with idol-like majesty), Derain was far from breaking forms down and subjecting them to an analysis that would lead to an almost abstract system of facets; instead, he desperately sought to keep them whole, at the risk of a hieraticism that has led some to call this period of his painting "Gothic" or "Byzantine."

In *Portrait of Iturrino*, the principal reference is to Spain, not only because of the very choice of model but also because of the range of color, which is limited to grays, blacks, and browns. The gray, cloudy background, which Derain uses to isolate and even further hieraticize the stiff wooden figure, reappeared in other portraits until around 1920. This approach, and this manner of isolating the face, particularly interested Alberto Giacometti, who saw *Portrait of Iturrino* at the retrospective organized by the Musée national d'art moderne in 1954 after Derain's death. He

immediately made an engraving of it, and described it several years later as "a copy of the Spanish (I think) guitarist, the man with the gray beard, slightly slanted in the painting, his hands on his knees, one of my favorite paintings by Derain." — I. M. F.

Nicolas de Staël
1914–1955

Nicolas de Staël was born January 5, 1914, in Saint Petersburg, Russia. As descendents of Baltic nobility, his family fled the Russian Revolution, emigrating to Ostrow, Poland, in 1919. After the deaths of their father in 1921 and mother in 1922, de Staël and his two sisters were sent to live with family friends in Brussels. There, he received a classical education, completing his studies at the Académie Royale des Beaux-Arts in 1936.

In 1938, after extensive travel in Europe and North Africa, de Staël moved to Paris. There, he worked briefly in Fernand Léger's studio, but he spent most of his time in the Musée du Louvre, studying the works of Jean Baptiste Siméon Chardin and other old masters. With the outbreak of war in 1939, de Staël joined the Foreign Legion in 1940 and served in Tunisia. After his demobilization, he moved to Nice, and then back to Paris in 1943, where he began to paint on a large scale. De Staël had his first solo show in May 1944 at Galerie l'Esquisse, Paris.

The years between 1944 and 1955 marked a significant period for de Staël's artistic and creative development. The compositions of 1946 to 1948 were charged with tension and violent movement, as opposing diagonals and dynamic lines, painted in a thick impasto of somber colors that were compressed together on the canvas. Toward the end of 1948, de Staël began to produce tranquil paintings of large, static planes by using a lighter palette of

colors. Between 1952 and 1955, as the artist combined elements of figuration with his abstract style, his paintings evoked images of figures, landscapes, and still lifes despite the simplification of forms.

De Staël became a naturalized French citizen in 1948. In the spring of 1950, his work was shown for the first time in New York in two group exhibitions, both organized by Galerie Louis Carré. Two years later, de Staël showed his paintings at the Matthiesen Gallery, London. This important exhibition, favorably received by the public, was instrumental in affirming his reputation worldwide. In November 1954, he separated himself from his family and moved to Antibes. After suffering bouts of insomnia, exhaustion, and loneliness, the artist committed suicide by throwing himself out of his studio window on March 16, 1955.

The Roofs (Les Toits), 1952 (cat. no. 268)

The Roofs, sometimes called either *The Dieppe Sky* (in a letter from de Staël to Denys Sutton dated May 1952) or *The Roofs of Paris*—expresses the painter's desire for a return to more perceptible figuration. Following the large abstract compositions of 1949–50, and continuing the series of "walls" of 1951, de Staël used larger and larger formats, working with a trowel to apply his paint as it became increasingly thick.

Here, he titles the work from an actual visual reference—the Dieppe sky, or the rooftops he saw from his Paris studio—and he also engages the field of his own imagination. In constructing a frontal composition, de Staël calls traditional perspective into question and asserts the verticality of the support. In keeping with a procedure he began in 1951, this composition is comprised of simple elements, based on the strict duality of a "wall" of solidly imbricated tesserae and a purely abstract, lightly modulated area, all of which combine to give the work its monumental appearance. The melancholy created by the painting's horizontality and its gray, blue, and white color scheme balances the restrained violence, the blunt energy emanating from the "wall." By making form and contour coincide, the painter affirms the necessity of each of these squares—not for their optical plays of distance and proximity, but for their individual values, as in the series *Bottles in the Studio* and in the still lifes of the same year. For de Staël, forms remain inseparable from impulses, even though he wrote in a letter that he was not an exponent of "psychophysiology on a moving field"; he always preferred to abide by an exact definition of his terms, distinguishing between lines and contours, colors and color planes, one value and another. —E. B.

Daniel Dezeuze
b. 1942

Daniel Dezeuze was born in 1942 in Alès, France. He studied at the Ecole des Beaux-Arts, Montpellier, from 1959 to 1962. In 1965, while visiting North America, he became interested in the work of American artists such as Franz Kline and Jackson Pollock. During this time, he lived in Canada and made several long trips to Mexico, pursuing his interest in the early indigenous native cultures of Mexico. He was also fascinated by the nomadic and adaptive characteristics of certain Native American art.

In 1965, he began to make painted collages on the pages of stamp-collecting albums and to use geometric aluminum foil cutouts to reflect the image of the viewer. In 1967, during the time of the communal endeavors of Daniel Buren, Olivier Mosset, Michel Parmentier, and Niele Toroni (BMPT), and a few months after Claude Viallat had begun to make his imprints on supple cloth, Dezeuze chose the naked stretcher as the subject of his work.

The story of his work thereafter becomes intermingled with that of the Supports-Surfaces movement, of which he was a founding member in 1970. In 1971, Dezeuze became one of the founding members of the *revue Peinture, Cahiers théoretiques*. He resigned in 1972, both from the Supports-Surfaces group and the review, and left Paris for Nice. The essential concern of his work at this time was visually to formulate the disappearance of the painting while still remaining in the realm of the pictorial.

Since 1977, Dezeuze has been teaching at the Ecole des Beaux-Arts, Montpellier. His work has been included in many exhibitions from the 1970s to the present, including shows at the Yvon Lambert gallery, Paris, in 1973, 1981, 1983, 1985, 1987, and 1991, as well as abroad at the Kunstmuseum, Lucerne, in 1974, the Julian Pretto gallery, New York, in 1977, the Rudolf Zwirner gallery, Cologne, in 1978, and the Haags Gemeentemuseum in 1987.

Stretched Plastic on Chassis (Châssis plastic tendu), 1967 (cat. no. 344)

The frame as emblematic form, or as a symbol of research beyond the classical context of painting, is a frequent theme in postwar art. In short—whether it introduces a gesture of negation or derision by setting itself in opposition to the pictorial composition, or it affirms an archetypal figure of painting—the frame, in its different uses, traverses modernity and represents an obligatory passage for many contemporary plastic processes.

Directly inspired by Lucio Fontana, but with less brutality, Dezeuze began by cutting the canvas, thus allowing its supporting structure to appear. It was an era that no longer tolerated the great lyrical flights that had replaced academism in painting during previous decades. Yet many young artists of the mid-1960s still wanted to have a go at painting; they sought more rigor and wanted to establish the basis for a reflection of the actual foundations of pictorial fact. In 1967—the year of the joint actions of BMPT—several months after Viallat began to reproduce his prints on supple sheets, Dezeuze chose the bare frame as a subject for his work. According to his format, the frame was covered with a sheet of transparent plastic simulating canvas or painted with walnut stain. It was always placed on the ground, leaning against the wall, in the same waiting position as if in the studio.

Much was written during the 1970s about these frames by Dezeuze, properly giving them a founding place, both with regard to the evolution of his work, and in relation to the theoretical foundations for the Supports-Surfaces movement. "Thus imagined, the pictorial practice can, without being reduced, take place otherwise," concluded Dezeuze in a short note in 1969 that is also the first text he published. It was a question of creating a tabula rasa, of simplifying the elements used, of leaving only a reduced portion to subjectivity, or if possible, eliminating it. It is all the more remarkable that the work was so quickly diversified. Dezeuze's research quickly disrupted the simple formal approach to the frame by offering derivatives that were sometimes disconcerting, as in *Stretched Plastic on Chassis*, with its fragile tarlatan ladders, their racks impregnated with green or orange. —A. P.

Jean Dubuffet

1901–1985

Jean Dubuffet was born July 31, 1901, in Le Havre. He attended art classes in his youth and in 1918 moved to Paris to study at the Académie Julian, which he left after six months. During this time, Dubuffet met Raoul Dufy, Max Jacob, Fernand Léger, and Suzanne Valadon and became fascinated with Hans Prinzhorn's book on psychopathic art. He traveled to Italy in 1923 and South America in 1924. Then, Dubuffet gave up painting for about ten years, working as an industrial draftsman and later in the family wine business. He committed himself to becoming an artist in 1942.

Dubuffet's first solo exhibition was held at the Galerie René Drouin, Paris, in 1944. During the 1940s, the artist associated with André Breton, Georges Limbour, Jean Paulhan, and Charles Ratton. His style and subject matter in this period owed a debt to Paul Klee. From 1945, he collected Art Brut, spontaneous, direct works by untutored individuals, such as mental patients. The Pierre Matisse Gallery gave him his first solo show in New York in 1947.

From 1951 to 1952, Dubuffet lived in New York. He then returned to Paris, where a retrospective of his work took place at the Cercle Volney in 1954. His first museum retrospective occurred in 1957 at the Schloss Morsbroich, Leverkusen. (Dubuffet exhibitions have since been held at the Musée des arts décoratifs, Paris, the Museum of Modern Art, New York, the Art Institute of Chicago, the Stedelijk Museum, Amsterdam, the Tate Gallery, London, and the Solomon R. Guggenheim Museum, New York.) His *L'Hourloupe*, a series of paintings begun in 1962, were exhibited at the Palazzo Grassi, Venice, in 1964. A collection of Dubuffet's writings, *Prospectus et tous écrits suivants*, was published in 1967, the same year he started his architectural structures. Soon thereafter, he began numerous commissions for monumental outdoor sculptures. In 1971 he produced his first theater props, the "practicables." A Dubuffet retrospective was presented at the Akademie der Künste, Berlin, the Museum Moderner Kunst, Vienna, and the

Joseph-Haubrichkunsthalle, Cologne, in 1980–81. In 1981, the Solomon R. Guggenheim Museum observed the artist's eightieth birthday with an exhibition. Dubuffet died May 12, 1985, in Paris.

Dhôtel nuancé d'abricot, 1947 (cat. no. 255)

Dubuffet's quest for "what matters"—his *"entrée en matière,"* as Max Loreau superbly puts it—developed very rapidly through the questioning of painting's classical vehicle, the oil-based medium, into which he introduced a great diversity of ingredients (sand, plaster, dust from the studio, etc.), or which he rejected altogether, most often in favor of materials evoking "a dirty gray mud of indefinable color" or "used motor oil." The deliberately lively colors of the *Marionettes* (1942–45) were followed by the "monochrome registers" of *Mirobolus, Macadam & Cie* (1945–46). From these emerged the first portraits (of Jean Paulhan) in July 1945, foretelling the series *Plus beaux qu'ils croient*. From August 1946 to September 1947, Dubuffet created portraits of the painters and writers gravitating around Florence Gould and her literary luncheons. Beginning with the portrait of Pierre Benoît, the series rapidly shed any naturalistic faithfulness, tending instead toward the magical effigy, the archetypal figure, sometimes with one or two particular details grafted on: a rabbit snout, tufts of hair, and so on. Painted among the last in this series, *Dhôtel nuancé d'abricot*, a portrait of André Dhôtel, "nuanced with apricot," is one of the most hallucinatory, emanating a spellbinding quality of presence beneath the cruelty of the gaze. Much like a fetish image, the figure is represented hastily, incised into the material (an oil thickened with sand and gravel), closer to graffiti than to naturalistic drawing. The contrast of the savage line work, a veritable scar on the surface, renders the color all the softer, revealing through it the artist's unique pictorial concerns. Beyond their evocative presence, the *Portraits* are first and foremost acts of painting. As Dubuffet himself would stress: "These portraits were antipsychological, anti-individual, nourished on the idea that one who wishes to paint the important things needs not take much account, even in a portrait, of the chance futilities—a fatter face, a shorter nose—that happen to make one person different from another, nor of their more or less bitter or vivacious characters." In each of the *Portraits*, as in the undifferentiated figures of *Mirobolus, Macadam & Cie*, what really counts is what Francis Ponge called the "rage of expression." As Dubuffet said: "Art must arise from the material and the tool, and must retain the trace of the tool and of the tool's struggle with the material."

Dubuffet's first exhibition already stirred controversy (a few fervent admirers and far more detractors). But it was with the presentation of the figures of *Mirobolus, Macadam & Cie*, and then the *Portraits*, that the polemic reached its highest pitch, so powerful does the taboo of the human figure remain in Western civilizations. — D. A.

Pierre Matisse, portrait obscur, August 1947 (cat. no. 254)

In the wonderful text "Little Chat," Dubuffet wrote: "For a portrait to work really well for me, I need for it to be barely a portrait. Or in the extreme case, for it to cease being a portrait at all. And that's when it begins to works in all its strength. I really like things taken to their furthermost possible limit." Dubuffet's portraits of 1946 and 1947 are drawn, for the most part, from the gallery of illustrious writers and painters in the circle of Paulhan.

On January 10, 1947, Dubuffet had written to the art dealer Pierre Matisse: "I always work on my portraits with the stubbornness of a mule. . . . All my works are now on canvas and in good materials of proven solidity and quick-drying. . . . But still no bright colors, still few colors and dirty unnameable colors, vaguely brownish or gray and eggshell. I'm stubborn about that too. There are more than enough painters who use bright colors, and just as I employ humble, miserable, disreputable means in my drawing, I also want, as far as colors are concerned, to use the same sort of means."

Pierre Matisse, portrait obscur is mentioned in a handwritten note by the artist on July 25, 1947, and it was included in the preliminary lists for an exhibition in August, under the titles of *Pierre Matisse corbeau* and *Pierre Matisse portrait secret*. It is listed as number thirty-four in the exhibition catalogue of the Galerie René Drouin, with the title *Pierre Matisse portrait obscur*. It was clearly preceded by a charcoal drawing on white gouache background.

In 1947, an important year in Dubuffet's relationship with Matisse, the artist had his first New York show early that year at the dealer's gallery, which led to the formation of his first circle of American collectors, and then he had a second show there in the fall. But it was not until a year later, from November to December 1948, that eleven portraits, including *Pierre Matisse portrait obscur*, were finally exhibited there. — G. V.

Le Métafisyx, 1950 (cat. no. 256)

With the *Corps de Dame* series, which includes *Le Métafisyx*, Dubuffet ceaselessly reiterated his attack on the divine image, striking in this case at the natural embodiment of grace. In response to the accusations of ugliness commonly addressed to him at the time, Dubuffet disputed the "accidental and highly specious convention" of beauty, claiming on the contrary that he proposed a "fervent celebration" of the real. Perhaps the outrageous character of the drawing in the *Corps de Dame*—echoed across the Atlantic by de Kooning's American *Women*—arose from an increasing need to underline the subject, even as the treatment became more abstract. Almost entirely filling the rather large, 116 by 89 centimeter format used for most of this series, the *Corps de Dame* have almost the same structure as the *Tables paysagées*, which were to become one of the

painter's themes of predilection, and of which *Table nue* (1957, Musée national d'art moderne, Paris) is a late descendant. The lines violently incised into the material, defining the most precise sexual characteristics of the woman's body, nonetheless possess an ambiguity; Max Loreau notes that lines running through the body of the *Métafisyx* are organized in a way similar to those which bring forth the face of Jules Supervielle in the *Portraits*. As always for Dubuffet, it is a matter of closely linking "the highly general and the highly particular, the highly subjective and the highly objective, the metaphysical and the grotesquely trivial." — D. A.

Triumph and Glory (Triomphe et gloire), December 1950 (cat. no. 257)

In this additional work from Dubuffet's *Corps de dame* series, the woman's body is transformed into a flattened textured surface, adapted to fit the large rectilinear canvas. As in other works in the series, only essential physiological details have been scratched into its wet surface; the prevailing impression is instead of built-up layers of paint, applied like plaster to a wall, crudely and bluntly portraying an abstracted earthy femininity. Dubuffet insisted that he was protesting against certain traditional ideals of beauty—those "inherited from the Greeks and cultivated by magazine covers." While many critics and art historians have seen these images as abominations, Dubuffet claimed that the *Corps de dame* series celebrated a more real ideal of woman. The artist's claim is bolstered here by the painting's title, *Triumph and Glory*, and by its image of stalwart presence and fundamental solidity. — SRGM

The Traveler without a Compass, July 8, 1952 (Le Voyageur sans boussole, 8 juillet 1952), 1952 (cat. no. 258), and *Knoll of Visions (La Butte aux visions)*, August 23, 1952 (cat. no. 259)

The confusion of values that returns the observer to a state of innocence is brought to its extreme limit in these works from Dubuffet's *Mental Landscapes (Paysages du mental)*. Never before this series (whose title underscores at once a break with naturalistic representation and a metaphysical quality) had Dubuffet's pictorial material been so thick; to ensure that these dense paintings would adhere, he chose hardboard instead of canvas as a support. Ambiguity reigns in these works—the impasto suggests undefinable presences, and the abolition of perspective blurs all spatial representation to the point where it is difficult to decide if the spaces are bird's-eye views or geologist's cross-sections. The gangue-like color of these paintings, and of this series itself, suggests fossilized objects or figures, forcing the observer to situate himself beyond the human condition, at a chance juncture in the expansive continuum of time. As much as the small figure in the painting from July 1952, it is the observer who, having left the familiar lands of official art, is the *Traveler without a Compass*. — D. A.

Marcel Duchamp
1887–1968

Henri-Robert-Marcel Duchamp was born July 28, 1887, near Blainville, France. In 1904, he joined his artist brothers, Jacques Villon and Raymond Duchamp-Villon, in Paris, where he studied painting at the Académie Julian until 1905. Duchamp's early works were Post-Impressionist in style. He exhibited for the first time in 1909 at the Salon des Indépendants and the Salon d'Automne in Paris. His paintings of 1911 were directly related to Cubism but emphasized successive images of a single body in motion. In 1912, he painted the definitive version of *Nude Descending a Staircase*; this was shown at the Salon de la Section d'Or of that same year and subsequently created great controversy at the Armory Show in New York in 1913.

Duchamp's radical and iconoclastic ideas predated the founding of the Dada movement in Zurich in 1916. By 1913, he had abandoned traditional painting and drawing for various experimental forms including mechanical drawings, studies, and notations that would be incorporated in a major work, *The Bride Stripped Bare by Her Bachelors, Even* (1915–23; also known as *The Large Glass*). In 1914, Duchamp introduced his readymades—common objects, sometimes altered, presented as works of art—which had a revolutionary impact upon many painters and sculptors. In 1915, Duchamp came to New York, where his circle included Katherine Dreier and Man Ray, with whom he founded the Société Anonyme, as well as Louise and Walter Arensberg, Francis Picabia, and other avant-garde figures.

After playing chess avidly for nine months in Buenos Aires, Duchamp returned to France in the summer of 1919 and associated with the Dada group in Paris. In New York in 1920, he made his first motor-driven constructions and invented Rrose Sélavy, his feminine alter ego. Duchamp moved back to Paris in 1923 and seemed to have abandoned art for chess but in fact continued his artistic experiments. From the mid-1930s, he collaborated with the Surrealists and participated in

their exhibitions. Duchamp settled permanently in New York in 1942 and became a United States citizen in 1955. During the 1940s, he associated and exhibited with the Surrealist émigrés in New York, and in 1946 began *Etant donnés: 1. la chute d'eau 2. le gaz d'éclairage*, a major assemblage on which he worked secretly for the next twenty years. He died October 2, 1968, in the Paris suburb of Neuilly-sur-Seine.

Apropos of Little Sister (A propos de jeune soeur), October 1911 (cat. no. 145)

Before Duchamp notoriously renounced the tactility and visual richness of "retinal" art in 1913, he had explored a wide range of painterly styles. The impact of Cubism began to be felt in Duchamp's work of 1911, the year he painted *Apropos of Little Sister*. Prior to this date, he had worked through the influences of Paul Cézanne and Henri Matisse and showed a preference for figure painting, primarily portraits of his relatives. With a close-knit family of two brothers and three sisters, Duchamp had a ready supply of models. Of Duchamp's sisters, the one featured in *Apropos of Little Sister* is thought to be Magdelaine Duchamp, seated as she reads or works by candlelight.

This painting shares many features with Duchamp's other paintings of 1911—above all, its fractured treatment of the body. The broken human form resembles the faceted figures of František Kupka, an artist associated, like Duchamp was at the time, with the Puteaux group, and may also derive from the cinema or chronophotographs documenting bodies in motion. — S. R.

Study for Chess Players (Les Joueurs d'échecs), late 1911 (cat. no. 146), and *The Chess Players (Les Joueurs d'échecs)*, December 1911 (cat. no. 147)

Made after a series of preparatory drawings, including the ink and watercolor study included here, *The Chess Players* is itself a study for the definitive canvas, *Portrait of Chess Players*, first shown at the Salon de la Section d'Or in 1912. An obvious reprise of Cézanne's painting, *The Card Players* (1890–92), Duchamp's painting and his study for it display the underlying relationship between his work and that of Cézanne and Cubism. However, they still assert rather different concerns, such as space, which they do not define but merely suggest; the execution of a smooth painted surface; and a preoccupation with the problematics of movement, superimposed on the composition, and related to the concerns of the Italian Futurists. In reducing the space of the canvas by framing it vertically with two black bands, Duchamp is already attempting to give it the virtual aspect of a chessboard. He abandons the monotone brownish palette, the *camaïeu* of Analytical Cubism, and instead colors the painting with the green light of the gas lamp, thus sweeping away the avatars of realism in order to elaborate a method based on artifice. — B. B.

Nude (Study), Sad Young Man on a Train (Nu [esquisse], jeune homme triste dans un train), 1911–12 (cat. no. 149)

Nude (Study), Sad Young Man on a Train, which Duchamp identified as a self-portrait, was probably begun during December 1911 in Neuilly, while he was exploring ideas that would lead to the controversial *Nude Descending a Staircase No. 2* in 1912. In *Nude (Study), Sad Young Man on a Train* his transitory though acute interest in Cubism is manifested in the subdued palette, emphasis on the flat surface of the picture plane, and subordination of representational fidelity to the demands of the abstract composition.

Duchamp's primary concern in this painting is the depiction of two movements: that of the train in which we observe the young man smoking and that of the lurching figure itself. The forward motion of the train is suggested by the multiplication of the lines and volumes of the figure, a semitransparent form through which we can see windows, themselves transparent and presumably presenting a blurred, "moving" landscape. The independent sideways motion of the figure is represented by a directionally contrary series of repetitions. These two series of replications suggest the multiple images of chronophotography, which Duchamp acknowledged as an influence, and the related ideas of the Italian Futurists, of which he was at least aware by this time. Here he uses the device of replication not only to illustrate movement but also to integrate the young man—whose swaying, drooping pose contributes to the air of melancholy—with his murky surroundings. Shortly after the execution of this and similar works, Duchamp lost interest in Cubism and developed his eccentric vocabulary of mechanomorphic elements, which foreshadowed aspects of Dada. — L. F.

First study for *The Bride Stripped Bare by the Bachelors (La Mariée mise à nu par les célibataires)*, 1912 (cat. no. 148)

This study for *The Bride Stripped Bare by the Bachelors* was made in July and August 1912 in Munich, where Duchamp had gone in hopes of "traveling like a young man." This journey, which corresponded to a period of intense activity for the artist, has been the object of intense speculation on the part of art historians Jack Burnham, Jean Clair, John Golding, Jules Laforgue, and Ulf Linde. Burnham noted that it was in the ancient Bavarian metropolis that Duchamp first learned about alchemy and discovered in its symbolism the tool he needed to "break the chains of naturalism." Linde compared this drawing—the first to introduce the theme of Duchamp's magnum opus, *The Large Glass*—to an illustration drawn from a manuscript of the philosopher Solidonius, reproduced in Canseliet's *Alchimie*. Duchamp, a librarian at the time, naturally had access to manuscripts and other books dealing with alchemy and with what Laforgue calls "the dust of the stars." The theme Duchamp would borrow

above all was that of the philosophical Marriage of the Virgin, who, stripped of her clothing, was supposed to symbolize the alchemical material that, during its transformation into the gold of "Marriage," becomes liquefied and undergoes a general metamorphosis of its state. Clair pointed out, however, that if one consults the original manuscript in the Bibliothèque de l'Arsenal, Paris, "one notes that not only has Canseliet altered the primitive image representing a blond young man, and not a young woman, but the legend as well, which concerns not a 'Bride stripped bare' but the Sun between Mercury and Pluto."

There is no doubt, however, as Golding confirmed, that this drawing, in bringing together three mechanomorphic figures, resembles Etienne-Jules Marey's chronophotographs of the successive phases of a fencing match. In this interpretation of a three-way combat—with the central character of "The Bride" caught between the two bachelors aiming their swords at her—the amorous principle would thus be transformed into a game of thrust and parry. — B. B.

Box in a Valise (Boîte-en-valise), 1941/1961 (cat. no. 250)

Box in a Valise, begun in Paris in 1938 and finished in New York in 1941, is a collection of reproductions of Duchamp's most significant works. Duchamp made multiple copies of it, in regular as well as deluxe leatherbound editions. *Box in a Valise* is a metamuseum and a performance of the artist as curator. For this work, Duchamp gathered photographic reproductions of his paintings and objects, painstakingly mounted them on cardboard or black sheets of paper, and sometimes hand colored and "framed" them with low-grade wooden strips. Several of his readymades were refabricated in miniature. The clamshell box was designed so that the top can swing open and function as a display case. Panels on which the artist's celebrated and derided early works are mounted slide out in a mini-exhibition. When assembled, the works read from left to right in a continuous frieze: *The Bride* (1912); *The King and Queen Traversed by Swift Nudes* (1912); a panel onto which three-dimensional replicas of the readymades *Paris Air* (1919), *Traveler's Folding Item* (1917), and *Fountain* (1917) are stacked vertically; *The Bride Stripped Bare by Her Bachelors, Even (The Large Glass)* (1915–23) is at the center, enjoying pride of place; and a panel onto which photographic reproductions of *Tu m'* (1918), *Ready Made (Comb)* (1916), and *Nine Malic Moulds* (1914; as with *The Large Glass*, this work is reproduced on cellulose acetate to preserve its transparency) are mounted vertically. Attached to the box itself are paper pop-up versions of *Why Not Sneeze Rrose Sélavy?* (1921) and *Three Standard Stoppages* (1913–14), in addition to a second box, which contains flat reproductions of the remaining works, for a total of sixty-eight objects.

Box in a Valise is, in one sense, an inversion of inversions. If Duchamp's early Cubist-inspired

paintings were understood as unique canvases, they are represented here as cheap mechanical reproductions in kitschy frames. If the brilliance of the readymade lies in Duchamp's transposition of the art act from one of creation (as in making a painting or sculpture) to one of nomination (designating a preexisting, non-art object a work of art simply by saying it is), everything is reversed in this work—for *Box in a Valise* the "readymades" were in fact laboriously constructed by hand to seem as if they were industrially fabricated. In this gambit, humor and irony were the artist's primary tools, which he did not hesitate to turn on himself. Recycling works and presenting them anew was central to Duchamp's practice of resisting closure. He once said that an unfinished thing "provides more warmth," and thus he endeavored by dint of reinvention to render his oeuvre perpetually unfinished. — R. C.

Not a Shoe, 1950 (cat. no. 245)

Not a Shoe is the first of four erotic objects cast in plaster (the others are *Female Fig Leaf*, 1950, *Objet-dard*, 1951, and *Coin de chasteté*, 1954) as preludes to the large plaster figure in the installation *Etant donnés*, on which he had been secretly working since 1946. If the Malic Moulds of *The Large Glass* contained, engraved, the full form of the Bachelors, these castings, with their phallic appearance, incarnate in full the concave form of the Bride's organs. Negative molds of "selected morsels" of the feminine sex organ or positive molds of the male sex organ, these truly "femâlic" objects convey—beyond the alternatives of the hollow and the full, of the concave and the convex, which are the basis of Duchamp's thoughts on the original and the simulated—the principles of sexual ambivalence and reversibility dear to Duchamp's alter ego, Rrose Sélavy; it is an ambiguity rendered, kinesthetically, by electroplate imitating bronze, by making them light although they are perceived as being heavy (the inverse process of that adopted in 1921 by Duchamp for *Why Not Sneeze Rrose Sélavy?*). Taking on the appearance here of a shoe in allusion to the common French expression, "Find your shoe on your foot," *Not a Shoe* is considered a rough outline for the future *Coin de chasteté*, which consists of two narrowly fitted elements: one in pink dental plastic, the other in electroplated plaster (identical to the former). From the collection of Julien Levy, this innovative work has remained in its original condition, the only object in the series that was not remade by Man Ray or by Arturo Schwarz. — A. L. B.

Female Fig Leaf (Feuille de vigne femelle), 1950–51 (cat. no. 246)

Female Fig Leaf is a famous work by Duchamp for which the processes, and thus the exact status, have not yet been clarified. Several art historians and artists have tried to describe *Female Fig Leaf*. Pierre Cabanne wanted to include it in the series of works that he called erotic readymades, but Duchamp responded: "These are not readymades

but sculpted things, plaster things." Robert Lebel spoke of a "simulated casting of the feminine organ," followed by Richard Hamilton, who described the sculpture as "an enigmatic object appearing to be molded on a feminine sex organ, but in fact modelled by hand."

It seems more exact to recognize in this ambiguous work a casting (of a female sex organ)—based on a procedure that Man Ray said he carried out with Duchamp on the body of a prostitute—corrected, checked, lightly sanded, etc. If Duchamp had wanted to maintain the enigma of this work's origin, it is because the reference to a real body is at the same time a reference, still more persistent, to the fictitious body of *Etant donnés*, for which this can be considered a preparatory study in miniature. It was made "unreadable"—at a time when Duchamp kept the making of *Etant donnés* secret—by a simple switch from form (a crack) to counter-form (a strip). This reversibility is at the heart not only of Duchamp's erotic thought but of all his technical thought and practice.

Based on two originals in electroplated plaster, one of which was given to Man Ray, an edition of six copies (in painted plaster) was made by the latter in 1951. A second edition (in bronze) was made in 1961, under the auspices of the Rive Droite gallery. — D. S. and G. D.-H.

With My Tongue in My Cheek, summer 1959 (cat. no. 248), *Still Torture (Torture-morte),* summer 1959 (cat. no. 247), and *Still Sculpture (Sculpture-morte),* summer 1959 (cat. no. 249)

In 1959, Duchamp sent the three assemblage objects *With My Tongue in My Cheek, Still Torture,* and *Still Sculpture* from Cadaqués to his friend Robert Lebel in Paris; these three hermetically sealed glass boxes might be called watchful mailboxes, lascivious letters, conceived like so many others (*Allégorie de genre,* 1943, *Prière de toucher,* 1947, and *Boîte alerte,* 1959) on the occasion of publications or exhibitions. In this case, the objects constituted signs of life or sarcastic reliquaries of a Duchamp who had been absent from the book party for Lebel's monograph *Sur Marcel Duchamp,* held at La Hune bookstore in Paris, several months earlier.

These three assemblages may also covertly allude to Duchamp's large sculptural installation, *Etant donnés,* which he worked on from 1946 to 1966. Like his erotic plaster casts of the early 1950s (*Not a Shoe, Feuille de vigne femelle, Objet-dard,* and *Coin de chasteté*), these three facsimiles, in plaster casts or simulacra, anticipate *Etant donnés,* the great three-dimensional assemblage that celebrates the wedding of Eros and Thanatos. There, the effigy of the Bride's strangely violated body is presented to the observer's eyes like a gigantic still life.

Still Torture is a plaster cast of the sole of Duchamp's foot, painted pink to heighten its life-like illusionism and to "sign" this work Rrose Sélavy. It is a dead fragment already beset by flies,

themselves dead and crushed, suggesting some past torture to which the skin had been subjected, with the characteristic ambiguity and reversibility of phenomena so dear to Duchamp. *Still Sculpture* presents an accumulation of little marzipans imitating vegetables, found tidbits of Spanish gourmandise, in a three-dimensional trompe l'oeil, an anamorphic assemblage reminiscent of Giuseppe Arcimboldo. It is Duchamp's last altered readymade, which some have seen as the cigar-smoker's self-portrait. *With My Tongue in My Cheek* is even more of a relic than the other two objects: it is the cast, or rather the deathlike imprint of Duchamp's cheek, from which hair ends are still sticking out, superimposed on the academic medallion-like profile of Duchamp's face. The time lag between apparition and appearance here lies at the core of the work. This emblematic icon effects a splitting-redoubling (in three dimensions) of the simulacrum of the self, thus making perfectly explicit the deadly reversibility of the vision established by Duchamp: the viewer of the dead Bride of *Etant donnés* becomes the object viewed, becomes in turn the dead, fragmented mold tortured by the effect of consummated desire.

These three facsimile fragments of Duchamp's body are inseparable from one another—in fact the critic Georges Bauer likened them to the three panels of a triptych. They are presented sarcastically as so many pieces in the game between "the I and the Me," which this passionate chess player developed throughout his life. They constitute truly humorous rebuses with hidden secrets, and their titles (in the manner of Raymond Roussel), puns on the theme of the *nature morte* (still life), play an active part. For instance, while the title of *With My Tongue in My Cheek* refers to some sort of trick being played, the work physically suggests the existence of something being concealed by the artist—in this case, *Etant donnés.* Perhaps *Still Torture* and *Still Sculpture* herald the "torture" of the dead Bride, as it would be revealed magnificently in *Etant donnés.* — A. L. B.

Raymond Duchamp-Villon

1876–1918

Raymond Duchamp-Villon was born November 5, 1876, as Pierre-Maurice-Raymond Duchamp, in Damville, near Rouen. From 1894 to 1898, he studied medicine at the University of Paris. When illness forced him to abandon his studies, he decided to make a career in sculpture, until then an avocation. During the early years of the century, he moved to Paris, where he exhibited for the first time at the Salon de la Société Nationale des Beaux-Arts in 1902. His second show was held at the same salon in 1903, the year he settled in Neuilly-sur-Seine. In 1905, he had his first exhibition at the Salon d'Automne and a show at the Galerie Legrip, Rouen, with his brother, the painter Jacques Villon, with whom he moved to Puteaux two years later.

His participation in the jury of the sculpture section of the Salon d'Automne began in 1907 and was instrumental in promoting the Cubists in the early 1910s. Around this time, he, Villon, and their other brother, Marcel Duchamp, attended weekly meetings of the Puteaux group of artists and critics. In 1911, he exhibited at the Galerie de l'art contemporain, Paris; the following year, his work was included in a show organized by the Duchamp brothers at the Salon de la Section d'Or at the Galerie de la Boétie. Duchamp-Villon's work was exhibited at the Armory Show in New York in 1913 and the Galerie André Groult, Paris, the Galerie S. V. U. Mánes, Prague, and Der Sturm gallery, Berlin, in 1914. During World War I, Duchamp-Villon served in the army in a medical capacity, but was able to continue work on his major sculpture *The Horse.* He contracted typhoid fever in late 1916 while stationed at Champagne; the disease ultimately resulted in his death on October 9, 1918, in the military hospital at Cannes.

Head of a Horse (Tête de cheval), 1914 (cast 1976) (cat. no. 64), and *The Horse (Le Cheval),* 1914 (cast ca. 1930) (cat. no. 65)

Duchamp-Villon began work in 1914 on the plaster originals of *Head of a Horse* and *The Horse,* two

related works that show composite images of an animal and machine; he finished *The Horse* while on leaves from military duty in the fall. These works were preceded by numerous sketches and by several other versions initiated in 1913. Whereas the original conceptions were relatively naturalistic, in these works he developed increasingly dynamic, smooth-surfaced and geometric syntheses of horse and machine. They are highly abstracted, with parts of the horse's physiognomy replaced by mechanical elements. *Head of a Horse*, with its gleaming dark planes and simplified forms, suggests heavy industrial equipment. In the sculpture of the whole horse, there are vestiges of the artist's earlier, more naturalistic conceptions; the animal appears to be gathering its hooves, summoning strength to jump. Duchamp-Villon closely observed the dynamics of the movement of horses during his experience in the cavalry; he also studied the subject in the late nineteenth-century photographic experiments of Eadweard Muybridge and Etienne-Jules Marey.

With a handful of other sculptors, such as Alexander Archipenko, Umberto Boccioni, and Constantin Brancusi, Duchamp-Villon overturned conventional representation of form to suggest instead its inner forces. He associated these forces with the energy of the machine. The visual movement of the pistons, wheels, and shafts of these sculptures turn a creature of nature into a poised mechanical dynamo. The fusion of the horse, traditional symbol of power, and the machine that was replacing it reflects the emerging awareness of the new technological age.

The entire series of *The Horse* was cast in bronze after the artist's death, according to his instructions. The *Head of a Horse* was cast later, and its status as a finished work or an element of a never-executed monumental horse, has never been known. — MNAM and SRGM

Max Ernst
1891–1976

Max Ernst was born April 2, 1891, in Bruhl, Germany. He enrolled in the University at Bonn in 1909 to study philosophy but soon abandoned this pursuit to concentrate on art. At this time, he was interested in psychology and the art of the mentally ill. In 1911, Ernst became a friend of August Macke and joined the Rheinische Expressionisten group in Bonn. Ernst showed for the first time in 1912 at the Galerie Feldman, Cologne. At the *Sonderbund* exhibition of that year in Cologne, he saw the work of Paul Cézanne, Edvard Munch, Pablo Picasso, and Vincent van Gogh. In 1913, he met Guillaume Apollinaire and Robert Delaunay and traveled to Paris. Ernst participated that same year in the *Erste deutsche Herbstsalon*. In 1914, he met Jean Arp, who was to become a lifelong friend.

Despite military service throughout World War I, Ernst was able to continue painting and to exhibit in Berlin at Der Sturm gallery in 1916. He returned to Cologne in 1918. The next year, he produced his first collages and founded the short-lived Cologne Dada movement with Johannes Theodor Baargeld; they were joined by Arp and others. In 1921, Ernst exhibited for the first time in Paris, at the Galerie Au Sans Pareil. He was involved in Surrealist activities in the early 1920s with Paul Eluard and André Breton. In 1925, Ernst executed his first frottages; a series of frottages was published in his book *Histoire naturelle* in 1926. He collaborated with Joan Miró on ballet designs for Sergei Diaghilev that same year. The first of his collage-novels, *La Femme 100 têtes*, was published in 1929. The following year, the artist collaborated with Luis Buñuel and Salvador Dalí on the film *L'Age d'or*.

His first American show was held at the Julien Levy Gallery, New York, in 1932. In 1936, Ernst was represented in *Fantastic Art, Dada, Surrealism* at the Museum of Modern Art, New York. In 1939, he was interned in France as an enemy alien. Two years later, Ernst fled to the United States with Peggy Guggenheim, whom he married early in 1942. After their divorce, he married Dorothea Tanning and in 1953 resettled in France. Ernst received the Grand Prize for painting at the Venice *Biennale* in 1954, and in 1975 the Solomon R. Guggenheim Museum, New York, gave him a retrospective, which traveled in modified form to the Musée national d'art moderne, Paris, in 1975. He died April 1, 1976, in Paris.

Little Machine Constructed by Minimax Dadamax in Person (Von minimax dadamax selbst konstruirtes maschinchen), 1919–20 (cat. no. 161)

Little Machine Constructed by Minimax Dadamax in Person was executed in Cologne the year Dada was established there. It belongs to a series of about fifty works (which includes *The Great Orthochromatic Wheel that Makes Love to Measure*) dating from 1919–20, based on diagrams of scientific instruments, in which Ernst used printer's plates to reproduce preexisting images. The impressions, once altered by traditional coloristic and modeling effects, occupy a position between found object and artistic product, as do his collages.

In both subject and style, the series can be compared with Francis Picabia's mechanomorphic drawings and paintings. These artists shared an interest in typography, printed images, and language; many of the forms in the present work can be read as letters. They also describe a mechanical structure that symbolizes sexual activity, as do Picabia's and Marcel Duchamp's works from this period.

Ernst's machine is a fantasized solution to the psychological pressures of sexual performance, as announced in the humorously heroic inscription at the bottom of the sheet: "Little machine constructed by minimax dadamax in person for fearless pollination of female suckers at the beginning of the change of life and for other such fearless functions." The right side of the machine seems to comprise a miniature laboratory for the production of semen, which is indicated as a red drop that courses through passageways to the left side of the apparatus. The drop finally issues from the yellow faucet, accompanied by a whimsically self-assured and cheerful "Bonjour." Alternatively, the machine can be seen as a combination of male and female halves. The female (at the right) is dowdy and angular; the more brilliantly colored male (at the left) "fearlessly" points away from her. — L. F.

The Great Orthochromatic Wheel that Makes Love to Measure (La Grande Roue orthochromatique qui fait l'amour sur mesure), 1920 (cat. no. 162)

The frottage *The Great Orthochromatic Wheel that Makes Love to Measure* belongs to a unique series of twelve plates, each with the same image, executed in the middle of the Dada period in 1919 and 1920 in Cologne. In technique, these works are before their time, since Ernst did not announce the "discovery" of the formal and oneiric possibilities of the frottage technique until 1925. By manipulating ordinary objects in these works—in this case, wooden printer's blocks and characters—Ernst experimented simultaneously with the possibilities of assembly and disassembly, of reversal and doubling of identical forms, and with the ambiguous combination of different techniques (impressions, rubbings, retouchings in pen, watercolor, or gouache). The result is a compact, unified image of the living, humorous, mechanized universe reminiscent of the poetic alphabet of Arthur Rimbaud.

Exhibited together with some collages in May 1921 at the Parisian bookstore Au Sans Pareil, *The Great Orthochromatic Wheel that Makes Love to Measure*—its title contributing to the poetic functioning of the image—was purchased, most likely on that occasion, by Eluard. Put up for sale with the rest of Eluard's collection at the Hôtel Drouot in 1924, it soon became the property of Michel Leiris. —A. L. B.

Ubu Imperator, 1923 (cat. no. 163)

Ubu Imperator, acquired by Eluard together with the rest of Ernst's first large oil paintings conceived before the artist left for Paris in 1922, directly marks the painter's entry into the

Surrealist field. It clamorously illustrates the skillful combination of heterogeneous elements inherited from the collage technique. In their new arrangement, these elements constitute another reality, one that is enigmatic and endowed "with a rigorous power of persuasion proportional to the violence of the initial shock it produced," to use Breton's words. In an empty, sun-drenched scene reminiscent of Giorgio de Chirico, a strange, monumental human top teeters on its fine-pointed tip. It is a highly complex image of the mockery of power. Père Ubu, a grotesque symbol of authority adopted from Alfred Jarry's play *Ubu Roi*, here assumes the ridiculous form of a fat, framed carcass; his appearance is the result of one of those hallucinations Ernst cultivated from an illustration of the bronze casting of Edmé Bouchardon's equestrian statue of Louis XV. The reinforced molding, from which sprout human hair and limbs, seems self-propelled, a kind of absurd robot. Moreover, this image recalls one of Ernst's childhood fantasies, a "vision of half-sleep," as the artist himself described it in a 1927 issue of the journal *La Révolution surréaliste*. In this vision, his father gradually metamorphosed into a monumental top, a whip/phallus, and a pencil. This strange image reappears, illustrating the artist's dream almost verbatim, in the first version (now lost) of *Femme, Vieillard et fleur* (1923); the second version, the "censored" version, with the top now gone, is at the Museum of Modern Art, New York. The symbolic content attached to this image must have been indeed considerable: the prestige of paternal authority, linked to sex and to artistic creation, the last two always closely connected in Ernst's imagination, vanish like smoke in this treatment, here appearing as a vacillating, erratic, childhood toy.

Behind the buffoonery of power represented by *Ubu Imperator*, all traditional aesthetics—those of rational composition and geometrical perspective—likewise seem to be held up for ridicule in the top: the pinpoint will trace only mechanical, wild, undulating, aleatory lines across the ground. The whole liberating practice of automatic drawing claimed by the Surrealists is suggested here, as is the practice of "dripping." Thus, one year before the appearance of the first *Manifesto of Surrealism*, Ernst seems to define not only the formal paths he would take—a complex visual alchemy of resurgent, overlapping symbols—but, more importantly, the meaning of his own attitude toward the act of painting, a pose of distance and derision that would dominate his whole aesthetic. — A. L. B.

The Kiss (*Le Baiser*), 1927 (cat. no. 167)

From humorously clinical depictions of erotic events in the Dada period, Ernst moved on to celebrations of uninhibited sexuality in his Surrealist works. His liaison and marriage with the young Marie-Berthe Aurenche in 1927 may have inspired the erotic subject matter of *The Kiss* and others of this year. The major compositional lines of this work may have been determined by dropping

string on a preparatory surface, a procedure that accorded with Surrealist notions of the importance of chance effects. However, Ernst used a coordinate grid system to transfer his string configurations to canvas, thus subjecting these chance effects to conscious manipulation. Visually, the technique produces undulating calligraphic rhythms, like those traced here against the glowing earth and sky colors.

The centralized, pyramidal grouping and the embracing gesture of the upper figure in *The Kiss* led Nicolas and Elena Calas to compare it with Renaissance compositions, specifically Leonardo da Vinci's *Virgin and Saint Anne with the Christ Child and the Young Saint John the Baptist* (1500–01). The Leonardo work was the subject of a psychosexual interpretation by Sigmund Freud, whose writings were important to Ernst and other Surrealists. The adaptation of a religious subject would add an edge of blasphemy to the exuberant lasciviousness of Ernst's painting. — L. F.

Chimera (*Chimère*), 1928 (cat. no. 168)

Acquired immediately by Breton, who jealously kept it in his own collection, *Chimera* still has the same shock effect that must have swept Breton away. Violently hieratic, much more disturbing than *Monuments aux oiseaux* and *Après nous la maternité* (both 1927), to which it is related, this painting is exceptionally emblematic in itself; further, it may be seen as an emblem of Surrealism as a whole. The chimera, that monstrous creature produced by a collage of different animal parts, the fruit of a melancholy imagination (Ernst "cites" Leonardo, Gentile Bellini, William Blake, and Arnold Böcklin), could be considered a "Surrealist" apparition par excellence, chosen by Breton himself in 1933 to illustrate *Le Message automatique* and by Ernst to embody the mechanism of inspiration. *Chimera* may also be seen as the objectification of Ernst's personal "daemon," his "satanas": this proud eagle with feminine torso could only be his own phantasmic double, Ernst's future alter ego of the 1930s, "Loplop," who already appears as a hermaphroditic bird in the 1925 painting *Natural History*, and the bird-child associated with the mother-father couple of *A Night of Love* (1927) and *The Kiss*. Developed with disturbing breadth and power, this winged triangulated apparition may be the locus where Freud's text *Leonardo da Vinci and a Memory of His Childhood* and a recurrent childhood memory of Ernst's meet and intermingle. Beneath its chimerical disguise, the vulture-female thus becomes the wholly sacrilegious, derisory image of a threefold identification: Baby Jesus, Leonardo, and Ernst.

To the force of this visual phantasm a total formal control is applied. According to the practice of inversion and dissimulation so dear to Ernst, the unity and simplicity of the image mask the multiplicity and ambiguity of the symbols present. With a mastery of formal means, Ernst reconstitutes, in its original force, all the energy that

presided over his hallucination, the poetic power of which remains a blend of fascination and horror. — A. L. B.

Garden Airplane Trap (*Jardin gobe-avions*), 1935 (cat. no. 176), and Garden Airplane Trap (*Jardin gobe-avions*), 1935–36 (cat. no. 177)

Ernst's ever-vigilant exploration of materials through rubbing, scratching, and other derivative procedures gave rise to strange writing metamorphic forms, which in turn led to the stunning *Garden Airplane Traps*, painted in oil in the mid-1930s. These partitioned airplane traps are bathed in a desertlike, solar calm that oozes an uneasiness reminiscent of de Chirico's paintings. Ernst's sharp-edged carcasses, recalling the murderous female-airplanes and grasshoppers that appeared in earlier works, break down, releasing menacing bouquets of vegetation. The soft and ethereal brightness of the pastel colors scarcely masks the violence of the deadly threat of battle.

Others, including art critic John Russell, have interpreted the *Garden Airplane Traps* in terms of Ernst's alter ego, the bird, and the games of power and victimization played out in human sexual relationships. Russell saw the airplane parts as surrogates for the bird, and the vegetation as trophies of victory or "wreaths laid upon the grave of some passionate impulse," as traps that have captured the airplanes. As Russell wrote: "On the one hand, the vulnerability not merely of the bird, with whom Ernst had so often identified himself, but of that mechanized and seemingly all-powerful bird, the airplane. On the other, the capacity for deceit and destruction which lies hidden within what is traditionally a zone of exalted pleasure."

Further, Ernst here seems to foreshadow the petrifaction of his 1935–36 painting *Whole Cities*, in which deserted citadels are invaded by mossy vegetation, as well as those dangerous paradises in paintings of 1936, in which frolic the praying mantises of the *Feasts of Hunger* and the promising, luxuriant nymphs of *Déjeuner sur l'herbe* and *Garden of the Hesperides*. –A. L. B.

Attirement of the Bride (*La Toilette de la mariée*), 1940 (cat. no. 178)

Attirement of the Bride is an example of Ernst's illusionistic Surrealism, in which a traditional technique is applied to an incongruous or unsettling subject. The theatrical, evocative scene has roots in late nineteenth-century Symbolist painting, especially that of Gustave Moreau. It also echoes the settings and motifs of sixteenth-century German art; in particular, the willowy, swollen-bellied figure types recall those of Lucas Cranach the Elder. The architectural backdrop, with its strong contrast of light and shadow and its inconsistent perspective, shows the additional influence of de Chirico, whose work had overwhelmed Ernst when he first saw it in 1919.

The pageantry and elegance of the image are contrasted with its primitivizing aspects—the garish colors, the animal and monster forms—and

the blunt phallic symbolism of the poised spear-head. The central scene is contrasted as well with its counterpart in the picture-within-a-picture at the upper left, in which the bride appears in the same pose, striding through a landscape of over-grown classical ruins. There Ernst used the technique of decalcomania, invented in 1935 by Oscar Domínguez, in which diluted paint is pressed onto a surface with an object that distributes it unevenly, such as a pane of glass. A suggestive textured pattern results.

The title of this work had occurred to Ernst at least as early as 1936, when he italicized it in a text in his book *Beyond Painting*. Ernst had long identified himself with the bird, and had invented an alter ego, Loplop, Superior of the Birds, in 1929. Thus, one may interpret the bird-man at the left as a depiction of the artist and the bride as a representation of the Surrealist artist Leonora Carrington. — L. F.

The Antipope, December 1941–March 1942 (cat. no. 179)

Ernst settled in New York in 1941 after escaping from Europe with the help of Peggy Guggenheim. The same year, he executed a small oil on card-board (now in the Peggy Guggenheim Collection, Venice) that became the basis for the large-scale *The Antipope*. When Guggenheim saw the small version, she interpreted a dainty horse-human fig-ure on the right as Ernst, who was being fondled by a woman she identified as herself. She wrote that Ernst conceded that a third figure, depicted in a three-quarter rear view, was her daughter Pegeen; she did not attempt to identify another horse-headed female to the left. When Ernst undertook the large version from December to March he changed the body of the "Peggy" figure into a greenish column and transferred her amorous gesture to a new character, who wears a pink tunic and is depicted in a relatively naturalis-tic way. The "Pegeen" figure in the center appears to have two faces, one of a flayed horse that looks at the horse-woman at the left. The other, with only its cheek and jaw visible, gazes in the oppo-site direction, out over the grim lagoon, like a pen-sive subject conceived by Caspar David Friedrich.

The great upheavals in Ernst's personal life during this period encourage such a bio-graphical interpretation. Despite his marriage to Guggenheim, he was deeply involved with Carrington at this time, and spent hours riding horses with her. As birds were an obsession for Ernst, so horses were for Carrington. Her identifi-cation with them is suggested throughout her col-lection of stories *La Dame ovale*, published in 1939 with seven illustrations by Ernst, two of which include metamorphosed horse creatures. It is plausible that the alienated horse-woman of *The Antipope*, who twists furtively to watch the other horse-figure, represents a vision of Guggenheim. Like the triumphal bride in *Attirement of the Bride*, she wears an owl headgear. Her irreconcilable separation from her companion is expressed

graphically by the device of the diagonally posi-tioned spear that bisects the canvas. The features of the green totemic figure resemble those of Carrington, whose relationship with Ernst was to end soon after the painting was completed, when she moved to Mexico. — L. F.

Jean Fautrier
1898–1964

Jean Fautrier was born May 16, 1898, in Paris. Upon the death of his father in 1908, Fautrier was raised in London, where he attended the Royal Academy of Art in 1912, and later the Slade School of Art. After serving in the French army and auxil-iary corps from 1917 to 1921, Fautrier settled in Paris and returned to painting.

Fautrier's first two solo exhibitions took place at Galerie Visconti, Paris, in 1924 and at Galerie Fabre, Paris, in 1925. In 1928, Fautrier became acquainted with the writer André Malraux, who later played a significant role in reestablishing his artistic reputation after the next war. It was Malraux who encouraged Fautrier to produce *L'Enfer* (1928), a series of lithographs illustrating scenes from Dante's *Inferno*.

Suffering from the economic depression, Fautrier abandoned painting from 1935 to 1939 and moved to Tignes and Val-d'Isère, where he made a living as an innkeeper and ski instructor. After returning to Paris in 1940, he befriended the avant-garde writers and poets Paul Eluard, Jean Paulhan, and Francis Ponge. In January 1943, Galerie René Drouin, Paris, gave Fautrier a retro-spective exhibition. Two years later, the gallery exhibited *Otages*, a series of panels, begun in 1942, which abstractly depicted the remains of mutilated heads and alluded to the atrocities of war. Fautrier executed the panels in his signature technique of applying alternate layers of white paint and thick impasto onto an absorbent ground created by lay-ers of paper on canvas. The exhibition also included a selection of expressive sculptures made between 1940 and 1943, which portrayed heads tortured and disfigured in the same vein as in the paintings.

Fautrier's work was associated with the Art Informel movement. Rejecting the idea of paint-ing defined forms, Fautrier derived his forms through the manipulation of his materials. In 1951, he participated in the exhibition *Les Signifiants de l'Informel*, which was organized by Michel Tapié and presented at the Galerie Paul Facchetti, Paris. Other artists in the show included Jean Dubuffet, Henri Michaux, and Jean-Paul Riopelle.

In 1955, Galerie Rive Droite, Paris, exhibited *Les Objets*, a series of Fautrier's works dated from 1928 to 1955. A year later, the gallery showed a series of canvases, dated from 1945 to 1955, titled *Les Nus*. Comprised of paintings portraying identi-fiable subjects, these two series attested to Fautrier's rejection of abstraction.

After a 1957 exhibition at the Sidney Janis Gallery, New York, Fautrier exhibited internation-ally and gained worldwide recognition. He won grand prizes at both the 1960 Venice *Biennale* and the 1961 Tokyo *Biennial*. In 1964, the Musée d'art moderne de la Ville de Paris organized a retro-spective exhibition, for which Fautrier prepared while he was extremely ill. The artist died July 21, 1964, in Châtenay-Malabry, without having seen the opening of his exhibition.

L'Ecorché, 1944 (cat. no. 253)

The beautiful, terrifying Fautrier exhibition titled *Les Otages*, organized by René Drouin in his Paris gallery in the fall of 1945, was one of the major art events of the immediate postwar period in Paris. Fautrier showed some fifty works fresh from the studio, some of them perhaps executed as early as 1942 but dated, signed, and given their final titles only after the Liberation. These *Hostages* were painted for the most part just outside Paris in Châtenay-Malabry, the site of numerous execu-tions and firing squads in 1943.

In these works, Fautrier experimented with a new technique: on the paper support, which was later mounted on canvas, he superimposed thick layers of gesso, oil, and glue, without hesitating to add other materials such as pigment powder, watercolor, and inks. Finally, the slightest of graphic elements, jumbled marks, and outlines were inscribed on this rough background. The almost intolerable contrast between the atrocious subject and the loveliness and lightness of the col-ors was deeply felt and forcefully described by the first witnesses of this art, whether or not they were supporters of Fautrier—such as Malraux, who wrote the preface to the 1945 catalogue, Marcel Arland, who wrote an important article on the show, or Michel Ragon, the author of a 1957 monograph on the artist. In that work, Ragon con-trasted, one element at a time, the subject (evok-ing decaying, tortured bodies, faces reduced to a bloody pulp) and the tenderness of the color range, floral pinks and cerulean blues in particular.

Most of the paintings presented were small heads or busts; only a few of the larger paintings dared to tackle the representation—if one may call

it that—of whole, mutilated figures. *L'Ecorché*, one of these five or so canvases, is perhaps the most striking because of the unbearable quartering it seems to evoke. It bears witness to a dramatic moment in French history; as Malraux wrote, these paintings were "the first attempt to strip down contemporary suffering to the point of discovering its ideograms of pathos, imbuing it throughout with power, henceforth in the eternal mode." —I. M. F.

Femme douce, 1946 (cat. no. 252)

Paradoxically, *Femme douce*—alluding to the female body, the thighs and breasts compressed together—was presented at the Salon des Réalités Nouvelles, Paris, where only purely abstract works were tolerated. From the beginning, Fautrier put himself at odds with the Art Informel movement. He declared that reality must exist within the work, that it was the raw material of this "live work," and that it held and made the work under the form.

Although there exist expressions of delirium and joyous satisfaction in the spontaneous gestures that crush tubes of white color one on top of the other, the drawing, even liberated from its form, remains a contour and is never the product of a blind projection but clearly indicates references to female anatomy. Here, Fautrier also distances himself from his rival Dubuffet, who debases his *Corps de dame* series in a bituminous, dirty material. Fautrier practiced a "pretty" art, with green and pink tones, which even Malraux found too soft, a well-made painting, designed to harmonize with rustic furniture. This is what art critics Ragon and Pierre Restany correctly saw in the series of nudes: "They are of firm flesh, with multiple breasts. They have a strip-tease side, with lingerie rose color and fresh thighs pink. As with the flesh from the *Hostages* series, which appears to be mixed with earth that has started to digest these cadavers, Fautrier's naked flesh is kneaded in with their dresses." In effect, the eroticism of the 1950s seems to be fossilized in these material strategies and pictorial impasto. —Ch. D.

Lucio Fontana
1899–1968

Lucio Fontana was born February 19, 1899, in Rosario de Santa Fé, Argentina. His father was Italian and his mother Argentinean. He lived in Milan from 1905 to 1922 and then moved back to Argentina, where he worked as a sculptor in his father's studio for several years before opening his own. In 1926, he participated in the first exhibition of Nexus, a group of young Argentinean artists working in Rosario de Santa Fé. Upon his return to Milan in 1928, Fontana enrolled at the Accademia di Belle Arti di Brera, which he attended for two years.

The Galleria Il Milione, Milan, organized Fontana's first solo exhibition in 1930. In 1934, he joined the group of abstract Italian sculptors associated with Galleria Il Milione. The artist traveled to Paris in 1935 and joined the Abstraction-Création group. The same year, he developed his skills in ceramics in Albisola, Italy, and later at the Sèvres factory, near Paris. In 1939, he joined the Corrente, a Milan group of expressionist artists. He also intensified his lifelong collaboration with architects during this period.

In 1940, Fontana moved to Buenos Aires. With some of his students, he founded in 1946 the Academia de Altamira from which emerged the Manifiesto Blanco group. He moved back to Milan in 1947 and in collaboration with a group of writers and philosophers signed the *Primo manifesto dello spazialismo*. He subsequently resumed his ceramic work in Albisola to explore these new ideas with his *Spatial Concepts (Concetti spaziali)*.

The year 1949 marked a turning point in his career; he concurrently created the *Holes (Buchi)*, his first series of paintings in which he punctured the canvas, and his first spatial environment, a combination of shapeless sculptures, fluorescent paintings, and black lights to be viewed in a dark room. The latter work soon led him to employ neon tubing in ceiling decoration. In the early 1950s, he participated in the Italian Art Informel exhibitions. During this decade, he explored working with various effects, such as slashing and perforating, in both painting and sculpture. The artist visited New York in 1961 during a show of his work at the Martha Jackson Gallery. In 1966, he

designed opera sets and costumes for La Scala, Milan.

In the last year of his career, Fontana became increasingly interested in the staging of his work in the many exhibitions that honored him worldwide, as well as in the idea of purity achieved in his last white canvases. These concerns were prominent at the 1966 Venice *Biennale* for which he designed the environment for his work, and at the 1968 *Documenta* in Kassel. Fontana died September 7, 1968, in Comabbio, Italy.

Black Sculpture—Spatial Concept (Scultura nera—Concetto spaziale), 1947 (cat. no. 285)

Back in Milan after seven years of voluntary exile in Buenos Aires, where he had drafted the *Manifiesto blanco*, Fontana co-authored and published a new version of it in 1947, titled *Primo manifesto dello spazialismo*. In the same period, he brought together a group of draftsmen of free automatic writing with whom he expressed his wish to found a project that would be at once "idealistic and modern." From this "material and informal" period comes *Black Sculpture—Spatial Concept*, a work that inaugurates Fontana's experimentation with space as material, one of the fundamental themes of his art.

Here the clay, cast in bronze, presents itself as a ritualized object, ridding itself of all anthropomorphism. The work inaugurates and foreshadows a mental space that is utopian in character. It is posited as project, as unfinished fragment, and suggests above all a germination, a figure still in gestation, a process.

It is on this basis that Fontana was one of the central figures of the postwar Italian avant-garde. Leaving behind the conflict between abstraction and figuration he had cultivated since the late 1920s, which had become dated, he found in the physical and tactile recognition of artistic material the foundations of radically innovative aesthetics. —B. B.

Spatial Concept (Concetto spaziale), 1949 (cat. no. 286)

In 1949, Fontana began to work on the *Holes*, using a point to puncture mounted paper or canvas that served as a kind of spatial screen. At the same time, he executed his first works in neon. Yet he was also continuing to create works in clay and terra-cotta, in close proximity and friendship with the Italian sculptors Tullio d'Albisola and Leoncillo.

Tempted by decorative art, which he easily mastered—to the point of becoming one of the central figures in Milanese design in the 1950s—Fontana became intensely productive, combining virtuosity and the singularity of a few very exceptional works. *Spatial Concept* is, in this respect, a magnificent, exemplary work.

Fontana expressed his basic thoughts on the future of art at the time as follows: "Neither painting nor sculpture, nor lines defined in space, but a continuity of space in material." A later manifesto

of his from 1951 states the intentions: "to consider as reality these spaces, this vision of universal matter through which science, philosophy and art, as knowledge and intuition, have nourished the human spirit . . . to represent this energy, which today is shown to be pure 'material,' while these spaces appear as 'plastic material.'" *Spatial Concept* is therefore preeminently the most sensitive translation of the artist's ideas; here space becomes material and material pure energy. Neither painting nor sculpture, it is in more than one way exemplary of the "spatialism" the artist would later develop simultaneously in various different settings.

Formulated at the same time as Jackson Pollock's first abstract paintings, and shortly before the thick *impasti* of Jean Dubuffet and Jean Fautrier, Fontana's problematics, despite formal and historical proximity to them, is nevertheless a far cry from those visions.

Because of its size—it is, in fact the largest sculpture ever made by Fontana in this mode—its black color, its unusual technique, its neutral, "formless" format, as well as the lyrical and baroque gesture that constitutes it, this *Spatial Concept* remains utterly unique, defying all traditional categories to the point of rendering them obsolete. — B. B. and M. B.

Spatial Concept, Expectations (*Concetto spaziale, Attese*), 1959 (cat. no. 292)

Fontana's respect for the advancements of science and technology during the twentieth century led him to approach his art as a series of investigations into a wide variety of mediums and methods. In his manifestos, Fontana announced his goals for a "spatialist" art, one that could engage technology to achieve an expression of the fourth dimension. He wanted to meld the categories of architecture, sculpture, and painting to create a groundbreaking new aesthetic idiom.

From 1947 on, Fontana's experiments were often entitled *Concetti spaziali*, among which a progression of categories unfolds. Beginning in 1958, Fontana purified his paintings by creating matte, monochrome surfaces, thus focusing the viewer's attention on the slices that rend the skin of the canvas. Paintings such as *Spatial Concept, Expectations* are among these *Cuts* (*Tagli*), whose violent jags enforce the idea that the painting is an object, not solely a surface.

Many of Fontana's proclamations echo Futurist declarations made before World War I. The artist's wish that his materials be integrated with space, his need to express movement through gesture, and his interest in states of being (exemplified in his use of the word "expectations" in the title of this work), suggest the artist's familiarity with the work of Umberto Boccioni, a leading Futurist sculptor, painter, and theorist whom Fontana cited as an inspiration. — J. B.

Spatial Concept (*Concetto spaziale*), 1960 (cat. no. 287)

This very important *Spatial Concept* serves as a kind of synthesis of the series of *Holes* begun in 1949. Fontana always worked in cycles, but he also worked simultaneously on different supports, following different procedures. Large-scale works are, however, rather rare in his production, as though the concern for any monumentality whatsoever fundamentally contradicted the very nature of his project. In this respect, this *Spatial Concept* stands as an exception, since we know of only one other work of comparable size and technique, currently still in the collections of the Fontana Foundation.

The piece here combines the problematics of the planarity of the canvas with the texture of the painting. The surface seems coated with slip, resembling the raw clay of the contemporaneous *Nature* series. Two aleatory spaces are plotted, distinguished by different shades of basalt gray. Etched into the material, two cords define an ambiguous space and juxtapose the geometric rigor of the surface with the trace of the human hand.

The material is scratched, as with a stiletto, the surface punctuated with little pockmarks effected with the aid of a sculptor's tool. Thickly covered with oil paint, the surface of the canvas contracted while drying. It has turned the paint into a skin, a deposit similar to what forms on the surface of a jar of paint left open. The work is thus like the unmediated memory of the gesture, comparable in this respect to the "drip" that sweeps across the canvas, vindicating a transitory state essential to all painting, which inscribes in its space the time of its coming into being. Intended as a link to otherness, Fontana's work seems to represent a crater in metamorphic form. Here the counterpart to the limitless spaces of "dripping" is the image of an unknown land. — B. B.

Spatial Concept, Expectations (*Concetto spaziale, Attese*), 1965 (cat. no. 293)

In 1958, Fontana made his first *Cuts*, or cut paintings, the single gesture for which he is best known. The notion of form developing through actions—in this case, a razor slicing through canvas—was a theme developed by Fontana in his several manifestos. Gesture was also at the heart of *Il Gesto*, the journal of the Movimento Arte Nucleare, to which Fontana contributed in the 1950s. For this group, a loose international coalition based in Milan, "*Matiere + Mouvement = Feu*" (Matter + movement = fire). Fontana's works, as well as those of Pierre Alechinsky, Enrico Baj, and Roberto Matta were cited as prime examples of this concept.

This *Spatial Concept, Expectations*, is a monumental white monochrome canvas marked by five crisp slashes. The slightly diagonal orientation of these cuts and their cascade from upper left to lower right contribute to a sense of pulsating movement both through and across the canvas.

With the *Cuts*, Fontana solved some of the problems posed by *Unique Forms of Continuity in Space* (1913), a static bronze sculpture with which Boccioni endeavored to embody forward motion. The *Cuts* literalize Futurist attempts to penetrate space and to fragment the uniform picture plane. In its rhythmic, downward-thrusting lines of force and in its assault on the purity of a venerated genre, *Spatial Concept, Expectations* resonates with Marcel Duchamp's *Nude Descending a Staircase No. 2* (1912). Where Duchamp scandalized contemporary viewers by mechanizing and animating the odalisque, Fontana wrought similar havoc on the monochrome. *Spatial Concept, Expectations* demonstrates the unique blend of sensuality, violence, elegance, and wit that characterizes Fontana's entire oeuvre. — R. C.

Alberto Giacometti
1901–1966

Alberto Giacometti was born October 10, 1901, in Borgonovo, Switzerland, and grew up in the nearby town of Stampa. His father, Giovanni, was a Post-Impressionist painter. From 1919 to 1920, he studied painting at the Ecole des Beaux-Arts and sculpture and drawing at the Ecole des Arts et Métiers in Geneva. In 1920, he traveled to Italy, where he was impressed by the works of Alexander Archipenko and Paul Cézanne at the Venice *Biennale*. He was also deeply affected by African and Egyptian art and by the masterpieces of Giotto and Tintoretto. In 1922, Giacometti settled in Paris, making frequent visits to Stampa, and occasionally attended Antoine Bourdelle's sculpture classes.

In 1927, the artist moved into a studio with his brother, Diego, his lifelong companion and assistant, and exhibited his sculpture for the first time at the Salon des Tuileries, Paris. His first show in Switzerland, shared with his father, was held at the Galerie Aktuaryus, Zurich, in 1927. The following year, Giacometti met André Masson, and by 1930 he was a participant in the Surrealist cir-

cle. His first solo show took place in 1932 at the Galerie Pierre Colle, Paris. In 1934, his first American solo exhibition opened at the Julien Levy Gallery, New York. During the early 1940s, he became friends with Simone de Beauvoir, Pablo Picasso, and Jean-Paul Sartre. From 1942, Giacometti lived in Geneva, where he associated with the publisher Albert Skira.

He returned to Paris in 1946. In 1948, he was given a solo show at the Pierre Matisse Gallery, New York. The artist's friendship with Samuel Beckett began around 1951. In 1955, he was honored with retrospectives at the Arts Council Gallery, London, and the Solomon R. Guggenheim Museum, New York. He received the Sculpture Prize at the 1961 *Carnegie International* in Pittsburgh and the First Prize for Sculpture at the 1962 Venice *Biennale*, where he was given his own exhibition area. In 1965, Giacometti exhibitions were organized by the Tate Gallery, London, the Museum of Modern Art, New York, the Louisiana Museum in Humlebaek, Denmark, and the Stedelijk Museum, Amsterdam. That same year, he was awarded the Grand National Prize for Art by the French government. Giacometti died January 11, 1966, in Chur.

Spoon Woman (Femme-cuiller), 1926 (cat. no. 191)

Giacometti was twenty years old when he settled in Paris in order to pursue a career as a sculptor, studying under Bourdelle at the Académie de la Grande Chaumière. There, he learned from classical sculpture and the prevailing Cubist idiom, but it was not until he began to interpret "primitive" objects that he was able to liberate himself from the influence of his teachers.

Captivating the avant-garde, African and Oceanic art took hold in the early years of the twentieth century. Giacometti's knowledge of African art derived from several sources, including a patron's private collection, new publications on the subject, and an exhibition he saw during the winter of 1923–24 at the Musée des arts décoratifs, Paris. Not long after, he began to create works filtered through the lens of this awareness. *Spoon Woman*, one of the artist's first mature works, explores the metaphor employed in ceremonial spoons of the African Dan culture, in which the bowl of the utensil can be equated with a woman's womb. But Giacometti's life-sized sculpture—his first large-scale work—reverses the equivalence. As art historian and theorist Rosalind Krauss has noted: "By taking the metaphor and inverting it, so that 'a spoon is like a woman' becomes 'a woman is like a spoon,' Giacometti was able to intensify the idea and to make it universal by generalizing the forms of the sometimes rather naturalistic African carvings toward a more prismatic abstraction."

Giacometti's sculptural forays into the realms of African and Oceanic art captured the attention of the Surrealists, whose ranks he joined in 1929. Many of the Surrealists collected "primitive" art and, like Giacometti, absorbed its lessons in order

to break from the conventions of Western artistic representation. In Giacometti's oeuvre, *Spoon Woman* represents the culmination of such early sculptural investigations, with its totemic form evoking the geometric concerns of Cubism, the primitivizing influence of African and Oceanic art, and the themes of fertility evident in his early work. —J. B. and J. F. R.

Man and Woman (Homme et femme), 1928–29 (cat. no. 192)

By 1928, the explicit representation of sexual desire had invaded painting; taboos were falling as Surrealist propaganda shook up the status quo. In *Man and Woman*, Giacometti focused on the principle of a "coupled" articulation of two complementary forms, as he had in 1927 in *Dancers*, but here he explores the very image of coitus: two flat forms arch in a tension dictated by desire; face to face, the man is reduced to an arc tautened by its pointed rod, the woman to a concave "spoon" with a minuscule orifice at its center and ending in a zigzag on top. Giacometti's constant symbolism here assumes quasi-abstract forms. A proper reading of this veritable pictogram (which should be read from the side) required an initiation, which fell to Michel Leiris. In 1929, he published the first study on Giacometti in the journal *Documents*; the issue included a reproduction of the plaster cast, now lost, of *Man and Woman*. Leiris pointed out that archaic fetishism continues to throb in all civilized men and to regulate their mores. In his eyes, one of Giacometti's premier merits was that of giving form to this constant of humanity.

Already priceless for being the only proof in bronze, this exceptional piece presents, for the first time, the image of desire's very functioning, its mechanism of reversibility (which further refers to the reversibility of the gaze, which was so important to Giacometti). The "unpleasant," menacing sign of the pointed rod, soon reappears in *Point to the Eye* in 1932. — Ch. D.

Point to the Eye (La Pointe à l'oeil), 1932 (cat. no. 193)

Large as a table centerpiece—made to be placed on furniture, on a fireplace, in a window, but not on a pedestal—*Point to the Eye* is one of the masterpieces of sculpture from the period between the two World Wars. By its size and its execution, it easily takes its place in the specific category of objets d'art. But by the richness of interpretations it has provoked (the most recent, by Jean Clair in the *Cahiers de MNAM* in 1983, remains one of the most relevant), it is a sculpture that partakes in the most innovative Surrealist aesthetic, not limited to the plastic illustration of the theses of celebrated poets.

Point to the Eye is a matter for sharp reflection on the process of vision, of representation; it is an actual device for viewing, a human astrolabe, and it foreshadows later phenomenological investigations of perception. This "machine" consists of a

plate with engraved geometric marks that delimit the field of action of the two moving parts: a minuscule pierced skull, perched on the point of a metal structure that has "small residual elements that evoke a rib cage," and a second element, an enormous horn, also stuck on a needle, that points menacingly in the direction of the skull's orbital cavity. In this work, one finds one of the first examples of the distortions that the artist continued to use for the rest of his life, an optical effect whose interpretation remains open, since Giacometti did not leave instructions.

Several times, in the guise of description, he sketched the work in profile, establishing a relationship that was already familiar to him from the flat sculptures he had made before. He also had it photographed by Man Ray in 1932; the photographs were reproduced in *Cahiers d'Art* in 1932. But it would seem that the best way to present it would be to put it at the viewer's eye level so that the eye would focus on the spot exactly between the menacing point of the horn and the cranial cavity. There was a first version of this sculpture, in plaster, a model certainly executed by Giacometti in 1931, and Man Ray's photograph of it was reproduced as *Disintegrating relations (Relations désagrégantes)*, but it is impossible to establish if this title came from the editor of *Cahiers d'Art*, Christian Zervos, or from the artist. According to his brother, Diego, the execution of the model in wood by a neighborhood cabinet-maker took place much later. Be that as it may, when Giacometti once again referred to the work in 1947, in a letter to Pierre Matisse, he called it *Menacing Point, The Eye of a Skull (Pointe menaçante, l'oeil d'une tête-crane)* and not yet *Point to the Eye*. —Ch. D.

Women with Their Throats Cut (Femmes égorgées), 1932 (cat. no. 194), and *Woman with Her Throat Cut (Femme égorgée)*, 1932 (cast 1940) (cat. no. 195)

In a group of works made between 1930 and 1933, Giacometti used the Surrealist techniques of shocking juxtaposition, and the distortion and displacement of anatomical parts, to express the fears and urges of the subconscious. The aggressiveness with which the human figure is treated in these fantasies of brutal erotic assault graphically conveys their content. The female, seen in horror and longing as both victim and victimizer of male sexuality, is often a crustacean or insectlike form. *Woman with Her Throat Cut* is a particularly vicious image: the body is splayed open, disemboweled, arched in a paroxysm of sex and death. Eros and Thanatos, seen here as a single theme, are distinguished and perhaps treated separately in two preparatory images (Musée national d'art moderne, Paris) made the same year. In the sketch *Women with Their Throats Cut*, the upper image clearly conveys the idea of sexual violence; it is a figure writhing on its back, neck sliced open, abdomen pierced through by a pointed missilelike form. The lower figure is less easily deciphered but does indicate the development of a

ribbed neck that would also appear in the sculpture. Unlike the final product, however, the sketch shows a pointed autoerotic form probing beneath an outer sheath on the figure's torso.

Body parts are translated into schematic abstract forms in the drawing and in the sculpture, which includes the spoon shape of the female torso, the rib and backbone motif, and the pod shape of the phallus. Here a vegetal form resembling the pelvic bone terminates one arm, and a phalluslike spindle, the only movable part, gruesomely anchors the other; the woman's backbone pins one leg by fusing with it; and her slit carotid immobilizes her head. The memory of violence is frozen in the rigidity of rigor mortis. The psychological torment and the sadistic misogyny projected by this sculpture are in startling contrast to the serenity of contemporaneous pieces by Giacometti. — MNAM and SRGM

Nose (*Le Nez*), 1947 (cat. no. 196), and *Nose* (*Le Nez*), 1947 (cat. no. 197)

In about 1947, Giacometti's tall, thin skeletal figures began to appear. In the two *Nose* sculptures, the investigation of space preoccupies the artist as it had in the early 1940s, when he sculpted extremely small figures on large bases. Made during the height of Existentialism, the philosophical and literary movement led by Giacometti's friend Sartre, these sculptures reflect a view of man isolated and essentially alone, captive within his individual existence. There are slight variations between the first version, with its plaster head, and the later version, with the head cast in bronze from the plaster: the proportions of the steel, cagelike structure have changed; the way the head is hung has shifted from being suspended in one position, to hanging free; and feet have been added to the bottom of the supporting rods.

The absurdly elongated nose juts out at the viewer in each sculpture, recalling masks from the Venetian *carnevale*. It seems to directly refer to the character Pinocchio, thus raising issues of morality and responsibility for one's actions—issues that interested the Existentialists. The figure's wide-open mouth suggests a scream of anguish, while the cord attached to its head evokes the gallows. The *Nose* sculptures present a harrowing, unnerving image of the human condition. — MNAM and SRGM

Piazza, 1947–48 (cast 1948–49) (cat. no. 198)

In the late 1940s, Giacometti produced thin attenuated figures not only of life-size height but also on the miniature scale of the figures who inhabit his *Piazza*. Four men stride across a wide plaza, each moving toward the center, yet none apparently directed toward an encounter with another. A single woman, stiffly posed, stands isolated and motionless near the center. The featureless figures exist independently within their haphazardly grouped unity, their multiple, nonconverging paths suggesting the individual ambitions and absorptions of strangers.

The flat bronze slab on which the figures stand serves both as base and as the plaza setting. Such a tabular format first appears in *The Palace at 4 a.m.* (1932–33), a highly theatrical work of Giacometti's Surrealist period. Giacometti began placing individual figures on large bases as early as 1942, but only in 1948, in *Three Men Walking*, did a group of attenuated figures appear on a thin square bronze base, which suggests a city square.

Giacometti's scene derives from modern urban experience. He stated: "In the street people astound and interest me more than any sculpture or painting. Every second the people stream together and go apart, then they approach each other to get closer to one another. They unceasingly form and re-form living compositions in unbelievable complexity. . . . It's the totality of this life that I want to reproduce in everything I do."

There are five different casts of this work, and a somewhat larger version with the figures placed in slightly different positions exists in five casts as well. In all of these sculptures, an eye-level examination of the work alters the scale of miniaturization first perceived by the viewer. The vastness of the empty piazza and the anonymity of the figures are revealed by such close-up scrutiny. — E. C. C.

Diego, 1953 (cat. no. 201)

In 1925, Diego was sent to Paris by his mother to live with his older brother, Alberto, who was just beginning his artistic career. In addition to making plaster casts and patinating bronzes in the studio, Diego modeled for his brother, posing almost daily from 1935 to 1940. Giacometti later observed that when he worked from memory, the heads that resulted most often resembled Diego's.

In his sculptural work of the 1940s, Giacometti often explored spatial relations, sculpting extremely small, attenuated figures on large bases to create a sense of alienation. He continued in this manner throughout his career, suggesting the loneliness caused by each individual's isolation within his own existence. This interest carried over into Giacometti's painting, which he resumed after World War II, having largely abandoned it at the time his brother came to live with him. *Diego*, a portrait of his brother, conveys the psychological isolation expressed in Giacometti's sculptural work. As in his sculpture, the figure in the painting is insistently frontal, although here the extreme attenuation is replaced by rounder, less exaggerated forms. Diego is presented within the confines of a cagelike structure—which appears with some frequency in Giacometti's sculpture—denoting the architecture of the room. The structure serves to distance the sitter, an effect that is compounded by the diminutive scale of the figure as well as by the effect of a frame at the edges of the canvas.

This focus on the solitary figure could be seen within the context of the postwar existential angst that was voiced by Sartre. At the time of this painting, the artist's relationship with Beckett had intensified. The atmosphere of melancholia is deepened both by the artist's muted palette, which seems to drain life from the sitter and by the figure's near-transparency in a haze of reworked paint—creating a haunting, incorporeal portrait. — J. B. and J. F. R.

Portrait of Isaku Yanaihara (*Portrait d'Isaku Yanaihara*), 1956 (cat. no. 202)

Between September 1956 and the summer of 1961, Giacometti executed more than a dozen painted portraits of Isaku Yanaihara, a young Japanese professor from Osaka University, who came to Paris in 1954 to conduct research on Existentialism. In November 1955, he interviewed Sartre, who led him to Giacometti. From the first series of sittings in September 1956, Yanaihara was trapped in his role as a model, which not only made him postpone his return via Egypt to Japan that autumn but also made him return to France each summer (except in 1958).

It was undoubtedly a test of patience, hard and rigorous, for the model to sit repeatedly for these paintings, but it was also agonizing for the artist. Giacometti was obstinate and desperate with this particular unfamiliar face; until that time only his wife, Annette, his brother, Diego, or his mother had posed for him. Yanaihara's face was smooth and enigmatic, precipitating new difficulties for Giacometti, who wrote, "It seemed to me that I had made some progress until I began working with Yanaihara. This was in 1956; from that time, everything went from bad to worse." Jean Genet also attests to this fact: "during the entire time he struggled with the face of Yanaihara (one can imagine this face offering and refusing to allow its image to appear on the canvas as if it had to protect its unique identity), I had the moving example of a man who was never mistaken, but who was continually lost. He always went deeper, into impossible regions, without exit. He has emerged from them now, with his work still simultaneously dark and dazzling."

Attributed to the year 1956, this *Portrait of Isaku Yanaihara* is the first of a series that led Giacometti to confront "the impossibility of penetrating further into the living reality of another and of an unknown other," according to Yves Bonnefoy. The painful experience of disaster caused Giacometti to say, "I am back where I was in 1925," that is to say, with the impossibility of making a head, of capturing the lifelike reality of a head. This painted sketch was abandoned, as would be all the portraits of Yanaihara and, henceforth, all of Giacometti's paintings—arbitrarily stopped in the course of an inaccessible conclusion.

With a brush, Giacometti drew several succinct lines for the space—a space not in perspective, not identifiable, impossible to measure—or to outline the hesitant framework. The quickly brushed luminous modulations of gray-brown-yellow constitute the actual gulf of emptiness from which the face emerges, the insurmountable distance that separates the painter (or the viewer)

from the model; it is "painting with lost background," as art historian Jacques Dupin described it, a real vibratile cloth, unstable, in the center of which is inserted Yanaihara's head and chest. For the chest and joined hands, some strokes are applied with a wider brush to deliver a quick graphic diagram of a body that has no contour, no fixed measure. Everything rushes toward the ball of the head, which occupies the center of the painting, constituting its hard pit: a dense network of concentric, orthogonal, nervous and short, black and white lines, the shape of an unstable maze, with an elasticity that is almost menacing with shadows and light. What is attempted here is the placement of a trellis that is the "frame" of the head and, provisionally, its actual "body." In frontal view, Yanaihara's face barely appears from the unformed mass of hair and the surrounding space; yet in a sort of living confrontation, it obliges the onlooker to feel the fugitive enigmatic presence of its load of flesh. — A. L. B

Julio González
1876–1942

Julio González was born September 21, 1876, in Barcelona. With his older brother Joan he worked in his father's metalsmith shop; during the evenings they took classes at the Escuela de Bellas Artes. González exhibited metalwork at the *Exposición de bellas artes e industrias artísticas* in Barcelona in 1892, 1896, and 1898, and at the *World's Columbian Exposition* in Chicago in 1893. In 1897, he began to frequent Els Quatre Gats, a café in Barcelona, where he met Pablo Picasso.

In 1900, González moved to Paris; there he began to associate with Pablo Gargallo, Juan Gris, Manolo Hugué, Max Jacob, and Jaime Sabartés. His first embossed metalwork was produced in 1900. He exhibited with the Société Nationale des Beaux-Arts in 1903, 1909, and frequently during the early 1920s. González participated in the Salon des Indépendants in 1907 and occasionally

thereafter. He first exhibited paintings at the Salon d'Automne in 1909, and showed both sculpture and paintings there regularly during the 1910s and 1920s. In 1918, González worked at the Renault factory at Boulogne-Billancourt, where he learned techniques of autogenous welding he used later in iron sculptures. In 1920, he became reacquainted with Picasso.

González's first solo exhibition, which included paintings, sculpture, drawings, jewelry, and objets d'art, was held in 1922 at the Galerie Povolovsky, Paris. The following year he was given a solo show of works in similarly varied mediums at the Galerie du Caméléon in Paris. In 1923, González participated in the first Salon du Montparnasse, Paris, with Raoul Dufy, Paco Durrio, Othon Friesz, and others. In 1924, he was included in the exhibition *Les Amis du Montparnasse* at the Salon des Tuileries and the Salon d'Automne in Paris. He made his first iron sculptures in 1927. From 1928 to 1931, González provided technical assistance to Picasso in executing sculptures in iron. In 1930, he was given a solo sculpture exhibition at the Galerie de France, Paris, and the following year showed at the Salon des Surindépendants for the first time. In 1937, he contributed to the Spanish Pavilion of the *Exposition internationale*, Paris, and *Cubism and Abstract Art* at the Museum of Modern Art, New York. That same year, he moved to Arcueil, near Paris, where he died March 27, 1942.

Woman Combing Her Hair I (*Femme se coiffant I*), ca. 1931 (cat. no. 93)

Playing on a motif drawn from everyday reality, this work shows González's technical mastery, as well as the originality of his sculptural vision. In a series of drawings begun in 1924, he experimented with the motif over a long period, progressively breaking down lights and shadows. The early drawings display a graphic concern, while the later ones, which can be considered preparatory to execution, show the preoccupations of a sculptor: the woman's silhouette and her gestures are reduced to an abstract, formal cipher made up only of lines and planes. No element in the sculpture is arbitrary, each is a "distillation" of a detail of the woman—her hair, her *décolleté*, her hip, her knee; in their final translation, these elements are all reformulated according to the possibilities of working in iron. A prime example of sculpture as "drawing in space," this work clearly shows the influence of Picasso, who taught the artist the importance of lightness and transparency, as well as the technical and sculptural use of assemblage. González, in turn, wrote that sculpture should be transparent, so that no single surface would hide another; this was an approach that grew in radical opposition to traditions of sculpture in the round.
— MNAM

Arshile Gorky
1904–1948

Arshile Gorky was born April 15, 1904, as Vosdanik Adoian, in Khorkom, Armenia. The Adoians became refugees from the Turkish invasion; Gorky himself left Van in 1915 and arrived in the United States about March 1, 1920. He stayed with relatives in Watertown, Massachusetts, and with his father, who had settled in Providence. By 1922, he lived in Watertown and taught at the New School of Design, Boston. In 1925, he moved to New York and changed his name to Arshile Gorky. He entered the Grand Central School of Art, New York, as a student but soon became an instructor of drawing; from 1926 to 1931, he was a member of the faculty. Throughout the 1920s, Gorky's painting was influenced by Georges Braque, Paul Cézanne, and, above all, Pablo Picasso.

In 1930, Gorky's work was included in a group show at the Museum of Modern Art, New York. During the 1930s, he associated closely with Stuart Davis, Willem de Kooning, and John Graham; he shared a studio with de Kooning late in the decade. Gorky's first solo show took place at the Mellon Galleries, Philadelphia, in 1931. From 1935 to 1937, he worked under the WPA Federal Art Project on murals for Newark Airport. His involvement with the WPA continued into 1941. Gorky's first solo show in New York was held at the Boyer Galleries in 1938. The San Francisco Museum of Art exhibited his work in 1941.

In the 1940s, he was profoundly affected by the work of European Surrealists, particularly Joan Miró, André Masson, and Roberto Matta. By 1944, he met André Breton and became a friend of other Surrealist emigrés in this country. Gorky's first exhibition at the Julien Levy Gallery, New York, took place in 1945. From 1942 to 1948, he worked for part of each year in the countryside of Connecticut or Virginia. A succession of personal tragedies, including a fire in his studio that destroyed much of his work, a serious operation, and an automobile accident, preceded Gorky's

death by suicide on July 21, 1948, in Sherman, Connecticut.

Untitled, summer 1944 (cat. no. 230)

Gorky spent the greater part of 1944 at Crooked Run Farm in Hamilton, Virginia, where he produced a large number of drawings, many of which were conceived as preliminary studies for paintings. This work is preceded by such a study, a closely related untitled drawing of 1944, that sets out its motifs, their ordering within the composition, and the arrangement of color. Apart from the transformation of an empty contour at the upper center into a solid, anchored black form, only insignificant compositional and coloristic changes appear in the finished painting.

Gorky's enthusiastic response to the natural surroundings of rural Virginia infused his work with expressive freedom. Landscape references appear in *Untitled*; though the white ground is uniform, it is empty at the very top of the canvas, suggesting a slice of sky, while the "earth" below is replete with vegetal shapes and floral colors. A clear gravitational sense is produced by the dripping of paint thinned with turpentine, a technique suggested by Matta. As in *They Will Take My Island* of the same year, an aggressive diagonal accent cuts through the upper center of the canvas.

The techniques and content of Surrealism influenced the development of Gorky's language of free, organic, vitally curvilinear forms. Joan Miró's example is particularly evident here, in the disposition of floating abstract units on an indeterminate background, and in details such as flamelike shapes, dotted ovals, and suggestions of genitals. Unlike Miró, however, Gorky enmeshes his forms with one another to create the overall structure. Textured, insubstantial clouds of color occasionally pertain to the graphic form they accompany, but more often are independent elements, as in the work of Vasily Kandinsky. The curves, inflection, and directionality of Gorky's line likewise free it from descriptive function. In his emphasis on the autonomous expressive potential of line, form, and color, Gorky anticipated the concerns of Abstract Expressionism. — L. F.

Landscape-Table, 1945 (cat. no. 231)

The only work by Gorky at the Musée national d'art moderne, Paris, this painting comes from the collection of Julien Levy, who had been a close friend of the painter since 1932 and became his first dealer in New York. *Landscape-Table* fully demonstrates Gorky's mastery of a new pictorial language, one that diverged from previous stylistic approaches that were too closely linked to the art of Picasso and Miró.

By 1944, Gorky had developed a light, supple and discontinuous stroke that united the different areas of color and surrounded them, creating "hybrid" shapes, to use Breton's expression, "made up mostly of childhood and other memories." These natural shapes produced a fluid, mov-

ing space, like those of Matta and Masson. But far from choosing images from the unconscious, Gorky, like Miró, used nature itself as a starting point, and created a vision of natural forms that were deformed to the point of abstraction. The delicate flow of the line, the nuance of tone, the broken-down shapes and the sense of fantasy are not without parallel to the work of Paul Klee.

Beginning in the years 1945–46, Gorky explored a totally open space in which shapes and shadows became attenuated, the color more evanescent, and the line more nervous. A painter of nature crossed by memory, Gorky transcribed a space that straddles representation and abstraction, crosses the realism of the outer world with forms of the imagination. He is thus considered the last Surrealist and the first Abstract Expressionist. Using a flow of shapes that change before the eyes into sexual, floral, vegetal, and organic images, the landscape here becomes a "table" laden with all sorts of signs, or a dissecting table of forms, in homage to the Comte de Lautréamont. — C. S.

Juan Gris

1887–1927

Juan Gris was born March 23, 1887, as José Victoriano Carmelo Carlos González-Pérez, in Madrid. He studied mechanical drawing at the Escuela de Artes y Manufacturas in Madrid from 1902 to 1904, during which time he contributed drawings to local periodicals. From 1904 to 1905, he studied painting with the academic artist José Maria Carbonero. In 1906, he moved to Paris, where he lived for most of the remainder of his life. His friends in Paris included Georges Braque, Fernand Léger, and Pablo Picasso and the writers Guillaume Apollinaire, Max Jacob, and Maurice Raynal. Although he continued to submit humorous illustrations to journals such as *L'Assiette au beurre*, *Le Charivari*, and *Le Cri de Paris*, Gris began to paint seriously in 1910. By 1912, he had developed a personal Cubist style.

He exhibited for the first time in 1912: at the Salon des Indépendants, Paris, Galeries Dalmau, Barcelona, Der Sturm gallery, Berlin, the Salon de la Société Normande de peinture moderne,

Rouen, and the Salon de la Section d'Or, Paris. That same year, Daniel-Henri Kahnweiler signed Gris to a contract that gave Kahnweiler exclusive rights to the artist's work. Gris became a good friend of Henri Matisse in 1914 and over the next several years formed close relationships with Jacques Lipchitz and Jean Metzinger. After Kahnweiler fled Paris at the outbreak of World War I, Gris signed a contract with Léonce Rosenberg in 1916. His first major solo show was held at Rosenberg's Galerie l'effort moderne, Paris, 1919. The following year, Kahnweiler returned and once again became Gris's dealer.

In 1922, the painter first designed ballet sets and costumes for Sergei Diaghilev. Gris articulated most of his aesthetic theories during 1924 and 1925. He delivered his definitive lecture, "Des possibilités de la peinture," at the Sorbonne in 1924. Gris exhibitions took place at the Galerie Simon, Paris, and the Galerie Flechtheim, Berlin, in 1923 and at the Galerie Flechtheim, Düsseldorf, in 1925. As his health declined, Gris made frequent visits to the south of France. Gris died May 11, 1927, in Boulogne-sur-Seine.

Glass and Checkerboard (*Verre et damier*), 1914 (cat. no. 27)

In 1914, Gris used the *papier collé* technique for fifty or so compositions, which were often rather large in size, with paper pasted onto canvas, so that they actually have the same status as paintings. He perfected a personal method of working, merely intuited in the preceding years, which he called "deductive." As Gris explained in 1923, "The quality or the size of a shape or a color suggests to me the denomination or an adjective of an object. Thus I never know beforehand what the object represented will look like."

Hence, unlike Braque who would plan in advance to place a piece of wood veneer or tapestry galloon in a drawing, and then move it to better make it fit, Gris first placed the cut-out shapes of differing materials according to the laws of what he called an "abstract architecture." Only then did he qualify and individualize it through drawing, shadows, and dots. In *Glass and Checkerboard*, the small rectangle of dark red paper is intended as a glass of wine, the wood veneer as a table in one place, a checkerboard in another, and the floral wallpaper as a curtain, suggesting the space of a room. Art historian Douglas Cooper noted in 1977, "The paper elements in the collages of Gris are thus bearers of three different meanings: their own meaning, their meaning as color or decoration, and their pictorial meaning resulting from their modifications." Certainly one of Gris's most important contributions to the history of Cubism, his *papiers collés* also play an essential role in his own evolution toward clarification, indeed, toward abstraction. — I. M. F.

Bottle of Rum and Newspaper (*Bouteille de rhum et journal*), June 1914 (cat. no. 26)

In 1913, Gris began using the technique of *papier collé* developed by Georges Braque and Pablo Picasso, with whom he had been working in close contact since 1911. By 1914, Gris's handling of the technique had become personal and sophisticated, as evidenced by works such as *Bottle of Rum and Newspaper*, executed in Paris shortly before he left for Collioure at the end of June. Here, the pasted elements overlap and intermesh with one another in relationships suggesting mathematical rigor. These collaged papers cover the entire surface of the canvas, simultaneously forming an abstract composition and serving as a multilayered support for naturalistic details.

The dynamism of the picture derives from the tension between horizontals, verticals, and thrusting diagonals. Gris presents the table as if it were viewed from several vantage points at once, demonstrating that a diagonal can be understood as a horizontal perceived from an oblique angle, and also suggesting the movement of the observer or artist around objects. The telescoping of a number of viewpoints in a single image produces the illusion of spatial dislocation of the objects themselves. Dissected parts of the bottle of rum, recognizable by its shape or by its label, float beside, below, or above the drawing of the complete bottle. These paper cutouts, at once more tangible and more fragmented than the shadowy outline, confuse one's perceptions of the bottle's presence.

Gris confounds expectations of the nature of materials. He usually depicts the glass objects as transparent and the others as opaque but does not hesitate to betray this faithfulness to the properties of objects when formal demands intercede. — L. F.

The Breakfast Table (*Le Petit Déjeuner*), 1915 (cat. no. 28)

From June to October, 1914, Gris lived in Collioure, on the southern French coast, near the Spanish border. There, he befriended Matisse who helped him a great deal during this difficult time. Kahnweiler has discussed the important exchanges between the two artists, as well as the possible influence of Gris's Cubism on Matisse during the two or three following years. But we should also wonder about the impact the personality and the painting of a man almost twenty years his elder would have had on Gris, especially someone like Matisse, who was in full possession of his talent, and at a particularly grand moment in his work.

One can see the effect in Gris's series of *Windows* painted in 1915. In that series, Gris reworked the Matissian theme of the "passage" through the open window between the interior and exterior. Gris is thus the only one among the Cubists to allow air from the outside into the confined space of the still life. Using his own methods, codified by Cubism yet rejected by Matisse — cut-outs, superimposition, the tipping

of planes, objects dislocated and fragmented in order to be perceived more completely — he succeeded in creating a synthetic space. In *The Breakfast Table*, the blue clarity of the sky framed by the window and the intimacy of the interior, suggested by the warmth of the wood veneer and the deep red color on the right, come placidly together around a morning still-life. A coffee maker, coffee grinder, bowl, and newspaper are placed on a white damask checked tablecloth, a subtle reference to the checkerboard, which was a fundamental motif in Gris's repertoire. Perpetually restless and unsatisfied, Gris nonetheless had the feeling that his canvases of this time were on the right track. He wrote modestly to Kahnweiler on December 4, 1915, a few weeks after completing *The Breakfast Table*, "I think I'm making progress in my painting. It seems to me that it is settling down and that everything is becoming concrete and concise." — I. M. F.

George Grosz

1893–1959

George Grosz was born July 26, 1893, as Georg Ehrenfried Gross, in Berlin. From 1909 to 1911, he studied at the Royal Academy, Dresden, and the following year at the Berlin Kunstgewerbeschule, graduating in 1917.

While in Berlin, he worked mainly on book illustrations and sketches of Berlin cabaret life, which he successfully sold to magazines. Honoré Daumier, Francesco Goya, and the cartoonist Wilhelm Busch were among his earliest influences. In 1914 and 1917, he was drafted into the German Army but each time he was discharged because of physical and mental illnesses. His experience on the front and in the hospitals, and the disillusion suffered on his return to civilian life profoundly informed Grosz's highly satirical sketches and paintings of a decadent Weimar society. These brutal caricatures were made in

the tense linear style that was to become his trademark.

As a member of the Berlin Club Dada, which he joined in 1919, he worked on periodicals and books and made Dada collages, sometimes in collaboration with John Heartfield. Like the other members of the group, he joined the Communist party. In 1920, he had his first solo show at the Galerie Neue Kunst/Hans Goltz, Munich, and participated in the organization of the *First International Dada Fair*. In 1921, he was tried, convicted, and fined for attacking the Reichswehr in his political portfolio *Gott mit Uns*. From 1921 until 1931, Grosz was prosecuted several times for indecency, slander, and blasphemy.

Because of the poignant objective realism Grosz displayed in his art, he was associated with the painters of the Neue Sachlichkeit, especially with Max Beckmann and Otto Dix, and was included in the seminal exhibition of the group in Mannheim in 1925. Grosz left Germany in 1933 to live permanently in the United States. He taught at the Art Students League, New York, and founded his own art school together with Maurice Sterne.

In 1937, his work was included in the infamous traveling exhibition *Degenerate Art* (*Entartete Kunst*) in Germany. This year and the following year, he received a Guggenheim Fellowship. In 1941, the Museum of Modern Art, New York, organized the exhibition *George Grosz: A Retrospective Exhibition*, which toured in the United States. In 1946, Grosz published his autobiography, *A Little Yes and a Big No*, in New York. In 1954, the Whitney Museum of American Art, New York, mounted a retrospective exhibition of Grosz's work that traveled throughout the United States. Germany paid homage to Grosz with a retrospective of his work at the Staatliche Kunsthalle Baden-Baden in 1957, which traveled in Germany and France. Only weeks after his return to Berlin, Grosz died July 5, 1959.

Remember Uncle August, the Unhappy Inventor, 1919 (cat. no. 159)

Remember Uncle August, the Unhappy Inventor is the title written on the stretcher of this unusual canvas, but the work was exhibited in 1920 as *Victim of Society* at the *First International Dada Fair* in Berlin. In an impressive commentary on this work in the exhibition catalogue, Wieland Herzfelde addresses the subject of the great question mark lying across the man's forehead: "The content of the question is dead. It has paled, hibernated, become the habitual incomprehension generated by a brain rendered heavy as a stone by the mute awareness of being an abortion." The analysis, the autopsy that Herzfelde practices on this stillbirth of industrial civilization closes with his assertion that "the possibility of evolution is nipped in the bud. All that remains is the habit of carefully buttoning one's jacket to one's neck, following the motto: 'Modest but honest.'"

The only large-format collage on canvas created

at this time, this work can be seen as a veritable manifesto of Dada experimentation. As partisans of anti-art, adverse to all reigning aesthetic ideas, the Dadaists discovered the technique of collage to be a "materialization with brush and scissors," to use Grosz's own terms; it was one of their favorite means of expression, one which became the instrument of their cultural putsch. "Propagandada" Grosz, as the self-proclaimed engineer of his works rather than their painter, questions here not the "sublime art of painting" but also all cultural and technocratic ideologies formulated by society. — MNAM

Raymond Hains
b. 1926

Raymond Hains was born September 11, 1926, in Saint-Brieuc, France, where his parents ran a painting business and a gallery. After graduating from high school, he briefly attended the Ecole des Beaux-Arts, Rennes, where he met Jacques de la Villeglé in 1945. Deeply inspired by a book on photography and by his own experience with the medium, he moved to Paris just after World War II, where he was hired to work in the photography laboratory of the magazine *France-Illustration*. In 1947, in his Paris apartment, he made his first photograms and solarizations, photographs of assemblages of objects deformed or multiplied by mirrors. He continued to experiment, using tesselated glass lenses to deform the letters of the alphabet. By 1949, he had made an abstract short film in black and white, in which many frames were devoted to shots of torn poster advertisements in the street.

During that same year, with Villeglé, he began his activity as *décollagiste*; they appropriated public posters torn by passersby in the street and presented them as works of art. In 1957, Colette Allendy held an exhibition of these works titled *Loi du 29 juillet 1881 ou la lyrisme à la sauvette* (Law of July 29, 1881, or the lyricism of the hasty retreat) at her gallery in Paris. In 1959, the first Paris *Biennale* devoted a room to the *décollagistes* (François Dufrêne, Hains, and Villeglé); Hains exhibited a *palissade* work seven meters long, made using the industrial metal sheets often found under posters, which created a scandal.

Meanwhile, Hains had been pursuing his cinematographic activity with Villeglé. The films *Pénélope* and *Loi du 29 juillet 1881* were shown in 1954, at a gathering hosted by Marie Raymond, the mother of Yves Klein.

In 1960, Hains participated in the founding of the Nouveau Réalisme group, even though his work was far outside the scope of this movement, as well as that of *affichisme* (poster-art). Through a system of analogical appropriations, Hains's art set up a disjointing of the ideas of signifier/signified. His work of the 1960s is characterized by a study of ways to see an object, photographing and filming a poster, ungluing it, exhibiting it, exposing its support. Developing word plays and a system of equivalences between object, word, and image, Hains has continued to build his vocabulary within the confines of the image and language.

He has been included in numerous exhibitions and festivals, including the festival of Nouveau Réalisme in Nice in 1961 and the exhibition *Saffa et Seita* in Venice in 1964. Since 1975, Hains has been working with file-cards, multiplying notes and photographs, which he classifies in archival boxes. His more recent one-person exhibitions include a show at the P.S.1 Contemporary Art Center, New York, in 1989, and a show at the Musée national d'art moderne, Paris, in 1990.

Ach Alma Manetro, 1949 (cat. no. 294)

The first of the shredded placards torn off by four hands in 1949, *Ach Alma Manetro* was presented in 1957 at a Hains and Villeglé exhibition at Galerie Colette Allendy in Paris. The invitation to the show read, "Colette Allendy invites you to cross the fence of the law of July 29, 1881, exhibition or slapdash lyricism." The ambition of the two artists was to make their own "Bayeux tapestry." Made up of predominantly typographic concert announcements, Hains and Villeglé's work is in fact related, in its format, to that needlepoint panorama from the eleventh century. Its genesis, however, was the fruit of the random, aggressive work of anonymous hands.

This process of anonymous shredding gave rise to the notion of *décollage*, which was later defined by the chief proponent of Nouveau Réalisme, Pierre Restany, as follows: "*Décollage* is a gesture of direct, immediate appropriation which excludes *a priori* any wish to add or compose, and in this sense [it] is the opposite of collage. *Décollage* asserts the primacy of invention over creation, of found beauty over created beauty." Nevertheless, this collaborative work is also a winking homage to Georges Braque's and Pablo Picasso's *papiers collés*. Quite likely, the musical connotation of the torn placards and the suffix "ACH" allude to Braque's and Picasso's inclusions of Bach's name in their early collages of 1912 and 1913, as art historian Benjamin Buchloh has pointed out. Indeed, the *décollages* present a similar structure of simple, superimposed planes, suggesting a space without depth. From Ach to Bach, from Braque to

décollage, from performance halls to the subway, this frieze of urban folklore captures the explosion of visual language and realizes on the pictorial plane an evolution parallel to that occurring at the same time in the domains of literature (sound poetry) and music (concrete music). — N. F.

Hans Hartung
1904–1989

Hans Heinrich Hartung was born September 21, 1904, in Leipzig. From 1924 to 1925, he studied art history at the Akademie der Schönen Künste and philosophy at the University of Leipzig. He continued his studies at the academies of Dresden and Munich.

At the *International Ausstellung* of 1926 in Dresden, Hartung was introduced to the work of Edvard Munch, Vincent van Gogh, the French Impressionists, the Fauves, and the Cubists. Later that year he settled in Paris. His first solo exhibition was held at the Galerie Heinrich Kühl, Dresden, in 1931. Hartung fled Germany the following year for the Balearic Islands. After a brief visit to Berlin in 1935, the artist left Germany forever, moving back to Paris, where he met Alexander Calder, Joan Miró, and Piet Mondrian and began showing at the Salon des Surindépendants. He participated in an exhibition at the Galerie Pierre in 1936 with Jean Arp, Jean Hélion, Vasily Kandinsky, and others. The following year, he took part in an international show at the Jeu de Paume, where he was impressed by the sculpture of Julio González, whose daughter he later married.

After serving in the French Foreign Legion during World War II, the French government decorated Hartung and granted him citizenship in 1945. That same year, his work was included in group exhibitions at the Galerie Denise René and the Galerie Colette Allendy in Paris, and he participated in the Salon des Réalités Nouvelles. He met Mark Rothko and Pierre Soulages in 1947, the year of his first solo show in Paris at the Galerie Lydia Conti. The following year, his work was shown at the Venice *Biennale* and in a circulating exhibition of French art in Germany. Throughout the 1950s and 1960s, Hartung exhibited widely in Europe and the United States. He was awarded

the International Grand Prize for Painting at the 1960 Venice *Biennale*. Traveling Hartung retrospectives opened in Switzerland in 1963, in France in 1969, and in Germany in 1974. In 1975, his photographs were published in *An Unnoticed World Seen by Hans Hartung*, and he was honored with a solo show at the Metropolitan Museum of Art, New York. He settled in Antibes in 1972; in his later years, confined to a wheelchair and unable to hold a brush, he continued to paint huge works using spray guns. Hartung died December 7, 1989, in Antibes.

T. 1935-1, 1935 (cat. no. 265)

The title of this oil painting, *T. 1935-1*, derives from nomenclature the artist adopted in 1934 to name his works: T for *toile* (canvas); 1935, the year; and 1, the number in the order of realization of the works. Designated as *toile*, without any descriptive, poetic, or phonetic subtitle, the painting assumes an "unnameable" abstract slant. On the other hand, its numerical indexing immediately sets its place in the chronology of an oeuvre whose sole principle is the biographical identity of the artist. Thus is founded the concept of a plastic reality freed of representative reference, pointing only to the relationships between the paintings themselves.

T. 1935-1 comes at the end of a ten-year period during which Hartung confronted a Western vocabulary of acquired forms—he studied the great masters, absorbing the influence of the German Expressionists, encountering and rejecting Kandinsky's abstraction and the Bauhaus aesthetic, discovering and embracing Cubist and Fauvist painting. Rather than identifying with any avant-garde currents, he searched for a principle capable of guiding and legitimizing his nonformal compositions; he followed the mathematical principles of the Golden Number to a point at which he was able to leave them behind, having achieved an "instinctive," gestural execution. Coming at the end of this developmental period, *T. 1935-1* inaugurates Hartung's mature style. The compositional technique of painting isolated areas recalls Miró, who indeed influenced Hartung, but it also bears witness to his efforts to reduce his palette, which he had been carrying out since the dazzling watercolors of his youth. — A. B.

T-50 Painting 8 (T-50 peinture 8), 1950 (cat. no. 274)

T-50 Painting 8 illustrates a central theme in Hartung's work from the postwar period, namely the idea that every painted form is determined by the movement that created it. In this composition, the inspiration for his subject does not come from the outside world; he is inspired by the medium of painting itself or more precisely by the gestural quality of the brushwork.

The period following World War II provided fertile terrain for Hartung's ideas. He met other painters who were also interested in expressing the direct nature of creation. *T-50 Painting 8*

was made two years after the group exhibition *HWPSMTB* at the Galerie Colette Allendy, which marked the advent of the Lyrical Abstract style. Based on the application of patches of color for their own sake, regardless of subject or theme, this style would later be known as Tachisme. In this work, Hartung explored the vocabulary of the brush, juxtaposing broad bands of color in the background with entangled bundles of sharp lines that threaten to obscure them. His use of flat color heightens the confrontation between the curved and straight lines that animate his canvas. Emphasizing the spontaneous play of lines, it is obvious that the graphic character of Hartung's work is evocative of calligraphy. Alternately embracing and rejecting this affinity, the artist never allowed this one idea to determine his production. In this and other canvases, Hartung establishes a loose harmony in which each gesture is repeated and obscured by subsequent movements. Freed from stylistic conventions, Hartung sought to represent an innate expression of the processes of painting. — J. S. C.

Raoul Hausmann
1886–1971

Raoul Hausmann was born July 12, 1886, in Vienna, to Czechoslovakian parents. The son of an academic painter, he worked in his father's studio during his youth. When his family moved to Berlin in 1900, he began seriously studying painting and sculpture.

In 1916, he started working for the magazines *Die Aktion* and *Die Freie Strasse*, and between 1918 and 1919 he edited the latter publication. In 1917, when Richard Huelsenbeck brought Dada to Berlin, Hausmann immediately joined him and helped form the Club Dada in 1918. Faced with the brutal social and financial realities of life in Germany after World War I, Berlin Dada was aggressively political and antibourgeois. Inspired by a revolutionary view of the world and refusing to follow any aesthetic rules, the Berlin Dadaists created new forms of expression using collages of different materials, photomontage, and other sculpture-objects. Although they only stayed

together for two years, their two group shows in 1919 and 1920 caused much controversy: several Dadaists were prosecuted in 1921 for defamation of the German Army and pornography.

As one of the pioneers of photomontage, and as an author, artist, and performer of phonetic poetry, Hausmann was an essential figure for the Berlin Dada group. He continued to experiment with visual codes and spoken language throughout the 1920s and 1930s. He published two books during this period: *Material der Malerei, Plastik, Architektur* (1918) and *Hurra! Hurra! Hurra!* (1920). When the Nazi party came to power in 1933, he left Germany and was officially labeled a degenerate artist by them. He traveled widely throughout the rest of the decade. During World War II, he lived in the south of France and survived by giving German, Spanish, and English lessons.

After the war, Hausmann slowly returned to his various activities, including painting and writing and making pictograms, photomontages, photograms, and collages. After 1948, he regularly showed his work in France. Numerous museum exhibitions in Europe from 1959 onward confirmed a growing interest in the Dada movement. In 1967, the first retrospective of Hausmann's work was held at the Moderna Museet in Stockholm. Working up until his death, he died February 1, 1971, in Limoges.

The Spirit of Our Time (Mechanical Head) (Der Geist unserer Zeit [Mechanischer Kopf]), 1919 (cat. no. 160)

The assemblage *The Spirit of our Time (Mechanical Head)*, a fetish of the Dadaists, was in the possession of Hannah Höch, who was an artist and Hausmann's companion from the Berlin Dada period, for forty years before it joined the collection of the Musée national d'art moderne, Paris, in 1966. It has been described, perhaps by Hausmann himself, as a "fine head in wood, carefully polished . . . crowned by a foldable cup, and provided (among other things) with a fine wallet affixed to the rear, a stem of a tobacco pipe, and a small white box with the number 22." In spite of this work's absence from the famous *First International Dada Fair* in Berlin in 1920—it was not even mentioned in the exhibition catalogue— it was shown many times, according to Hausmann, in the exhibitions of the *Novembergruppe* in 1919 and 1920, where it must have provided a hilarious example of the artist's intentions. "The assemblage," he said, "is a creation that runs counter to any sense of pathos or bounds. The assemblage presents itself through its elements, which are opposed to one another; it is not a pseudo-logic of fine truth—it simply *is* and it exists. This is the content or meaning of Anti-Art." — MNAM

Jean Hélion

1904–1987

Jean Hélion was born April 21, 1904, in Couterne, France. He entered the Institut Industriel du Nord, Lille, to study chemistry in 1920 but left the following year to become an architectural apprentice in Paris. He painted while working as an architectural draftsman in the early 1920s. Hélion attracted the attention of the collector Georges Bine in 1925 and was soon able to devote himself entirely to painting. In 1927, he met Joaquín Torres-García, who collaborated on *L'Acte*, a short-lived magazine founded by Hélion and others.

Hélion first exhibited at the Salon des Indépendants in 1928. Shortly thereafter he became acquainted with Jean Arp, Piet Mondrian, and Antoine Pevsner. By 1929, his work was non-figurative. With Theo van Doesburg and others in 1930, he formed the artists' association Art Concret and the periodical of the same name. This group was succeeded by Abstraction-Création the following year. In 1931, after traveling through Europe and the Soviet Union, Hélion returned to Paris, where he met Marcel Duchamp, Max Ernst, and Tristan Tzara. His first solo show was held at the Galerie Pierre, Paris, in 1932. That same year, Hélion made his first visit to New York, where he was given a solo exhibition at the John Becker Gallery at the end of 1933. After returning to Europe from a second trip to the United States in 1934, he met Jacques Lipchitz, Joan Miró, and Ben Nicholson. In 1936, he settled in the United States, dividing his time between Virginia and New York. That year, solo shows of his work took place at the Galerie Cahiers d'art, Paris, and the Valentine Gallery, New York. The artist traveled to Paris in 1938 on the occasion of his solo exhibition at the Galerie Pierre, and he became a friend of Paul Eluard, Roberto Matta, and Yves Tanguy.

Shortly after joining the French army in 1940, he was taken prisoner and sent to a camp in Pomerania and then in Stettin. Hélion escaped in 1942 and that same year made his way to France and the United States. In 1943, he began to paint in a figurative style again. His book *They Shall Not Have Me* was published in 1943, a year in which he was given solo shows at the Arts Club of Chicago and Peggy Guggenheim's Art of This Century, New York. Hélion returned to Paris in 1946. Throughout the 1950s and 1960s, his work was shown in Europe and New York. During the 1970s, he exhibited primarily in France. Hélion died October 27, 1987, in Paris.

Equilibrium (*Equilibre*), 1933–34 (cat. no. 136)

Between 1932 and 1935, Hélion created a series of paintings exploring states of visual equilibrium, generally working with drawings and oil studies before reaching the formal solutions of his large canvases. His concern in the present work is to establish a balance between the blocky, simple, essentially rectangular mass on the right with the more complex, more colorful, and varied forms on the left. The construction on the left, which is composed of overlapping and interpenetrating curves, bars, and lines, is not continuous. Careful inspection reveals that the unit of four elements in the upper left corner (the red, gray, and black bars and the green shape) does not touch the forms immediately below it. A similarly strategic use of discontinuous forms occurs in other works in the *Equilibrium* series. In this painting, the subtly disconnected arrangement contributes to the sense of movement and dispersion of the left side of the composition. The multiple hues used at the left also generate visual complexity. The horizontal curves on the left all point to the central white void, which is embraced by the more rigidly horizontal dark blue and light green arms of the stable construction on the right. Vibrant red and orange bars unite the edges of the composition with central forms and bind together right and left halves. A state of visual balance is thus achieved without resorting to the purely rectilinear, often programmatic formulations of the De Stijl artists who had influenced Hélion. The *Equilibrium* series, embodying ideas of suspension and tension of two-dimensional forms, inspired Alexander Calder, who was contemporaneously developing his wind-driven mobiles. — E. C. C.

Eva Hesse

1936–1970

Eva Hesse was born January 11, 1936, in Hamburg. Her family fled the Nazis and arrived in New York in 1939. She became a United States citizen in 1945. When Hesse was ten years old, her mother committed suicide. Racked with anxiety throughout most of her life, Hesse nonetheless persevered in her single-minded pursuit of making art. She attended the High School of Industrial Arts, then Pratt Institute in Brooklyn in 1952, and Cooper Union from 1954 to 1957. After winning a scholarship to Yale-Norfolk Summer Art School in 1957, she was accepted by Yale University's School of Art and Architecture, where she studied painting with Josef Albers. In 1959, Hesse received her B.F.A. from Yale and returned to New York.

In 1961, Hesse was included in group exhibitions at the Brooklyn Museum, and at the John Heller Gallery, New York. That year, she married the sculptor Tom Doyle. She made her first sculpture in 1962, and had her first solo show, of drawings, the following year at the Allan Stone Gallery, New York. In 1964, she and Doyle spent over a year living in Kettwig-am-Ruhr, Germany, under the patronage of a German textile manufacturer and art collector. While in Europe, they traveled intermittently to Italy, France, and Switzerland. Hesse's first one-person show of sculpture was presented at the Kunstverein für die Rheinlande und Westfalen, Düsseldorf, in 1965.

She and Doyle returned to New York in 1965 and separated after several months. Hesse began to use latex to make sculpture in 1967, and then fiberglass the following year. She started to gain recognition by the late 1960s, with solo shows at the Fischbach Gallery, New York, and inclusion in many important group exhibitions. While Hesse's work shows affinities with the concerns of Minimalism, it cannot be easily characterized under any particular art movement. From 1968 to 1970, Hesse taught at the School of Visual Arts, New York. In 1969, she was diagnosed with a

brain tumor, and after three operations within a year, she died May 29, 1970.

Untitled (Seven Poles), 1970 (cat. no. 324)

The very last work of Hesse, *Untitled (Seven Poles)* is made up of seven elements suspended from the ceiling. It was executed for the most part by her assistants Bill Barrette and Jonathan Singer, under the direction of Doug Johns, a friend of Hesse's and her technical advisor since 1968. The conception of the work dates from 1969 and 1970. Barrette has fully documented the material realization of the sculpture, which took place between early March and mid-May of 1970. It was preceded by several drawings and a maquette (also in the possession of the Musée national d'art moderne, Paris), in which the seven elements, all turned inward and connected to one another, are fixed on a square base. In early March, execution began in Hesse's studio. Skeletons of metal wire were wrapped with sheaths of polyethylene, then thinner wire, and covered with small pieces of fiberglass imbued with resin until a kind of translucent skin began to form. It soon became clear that with a base, the sculpture would become untransportable; Hesse decided to keep each element freestanding, and the poles would no longer all face inward. When the artist was hospitalized, her assistants completed the work and installed it in an exhibition at the Owens-Corning Fiberglas Center, New York, which opened on May 14. A photograph of the installation was submitted to Hesse, who approved it before her death.

This work, which some see as a response to the 1952 Jackson Pollock painting *Blue Poles*, might have—according to Barrette, who cited Ruth Vollmer, an artist and friend of Hesse's who had visited Mexico with her in 1968— its origin in a group of Olmec figurines Hesse had seen at the National Museum of Anthropology, Mexico City. She had already invoked ancient sculpture in works such as *Ishtar* (1965) and *Laocoön* (1966). With individualized yet repetitive L-shaped poles, this work incorporates the force of gravity in the way it hangs from the ceiling and rests directly on the floor; it shows Hesse at the forefront of some of the most prevalent art issues of the late 1960s, even though she was gravely ill. In both its forms and textures, *Untitled (Seven Poles)* shows a very marked organic quality, and in this sense it prefigures certain works of more contemporary artists such as Kiki Smith and Jana Sterbak. —J.S.

Hans Hofmann
1880–1966

Hans Hofmann was born March 21, 1880, in Weissenburg, Bavaria. He was raised in Munich, where in 1898 he began to study at various art schools. The patronage of Philip Freudenberg, a Berlin art collector, enabled Hofmann to live in Paris from 1904 to 1914. In Paris, he attended the Académie de la Grande Chaumière; he met Georges Braque, Pablo Picasso, and other Cubists and was a friend of Robert Delaunay, who stimulated his interest in color. In 1909, Hofmann exhibited with the Secession in Berlin, and in 1910 was given his first solo exhibition at Paul Cassirer's gallery there. During this period he painted in a Cubist style.

At the outbreak of World War I, Hofmann was in Munich; he remained there and in 1915 opened an art school, which became highly successful. The artist taught at the University of California at Berkeley during the summer of 1930. He returned to teach in California in 1931, and his first exhibition in the United States took place that summer at the California Palace of the Legion of Honor, San Francisco. In 1932, he closed his Munich school and decided to settle in the United States. His first school in New York opened in 1933 and was succeeded in 1934 by the Hans Hofmann School of Fine Arts; in 1935, he established a summer school in Provincetown, Massachusetts.

After an extended period devoted to drawing, Hofmann returned to painting in 1935, combining Cubist structure, vivid color, and emphatic gesture. He became a United States citizen in 1941. The artist's completely abstract works date from the 1940s. His first solo exhibition in New York took place at Peggy Guggenheim's gallery, Art of This Century, in 1944. Hofmann was an important influence upon younger artists. In 1958, he closed his schools to devote himself full time to painting. Hofmann died February 17, 1966, in New York.

The Gate, 1959–60 (cat. no. 275)

Hofmann synthesized other movements into his own glowing combination of Expressionism and De Stijl. Made in 1959 and 1960, *The Gate* belongs to a series of works loosely devoted to architectonic volumes. Hofmann used contrasting

rectangles of primary and secondary colors to reinforce the shape of his essentially unvarying easel-painting format. Although *The Gate* is without an obvious representational subject, Hofmann insisted that, even in abstraction, students should always work from some form of nature. With determination, a viewer can see that the complex spatial relationship established by the floating planes of color begins to resemble a gate, as indicated in the title.

Alain Jacquet
b. 1939

Alain Jacquet was born February 22, 1939, in Neuilly-sur-Seine. He studied at the Paris Ecole des Beaux-Arts, and in 1960–61, he met the Nouveaux Réalistes. His first paintings created in 1960 resemble abstract figures, but in reality they delineate the compartments of a parlor game, *le jacquet* (backgammon). His first solo exhibition took place in Paris, at the Breteau gallery in 1961.

His art evolved with a recurrent parodic spirit; in 1963, he appropriated emblematic images from art history in a series entitled *Camouflages*—which involved the parasitic use of images borrowed from popular culture and ancient and contemporary art history—an unusual prefiguration of various "simulationisms" or "appropriations" which would proliferate in the 1980s. The same year, he showed his works in London for the first time, at the Robert Frazer gallery. In 1964, Alain Jacquet took his first trip to New York, where he settled, met representatives of American Pop art, and exhibited his works for the first time at the Iolas Gallery. This year was rich in events, including the the founding of Mechanical Art (Mec Art), or photomechanic painting. Using a palette reduced to six colors, he cut out, borrowed, transformed, wove, and reproduced by silkscreen his motifs on various supports. Mec Art was consecrated by the exhibition *Hommage à Nicephore Niepce* at Gallery J, Paris, in 1965, which included Gianni Bertini, Pol Bury, Jacquet, and Mimmo Rotella.

During the course of the year 1965, Jacquet traveled throughout Europe and visited Guyana and Brazil. Pursuing his interest in photographic

reproduction techniques and the effects of their limited color palettes, he favored the use of the screen and the dot, which he worked with for six years on the most varied supports. In 1965, he participated in various exhibitions in Paris at the Gallery J, the Lawrence Rubin gallery, and the Rémi Audouin gallery, as well as abroad at the Museo de Arte Moderna and the Relevo gallery in Rio de Janiero and the Bruno Bischofberger gallery, Zurich. In 1968, his works were exhibited at the Museum of Contemporary Art, Chicago, and the Yvon Lambert gallery, Paris. In 1969, he received his first commission within the context of "research into art and industry" for the Renault industries. The Foksal gallery, Warsaw, devoted an exhibition to him in 1970. During the 1970s, Jacquet worked with silkscreened images made from photographs of the earth taken from outer space.

The artist settled in 1978 on the island of Saint Martin, and the same year an exhibition devoted to him was presented at the Musée d'art moderne de la Ville de Paris as well as at the Musée d'art et d'histoire, Geneva. In 1980, the artist moved to New York and lived between Saint Martin and New York until 1989, the date he returned to Paris and worked in a studio lent to him by the Musée national d'art moderne, Paris. During the 1980s, he returned to the traditional technique of oil painting. Since 1989, Jacquet has lived between New York and Paris.

In 1990, Jacquet's work was presented in the French Pavilion of the São Paulo *Bienal*. These works were then exhibited in the Centre de la Vieille Charité, Marseilles. In Paris, the Musée national d'art moderne devoted an exhibition to his recent works in 1993.

Luncheon on the Grass (*Le Déjeuner sur l'herbe*), 1964 (cat. no. 309)

Luncheon on the Grass marked the end of an epoch. It is a thoroughgoing reinterpretation of Edouard Manet's 1863 painting of the same title; it is a logical follow-up to the original, which itself was certainly provocative and had been plagiarized from an engraving that the Renaissance artist Marcantonio Raimondi made after a painting by Raphael. In Jacquet's work, the characters were reenacted by walk-ons (including art historian Pierre Restany), and the photographic image was silkscreened onto canvas so that the screen pattern is quite visible. Otto Hahn, a loyal defender of Jacquet's work, has said about this work and others related to it: "Depending on the choice of screen, the image differs: and here we touch upon the relativity of the gaze, of comprehension. . . . Perhaps we are never really able to see reality, except through the frozen filter of culture, and perhaps there are only infinite ways of reinterpreting culture, and no single interpretation is more true than any other."

For several years afterward, Jacquet continued to create variations of this and other silkscreens, creating ironic metaphors for the concept of style.

After *Luncheon on the Grass*, Jacquet put numerous additional icons of painting to the test, including, among others, the famous *Portrait of Gabrielle d'Estrées with One of Her Sisters* in the Musée du Louvre, which became Jacquet's *Gaby d'Estrées* (1965, Musée national d'art moderne). The diminutive name well captures the transformations imposed on the sixteenth-century painting by transposing it into the 1960s. The essential remains: the allegory, the erotic ambiguity, the provocative gazes looking out at the viewer, which make the subjects—whether in a palace or in a low-income high-rise, in the woods or by the pool—still touch our innermost recesses. Through this method of transferred photographs, Jacquet joined the ranks of Mec Art. This was an art of *mechanical reproduction*, an art of the industrial age, in which—as elucidated by the philosopher and cultural theoretician Walter Benjamin—craftsmanship no longer plays a part, thus precluding the aura of originality and uniqueness. — D.S.

Jasper Johns

b. 1930

Jasper Johns, Jr., was born May 15, 1930, in Augusta, Georgia, and was raised in South Carolina. In the fall of 1947, he enrolled at the University of South Carolina, Columbia, to study art but left in December 1948 to attend the Parsons School of Design, New York, from January to June 1949. Drafted into the United States Army, Johns served from May 1951 to late 1952 in South Carolina, where he operated the Fort Jackson Gallery, exhibiting artworks made by fellow soldiers. After a period of service in Japan, Johns returned to New York where he met Robert Rauschenberg in late 1953.

Johns and Rauschenberg worked closely until 1961 and are regarded as an important bridge between Abstract Expressionism and Pop and Minimal art. Johns was also significantly influenced by his friendships with John Cage and Merce Cunningham (for whom he designed sets and costumes and acted as artistic advisor from 1967 to 1980) and by his admiration for Marcel Duchamp. In late 1954, Johns began to work with encaustic, painting such two-dimensional objects as flags, targets, maps, numerals, and letters, treating these familiar motifs without recourse to illusionism, and emphasizing the painting's physical presence as an object. In some paintings, he incorporated actual three-dimensional objects such as a ball, a book, or a stretcher.

Johns's first solo exhibition was held at the Leo Castelli Gallery, New York, in January 1958, the success of which firmly established his career. He began to work with Sculp-metal in 1958 and to make cast-bronze sculptures in 1960 as well as to explore printmaking. His first retrospective was held in 1964 at the Jewish Museum, New York. He continued to develop important motifs in his work, including the map of the United States and the flagstone and crosshatch patterns, which allowed him to explore concepts of literalness, repetition, order, and patterning. In 1972, Johns established a home and studio on the island of Saint Martin. A retrospective organized by the Whitney Museum of American Art traveled, after its New York exhibition, to Europe, Japan, and San Francisco during 1977 and 1978.

In the 1980s, Johns began to explore illusion through the use of trompe l'oeil and the inclusion of "trick" images adopted from perceptual psychology. Recent paintings have addressed the seasons and his own career and have included imagistic references to paintings by Paul Cézanne, Matthias Grünewald, and Hans Holbein. A retrospective organized by the Museum of Modern Art, New York, in 1996–97, traveled to Germany and Japan. Johns lives and works in New York, Saint Martin, and Connecticut.

Figure 5, 1960 (cat. no. 296)

Figure 5 is the only Johns painting to date in a public French art collection, which gives some indication of how much the French art scene has misunderstood his major body of work. Johns is, in fact, the artist in whom the relationship between Abstract Expressionism and later Pop art and Conceptual art finds its fundamental dimension. For this simple reason, and for many others, he is the indispensable stepping-stone to any serious consideration of the status of contemporary painting and its very conditions of existence and validity.

Without ever renouncing a rich virtuosity and savoir-faire, Johns by the early 1950s was laying the foundations for a possible coexistence of the original work and its reproduction, as text and image.

In this respect, *Figure 5* is not ambiguous but rather highly programmatic and reflexive, like those subjects—ranging from targets and cards to alphabets and stripes—which make up the vocabulary that enabled Johns in those years to question the relationship between painting and language, the equivalence of painting *as* language.

Figure 5 inevitably makes one think, on first viewing, of the use of this same number by Charles Demuth in his painting *I Saw the Figure 5 in Gold* (1928). But the resemblance is only superficial; indeed the decimal system appears repeatedly in Johns's work. *Figure 5* thus is first of all the inscription, in typographical form, of an Arabic numeral on the whole surface of a painting. A numerical character, it is above all a conventional sign. Neither calculus nor arithmetic, neither sum nor cryptography, neither insignia nor monogram, but rather, as the title says, a figure. A figure that one can say avails itself of all meanings and significations that one might wish to grant it—a representation through language, a veritable trope.

One will also grant this number, like the others in the same series, not a definite meaning but perhaps a deliberately indefinite one; *Figure 5* concludes nothing, enumerates nothing, but rather deliberately opens up to an infinity of meanings that include a questioning of painting and its subject, painting as sign and sign as painting. In this way, *Figure 5* becomes above all an object of painting, a grisaille of black and white, painted in broad strokes that in spots allow the newspaper support, glued onto the canvas, to show through.

An admirable synthesis of different interrogations of painting from Cézanne to Cubism to Abstract Expressionism, Johns's work, which never ceases to question painting, has presented itself from the start as a critical and theoretical tool essential to an integration of American art in the larger context of modernity. Such is the authority and influence it continues to exert to this day. — B. B.

Asger Jorn

1914–1973

Asger Jorn was born March 3, 1914, as Asger Oluf Jørgensen, in Vejrum, Denmark. In fall 1936, he visited Paris, where he studied at Fernand Léger's Académie Contemporaine. During the war, Jorn

remained in Denmark, painting canvases that reflect the influence of James Ensor, Vasily Kandinsky, Paul Klee, and Joan Miró and contributing to the magazine *Helhesten*.

Jorn traveled to Swedish Lapland in the summer of 1946, met George Constant in Paris that fall, and spent six months in Djerba in 1947–48. His first solo exhibition in Paris took place in 1948 at the Galerie Breteau. At about the same time, the CoBrA (an acronym for Copenhagen, Brussels, and Amsterdam) movement was founded by Karel Appel, Constant, Corneille, Christian Dotremont, Jorn, and Joseph Noiret. The group's unifying doctrine was the complete freedom of expression, with an emphasis on color and brushwork. Jorn edited monographs of the Bibliothèque CoBrA before disassociating himself from the movement.

In 1951, Jorn returned, poor and ill, to Silkeborg, his hometown in Denmark. He began his intensive work in ceramics in 1953. The following year, he settled in Albisola, Italy, and participated in a continuation of CoBrA called Mouvement International pour un Bauhaus Imaginiste. Jorn's activities included painting, collage, book illustration, prints, drawings, ceramics, tapestries, commissions for murals, and, in his last years, sculpture. He participated in the Situationist International movement from 1957 to 1961 and worked on a study of early Scandinavian art between 1961 and 1965. After the mid-1950s, Jorn divided his time between Paris and Albisola. His first solo show in New York took place in 1962 at the Lefebre Gallery. From 1966, Jorn concentrated on oil painting and traveled frequently, visiting Cuba, England, Scotland, the United States, and the Orient. Jorn died May 1, 1973, in Aarhus, Denmark.

Lord of the Mountain Trolls (*Dovre gubben*), 1959 (cat. no. 262)

In May 1959, the Rive Gauche Gallery, Paris, exhibited the first group of Jorn's *Modifications*, which included *Lord of the Mountain Trolls*. These works were made from a series of landscape paintings purchased at the flea market; they were displayed more as symbols of manipulation and destruction than as a simple form of collage. With this exhibition, Jorn wanted to show that "painting's favorite food is painting." He wanted to erect a monument to bad painting, which he preferred to good painting, since he believed it stimulated inspiration. He sacrificed this painting, he said, "barbarously, in public and with ceremony," adding, "what I like is that I solemnly tipped my hat and allowed my victim's blood to flow, while Baudelaire's hymn to beauty intoned."

Before the visitation of what Jorn called a "colored cyclone," *Lord of the Mountain Trolls* must have shown a classical and somewhat drab depiction of a mountainous landscape crossed by a river that flows into a waterfall. Jorn left the waterfall intact but set fire to the right bank and poured incandescent flows of lava on the left bank; he out-

lined the rocks and slopes with black, to which he attached spots or trails of bright color. In the sky, he unleashed an ample, quasi-figural form, perhaps a genie born of the mountainous heights. "Jorn delighted," Michel Ragon has noted, "in metamorphoses; his characters are often landscapes, man is always linked to the earth-mother, covered with mud. . . . [he is] a timeless gestural painter, a spontaneous painter, an ambiguous painter (his characters are man, animal, plant and world-in-childbirth all at once)." — F. Th.

Green Ballet (*Il balletto verde*), 1960 (cat. no. 261)

A leading force in the anti-bourgeois and anti-idealist group CoBrA in 1948 and the revolutionary Situationist International movement in 1957, Jorn worked to develop a form of expression similar to that of Abstract Expressionism in the United States. To achieve this, he focused on the materiality of painting and the physical automatism of creation. *Green Ballet* illustrates Jorn's passion for color and texture, but despite the literary quality of its title it refuses a simple interpretation or reading. Divided diagonally, one section of the composition is dominated by green. These broad strokes of color are placed in direct opposition to the floating circular shapes described in blue, red, and black that inhabit the other area of the canvas. The result is a dynamic, asymmetrical, and textually aggressive composition. However, although the title does allude to movement and many shapes do evoke the pirouette motion associated with classical dance, green is not used to describe this sort of movement. On the contrary, Jorn ironically uses sweeping applications of green to paint over and obscure existing elements of the composition. Thus, the color green, despite its positive connotations in the title of this work, reveals itself to be essentially a destructive element in the composition and its dance is a macabre one.

Marked by a painterly aesthetic of heavily applied pigment and pure colour, *Green Ballet* is emblematic of Jorn's production of the 1960s. A revolutionary figure, he strived to surpass the simple satire of past artistic traditions and the dogmatic nonfigurative attitudes that were in vogue after the World War II. He advocated experimentation, spontaneity, and simple forms in painting but nevertheless saw his work as part of a larger historical perspective. Expressing the violence underlying the mid-twentieth century, his compositions have a direct and immediate effect. — J. S. C.

Donald Judd

1928–1994

Donald Judd was born June 3, 1928, in Excelsior Springs, Missouri. He registered at the Art Students League, New York, in 1948 but transferred a few months later to the College of William and Mary, Williamsburg. In 1949, he moved back to New York to study philosophy at Columbia University while he took art classes at the Art Students League.

The Panoramas Gallery organized his first solo exhibition in 1957. The same year, Judd took art history classes at Columbia University. He began to write articles for *Art News* in 1959 and the next year became a contributing editor for *Arts Magazine* until 1965, when he wrote reviews for *Art International*. In the early 1960s, he switched from painting to sculpture and started to develop an interest in architecture. Judd challenged the artistic convention of originality by using industrial processes and materials—such as steel, concrete, or plywood—to create large, hollow Minimalist sculptures, mostly in the form of boxes, which he arranged in repeated simple geometric forms.

His second solo show was held at the Green Gallery, New York, in 1963. From 1962 to 1964, he worked as an instructor at the Brooklyn Institute of Arts and Sciences. The Leo Castelli Gallery, New York, organized the first of a long series of individual exhibitions in 1966. This year, Judd was also hired as a visiting artist at Dartmouth College, Hanover, New Hampshire, and the following year he taught sculpture at Yale University, New Haven. The Whitney Museum of American Art, New York, organized the first retrospective of his work in 1968. During this decade, the artist received many fellowships, among them the John Simon Guggenheim Memorial grant in 1968.

In 1971, he participated in the *Guggenheim International Award Exhibition*, along with other Minimalist and Conceptual artists. Judd moved to Marfa, Texas, in 1972. He participated in his first Venice *Biennale* in 1980, and in the *Documenta*, Kassel, in 1982. In 1984, he started designing furniture for the purpose of manufacturing. During the first half of the 1980s, Judd drew the plans for the Chinati Foundation, Marfa; the renovated compound of buildings opened in 1986 as a showcase for his sculptures, as well as for the work of other contemporary artists.

In 1987, Judd was honored by a large exhibition at the Stedelijk Van Abbemuseum, Eindhoven; this show traveled to Düsseldorf, Paris, Barcelona, and Turin. The Whitney Museum of American Art organized a traveling retrospective of his work in 1988. In 1992, he was elected a member at the Royal Academy of Fine Arts, Stockholm, and received a prize from the Stankowski Foundation, Stuttgart, increasing the list of his numerous awards. During his lifetime, Judd published a large body of theoretical writings, in which he rigorously promoted the cause of Minimal art; these essays were consolidated in two volumes published in 1975 and 1987. The artist died February 12, 1994, in New York.

Untitled, 1965 (cat. no. 338)

Because he sought to give a new foundation to the elements of sculpture and the conception of its realization, Judd remains an emblematic figure of contemporary American sculpture. His analyses of Abstract Expressionism and Constructivism, in both his critical writings and his creative works, led him to detach himself from all pathos and subjectivity, and to elaborate a strict formulation of volumes in space. At his prompting, Minimalist sculpture developed along principles of its own. Constructed according to industrial givens and procedures of modern factory production, it was formed according to simple mathematical schemas, elementary progressions, and geometrical configurations.

Always three-dimensional, Judd's works are easily identifiable primary structures defined according to serial principles and simple visual codes. "Small size has a large importance," the artist claimed, insisting on the work of preparation and the notion of scale, which often led him to conceive his work in relation to the surrounding space. The minimum entity was established with the square, circle, and rectangle, unmodified by gesture or movement. Geometric in their essence, these forms find their place in the constructed or open space, on the ground or on the wall. They establish a specific relationship between painting and sculpture on the basis of the materials and colors of which they are made up.

Untitled is a parallelepiped partially covered in fluorescent orange Plexiglas and equipped with four wires and turnbuckles that allowed the artist to assert two opposing realities: fragility and solidity. Judd wanted the observer's understanding of the work and the materials of which it is made to be a structuring experience. Sensitive to phenomenological thought, the artist varied his series on the basis of systematic juxtapositions of plastics and metals. Opacity and transparency, as well as positive and negative spaces, are often presented in mutual contrast and resonance. They prompt a dialectical relationship between the space of the sculpture and that of its surroundings. —J.P.B.

Untitled, 1970 (cat. no. 340)

In his 1965 essay "Specific Objects," Judd referred to his art as "three-dimensional work," using the term to bypass the limitations imposed by the category of painting or sculpture. According to the artist, "specific objects" reject illusionistic space in favor of actual space. To that end, he eliminated bases, pedestals, and frames from his work, emphasizing the forms themselves and the importance of perception in experiencing the work.

In the mid-1960s, he began to order rectilinear units according to specific mathematical progressions rather than using equidistant spacing. *Untitled* uses the Fibonacci sequence—a mathematical progression in which every number is the sum of the two previous numbers: 1, 1, 2, 3, 5, etc.—as a system for sizing and spacing the forms. Expanding his mediums, beyond the industrial metals he used in early years, to include brass, copper, anodized aluminum, and other materials, Judd developed a rich vocabulary based on the geometric form. —G. M. K.

Vasily Kandinsky

1866–1944

Vasily Kandinsky was born December 4, 1866, in Moscow. In 1886–92, he studied law and economics at the University of Moscow, where he lectured after graduation. In 1896, he declined a teaching position in order to study art in Munich with Anton Ažbe from 1897 to 1899 and at the Akademie with Franz von Stuck in 1900. Kandinsky taught in 1901–03 at the art school of the Phalanx, a group he had cofounded in Munich. One of his students, Gabriele Münter, would be his companion until 1914. In 1902, Kandinsky exhibited for the first time with the Berlin Secession and produced his first woodcuts. In 1903 and 1904, he began his travels in Italy, the Netherlands, and North Africa and his visits to Russia. He showed at the Salon d'Automne in Paris from 1904.

In 1909, Kandinsky was elected president of the newly founded Neue Künstlervereinigung München (NKVM). The group's first show took place at the Moderne Galerie Thannhauser in Munich in 1909. In 1911, Kandinsky and Franz Marc began to make plans for *The Blue Rider Almanac (Almanach der Blaue Reiter)*. Kandinsky's *On the Spiritual in Art (Über das Geistige in der Kunst)* was published in December 1911. He and Marc withdrew from the NKVM in that month, and shortly thereafter the Blaue Reiter's first exhibition was held at the Moderne Galerie. In 1912, the second Blaue Reiter show was held at the Galerie Hans Goltz, Munich, and the *Almanach der Blaue Reiter* appeared. Kandinsky's first solo show was held at Der Sturm gallery in Berlin in 1912. In 1913, one of his works was included in the Armory Show in New York and the *Erste deutsche Herbstsalon* in Berlin. Kandinsky lived in Russia from 1914 to 1921, principally in Moscow, where he held a position at the People's Commissariat of Education.

Kandinsky began teaching at the Bauhaus in Weimar in 1922. In 1923, he was given his first solo show in New York by the Société Anonyme, of which he became vice-president. Lyonel Feininger, Alexej Jawlensky, Kandinsky, and Paul Klee made up the Blaue Vier (Blue Four) group, formed in 1924. He moved with the Bauhaus to Dessau in 1925 and became a German citizen in 1928. The Nazi government closed the Bauhaus in 1933 and later that year Kandinsky settled in Neuilly-sur-Seine near Paris; he acquired French citizenship in 1939. Fifty-seven of his works were confiscated by the Nazis in the 1937 purge of "degenerate art." Kandinsky died December 13, 1944, in Neuilly.

Study for *Landscape with Tower (Landschaft mit Turm)*, 1908 (cat. no. 110), and *Landscape with Tower (Landschaft mit Turm)*, 1908 (cat. no. 111)

The tower is that of a brewery just outside the village of Murnau. There is nothing picturesque about this architectural excrescence jutting up from the banal foliage—in fact, all the landscape studies that Kandinsky ceaselessly painted from the very beginning have the same lack of appeal in the choice of motif. He was not touched by the recognizable; by choosing an arbitrary view that was entirely personal to him, he was instead trying to translate his feelings, giving priority to the atmosphere of the place over its specific elements. Until his return to Paris in 1907, Kandinsky used a Divisionist stroke close to that of the Pointillists. In *Landscape with Tower*, not only did he broaden his brushstroke, playing with violently contrasting colors, but he started working in larger formats. Judging from the size and format of the study for *Landscape with Tower*, it appears that Kandinsky first made a preparatory oil sketch outside, then returned to the studio, where he had greater freedom of expression. There are only superficial differences between the composition of the study and the final work, yet the final colors differ significantly, showing the development of Kandinsky's spontaneous lyricism. Abandoning the last conventions of the landscape painter in favor of a cosmic lyricism, the author merges sky and earth; the clouds float as much in the sky as on the green of the trees, and a single density infuses both heaven and earth. It is principally this arbitrary levitation that distinguishes the painters of the Neue Künstlervereinigung München from the painters of the *Brücke* or the French Fauves. —Ch. D.

Blue Mountain (*Der blaue Berg*), 1908–09 (cat. no. 112)

From 1902 until 1913, the horse and rider motif figured prominently in Vasily Kandinsky's paintings. This motif symbolized his crusade against conventional aesthetic values and his dream of a better, more spiritual future through the transformative powers of art. *Blue Mountain* dates from 1908–9, a transitional time in Kandinsky's career, as his style became increasingly abstract and expressionistic. While identifiable forms can still be discerned in this picture, they have lost their impact as representational images, and read instead as modulated areas of brilliant color. The flattened forms emphasize the upward thrust of the composition, culminating above the mountain where three distinct areas appear ready to collide. —SRGM

Landscape with Factory Chimney (*Landschaft mit Fabrikschornstein*), 1910 (cat. no. 113)

Kandinsky's art was developing ever closer to complete abstraction as he painted works such as *Landscape with Factory Chimney* during his years in Munich. He had already been exploring an extreme simplification of forms inspired by folk art practices, such as glass painting from his native Russia, as well as woodcuts, which he experimented with as early as 1902. He fused this primitive style with the color effects of Fauve painters such as André Derain, Maurice de Vlaminck, and Henri Matisse, and began producing brilliant, large-scale oils.

Kandinsky's strategy of abstracting from the landscape can be seen in a fertile stage here: the rough shapes of the hills, the melding of those forms with the sky, the shrubbery which cannot quite be distinguished from the earth. Within two years, the inspiration of such forms as gleaned from nature would lead to the explosion of abstract color symphonies. Not only the style, but very specific motifs of those compositions from the early 1910s can already be discerned in *Landscape with Factory Chimney*: unstable towers, cities on hills, violent skies, all rendered in meticulously crafted color combinations. The rich, ruby red vertical of the chimney that cuts through the upper right of the picture frame would be reconfigured as a dramatic diagonal in later works.

As Kandinsky proceeded from this stage of his career, he would work to veil his apocalyptic motifs further, both to draw the viewer in and to symbolize the end of the bourgeois, materialistic world which he claimed would give way to a utopic, spiritually-guided universe. In his highly influential *On the Spiritual in Art*, Kandinsky expressed admiration for the seekers of "the inner spirit in outer things." — R. C.

Impression V (*Park*), 1911 (cat. no. 114)

The double title is a key to the comprehension of this canvas, which could be considered one of the first successful abstract paintings, were there not still minute references to conventional reality. Kandinsky was innovative when he gave his paintings antiseptic titles to describe his "emancipated" landscapes. To classify them more precisely, in fact, he made distinctions between *Impressions*, *Improvisations*, and *Compositions*, the last of which are large in format and the product of slowly pondered, pure conceptual speculation. Within each series, he adopted a chronological numbering system that succeeded in erasing any reference to the initial element upon which his creation was based. In *Impression V*, the fifth in a series of six, all from 1911, this element is indicated in parentheses, through an evasive allusion

to the English garden in Munich: the simple word "park" leads us to read the black marks floating above the spots of color as the silhouetted profiles of a man and a woman on horseback, and two figures seated on a bench. Kandinsky's intention was certainly not to present a riddle to the spectator through the title, but rather to define a painterly idiom that would express effusion: to communicate his feeling, his "impression," which he recreates through the fusion of compositional elements. In depriving the public not only of visual depiction, but also of the signpost represented by a descriptive title, Kandinsky left utter confusion for the viewer as he made larger and larger canvases covered with spots of brighter and brighter color. People cried hoax when this *Impression V* was exhibited in the Salon des Indépendants in Paris in 1911, and they mocked this "Radinsky. Sensation no. 629. Painting microbe (enlarged 1,000,000 times)." — Ch. D.

Study for *Improvisation 28* (second version), 1912 (cat. no. 116), and *Improvisation 28* (second version), 1912 (cat. no. 117)

The shift in the titles of Kandinsky's paintings from those recalling literary themes to those evoking musical creations—*Impressions*, *Improvisations*, and *Compositions*—marks the artist's increasing experimentation with abstracted forms in 1911. He described his *Improvisations* as "chiefly unconscious . . . expressions of events of an inner character." While Kandinsky advocated abstraction as the best mode of painting for expressing an artist's innermost resources and indicating the existence of an otherwise invisible, spiritual realm, he realized that it would be necessary to develop such a style slowly in order for the public to understand its message. In his *On the Spiritual in Art*, Kandinsky proposed a method of veiling and simplifying pictorial images so that the essential objects of a composition would be barely recognizable. Admitting that "today we are still firmly bound to the outward appearance of nature and must draw forms from it," he suggested that there existed a hidden pictorial construction that would "emerge unnoticed from the picture and [would thus be] less suited to the eye than the soul."

As in all of Kandinsky's other *Improvisations*, motifs emerge in the second version of *Improvisation 28* to reveal a unifying theme in the work from this period: the Apocalypse as described in the Revelation of Saint John the Divine. Slightly more explicit images of an embracing couple, shining sun, celebratory candles, boat, waves, serpent, and, perhaps, cannons emerge in the study for the painting. The painting itself initially appears to be defined entirely in abstract terms by dynamic lines and seemingly random patches of color. Both the canvas and the study are divided into two sections by transparent tubular forms that traverse the picture vertically. The right portion of the scene, containing the couple, sun, and candles, may represent a future of

hope and redemption after an apocalyptic deluge that is suggested on the left by the waves and cannons. — N. S.

With the Black Arc (*Mit dem schwarzen Bogen*), 1912 (cat. no. 115)

No doubt the most important work of the Musée national d'art moderne's Kandinsky bequest, *With the Black Arc* has become a well-known symbol of Kandinsky's painting through its incessant trips around the world since World War II. While this is justified both by his frequent use of a square and by the novelty of his abstract approach, this work did not enjoy such exceptional success during Kandinsky's lifetime: after its first exposure at the *Kandinsky* exhibition at the Sturm gallery in Berlin in 1912, the canvas remained in the possession of Gabriele Münter until 1926 (when it was deposited for a time at the König Albert Museum of Zwickau) and was passed over in silence by Kandinsky himself, who considered it dated. It did not reappear officially until the 1937 exhibition, *Origines et développements de l'art international indépendant*, at the Jeu de Paume in Paris.

Traditionally, *With the Black Arc* is linked to the series of works on the theme of the cataclysm, the dissonant confrontation of opposite forces; however, there is no reference that might indicate this link. Moreover, some have sought to explain the importance of the large black shape that is the source of the title and that marks the entire surface of the canvas; the evocation of the troika is too common in Kandinsky's lyricism for one not to see the black shape as plausibly referring to the yoke harnessing that folkloric team of horses, and the bluish white areas as allusions to silent snowy expanses (the word *douga*, or yoke, appeared in the Russian title inscribed by Kandinsky). But these are mere speculations. This composition presents an awkward angle bisected by a sign, indicating that the pictorial space does not completely adhere to the surface of the canvas upon which it is painted. There is no trace of space based on traditional perspective: the painting has no top or bottom other than the arbitrary ones given by Kandinsky who, true to habit, charges the top part of the painting more than the bottom, hence creating a sense of disequilibrium. Since at this date the painter associated with Robert Delaunay in Paris, critics in France did not fail to compare this strange composition to the results of Orphism and to classify superficially Kandinsky's art among the sequels of Cubism. Critics were completely baffled by the new possibilities of a painting whose only purpose was itself; and whose descriptive nomenclatures would not be found until twenty years later. — Ch. D.

Study for *In the Black Square* (*Im schwarzen Viereck*), 1923 (cat. no. 118), and *In the Black Square* (*Im schwarzem Viereck*), June 1923 (cat. no. 119)

Throughout his life, Kandinsky tirelessly reworked the troubling theme of the rider and his mount.

Treated in 1922 in *Watercolor No. 23* (Musée national d'art moderne, Paris), in a language that was still expressive and free, Kandinsky reduced the support of the signified to a few colored lines. This same theme is developed with virtuosity the following year in a quite different language, consisting of primary geometric shapes made with a compass or ruler, and with the application, in spots and by dabbing, of black pigment. The image obtained in this fashion is inscribed in an irregular quadrilateral, slightly inclined, with a vertical deviation that underscores the progression of the knight with his lance (alias Saint George). This same configuration, likewise inscribed in a black square, was painted on canvas and completed in June, while the watercolor, which is almost identical, appears to be dated July.

In the Black Square and its study epitomize Kandinsky's synthesis of Russian avant-garde art and his own lyrical abstraction: the white trapezoid recalls Malevich's Suprematist paintings, but the dynamic compositional elements still refer to the landscape, horse, and rider. The two variations were shown for the first time in 1923, the canvas at the first great Bauhaus exhibition, and the watercolor in Berlin, at the Nierendorf Gallery. — MNAM and SRGM

Violet-Orange, October 1935 (cat. no. 120)

As in many of Kandinsky's canvases, the composition of *Violet-Orange* is divided into independent floating elements and includes a miniature "picture within a picture." The black vertical rectangle in the upper center appears as a separate entity, containing its own constellation of moving parts: falling ladder, curving rainbow, sashes of color, and other forms. This structural strategy first became evident in a 1929 painting aptly titled *Picture within a Picture*.

Kandinsky employed this compositional device to enforce spatial relationships and the illusion of three-dimensionality within his canvases. It was his desire that the viewer feel compelled, by virtue of layered planes and seemingly recessive space, to mentally enter the paintings. "For many years," he claimed in his autobiographical reminiscences, "I have sought the possibility of letting the viewer 'stroll' within the picture, forcing him to become absorbed in the picture, forgetful of himself." — N. S.

Reciprocal Agreement (*Accord réciproque*), 1942 (cat. no. 121)

During the German occupation of France, there were very few painters who continued to practice what is known conventionally as abstraction. Kandinsky was one of them, and he persevered to show the fruits of his labor in the small rooms of the Jeanne Bucher Gallery, on the Boulevard du Montparnasse. These were but modest affairs that left little trace in the papers: the reporters rarely came and it was ill-advised to speak of this "degenerate art" which, paradoxically, found takers only among the occupiers of refined taste. Moreover, it

was difficult to get new supplies from the paint merchants, a situation one must understand in order to fully appreciate *Reciprocal Accord*, which is the largest of Kandinsky's last paintings.

The composition, as its title indicates, rests on a problem of precarious equilibrium. As usual, Kandinsky has charged the top of the painting with two large opposing shapes, leaving the center empty. A multitude of small elements—some geometric, others amorphous, others cellular, such as the apparent embryo that occupies the center of the composition—multiply the focal points. The color seems deliberately spent: a series of gradations of gray, pink and cream interfere with one another through transparencies. This is a painstaking and complicated art that would remain for a long time without a champion, but which recently has won new attention, not from critics or art historians, but from a few of the most important contemporary artists in the United States. — Ch. D.

Ellsworth Kelly

b. 1923

Ellsworth Kelly was born May 31, 1923, in Newburgh, New York. He studied at Pratt Institute, Brooklyn, from 1941 to 1943. After military service from 1943 to 1945, he attended the School of the Museum of Fine Arts, Boston, from 1946 to 1947. The following year, Kelly went to France and enrolled at the Ecole des Beaux-Arts in Paris under the G.I. Bill. In France, he continued to study Romanesque art and architecture and Byzantine art; here, he was introduced to Surrealism and Neo-Plasticism, which led him to experiment with automatic drawing and geometric abstraction.

Kelly abstracts the forms in his paintings from observations of the real world, such as shadows cast by trees or the spaces between architectural elements. In 1950, Kelly met Jean Arp and that same year began to make shaped-wood reliefs and collages in which elements were arranged according to the laws of chance. He soon began to make paintings in separate panels that can be recombined to produce alternate compositions, as well

as multipanel paintings in which each canvas is painted a single color. During the 1950s, he traveled throughout France, where he met Constantin Brancusi, Alexander Calder, Alberto Magnelli, Francis Picabia, and Georges Vantongerloo, among other artists. His first solo show took place at the Galerie Arnaud, Paris, in 1951.

Kelly returned to the United States in 1954, living first in a studio apartment on Broad Street, and then at Coenties Slip in lower Manhattan, where his neighbors would through the years include Robert Indiana, Agnes Martin, Fred Mitchell, James Rosenquist, Lenore Tawney, and Jack Youngerman. Kelly continued to develop and expand the vocabulary of painting, exploring issues of form and ground with his flatly painted canvases. His first solo show in New York was held at the Betty Parsons Gallery in 1956, and two years later he was included in the *Sixteen Americans* exhibition at the Museum of Modern Art, New York. In 1958, he also began to make freestanding sculptures. He moved out of Manhattan in 1970, set up a studio in Chatham, and a home in nearby Spencertown, New York.

Kelly's first retrospective was held at the Museum of Modern Art, New York, in 1973. The following year, Kelly began an ongoing series of totemic sculptures in steel and aluminum. He traveled throughout Spain, Italy, and France in 1977, when his work was included in *Documenta VI*. He has executed many public commissions, including a mural for UNESCO in Paris in 1969, sculpture for the city of Barcelona in 1978, and a memorial for the United States Holocaust Memorial Museum, Washington, D.C., in 1993. Kelly's extensive work has been recognized in numerous retrospective exhibitions, including a sculpture exhibition at the Whitney Museum of American Art, New York, in 1982; an exhibition of works on paper and a show of his print works that traveled extensively in the United States and Canada from 1987–88; and a career retrospective in 1996 organized by the Solomon R. Guggenheim Museum, New York, which traveled to the Museum of Contemporary Art, Los Angeles; the Tate Gallery, London; and the Haus der Kunst, Munich. Kelly lives and works in Spencertown.

Eleven Panels, Kite II, 1952 (cat. no. 331)

Kelly began to develop the principle of multipanel paintings in 1949, when he moved to Paris for a sojourn of several years, before returning to the United States in 1954. *Window, Museum of Modern Art, Paris* (1949) may be considered one of the founding works of this new beginning, which by 1951 became more systematic in nature, eschewing any allusion to representation. When he moved to Sanary, in the south of France, from November 1951 to May 1952, Kelly sought to eliminate all principles of composition other than those suggested to him by the form and color of the stretcher. He gradually rid himself of any remaining traces of the influence that Arp or Henri Matisse's paper cutouts might still have had on

him. He was working toward developing an anonymous painting, without personal signature, and conceived an abstractionism based entirely on the structure of the stretcher and the diversity of his color range.

His attention to architecture, however, which he repeatedly photographed, constituted an ongoing primary source and reference, as evidenced by the fragments and details recreated from memory in his drawings and collages from this time. To this concern for architectural structures and their relationship to space, he would add as well the principle of indeterminacy to harmonize the different panels of color, eliminating all trace of the artist's hand.

Eleven Panels, Kite II, painted in 1952, thus belongs to a very specific phase in the elaboration of a principle formulated three years earlier. The multiplication of variations, revolving around the repetition of identical formats combined in a variety of ways to reconstitute a flat, rectangular surface in direct relation with the wall, would lead Kelly to develop a principle of seriality based on what art historian Yve-Alain Bois has called a "principle of anti-composition."

It is clearly on this merit, and because he raised the question of abstraction to a new conceptual level, that Kelly has become essential to an understanding of the kind of Modernism that emerged quite a few years later. — B. B.

Paul Klee

1879–1940

Paul Klee was born December 18, 1879, in Munchenbuchsee, Switzerland, into a family of musicians. His childhood love of music was always to remain profoundly important in his life and work. From 1898 to 1901, Klee studied in Munich, first with Heinrich Knirr, then at the Akademie under Franz von Stuck. Upon completing his schooling, he traveled to Italy in the first in a series of trips abroad that nourished his visual sensibilities. He settled in Bern in 1902. A series of his satirical etchings was exhibited at the Munich Secession in 1906. That same year, Klee married and moved to Munich. Here he gained

exposure to Modern art. Klee's work was shown at the Kunstmuseum Bern in 1910 and at Heinrich Thannhauser's Moderne Galerie, Munich, in 1911.

Klee met Alexej Jawlensky, Vasily Kandinsky, August Macke, Franz Marc, and other avant-garde figures in 1911; he participated in important shows of advanced art, including the second Blaue Reiter exhibition in 1912, and the *Erste deutsche Herbstsalon* in 1913. In 1912, he visited Paris for the second time, where he saw the work of Georges Braque and Pablo Picasso and met Robert Delaunay. Klee helped found the Neue Münchner Secession in 1914. Color became central to his art only after a revelatory trip to North Africa in 1914.

In 1920, a major Klee retrospective was held at the Galerie Hans Goltz, Munich; his *Schöpferische Konfession* (*Creative Credo*) was published; he was also appointed to the faculty of the Bauhaus. Klee taught at the Bauhaus in Weimar from 1921 to 1926 and in Dessau from 1926 to 1931. During his tenure, he was in close contact with other Bauhaus masters such as Kandinsky and Lyonel Feininger. In 1924 the Blaue Vier, consisting of Feininger, Jawlensky, Kandinsky, and Klee, was founded. Among his notable exhibitions of this period were his first in the United States at the Société Anonyme, New York, in 1924; his first major show in Paris the following year at the Galerie Vavin-Raspail; and an exhibition at the Museum of Modern Art, New York, in 1930. Klee went to Düsseldorf to teach at the Akademie in 1931, shortly before the Nazis closed the Bauhaus. Forced by the Nazis to leave his position in Düsseldorf in 1933, Klee settled in Bern. Major Klee exhibitions took place in Bern and Basel in 1935 and in Zurich in 1940. Klee died on June 29, 1940, in Muralto-Locarno, Switzerland.

Analysis of Diverse Perversities (*Analyse Verschiedener Perversitaeten*), 1922 (cat. no. 123)

In 1922, Klee had been professor at the Weimar Bauhaus for a year. In his courses, as in his work, he was particularly interested in the dynamism of things and beings and the way it could be expressed in lines, directions, and concatenations. One finds, for example, in the watercolor *Analysis of Diverse Perversities* an example of his conception of the world, a "dynamism without beginning or end" where the microscopic and the macroscopic are part of one same machinery that, when seen by the creator—artist or god, as the case may be—looks, in the final analysis, rather comical. Here man is caught up in a universal mesh of gears, and the same forces drive the insect, the bird, and the individual. Nature is viewed humorously as a system of wheels and pulleys: "human animal, clock of blood," the artist wrote in his journal a few years before this work. The bearded man is perhaps the "analyst of diverse perversities," whether he is setting in motion the gearwork of pulleys and lines, or merely recording it. Is he analyzing the headless man lying down below? Is he setting in motion the digestive system of the bird in the cage? Does the letter *P* over his brow

stand for Professor? Is this, in short, a psychoanalytic "treatment"? In any case, the arrow over the head of the P-man no doubt signifies that the painter's interpretation of the work is something for which he has not given us the key.

Klee must have been particularly attached to this piece, since he designated it in his catalogue as "S.C.L." (*Sonderklasse*, "exceptional class"), indicating that it could not be sold without his prior consent. — F. C.-N.

Dance You Monster to My Soft Song! (*Tanze Du Ungeheuer zu meinem sanften Lied!*), 1922 (cat. no. 122)

The title of this work reveals Klee's imagination and the essentially personal, often inexplicable humor of his art. The monster—whose large head, prominent nose, bearded chin, and pincenez bear a certain resemblance to caricatures of Richard Wagner—dominates the composition. His presence hovers over the small figure at a mechanical organ and the inscription that provides the title. Klee has eliminated all conventional spatial and temporal indications and created a world of musical fantasy.

In this work, Klee, a technical innovator, employed his special oil transfer drawing technique. In effect, this technique may be likened to carbon copies, in which lines on a top sheet of paper are transferred in ink or oil to a surface below by the pressure of a stylus or pen; the resulting lines have a feathered, smudged quality reminiscent of mass-produced printed materials. Devised during Klee's Bauhaus years, the oil transfer method was used for drawings and paintings that are among the artist's most idiosyncratically playful images.

Red Balloon (*Roter Ballon*), 1922 (cat. no. 124)

This ethereal scene, half-abstract, half-representational, was made just one year before Klee ventured into creating purely abstract compositions of colored rectangles. He was enjoying great success as a teacher at the Bauhaus during one of the most fertile periods in his career. With delicate pastel hues and a sensation of forms floating in space, Klee makes only the slightest references to doorways, walls, windows and rooftops in a scene that is simultaneously fantastic and intelligible. United overall by a consistently soft, dark line that was transferred from a preparatory drawing to the surface of this canvas, and by warm touches of red distributed throughout the composition, this painting shows Klee in the midst of experimentation with his technical and compositional practices. Poised above this charming cityscape, a red balloon is detached from the rest of the composition, extending the overall visual sensation of drifting lightness and freedom of movement. — SRGM

KN the Smith (*KN der Schmied*), 1922 (cat. no. 125)

A gift from Klee to Kandinsky while they were teaching together at the Bauhaus, this canvas hung in a place of honor in Kandinsky's living room at Dessau, bearing witness to the painter's appreciation. The title, interpreted metaphorically (one becomes a blacksmith by forging), is also indicative of the artists' friendship. The capital letters *KN* in black, on the upper left, prominent against the empty background, could very well be a dedication to Kandinsky and his wife, Nina. In any case, the figure is a dream being, a forger of tales with a velvety eye who, although he does not really work iron with a hammer, imagines, invents all sort of forms, like a painter: he rises up like an apparition in a halo of light, surrounded by the hearth-fire of a red-violet ground. The color, which is in places as transparent as watercolor, is absorbed by the thick burlap cloth. The coarse weave accentuates certain brushstrokes and, like the fine hatching in other areas, recalls the work of an engraver.

In 1922, the arrow became a very important element for Klee, as he notes in a lesson devoted to the "analysis of symbols of moving forms": "The arrow embodies the process of displacement and expresses unfolding in space." Symbolizing here the movements of the forge and the repetitive hammering of the blacksmith, the arrows affirm a pictorial function, punctuating the modulations; their red-vermilion color creates equilibrium in the chiaroscuro of the background. — C. S.

Rhythmical (*Rhythmisches*), 1930 (cat. no. 126)

Parallel to his work with line and drawing at the Bauhaus, Klee pursued the exploration of form using exclusively painterly means. There are two other very similar works painted on cardboard, dating from the same year, titled *Squares in a Ternary Rhythm* (*Dreitakt in Geviert*) and *In Rhythm More Strict and More Free* (*Rhythmisches strenger und freir*); *Rhythmical* is the only one on canvas. These works occupy an important place halfway between Klee's Cubist-derived planar compositions and his "magic squares." Using the checkerboard as his starting point, Klee here created a variation on the theme of the square in black and white: all other shapes and colors are eliminated. Vibrating against an ocher background, the white, gray, and black forms are arranged according to a rigorous three-beat rhythm that is only modified after the fourth "line." Klee translates the dynamic tension between the tonal values of the three (non-) colors. The effects of the palette knife, held horizontally, further enhance the lively irregularity of the shapes of the squares themselves. Klee here helps lay the foundations for a new kind of plasticity and optical mobility in painting. — C. S.

New Harmony (*Neue Harmonie*), 1936 (cat. no. 127)

New Harmony is one of only twenty-five works Klee executed in 1936, when he was very ill. From the

series of paintings called *Magic Squares* (*Magische Quadrate*) it contains the two-dimensional colored rectangles that first appeared in his art in 1923. Essentially, it looks back to Klee's color theory of the 1920s, and even the title belongs with those works he designated *Architecture, Harmony, and Sound* (*Architektur, Harmonie und Klang*). While related to *Ancient Sound* (*Alter Klang*, 1925), *New Harmony* has brighter colors over dark under-painting, which are firmly anchored into a more rigorous grid pattern. According to art historian Andrew Kagan, the composition is based on the principle of inverted bilateral symmetry (the right side of the canvas is an upside-down reflection of the left), and the tonal distribution of juxtaposed, noncomplementary colors evokes the non-thematic, monodic twelve-tone music of Arnold Schoenberg. Kagan notes, in conjunction with this reading, that Klee used twelve hues in *New Harmony*, save for the neutral gray and the black underpainting. — SRGM

Boy with Toys (*Knabe mit Spielsachen*), 1940
(cat. no. 128)

Boy with Toys is one of the last paintings of Klee's lifetime, completed only shortly before his death, after a five-year long decline caused by a deadly inflammatory tissue disease. In the two years following the outburst of scleroderma in 1935, Klee's productivity dropped radically. But the realization that he hadn't much time to live resulted in an explosive creativity and the formulation of yet another style in 1937, which he feverishly explored until his death in 1940. After years of investigations in the sphere of color, Klee returned to the line and to his "fundamentally graphic talent." In *Boy with Toys*, bold, thick lines relieve the color of the structural function it had since Klee had mastered it in 1914 and he finally, as he himself put it, became a painter. In *Boy with Toys*, crude bars of black paint determine the formal composition and the distribution of the color on the canvas. Contrary to the mystical fantasy world of thin and agitated drawn lines, which inhabits his paintings until 1937, and which seem to have an independent life from the underlying color composition, the lines in *Boy with Toys* are painted rather than drawn. Klee presents the viewer with a fundamentally different conception of the line as a dominant painterly means. So rigorous is its separation of the color fields that it hardly ever allows the same color in adjoining fields but requires a modulation, a change of hue. The color fields are painted unevenly, in short, thick brushstrokes, with the color applied in thin transparent layers, which renders the process even more visible.

The rough, seemingly primitive composition recalls the simple and direct rendering of a subject in children's art. In *Boy with Toys*, children's painting is recalled by not only the style of the painting but the subject itself, which refers directly to the stage of life with which Klee's art is so often associated. The toys of the title point toward one of the key concepts of Klee's artistic vision: the idea of

play, so genuine to the childish realm. It is in the concept of play as a free, self-containing act, which has no other purpose outside itself, that Klee relates the artistic act to the actions of a child. Klee's childlike "primitivism," however, is not only a simple and naive recreation of a child's vision of the world, but an aesthetic decision, an act of conscious abstraction and reduction with only one motif: an elementary creation. In face of impending death, Klee seems to have felt an increasing urge to recall once again this ambivalent but fundamental element of his art. But the play enacted in *Boy with Toys* has lost its genuine ease and lightness: the boy's "dance" with his toys seems like a last desperate attempt to revive the game.
—C. R. S.

Hardship by Drought (*Not durch Dürre*), 1940
(cat. no. 129)

Klee's universe has turned totally upside down: haunted by death, this work, as its title indicates, bears witness to the artist's suffering a few months before he died. Directly confronted with illness, Klee depicted himself as a figure lying down, disjointed, disheveled, captive. The purplish red and ocher tones are transparent, as if emptied of their substance; they vibrate only through the thick black outlines and the ocher-white ground worked with a palette-knife. The little man is extremely schematic: his face is no more than a mask. It seems as if two "open" heads, on the point of leaving the frame—or the world of the living—are pulling him from each end, one by the head, the other by the feet, like two guardian angels. Klee felt close to the poet Rainer Maria Rilke (whom he met in Zurich) for whom, in the *Duinese Elegies* (*Duineser Elegien*, 1923), the angels are neither of this world nor the next, but are part of a "great unity." Between the *Angels* (*Engles*) and the *Doorkeepers*, according to the classification of the last canvases by art historian Will Grohmann, *Hardship by Drought* announces Klee's last journey: "In *Hardship* [he] leaves this world and pursues his construction in another world that has the right to be, to be fully." For Klee, death makes it possible to communicate with the invisible, to go back to the source and participate finally in the great All. —C. S.

Yves Klein
1928–1962

Yves Klein was born April 28, 1928, in Nice. From 1944 to 1946, he studied at the Ecole nationale de la marine marchande and the Ecole nationale des langues orientales and began practicing judo. At this time he became friends with Arman Fernandez and Claude Pascal and started to paint. Klein composed his first *Symphonie monoton* in 1947. During the years 1948 to 1952, he traveled to Italy, Great Britain, Spain, and Japan. In 1955, Klein settled permanently in Paris, where he was given a solo exhibition at the Club des solitaires. His monochrome paintings were shown at the Galerie Colette Allendy, Paris, in 1956.

The artist entered his blue period in 1957; this year a double exhibition of his work was held at the Galerie Iris Clert and the Galerie Colette Allendy, both in Paris. In 1958, he began using nude models as "living paintbrushes." Also in that year, he undertook a project for the decoration of the entrance hall of the new opera house in Gelsenkirchen, Germany. The first manifesto of the group Nouveaux Réalistes was written in 1960 by Pierre Restany and signed by Arman, Klein, Daniel Spoerri, Jean Tinguely, and others. In 1961, Klein was given a retrospective at the Museum Haus Lange, Krefeld, and his first solo exhibition in the United States at the Leo Castelli Gallery, New York. He and architect Claude Parent collaborated that year on the design for fountains of water and fire, *Les Fontaines de Varsovie*, for the Palais de Chaillot, Paris. In 1962, Klein executed a plaster cast of Arman and took part in the exhibition *Antagonismes 2: L'Objet* at the Musée des arts décoratifs, Paris. Shortly before his death he appeared in the film *Mondo Cane* (1962). Klein died suddenly on June 6, 1962, in Paris.

Anthropometry of the Blue Period (ANT 82)
(*Anthropométrie de l'époque bleue [ANT 82]*), 1960
(cat. no. 299) and *Large Blue Anthropometry*
(*ANT 105*) (*La Grande Anthropométrie bleue*
[*ANT 105*]), ca. 1960 (cat. no. 301)

These paintings were made with the impressions
of bodies coated in pigment on paper that was
later mounted on canvas. By setting up a system
of pressing the body against the support in his
series of *Anthropometries*, Klein rejected any illu-
sion of a third dimension in the pictorial space. If
there is a "return to the figure" here, it is in a
space without representation, in the literal evi-
dence of the model's work "after nature," or "in
the flesh." The subject, object, and medium
become confused with one another to produce a
first-of-a-kind painting, the negative trace of pres-
ence: an index, in the semiological sense of the
term. In this respect, the contact technique of the
Anthropometries may be likened to that of Klein's
Cosmogonies or *Moulages* (*Castings*), created by
direct casts of vegetation or the body, or to the
photographs Klein made during the last two years
of his life, between 1960 and 1962. Color in its
chemical state, which all painters use, is an excel-
lent medium for making a print of an "event."

One of these events took the form of a provoca-
tive performance in 1960 at the Galerie interna-
tional d'art contemporain, Paris, when Klein made
Anthropometry paintings before an audience. By its
very overstatement, this performance constituted a
critical version of the great spectacles of Action
Painting. Through the transference of pigment
and the permeability of the support, pure color is
carried from the body to the paper and from the
canvas to the eye. And thus the cycle of visual sat-
uration produced by the monochromes is com-
plete. — A. B.

Monochrome IKB 3, 1960 (cat. no. 300)

"Blue has no dimension, it is outside dimension,
whereas other colors have dimension. They are
pre-psychological spaces. . . . All colors carry asso-
ciations with concrete ideas . . . while blue at most
reminds us of the sea and the sky, which in the
end are the most abstract things in tangible, visi-
ble nature." Klein's chemical elaboration of these
nuances inaugurate his "epoca blu." The variety of
supports, formats, and textures of the 194 IKB
(International Klein Blue) works realized by Klein
between 1955 and 1962 allow us to precisely situ-
ate this work within a series of fifteen IKB
monochromes of the same size, five of which bear
the signature, "Yves le Monochrome." With their
unusual dimensions ("barely taller than the aver-
age [height] of the viewers and less in width than
the span of the arms"), their thinness ("some of
the flattest paintings ever made"), and their rich-
ness of texture and tone, these paintings appeal to
the viewer's entire visual field. Klein here reverses
the process used in the yellow, violet, and green
monochromes; those were objectified rectilinear
objects jutting out from wall moldings, like boxes
of color. He replaced it with a strategy that invades

and captures the gaze in a tactile manner: the blue
of *Monochrome IKB 3* attains a degree of pigment
density that is compact and sensitive to the slight-
est breath, chromatically tending to purplish phos-
phorescences. According to Klein, it makes
concrete the "color of space itself," which alone
can rival "emptiness."

Citing philosopher Gaston Bachelard's state-
ment, "At first there is nothing, then there is deep
nothingness, then deep blue," Klein developed a
phenomenology of monochromes that proceeded
from the following three principles: pigment
intensity, retinal visual persistence as memory,
and emptiness as the condition of all color. At the
outermost point of this "monochrome adventure,"
he saw himself as the painter of an "elemental"
art, an art of Air and Fire: "Note: fire is blue and
not red or yellow." — A. B.

Franz Kline

1910–1962

Franz Josef Kline was born May 23, 1910, in
Wilkes-Barre, Pennsylvania. While enrolled at
Boston University, he took art classes at the
Boston Art Students League from 1931 to 1935.
In 1935, Kline went to London and attended
Heatherley's Art School from 1936 to 1938. He
settled permanently in New York in 1939. Kline
was fortunate to have the financial support and
friendship of two patrons, Dr. Theodore J. Edlich,
Jr., and I. David Orr, who commissioned numer-
ous portraits and bought many other works from
him. During the late 1930s and 1940s, Kline
painted cityscapes and landscapes of the coal-
mining district where he was raised as well as
commissioned murals and portraits. In this period
he received awards in several National Academy
of Design Annuals.

In 1943, Kline met Willem de Kooning at
Conrad Marca-Relli's studio and within the next
few years also met Jackson Pollock. Kline's inter-
est in Japanese art began at this time. His mature
abstract style, developed in the late 1940s, is char-
acterized by bold gestural strokes of fast-drying
black and white enamel. His first solo exhibition
was held at the Egan Gallery, New York, in 1950.
Soon after, he was recognized as a major figure in

the emerging Abstract Expressionist movement.
Although Kline was best-known for his black-and-
white paintings, he also worked extensively in
color, from the mid-1950s to the end of his life.

Kline spent a month in Europe in 1960 and
traveled mostly in Italy. In the decade before his
death, he was included in major international
exhibitions, including the 1956 and 1960 Venice
Biennales and the 1957 São Paulo *Bienal*, and he
won a number of important prizes. Kline died
May 13, 1962, in New York. The Gallery of
Modern Art, Washington, D.C., organized a
memorial exhibition of his work that same year.

Painting No. 7, 1952 (cat. no. 271)

By the end of the 1940s, Kline's work was already
yielding to a looser application of paint and a more
emphatic expressionistic technique, and in the
early 1950s, he was applying black and white com-
mercial paint with housepainter's brushes to large
canvases. He became known as an Action painter
because his work expressed movement and
energy, emphasizing dynamic line. The character-
istic black slashes of *Painting No. 7* suggest the
full body movement of the artist as he sponta-
neously applied the paint, incorporating chance
splatters and smearing. In fact, Kline's paintings
were constructed only to *look* as if they were
painted in a moment of inspiration—they usually
resulted from the transfer of a sketch to the
canvas.

Unlike de Kooning and Pollock, Kline never
flirted with figuration in his abstract paintings,
and he avoided spatial ambiguity. *Painting No. 7*
is among the artist's most straightforward state-
ments; it also demonstrates his knowledge of art
history. Kline's emphasis on the square in this
and other works suggests his interest in Josef
Albers and Kazimir Malevich. Art historian Harry
Gaugh cites Piet Mondrian's 1930 *Composition
No. 1* (also known as *Composition 1A*) as an influ-
ence, and also contends that the compositional
structure of *Painting No. 7* recalls James McNeill
Whistler's *Arrangement in Black and Gray: The
Artist's Mother* (1871). Though the similarity
between the latter two paintings might appear
incidental, Kline referred to Whistler in other
paintings, and the austere geometry of Whistler's
canvas would have appealed to him. — J. B.

Jannis Kounellis
b. 1936

Jannis Kounellis was born in 1936 in Piraeus, Greece. In 1956, Kounellis moved to Rome and enrolled in the Accademia di Belle Arti. While still a student, he had his first solo show, titled *L'alfabeto di Kounellis*, at the Galleria la Tartaruga, Rome. The artist exhibited black and white canvases that demonstrated little painterliness; on their surfaces the artist stenciled letters and numbers.

Influenced by Alberto Burri as well as Lucio Fontana, whose work offered an alternative to the expressionism of Art Informel, Kounellis was looking to push painting into new territory. He was inspired, too, by the work of Jackson Pollock and Franz Kline, and by the earlier abstractions of Kazimir Malevich and Piet Mondrian. Kounellis's painting would gradually become sculptural; by 1963 the artist was using found elements in his paintings. Kounellis began to use live animals in his art during the late 1960s: one of his best-known works included eleven horses installed in the gallery. Kounellis not only questioned the traditionally pristine, sterile environment of the gallery but also transformed art into a breathing entity. His diverse materials from the late 1960s onward included fire, earth, and gold, sometimes alluding to his interest in alchemy. Burlap sacks were introduced, in an homage to Burri, though they were stripped of the painting frame and exhibited as objects in space. Additional materials have included bed frames, doorways, windows, and coatracks. People, too, began to enter his art, adding a performative dimension to his installations. In the 1970s and 1980s, Kounellis continued to build his vocabulary of materials, introducing smoke, shelving units, trolleys, blockaded openings, mounds of coffee grounds, and coal, as well as other indicators of commerce, transportation, and economics. These diverse fragments speak to general cultural history, while simultaneously they combine to form a rich and evocative history of meaning within Kounellis's oeuvre.

In 1967, Kounellis was included in an important group exhibition entitled *Arte povera e IM spazio* at the Galleria La Bertesca, Genoa. Curator Germano Celant coined the term Arte Povera to refer to the humble materials, sometimes described as detritus, which Kounellis and others were employing at the time to make their elemental, anti-elitist art. Kounellis had his first solo show in New York in 1972 at the Sonnabend Gallery. During the 1970s and 1980s, his work was shown extensively; among these presentations was a Kounellis exhibition that traveled in the early 1980s to several museums in Europe, including the Stedelijk Van Abbemuseum, Eindhoven; Obra Social, Caja de Pensiones, Madrid; the Whitechapel Art Gallery, London; and the Staatliche Kunsthalle, Baden-Baden. In 1985, the Musée d'art contemporain, Bordeaux, mounted an important exhibition of the artist's production. The following year, the Museum of Contemporary Art, Chicago, staged a retrospective exhibition of Kounellis's work; the show traveled to the Musée d'art contemporain, Montreal. In 1989, the artist was given an exhibition at the Espai Pobenou in Barcelona. In 1994, Kounellis installed a selection of over thirty years of his work in a boat called *Ionion* and docked this floating retrospective in his home port of Piraeus. The Museo Nacional Centro de Arte Reina Sofía held an exhibition of Kounellis's work in Madrid in 1997. The artist lives and works in Rome.

Untitled, 1969 (cat. no. 327)

Another piece included in the programmatic exhibition that Kounellis mounted in Naples in 1969, *Untitled* (referred to as *Coffee Scales*, for practical purposes) is an essential component of the whole range of Kounellis's works from this period. Each part of the whole would in fact reappear over the course of the different shows and events Kounellis put together, like so many elements of a complex rebus exalting sense and the senses.

Untitled appeals more to the sense of smell than to sight: it consists of little scale-plates suspended from one another, on which simple piles of ground coffee have been placed. Once again, Kounellis invokes a classical theme not by description or allegory, but by the physical presence of elements. More than a contemporary *vanitas*, this work presents itself as an ensemble of tools enabling us to experience the past and present foundations of myth in our present day.

Here the volatile emanation, the odor, is set against the tangible form of the object. It replaces the latter with its own intoxicating presence, perpetuating itself, as it is recreated in our minds, as the essence of a buried reality. — B. B.

Untitled, 1969 (cat. no. 328)

Like most of the central figures of the Arte Povera movement, Kounellis generally refuses to give his works titles. This piece, commonly called *The Braid*, was included in the now famous exhibition held in 1969 at Lucio Amelio's gallery,

Modern Art Agency, in Naples; another work bore the inscription *Libertà o Morte W Marat e W Robespierre* (*Liberty or Death Long Live Marat Long Live Robespierre*). For an artist who was extremely attentive to the social situation and the political events of the era, this libertarian position seems intended as a statement of purpose.

What indeed could be more unusual than to reject all conventional forms of artistic practice, and to attempt to reintroduce a reading of the present in the light of the past, prompting the use of preexisting elements of every sort? The metal sheet, like the tress of hair coming out of it, are images at once antithetical and inscribed in the history of our origins: the first refers to the painting as the symbolic form par excellence of our culture, while the other harks back to the myths and archaisms of our civilization, without, however, engaging in any sort of narrative.

All interpretation of this work will thus be linked to the history and specific knowledge that each viewer possesses. The metal sheet and braid of hair stand as the actualization of a myth, according to Celant. They neither depict nor avail themselves of artifices or accepted conventions; rather they point to the dialectics of contradictory elements, to the essential opposition between manufactured form and matter in its pure state. — B. B.

František Kupka
1871–1957

František Kupka was born September 22, 1871, in Opocno in eastern Bohemia. From 1889 to 1892, he studied at the Prague Academy. At this time, he painted historical and patriotic themes. In 1892, Kupka enrolled at the Akademie der Bildenden Künste, Vienna, where he concentrated on symbolic and allegorical subjects. He exhibited at the Kunstverein, Vienna, in 1894. His involvement with theosophy and Eastern philosophy dates from this period. By spring 1896, Kupka had settled in Paris; there he attended the Académie Julian briefly and then studied with Jean-Pierre Laurens at the Ecole des Beaux-Arts.

Kupka worked as an illustrator of books and posters and, during his early years in Paris, became known for his satirical drawings for newspapers and magazines. In 1906, he settled in Puteaux, a suburb of Paris, and that same year exhibited for the first time at the Salon d'Automne. Kupka was deeply impressed by the first Futurist manifesto, published in 1909 in *Le Figaro*. Kupka's work became increasingly abstract around 1910–11, reflecting his theories of motion, color, and the relationship between music and painting. In 1911, he attended meetings of the Puteaux group. In 1912, he exhibited at the Salon des Indépendants in the Cubist room, although he did not wish to be identified with any movement.

La Création dans les arts plastiques (*Creation in the Visual Arts*), a book Kupka completed in 1913, was published in Prague in 1923. In 1921, his first solo show in Paris was held at Galerie Povolozky. In 1931, he was a founding member of Abstraction-Création together with Jean Arp, Albert Gleizes, Jean Hélion, Auguste Herbin, Theo van Doesburg, and Georges Vantongerloo; in 1936, his work was included in the exhibition *Cubism and Abstract Art* at the Museum of Modern Art, New York, and in an important show with Alphonse Mucha at the Jeu de Paume, Paris. A retrospective of his work took place at the Galerie S. V. U. Mánes in Prague in 1946. The same year Kupka participated in the Salon des Réalités Nouvelles, Paris, where he continued to exhibit regularly until his death. During the early 1950s, he gained general recognition and had several solo shows in New York. Kupka died in Puteaux on June 24, 1957. Kupka retrospectives were held at the Musée national d'art moderne, Paris, in 1958 and the Solomon R. Guggenheim Museum, New York, in 1975.

Study for *Planes by Colors, Large Nude* (*Plans par couleurs, grand nu*), ca. 1906–08 (cat. no. 40), study for *Planes by Colors, Large Nude* (*Plans par couleurs, grand nu*), ca. 1909 (cat. no. 39), and *Planes by Colors, Large Nude* (*Plans par couleurs, grand nu*), 1909–10 (cat. no. 41)

Although his work reveals a familiarity with Pointillism, Symbolism, Fauvism, and Cubism, Kupka was not allied with any particular movement. He worked on the theme of the *Large Nude* over a period of many years, at least from 1904 to 1909–10. More than twenty studies in pencil, charcoal, and pastel are known today; two are included here. In comparison to the final interpretation seen here, the earliest versions are extremely academic. Through the years, it is possible to see the subject evolve from a reclining nude to a formal arrangement of color planes.

Among the phrases found consistently in Kupka's autobiographical notes are "a magnified pointillism" and "blunt planes," terms that describe this painting and the studies made in preparation for it. The phrase "planes by colors" first appeared in Kupka's writings in a manuscript of 1910–11, shortly after the final version of the

painting had been completed. In the artist's 1912–13 manuscript, one passage in particular provides an insight into what Kupka was striving to achieve in *Large Nude*: "The principle of construction, the scaffolding of a work, is in the large planes of color." Obviously, Kupka was trying to break away from the traditional practices of rendering illusionistic volume through shading and perspective. To Kupka, modeling and three-dimensional form belong to the sculptor's art. The painter, whose support is two-dimensional, determines his forms by color alone. — MNAM

Study for *Vertical Planes* (*Plans verticaux*), 1911–13 (cat. no. 43), study for *Vertical Planes III* (*Plans verticaux III*), 1912–13 (cat. no. 42), and *Vertical Planes [I]* (*Plans verticaux [I]*), 1912–13 (cat. no. 44)

In 1912, all of Kupka's motifs of spiritualist inspiration—the standing man stretching toward the heavens, the Gothic church, the rain, moonlight—disappeared. Just as in *Amorpha, Fugue in Two Colors* (*Amorpha, fugue à deux coleurs*), Kupka reached a pinnacle in his research on rotational movement; he attained a pure verticality, established as meaningful form in itself. The vertical planes, completely detached from any reference to nature or traditional pictorial order, are now suspended in an indeterminate spatial field. The two preparatory studies presented here provide a glimpse of the artist's experimentation with different configurations of vertical shapes and volumes, as well as the varied effects of horizontal, diagonal, or vertical hatching.

In 1912, Kupka wrote, "Rectilinear order would appear to be the most energetic, the most abstract, the most elegant and absolute . . . The vertical line is like a man standing when top and bottom are suspended and, since they stretch toward each other, they become united, identical, one. . . Deep and silent, a vertical plane engenders the concept of space." — MNAM

Study for *Around a Point* (*Autour d'un point*), 1918–20 (cat. no. 47), study for *Around a Point* (*Autour d'un point*), 1919–20 (cat. no. 48), study for *Around a Point* (*Autour d'un point*), 1919–20 (cat. no. 50), study for *Around a Point* (*Autour d'un point*), ca. 1920–25 (cat. no. 49), and *Around a Point* (*Autour d'un point*), ca. 1925–1930/1934 (cat. no. 51)

Drawing inspiration from the motif of a lotus flower and its reflection in water, the theme of "around a point" goes back to the years 1911–12, as indicated by the range of dates (1911–30) noted by Kupka himself at the bottom of the work. At this date, he had already written of "a point that acts like a nucleus. [A] concentration of rays." Of the many related studies on paper from 1918 and into the 1920s, four of which are included here, some are directly inspired by flowers, others are more abstract, showing similarities to the artist's *Newton's Discs* series of 1911–12 as well as his *Animated Lines* series from the 1920s. All show the same turning, both centrifugal and centripetal,

of interlaced circles and ellipses vibrating with luminous color.

The formal arrangement of the painting, carefully worked out with colored contrasts and harmonies, represented for Kupka the movement of universal gravitation and the circular, energetic pulsion of organic life.

According to documents of the time, Kupka completed a definitive version of *Around a Point* in about 1927, then in 1934 suppressed some colored motifs in the lower parts to lighten the composition. — MNAM and SRGM

Tale of Pistils and Stamens No. II (*Conte de pistils et d'étamines nº II*), 1919–20 (cat. no. 46)

From 1919 to 1920, Kupka created four variations on this theme. The date 1923 inscribed on the canvas can be considered false, since the painting was presented at the Salon d'Automne in 1919; Kupka may have reworked (and dated) it afterward.

His fascination with natural phenomena and especially with growth and fertilization, representing a "vital impulse," can be traced far into his past. Already in 1912 he noted, "In broad daylight, all the plants grow flowers toward the heavens. The stamens, with their joyous phallic shapes, fecundate the gracious pistils. It's a real feast of pollen in the sun-drenched gynoecium, surrounded by petals that open up to protect the event of conception."

Some canvases in the series in fact show teeming small male and female nudes, in explicit reference to procreation. Here the rich colors, the swirling shapes radiating around a vital center, foaming in successive waves, produce baroque effects by their very excess, yet they perfectly evoke the process of plant growth pushed to its culmination. — MNAM

The Colored One (*La Colorée*), ca. 1919–1920 (cat. no. 45)

In *The Colored One*, Kupka depicts a nude woman lying down, her legs extended to encircle the golden disc of the sun above. During this period, Kupka was preoccupied with the natural processes of germination and reproduction; here he celebrates female sexuality and even likens a woman's body to a flower opening in the sun. The radiant, translucent color heightens the picture's symbolism, while its figurative imagery is rare in Kupka's work after World War I. *The Colored One* reflects Kupka's interest in both macrocosmic process and microcosmic germination and bears comparison, in formal and thematic terms, with his contemporaneous painting series titled *Tale of Pistils and Stamens.* — SRGM

Wifredo Lam

1902–1982

Wifredo Oscar de la Concepción Lam y Castilla was born December 8, 1902 in Sagua la Grande, Cuba. In 1916, his family moved to Havana, where he attended the Escuela de Bellas Artes. During the early 1920s, he exhibited at the Salon de la Asociación de Pintores y Escultores in Havana. In 1923, Lam moved to Madrid, where he studied at the studio of Fernando Alvarez de Sotomayor, the Director of the Museo del Prado (and a teacher of Salvador Dalí). In 1929, Lam married Eva Piriz, who died of tuberculosis two years later, as did their young son. This tragic event may have contributed to the dark and brooding appearance of much of Lam's later work.

In the early 1930s, the effects of Surrealism were evident in Lam's work, as was the influence of Henri Matisse and possibly Joaquín Torres-García. In 1936, a traveling exhibition of the work of Pablo Picasso shown in Barcelona, Bilbao, and Madrid proved inspirational to Lam both artistically and politically. He moved to Paris in 1938, where Picasso took him under his wing and encouraged his interest in African art and primitive masks. During that year, he also traveled to Mexico, where he stayed with Frida Kahlo and Diego Rivera. Lam's own multicultural heritage (as the son of a Chinese father and a mother of Congolese and European descent) and his involvement with Santería, a religion rooted in African culture, would soon become integral to his work. By the late 1930s, Lam was associated with the Surrealists. He had his first solo show at the Galerie Pierre Loeb in Paris in 1939, and his work was exhibited with Picasso's at the Perls Galleries, New York.

During World War II, Lam spent most of his time in the Caribbean, along with André Breton and André Masson, whose poem *Fata Morgana* Lam illustrated in 1940. Lam eventually made his way to Havana in 1941. His first year in Cuba marked a watershed in his artistic development; he was introduced to the theories of Carl Jung, and by the end of 1942 he had begun his powerful painting *Jungle*. Lam's exploration of mythic images paralleled that of his contemporaries in

New York, the Abstract Expressionists, though Lam used specific subject matter. Lam created his own style by fusing Surrealism and Cubism with the spirit and forms of the Caribbean.

Between 1942 and 1950, the artist exhibited regularly at the Pierre Matisse Gallery in New York. His second marriage, to Helena Holzer in 1944, ended in divorce in 1950. In 1946, after a six-month stay in Haiti, Lam returned to France via New York. In 1948, he met Asger Jorn, who was a friend for many years. He traveled extensively until 1952, then settled for three years in Paris before resuming his travels again in 1955. In 1960, Lam established a studio in Albisola Mare, on the Italian coast. The winter of that year he married Swedish painter Lou Laurin, with whom he would have three sons. In 1964, he received the Guggenheim International Award, and two years later there were multiple retrospectives of Lam's work at the Kunsthalle Basel; the Kestner-Gesellschaft, Hannover; the Stedelijk Museum, Amsterdam; the Moderna Museet, Stockholm; and the Palais des Beaux-Arts, Brussels. In 1968, a retrospective exhibition was held at the Musée d'art moderne de la Ville de Paris. Lam died September 11, 1982 , in Paris.

Light in the Forest (*Lumière dans la forêt*), 1942 (cat. no. 227)

Soon after Lam returned to his native country, Cuba, in 1941, he developed an entirely new repertoire of forms and symbols. Some have called his work from this period an idyllic return to the sources of the West-Indian and Afro-Cuban folkloric universe; in fact, under the dictatorship of Gerardo Machado, Cuba had become a "paradise" of gambling, prostitution, and cigars, where corruption and misery reigned. Armed with his European experience, Lam reacted violently to the pillaging of a culture whose original power, buried under phony folklore, he sought to restore. For the struggles and hopes of an entire people, Lam succeeded in finding a form and an original iconography that would translate the mestizo world and soul into a resolutely modern language. In the works of the poets Nicolás Guillen and Aimé Césare, one finds parallels to Lam's assimilation of European forms to express a culture that was radically other—an approach that only the Surrealists respected at the time.

This painting may be considered one of many preparatory works for *The Jungle*, painted the same year, which Cuban writer Edmundo Desnoes has described as "a synthesis of the language of modern painting and the explosive reality of the colonized world." In these large preparatory gouaches on paper (which would later be mounted on canvas), tropical vegetation metamorphoses into masked figures, borrowing from human, vegetal and animal forms. The figures surge forth from a forest haunted with spirits invoked by Afro-Cuban cults. —C. D.

Mikhail Larionov

1881–1964

Mikhail Federovich Larionov was born May 22, 1881, at Tiraspol in Bessarabia, Russia. From 1898 to 1908, he studied at the Moscow School of Painting, Sculpture, and Architecture, where he met Natalia Goncharova; the two lived and worked together until her death in 1962. In 1906, he visited Paris with Sergei Diaghilev, who included Larionov's work in the exhibition of Russian artists at the Salon d'Automne of that year. In 1907 the artist abandoned the Impressionism of his previous work for a neoprimitive style inspired by Russian folk art. With the Burliuk brothers and others he formed the Blue Rose group, under whose auspices the review *The Golden Fleece* was published. The first *Golden Fleece* exhibition of 1908 in Moscow introduced many Modern French masters to the Russian public. Larionov also organized the avant-garde *Link* and *Donkey's Tail* exhibitions of 1908 and 1912, respectively, and founded the Jack of Diamonds group in 1910.

In 1911, he developed a personal abstract style that would later be known as Rayonism. An amalgam of Cubism and Italian Futurism, with an emphasis on dynamic, linear light rays, Rayonism received its public debut at the *Target* exhibition of 1913. That same year Larionov's *Rayonist Manifesto* was published in Moscow. The artist also participated in the *Erste deutsche Herbstsalon* at the Der Sturm gallery, Berlin, in 1913, and the following year organized the exhibition *No. 4* in Moscow. In May 1914, Larionov and Goncharova accompanied Diaghilev's Ballets Russes to Paris; there Larionov associated with Guillaume Apollinaire. Larionov returned to Russia in July upon the outbreak of World War I and served at the front until his demobilization for health reasons. He then

rejoined Diaghilev in Switzerland and devoted himself almost exclusively to designing sets and costumes for the Ballets Russes. After Diaghilev died in 1929, Larionov organized a retrospective of maquettes, costumes, and decor for his ballets at the Galerie Billiet in Paris in 1930, at which time he published *Les Ballets Russes de Diaghilev* with Goncharova and Pierre Vorms.

In 1938, Larionov became a French citizen. He and Goncharova were given a number of joint exhibitions throughout their careers, among them retrospectives in Paris at the Galerie des Deux-Iles in 1948, the Galerie de l'Institut in 1952, and the Musé national d'art moderne in 1963. A solo exhibition of Larionov's work was held in 1956 at the Galerie de l'Institut. Larionov died May 10, 1964, at Fontenay-aux-Roses, France.

Autumn (Osen'), 1912 (cat. no. 97)

This painting, unsigned and without date, acquired from the artist's second wife, Alexandra Larionov, may be considered an artistic manifesto of Larionov's primitivism and anti-aestheticism. It is from a series of four paintings of the seasons, which probably was presented in Moscow for the first time at the *Target* exhibition in April 1913. Although subsequently divided up (two are now in the State Tret'yakov Gallery in Moscow), the four panels have been brought together several times for exhibitions.

The revival of the folk arts was not limited to Russia, nor was it a new phenomenon. The artists Larionov would call "the Munich decadents" after 1912 (some of whom he himself had exhibited in the 1910 and 1912 *Jack of Diamonds* exhibitions, such as Vasily Kandinsky and the artists of the Neue Künstlervereinigung and the Blaue Reiter) attached tremendous importance to folk arts. The same was true, before Larionov, of the Russian association of artists called the Wanderers, who in their work exalted the virtues and character of the common people. Equally relevant is the work of Savva Mamontov and Princess Maria Tenisheva, who created colonies of artists and craftsmen after the fashion of William Morris. Perhaps in reaction to the rapid progress of technology, which was particularly spectacular in Russia at the start of the century, in 1908 certain avant-garde artists, taking their cue from Larionov, found their inspiration in national art: in *loubki* (popular broadsheets), icons, painted signs, children's drawings, and graffiti.

The surface of this painting is divided into four unequal sections, three of which contain episodes inspired by Siberian embroidery. Human figures, animals, and trees are reduced to schematic silhouettes drawn against a barely modulated, uniform blue background. Larionov's desire to negate space, which he considered an illusion, and to emphasize the flatness of the canvas also led him to include writing in the painting. On the lower right, a poem celebrates the raptures of the grape harvest. The easel painting is thus comparable to a popular broadsheet, accompanied by an explanatory legend, or to a page of illustrated text. In returning to early pictorial sources and in mixing artistic genres, Larionov's intention was to give new impetus to ossified academic art and at the same time to make art accessible to all. —MNAM

Glass (Steklo), 1912 (cat. no. 98)

Larionov was not only a painter but an organizer of exhibitions and the author of the *Rayonist Manifesto*. He considered *Glass* to have been his first Rayonist picture. The painting reveals an awareness of Futurism and Cubism: in it Larionov has depicted five tumblers, a goblet, and two bottles so that their essential forms are retained and lines represent rays reflected from the objects. As early as 1913, a reviewer of Larionov's and Goncharova's work observed that Larionov was not painting a still life but "simply 'glass' as a universal condition of glass with all its manifestations and properties—fragility, ease in breaking, sharpness, transparency, brittleness, ability to make sounds, i.e. the sum of all the sensations, obtainable from glass." —V. E. B.

Sunny Day (Journée Ensoleillée), 1913–14 (cat. no. 99)

This painting was a gift to the poet and champion of the avant-garde, Guillaume Apollinaire, who seems to have met Larionov and Goncharova in May 1914 in Paris on the occasion of the production of *The Golden Cockerel*, a ballet by Diaghilev for which Goncharova designed the set and costumes. Paul Guillaume showed a selection of works by these "Russian Futurists" in his Paris gallery in 1914, perhaps at the urging of his friend Apollinaire. As a gesture of thanks for the laudatory introduction Apollinaire wrote for the exhibition catalogue, and for the strings he pulled with the press, Larionov gave him this strange painting. The work fell into total oblivion after Apollinaire's premature death in 1918; it even lost its original title.

Art historian Anthony Parton has traced the history of the work, and we now know it was first illustrated and mentioned in a sarcastic article published in the Russian press in 1914 at the time of the *No. 4* exhibition, the last show organized by Larionov in Moscow before he left for Paris. The chaotic intersection of many-colored beams sweeps across the surface of the canvas, contributing to what Larionov called a "structural construction"; its intentionally amorphous appearance is underscored by strange reliefs of paper-pulp, a procedure seldom used by the artist. The painting remains impenetrable to any attempts at interpretation: all one can make out are a few musical notes and isolated letters such as the *KA* inscribed at the center of the canvas, probably a reference to the famous poem by Velimir Khlebnikov. —MNAM

Henri Laurens
1885–1954

Henri Laurens was born February 18, 1885, in Paris, where he attended drawing classes in 1899. The sculpture he produced during the early years of the twentieth century reflects the influence of Auguste Rodin. In 1911, Laurens entered into a lifelong friendship with Georges Braque, who introduced him to Cubism. He participated for the first time in the Salon des Indépendants in Paris in 1913, and two years later met Juan Gris, Amedeo Modigliani, and Pablo Picasso. From 1916, Laurens executed Cubist collages and constructions. He became a friend of Pierre Reverdy in 1915 and illustrated the writer's *Poèmes en prose* that same year.

The artist was given a solo show at Léonce Rosenberg's Galerie l'Effort Moderne, Paris, in 1917, and signed a contract there the following year. During the 1920s, he executed designs for various architectural projects and stage decors. From 1932 to 1933, he divided his time between Paris and nearby Etang-la-Ville, where his neighbors were Aristide Maillol and Ker-Xavier Roussel. Laurens contributed substantially to the *Internationale exhibition* in Paris in 1937. In 1938, he shared an exhibition with Braque and Picasso that traveled from Oslo to Stockholm and Copenhagen. His work was shown in 1945 at the Galerie Louis Carré, Paris, and in 1947 at the Buchholz Gallery, New York. About this time, Laurens made prints for book illustrations. He was represented at the Venice *Biennale* in 1948 and 1950. An exhibition of his work was organized by the Palais des Beaux-Arts, Brussels, in 1949, and a Laurens retrospective took place at the Musée national d'art moderne de la Ville de Paris in 1951. The following year he received a commission for a monumental sculpture for the University of Caracas. He exhibited extensively in Europe and the United States during the early 1950s and received the Prize of the IV Centenary of São Paulo at the São Paulo *Bienal* in 1953. Laurens died May 5, 1954, in Paris.

Bottle of Beaune (La Bouteille de Beaune), 1918 (cat. no. 72)

Rather than follow a chronology that is still uncertain, it seems preferable to approach the twenty-

five sculptures made by Laurens between 1915 and 1918 on the basis of their subject matter—heads, figures, bottles, and musical instruments—which also appeared in his constructions and *papiers collés* of this period. These constructions obviously owe a great deal to Picasso and Braque and the language they invented before 1914. Like the sculptures of Picasso, they are essentially frontal, created by an intersection of narrow planes in wood or metal. They share the usual Cubist motifs—transparent glasses and bottles, hollow guitars: all open, or rather emptied out, objects, forms analyzed and broken down. Art historian Margit Rowell has pointed out, however, that where Picasso often created "shallow space, arrived at through the tight interplay of pictorial planes . . . Laurens's priorities were sculptural"; with their inclined or concave planes, Laurens's constructions convey depth and define both solid and hollow volumes. "In a sculpture," the artist wrote, "the hollows must have as much importance as the solids." Laurens was also interested in creating the effects of shadow and light through polychromy, rather than limiting the tonal variations to the effects of incidental light, as in monochromatic sculpture. He wrote, "A statue that is not polychromaticized undergoes displacements of light and shadow and is endlessly changing: for me the point, in making a sculpture polychromatic, was to let it have its own light."

Laurens carefully chooses the most ordinary of materials, depending on the kind of space required: sheet metal for convex spaces, such a bottle or a thin plane of wood to suggest the slant of a pedestal table. He hardly ever puts any trust in chance; he does not *assemble* found objects, pieces of crude reality. Rather, he slices, cuts, and rounds off, to *construct* an object according to very specific goals. Laurens's art, like that of Juan Gris, whom he visited often during the period of these constructions, is a calculated, conscious art, a research into the intellect as well as the senses. — I. M. F.

Head (*Tête*), 1918–19 (cat. no. 73)

This monumental *Head*, chosen and acquired by Alberto Magnelli, is the culmination of a series, and it magnificently closes Laurens's cycle of Cubist works. In a letter to his dealer Léonce Rosenberg, dated December 15, 1916, the sculptor set up a program of very precise work for himself: "I am working on sculptures, a head and a still life, and I have succeeded in executing the head, which belongs to you, in wood, but I still have parts left to paint. The other piece I'm working on is in the developmental stage, and I would like to execute it in a different material, to give variety not only to the size, but also to the density of volume, and to use only geometrically determined shapes, which is to say, those that already have a life of their own and are consequently unlikely to change character under different lighting." The stone *Head* seems to finalize this process and to recapitulate all the elements.

"Different material": after having worked for several years with very light materials (paper, cardboard, sheet-metal, and cut wood), Laurens needed to return to the density of stone, which he had learned to cut at Parisian construction sites between 1899 and 1902. Delicately hollowed out to reveal a complex play of angles, the stone, however, presents an imposing, heavy mass on first glance. The mass outweighs the empty spaces, volume outweighs line. The polychromy, just as carefully calculated, introduces another geometric grid and allows one to avoid the uncertainty of changing lighting, or uncontrolled displacements of light and shadow, by giving the sculpture "its own light," a concern that remained constant in Laurens. Presenting at least four totally different and unexpected points of view to the spectator ("a space with four opposing points, which I believe gives a maximum field of vision," Laurens wrote to his dealer), this at once majestic and playful *Head* combines all the spatial and polychromatic implications of the constructions in a single, dense nucleus—a mass that is intersected, but no longer broken up, by Cubist angles. — I. M. F.

Fernand Léger
1881–1955

Jules Fernand Henri Léger was born February 4, 1881, in Argentan, France. After apprenticing with an architect in Caen from 1897 to 1899, Léger settled in Paris in 1900 and supported himself as an architectural draftsman. He was refused entrance to the Ecole des Beaux-Arts but nevertheless attended classes there; he also studied at the Académie Julian. Léger's earliest known works, which date from 1905, were primarily influenced by Impressionism. The experience of seeing the Paul Cézanne retrospective at the Salon d'Automne in 1907 and his contact with the early Cubism of Pablo Picasso and Georges Braque had an extremely significant impact on the development of his personal style. In 1910, he exhibited with Braque and Picasso at Daniel-Henri Kahnweiler's gallery, where he was given a solo show in 1912. From 1911 to 1914, Léger's work became increasingly abstract, and he started

to limit his color to the primaries and black and white.

Léger served in the military from 1914 to 1917. His "mechanical" period, in which figures and objects are characterized by tubular, machinelike forms, began in 1917. During the early 1920s, he collaborated with the writer Blaise Cendrars on films and designed sets and costumes for Rolf de Maré's *Ballet suédois*; in 1923–24 he made his first film without a plot, *Ballet mécanique*. Léger opened an atelier with Amédée Ozenfant in 1924 and in 1925 presented his first murals at Le Corbusier's Pavillon de l'esprit nouveau at the *Exposition internationale des arts décoratifs*. In 1931, he visited the United States for the first time. In 1935, the Museum of Modern Art, New York, and the Art Institute of Chicago presented exhibitions of his work. Léger lived in the United States from 1940 to 1945 but returned to France after the war. In the decade before his death, Léger's wide-ranging projects included book illustrations, monumental figure paintings and murals, stained-glass windows, mosaics, polychrome ceramic sculptures, and set and costume designs. In 1955, he won the Grand Prize at the São Paulo *Bienal*. Léger died August 17 of that year, at his home in Gif-sur-Yvette, France. The Musée National Fernand Léger was founded in 1957 in Biot.

The Wedding (*La Noce*), 1911 (cat. no. 55)

Undated by Léger, which is exceptional in his oeuvre, this canvas is closer to the preoccupations of the Puteaux group gathered around Jacques Villon than to the Analytic Cubism of Georges Braque and Pablo Picasso. Framed by rounded or slightly pointed shapes, the pictorial surface is barely colored, white and ocher, in a manner similar to paintings of this period by Robert Delaunay, Albert Gleizes, or Henri Le Fauconnier.

Suggesting a procession pressing around newlyweds crossing a village street, a throng of broken-up geometric surfaces squeeze around the image of the central couple, which is rendered in large planes. We already see the tubular shapes characteristic of Léger, the calculated effects of contrast and the few areas of bright color that would be developed more intensely in the following year. "Between 1909 and 1912, I fought the battle of color with Robert Delaunay," Léger wrote.

Here, at the height of the Cubist period, Léger asserted his independent spirit. While the contours outlined in black, the angular and deformed faces and the overlapping and monochrome geometrical surfaces confirm an openly Cubist approach, the anecdotal theme, the depth of the space, the dynamic movement of the piece as a whole, and the bright colors demonstrate Léger's obvious desire to keep a distance. — C. L.

The Smokers (*Les Fumeurs*), December 1911–January 1912 (cat. no. 54)

By the height of Analytic Cubism in 1912, Léger had developed his own vocabulary of precisely delineated forms; in comparison to Picasso's and

Braque's methods, Léger's fragmented units are larger, arcs predominate, and color prevails. The curving, overlapping planes of *The Smokers* describe the corporeal forms of the paintings' subject while articulating an allover, rhythmically patterned surface. The resulting oscillation between volumentric body and dynamic space owes as much to Futurist aesthetics as to Analytic Cubism.

The Smokers is closely related to *The Wedding* (1911, Musée national d'art moderne, Paris). Léger's choice of smoke as a subject can be seen within the wider context of an interest on the part of artists at that time in atmospheric phenomena and a wish to give substance to clouds, steam, rain, and snow. — SRGM

Nude in the Studio (*Nu dans l'atelier*), 1912 (cat. no. 52), and *Nude Model in the Studio* (*Le Modèle nu dans l'atelier*), 1912–13 (cat. no. 53)

In 1912 and 1913, Léger executed a series of drawings of standing, reclining, bending, and seated nudes. As seen here, he would sometimes abandon color to study shapes and volumes more systematically in preparation for paintings on this theme. These works mark a transition between the *Smokers* series of 1912 and the development of the famous *Contrasts of Form* series begun in 1913, and they manifest the principle of "contrast" that guides Léger's entire oeuvre. He wrote, "In seeking the state of plastic intensity, I apply the law of contrasts, which is eternal, as a means of equivalence in life. I organize the opposition of values, lines and contrasting colors." While Léger preserves a few references to reality, he applies these principles with a rigor that verges on abstraction: the black lines form a network of repeated cylindrical or conical shapes, while only pure color is used: blue, green, and red alternate with white. The Cubist canvases of Picasso and Braque regularly exhibited by Daniel-Henri Kahnweiler could not have left Léger indifferent, but his attempts at abstraction never led him to abandon totally either color or subject. — SRGM

Reading (*La Lecture*), 1924 (cat. no. 56)

Léger's production at the beginning of the 1920s is intense: realistic subjects and especially the human figure regain a privileged position, favored once again amid the "return to order" that permeated French culture after World War I. At the same time, Léger's predilection for geometric and rectilinear backgrounds may show a "purist" sensibility influenced by the principles of De Stijl, and, in particular, the paintings of Piet Mondrian. Léger repeated the motif of this composition, or of the reclining woman, in different techniques and sizes, specifying the status of each work on its reverse—first state, study, or definitive state, as in the case of this painting.

By this point, Léger had reduced the composition to only a few modules accentuated by black outlining. He has achieved a harmony of more muted colors, and a more "close-up" representation of the figures, due in part to his work in cin-

ema. In 1924, Léger's dealer, Léonce Rosenberg, wrote to Léger's wife, Jeanne: "I can expect a high price for *Reading* because it is an exceptional work in the whole production of Fernand Léger. By unanimous consent, it's your husband's finest painting." — C. L.

Woman Holding a Vase (definitive state) (*Femme tenant un vase* [état définitif]), 1927 (cat. no. 57)

Léger's streamlined forms date from World War I, when he served in the French army. As the call to political and aesthetic order resounded throughout postwar French society in a nationalistic attempt to restore its rationalist heritage, Léger introduced the monumental, classical figure into his art. The absolute calm and stasis of *Woman Holding a Vase* demonstrates his affinities with the neo-antique depictions of women by Picasso and Gino Severini. It also shows Léger's sympathies with the Purist ideals of Amédée Ozenfant and Le Corbusier, who called for a revival of classical aesthetic consonance as a symbol of renewed social harmony. Léger's palette of blue, yellow, red, and black was indebted to Mondrian's De Stijl paintings of the time, further evincing Léger's identification with utopian and reconstructivist postwar ideals. — N. S.

Composition with Two Parrots (*Composition aux deux perroquets*), 1935–39 (cat. no. 58)

By 1935, the theme of the acrobat occupied many of Léger's explorations. As early as 1933, a study in oil titled *Parrots* displayed the principle elements of this work. Numerous additional studies in oil, ink, gouache, and pencil were made in preparation for this final version, on which he worked for many years, contrary to his custom. The figures—which seem to come out of the canvas endowed with spectacular energy and power, but also with a surprising lightness in their arabesquelike movements—contrast with the formal opposition of undulating clouds and rectilinear solid posts. At the last moment, the parrots were added "to serve," as Jean Leymarie notes, "as chromatic flashes and plastic balances."

Considered by Léger to be one of his most successful works, *Composition with Two Parrots* was exhibited in France for only one day before it left for the United States, where it enjoyed immense success when exhibited at the Museum of Modern Art, New York. At Léger's request, it was returned to Paris in 1949 for his first retrospective, before the artist gave it to the Musée national d'art moderne. — C. L.

Adieu New York, 1946 (cat. no. 59)

This painting was made after Léger returned from his last sojourn to New York, from October 1940 to December 1945. Over ten years earlier, his first impression of New York had been of "the most colossal spectacle in the world. . . . The apotheosis of vertical architecture . . . an unprecedented elegance emanates from this geometrical abstraction.

New York has a natural beauty, like the natural elements, like trees, mountains or flowers. It is its strength and its variety. To want to make artistic use of such a subject is folly. One can modestly admire, and that is all." In contrast to such abounding enthusasm, when Pierre Descargues was to visit Léger's studio in rue Notre-Dame-des-Champs in April 1946, the artist pulled out several paintings, pointing to the present one, and said, "That's America, my last painting, *Adieu New York*, written on a streamer. The U.S., you know, is a country of countless dumping grounds. Instead of repairing things, they throw everything away. And so here, you see, there are pieces of scrap metal, machine cranks, even neckties. What I really loved there was making loud paintings of all that."

In spring 1943, on his way to Montreal for a show of his work, Léger had to make a stop at the border train station in Rouses Point, New York, on Lake Champlain. He was immediately struck by how much the valley, where the inhabitants still spoke French, resembled his native Normandy landscape. The following summer, he stayed for three months, and thereafter spent every summer there until he returned to France. It was in this rural environment that he found abandoned farms: harrows, plows, planting machines half buried in the ground, overgrown with aggressive weeds, and wagon wheels lying on the ground or leaning against walls. "That's a spectacle you don't see in Europe," said Léger.

Adieu New York, begun in the U.S. and completed in France, well reflects this Rouses Point spectacle and atmosphere, which permeates the entire *American Landscapes* series of 1943–44. "I painted [the] series of American landscapes by drawing inspiration from the contrast presented by an abandoned machine, become old junk metal, and the vegetation devouring it. Nature eats it up. You see it disappearing under the plants and flowers of the fields. The opposition between this mass of twisted metal and the daisies blooming on it creates a very vivid, endearing charm."

In this work, we also find a new painting method: the color is disassociated from the drawing, through a technique of "color outside" as opposed to that of "color inside." This phenomenon was born in America, the artist claims, and was inspired by the brilliant floodlights of Broadway. "I freed color from form by arranging it in large areas without forcing it to take the shape of the outlines of objects. It thereby keeps all its strength, as does the drawing." — C. L.

The Great Parade (definitive state) (*La Grande Parade* [état définitif]), 1954 (cat. no. 60)

Unlike many of his School of Paris colleagues, Léger eschewed using collaged fragments to represent everyday life, instead developing proletarian themes that he executed in ever larger formats. *The Great Parade* is the summation of his lifelong attempt to devise an imagery of the everyday within the realm of painting. It was preceded by

hundreds of preparatory studies in which Léger methodically resolved every detail of the complex composition. The stately procession of figures is couched in the rhetoric of monumental history painting with only the integrity of its subject matter saving it from the pomposity of a modern allegory.

This subject matter reveals Léger's political sympathies and intentions. An ardent believer in equality, and apparently in the equality of the sexes as well, Léger depicted men and women as indistinguishable equals on a wide swath of blue. The composition further relates to the concept of leisure and its indexation to class. The lower classes did not know leisure time until the late nineteenth century, when labor-saving industrialization and transportation advances made vacations possible. The circus is a place where all people are equal, united in their enjoyment of the spectacle. Its capacity to entertain became a metaphor for Léger's vision of art as a vehicle for the transformation of society. His hope was to create a painting with universally appealing values. Seemingly timeless, Léger's work was didactically intended to remind people of their fundamental right to self-fulfillment. — C. L.

Roy Lichtenstein

1923–1997

Roy Lichtenstein was born October 27, 1923, in New York City. In 1939, he studied under Reginald Marsh at the Art Students League in New York, and the following year under Hoyt L. Sherman at the School of Fine Arts at Ohio State University, Columbus. He served in the army from 1943 to 1946, after which he resumed his studies and was hired as an instructor. He obtained a Master of Fine Arts degree in 1949. In 1951, the Carlebach Gallery, New York, organized a solo exhibition of his semi-abstract paintings of the old West. Shortly thereafter, the artist moved to Cleveland, where he continued painting while working as an engineering draftsman to support his growing family.

From 1957 to 1960, Lichtenstein obtained a teaching position at the New York State College of Education, Oswego. By then, he had begun to include loosely drawn cartoon characters in his increasingly abstract canvases. From 1960 to

1963, he lived in New Jersey while teaching at Douglass College, a division of Rutgers University in New Brunswick, New Jersey. He met artists such as Jim Dine, Allan Kaprow, Claes Oldenburg, Lucas Samaras, George Segal, and Robert Whitman, who were all experimenting with different kinds of art based on everyday life. In 1961, he began to make paintings consisting exclusively of comic-strip figures, and introduced his Benday-dot grounds, lettering, and balloons; he also started cropping images from advertisements. From 1964 and into the next decade, he successively depicted stylized landscapes, consumer-product packaging, adaptations of paintings by famous artists, geometric elements from Art Deco design (the *Modern* series), parodies of the Abstract Expressionists' style (the *Brushstrokes* series), and explosions. They all underlined the contradictions of representing three dimensions on a flat surface.

In the early 1970s, he explored this formal question further with his abstract *Mirrors* and *Entablatures* series. Beginning in 1974 and up to the 1980s, he probed another long-standing issue: the concept of artistic style. All his series of works played with the characteristics of well-known twentieth-century art movements. Lichtenstein continued to question the role of style in consumer culture in his 1990s series of *Interiors*, which included images of his own works as decorative elements. In his attempt to fully grasp and expose how the forms, materials, and methods of production have shaped the images of Western society, the artist has also explored other mediums such as polychromatic ceramic, aluminum, brass, and serigraphs.

Since 1962, Lichtenstein's work has been represented by Leo Castelli Gallery, New York. He participated in the Venice *Biennale* in 1966, and was honored with solo exhibitions in 1967 and 1968 at the Pasadena Art Museum and the Solomon R. Guggenheim Museum, New York, respectively. The artist was the subject of a major retrospective at the Guggenheim in 1994, three years before his death September 30, 1997.

Grrrrrrrrrrr!!, 1965 (cat. no. 310)

Lichtenstein helped usher in the Pop art movement in the United States in the 1960s. Inspired by popular culture and mass media, he made artworks with a new focus on urban society, exploring the U.S. and its people in terms of familiar imagery from everyday life. With his large-scale paintings of comic-strip panels and his deadpan renditions of advertisements, Lichtenstein celebrates and critiques some of the more absurd aspects of American society and creates a composite portrait of consumer culture.

While the specific source of his 1965 painting *Grrrrrrrrrrr!!* has not been identified, Lichtenstein had begun to make paintings of cartoon characters, comic-strip panels, and generic advertising imagery in 1961. One of the very few animal images from this time period (there is also *Cat*, 1961, whose source was a bag of kitty litter), this

work depicts a dog, menacingly confronting the viewer, its large head centered in the picture plane. The work's title is painted across the bottom of the canvas in clunky block letters—a string of *r*s underlining the dog's stare.

Borrowing conventions associated with commercial printing processes—incisive black outlines, few and bold colors, and Benday dots— Lichtenstein fused art production with the appearance of mass-production. The grid of dots that comprises the background blue sky in this work mimics the thousands of dots used to create expanses of color by inexpensive printing methods. After experimenting with making these imitation Benday dots with a brush or with a handmade stencil, Lichtenstein switched in 1963 to a manufactured screen that allowed for more precise results.

Grrrrrrrrrrr!! ultimately takes as its subject the artificiality of artistic representation and brings into question the role of art in the twentieth century. By employing "low" art images in "high" art places, the wit and strength of Lichtenstein's work lie in its ability to subvert, by altering the familiar and thereby challenging us to redefine how we see the world. — T. B.

Jacques Lipchitz

1891–1973

Chaim Jacob Lipchitz was born August 22, 1891, in Druskieniki, Lithuania. At age eighteen he moved to Paris, where he attended the Ecole des Beaux-Arts and the Académie Julian and soon met Georges Braque, Juan Gris, and Pablo Picasso. In 1912, he began exhibiting at the Salon National des Beaux-Arts and the Salon d'Automne. Lipchitz's first solo show was held at Léonce Rosenberg's Galerie l'Effort Moderne in Paris in 1920. Two years later he executed five bas-reliefs for the Barnes Foundation in Merion, Pennsylvania. In 1924, the artist became a French citizen and the following year moved to Boulogne-sur-Seine. He received a commission from the Viscount Charles de Noailles in 1927 for the sculpture *Joy of Life*.

Lipchitz's first important retrospective took place at Jeanne Bucher's Galerie de la Renaissance in Paris in 1930. The Brummer Gallery in New York hosted his first large show in the United

States in 1935. In 1941, Lipchitz fled Paris for New York, where he began exhibiting regularly at Curt Valentin's Buchholz Gallery. He settled in Hastings-on-Hudson, New York, in 1947. In 1954, a Lipchitz retrospective traveled from the Museum of Modern Art, New York, to the Walker Art Center, Minneapolis, and the Cleveland Museum of Art. In 1958, Lipchitz collaborated with the architect Philip Johnson on the Roofless Church in New Harmony, Indiana. That same year he became a United States citizen. His series of small bronzes *To the Limit of the Possible* was shown at Fine Arts Associates, New York, in 1959. He visited Israel for the first time in 1963. From 1964 to 1966, Lipchitz showed annually at the Marlborough-Gerson Gallery in New York. Beginning in 1963, he spent several months of each year casting in Pietrasanta, Italy.

From 1970 until 1973, he worked on large-scale commissions for the Municipal Plaza, Philadelphia; Columbia University, New York; and the Hadassah Medical Center near Jerusalem. These projects were completed by Lipchitz's wife, Yulla, after his death. In 1972, the artist's autobiography was published on the occasion of an exhibition of his sculpture at the Metropolitan Museum of Art, New York. Lipchitz died May 26, 1973, on Capri, and was buried in Jerusalem.

Standing Personage (Personnage debout), 1916 (cat. no. 70)

More than fifty years after its execution, Lipchitz stated that *Standing Personage* "was completely realized in the round as a three-dimensional object existing in three-dimensional space. Thus, when it is seen in a photograph, it is impossible to understand the work fully. The vertical architectural basis of the structure is apparent. . . . While this sculpture is in one sense an architectural construction, it is also clearly a figure or figures. The V-shaped curves rising from the sharp vertical in the upper central area reiterate the eyebrows and nose of the slightly earlier head, and the angled elements at the bottom can be either the buttresses supporting a Gothic vault or the legs of a seated figure."

In addition to this version, which was carved from a limestone block, Lipchitz made a plaster version of similar dimensions around 1916 (Musée national d'art moderne, Paris) that was cast in bronze. — V. E. B.

Sailor with Guitar (Marin à la guitare), 1917–18 (cat. no. 71)

The theme of the sailor with guitar—certainly familiar to the Cubist imagination—goes back to a trip to Majorca Lipchitz took during the summer of 1914 with other artists, including Maria Blanchard and Diego Rivera. This trip was particularly important since it marks Lipchitz's first Cubist works. After his first sculpture on this theme, Lipchitz returned to it again, in a more masterful way, in 1916, 1917, and 1918. This 1917 version was his favorite, because of the rendering

of movement, the arrangement of shapes that fluctuate between abstraction and figuration, and the dynamic equilibrium of volumes. While the work presents a solid construction of overlapping geometric shapes (somewhat reminiscent of the work of certain contemporary architects, such as Adolf Loos), this *Sailor with Guitar* already has curves that break with the static quality of the preceding works and prefigure Lipchitz's future evolution.

As with other sculptures of the time, this work was made from a single stone (the material for which it was conceived) and executed by an assistant from a plaster model, with the finishing done by Lipchitz, who in this work wanted to situate himself in the "tradition of all the master-sculptors, from Michelangelo to Rodin." It belonged to Le Corbusier, who displayed it in a prominent place, among Léger's paintings in his Pavillon de l'Esprit Nouveau at the *Exposition internationale des arts décoratifs* in 1925, the year in which Lipchitz moved into the studio he had commissioned from the architect. — V. W.

René Magritte
1898–1967

René François Ghislain Magritte was born November 21, 1898, in Lessines, Belgium. He studied intermittently between 1916 and 1918 at the Académie Royale des Beaux-Arts in Brussels. Magritte first exhibited at the Centre d'Art in Brussels in 1920. After completing military service in 1921, he worked briefly as a designer in a wallpaper factory. In 1923, he participated with Lyonel Feininger, Paul Joostens, El Lissitzky, and László Moholy-Nagy in an exhibition at the Cercle Royal Artistique, Antwerp. In 1924, he collaborated with E. L. T. Mesens on the review *Oesophage*.

In 1927, Magritte was given his first solo exhibition at the Galerie le Centaure, Brussels. Later that year, the artist left Brussels to establish himself in Le Perreux-sur-Marne, near Paris, where he frequented the Surrealist circle, which included Jean Arp, André Breton, Salvador Dalí, Paul Eluard, and Joan Miró. In 1928, Magritte took part in the *Exposition surréaliste* at the Galerie Goemans in Paris. He returned to Belgium in 1930, and three

years later was given a solo show at the Palais des Beaux-Arts in Brussels. Magritte's first solo exhibition in the United States took place at the Julien Levy Gallery, New York, in 1936 and his first in England at the London Gallery in 1938. He was represented as well in the 1936 *Fantastic Art, Dada, Surrealism* exhibition at the Museum of Modern Art, New York.

Throughout the 1940s, Magritte showed frequently at the Galerie Dietrich in Brussels. During the following two decades, he executed various mural commissions in Belgium. From 1953, he exhibited frequently at the galleries of Alexander Iolas in New York, Paris, and Geneva. Magritte retrospectives were held in 1954 at the Palais des Beaux-Arts in Brussels and in 1960 at the Museum for Contemporary Arts, Dallas, and the Museum of Fine Arts, Houston. On the occasion of his retrospective at the Museum of Modern Art, New York, in 1965, Magritte traveled to the United States for the first time, and the following year he visited Israel. Magritte died August 15, 1967, in Brussels, shortly after the opening of an exhibition of his work at the Museum Boymans-van Beuningen, Rotterdam.

The Secret Double (Le Double secret), 1927 (cat. no. 169)

In this successful work, the functioning and sense of the Magrittean image are clearly established: the work is illusionistic by virtue of a rigorously academic pictorial style, as seen in its fine glaze, in the artist's perfection of his modeling, and in his exquisite detail. A man's head, or rather a wax mask, is split in two by the lateral displacement of one of its halves, as if it has been cut with scissors. While the allusion to cutting and displacement refers to the collage technique, the interrogation of the enigmatic qualities of a face derive directly from the metaphysics of Giorgio de Chirico.

Magritte reveals the interior void of the human being as dark, unidentifiable space, doubly secret. There is an overall silence that is deepened in the background by the maritime horizon; and there are strange iron bells, taken from childhood memories of horse bells, invading the surface like parasites. In making it possible to see the gulf that separates the being from its image, its fragile envelope, Magritte reveals the betrayal of the visible, but also the mystery of the real. Situated between the latter and his trompe-l'oeil mask, this gulf is actually that of painting, a place of volumetric illusion, of analogical resonance. — A. L. B.

Voice of Space (La Voix des airs), 1931 (cat. no. 170)

Influenced by de Chirico, Magritte sought to strip objects of their usual functions and meanings in order to convey an irrationally compelling image. In *Voice of Space* (of which three other oil versions exist), the bells float in the air; elsewhere they occupy human bodies or replace blossoms on bushes. By distorting the scale, weight, and use of an ordinary object and inserting it into a variety of unaccustomed contexts, Magritte confers on that

object a fetishistic intensity. He has written of the jingle bell, a motif that recurs often in his work, "I caused the iron bells hanging from the necks of our admirable horses to sprout like dangerous plants at the edge of an abyss."

The disturbing impact of the bells presented in an unfamiliar setting is intensified by the cool academic precision with which they and their environment are painted. The dainty slice of landscape could be the backdrop of an early Renaissance painting, while the bells themselves, in their rotund and glowing monumentality, impart a mysterious resonance. — L. F.

The Red Model (*Le Modèle rouge*), 1935 (cat. no. 186)

This subject, a perfect example of a double, metamorphic, Surrealist image, gave rise to several versions in oil, gouache, and drawing. There are seven in all, dating from 1935 to 1964; according to art historian David Sylvester, this is the second version, exhibited in 1936 at the Julien Levy Gallery, New York, and chosen by Breton for the cover of the second edition of *Surréalisme et la peinture* in 1945. In the series, with its infinitesimal variants, Magritte seemed to follow a process of copying the imitation, humorously subverting the notion of the original in painting.

Corresponding perfectly with the poetics of the Surrealist visual pun and the blurring of meaning, the image brings into play the affinity between the contents and their "container," their metaphorical association in a single object. It is a play, too, on the reality of the hidden and the vanity of the displayed, the dominance of sensation over perception, of the natural over the manufactured, the oppressor over the oppressed (in this regard, one interpretation has gone so far as to see the title as a reference to the revolutionary program of the Communists). Perhaps inspired by the shop sign of a cobbler in Tours, which Max Ernst supposedly described to him, Magritte used this motif to humorously express his will to overturn established values: "The problem of shoes shows how the most barbarous things become, by force of habit, perfectly conventional. In *The Red Model* you feel that the union of a human foot and a leather shoe implies, in fact, a monstrous custom" (*La Ligne de vie*, November 20, 1938). A living still life set on an unpleasant ground of pebbles, in front of a wall of wood planks, detached from the body, autonomous, the fragment of reality may thus become a metaphorical object, the locus of a sudden analogical contraction. In effecting this visual hallucination, painting thus becomes exactly what Magritte wanted it to be: "the permanent revolt against the commonplaces of existence." — A. L. B.

Kazimir Malevich
1878–1935

Kazimir Severinovich Malevich was born February 26, 1878, near Kiev. He studied at the Moscow Institute of Painting, Sculpture, and Architecture in 1903. During the early years of his career, he experimented with various Modernist styles and participated in avant-garde exhibitions, such as those of the Moscow Artists' Association, which included Vasily Kandinsky and Mikhail Larionov, and the *Jack of Diamonds* exhibition of 1910 in Moscow. Malevich showed his neoprimitivist paintings of peasants at the exhibition *Donkey's Tail* in 1912. After this exhibition he broke with Larionov's group. In 1913, with composer Mikhail Matiushin and writer Alexei Kruchenykh, Malevich drafted a manifesto for the First Futurist Congress. That same year he designed the sets and costumes for the opera *Victory over the Sun* by Matiushin and Kruchenykh. Malevich showed at the Salon des Indépendants in Paris in 1914.

At the *0.10 Last Futurist Exhibition of Pictures* in Petrograd in 1915, Malevich introduced his non-objective, geometric Suprematist paintings. In 1919, he began to explore the three-dimensional applications of Suprematism in architectural models. Following the Bolshevik Revolution in 1917, Malevich and other advanced artists were encouraged by the Soviet government and attained prominent administrative and teaching positions. Malevich began teaching at the Vitebsk Popular Art School in 1919; he soon became its director. In 1919–20 he was given a solo show at the *Sixteenth State Exhibition* in Moscow, which focused on Suprematism and other non-objective styles. Malevich and his students at Vitebsk formed the Suprematist group Unovis. From 1922 to 1927, he taught at the Institute of Artistic Culture in Petrograd, and between 1924 and 1926 he worked primarily on architectural models with his students.

In 1927, Malevich traveled with an exhibition of his paintings to Warsaw and also went to Berlin, where his work was shown at the *Grosse Berliner Kunstausstellung*. In Germany, he met Jean Arp, Naum Gabo, Le Corbusier, and Kurt Schwitters and visited the Bauhaus where he met Walter Gropius. The Tret'yakov Gallery in Moscow gave

Malevich a solo exhibition in 1929. Because of his connections with German artists he was arrested in 1930, and many of his manuscripts were destroyed. In his final period, he painted in a representational style. Malevich died May 15, 1935, in Leningrad.

Peasant Women (*Krestianka*), ca. 1910–12 (cat. no. 100), and *Morning in the Village after Snowstorm* (*Utro posle v'iugi v derevne*), 1912 (cat. no. 101)

The paintings of the Russian avant-garde have, in general, elicited two types of interpretation: one focuses on issues of technique and style, the other concentrates on social and political issues. The former method is usually applied to Malevich's early paintings, grounded as they are in the forms of Cubism, Futurism, and other contemporaneous art movements; the latter largely avoids Malevich in favor of more politically engaged artists such as El Lissitzky, Aleksandr Rodchenko, and Vladimir Tatlin.

From the formalist's standpoint, *Morning in the Village after Snowstorm* is, in its mastery of complex colors and shapes, a perfect example of the newly created Russian style Cubo-Futurism. *Peasant Women*, a pencil sketch dating from the years leading up to the painting, shows a shorthand version of the schematized, geometrically simplified figures Malevich was using during this period. The figures have been called a continuation of the genre types Malevich portrayed in his neoprimitive paintings, their depiction seemingly reliant on Fernand Léger's work, which Malevich could have known from an exhibition in Moscow in February 1912 or through reproductions. This phase in his career has been seen as Malevich's formidable stopover on his journey toward abstraction and the development of Suprematism.

But to ignore the political and social dimensions of Malevich's art is to pay it a disservice. Malevich came from humble circumstances and it is clear from autobiographical accounts that vivid memories of his country childhood compensated for his lack of a formal art education. *Morning in the Village after Snowstorm* demonstrates that Malevich's hard-won skills as a sophisticated painter were rooted in an unmistakably Russian experience. If art can be said to augur the future, then Malevich's repeated decision to depict peasants—on the brink of the October Revolution—cannot have been merely coincidental. — C. L.

Black Cross (*Černyj krest'*), 1915 (cat. no. 103)

In December 1915, at the *0.10 Last Futurist Exhibition of Pictures* organized by Ivan Puni in Petrograd, Malevich exhibited thirty-eight canvases—his first abstract Suprematist works. As Malevich claimed in the accompanying catalogue, "I metamorphosed myself into zero forms, going beyond zero, to creation, which is to say suprematism, a new pictorial realism, non-objective creation." The radical nature of what he characterized as a "cold, closed and uncomplacent system" led

him to conceive of a series of "minimal" geometric units—square, circle, rectangle, triangle, cross—which are black against a white ground. The realism of objects is thus abolished in favor of these "pictorial units of colors, constructed in such a way as to depend neither on form, nor color, nor their situations with regard to another unit." All of Malevich's "units" are derived from the square: the circle, "the fundamental Suprematist element, first shape made from the square," is obtained by the rotation of the latter; the cross, elected "third basic element" of Suprematism, originates from the division of the square into two rectangles, one of which pivots ninety degrees on the other.

Whether it is this painting from 1915, or any of several others presenting the same form, the Suprematist cross shows infinite variations of value and treatment in the tracing of its contours. Far from being a frigid, static shape with rigid limits, it vibrates with a tension that traverses the entire space and extends through its two "surface-planes" crossing each other at right angles: its irregular arms, strongly sloped and set off from each other, reject all rigidity. Nurtured by the ideas of the philosopher Piotr Ouspenski concerning the fourth dimension, Malevich succeeded in eliciting, in a two-dimensional space-plane, the creation of a dynamic field charged with energy. While perhaps intended to be a symbol of the death of painting, or a religious symbol, the signification of this pure plastic sign remains obscure. Along with the square, the cross became a recurring theme in Malevich's entire body of work, punctuating the stages of his creation and bearing multiple symbolic functions—funerary, immaculate, flamboyant, or tinged with blood in his last paintings of the 1930s. — B. L.

Untitled, ca. 1916 (cat. no. 104)

Malevich proposed the reductive, abstract style of Suprematism as an alternative to earlier art forms, which he considered inappropriate to his own time. He observed that the proportions of forms in art of the past corresponded with those of objects in nature, which are determined by their function. In opposition to this he proposed a self-referential art in which proportion, scale, color, and disposition obey intrinsic, nonutilitarian laws. Malevich considered his non-objective forms to be reproductions of purely affective sensations that bore no relation to external phenomena. He rejected conventions of gravity, clear orientation, horizon line, and perspective systems.

Malevich's units are developed from the straight line and its two-dimensional extension, the plane, and are constituted by contrasting areas of unmodeled color, distinguished by various textural effects. The diagonal orientation of geometric forms creates rhythms on the surface of the canvas. The overlapping of elements and their varying scale relationships within a white ground provide a sense of indefinitely extensive space. Though the organization of the pictorial forms does not correspond with that of traditional subjects, there are

various internal regulatory principles. In the present work a magnetic attraction and repulsion seem to dictate the slow rotational movement of parts. — L. F.

Man and Horse, 1933 (cat. no. 105)

Malevich used the Suprematist principle of dynamism to shift or destabilize the composition of this late work. His approach is bold, executed in long strokes charged with pigment. The paint, hardly diluted in certain places, is applied only to the very surface of the prepared canvas, which it does not cover entirely; in certain background spaces, one can see traces of charcoal drawing on the white ground. The surfaces treated with several colors, the horse and the blouse, show the use of full brush, or fresh half-brush methods. This refusal to use the transitional effects of half-tone and chiaroscuro lend a spontaneity, almost a violence to the painting's execution, which appears to have been completed in one draft.

The exact subject of the work remains enigmatic. The peasant, recognizable by his blouse and beard, takes a great stride forward, while the horse grazes in the background. Man and Horse is related to an ensemble of works from the late 1920s and early 1930s. The dark, oblique oval of the man's beard, a symmetrical counterpoint to the oval of his face, is found in related drawings, and there is a preparatory drawing for this specific painting, with notations of color for the various areas.

In the late 1920s, Malevich was searching for a new classicism, a new foundation for his painting in the wake of Suprematism. While his abandonment of former principles may disappoint the contemporary observer, it would be incorrect to attribute this evolution purely and simply to his submission to the more and more pressing dictates of political powers.

Malevich's insistence on the theme of peasantry is, on the contrary, a courageous stance in favor of this sacrificed class. Many times he had himself been photographed in peasant dress. The decision made by the Central Committee in 1928 to abandon the New Economic Policy and adopt the Five-Year Plan aimed at considerably accelerating the rhythm of industrialization of the country, yet at the same time it condemned the agricultural class, from which the necessary sums for this industrial revolution had to be raised. In 1929 and 1930, the Communist Party, often using force, began a huge campaign of collectivization of farms. The undertaking met with great resistance, causing the death of three to four million peasants, and, augmented by mediocre harvests from 1931 to 1933, it ultimately ended in economic failure. This explains the amputation of the peasant's arms, symbol of his social status, now decimated and deprived of movement. — J. H. M.

Man Ray
1890–1976

Man Ray (a pseudonym adopted by the artist) was born Emmanuel Radnitsky on August 27, 1890, in Philadelphia, and moved to New York with his family seven years later. In New York, he frequented Alfred Stieglitz's gallery "291" in 1911 and attended classes at the Ferrer Center in 1912. In 1915, his first solo show was held at the Daniel Gallery, New York. About this time, he took up photography, the medium for which he was to become best known. He entered into a lifelong friendship with Marcel Duchamp, with whom he and Walter Arensberg founded the Society of Independent Artists in 1916. With Duchamp, Katherine Dreier, Henry Hudson, and Andrew McLaren, Man Ray established the Société Anonyme, which he named, in 1920. Before the artist moved from New York to Paris in 1921, Man Ray and Duchamp published the only issue of New York Dada.

In Paris, Man Ray was given a solo exhibition at the Librairie Six in 1921. His first Rayographs (photographic images produced without a camera) were published in Les Champs délicieux, rayographies in 1922, the year the artist participated in the Salon Dada at the Galerie Montaigne in Paris. With Jean Arp, Giorgio de Chirico, Max Ernst, André Masson, Joan Miró, and Pablo Picasso, he was represented in the first Surrealist exhibition at the Galerie Pierre, Paris, in 1925. From 1923 to 1929, he made the films The Return to Reason (Le Retour à la raison, 1923), Emak Bakia (1926), L'Etoile de mer (1928), and The Mystery of the Château of Dice (Les Mystères du château de dé, 1929). In 1932, Man Ray's work was included in Dada, 1916–1932 at the Galerie de l'Institut, Paris, and in a Surrealist show at the Julien Levy Gallery, New York. He collaborated with Paul Eluard on the books Facile (1935) and Les Mains libres (1937). In 1936, he went to New York on the occasion of the Fantastic Art, Dada, Surrealism exhibition at the Museum of Modern Art, New York, in which his work appeared.

The artist left France in 1940, shortly before the German occupation, making his way to Hollywood and then to New York. In 1951, he returned to

Paris, where he was given a solo show at the Galerie Berggruen. In 1959, a solo exhibition of Man Ray's work was held at the Institute of Contemporary Art in London. His autobiography *Self Portrait* was published in 1963. Ten years later, the Metropolitan Museum of Art, New York, presented 125 of his photographic works. Man Ray died November 18, 1976, in Paris.

Lampshade, 1919/1954 (cat. no. 151)

The "do-it-yourself" system characterizes Man Ray's spirit of artistic invention, and corresponds to the poetics of humor and games of which he and Duchamp were the most ingenious craftsmen. The conventional boundaries between manufactured object, art object, and piece of furniture were blurred, originating from the resolutely non-aesthetic environment of Man Ray's studio. *Lampshade*, first "invented" in 1919, offers a prime example of this: one of the first objects, along with *New York* (1920), to be conceived by Man Ray in New York, it consisted of a spiral of cardboard cut into the form of a lampshade and suspended from a rod. At once a "mobile" before its time and a found object, it may be seen as a Dada equivalent to Duchamp's readymades, particularly close to *Hat Rack* from 1917 (a hat rack hanging on the end of a string). With the first original destroyed (though Man Ray's photograph of it was published in no. 13 of *391* in January 1920), Man Ray executed another *Lampshade* in 1921, "modified" in painted metal for Dreier. It was probably the 1921 version that was used for the film *Le Retour de la raison* (1923) and which appeared in a photograph taken in 1922 by Man Ray. Two new replicas, in paper, were supposedly executed in 1923 for the Viscount Charles de Noailles. It seems that *Lampshade* became a fetish of Man Ray's, for it even appears in some of his paintings. This unique example from 1954, larger in size than the others, was a permanent fixture at the artist's Parisian residence on rue Férou. — A. L. B.

Piero Manzoni
1933–1963

Piero Manzoni was born July 13, 1933, in Soncino, Italy. After studying law and then philosophy, he turned to making art. His early works were figurative landscape paintings executed during the early 1950s. His technique changed in 1956, when he began to make paintings featuring impressions of household objects dipped in paint. Manzoni then produced a series of works that emphasize the physical nature of materials, which were exhibited at the Castello Sforzesco in Soncino in 1956.

Although Manzoni belonged to a younger generation of artists who repudiated the gestural idiom of Art Informel, his work reflects an interest in materials influenced by Alberto Burri. An exhibition of Yves Klein's blue monochrome paintings held in Milan in 1957 proved pivotal to Manzoni's artistic development as well, for in that year Manzoni began his *Achrome* series, works which focus on the absence of image. The first *Achromes* were made of raw canvas that is creased, molded, or covered with gesso or kaolin; in the next six years, the *Achromes* evolved into constructions of organic matter and furlike fiberglass. Manzoni also joined the Gruppo Nucleare in 1957, with whom he coauthored several manifestos, collaborated on its journal, *Il Gesto*, and exhibited at the Galleria San Fedele, Milan. In 1958, Manzoni participated in a show with Enrico Baj and Lucio Fontana at the Galleria Bergamo, Milan.

Manzoni broke with the Gruppo Nucleare in 1959, founding, with Enrico Castellani, a new theoretical journal called *Azimuth* and the Azimut Gallery, where he exhibited that year. At this time, Manzoni produced conceptual sculptures that question the value of the artist's touch, such as the *Lignes* drawn on paper rolled into tubular containers and *The Artist's Breath* series in which he inflated balloons, valuing his breath at 200 lire per liter. He continued in a related vein in 1960, selling his own thumbprints. In 1961, Manzoni transformed the human body into art, signing live models, called *Living Sculptures*, and canning excrement, titled *Artist's Shit* (sold by weight at the market price for gold). These works are, in part, inspired by Marcel Duchamp's readymades, which recast the anti-aesthetic as high art.

In 1962, Manzoni participated in an exhibition of the Zero Group at the Stedelijk Museum, Amsterdam. Later that year his most significant works were exhibited at the Galleria del Cernobio, Milan. He died February 6, 1963, in Milan.

Achrome, 1959 (cat. no. 314)

The most important of Manzoni's works in the Musée national d'art moderne's collection, this "achrome" belongs to the series of the same name begun in 1957. Its principle is that it was made from "pure materials": Manzoni used kaolin, a white clay, on a stretched canvas that had first been brushed with sizing. The only preparation he allowed himself was that which captured the gesture. The whiteness, which in his work is supposed to be only an absence of color, determines the title of the work: *Achrome*. Manzoni soaked a second piece of cloth, and allowed it to set on top of the canvas, following the natural movement of

its wrapping, without any concern whatsoever for composition. The point is thus to establish an encounter between a stable surface and a malleable material, so that each material experiences the other, and to convey a critical fact in the very locus of painting itself, within the frame—in both the literal and figurative sense—in which it occurs. In a text published in *Libre dimension*, Manzoni wrote: "The material becomes pure energy," and, "Why isn't (a limitless surface such as a painting) a free surface? Why not seek to discover the limitless meaning of a total surface, a pure and absolute light?" An obliteration of painting in its process of production, yet somehow beyond analysis, the achrome expresses a metaphysical idealism comparable to that of Klein. — B. B.

Artist's Shit No. 031 (Merda d'artista n. 031), 1961 (cat. no. 315)

In May 1961, continuing his program of subversive, playful alchemy, Manzoni contributed ninety cans of shit to the inventory of contemporary art, of which the Musée national d'art moderne owns number 031. From boxes to be emptied out (which is how Manzoni saw his paintings) to cans into which one empties oneself out, there was only one step to be taken, which Manzoni did not hesitate to take. The two acts cannot, in fact, be separated: they correspond to each other, though at a distance, in the continuum of Manzoni's search for a "primordial sign." For even though in the latter act a certain provocation in the face of the constipation of the art milieu comes into play, it is no less true that Manzoni's "ready-merde"—like Duchamp's "ready-made," according to Thierry de Duve—corresponds above all to a series of painterly gambits, even if they are attempts at ingestion. And, as no one can deny, after ingestion comes defecation: once painting has been swallowed—as in the series *Achromes* and *Lines*, which correspond to an engulfment of their two essential principles, color and drawing, respectively—it comes out in a different state. Moreover, fecal monochromy, like rituals of ingestion, has a long history. Let us not forget that one of the earliest practices of symbolism in man, in the form of a fable, consisted of eating the dead ancestor and then covering the remains with excrement; which takes us from the achromy of bones to fecal painting.

"The work of art," wrote Manzoni, "finds its source in an unconscious impulse issued from a collective substratum of universal value. It is from this common foundation that all people derive their gestures and the artist roots the *arkhai* of organic existence. . . . The work of art thus acquires a totemic value, as living myth, primary and direct expression freed of symbolic or descriptive burdens."

Clearly, today, we cannot help but recognize the "totemic value" of Manzoni's can of shit. While it addressed the mercantile system (it was literally worth its weight in gold), just as the plastic-

wrapped corpses planned by Manzoni would have been an homage to the museum system, *Artist's Shit No. 031* is also one of the most accomplished self-portraits of recent art. — C. M.

Franz Marc

1880–1916

Franz Marc was born February 8, 1880, in Munich. The son of a landscape painter, he decided to become an artist after a year of military service interrupted his plans to study philology. From 1900 to 1902, he studied at the Akademie in Munich with Gabriel von Hackl and Wilhelm von Diez. The following year during a visit to France, he was introduced to Japanese woodcuts and the work of the Impressionists in Paris.

Marc suffered from severe depressions from 1904 to 1907. In 1907, Marc went again to Paris, where he responded enthusiastically to the work of Paul Gauguin, Vincent van Gogh, the Cubists, and the Expressionists; later, he was impressed by the Henri Matisse exhibition in Munich in 1910. During this period, he received steady income from the animal-anatomy lessons he gave to artists.

In 1910, his first solo show was held at the Kunsthandlung Brackl, Munich, and Marc met August Macke and the collector Bernhard Koehler. He publicly defended the Neue Künstlervereinigung München (NKVM) and was formally welcomed into the group early in 1911, when he met Vasily Kandinsky. After internal dissension split the NKVM, he and Kandinsky formed the Blaue Reiter, whose first exhibition took place in December 1911 at the Moderne Galerie Thannhauser, Munich. Marc invited members of the Berlin Brücke group to participate in the second Blaue Reiter show two months later at the Galerie Hans Goltz, Munich. The *Almanach der Blaue Reiter* was published with lead articles by Marc in May 1912. When World War I broke out

in August 1914, Marc immediately enlisted. He was deeply troubled by Macke's death in action shortly thereafter; during the war, he produced his *Sketchbook from the Field*. Marc died March 4, 1916, at Verdun.

Stables (Stallungen), 1913 (cat. no. 34)

Like his fellow artists in the Blaue Reiter group, Marc searched for ways to reflect inner spiritual and emotional states through art. Marc's approach was oriented toward nature, founded on the pantheistic belief that animals possessed a certain godliness that men had long since lost. He completed *Stables*, the last major work based on his favorite subject, the horse, by the end of 1913. During the course of the year, Marc had become increasingly interested in abstract pictorial modes to express universal aspects of existence. Rather than portraying the natural world from the point of view of the individual animal, Marc now saw his subjects as part of a larger unified field and treated them in terms of the overall structure of the composition. In *Stables*, the images of horse and stables are almost indistinguishable. The artist arranged a group of five red, blue, and white horses within a framework of parallel and crossing diagonals. Massed on the picture plane, the horses are transformed into flat colored shapes. The curvilinear patterns of the animals' tails and the shifting planes of vivid, light-filled colors suggest the influence of the Futurists and Robert Delaunay, whom Marc had met during a trip to Paris in 1912. — SRGM

Brice Marden

b. 1938

Brice Marden was born October 15, 1938, in Bronxville, New York. He attended Florida Southern College, Lakeland, from 1957 to 1958 and the Boston University School of Fine and Applied Arts from 1958 to 1961, when he received his B.F.A. degree. In the summer of 1961, he attended Yale Norfolk Summer School of Music and Art in Norfolk, Connecticut, and went on to enroll at the Yale University School of Art and

Architecture, New Haven, receiving an M.F.A. degree in 1963.

It was at Yale that Marden developed the formal strategies that characterized his painting of the following decades: preoccupation with rectangular formats and repeated use of a muted, extremely individualized palette. He has described his early works as highly emotional and subjective, despite their apparent lack of referentiality.

In the summer of 1963, Marden moved to New York with his wife, Pauline Baez, whom he had married in 1960, and with whom he had a son, Nicholas. They later divorced and he married Helen Harrington in 1969. He worked as a guard in 1963 and 1964 at the Jewish Museum, where he came into contact with the work of Jasper Johns, an artist whom he studied in depth and whose work furthered his interest in gridded compositions.

Marden made his first monochromatic single-panel painting in the winter of 1964. It was during this time that his first solo exhibition was presented at the Wilcox Gallery, Swarthmore College, Swarthmore, Pennsylvania. Marden spent the spring and summer of 1964 in Paris, where he was inspired by the work of Alberto Giacometti. His first solo show in New York was held at the Bykert Gallery in 1966, and in the fall of that year, he became the general assistant to Robert Rauschenberg. In 1968, he began constructing his paintings with multiple panels. From 1969 to 1974, he was a painting instructor at the School of Visual Arts in New York.

In 1972, his work was showcased at *Documenta V* in Kassel, and he was honored with a retrospective at the Solomon R. Guggenheim Museum, New York, in 1975. A show of drawings made between 1964 and 1974 traveled in 1974 to the Contemporary Arts Museum, Houston; the Fort Worth Art Museum; and the Minneapolis Institute of Arts. In 1977, Marden traveled to Rome and Pompeii, where he strengthened an interest in Roman and Greek art and architecture, which would influence his work of the late 1970s and early 1980s.

In the mid-1980s, Marden turned away from Minimalism toward gestural abstraction. Around this time, Marden traveled to Thailand where he became interested in Far Eastern calligraphy and the art of the brushstroke. During the 1990s, Marden has continued to exhibit regularly in New York. He was the subject of two major traveling shows, *Brice Marden—Cold Mountain*, at the Dia Center for the Arts, New York; the Walker Art Center, Minneapolis; the Menil Collection, Houston; Museo Nacional Centro de Arte Reina Sofía, Madrid; and Kunstmuseum, Bonn, in 1991 and 1992. A show of his *Work books 1965–1995* traveled in 1997–98 to the Staatliche Graphische Sammlung, Munchen; Kunstmuseum, Winterthur; Wexner Art Center, Ohio; and the Fogg Art Museum, Cambridge, Massachusetts.

Private Title, 1966 (cat. no. 336)

Marden's first solo exhibition was organized by
Klaus Kertess at the Bykert Gallery in 1966. The
show consisted of monochrome panels painted in
a range of earth tones; their resonance with soil
was reinforced by the horizontal landscape format
that the works in this exhibition all shared. Some
are decidedly monumental, enveloping the
viewer's peripheral vision in a field of loam, while
smaller works, such as *Private Title*, function less
as surrounds than as presences. The shift from
landscape to human scale also changes one's
response to the color of the canvases. If in larger
format the tans and grays of these monochromes
conjure associations of clay or dirt, the surfaces of
the human-scaled works, though innocent of figu-
ration, read convincingly as skin.

Marden built his monochromes in a methodic,
ritualistic manner. He combined oil paint with
melted beeswax and brushed it over a heavily ges-
soed canvas. The artist then evened out the sur-
face with a palette-knife, mimicking the technique
of a mason with his trowel. The wax cools in about
half an hour; if Marden was not satisfied with the
result he scraped off the layer and began anew.
The slow and steady act of composition is so
important to the work that Marden indexed his
process at the base of canvases from this period.
He penciled a one-inch margin beneath which he
did not paint, but in which drips from the space
above were allowed to accumulate. If the upper
portion of the work is sealed tight with multiple
swathes of oil and wax, in the lower register the
canvas is allowed to breathe.

By publicly exhibiting a work called *Private
Title*, Marden repeated the flirtatious, attraction/
repulsion effect of the paintings themselves.
Functioning within a Minimalist vocabulary of
regular geometry and serial repetition, his
monochromes refer to the industrial, the mathe-
matic, the impersonal. Being opaque, they deny
visual or metaphoric entry. At the same time,
these works are possessed of a palpably sensuous
surface. If the rigid and regular forms of the can-
vases establish a certain psychological distance,
their dense, smooth, and fragrant membranes also
invite a form of corporeal engagement. — R. C.

André Masson
1896–1987

André Masson was born January 4, 1896 in
Balagny-sur-Thérain, France. He grew up in Lille,
and Brussels, where he attended the Académie
Royale des Beaux-Arts, Bruxelles, from the age of
nine onward. In 1912, Masson settled in Paris,
where he continued his studies at the Ecole
Nationale Supérieure des Beaux-Arts, Paris. He
served in the French Army in World War I, during
which time he was wounded and subsequently
hospitalized for many months. Returning to Paris,
he held various jobs throughout the 1920s. In
1920, he married Odette Cabalé, who gave birth to
their daughter that year.

Daniel-Henri Kahnweiler became interested in
Masson's work in 1922 and exhibited it at his
gallery, Galerie Simon, in a group exhibition in
1923 and in a solo exhibition the following year.
Masson had been experimenting with "automatic"
drawing as a way of deriving imagery from sub-
conscious thought. He met André Breton in 1924
and became involved with the Surrealist group of
artists and writers, signing the group's manifesto
the following year. By 1929, however, because of a
disagreement with Breton, Masson was excluded
from signing the second manifesto. Despite their
complicated relationship, Masson remained
involved with the Surrealists until 1943, when he
had a final falling out with Breton. Masson's
Surrealist work is noted for its vivid palette and its
themes of metamorphosis, fantasy, and eroticism.
His works of automatism are known to have influ-
enced Jean Degottex, Arshile Gorky, Georges
Mathieu, Roberto Matta, Jackson Pollock, and
other younger artists.

Inspired by the work of Alberto Giacometti,
whom he met in 1927, Masson created his first
sculptures during the following year. In 1930,
Masson and Georges Bataille founded *Minotaure*,
an important journal for Surrealist writers and
artists. During this same year, he divorced Cabalé.
In 1931, based on the recommendation of Pablo
Picasso, Masson signed with the dealer Paul
Rosenberg. He had his first New York exhibition
at Pierre Matisse Gallery in 1932. In the same
year, he moved to Grasse in southern France,
where he created theater designs for the Ballet
Russe de Monte Carlo and worked as an illustrator

for *Acephale*, a journal edited by Bataille. In 1933
Masson showed with Galerie Wildenstein in Paris.
In 1934, he moved to Tossa de Mar, Spain. There,
he married Rose Maklès, who gave birth to their
son in 1935.

Masson returned to France the following year,
first settling in Lyons-la-Forêt and then from
1940–41 in Freluc. He continued to pursue his
interest in theater design. The Museum of
Modern Art, New York, included Masson in the
1936 exhibition *Fantastic Art, Dada, Surrealism*
and was the first museum to purchase one of
his paintings. During World War II, Masson
emigrated to New Preston, Connecticut, where he
lived from 1941–45, before moving back to France
in 1946, settling in Poitres. From 1950 onward,
Masson traveled extensively in Europe, particularly
in Italy. In 1965, the Musée national d'art
moderne, Paris, organized an extensive retrospec-
tive exhibition; and in 1977 the Museum of
Modern Art, New York, mounted a retrospective
that traveled to the Grand Palais, Paris. In 1986,
Rose Masson died. Masson died October 28, 1987,
in Paris.

Entanglement (Enchevêtrement), 1941 (cat. no. 233)

Given its method and support (distemper on card-
board), this small painting might be considered a
sketch. But the term ill suits this successful work,
with its jubilant colors and signs. Masson here
breaks away from demonstrative or metaphysical
figuration. His mastery of automatic drawing and
ink techniques in general led Masson, after the
1930s and especially during his stay in the United
States, to take his cues from handwriting and
calligraphy. Without adopting the constraints of
composition upon which those arts are based,
Masson established a painting of marks, spots,
and textures that fill the whole space: it is indeed a
preliminary to what American art criticism would
baptize "Action Painting." *Entanglement* is a gestu-
ral type of painting, in which Masson pushes the
experience of controlled freedom to its limits, over
a small surface that thus acquires a monumental
character. Unexpected in appearance, the alterna-
tion between figuration and abstraction is not
unusual among a number of Surrealist painters,
and it constituted a particularly effective model for
the New York painters.

Masson always kept this little painting in his
studio, as it represented a moment when he
played his "last card." The search for the origins of
the New York School led to its public rediscovery
in exhibitions in the 1970s. The seductiveness of
the work in itself, with its color and its dynamism,
is undeniable. — F. L.

Pythia (La Pythie), 1943 (cat. no. 224)

During his stay in the United States, Masson con-
tinued to allude to Greek mythology in his art, as
if the tragic themes of a lost civilization would
always have a valid reality for all. Due to her role
as oracle, Pythia was a figure beloved by the
Surrealists. Masson was, however, the only one

who created an image of her, preparing large pastel sketches and choosing a large format for this painting. A nude female body, head raised, arms raised, agitated: a basic image. Motifs such as the raised hand may be found in other paintings—for example, in *Patipha* (1943). The surface is animated with the aid of colored matrices: black, yellow, and red move with the lines, lighting them as if they were halos of light, while the composition is decentralized into three separate areas linked by layers that are the color of fire. The somewhat strained application of figures with stilted hands of the years 1922–24 gave way to the dramatic and moving gestures that would henceforth govern Masson's iconography. — F. L.

Henri Matisse

1869–1954

Henri-Emile-Benoît Matisse was born December 31, 1869, in Le Cateau–Cambrésis, France. He grew up at Bohain-en-Vermandois and studied law in Paris from 1887 to 1889. By 1891, he had abandoned law and started to paint. In Paris, Matisse studied art briefly at the Académie Julian and then at the Ecole des Beaux-Arts with Gustave Moreau.

In 1901, Matisse exhibited at the Salon des Indépendants in Paris and met another future leader of the Fauve movement, Maurice de Vlaminck. His first solo show took place at the Galerie Vollard in 1904. Both Leo and Gertrude Stein, as well as Etta and Claribel Cone, began to collect Matisse's work at that time. Like many avant-garde artists in Paris, Matisse was receptive to a broad range of influences. He was one of the first painters to take an interest in "primitive" art. Matisse abandoned the palette of the Impressionists and established his characteristic style with its flat, brilliant color and fluid line. His subjects were primarily women, interiors, and still lifes. In 1913, his work was included in the Armory Show in New York. By 1923, two Russians, Sergei Shchukin and Ivan Morosov, had purchased nearly fifty of his paintings.

From the early 1920s until 1939, Matisse divided his time primarily between the south of France and Paris. During this period, he worked on paintings, sculptures, lithographs, and etchings, as well as on murals for the Barnes Foundation, Merion, Pennsylvania, designs for

tapestries, and set and costume designs for Léonide Massine's ballet *Rouge et noir*. While recuperating from two major operations in 1941 and 1942, Matisse concentrated on a technique he had devised earlier: *papiers découpés* (paper cutouts). *Jazz*, written and illustrated by Matisse, was published in 1947. The plates are stencil reproductions of paper cutouts. In 1948, he began the design for the decoration of the Chapelle du Rosaire at Vence, which was completed and consecrated in 1951. Matisse continued to make his large paper cutouts, the last of which was a design for the rose window at Union Church of Pocantico Hills, New York. He died November 3, 1954, in Nice.

Study for *Le Luxe I*, 1907 (cat. no. 10), and *Le Luxe I*, summer 1907 (cat. no. 11)

There are two versions of *Le Luxe*. The first was painted at Collioure during the winter of 1907 and exhibited at the Salon d'Automne the same year, where it was presented as a "sketch." This characterization did not disarm the critics, however, who remained reticent before what they deemed to be "flat coloration," "elementary relationships," and "waves of color without definite representation." Nonetheless, this ambitious "sketch" was preceded by several studies, and even by a cartoon squared for transfer to the canvas (Musée national d'art moderne, Paris).

The motif comes from a series of works on the theme of the Golden Age, which preoccupied Matisse for several years after *Luxe, calme et volupté* (1904), *Pastoral Scene (Pastorale)* and *Joie de vivre* (both 1906), and which led up to *Dance (La Danse*, 1909) and *Music (La Musique*, 1910). An enlarged and monumentalized fragment of one of the groups in *Luxe, calme et volupté, Le Luxe I* is perhaps also inspired by a canvas by Pierre Puvis de Chavannes, *Young Girls by the Sea (Jeunes filles au bord de mer*, 1879), in which three figures are also shown. Matisse would particularly accentuate the decorative element—which is also the case with Puvis—in the second version on this theme, executed at the beginning of 1908. In the first version, on the other hand, there are Impressionistic iridescences in the rapidly brushed and sketched areas, creating a sort of vibration that contradicts the clarity of drawing and the general simplicity of the canvas. — I. M. F.

French Window at Collioure (Porte-fenêtre à Collioure), September–October 1914 (cat. no. 12)

Matisse painted this work at Collioure, during the end of the summer of 1914. His intention was to fill the central area with a view, but now only the rails of the balcony remain, covered in black yet still visible in the wavering light. The last day he worked on the canvas, Matisse removed part of these elements and covered this area with a wash of black. He did not sign the canvas, but kept it. It was not discovered, restored, and exhibited until after his death.

The theme of the window, especially after 1905, is essential to Matisse's works, as many art historians have noted. For Matisse, the window was not a boundary or separation—on the contrary, it was a privileged site where the cohesion of space, its continuity both inside and out, became visible. A metaphor for painting is thus pushed to the extreme: the formal identification of the rectangular canvas with the rectangular window is not part of the painting, but all of it. The four sides of the stretcher determine the four sides of the French window, and nearly constitute its frame. Matisse's endeavor to simplify painting is made radical here by the wash of black applied at the last moment, a decision that has disturbing and subtle effects. *French Window at Collioure* constitutes an important moment in Matisse's work: a point of no return, but also the signpost of future experimentation; it is as if this black, annulling the pinks, oranges, and greens of the windows painted ten years earlier in Collioure, was nonetheless their exact equivalent, containing all the colors and the sparkling light of the French Midi, through a reversal that Matisse would never cease exploring. — I. M. F.

The Italian Woman (L'Italienne), 1916 (cat. no. 13)

Matisse often painted the same subject in versions that range from relatively realistic to more abstract or schematic. At times, the transition from realism to abstraction could be enacted in a single canvas, as is the case with *The Italian Woman*, the first of many portraits Matisse painted of a professional Italian model named Laurette. The purposefully visible pentimenti and labored convergence of lines bear witness to his perpetual struggle "to reach that state of condensation of sensations which constitutes a picture." Matisse was not interested in capturing momentary impressions; he strove to create an enduring conception.

From the earlier state of the portrait, which depicts a heavier woman, Matisse pared down Laurette's image, in the process making her less corporeal and more ethereal. Using the conventions of religious painting—a frontal pose, introspective countenance, and flat background devoid of any indication of location—he created an icon of Woman. The emphatic eyes and brow, elongated nose, and pursed lips of her schematic face resemble an African mask, implying that Matisse, like so many Modern artists, equated the idea of Woman with the foreign, exotic, and "primitive"; he continued in this vein, posing the same model with a turban and a mantilla.

The spatial ambiguity of this portrait—the way the arms appear flat while the background overtakes a shoulder, for example—reveals Matisse's relationship to Paul Cézanne via the bolder experiments of Cubism. In a 1913 portrait of his wife, Matisse had played with the distinctions between volume and plane by including a flattened scarf that wraps around her arm. This treatment anticipates the shawllike background of *The Italian Woman*. These paintings recall Cézanne's series of

portraits of Madame Cézanne (one of which was owned by Matisse) both formally and iconographically, although Matisse's images are more radically schematized and distilled.

The austerity of color and severe reduction of *The Italian Woman* is characteristic of Matisse's work from 1914 to 1918. The art historian Pierre Schneider has suggested that these elements embody the artist's response to the devastation of World War I. —J. B.

Portrait of Greta Prozor (*Portrait de Greta Prozor*), late 1916 (cat. no. 14)

A frequent visitor to the artistic and literary milieus of Paris in the 1910s, Greta Prozor was the daughter of a Lithuanian intellectual and the wife of one of the many Scandinavian students at the Matisse Academy. Many drawings and two engravings preceded or accompanied the execution of this portrait, which never belonged to the model. According to Greta Prozor, who recorded her memoirs in 1967 for La Radio Suisse Romande, Matisse said "after a few sessions, that he had reached a point that did not satisfy him but that he could not go any further, and excused himself for having disturbed her." And yet the painting is fully part of the series of portraits from the period between 1913 and 1917, many of which are major works and, paradoxically, are among the most abstract that Matisse ever painted.

Here Matisse uses the dark palette of gray, black, and dark blue which marked the years of World War I, yet which also corresponds to the austerity of the model's dress—a high stiff collar, a dark hat with little adornment, and a severe hairstyle. But the gilded ocher found both below and on top of the gray modulates the ensemble; it gives these superimpositions transparency and light and, like the background of a traditional icon, helps to sacralize this tall, thin figure. The role of the black lines, as in other contemporary paintings, is neither to outline the shapes nor to emphasize areas of color: according to poet and scholar Dominique Fourcade, they "run through the color. . . . run through space, from one shape to another, to set tensions into play . . . Matisse assigns them the task of speaking of a second subject, a sort of super-subject, which would be the moral person or the poetic being of the model and the only way to gain access to her truth." —I. M. F.

The Dream (*Le Rêve*), 1935 (cat. no. 94)

In 1935, Lydia Delectorskaya posed for Matisse on a regular basis. The meeting of a new model coincided with, or even set into motion, a different crystallization, and it made a new series possible. We know how important the relationship to the model was for Matisse, who declared in 1939: "My models, human forms, are never *walk-ons* in an interior. They are the principle theme of my work. I depend absolutely on my models, whom I observe freely and only afterward decide to position in a pose that most corresponds to their natu-

ral inclinations. When I take a new model, it is in the abandon of resting that I divine the pose that suits her, and to which I enslave myself." The pose of *The Dream*, painted in April and May, was thus specific to the new model. It would be reused in *Blue Eyes* (*Les Yeux bleus*, 1935) and on many other occasions, in drawing and painting, in the following years.

Developed at the same time as *Large Reclining Nude [The Pink Nude]* (*Grand nu couché [Nu rose]*), the most important painting of the year 1935, painted from May to November, *The Dream* constitutes a preparatory stage: it has the same checked cloth on the sofa, the harmony between blue and pink, and the exploration of an arabesque highlighting and differentiating the figure as simply as possible on a unified ground. But all this, expressed here with a serene tenderness, would be pushed to the extreme in *The Pink Nude*, a harsher, more radical canvas, more directly prefiguring the cutout gouaches. —I. M. F.

The Sorrow of the King (*La Tristesse du roi*), 1952 (cat. no. 15)

This large composition is probably related to a Biblical theme, but does it relate to "The Song of Songs" (which Matisse was considering illustrating at the time), or to Salomé dancing before Herod? Above all, it presents a reflection on old age and memory, a subject that had been addressed before Matisse by artists such as Nicolas Poussin, Titian, Rembrandt, and Pierre-Auguste Renoir (the latter two especially admired by Matisse). As art historian Pierre Schneider notes, *The Sorrow of the King* "is not only the plastic equivalent of reflections on aging, which were finally withdrawn from *Jazz*; it is also an homage to the painter of *David and Saül* [Rembrandt]." In spite of the jubilant audacity with which Matisse used his technique of cutout gouache, this painting is a classical and final self-portrait of the painter as an old man, amidst the "calm voluptuousness . . . of the sky, the waves, the splendors" enumerated by poet Charles Baudelaire in *La Vie antérieure* (1857). —I. M. F.

Roberto Matta

b. 1911

Roberto Sebastian Antonio Matta Echaurren was born November 11, 1911, in Santiago. After studying architecture at the Universidad Católica in Santiago, Matta went to Paris in 1933 to work as an apprentice to the architect Le Corbusier. By the mid-1930s, he knew André Breton, Salvador Dalí, and the poet Federico García Lorca. In 1937, he left Le Corbusier's atelier and joined the Surrealist movement. That same year, Matta's drawings were included in the Surrealist exhibition at Galerie Wildenstein in Paris. In 1938, he began painting with oils, executing a series of fantastic landscapes that he called "inscapes" or "psychological morphologies."

In 1939, Matta fled Europe for New York, where he associated with other Surrealist emigrés including Breton, Max Ernst, André Masson, and Yves Tanguy. The Julien Levy Gallery, New York, presented a solo show of his paintings in 1940, and he was included in the *Artists in Exile* exhibition at the Pierre Matisse Gallery, New York, in 1942. During the 1940s, Matta's paintings anticipated many innovations of the Abstract Expressionists and significantly influenced a number of New York School artists, in particular his friends Arshile Gorky and Robert Motherwell. Toward the end of the war, he painted increasingly monstrous imagery; the appearance of mechanical forms and cinematic effects in Matta's work reflects the influence of Marcel Duchamp, whom he met in 1944. He broke with the Surrealists in 1948 and returned to Europe, settling in Rome in 1953. A mural for the UNESCO building in Paris was executed by the artist in 1956. In 1957, he was honored with a retrospective at the Museum of Modern Art, New York. His work was exhibited at the Nationalgalerie, Berlin, in 1970 and at the Kestner-Gesellschaft, Hannover, in 1974. A retrospective of his work was presented at the Musée national d'art moderne, Paris, in 1985. Since that year, museums and galleries have organized solo exhibitions regularly in Europe and America. The artist lives and works in Italy.

Years of Fear, 1941 (cat. no. 229)

Fusing his architectural background with Surrealist concerns, Matta began to reconceptualize architecture as a malleable means of giving concrete form to unconscious urges. Like the Surrealists, Matta was disenchanted with familiar appearances and instead strove to convey emotions and experiences using the automatist technique. "Instead of showing something still, like a still life," he asked, "why not show life actually changing?" His "psychological morphologies" were the response to this challenge, an attempt to capture the mutable nature of human experience. In this effort, he was also influenced by Duchamp's *The Passage from Virgin to Bride* (1912), which first suggested to Matta the possibilities for representing metamorphosis on canvas. Using rags, sponges, and brushes to build up layers of pigment, Matta then rubbed away random areas to expose new forms beneath the surface. *Years of Fear* reveals the results of this technique in the amorphous, free-floating forms that imply a transformative process. In keeping with the term "inscape," which denotes a kind of mental landscape, Matta's earliest paintings were organized around a vestigial horizon; in *Years of Fear*, all traces of this representational device have disappeared, subsumed in a vortex of fluid paint. The painting was executed a few years after his arrival in New York in 1939—when he fled the war in Europe along with many of his Surrealist associates—and its title may be a reference to the fears and uncertainties endured during this period in exile. —J. F. R.

Xpace and the Ego, 1945 (cat. no. 232)

The appearance of a very large-format "screen," for which the foundation had already been laid with the 1943 triptychs *Prince of Blood* and *La Vertu noire*, marks the artist's decisive step in asserting a "new image of man." It is an ostentatious, shattering return to a "figuration" that the Americans saw as a surrender, the Surrealists as a betrayal. This painting presents a huge unified space, rendered tactile merely by variations of color and material. Further unified by a web of vibrant lines slashing through it, this composition has often been likened to the skeins of criss-crossing string set up by Duchamp in the *First Papers of Surrealism* exhibition in 1942. Totemic bodies, with limbs stretched and bent (reminiscent of Alberto Giacometti's *Invisible Object* [*L'Objet invisible*], the plaster cast of which Matta had acquired in 1943), with faces and hands contorted and clenched like talons (one thinks, again, of Giacometti's *Women with Their Throats Cut* [*Femmes égorgées*, 1932], here in the grips of one another). All of them are subjected to the same force, the dramatic force of Eros, and the death wish that violently dictates relationships between humans—the "Being-with," as Matta would put it.

These oddities may give a hint of the painting's personal "history," later revealed by Matta himself. It was apparently painted *over* the canvas of the

famous *Glassmaker* (*Vitreur*) executed in 1944, which had created an immediate sensation in New York. Matta then "erased" the work following a violent altercation, at Pierre Matisse's, with Breton and Ernst, who reproached him for having given "too human" a form to what Matta called the "new myth" of the transparent. Judging from the sole surviving documentation of *Glassmaker* (Breton repented and reproduced it in *Surrealism and Painting* in 1946), Matta, in superimposing *Xpace* on it, got rid of all architectural structure and reduced the "motifs." By accentuating the tonal and formal unity of the pictorial surface, he favors, simultaneously, and perhaps even ironically, the "gesture" and the line. And if the very spontaneity and rapidity of its realization—the continuous burst of the stroke, the drippings, the splashes, the visible marks of the work of the brush or rag—managed superficially to correspond to the orientation of his New York friends, one should make no mistake as to Matta's intentions: having disappeared in the title of *Xpace and the Ego*, the Glassmaker seems to reappear in the translucent avatars, the different "states of existence" of the ego dissolved in a space itself transparent.

During the period of this work, Duchamp had played an extremely influential role in Matta's life. Starting with Matta's drawing of *The Great Transparent Ones* (*Grands Transparents*, 1942) and up to the appearance of the *Glassmaker*, and in that truly "Duchampian suite" of such paintings as *Locus Solus*, *Years of Fear*, and *The Bachelor's Twenty Years of Fear* (all 1941), Matta never stops referring to Duchamp, the creator of *The Large Glass*. In a text Matta published about *The Large Glass* in 1944, he reiterates his fascination with the juxtaposition of substances—paint, glass, mirror—and with the fissures (concentric and rectilinear) of Duchamp's masterwork. All of these qualities are present in Matta's 1944–45 paintings, yet he builds his own myth of the great transparent through the use of explicit figuration in the "anatomical" morphology of the erased composition and in its replacement, *Xpace and the Ego*. Matta's intention is to involve the Glassmaker in a social and historical reality, somewhere between primitivism and science fiction. In this regard, *Xpace and the Ego* (and his subsequent work, *Being With* [*Etre avec*, 1945], even more so) take on the value of a manifesto. —A. L. B.

Mario Merz

b. 1925

Mario Merz was born January 1, 1925, in Milan. He grew up in Turin and attended medical school for two years at the Università degli Studi di Torino. During World War II he joined the anti-Fascist group Giustizia e Libertà and was arrested in 1945 and confined to jail, where he drew incessantly on whatever material he could find. In 1950, he began to paint with oil on canvas. His first solo exhibition, held at Galleria La Bussola, Turin, in 1954, included paintings whose organic imagery Merz considered representative of ecological systems. By 1966, he began to pierce canvases and objects, such as bottles, umbrellas, and raincoats, with neon tubes, altering the materials by symbolically infusing them with energy.

In 1967, he embarked on an association with several artists, including Giovanni Anselmo, Alighiero Boetti, Luciano Fabro, Jannis Kounellis, Giulio Paolini, Giuseppe Penone, Michelangelo Pistoletto, and Gilberto Zorio, which became a loosely defined art movement labeled Arte Povera by critic and curator Germano Celant. This movement was marked by an anti-elitist aesthetic, incorporating humble materials drawn from everyday life and the organic world in protest of the dehumanizing nature of industrialization and consumer capitalism.

Also in 1967, Merz adopted one of his signature motifs, the igloo. It was constructed with a metal skeleton and covered with fragments of clay, wax, mud, glass, burlap, and bundles of branches, and often political or literary phrases in neon tubing. He participated in significant international exhibitions of Conceptual, Process and Minimalist art, such as *Arte povera + azioni povera* in Amalfi at the Arsenali dell'Antica Repubblica in 1968 and *Live in Your Head: When Attitudes Become Form* at the Kunsthalle Bern in 1969, which traveled to Krefeld and London. In 1970, Merz began to utilize the Fibonacci formula of mathematical progression within his works, transmitting the concept visually through the use of the numerals and the figure of a spiral. By the time of his first solo museum exhibition in the United States, at the Walker Art Center, Minneapolis, in 1972, he had also added stacked newspapers, archetypal animals, and motorcycles to his iconography, to be

joined later by the table, symbolic as a locus of the human need for fulfillment and interaction. Merz often responds to the specific environment of his exhibitions by incorporating materials indigenous to the area as well as adjusting the scale of the work to the site. His first solo European museum exhibition took place at the Kunsthalle Basel in 1975, and his most recent retrospective was organized by the Solomon R. Guggenheim Museum, New York, in 1989. Merz works in Turin, where he resides with his wife, artist Marisa Merz.

Giap Igloo (Igloo di Giap), 1968 (cat. no. 330)

In the years 1966–68, which Celant has defined as a period of the "aestheticization of the real," Merz privileged the properties of excess and the free use of materials and signs in his search for a "veritable anti-iconography."

Giap Igloo, exhibited in 1969, together with two other works, Sit-in (1968) and Clay Igloo (1969), at the Sonnabend gallery in the artist's first solo show in Paris, was one of Merz's very first igloos. It is a metal structure—a skeleton of a sort—in the form of a hemisphere, over which a metal-wire trellis has been fastened. This is covered with small bags of plastic filled with clay. Numerous documentary photographs, including those of the Prospect 68 exhibition in September 1968 at the Düsseldorf Kunsthalle, and of installations at the Sonnabend and Konrad Fischer galleries, show different forms of realization of the igloo. The clay dirt sometimes appears naked, as in Clay Igloo, sometimes placed in bags, as in this igloo. Over the outside of the latter, in capital neon letters, is the statement of General Giap in Italian: SE IL NEMICO SI CONCENTRA PERDE TERRENO SE SI DISPERDE PERDE FORZA. GIAP (If the enemy masses his forces he loses ground; if he scatters, he loses strength).

Merz says he wanted to free himself "of the diver's suit that painting was." For him, "the igloo was born through a kind of knowledge" and embodies organic form par excellence. It is at once "the world" and a "little house." This fragile space, however, is not a retreat but rather, first and foremost, a figure of the duality of the inside and outside worlds, of a dialectic of opposites, on the borderline between emptiness and fullness. Merz says such a construction is always made "to shelter oneself, to confer some social dimension on man." The image of survival, the igloo is at once a nomadic structure and a home. Its existence is in no way related to that of architecture, but arises instead from the need to survive. The igloo thus presents itself as an anti-architecture, for it corresponds not to any mathematicization of space, but only to the precariousness of the immediate. "When I made the igloo," says Merz, "I acted with the power of the imagination, because the igloo is not only an elementariness of form but also a support for the imagination." The writing of General Giap's formulation in a spiral of neon tubes evokes at once the spiral as a symbolic form, a figure of the open work, and the Fibonacci progres-

sion, a "spiraloid organization different from Renaissance perspective." It also bears witness to the incursion in the work of a text that underscores the reality and necessity of a political implication. "For Giap, it's not a political solution, but a kind of Buddhist perception of war and the life of war. . . . What is manifest here," insists Merz, "is the Buddhist zero, and it's a construction that is supposed to recall zero-sums."

Contemporary with the Vietnam War, this work of Merz's was dictated by a system "more philosophically than religiously Buddhist"; it bore witness to the demands of that time. The igloo was at once a symbol of solitude and a manifesto. —B. B.

Henri Michaux
1899–1984

Henri Michaux was born May 24, 1899, in Namur, Belgium. His early childhood was spent in Brussels and his adolescence in a country boarding school where he majored in Flemish studies. From 1911 to 1917, he attended Jesuit College, Brussels, where he began to write. He studied medicine in 1919, but soon abandoned these studies to work as a ship's stoker visiting Holland, the United States, Argentina, Brazil, and France from 1920 to 1921. Returning to Brussels to work as a freelance writer and poet, Michaux's writings were first published in 1922, and within two years he had already gained recognition as an author. He moved to Paris, where he saw the work of Giorgio de Chirico, Max Ernst, and Paul Klee. During the mid-1920s, he began to draw and paint in his spare time, although he had no formal artistic training. In 1927, his first important book, Who I Was (Qui je fus), was published in Paris.

From the late 1920s to the late 1930s, Michaux traveled extensively, visiting Turkey, South America, India, and China, and wrote numerous books about his journeys. He began to draw and paint on a regular basis in 1937 and was given his first exhibition at the Librairie-Galerie de La Pléiade, Paris. In 1941, he married Louise Ferdiere, whose death in a tragic accident in 1948 drove him to produce hundreds of pen, ink, and wash drawings in a two-month period. Michaux

most often used india ink but he also worked in mediums such as oil and pastel. His series include the Alphabets (1924–34); Black Backgrounds (1937–38); Frottages (1944–47); and Movements (1950–51).

In 1954, Michaux began to experiment with hallucinogens, primarily mescaline, and from this time until 1962 he attempted to depict his drug-induced visions. These notorious drawings, some densely packed with rhythmic script, others with looser markings, are similar to automatic writing as explored earlier in the century by the Surrealists. Michaux has also given written accounts of these experiences in five books, including Misérable Miracle (1956). In 1960, he received the Prix Einaudi, Venice. In 1964, a Michaux retrospective was held at the Musée national d'art moderne, Paris, and his work was the subject of the film H.M. ou l'espace du dedans (1965). He refused the award of the Grand Prix National des Lettres, Paris, in 1965. The Galerie le Point Cardinal, Paris, began to represent Michaux in 1966 and showed his work regularly throughout the next decade. In 1978, the Musée national d'art moderne, Paris, held another retrospective, which traveled in part to the Solomon R. Gugenheim Museum, New York, and the Musée d'art contemporain, Montreal. Michaux died October 17, 1984, in Paris.

Prince of the Night (Le Prince de la nuit), 1937 (cat. no. 237)

This work is illustrated as part of a series of sixteen gouaches and pastels on black backgrounds in Peintures, published in 1938. In that book, Michaux explained his reasons not only for abandoning writing but also for deliberately choosing black in his art. Only this color allowed him "to return to the foundation, the origin, . . . to the basis of deep emotions." This "night of the history of humanity," this nourishing shadow, is the "crystal ball" in which Michaux "sees life emerge." For him, the form in gestation emerges with hesitation from the obligatory black, as the blind gaze of the audience fixes itself on the white ring of "the arena." Revealed as if by a flash, shapes that are still uncertain surge forth, in colors, coming from the night of time. A true moment of anguish, of derision, an act of exorcism, as Octavio Paz has noted, of a great visionary in search of the absolute; the work shows the artist in useless combat with the fugitive nature of a revelation that is destined to bury itself again in darkness. Fluorescences, phosphorescences—the colors explode in a thousand spots, hesitating to keep the shape of the Prince of Night, about whose vanity the poet Michaux writes in Peintures: "Prince of the night, of the double, of the gland in the stars, . . . of the siege of Death, of the useless column, of the supreme interrogation / Prince of the broken crown, the divided reign, of the wooden hand . . . / Prince petrified by the rose of the panther, lost Prince." —A. L. B.

Untitled, 1949 (cat. no. 239)

A face, several faces: the loneliness of being end-lessly repeated, the pain of a silent cry stretching the oval mouth-head open, sounding an echo. Michaux's human faces are riddled with holes, with trails of holes, their eyes and mouth confused in a single, blind gaze. These images from the postwar period, marked by the tragic, accidental death of Michaux's wife in February 1948, are snapshots of horror, anguish, and disarray. The bursts of ocher, blood red, blue, and black in which the features here consume themselves, liq-uefying and dissolving, are signs of a still incan-descent conflagration, a deadly burning. Appearances of distant interiors or disturbing dou-bles, they are "faces of lost people, criminals sometimes, neither known nor complete strangers either (strange, distant correspondences)," to use Michaux's words. "There is a certain inner phan-tom that I should be able to paint, but not the nose, the eyes, the hair—which are on the out-side, often like the soles of one's shoes. A fluid being that does not correspond to the skin and bones above." The formless, tremulous flow of the watercolor, drifting, spilling, escaping, and the sharp "flash" of little particles of colored gouache give temporary substance to these residual frag-ments of flayed beings, calling to mind the draw-ings of Antonin Artaud. On humble paper as sensitive as a sunflower leaf or a photographic plate, strange infiltrations occur; the simulacra of a latent figuration cast their impression. These are the precise phenomena of apparitions—of disap-pearances, of revelations, of recognitions. Full-scale trials, petrifying proofs rise up from the page: "The incandescent eyes of fate watch me unfold a disaster I cannot comprehend."

For the first time in his work, several hundred watercolors followed one immediately after the other at an unheard-of pace, definitively establish-ing Michaux as a painter. On the occasion of the two large exhibitions at the Galerie Drouin in 1948 and 1949, Henri-Pierre Roché underscored Michaux's need for exorcism: "His inspiration was so intense that sometimes he would throw down the finished gouache with his left hand while his right, without ever stopping, was already tracing a new one." This totally hypnotic, hallucinatory pro-cess led to a formidable speed of execution, which he would find again in his mescaline drawings and large, abstract ink blots of the 1950s. Here, however, Michaux has not yet abandoned the need for figuration and his obsessive questioning of facial apparitions, which issues from Paul Valéry's reflexive poem "*Se voir se voir*": "What are all these faces? Do they belong to others? Out of what depths? Might they not be simply the conscious-ness of my reflecting head?" —A. L. B.

Mescaline Drawing (*Dessin mescalinien*), 1958 (cat. no. 241), and *Mescaline Drawing* (*Dessin mescalinien*), 1958–59 (cat. no. 240)

Throughout Michaux's oeuvre, both literary and visual, the artist is driven by questions of greater

knowledge—the passion to understand nature, the universe, the self, and the spirit. Motivated by this sense of exploration, in 1954 Michaux began to use the hallucinogenic drug mescaline. While Michaux has become notorious for the five books he wrote describing these experiences and the numerous drawings and paintings he made in the wake of his hallucinations, these works are part of a continuum of ideas.

Michaux wrote that "mescaline multiplies, sharpens, accelerates, intensifies the inward moments of becoming conscious." Following his third experiment with mescaline, Michaux began to record his heightened sense of *l'espace du dedans* (the space within) by making drawings, mainly in india ink. Initially the drawings are very small and executed rapidly, in an attempt to cap-ture the terrific speed of his visions. Saturated with scrawled marks and overlapping forms, these drawings indicate a space that is infinite—at the same time both microscopic and immense.

Michaux first exhibited his mescaline drawings and paintings under the title *Description d'un trouble* at La Hune in Paris in January 1956. Also exhibited was his first book dealing with hallucina-tory phenomena, *Misérable Miracle*, in which Michaux wrote, "Mescaline upsets the composi-tion." In these drawings, balanced composition is replaced by a repetition and multiplication of forms. Some of the terms Michaux used to describe the forms elemental to his hallucinations include "zigzag lines," "points," "shafts," "pinnacles," "tips," "microscopic columns," "loops," "spirals," "extraordinary mountains," "furrows," "fissures," "ruins," "broken s's," and "incomplete o's."

By 1959, there was a change in Michaux's rela-tionship to the mind-altering drug: "We are no longer on the same terms with each other, mesca-line and I." At this time, Michaux's use of mes-caline was more controlled and conscious than in his earlier experiments. He had written, "To enjoy a drug, you have to like being a subject," but instead of being overtaken by the drug experience, his activity was by this point no longer passive. The two drawings shown here were made on the cusp of this change. They are larger and more expansive, illustrating the impressions of his new awareness, rather than literally documenting the vibrations of direct experience. —T. B.

Untitled, 1959 (cat. no. 242)

The first inks of 1950 made it possible for Michaux to juxtapose the multiple signs of the var-ious "Movements" within him—the aggressions, the disorders, the buried rejections. As such, these signs constituted a veritable "liberating" alphabet. In a new series *Peintures à l'encre* (*Ink Paintings*) executed between 1954 and 1956, then in a second in 1959, ink imposed itself as a material and became a disorderly projection, thrown in large blots and bursts on the paper. But the actual movement of these blots is problematic: bursting with ink, these "large indolent blobs capable of sprawling out everywhere . . . force him to see

clearly right away." Michaux jokingly described himself as "a *tachiste*, if I am one, who cannot tol-erate blots." To thwart their menacing inertia, forced to great rapidity of execution, the painter multiplies them in succession, making them sweep the space in every direction so that, quickly proliferating, they become an allover kind of com-position. As if filmed in their wild course, these blots, which are never abstract but always return to the human, disobey every order: here scattered, there clustered together, sometimes arranged in lines of combat, often moving in a large flux. They are whirlwinds, explosions, expeditions, floods, collisions—they are painting in migration. These inks suggest strange tales, strange geographies. —A. L. B.

Untitled, 1965 (cat. no. 238)

Characteristic of the artist's watercolors completed during this period, *Untitled* contains the image of a head and shoulders, sketched in a few strokes of paint, in blurred and disjointed lines that appear to have been made quickly and intuitively. Michaux's interest in working rapidly as a means of tapping into unconscious images may have come from his early contact with the Surrealists and from his familiarity with their experimental techniques. Michaux also believed that, since he never had formal art training, his work remained genuinely instinctive.

Schematic heads and faces frequently appear in Michaux's oeuvre, arising from the automatic pro-cesses he explored and introducing questions of identity and recognition that continually occupied the artist. As the artist himself mused, "Draw without anything particular in mind, scribble mechanically and faces almost always appear on the paper. Are they mine or someone else's? From what depths do they emerge?" —T. B.

Untitled, 1970? (cat. no. 243)

Michaux is frequently categorized as a Surrealist, although he never fully embraced the world view of this movement. He was interested in the meth-ods the Surrealists employed in order to gain bet-ter access to the realm of unconscious thought, and he appreciated the fact that their paintings did not merely "repeat reality."

Long after dissociating himself from the Surrealists, however, in 1954, he began to make his first india ink paintings according to a tech-nique that brings them to mind. As he described it, "One day I finally did it straight out. I emptied [the ink] out of the bottle with jerky movements and let it spread." In a combination of chance and manipulation, he created ink blots that suggest figurative images. Yet the works remain abstract, and Michaux firmly held that they should not be interpreted according to their imagery.

Michaux combined acrylic or oil paint with his india ink–blot technique during the 1970s. In *Untitled*, the ink blots turn into "dark pseudopods" moving collectively on a background of horizontal strokes of acrylic paint. The suggestion of a hori-

zon line and the patchy paint areas turn the background plane into a rough and unfamiliar landscape. In this setting, the blots can evoke human or animal likenesses, or elements in an otherworldly terrain. —T. B.

Joan Miró
1893–1983

Joan Miró Ferra was born April 20, 1893, in Barcelona. At the age of fourteen, he went to business school in Barcelona and also attended La Lonja, the academy of fine arts in the same city. Upon completing three years of art studies, he took a position as a clerk. After suffering a nervous breakdown, he abandoned business and resumed his art studies, attending Francesc Galí's Escola d'Art in Barcelona from 1912 to 1915. Miró received early encouragement from the dealer José Dalmau, who gave him his first solo show at his gallery in Barcelona in 1918. In 1917, he met Francis Picabia.

In 1919, Miró made his first trip to Paris, where he met Pablo Picasso. From 1920, Miró divided his time between Paris and Montroig. In Paris he associated with the poets Max Jacob, Pierre Reverdy, and Tristan Tzara and participated in Dada activities. Dalmau organized Miró's first solo show in Paris, at the Galerie la Licorne in 1921. His work was included in the Salon d'Automne of 1923. In 1924, Miró joined the Surrealist group. His solo show at the Galerie Pierre, Paris, in 1925 was a major Surrealist event; Miró was included in the first Surrealist exhibition at the Galerie Pierre that same year. He visited the Netherlands in 1928 and began a series of paintings inspired by Dutch masters. This year he also executed his first *papiers collés* and collages. In 1929, he started his experiments in lithography, and his first etchings date from 1933. During the early 1930s, he made Surrealist sculptures incorporating painted stones and found objects. In 1936, Miró left Spain because of the civil war; he returned in 1941.

An important Miró retrospective was held at the Museum of Modern Art, New York, in 1941. That year, Miró began working in ceramics with Josep Lloréns y Artigas and started to concentrate on prints; from 1954 to 1958, he worked almost exclusively in these two mediums. In 1958, Miró was given a Guggenheim International Award for murals for the UNESCO Building in Paris; the following year he resumed painting, initiating a series of mural-sized canvases. During the 1960s, he began to work intensively in sculpture. A major Miró retrospective took place at the Grand Palais in Paris in 1974. In 1978, the Musée national d'art moderne, Paris, exhibited over five hundred works in a major retrospective of his drawings. Miró died December 25, 1983, in Palma de Mallorca, Spain.

Bather (Baigneuse), winter 1924 (cat. no. 208), and *The Siesta (La Sieste)*, 1925 (cat. no. 209)

The canvases of 1924, and especially those of 1925, mark an important shift in Miró's work. For the first time there appear not only the customary repertory of personal signs and symbols but also an open pictorial space that is monochrome and without landmarks, nearly void. Although they are always based on reality, which Miró never wanted to abandon completely, these canvases also suggest the notion of a "dreamscape." *Bather* is inspired by a relatively simple theme, yet its execution—the monochromatic ground, the appearance of signs and the organization of space—already demonstrates an exceptionally audacious economy, similar to that of *Personage*, of the following year.

The Siesta is more complex in inspiration. In order to interpret this painting, it is necessary to refer to two preparatory drawings at the Fundació Joan Miró, Barcelona. In the first, an exceptionally descriptive and precise drawing, a woman is covered with a sheet, lying on the ground in front of a house with a sundial; on the beach, in the distance, four figures dance in a circle, while a fifth swims in the sea; above them are the peaks of the Montroig mountains, and a flaming sun rises in the sky. A second preparatory drawing is more directly related to the canvas, with emptier pictorial space and a more economic use of signs. In his *Catalan Notebooks* (1976), Miró later commented, "The eye of the woman looks at the number, Noon: the hour for eating and sleep." Steeped in the blue which invades the pictorial space in gentle waves and becomes the very field of his dreamlike vision, Miró thus devoted himself to a process of synthetic, almost abstract "recasting" of the different figurative elements: the woman and the house are joined in a single silhouette, a sort of white kite; the hands of the sundial are enlarged and indicate the number 12, siesta time; the ring of dancers are translated into a circle of dots; the peak of the mountains becomes a sort of inverted umbrella; and the sun is now a whirlwind in the sky, a symbol often present in Miró's later works. —A. L. B.

The Check (L'Addition), 1925 (cat. no. 212)

There is every reason to believe that the enigmatic, comical configurations spread across the large glued surface of *The Check* have a literary origin in Alfred Jarry's 1902 novel *The Supermale (Le Surmâle)*. In 1925, Miró was living on the rue Blomet with three poets, who had introduced him to the writings of Arthur Rimbaud, the Comte de Lautréamont, and, especially, Jarry, who made a strong impression on him. In *The Supermale*, the hero asserts that a man can make love an infinite number of times: put to the test, he gets down to business with his partner Ellen. Is he not perhaps evoked in the figure at the bottom left, disguised as a Native American (with feather and painted body) as the text describes him, and endowed with an outsized phallus? The eye of Dr. Bathybius, the only witness to the exploit, would be indicated by the circle from which a stream of dotted lines emerges, with the column of numbers indicating the counting he has undertaken. In Jarry, the body of the pale young woman ends up decomposing: Miró here reduces her to a bloodless face and a simple wire line.

As for the very particular aspect of the two figures in profile—crude masks mounted on stems, as found in many of Miró's canvases of the same date—it is very likely that they too come from Jarry. The first theatrical presentation of *Ubu Roi*, another of Miró's favorite books, in 1888, used marionettes; reproduced in *Les Soirées de Paris* in 1914, they have identical bean-shaped heads and bodies animated by the same wires. —A. L. B.

Painting (Peinture), 1925 (cat. no. 211)

In Miró's private system of imagery, motifs have symbolic meanings that vary according to their context. By studying the constellations of these motifs, one is encouraged to infer meanings appropriate to a particular painting. Two "personages" (the designation Miró used for his abstract figures) and a flame have been identified in this work. The personage on the right can perhaps be read as a female because of the curvaceous nature of the figure eight, and by analogy with forms in other paintings that are specifically identified by the artist as women. The black dot with radiating lines can be interpreted as the figure's eye receiving rays of light, or as a bodily or verbal emission, as in *Personage*, also of 1925. Moons, stars, suns, or planets float at the upper left of several canvases of the mid-1920s. In *Painting*, the semicircular orange-red image not only carries a cosmic implication, but also possibly doubles as the head of the second personage, probably a male. This head is presented in a combined full-face and profile view, in the manner of Picasso's Cubist portraits.

The flame, used repeatedly by Miró in this period, may signify sexual excitation in this context. The erotic content that prevails in much of his work in 1925 is particularly explicit in the *Dream* series (1925–27), in which two figures either approach each other or are united in sexual embrace. The two figures in *Painting* are less clearly conjoined. The submersion of legible subject matter and the ambiguity of the painting's meaning transfer the emphasis to the purely

abstract qualities of the work. Line and color articulate a language as complex and poetic as the hieroglyphic signs that constitute the imagery. The generalized ground, rich in texture from the uneven thinning of paint and the use of shadowy black, provides a warm and earthy support for the expressive black lines, the areas of red and yellow, and the staccato rhythm of dots. — L. F.

Personage (*Personnage*), summer 1925 (cat. no. 210)

In 1925, Miró's work took a decisive turn, stimulated, according to the artist, by hunger-induced hallucinations involving his impressions of poetry. These resulted in the artist's "dream paintings," such as *Personage*, in which ghostly figures hover in a bluish ether. Miró explored Surrealist automatism in these canvases, attempting to freely transcribe his wandering imagination without preconceived notions. Although these images are highly schematic, they are not without references to real things. In Miró's language of enigmatic signs, the forms in *Personage* depict a large vestigial foot and a head with three "teeth" in its grinning mouth; the star shape often represents female genitalia; and the dot with four rays symbolizes the vision of a disembodied eye. "For me a form is never something abstract," he said in 1948. "It is always a sign of something. It is always a man, a bird, or something else. For me painting is never form for form's sake." — J. B.

Object of Sunset (*L'Objet du couchant*), summer 1935–March 1936 (cat. no. 213)

Miró began to make strange objects in the early 1930s. Formerly owned by André Breton, *Object of Sunset* consists of a piece of wood painted red and decorated with bits of scrap iron that were intended to represent a couple. At least one precedent for this work dates back to 1933, when Miró cut out an advertisement of a battery with a similar silhouette, with springs on top. From 1933, too, there is a sketch of the *Object of Sunset* in its full conception, even including the female genitals on one side. This drawing is found in a sketchbook that was reused and completed in 1941, and in which Miró made more studies for this sculpture, following his usual procedure of giving himself some temporal distance from his subject in order to better grasp it. The juxtaposition of these two series of drawings, the one from 1933, the other from 1940–41, has created some confusion concerning the date of the object.

Miró later recalled in a letter, "It was made and painted in Montroig, with the trunk of a carob-tree, a tree of great beauty grown in this country. . . . [The] other objects were found at random during my walks. I'd also like to point out, and this is extremely important, that when I find anything at all, it is always due to magnetic forces that are stronger than me, that I am drawn in and fascinated. I brought this object back to Paris exactly as it was, to the Récamier hotel. . . . [It] is there that Pierre Matisse and Pierre Loeb came to see me to divide up my works, and I can't say

which of the two took it away, nor how, nor at what date it ended up with André Breton . . . I can tell you, just for the record, that everyone considered this object a farce, except, of course, André Breton, who was immediately struck by its magical side." Thus created in Montroig around 1935–36 and brought to Paris before Miró's period of exile from 1936 to 1940, *Object of Sunset* remained in France and was exhibited in the May 1936 *Exhibition of Surrealist Objects*, Galerie Charles Ratton, Paris, and acquired at that time by Breton. — A. L. B.

Blue I (*Bleu I*), March 1961 (cat. no. 221), *Blue II* (*Bleu II*), March 1961 (cat. no. 222), and *Blue III* (*Bleu III*), March 1961 (cat. no. 223)

This series of three monumental canvases was painted between December 1960 and March 1961 in the "grand atelier" in Palma de Mallorca that had been recently constructed by José Luis Sert. At last reunited according to the artist's wishes, these paintings might be considered a triptych marking the attainment—as Miró himself would say—of everything he had been "trying to do." Here the plastic synthesis and "mystical" decantation of his art are carried to an unprecedented scale, one certainly suggested to him by his American experience, after his sojourn in New York in 1959. The trio is the result of a long process of development and concentration, beginning with the first preparatory sketches made on February 27, 1960, and up to those of November 30, 1960, which are just as tiny. This process would culminate in early 1961 with their transposition to painting on a very large scale.

"The three large blue canvases, I took a long time to make them," Miró said. "Not to paint them, but to contemplate them before arriving at the desired bareness. . . . I began by drawing in charcoal, very precisely (I always get to work very early in the morning). In the afternoon, I would only look at what I had drawn. The rest of the day, I would prepare myself internally. And finally, I got down to painting: first the background, all in blue—but it wasn't just a question of laying the color down, like painting a building: all the movements of the brush, of the wrist, the breath of the hand, that all came into it too. 'Perfecting' the background put me in a position to continue the rest. The battle wore me out." The use of brushed blue—a choice consistent with his monochrome color of the 1920s and the propulsive matrix of his "dream paintings"—here becomes almost cosmic in its display, which is that of an infinite spatial field. He punctuates it with pure, minimal signs: lines, points, slashes, or other, more nebulous strokes, so many almost melodic modulations made by the hand, dictated by what Miró called his "Japanese archer-like" gesture, by the spiritual exercises, acts of breathing and of the mind, precisely controlled by the artist. As Margit Rowell notes, these mental landscapes are the "synthesis of the experience of being in the world. They are at once emptiness and fullness, meta-

physical dream and physical, plastic reality. Such are the constellations of signs inscribed onto the cosmic field, but they are more than this as well. They are also the traces of the profound thought and controlled gesture of an individual simultaneously existing and lost." As Miró himself put it, when speaking of these three magnificent blue paintings, "Through the few, very economical lines I've inscribed there, I have sought to give the gesture a quality so individual that it would become almost anonymous and thereby attain the universality of the act." — A. L. B.

Amedeo Modigliani
1884–1920

Amedeo Modigliani was born July 12, 1884 in Livorno, Italy. The serious illnesses he suffered during his childhood persisted throughout his life. At age fourteen, he began to study painting. He first experimented with sculpture during the summer of 1902 and the following year attended the Istituto di Belle Arti in Venice. Early in 1906, Modigliani went to Paris where he settled in Montmartre and attended the Académie Colarossi. His early work was influenced by Paul Cézanne, Paul Gauguin, Théophile Alexandre Steinlen, and Henri de Toulouse-Lautrec. In the fall of 1907, he met his first patron, Dr. Paul Alexandre, who purchased works from him before World War I. Modigliani exhibited in the Salon d'Automne in 1907 and 1912 and in the Salon des Indépendants in 1908, 1910, and 1911.

In 1909, Modigliani met Constantin Brancusi when both artists were living in Montparnasse. From 1909 to 1914, the Italian concentrated on sculpture, but he also drew and painted to a certain extent. However, the majority of his paintings date from 1916 to 1919. Modigliani's circle of friends first consisted of Max Jacob, Jacques Lipchitz, and the Portuguese sculptor Amedeo de Suza Cardoso; later, he associated with

Tsugouharu Foujita, Moïse Kisling, Jules Pascin, the Sitwells, Chaim Soutine, and Maurice Utrillo. His dealers were Paul Guillaume (1914–16) and Leopold Zborowski (by 1917). The only solo show given the artist during his lifetime took place at the Galerie Berthe Weill in December 1917.

In March 1917, Modigliani met Jeanne Hébuterne, who became his companion and model. From March or April 1918 until May 31, 1919, they lived in the south of France, in both Nice and Cagnes. Modigliani died January 24, 1920, in Paris.

Head (Tête), 1911–13 (cat. no. 74), and *Woman's Head (Tête de Femme)*, ca. 1912–13 (cat. no. 75)

Executed between 1909 and 1914, most of Modigliani's sculpted works have disappeared. The twenty-five remaining pieces, which range from rough shapes to completed works, are in stone, with the exception of two, one in wood and the other in marble. Like Brancusi, Modigliani detested Impressionist sculpture, modeling, works cast in bronze, Auguste Rodin, and Medardo Rosso. Convinced, again in agreement with Brancusi, of the necessity of direct cutting in order to restore an impression of hardness, he worked pieces of wood (beams he got from the subway) and blocks of stone (limestone from the vicinity of Verdun, taken from building sites), which give his sculptures their columnar forms. Like the *Caryatids*, the "columns of tenderness" Modigliani designed to support his temple of Beauty, the *Heads*, begun in 1911, seem to respond to an architectural function with their sturdy bases and sometimes unresolved tops. They are clearly related to *The Kiss* series of sculptures begun by Brancusi three years earlier, which have the same appearance of a barely cut block and the same geometrical simplification of features, with prominent eyes and barely inscribed hair.

Of many other suggested influences, two seem certain: the work of Sienese Gothic sculptor Tino di Camaino, for the long cylindrical necks and ovoid heads; and masks made by the Baulé people of Africa, for the general structure of the face, the flat planes of the face, the sharp bridge of the nose and, in some cases, the round and protruding mouth. As early as 1913, one finds the reflection of these sculptures in Pablo Gargallo's metal masks and in André Derain's "gothic" paintings. There exist two preparatory drawings for *Woman's Head*, where we see the same bands of hair, arched eyebrows, and smiling mouth, similar to those of archaic Kores. While the elongated face and enigmatic smile of *Woman's Head* suggest a possible date after 1912, the dating of *Head* may be based on its close resemblance to several sculpted heads that appear in a 1911 photograph and the fact that it was purchased from the artist's studio in 1913. —H. C.

Red Head (Tête rouge), 1915 (cat. no. 76)

This work belongs to a group of portraits made between 1914 and 1916. It especially resembles

Modigliani's portraits of Béatrice Hastings—one sees the same round face, the same red hair in bands and with bangs, the same features, the same gray eyes. The spherical shape of the head, rather uncommon for Modigliani, recalls his first two sculpted heads, perhaps inspired by Brancusi. As in many portraits of this period, Modigliani posed his model against a window casing or a panel that, indicating a diagonal like the knife in traditional still lifes, gives the composition a sense of spatial depth. Perhaps Modigliani was echoing the Cubists' preoccupation with showing both front and side views simultaneously, when he painted several axes and, particularly in the nose, joined certain planes in an asymmetrical way. —SRGM

László Moholy-Nagy
1895–1946

László Moholy-Nagy was born July 20, 1895 in Bacsbarsod, Hungary. In 1913, he began law studies at the University of Budapest, but interrupted them the following year to serve in the Austro-Hungarian army. While recovering from a wound in 1917, he founded the artists' group Ma (Today) with Ludwig Kassak and others in Szeged, Hungary, and started a literary magazine called *The Present (Jelenkor)*. After receiving his law degree, Moholy-Nagy moved to Vienna in 1919, where he collaborated on the Ma periodical *Horizont*. He traveled to Berlin in 1920 and began making "photograms" and Dada collages.

During the early 1920s, Moholy-Nagy contributed to several important art periodicals and coedited, with Kassak, *The Book of the New Artist (Das Buch neuer Künstler)*, a volume of poetry and essays on art. In 1921, he met El Lissitzky in Germany and traveled to Paris for the first time. His first solo exhibition was organized by Herwarth Walden at the Der Sturm gallery in Berlin in 1922. During this period, Moholy-Nagy was a seminal figure in the development of Constructivism. While teaching at the Bauhaus in Weimar in 1923, he became involved in stage and book design and edited and designed, with Walter

Gropius, the Bauhausbücher series published by the school. Moholy-Nagy moved with the Bauhaus to Dessau in 1925 and taught there until 1928, when he returned to Berlin to concentrate on stage design and film.

In 1930, he participated in the *Internationale Werkbund Ausstellung* in Paris. The artist moved to Amsterdam in 1934, the year a major retrospective of his work was held there, at the Stedelijk Museum. In 1935, Moholy-Nagy fled to London from the growing Nazi threat; there, he worked as a designer for various companies and on films and associated with Naum Gabo, Barbara Hepworth, and Henry Moore. In 1937, he was appointed director of the New Bauhaus in Chicago, which failed after less than a year because of financial problems. Moholy-Nagy established his own School of Design in Chicago in 1938 and in 1940 gave his first summer classes in rural Illinois. He joined the American Abstract Artists group in 1941 and in 1944 became a United States citizen. His book *Vision in Motion* was published in 1947, after his death on November 24, 1946 in Chicago.

A XX, 1924 (cat. no. 133)

Presented at the Bauhaus exhibition in Dessau in 1926, where it was conceived, and again in 1934 at the show of the Abstraction-Création group in Paris, *Composition A XX* is no doubt one of the most successful of Moholy-Nagy's paintings that are formal expressions of light. In order to "paint with light," Moholy-Nagy chose smooth surfaces with fine, transparent textures. There is transparency, too, in the intersecting geometric planes, which are at times hardly perceptible. With the austerity of its palette and the economy of its plastic vocabulary, it contrasts sharply with the other compositions of the same period, which are very colorful and complex in their spatial arrangements. It presents, on a frozen and airy ground, only simple, "minimal" shapes: circles crossed by transparent rectangular planes that intersect in space, suggesting a third dimension.

The exploration of luminous structures would lead Moholy-Nagy to the use of new materials. In a few years, he would try to paint on galalith, celluloid, Bakelite, and finally, aluminum; these trials paved the way for his work in kinetic and luminous sculptures. —B. L.

AXL II, 1927 (cat. no. 132)

Moholy-Nagy explored the manipulation of light as a plastic medium in a variety of interrelated disciplines: painting, film, photography, sculpture, and design. In *AXL II*, Moholy-Nagy suggests how light can be both ethereal and dense. Translucent rays emanate from an unidentified source beyond the composition, intersecting at a central cross-axis. Though thin and transparent, these forms appear to support the denser drawing at the center of the painting, which hangs from them as if suspended in an infinite space. As in a typical Bauhaus exercise, the axonometric design suggests how an abstract study of formal relationships

could be adapted to three-dimensional construction, serving as the starting point for the execution of a piece of furniture or a building. — M. D.

Piet Mondrian

1872–1944

Piet Mondrian was born Pieter Cornelis Mondriaan, Jr., on March 7, 1872, in Amersfoort, the Netherlands. He studied at the Rijksakademie van Beeldende Kunsten, Amsterdam, from 1892 to 1897. Until 1908, when he began to take annual trips to Domburg in Zeeland, Mondrian's work was naturalistic—incorporating successive influences of academic landscape and still-life painting, Dutch Impressionism, and Symbolism. In 1909, a major exhibition of his work (with that of Jan Sluyters and Cornelis Spoor) was held at the Stedelijk Museum, Amsterdam, and that same year he joined the Theosophic Society. In 1909 and 1910, he experimented with Pointillism and by 1911 had begun to work in a Cubist mode. After seeing original Cubist works by Georges Braque and Pablo Picasso at the first *Moderne Kunstkring* exhibition in 1911 in Amsterdam, Mondrian decided to move to Paris. There, from 1912 to 1914, he began to develop an independent abstract style.

Mondrian was visiting the Netherlands when World War I broke out and prevented his return to Paris. During the war years in Holland, he further reduced his colors and geometric shapes and formulated his non-objective Neo-Plastic style. In 1917, Mondrian became one of the founders of De Stijl. This group, which included Theo van Doesburg and Georges Vantongerloo, extended its principles of abstraction and simplification beyond painting and sculpture to architecture and graphic and industrial design. Mondrian's essays on abstract art were published in the periodical *De Stijl*. In July 1919 he returned to Paris; there he exhibited with De Stijl in 1923, but withdrew from the group after van Doesburg reintroduced diagonal elements into his work around 1925. In 1930 Mondrian showed with Cercle et Carré and in 1931 joined Abstraction-Création.

World War II forced Mondrian to move to London in 1938 and then to settle in New York in October 1940. In New York, he joined American

Abstract Artists and continued to publish texts on Neo-Plasticism. His late style evolved significantly in response to the city. In 1942, his first solo show took place at the Valentine Dudensing Gallery, New York. Mondrian died February 1, 1944, in New York.

Composition No. I; Composition 1A, 1930 (cat. no. 142)

In 1918, Mondrian created his first "losangique" paintings, such as *Composition No. I* (also known as *Composition 1A*), by tilting a square canvas forty-five degrees. There are sixteen such canvases still extant, ranging in date from 1918 to 1944. A large number of these diamond-shaped works were created in 1925 and 1926, following Mondrian's break with the De Stijl group over van Doesburg's introduction of the diagonal. Mondrian felt that in so doing van Doesburg had betrayed the movement's fundamental principles, thus forfeiting the static immutability achieved through stable verticals and horizontals. Mondrian asserted, however, that his own rotated canvases maintained the desired equilibrium of the grid, while the forty-five-degree turn allowed for longer lines.

From 1930 to 1933, Mondrian began to eliminate color in many of his canvases, producing in works like *Composition No. I* paintings of the utmost simplicity, in which the placement and varying thickness of lines determine the painting's rhythm. *Composition No. I* is the earlier of only two paintings by Mondrian in which none of the verticals and horizontals intersect within the confines of the canvas: two of them touch at the center of the lower right edge, but their intersection continues beyond the picture plane (suggesting that the work is taken from a larger whole). Art historian Rosalind Krauss notes that this exemplifies a centrifugal disposition of the grid, while works whose lines stop short of the picture's edge (implying that it is a self-contained unit) evince a centripetal tendency. Krauss argues that these dual and conflicting readings of the grid embody the central conflict of Mondrian's ambition: to represent properties of materials or perception while also responding to a higher spiritual call. — J. B.

Composition II, 1937 (cat. no. 143)

This canvas is part of a series that, after 1935, came closer to drawing than to painting, due to the artist's multiplication of black lines, and his greater and greater moderation of colored planes. The black grids produce contradictory optical effects: on the one hand, and especially when there is an arrangement of different thicknesses of lines, the effect is one of oscillations cutting into the white space; on the other hand, the evenly black contour of these lines tends to reconstruct a sense of planes, in the non-hierarchic places of their intersections, which fix the remaining colored rectangles, when they are correctly framed, on the same surface as the black lines and white planes. When, however, the colored planes, as in *Composition II*, are also pushed to the edges of the

canvas, an effect of lateralization and peripheral dispersion is produced, complementing this construction of a planar pictorial space.

The point was to create planarity through the subterfuge of drawing, without directly addressing the problem of a construction or a structuring of space through color. It was this, moreover, which inspired Mondrian to take a step away from this classical period of Neo-Plasticism during his New York years. — L. L.

New York City I, 1942 (cat. no. 144)

In this painting, Mondrian quite simply gets rid of the black grid of his Parisian Neo-Plasticist period and replaces it with a weave of primary colors. He even attempted, in subsequent paintings, to dispense with lines, once he abandoned the notion of planar space. What we are dealing with here is indeed color, its density and its powerful suggestion of depth. Rather than neutralizing depth at moments in the structure of the drawing, color becomes the sole producer of a flat construction of the pictorial space.

At the time of this painting, Mondrian wrote, in *A New Realism*, "The plurality of the varied and similar forms annihilates the existence of forms as entities. The similar forms do not show contrasts, but are in equivalent opposition."

Calculating the values that colors "naturally" establish, Mondrian seems to set his weave of yellow, red, and blue in a highly classical order, placing the warmest, most radiant color in the foreground, and the coldest, most distant color in the background of the painting. While this overlapping suggests a kind of depth—which led Clement Greenberg to say that "what we now have is a strictly optical, strictly pictorial three-dimensionality"—to stop at this would be to admit the failure of this new approach of Mondrian's. In fact, Mondrian destabilizes his own system of superimposition of yellow on red, and of red on blue, when he makes exceptions, causing the red to pass five times over the yellow and the blue once over the yellow. As art theorist Yve-Alain Bois wrote of this work, there is a subtle "braiding," which "transforms a contrast procedure (the overlapping) into an agent of planarity." Mondrian uses color to pervert, from within, the optical effects of different hues, and creates a planar composition full of optically and spatially conflicting ambiguities. — L. L.

François Morellet

b. 1931

François Morellet was born April 30, 1926, in Cholet, in northwest France. In 1937, after receiving a degree in Russian from the Ecole des langues orientales in Paris, he started painting. From 1948 to 1975, in addition to his work as an artist, Morellet was the general manager of his family's toy factory.

Although he was primarily a self-taught artist, he was greatly inspired by the abstract painters working in Paris after World War II. His first individual exhibition was held at the Cruze Gallery, Paris, in 1950. The following year, influenced by the work of Piet Mondrian and geometric abstraction, he began to simplify and systematize his paintings. In order to achieve more neutral surfaces, the artist used a roller instead of a paintbrush. Morellet exhausted ideas by making combinative series during the 1950s, experimenting with chance, kinetic, and optical operations. Along with the artists Julio le Parc, Joël Stein, Horacio Garcia-Rossi, Francisco Sobrino, and Jean-Pierre Yvaral, he founded the Groupe de Recherche d'Art Visuel (GRAV) in 1960. Together they collaborated on single works and *Labyrinths*, large installations of specific environments. Although the group ultimately disbanded in 1968, their collaborations provided Morellet with the opportunity to experiment with two fundamental elements of his mature work: neon and language. In his art using neon, Morellet plays with the visual similarity between ephemeral geometric forms and simple words. After this collaborative period, Morellet's work became more conceptual and often engaged viewers by making them take an active role in operating his pieces.

In 1971, the Centre national d'art contemporain, Paris, held the first retrospective of Morellet's work. This exhibition confirmed his interest in the fragmentation of space and the role of humor in art. Throughout the 1970s, he used mathematics to generate different series of works, the structures of which were paradoxically destabilized by the very rules that were used to generate them. In most of these pieces, the artist eliminated all pictorial aspects of the work and concentrated purely on structure. Made up of juxtaposed elements, it becomes obvious that each work is only one possible combination in a series of others.

A second retrospective of his work, organized by the Musée national d'art moderne, traveled from Paris to Amsterdam in 1986. True to his belief that an artist's arbitrary decisions should have a minimal impact on his or her work, Morellet continues to produce series of works that encourage viewers to interact with his art. He shows regularly in Europe and lives and works in Cholet.

3 x 3, 1954 (cat. no. 332)

In 1953, Morellet began to execute his first major compositions, including the painting *16 Squares*, made up of six black lines, three horizontal and three vertical, which divide the canvas into sixteen squares of equal size. From this point forward, the most striking aspect of his work is its rejection of all composition other than that dictated by some elementary principle or scheme. Each composition becomes the application of a rule established before execution, generally adapted to the use of the square as the perfect form.

Two years after his first attempts at radicalizing the principle of execution of the artwork, it became clear that Morellet had done away with both perceptible execution as suggested by the paintbrush, and the compositional principle as conceived by Mondrian and Theo van Doesburg. *3 x 3* belongs to this period, when the artist met Max Bill, whom he had traveled to see in Zurich. The influence of the Swiss Concrete Artists on Morellet is well known, as is the importance of the discovery of the Hochschule für Gestaltung, Ulm, which he visited the same year. Rare among the artists of his generation in associating with a movement outside of his own country, Morellet soon become one of the few French artists to find himself in touch with the international intellectual debate. Of equal importance was the singularity and difference of his approach, as well as the position that this would create in a French context still under the yoke of the French School and ready to submit to the often decorative principles of kinetic movement (*cinétisme*).

The work *3 x 3* consists of a single, monochrome color treated according to a simple principle of permutation of the bands that make it up. The repetition and seriality create a fragmentation of the surface and a composition whose sequencing anticipates some of the principles on the boundaries of Minimalism and Conceptualism. For this reason, the work of Morellet has ever since commanded attention as a necessary step foreshadowing many of the approaches that would emerge in Europe and the United States only several years later. — B. B.

6 Random Distributions of 4 Black and White Squares Using the Even and Odd Numbers of π (*6 Répartitions aléatoires de 4 carrés noirs et blancs d'après les chiffres pairs et impairs du nombre π*), 1958 (cat. no. 333)

After realizing his early abstract work while still under the influence of the postwar context, Morellet didn't wait long to give up all forms of tactile and material reduction. By the early 1950s, in fact, his search for a simplicity and a formal structure subject to deductive principles began to eclipse all other approaches. His discovery, in 1952, of the plastic structure of the decor of the Alhambra in Granada, and his (and others') application of a system based on simple rules drawn from mathematics, took precedence over all subjectivity, and engendered works of a serial and repetitive nature based on principles precluding any dimension of chance. The rule is at once elementary and determinant, and the construction conforms to its assertion and application.

This system is no longer the sort that might produce a surprise, but rather an imperiously organized order and an implicit recognition of the forms that might spring from it. In the brief article he published on the occasion of his show at the Galerie Colette Allendy gallery in 1958, Morellet summed up his position clearly: "We are convinced," he wrote, "that from the simplest relationships (such as geometrical elements, for example), we can derive not only a profound aesthetics, but an ever greater understanding of our own aesthetic sentiment." Morellet implies that from such relationships we will recognize how accustomed we are to expressive or subjective methods.

The present work is made up of six wood panels, each eighty centimeters square, arranged equidistant from one another. The rule guiding them is a simple one: each panel is divided into four equal parts. Each may be white or black; the figure pi will determine the result. The series is interrupted as soon as the different cases of figures has appeared. It is important to remember, once again, that in this work, no principle of organization engenders the image. Morellet is merely the observer of a code he is imposing, returning painting to its necessary speculative dimension. — B. B.

Robert Morris

b. 1931

Born February 9, 1931, in Kansas City, Missouri, Robert Morris turned to art and art criticism after studying engineering, eventually writing a 1966 master's thesis on Constantin Brancusi at Hunter College, New York. Since then, Morris has continued to write influential critical essays, four of which serve as a thumbnail chronology of his most important work: task-oriented dance ("Some Notes on Dance," 1965), Minimalist sculpture ("Notes on Sculpture," 1968), Process Art ("Anti Form," 1968), and Earthworks ("Aligned with Nazca," 1975).

During the 1950s, Morris grew interested in dance while living in San Francisco with his wife, the dancer and choreographer Simone Forti. After moving to New York in 1959, they participated in a loose-knit confederation of dancers known as the Judson Dance Theater, for which Morris choreographed a number of works, including *Arizona* (1963), *21.3* (1964), *Site* (1964), and *Waterman Switch* (1965).

During the 1960s and 1970s, Morris played a central role in defining three principal artistic movements of the period: Minimal sculpture, Process Art, and Earthworks. In fact, Morris created his earliest Minimalist objects as props for his dance performances—hence the rudimentary wooden construction of these boxlike forms, which reflected the Judson Dance Theater's emphasis on function over expression. Morris exhibited an entire room of these nondescript architectural elements at the Green Gallery in New York in 1964 and 1965. In the latter half of the 1960s, Morris explored more elaborate industrial processes for his Minimalist sculpture, such as aluminum and steel mesh. Like these industrial fabrications, a series of Neo-Dada sculptures Morris created in the 1960s also challenged the myth of artistic self-expression. These included ironic "self portraits" consisting of sculpted brains and electroencephalogram readouts as well as other works directly inspired by Marcel Duchamp's quasiscientific investigations of perception and measurement.

In the late 1960s and 1970s, the rigid plywood and steel of Morris's Minimal works gave way to the soft materials of his experiments with Process Art. Primary among these materials was felt, which Morris piled, stacked, and hung from the wall in a series of works that investigated the effects of gravity and stress on ordinary materials. A variety of these felt works were shown in 1968 at the Leo Castelli Gallery, New York. Subsequent projects Morris made during the late 1960s and early 1970s included indoor installations of such unorthodox materials as dirt and threadwaste, which resisted deliberate shaping into predetermined forms, and monumental outdoor Earthworks. Since the 1970s, Morris has explored such varied mediums as blindfolded drawings, mirror installations, encaustic paintings, and Hydrocal and fiberglass castings, on themes ranging from nuclear holocaust to Ludwig Wittgenstein's *Philosophical Investigations*.

Numerous museums have hosted solo exhibitions of his work, including New York's Whitney Museum of American Art in 1970, the Art Institute of Chicago in 1980, the Chicago Museum of Contemporary Art in 1986, and Washington, D.C.'s Corcoran Gallery of Art in 1990. In 1994, the Solomon R. Guggenheim Museum, New York, organized a major retrospective of the artist's work, which traveled to the Deichtorhallen in Hamburg and the Musée national d'art moderne in Paris. The artist lives and works in New York City and Gardiner, New York.

Card File, 1962 (cat. no. 316)

Card File corresponds to the mad project for a work that would only be made up of its own story: no more than a series of index cards, lined up in a file of the Cardex variety, bringing together, in alphabetical order, the data constituting the work. Under "Decision," one finds the first index cards chosen and the date of this choice; under "Mistakes," a review of the spelling mistakes made in the other files; under "Title," the title; under "Signature," Morris's signature, etc. Most of the cards refer to each other. This virtually unending game was ended by an arbitrary decision on 12–31–62, as one reads in the card marked "Work."

Card File foreshadowed the Conceptual Art movement, which in the 1960s and 1970s would endeavor to apply a linguistic model (in particular, that of J. L. Austin, whose articles were published under evocative titles such as "How to Do Things with Words") to the visual arts. Joseph Kosuth, one of the movement's main figures, has acknowledged *Card File* as a founding work. It has, moreover, has been cited in countless articles and publications on Conceptual Art as an essential reference point, together with another piece by Morris, the *Box*

with the Sound of Its Own Making, now in the collection of the Seattle Art Museum. — D. S.

Untitled, 1970 (cat. no. 323)

In 1968, Morris introduced an aesthetic approach that he articulated in an essay entitled "Anti-Form." In this and later writings, he reassessed his assumptions underlying Minimalist art and concluded that, contrary to earlier assertions, the construction of such objects *had* relied on subjective decisions and therefore resulted in icons—making them essentially no different from traditional sculpture. The art that he, Eva Hesse, Richard Serra, and others began to explore at the end of the 1960s stressed the unusual materials they employed—industrial components such as wire, rubber, and felt—and their response to simple actions such as cutting and dropping. *Untitled*, for example, is composed of dozens of sliced pink industrial felt pieces that have been dropped unceremoniously on the floor. Morris's scattered felt strips allude obliquely to the human body through their response to gravity and epidermal quality. The ragged, irregular contours of the jumbled heap refuse to conform to the strict unitary profile that is characteristic of Minimalist sculpture. This, along with its growing referentiality, led Morris's work of the late 1960s and early 1970s to be referred to by such terms as Anti-Form, Process Art, or Post-Minimalism. — J. B.

Bruce Nauman

b. 1941

Bruce Nauman was born December 6, 1941, in Fort Wayne, Indiana. He studied art, mathematics, and physics at the University of Wisconsin-Madison from 1960 to 1964. He went on to study under William Wiley and Robert Arneson at the University of California at Davis, graduating with an M.F.A in 1966. In 1964, Nauman gave up painting and began experimenting with sculpture and performance art and collaborated with William Allan and Robert Nelson on film projects. He supported himself teaching at the

San Francisco Art Institute from 1966 to 1968, and again at the University of California at Irvine, in 1970.

Since the mid-1960s, the artist has created an open-ended body of work that includes sculptures, films, holograms, interactive environments, neon wall reliefs, photographs, prints, sculptures, videotapes, and performance. His Conceptual work stresses meaning over aesthetics; it often uses irony and wordplay to raise issues about existence and alienation, and increasingly it provokes the viewer's participation and dismay.

In 1966, the Nicholas Wilder Gallery, Los Angeles, held Nauman's first individual exhibition. From 1968, onward the Leo Castelli Gallery, New York, and the Galerie Konrad Fischer, Düsseldorf, initiated a long series of solo shows. In 1968, he was invited for the first time to participate in *Documenta IV*, Kassel, and received a grant from the National Endowment for the Arts that enabled him to work in New York for one year. In 1972, the Los Angeles County Museum of Art and the Whitney Museum of American Art, New York, organized the first retrospective exhibition of the artist's work. Nauman moved to New Mexico in 1979. He married the painter Susan Rothenberg in 1989. Since the mid-1980s, primarily working with sculpture and video, he has developed disturbing psychological and physical themes with imagery based on animal and human body parts.

Nauman has received many honors including the title of Honorary Doctor of Fine Arts from the San Francisco Art Institute in 1989, the Max Beckmann Prize in 1990, the Wolf Prize in Arts-Sculpture in 1993, and the Wexner Prize in 1994. The most recent Nauman retrospective was organized by the Walker Art Center, Minneapolis, and traveled to many venues throughout America and Europe from 1993 to 1995. Nauman lives and works in Galisteo, New Mexico.

My Last Name Extended Fourteen Times Vertically, 1967 (cat. no. 321)

It is ironic that an artist whose work is so complex and varied that it has been given many classifications, including Body Art, Process Art, Anti-Formalism, Conceptualism, has examined the limitations of naming and the imprecision of language. In 1967, Nauman created two works in neon based on his own first and last names, *My Last Name Extended Fourteen Times Vertically* and *My Name as Though It Were Written on the Surface of the Moon*. These are among his earliest works incorporating text, and they were in part influenced by his interest in the writings of Ludwig Wittgenstein, the philosopher who emphasizes the ambiguity of language and its function as an arbitrary system of names. Wittgenstein cites proper names, in particular, as acute examples of words that have no meaning.

Based on the artist's actual handwriting, *My Last Name Extended Fourteen Times Vertically* is an enlarged and protracted rendering of the artist's

signature, which has become so distorted that it is unrecognizable as a name and has become an abstraction. Unlike many of Nauman's works that manipulate words to investigate multiple layers of meaning, this sculpture emphasizes the visual aspects of language, removing it from any recognizable context of communication. In his original conception of this piece, Nauman magnified his name seven times, in reference to classical proportions of beauty based on the belief that a perfect body is seven times the size of its head. Not finding this level of exaggeration abstract enough, however, the artist multiplied his formula again by two. To render his name even more illegible, the artist chose an uncommonly used and difficult-to-read pale-purple neon.

Nauman's transformation of his own name is an extension of his investigations of the body and self as physical and psychological terrain, much like the templates and impressions the artist has made of his own body parts. The sculptural transcription of his autograph is a study of his name as object as well as a reference to the historical significance of the artist's signature. (Nauman has recalled the impact of seeing the prominence of Barnett Newman's signature on one of his canvases.) In this case, his own neon signature has become the entire work. Transformed into an abstract gesture, a line drawn with light, the work becomes an additional allusion to the Abstract Expressionists and the particular aura they assigned to the hand of the artist. In this context, Nauman's use of an industrially made material accentuates the irony of the piece. —S. C.

Claes Oldenburg

b. 1929

Claes Oldenburg was born January 28, 1929 in Stockholm. His father was a diplomat, and the family lived in the United States and Norway before settling in Chicago in 1936. Oldenburg studied literature and art history at Yale University from 1946 to 1950. He subsequently studied art under Paul Weighardt at the Art Institute of Chicago from 1950 to 1954. During the first two years of art school, he also worked as an apprentice reporter at the City News Bureau of Chicago,

and afterward opened a studio, where he made magazine illustrations and easel paintings. Oldenburg eventually became an American citizen in December 1953.

In 1957, he moved to New York and met several artists making early performance work, including George Brecht, Allan Kaprow, George Segal, and Robert Whitman. Oldenburg soon became a prominent figure in Happenings and performance art during the late 1950s and early 1960s. In 1959, the Judson Gallery exhibited a series of Oldenburg's enigmatic images, ranging from monstrous human figures to everyday objects, made from a mix of drawings, collages, and papier-mâché. In 1961, he opened *The Store* in his studio, where he recreated the environment of neighborhood shops. He displayed familiar objects made out of plaster, reflecting American society's celebration of consumption, and was soon heralded as a Pop artist with the emergence of the movement in 1962.

Oldenburg realized his first outdoor public monument in 1967 in the form of a Conceptual performance/action behind the Metropolitan Museum of Art, New York. As a protest against the war, he had a crew dig a rectangular hole in the ground the size of a grave and then refill it. Beginning in the mid-1960s, he also proposed colossal art projects for several cities, and by 1969, his first such iconic work, *Lipstick (Ascending) on Caterpillar Tracks*, was installed at Yale University, New Haven. Most of his large-scale projects were made with the collaboration of Coosje van Bruggen, whom he married in 1977. In the mid-1970s and again in the 1990s, Oldenburg and van Bruggen have collaborated with the architect Frank O. Gehry, breaking the boundaries between architecture and sculpture. In 1991, Oldenburg and van Bruggen executed a binocular-shaped sculpture-building as part of Gehry's Chiat/Day building in Los Angeles.

Over the past three decades, Oldenburg's works have been the subject of numerous performances and exhibitions. In 1985, *Il Corso del Coltello* was performed in Venice. It included the *Knife Ship*, a giant Swiss Army knife equipped with oars; for the performance, the ship was set afloat in front of the Arsenal in an attempt to combine art, architecture, and theater. The *Knife Ship* traveled to museums throughout America and Europe from 1986 to 1988. Oldenburg was honored with a solo exhibition of his work at the Museum of Modern Art, New York, in 1969, and with a retrospective organized by the National Gallery, Washington, D.C., and the Solomon R. Guggenheim Museum, New York, in 1995. Oldenburg and van Bruggen live and work in New York City.

Auto Tire with Fragment of Price, 1961 (cat. no. 302)

When inaugurating *The Store* in 1961, Oldenburg, wishing to combine sculpture and performance on the Lower East Side of New York, created a considerable assortment of replicas of objects in plaster and papier-mâché, crowding them into the shop

window and the room inside. Shirts, shoes, girdles, pie slices, baked apples, watch-bracelets, caps, and giant price tags piled up in a kind of bazaar similar to those one might have found in New York at the time. Having deliberately chosen to surround himself with ordinary objects in a resolutely "non-artistic" context, Oldenburg was combining a critique of the mercantile exploitation of art with his desire to attack the airtight partition separating art and life.

While *The Store* was open for a relatively brief period of time in 1961 and 1962, its impact and motley stock of accessories—to which *Auto Tire with Fragments of Price* belongs—engendered an endless number of images and signs in which the quintessence of the emerging Pop art would be easily recognized. — B. B.

Soft Pay-Telephone, 1963 (cat. no. 312)

Oldenburg's absorption with the commonplace was first manifested in his personal collection of toys, plastic food, and kitschy knick-knacks. These objects served as prototypes for the pieces the artist included in his early Happenings and installations.

Such sculptural articles played a more central role in Oldenburg's fabricated environment *The Store*, in one version of which he filled a Manhattan storefront with colorfully painted simulations of ordinary items—including articles of clothing (lingerie, in particular) and sundry food products—which he sold as merchandise. Because of its conflation of creativity with commerce, *The Store* is often cited as a definitive moment in the emergence of Pop art.

The lumpy wares sold at *The Store*, and their later incarnations as large-scale, stuffed vinyl sculptures such as this pay telephone, may be seen as substitutions for and references to the human body. Through their malleable forms and susceptibility to the effects of gravity, these supple sculptures often suggest specific anatomical parts: hamburgers are breasts, a tube of toothpaste is a phallus. Passive and limp, but potentially arousable, the pieces allude to the sexual, a realm that has been repressed in much Modern, abstract art. By asserting the sensual through the mundane, Oldenburg explores the ways in which everyday objects are so much an extension of ourselves. Anyone familiar with Freud's interpretation of dreams, in which domestic items are surrogates for human anatomy, will find a similar equation in Oldenburg's art. As the artist has said, "I never make representations of bodies but of things that relate to bodies so that the body sensation is passed along to the spectator either literally or by suggestion." — N. S.

Soft Drum Set—Ghost Version, 1972 (cat. no. 313)

This enormous "ghost" drum set was first imagined in 1966—in a monumental version continuing the series of *Colossal Monuments* presented in New York the previous year—as "a pleasure palace" for concerts, circuses, and other public spectacles in Battersea Park, London. The Cleveland Museum has a version similar to this one, but smaller in size. According to Oldenburg himself, "The *Drum Set* is more a landscape than a body, a kind of Brueghelian panorama." Its whiteness recalls the snowy peaks and cloudy skies of Aspen, Colorado, where Oldenburg lived briefly in 1967.

Like Joseph Cornell's mysterious boxes or Jim Dine's *Putney Winter Heart #3* (1971–72), this piece is also a crystallization of old memories: "My first and only musical instrument was a drum bought in Chicago when I was five. I used it to get attention, opening the windows and playing as loudly as I could." Regarding the physical attributes of such sculptures, Oldenburg has explained, "The ultimate act, that of making things soft, is like the kiss of death for their functionalism and classicism. The object's soul, one might say, rises up in the sky in the guise of a ghost. Its exorcised spirit returns to the realm of geometry." — J.-P. B.

Pino Pascali
1935–1968

Pino, né Giuseppe, Pascali was born October 11, 1935, in Bari. He originally pursued a career in set design, moving to Rome in 1956 to enroll in Toti Scialoja's course in scenography at the Accademia di Belle Arti. He graduated from the Accademia in 1959. After working briefly for cinema and television studios, Pascali turned to making sculpture in 1960. The theater, however, remained a significant influence in his art: aspects of scenography were incorporated into his sculpture, the mise-en-scène of his installations was an inherent component of his works, and he staged his own performances. Pascali's first solo show, *Pieces of Woman (Pezzi di Donna)*, was held in 1965 at the Galleria La Tartaruga, Rome. He also presented his first performance that year in Rome at the Galleria La Salita.

Pascali's sculpture, produced from nontraditional materials (from earth to feathers to synthetic brushes), simulates objects from contemporary culture, living creatures, forms from nature, agricultural landscapes, and "primitive" structures. Though recognizable entities are depicted, the atypical mediums used, the some-times unrealistic size of the things portrayed, and their incongruous placement in interior spaces often contradict or undermine the apparent meaning of that which is represented.

In 1966, Pascali's *Arms (Armi)* series was shown at the Galleria Sperone, Turin. Though seemingly functional military weapons, these are actually flimsy and inoperable assemblages, forged from found objects, which served as ironic commentary on the political atmosphere. Pascali moved on to fabricate his *Finte sculture*, made of canvas stretched over wood skeletons in the shapes of mammals and elemental forms. In 1967, he had a solo show at the Thelen Galerie, Essen. In this year, Pascali began to juxtapose organic and industrial mediums, such as water and aluminum, for a series he called *Elements of Nature (Elementi della natura)*. One of these pieces was included in the seminal exhibition at the Galleria La Bertesca, Genoa, which heralded the inception of the anti-elitist Arte Povera movement.

By 1968, Pascali launched the series *Reconstructions of Nature (Ricostruzioni della natura)*, in which he employed primarily artificial materials like acrylic fur to construct insects or arthropods and crafted archaic bridges from woven steel wool. At the 1968 Venice *Biennale*, a gallery was dedicated to Pascali's work and that year's prize was awarded to him. The artist's career was cut short when he perished in a motorcycle accident September 11, 1968, in Rome.

Aesop's Quills (Le Penne di Esopo), 1968 (cat. no. 325)

If we needed to remind ourselves of Arte Povera's link with archaism and its tutelary figures, we would certainly find an excellent example in *Aesop's Feathers*, exhibited at the 1968 Venice *Biennale*. We are well familiar with the fascination the Greek fabulist has elicited over the centuries; the fables attributed to him were, indeed, the model for the apologue, a literary genre that, from Phaedrus to Jean de La Fontaine, had been a source of inspiration within Western culture. What could be more simple, then, than recognizing, in this work's title, an homage by Pascali to the ancient storyteller, an homage which, moreover, he had made into the title of a preparatory drawing for this piece.

Belonging to the series *Elements and Reconstructions of Nature*, which Pascali created in 1967 and 1968, the year of his death, this piece is essential to an understanding of the situation of art in the Italy of the 1960s. It bears witness to an oeuvre which, in its brevity, sought not to privilege any specific vocabulary but rather asserted itself in terms of its freedom of choice in the materials constituting it, which revolve around a series of different propositions and definable cycles.

Coming after the 1964 *Quadri-Oggetto*, the 1965 *Armi* and the 1966 *Finte sculture*, the *Elements and Reconstructions of Nature* tie in with the nature-culture dialogue that was so lively during that decade,

humorously revisiting various both early and contemporary myths such from Ulysses to Tarzan.

Without ever abandoning this critical judgment and the will to question the complex and often ambiguous relationship between contemporary man and the origins of his history, Pascali attempts at once to create a vast program of invitation to nature on an oversized scale with artificial or incongruously natural materials, as well as to reconstitute the elementary objects and gestures of primitive man in his struggle for survival. Between the archaic imaginary and the trauma of the present day, Pascali beats a path that forever reminds us of his training as a scenographer and stage designer.

To what order of things, then, does this work belong, if not to that of the present-day signs that call attention, like a poetic figure, to contemporary man and to the threat that, with him, his founding myths might also disappear? The multitude of feathers stuck into the tondo-shaped weave of steel wool invokes at once the world of birds and that of writing, the invisible bonds between image and language. — B. B.

Antoine Pevsner
1884–1962

Antoine Pevsner was born January 18, 1884, in Orel, Russia. After leaving the Academy of Fine Arts, Saint Petersburg, in 1911, he traveled to Paris, where he saw the work of Robert Delaunay, Albert Gleizes, Fernand Léger, and Jean Metzinger. On a second visit to Paris in 1913, he met Amedeo Modigliani and Alexander Archipenko, who encouraged his interest in Cubism. Pevsner spent the war years 1915–17 in Oslo with his brother Naum Gabo. On his return to Russia in 1917, Pevsner began teaching at the Moscow Academy of Fine Arts with Vasily Kandinsky and Kazimir Malevich.

In 1920, he and Gabo published the *Realistic Manifesto*. Their work was included in the *Erste russische Kunstausstellung* at the Galerie van Diemen, Berlin, in 1922, held under the auspices of the Soviet government. The following year

Pevsner visited Berlin, where he met Marcel Duchamp and Katherine Dreier. He then traveled to Paris, where he settled permanently; in 1930, he became a French citizen. His work was included in an exhibition at the Little Review Gallery, New York, in 1926. He and Gabo designed sets for the ballet *La Chatte*, produced by Sergei Diaghilev in 1927. In Paris, the two brothers were leaders of the Constructivist members of Abstraction-Création, an alliance of artists who embraced a variety of abstract styles.

During the 1930s, Pevsner's work was shown in Amsterdam, Basel, London, New York, and Chicago. In 1946, Gleizes, Auguste Herbin, Pevsner, and others formed the group Réalités Nouvelles; their first exhibition was held at the Salon des Réalités Nouvelles in Paris in 1947. That same year, Pevsner's first solo show opened at the Galerie René Drouin, Paris. The Museum of Modern Art, New York, presented the exhibition *Gabo–Pevsner* in 1948, and in 1952 Pevsner participated in *Chefs-d'oeuvre du XXᵉ siècle* at the Musée national d'art moderne in Paris. The same museum organized a solo exhibition of his work in 1957. In 1958, he was represented in the French Pavilion at the Venice *Biennale*. Pevsner died April 12, 1962, in Paris.

Construction in Space (*Construction dans l'espace*), 1923–25 (cat. no. 134)

As art historian Benjamin Buchloh has well demonstrated, the art of Pevsner and his brother, Gabo, marks a withdrawal from Constructivist demands and from the Constructivist spirit of exploration; there is a distancing that is clearly visible in *Construction in Space*. In returning to the use of a base, and in the case of Pevsner in particular, to such traditional techniques and materials as casting and bronze, the two brothers did more than abandon the Constructivist principles; they rejected them. They renounced the questioning of the social role of sculpture, its mode of representation, and its aesthetic and attached conventions; the accent placed on weight; and even the symbolism of materials (according to El Lissitzky, "iron represented the will of the proletariat, glass was as limpid and pure as its conscience"). This ideological renouncement was already clear in Gabo and Pevsner's *Realistic Manifesto*, and Pevsner himself would recall in 1957, "We were detaching ourselves from the intellectual agitation of the years 1915–20, those times haunted by the desire to find new paths to spiritual understanding. We renounced the theoretical writings as well as the school's controversies. We were ceasing to focus attention on . . . the aspirations of the other European avant-gardes." When they adopted new materials (celluloid, Plexiglas, nylon, steel wire, chrome), the two brothers were using them, according to Buchloh, to create "new cultural icons for a society of industrial consumption." — V. W.

Anchored Cross (*La Croix ancrée*), 1933 (cat. no. 135)

Pevsner and his brother, Gabo, sought "the realization of [their] perceptions of the world in the forms of space and time," according to their *Realistic Manifesto* of 1920. They believed that space was given form through implications of depth rather than volume and they rejected mass as the basic sculptural element. Line, rendered dynamic through directionality, established kinetic rhythms. Like the Constructivists, they advocated the use of contemporary industrial materials; they did not carve or model these materials according to sculptural conventions, but constructed them according to principles of modern technology. In Gabo's and Pevsner's words, "The plumb-line in our hand, eyes as precise as a ruler, in a spirit as taut as a compass . . . we construct our work as the universe constructs its own, as the engineer constructs his bridges, as the mathematician his formula of the orbits."

As in the earlier sculpture *Construction in Space*, Pevsner complicates the delineation of space here by using a transparent substance in conjunction with opaque materials. The glass panes echo both the rounded excised outlines of the construction and its angular metal surfaces. The metal ribs anchor the panes of glass and hinge all planes, real and imagined, resulting in a complex structuring of space. Furthermore, they function visually as an Orthodox cross. The icons of Pevsner's native Russia, which had played a crucial role in the development of his notions of perspective, may have suggested the form. — L. F.

Francis Picabia
1879–1953

François Marie Martinez Picabia was born or about January 22, 1879, in Paris, of a Spanish father and a French mother. He was enrolled at

the Ecole des arts décoratifs in Paris from 1895 to 1897 and later studied with Fernand Cormon, Ferdinand Humbert, and Albert Charles Wallet. He began to paint in an Impressionist manner in the winter of 1902–03 and started to exhibit works in this style at the Salon d'Automne and the Salon des Indépendants of 1903. His first solo show was held at the Galerie Haussmann, Paris, in 1905. From 1908, elements of Fauvism and Neo-Impressionism as well as Cubism and other forms of abstraction appeared in his painting, and by 1912 he had evolved a personal amalgam of Cubism and Fauvism. Picabia worked in an abstract mode from this period until the early 1920s.

Picabia became a friend of Guillaume Apollinaire and Marcel Duchamp and associated with the Puteaux group in 1911 and 1912. He participated in the 1913 Armory Show, visiting New York on this occasion and frequenting avant-garde circles. Alfred Stieglitz gave him a solo exhibition at his gallery "291" that same year. In 1915, which marked the beginning of Picabia's machinist or mechanomorphic period, he and Duchamp, among others, instigated and participated in Dada manifestations in New York. Picabia lived in Barcelona in 1916 and 1917; in 1917 he published his first volume of poetry and the first issues of *391*, his magazine modeled after Stieglitz's periodical *291*. For the next few years Picabia remained involved with the Dadaists in Zurich and Paris, creating scandals at the Salon d'Automne, but finally denounced Dada in 1921 for no longer being "new." The following year, he moved to Tremblay-sur-Mauldre outside Paris, and returned to figurative art. In 1924, he attacked André Breton and the Surrealists in *391*.

Picabia moved to Mougins in 1925. During the 1930s, he became a close friend of Gertrude Stein. By the end of World War II, Picabia returned to Paris. He resumed painting in an abstract style and writing poetry. In March 1949, a retrospective of his work was held at the Galerie René Drouin in Paris. Picabia died November 30, 1953, in Paris.

Udnie, 1913 (cat. no. 150)

In 1947, at the insistence of Duchamp and Breton, Picabia recognized the importance of this painting; now it may be seen as an early masterwork in the artist's oeuvre. As in Picabia's works, *Tarantelle* (1912) and *Dance at the Source* (*Danse à la source*, 1912), one can see here the influence of Italian Futurism, particularly of Filippo Tommaso Marinetti's painting from 1910–11, *Pan-Pan's Dance in Monaco* (*Danse du Pan-Pan à Monaco*). Bedecked with a variety of subtitles (*Jeune fille américaine, La Danse . . .*), *Udnie* was painted after Picabia returned from New York, about the same time as *I See Again in Memory My Dear Udnie*. Gabrielle Buffet-Picabia has pointed out that the woman in question here was a Hindu dancer of Montmartre named Napierkowska, whom Picabia saw dancing aboard the Transatlantic in the middle of a storm. However, the work cannot be

visually deciphered. When Apollinaire saw it at the 1913 Salon d'Automne in Paris, he thought it an "ardent, mad work of art" and pointed out "the astonishing conflicts between the painterly material and the imagination." It is a prime example of what Picabia called "abstractional research," painted the same year that he published his *Amorphist Manifesto*. *Udnie* presents something quite different from the breakup of reality as practiced by the Cubists: it is a rebus, from which representational content has been jettisoned. Here, choreography and its spiral development through time and space appear as a metaphor for the elasticity of memory. — B. B.

Very Rare Picture on the Earth (*Très rare tableau sur la terre*), 1915 (cat. no. 152)

In 1915, Picabia abandoned his exploration of abstract form and color to adopt a new machinist idiom that he used until about 1923. Unlike Robert Delaunay or Fernand Léger, who saw the machine as an emblem of a new age, he was attracted to machine shapes for their intrinsic visual and functional qualities. He often used mechanomorphic images humorously as substitutes for human beings; for example, in *Here, This Is Stieglitz* (1915), Stieglitz, a photographer, is portrayed as a camera. In *Very Rare Picture on the Earth*, a self-generating, almost symmetrical machine is presented frontally, clearly silhouetted against a flat, impassive background. Like Picabia's own *Amorous Parade* (1917) or Duchamp's *The Bride Stripped Bare by Her Bachelors, Even* (1915–23), the present work might be read as the evocation of a sexual event in mechanical terms. This dispassionate view of sex is consonant with the antisentimental attitudes that were to characterize Dada. The work has also been interpreted as representing an alchemical processor, in part because of the coating of the two upper cylinders with gold and silver leaf respectively.

Not only is *Very Rare Picture on the Earth* one of Picabia's earliest mechanomorphic works, but it has been identified as his first collage. Its mounted wooden forms and integral frame draw attention to the work as object—the picture is not really a picture, making it "very rare" indeed. Thus, an ironic note is added to the humorous pomposity of the inscription at upper left. — L. F.

The Child Carburetor (*L'Enfant carburateur*), 1919 (cat. no. 153)

Picabia abandoned his successful career as a painter of coloristic, amorphous abstraction to devote himself, for a time, to the international Dada movement. A self-styled "congenial anarchist," Picabia, along with his colleague Duchamp, brought Dada to the New York art world in 1915, the same year he began making his enigmatic machinist portraits, such as *The Child Carburetor*, which had an immediate and lasting effect on American art. *The Child Carburetor* is based on an engineer's diagram of a "Racing Claudel" carburetor, but the descriptive labels that identify its vari-

ous mechanical elements establish a correspondence between machines and human bodies; the composition suggests two sets of male and female genitals. Considered within the context created by Duchamp's contemporaneous work *The Bride Stripped Bare by Her Bachelors, Even*, as art historian William Camfield has observed, *The Child Carburetor*, with its "bride" that is a kind of "motor" operated by "love gasoline," also becomes a love machine. Its forms and inscriptions abound in sexual analogies, but because the mechanical elements are nonoperative or "impotent," the sexual act is not consummated. Whether the implication can be drawn that procreation is an incidental consequence of sexual pleasure, or simply that this "child" machine has not yet sufficiently matured to its full potential, remains unclear. Picabia stressed the psychological possibilities of machines as metaphors for human sexuality, but he refused to explicate them. Beneath the humor of his witty pictograms and comic references to copulating anthropomorphic machines lies the suggestion of a critique—always formulated in a punning fashion—directed against the infallibility of science and the certainty of technological progress. *The Child Carburetor* and his other quirky, though beautifully painted, little machines (which he continued to make until 1922) are indeed fallible. If they are amusingly naive as science fictions or erotic machines, they are also entirely earnest in placing man at the center of Picabia's universe, albeit a mechanical one. — J. A.

Tobacco-Rat (*Tabac-Rat*), ca. 1919–20 (destroyed), refabricated ca. 1946–49 (cat. no. 155)

Of the three works submitted by Picabia to the Salon des Indépendants of February 1922, only *Danse de Saint-Guy*, as it was then titled, was accepted by the jury, which was presided over by Paul Signac. The jury's decision did not fail to provoke a noisy, skillfully orchestrated press campaign on the part of the artist. And yet, in comparison to Picabia's other submissions, the *Danse de Saint-Guy* marked the utmost point of Dadaist subversion: here Picabia presents a "transparent" painting, without canvas or painting material, reduced to the simple, absurd expediency of a frame with string and fragments of cardboard— a painting, that is, reduced to its packaging. The fanciful words Picabia customarily wrote on the canvas, holding the meaning of the image up to ridicule (as in the *haut, bas, fragile, à domicile* [top, bottom, fragile, delivery] written on another work, *Double World* [*Double Monde*] of 1919), are here placed on strips of cardboard summarily attached to the string. Picabia maintained that this work was not supposed to be hung from a wall, but suspended from the ceiling so it could be mobile and "divide the space into volumes." Picabia even had himself photographed as the "presenter" or "transporter" of the work, thereby implying that the interaction of observer and observed constitutes this transparent work of art. There are affinities between the *Danse de Saint-Guy* and contempora-

neous works by his friend, Duchamp—in particular *The Large Glass* (of which it represents the opposing counterpart), and *Sculpture for Traveling*.

Danse de Saint-Guy was modified by the artist after it had deteriorated at a later date—either on the occasion of one exhibition at the Galerie Colette Allendy in October 1946 or another at the Galerie René Drouin in 1949, when it was presented under the new title of *Tabac-Rat*. The apparatus of frame and twine was replaced, the string arrangement was modified and the fanciful original inscriptions, "Tabac / Je me couche / Quel beau soleil [Tobacco / I lie down / What a beautiful sun]," were changed to "Danse de Saint-Guy / Tabac-Rat / Francis Picabia." This second version, acquired from Picabia's estate, bears witness to its own earlier incarnation dating from the close of Picabia's Dadaist period. — A. L. B.

The Cacodylic Eye (*L'Oeil cacodylate*), 1921 (cat. no. 156)

Picabia created *The Cacodylic Eye* when he was stricken with shingles in his eye. Its title refers to the word *cacodyl*, which is an odorous chemical compound that takes fire on exposure to air, and which derives from the Greek for bad-smelling matter. Here, Picabia meets the challenge of creating an "original" work without laboring much over it. The boxed title at the top of this painting has its counterpart in the artist's name at the bottom, which is accompanied by a photo of Picabia. On the unadorned surface of the canvas are juxtaposed, around a large eye, a seeming infinity of signatures, aphorisms, and puns applied on the occasion of a midnight dinner with friends—a spontaneous, shared procedure, more tract than manifesto. Disdaining all craft and taste, it gives monumental form, unprecedented, to negation. Before *The Cacodylic Eye*, the surface of Picabia's works remained intact under the observer's gaze; however, this painting inaugurates an artistic practice of Parisian Dadas that has something of the prank in it, the *fredaine*, the etymology of which means "scoundrel." — B. B.

Straw Hat? (*Chapeau de paille?*), ca. 1921 (cat. no. 154)

Like *The Cacodylic Eye, Straw Hat?* deliberately makes use of "do-it-yourself" elements, leaving each observer, for instance, to interpret the awkwardly written phrase "*M . . . pour celui qui le regarde*" (M . . . for the one looking at it) however he or she likes. In counterpoint to this phrase, a nonchalant piece of string connects to the artist's calling card, cut into the shape of a heart, accompanied by an invitation to a cacodylic midnight dinner (presumably the one to which dozens of Picabia's friends were invited to help create his painting, *The Cacodylic Eye*).

Straw Hat? was one of two works rejected by the Salon des Indépendants of February 1922. Might the title be intended as a challenge to the jury? The fact remains that the insolence of this work ricochets back at those who forbade the work from being exhibited. — B. B.

Widow (*Veuve*), 1948 (cat. no. 244)

Widow is an example of Picabia's last manner, which followed his return to Paris in 1945. This work—together with *Hashish* (*Haschisch*, 1948), *Egoism* (*Egoïsme*, 1947–50), *I Ear You* (*Je vous entends*, 1948)—represents one the most accomplished of his late period. Displaying a veritable "creative impatience," and stimulated perhaps by the circle of young abstract painters (Camille Bryen, Hans Hartung, Pierre Soulages, Raoul Ubac, et al.) who claimed him as a precursor, Picabia at this time was executing works at an incredible speed, often painting over old canvases in a process of erasure and superimposition that was part of his "system." The paint is applied with a full brush, yielding thick spots and broad strokes and featuring bright, intense colors often used monochromatically or in luminous contrasts, with schematized, insistent geometric patterns. This almost brutal energy, which is in some ways reminiscent of his works from 1924 and 1925 such as *Woman with a Monocle* (*Femme au monocle*, 1924–26) and *Lecture*, here finds its formal vocabulary in the recurrent repertoire of circles, arcs, points, spirals, and rods—favorite optical motifs he first introduced in 1909 (in *Caoutchouc*), and which were the bases of the artist's most abstract series from the 1920–22 period. Aside from its references to African "primitivism" (Picabia at the time was a regular visitor to the Bal Nègre), the highly rhythmic web of concentric arcs and spirals traced in white against a dark background forms an optical alternative that signifies the ambivalence of perceptual approaches. These arcs and spirals seem to provide, thirty years later, a negative counterpoint to the geometric interlacing visible throughout his earlier paintings, *Double Monde* (1919) and *Serpentins* (1920). Behind the much criticized versatility of Picabia stands the true logic of his method. — A. L. B.

Pablo Picasso
1881–1973

Pablo Ruiz y Picasso was born October 25, 1881, in Málaga. The son of an academic painter, José Ruiz Blanco, he began to draw at an early age. In 1895, the family moved to Barcelona, and Picasso studied there at La Lonja, the academy of fine arts. His visit to Horta de Ebro from 1898 to 1899 and his association with the group at the café Els Quatre Gats about 1899 were crucial to his early artistic development. In 1900, Picasso's first exhibition took place in Barcelona, and that fall he went to Paris for the first of several stays during the early years of the century. Picasso settled in Paris in April 1904, and soon his circle of friends included Guillaume Apollinaire, Max Jacob, Gertrude and Leo Stein, as well as two dealers, Ambroise Vollard and Berthe Weill.

His style developed from the Blue Period (1901–04) to the Rose Period (1905) to the pivotal work *Les Demoiselles d'Avignon* (1907), and the subsequent evolution of Cubism from an Analytic phase (ca. 1908–11), through its Synthetic phase (beginning in 1912–13). Picasso's collaboration on ballet and theatrical productions began in 1916. Soon thereafter his work was characterized by neoclassicism and a renewed interest in drawing and figural representation. In the 1920s, the artist and his wife, Olga (whom he had married in 1918), continued to live in Paris, to travel frequently, and to spend their summers at the beach. From 1925 into the 1930s, Picasso was involved to a certain degree with the Surrealists, and from the fall of 1931 he was especially interested in making sculpture. With large exhibitions at the Galeries Georges Petit, Paris, and the Kunsthaus Zurich in 1932, and the publication of the first volume of Christian Zervos's catalogue raisonné the same year, Picasso's fame increased markedly.

By 1936, the Spanish Civil War had profoundly affected Picasso, the expression of which culminated in his painting *Guernica* (1937). Picasso's association with the Communist Party began in 1944. From the late 1940s, he lived in the south of France. Among the enormous number of Picasso exhibitions that were held during the artist's lifetime, those at the Museum of Modern Art, New

York, in 1939 and the Musée des arts décoratifs, Paris, in 1955 were most significant. In 1961, the artist married Jacqueline Roque, and they moved to Mougins. There Picasso continued his prolific work in painting, drawing, prints, ceramics, and sculpture until his death April 8, 1973.

Woman Ironing (La Repasseuse), 1904 (cat. no. 16)

With great poignancy, Picasso focused almost exclusively on the disenfranchised during his Blue Period, known for its melancholy palette of predominantly blue tones and its gloomy themes. Living in relative poverty as a young, unknown artist during his early years in Paris, Picasso no doubt empathized with the laborers and beggars around him and often portrayed them with great sensitivity and pathos. *Woman Ironing*, painted at the end of the Blue Period in a lighter but still bleak color scheme of whites and grays, is Picasso's quintessential image of travail and fatigue. Although rooted in the social and economic reality of turn-of-the-century Paris, the artist's expressionistic treatment of his subject— he endowed her with attenuated proportions and angular contours—reveals a distinct stylistic debt to the delicate, elongated forms of El Greco. Never simply a chronicler of empirical facts, Picasso here imbued his subject with a poetic, almost spiritual presence, making her a metaphor for the misfortunes of the working poor. The model appears in several of Picasso's canvases of 1904, and has been identified as Margot, the daughter of Frédé, who owned the café Le Lapin Agile, which Picasso and his friends frequented. — N. S.

Seated Nude (Nu assis), 1905 (cat. no. 17)

In April 1904, Picasso moved to Paris, to the building in Montmartre called the Bateau-Lavoir, where he stayed for five years. It was during this period that he painted *Seated Nude*, which shows the silhouette of a frail, slight woman with a fine, sharp profile, hair piled high on the head in a style found in many paintings and works on paper of this period, notably the *Woman Ironing* (1904). An impression of the woman's fragility, sadness, poverty, and loneliness dominates the atmosphere of these works. We find the same expressions of deep melancholy on the faces of Picasso's 1905 series of Saltimbanques, painted during his Rose Period. The ocher and brown color scheme replaces the dominant blue of the earlier works; golden highlights set off the woman's face, shoulders and hand placed flatly on the thigh. She seems to gaze at herself in a dark mirror. While the upper part of her body stands out against the uniformly gray background like a sculpture, the lower part of her body, cut off just below the knee, merges with the bench of the same brown color as the body.

This painting on cardboard represents a transition between Picasso's Blue and Rose Periods and can be situated at the end of the winter of 1904–05, a difficult and precarious time for Picasso, who had just met his future companion, Fernande Olivier. — C. L.

Fernande with a Black Mantilla (Fernande Olivier), 1905/1906 (cat. no. 18)

By 1905 and 1906, Picasso's attention began to shift from the creation of social and quasi-religious allegories to an investigation of space, volume, and perception, culminating in the invention of Cubism. His portrait *Fernande with a Black Mantilla* is a transitional work. Still somewhat expressionistic and romantic, with its bluish tonality and lively brushstrokes, the picture depicts his mistress, Olivier, wearing a mantilla, which perhaps symbolizes the artist's Spanish origins. The iconic stylization of her face and its abbreviated features, however, foretell Picasso's increasing interest in the abstract qualities and solidity of Iberian sculpture, which would profoundly influence his subsequent works. Though naturalistically delineated, the painting presages Picasso's imminent experiments with abstraction. — N. S.

Bust of a Woman (Buste de femme), 1907 (cat. no. 19)

Bust of a Woman is one of numerous preparatory studies for *Les Demoiselles d'Avignon* (1907), the first major work of Cubism. The most striking element in this painting, set in the middle of the face that it disfigures, is the long pointed nose familiarly referred to as the "wedge of brie." With its triangular form and its perpendicular projection from the plane of the face, the nose of the figure shows Picasso attempting to suggest relief without resorting to chiaroscuro or traditional perspective. In countless studies and sketches for *Les Demoiselles d'Avignon*, both painted and drawn, he studied the posture and face of each figure for the final composition, and experimented, as his research progressed, with different ways of conveying relief on a flat surface. The final painting presents two different types of women: those in the middle, with rounded contours and large, staring eyes, who derive from the forms of Iberian art, and the angular figures on the right, whose faces, laid on like masks, display the influence of African art. These different treatments correspond to two successive stages of work.

This *Bust of a Woman* falls midway between the two stages, to judge by the lively, colorful hatchings superimposed on its regular, rounded, stylized forms. The reduction of facial features to codified signs, to schematic planes resembling a mask, allowed Picasso to depersonalize the figure and to simultaneously represent several points of view. Indeed, in this three-quarter view of a head, the ear is portrayed in profile and the large eye is represented frontally, giving a sculptural tension to the form, underscored by the hatching of the background, the hair, and the nose. This *demoiselle* foreshadows the figure on the upper right of the final painting, who presents the same face in three-quarter view: there, Picasso takes his visual

aggressiveness even further, definitively breaking all bonds with perceptible representation. — M. L. B.

The Guitarist (Le Guitariste), summer 1910 (cat. no. 20)

Stretching the limits of abstraction, *The Guitarist* belongs to the most distilled, luminous phase of Cubism, that of the summer of 1910, when Picasso spent two months in Cadaqués in the company of Olivier and the André Derain and his wife. This sojourn, like all his Spanish sojourns, allowed him to complete a very important phase: "A great step has been made," Daniel-Henri Kahnweiler would say, "Picasso has exploded homogeneous form." All that remains here of the fragmentation of volume into facets are the outlines of the planes, which Picasso arranges according to the rhythm of the form represented. This rupture of contour does not lead to the destruction of the form, but instead creates a light, spatial framework. A single pictorial language is used for the figure and the space containing it.

This phase, when the primary concern was to lay bare the linear structure of the figure, was the most monochromatic of Cubism. This austerity allowed Picasso to highlight structure and to respect the unity of the painting. The transparent, crystalline unity suggested by the subtle modulations of beige and silver-gray and by the short, vibrant strokes, is evenly distributed over the entire surface of the painting. Thanks to a purification of form, Picasso here achieves a distillation of volume and asserts a new pictorial space, the palpable, "tactile" space described by Georges Braque, who was working in L'Estaque at this same time. — M. L. B.

Accordionist (L'Accordéoniste), summer 1911 (cat. no. 21)

A decisive moment in the development of Cubism occurred during the summer of 1911, when Picasso and Braque painted side by side in Céret, in the French Pyrenees. In Picasso's *Accordionist*, made during this time, the traditional relationship between figure and ground has been destroyed and replaced by a unified pictorial configuration. The extreme degree of fragmentation; flat, shaded planes; nondescriptive regularized brushstrokes; monochromatic color; and shallow space are all characteristic of the first, "Analytic" phase of Cubism.

With diligence, one can distinguish the general outlines of the seated accordionist, the centrally located folds of the accordion and its keys, and, in the lower portion of the canvas, the volutes of an armchair. But Picasso's elusive references to recognizable forms and objects cannot always be precisely identified and, as New York's Museum of Modern Art's founding director Alfred H. Barr, Jr. observed, "The mysterious tension between painted image and 'reality' remains." — SRGM

Portrait of a Young Girl (*Portrait de jeune fille*), 1914 (cat. no. 24)

Is this a *papier collé* or a painting? The illusion is striking. Is that a real piece of wallpaper on the right hand side of the painting, or an imitation? An imitation of an imitation, then. Picasso was not finished yet with juggling the discoveries he had made between 1912 and 1914 through the use of *papiers collés*, collage, and relief-paintings. Plays on words, plays on images, visual puns, questionings of representation and illusionism constituted at this point the basis of his painterly vocabulary.

This seductive painting, joyous and colorful, is a veritable anthology of the decorative motifs of Cubism: the faux marbling, armchair fringes, paper moldings, and pointillism are all repeated in other compositions, as are the framing of the fireplace on the left, the fruit dish, the armchair, the black mannequin head of the girl, and the large lace bonnet. The eccentric profusion of motifs is neutralized by the color green, which unifies the whole and further heightens, through its cool brightness, the effect of exuberance. This *Portrait of a Young Girl*, for which two preparatory drawings exist, marks the powerful return of painting and color in the work of Picasso. It belongs to the Avignon period, the summer of 1914, which has also been called the "rococo" period of Cubism, because of its decorative excesses, but also because of the supple, "baroque" forms that the painter uses. — M. L. B.

Glass of Absinthe (*Le Verre d'absinthe*), spring 1914 (cat. no. 62)

In the aesthetic atmosphere of 1914, there was one sculpture which, like Picasso's *Head of a Woman* (*Tête de femme*, 1909) or his *Constructions* in 1912, was of paramount importance: it was the *Glass of Absinthe*, which definitively broadened the possibilities of sculpture. To be more precise, one should actually refer to the "Glasses of Absinthe." The six bronze specimens cast from a wax mold were each colored differently by Picasso, and one of them is simply covered with brown sand. One finds oneself in the presence of a cycle of variations. The only differences among the pieces derive from their painting, but this fact changes each of them in significant fashion. The brown monochrome version differs greatly from the brightly colored ones. And the variations of coloring and accentuation of the parts give the impression that the forms themselves vary; the different paint applications serve to highlight different elements in different pieces, constantly creating new formal relationships. From this perspective, *Glass of Absinthe* is strictly linked to Synthetic Cubism: a more intense coloring is introduced and, more importantly, color serves to articulate and simplify.

This process has too often been seen only within the limits of Picasso's formal content, with its simultaneous representation of opened and closed volumes. That, however, was nothing new: in Picasso's paintings, we are constantly witnessing this sort of interpenetration. The glass is a subject very dear to Picasso. Glasses and bottles, because of their transparency and the optical refractions they present, stimulate the disaggregation and expansion of forms. The distortion and ambivalence of our visual experience occurs very naturally through these oppositions.

The glass is, in a more general sense, one of the essential themes of Cubism, as indicated in art historian Barr's Cubist iconography, his cataloguing of the different forms used by the artist. But what one should see first and foremost in these objects—as has also been shown for the musical instruments used in Cubist works—is their dynamic role in the realm of form. They all, in fact, have a plastic significance, beyond iconography. And the significance of these objects, which for the most part are very simple, lies in their powers of association. In Picasso's painting, the glass of absinthe is nothing new. What is new is Picasso's way of relating the art object to reality. The famous spoon introduced for its value as a real object in each of the six versions of this piece is an essential addition. Already in 1912, Picasso had stuck a piece of oilcloth in a painting, in the space reserved for the table. But while the oilcloth, in its insertion into the fictive domain of the painting, served to represent a reality, the spoon is limited to its own reality. A fragment of banal reality is thus introduced into the work of art. On three successive levels, the artist prompts a reference to reality: a representation, the glass; a reality, the spoon; and the imitation, of a piece of sugar. Picasso declares this intention out loud. He was conscious of the distinction between the object and the style created by the elements themselves: "I was interested in the relation between the real spoon and the modeled glass, . . . their manner of reacting to each other." This use of the spoon has been compared to Duchamp's use of readymades and found objects, which called into question the notion of traditional art. But in Picasso's case, the purpose is entirely different; art is not called into question. While Duchamp replaced the art object with any object, Picasso, for his part, chose to buy the object missing from his painting.

The artist invents a world, in which reality and art merge into a single unity that gives the object a new plastic significance. This is the most important revolution in the realm of sculpture in the twentieth century: for the first time, the artist no longer creates a work in its totality; indeed, he introduces a real object into the work. It is the genesis of a new aesthetic universe that takes advantage of the superimposition of art and reality. — W. S.

Pipe, Glass, Bottle of Vieux Marc (*Pipe, verre, bouteille de Vieux Marc*), spring 1914 (cat. no. 25)

After fragmenting representational form almost to the point of extinction in 1911, the following year Picasso and Braque reintroduced more legible imagery, usually derived from the environment of studio or café. Without abandoning all devices of Analytic Cubism, they developed a new idiom, referred to as Synthetic Cubism, in which they built their compositions with broader, flatter, and chromatically more varied planes. In the summer of 1912, Braque produced the first *papier collé*, in which cut paper is glued to the support and used as a compositional element. In the present example Picasso's pasted papers include printed material—a piece of wallpaper and the January 1, 1914, issue of *Lacerba*, a Futurist magazine founded in Florence in 1913. These elements mimic their functions in the external world and therefore introduce a new level of reality into the picture. The printed papers appear to be integrated into the pictorial space rather than lying flat on the surface. A transparent plane outlined in chalk appears to penetrate the newspaper and the guitar seems to cast a shadow on it; the actual physical presence of the wallpaper is similarly contradicted by the addition of drawing.

The treatment of other collaged papers multiplies meaning. In the case of the pipe or table leg, the cutout itself defines the contour of the object and is modeled accordingly with chalk. Penciled indications of other objects, such as the guitar or glass, ignore the shape of the pasted paper, which acts as both a support and a compositional element. The opacity of the collage materials is refuted and the transparency of the object depicted is upheld when Picasso discloses parts of the guitar behind the glass. On the other hand, a piece of *Lacerba* remains visible through the guitar, which in reality is opaque. Not only does each object have a multiple nature, but its relations in space to other objects are changeable and contradictory. The table assuredly occupies a space between the wall and the picture plane; its collaged corner overlaps a portion of wallpaper, and its visible leg obscures part of a baseboard molding. Yet the depth of this space is indeterminate, as the tabletop has reared up so that it is parallel to the picture plane. The respective situations in space of the still-life subjects are equally equivocal—the silhouette of the bottle of Vieux Marc simultaneously obscures and is obscured by the guitar. — L. F.

Mandolin and Guitar (*Mandoline et guitare*), 1924 (cat. no. 89)

One year before Picasso painted the monumental still life *Mandolin and Guitar*, Cubism's demise was announced during a Dada soiree in Paris by an audience member who shouted that "Picasso [was] dead on the field of battle"; the evening ended in a riot, which could be quelled only by the arrival of the police. Picasso's subsequent series of nine vibrantly colored still lifes (1924–25), executed in a bold Synthetic Cubist style of overlapping and contiguous forms, discredited such a judgment and asserted the enduring value of the technique. But the artist was not simply resuscitating his previous discoveries in creating this new work; the rounded, organic shapes and saturated hues attest to his appreciation of contemporary developments in Surrealist painting, particularly as evinced in the work of Joan Miró and André

Masson. The undulating lines, ornamental patterns, and broad chromatic elements of *Mandolin and Guitar* foretell the emergence of a fully evolved, sensual, biomorphic style in Picasso's art. — N. S.

Still Life with Classical Bust (*Nature morte à la tête antique*), 1925 (cat. no. 90)

After his rich Cubist experience, Picasso returned to a sort of classicism in the early 1920s. *Still Life with Classical Bust* represents a synthesis of late Cubism and the classical spirit, which some have gone so far as to call "Hellenistic." The presence of the ancient bust, finely etched with white strokes, suggests the style of ancient Greek vases. Also noteworthy is the play of curved and vertical lines and the cameo brown that spreads out in broad white areas and exceeds even the outlines of the drawing, in contrast to the chromatic violence of the paintings of the preceding years, such as the *Mandolin and Guitar* (1924, Solomon R. Guggenheim Museum, New York). The fruit dish, here seen in cross-section, is reminiscent of the Cubist manner. It would soon be time, however, to break with serene elegance and return to crude materials, to the fecund violence of "convulsive beauty" in which the Surrealists recognized themselves. By the end of this same year, 1925, Picasso would take part in the first Surrealist exhibition at the Galerie Pierre, Paris. — C. L.

The Studio (*L'Atelier*), 1928 (cat. no. 92)

In a series of paintings made between 1927 and 1929, Picasso built up a complex discourse on the activity of the artist, using the theme of the studio. Among the variations in the series, the closest to the present example is *The Studio* of 1927–28. Both works share the vivid palette of Synthetic Cubism, limited to draw attention to a conspicuous and authoritative execution in planar areas. This painterliness contrasts with the geometrized, linear contours that define the figures in the manner of Picasso's contemporaneous wire sculpture. The figures in this painting can be identified as a sculpted bust (at the left) and a full-length painted portrait (to the right). By depicting artistic representations of humans in a highly schematized form, Picasso places the figures at several removes from the world of living beings. He relies on the viewer's willingness to believe in the reality of depicted objects, however abstract, and to imagine a human exchange or relationship between the male and female forms. The bust's three eyes may reflect the artist's personal identification with the work of art. The theme of the artist's perception of himself and his subjects, and the theme of the interaction of reality and illusion, were central concerns throughout Picasso's life. — L. F.

Woman with Yellow Hair (*Femmes aux cheveux jaunes*), December 1931 (cat. no. 95)

When Picasso met Marie-Thérèse Walter on January 11, 1927, in front of Galeries Lafayette,

Paris, she was seventeen years old. As he was married at the time and she only a teenager, they were compelled to conceal their intense love affair. While their illicit liaison was hidden from public view, its earliest years are documented, albeit covertly, in Picasso's work. Five still lifes painted during 1927—incorporating the monograms "MT" and "MTP" as part of their compositions—cryptically announce the entry of Marie-Thérèse into the artists's life. By 1931, explicit references to her fecund, supple body and blond tresses appear in harmonious, voluptuous images such as *Woman with Yellow Hair*. Marie-Thérèse became a constant theme; she was portrayed reading, gazing into a mirror, and, most often, sleeping, which for Picasso was the most intimate of depictions.

The abbreviated delineation of her profile—a continuous, arched line from forehead to nose—became Picasso's emblem for his subject, and appears in numerous sculptures, prints, and paintings of his mistress. Rendered in a sweeping, curvilinear style, this painting of graceful repose is not so much a portrait of Marie-Thérèse the person as it is Picasso's abstract, poetic homage to his young muse. — N. S.

The Muse (*La Muse*), 1935 (cat. no. 96)

The theme of the girl drawing appears for the first time in January 1933, in two isolated drawings, each of which show a seated young girl, palette in hand, painting another girl who is lying down nude. In February 1935, the subject springs back up again with a biomorphic figure looking at itself in a mirror that reflects back a realistic portrait. This splitting of the real model and her portrait would be continued, in subsequent drawings, through the appearance of a second young woman, kneeling and asleep, and leaning against a table. A great many preparatory studies led up to the final version of *The Muse*, whose state is recorded by a subsequent drawing with annotations as to the colors. Picasso often executed two equivalent versions of a single work: the first version, this *Muse*, is slightly different from the second, in which the girl drawing is dressed, her head crowned with a floral wreath, her kneeling body rendered in curves and arabesques somewhat reminiscent of Henri Matisse's paintings.

This series of women in enclosed spaces, giving themselves over to reading, to daydreaming or to drawing, expresses Picasso's nostalgic aspiration to a peaceful, harmonious life ruled by the complicity and intimacy of female relationships. In fact, 1935 was a time of violent tension in Picasso's private life, "the worst period of my life," he would later say, since it was the year of his divorce from his wife, Olga, and the time of Marie-Thérèse's maternity. After this series, Picasso stopped painting for several months. — M. L. B.

Sigmar Polke
b. 1941

Sigmar Polke was born February 13, 1941, in Oels, Silesia (now Olesnica, Poland). In 1953, his family crossed illegally into West Germany and settled in Düsseldorf, where he studied glass painting from 1959 to 1960. From 1961 to 1967, he took classes at the Staatliche Kunstakademie Düsseldorf.

With Gerhard Richter and Konrad Lueg he organized the legendary *Demonstrative Ausstellung* in 1963, inaugurating what the artists called "Capitalist Realism," which was a humorous conflation of American-influenced Pop art and Eastern Bloc Socialist Realism. While turning one eye on consumer culture by adopting imagery from advertisements and the popular mediums, he turned the other on avant-garde art, ridiculing the great quest for abstraction in the early twentieth century and the meaningful gestures of the great Abstract Expressionists; he even toyed with a Conceptualist approach to painting late in the decade.

In 1966, Polke had his first solo exhibition at the Galerie René Block, Berlin. From the early 1970s on, Polke experimented with a seemingly unlimited number of themes and techniques, making complex compositions that defy any definite reading. Polke's work has been exhibited extensively during the last several decades. Galerie Konrad Fischer, run by his friend and former artist Konrad Lueg, presented several solo shows of Polke's work in the 1970s, as did the Galerie Michael Werner. A retrospective at the Kunsthalle Tübingen, which was also shown at the Kunsthalle Düsseldorf and at the Stedeljik Van Abbemuseum, Eindhoven in 1976, firmly established Polke's standing as an artist in Europe. He received the Will-Grohmann-Preis, Berlin, in 1982 and the Kurt-Schwitters-Preis, Hannover, in 1984. Polke represented Germany at the Venice *Biennale* in 1986, where he received the Golden Lion, the grand prize for painting. In 1983, an exhibition of Polke's latest work was shown at the Museum Boymans-van Beuningen, Rotterdam, and then at the Kunstmuseum Bonn, which also presented a retrospective exhibition of Polke's drawings and

sketchbooks in 1988. In 1990, the San Francisco Museum of Modern Art organized an retrospective of Polke's work, which traveled to museums throughout the United States. In 1977, he became full Professor at the Hochschule für Bildende Künste Hamburg, where he had taught since 1970. In 1994, Polke was honored with the Erasmus-Preis, and the following year he received the Carnegie Award. The most comprehensive retrospective to date was organized by the Kunst- und Ausstellungshalle der Bundesrepublik Deutschland, Bonn, in 1997, which then traveled to the Hamburger Bahnhof in Berlin. The artist has lived and worked in Cologne since 1978.

Pasadena, 1968 (cat. no. 311)

Pasadena exemplifies a method that questions art as high craft, yet remains obstinately ironic in the face of the significance usually granted to this art medium. This desacralization of traditional and modern painting was conducted, however, by a painter paradoxically attentive to the most figurative sorts of representations.

The question, then, was: How does one turn painting and figuration against themselves, but not against the painter? Answer: by practicing the most obviously naive sort of mimesis; or by using everyday objects to create the most mechanical scenes, grotesque in their ordinariness; or by reproducing pre-existing primary images, while partially depriving them of references, size relationships and textures. Or by making the contradictions of images simultaneously dazzling: this was the purpose of the silkscreened paintings of the 1960s.

In keeping with the Pop art technique, which reproduced and enlarged the dots of a mechanically printed image, Polke would use a silkscreen to enlarge a banal picture or detail that had already been subjected to reproduction. But Polke moved away from Pop art and altered its cold objective perfection by making the original reproduction exempt to its own mistakes or ambiguities. He thus compared himself to a lookout watching out for images falling into their own cracks.

Pasadena was made from a news image, a photograph of the moon's surface that obviously was not very legible; its painterly reproduction is even less so, but is decidedly intriguing. What, for example, are those spots coming out of the silk-screened background? Shadows? Only a caption, forming an integral part of the painting, accounts for a subject without any credible guarantee: the dark spot on the left corresponds to a small stone lying on the moon's surface, while the light spots are reflections of the sun. Without a verbalized description, the first image, considered "objective" and scientific, would look like the subject of an abstract painting. But with the description, its reproduction looks even stranger still.

Although these configurations are supposed to be seen as a whole, Polke insists on the relationship between a vision of the world in the form of dots and the emergence of an "other" reality.

He says, "In the first silkscreens, it's a matter of reproduction, mistaken impression and an attempt at personal expression, *to the point where the model becomes obliterated* and what was behind it comes forth and becomes something original and unusual." — N. P.

Jackson Pollock
1912–1956

Paul Jackson Pollock was born January 28, 1912, in Cody, Wyoming. He grew up in Arizona and California and in 1928 began to study painting at the Manual Arts High School, Los Angeles. In the fall of 1930, Pollock came to New York and studied under Thomas Hart Benton at the Art Students League. Benton encouraged him throughout the succeeding decade. By the early 1930s, Pollock knew and admired the murals of José Clemente Orozco and Diego Rivera. Although he traveled widely throughout the United States during the 1930s, much of Pollock's time was spent in New York, where he settled permanently in 1935 and worked on the WPA Federal Art Project from 1935 to 1942. In 1936, he worked in David Alfaro Siqueiros's experimental workshop in New York.

Pollock's first solo show was held at Peggy Guggenheim's Art of This Century gallery, New York, in 1943. Guggenheim gave him a contract that lasted through 1947, permitting him to devote all his time to painting. Prior to 1947, Pollock's work reflected the influence of Pablo Picasso and Surrealism. During the early 1940s, he contributed paintings to several exhibitions of Surrealist and abstract art, including *Natural, Insane, Surrealist Art* at Art of This Century in 1943, and *Abstract and Surrealist Art in America*, organized by Sidney Janis at the Mortimer Brandt Gallery, New York, in 1944.

From the fall of 1945, when artist Lee Krasner and Pollock were married, they lived in the Springs, East Hampton, New York. In 1952, Pollock's first solo show in Paris opened at the Studio Paul Facchetti and his first retrospective was organized by Clement Greenberg at

Bennington College, Bennington, Vermont. He was included in many group exhibitions, including the annuals at the Whitney Museum of American Art, New York, from 1946 and the Venice *Biennale* in 1950. Although his work was widely known and exhibited internationally, the artist never traveled outside the United States. He was killed in an automobile accident on August 11, 1956, in the Springs.

The Moon Woman, 1942 (cat. no. 225)

Like other members of the New York School, Pollock was influenced in his early work by Joan Miró and Picasso and seized on the Surrealists' concept of the unconscious as the source of art. In the late 1930s, Pollock introduced imagery based on totemic or mythic figures, ideographic signs, and ritualistic events, which have been interpreted as pertaining to the buried experiences and cultural memories of the psyche.

The Moon Woman suggests the example of Picasso, particularly his *Girl Before a Mirror* (*Jeune fille devant un miroir*, 1932). The palettes are similar, and both artists describe a solitary standing female as if she had been X-rayed, her backbone a broad black line from which her curving contours originate. Frontal and profile views of the face are combined to contrast two aspects of the self, one serene and public, the other dark and interior.

The subject of the Moon Woman, which Pollock treated in several drawings and paintings of the early 1940s, could have been available to him from various sources. At this time many artists, among them Pollock's friends William Baziotes and Robert Motherwell, were influenced by the fugitive, hallucinatory imagery of Charles Baudelaire and the French Symbolists. In his prose poem "Favors of the Moon," Baudelaire addresses the "image of the fearful goddess, the fateful godmother, the poisonous nurse of all the moonstruck of the world." The poem alludes to "ominous flowers that are like the censers of an unknown rite," a phrase uncannily applicable to Pollock's bouquet at the upper right. Although it is possible that Pollock knew the poem, it is likelier that he was affected in a more general way by the interest in Baudelaire and the Symbolists that was pervasive during the period. — L. F.

The Moon Woman Cuts the Circle, ca. 1943 (cat. no. 226)

This canvas is typical of Pollock's concerns in the early 1940s: it, too, shows the artist under the influence of Picasso, as he explored the techniques of automatism developed by André Masson and Miró. Behind the play of lines, inscribed in a flat circular design, one can still recognize a figure made up of a head and fragments of bodies associated with elements of fantastical creatures.

Having undergone psychoanalysis beginning in 1939, Pollock was deeply affected by Carl Jung's thoughts, which has prompted art historians to analyze this painting along psychoanalytical and mythological lines. While William Rubin saw it as

"Pollock's own birth as an artist," Lawrence Alloway thought it showed "the improvised as opposed to preconceived aspect of the figurative works"; others have noted a "possible reinforcement of the tendency to create myths that the painter shared with other New York artists." The Moon Woman theme has been compared, too, to a poem by Baudelaire.

Many commentators, however, follow Judith Wolfe, who saw not only a Picassoid head but also a Jungian symbol in Pollock's 1942 painting of the Moon Woman. Wolfe's interpretation extends to this work as well: "For Jung, the moon is a symbol of periodic creation, of death (when it disappears) and recreation. More importantly for Pollock, perhaps, the moon represents Hiana-Hecate: the young girl, the spirit-anima, contrasting with the terrible devouring Muse." Pollock may have been thinking, too, of Native American mythology, as suggested by the feathered headdress of the kneeling figure on the right. Moon Woman, related to the terrible, devouring Mother, tutelary mother of Jungian symbolism: these different ciphers, syncretic mixtures of primitive, archaic, and mythological elements, draw all their force from the aggressive, violent, even strident colors on the canvas. — C. S.

Two, 1943–45 (cat. no. 228)

As in *The Moon Woman*, Pollock depicts in *Two* a figurative subject in emblematic, abstract terms. Rapidly applied strokes of thick black paint harshly delimit the two totemic figures. A columnar figure on the left, probably male, faces the center. Black contours only partially delineate the white and flesh colored areas that signify his body, as Pollock separates and liberates line from a descriptive function. The figure on the right, possibly female, bends and thrusts in approaching the static figure on the left—a sexual union of the two is implied at the juncture of their bodies in the center of the canvas.

Careful examination of the paint surface reveals that the gray "ground" is actually extensive overpainting that covers and redefines broad areas of flesh color, white, and a lighter gray. Many of the harshest contours, such as the inner sides of the figures' upper torsos, are defined by this intrusive field of gray. Broad black strokes were applied on top of the overpainted ground in several areas: Pollock's imagery emerges with the painting process. A statement made by Pollock in 1947 about his mature art holds true for his earlier work as well: "The source of my painting is the unconscious. I approach painting the same way I approach drawing. That is direct—with no preliminary studies."

At about the same time he executed the present work, Pollock painted another encounter between two totemic beings, *Male and Female* (ca. 1942). Ciphers and mathematical signs appear in both canvases. In *Two*, several numerals, including 2, 3 and 6 (and possibly others between 1 and 8), may be discerned at the far right. In both works,

numerals serve at once as calligraphic marks and as signs: they reinforce the generally symbolic character of the painting without being invoked as specific references. Also, in both paintings two figures are brought together in agitated union, perhaps signifying the primacy of the male and the female in the genesis of human life. To be intrigued by such basic concepts, Pollock need not have relied exclusively on Jungian psychology or Native American mythology; he was interested in such phenomena because he sought to explore universal principles through his work. — E. C. C.

Enchanted Forest, 1947 (cat. no. 234)

Enchanted Forest exemplifies Jackson Pollock's mature abstract compositions created by the pouring, dripping, and splattering of paint on large, unstretched canvases. In *Enchanted Forest*, Pollock allows large areas of white to breathe amidst the network of moving, expanding line. He also reduces his palette to a restrained selection of gold, black, red, and white. Pollock creates a delicate balance of form and color through orchestrating syncopated rhythms of lines that surge, swell, retreat, and pause only briefly before plunging anew into continuous, lyrical motion. One's eye follows eagerly, pursuing first one dripping rope of color and then another, without being arrested by any dominant focus. Rather than describing a form, Pollock's line thus becomes continuous form itself.

Michael Fried has described Pollock's achievement: "[His] all-over line does not give rise to positive and negative areas. There is no inside or outside to Pollock's line or to the space through which it moves. And that is tantamount to claiming that line, in Pollock's all-over drip paintings of 1947–50, has been freed at last from the job of describing contours and bounding shapes." It is this redefinition of the traditional capacity of the artist's formal means that distinguishes Pollock's art in the history of Modernism. — E. C. C.

Painting, 1948 (cat. no. 235)

Exhibited in 1952 at the Studio Paul Facchetti during Pollock's first solo show in Paris, this painting on paper perfectly illustrates, in spite of its small size, the allover drip technique, which established a new relationship between the painter and his canvas. Pollock spoke of this in the following terms in 1950–51, in a film by Hans Namuth: "I do not work from drawings or color sketches. I paint directly. Usually I paint on the ground. . . . With the canvas on the ground, I feel closer to a painting, I become a part of it. In this way, I can walk around it, work on it from all four sides, and be in the painting, like the Indians of the West who work in sand. Sometimes I use a brush but often I prefer to use a stick. Sometimes, I pour paint directly from the can. . . . I also use sand, broken glass, pebbles, string, nails, and other elements foreign to painting. The painting method evolves naturally, based on need. I want to express my feelings rather than illustrate them."

The line of the pouring no longer circumscribes a plane or volume; it is not there to separate. Nor is it a moving point, a series of points or a bundle of points as one finds in Vasily Kandinsky, or a displaced line as with Paul Klee. Spreading laterally and developing all sorts of excrescences, the line acquires a new profile that "bites" (to use Fried's expression) the canvas on each of its edges. It is the trace, the imprint of a passing on the canvas, or more exactly over the canvas, since no hand or brush have touched the support. The line of paint is an indication of what has taken place, it is the trace of an event. Upheld by Harold Rosenberg, this interpretation is the basis of the term "Action Painting." — C. S.

The Deep, 1953 (cat. no. 236)

In the spring of 1951, Pollock began a series of black paintings that would interrupt, in a radical but momentary fashion, the classical period of the drip paintings. While the idea of working in a single color, black, was not new among the Abstract Expressionists—Franz Kline and Robert Motherwell were predecessors—Pollock's approach was different. He poured a very liquid "ink," a wash of sorts, onto the white canvas, producing nuances in the porous cloth that look like figures. The technique here is essentially that of the splashes the painter had been making for three years, using large syringes in the place of the sticks. The execution of these "drawings" on canvas, according to the artist's own descriptions, is distinguished from the traditional treatment of drawing.

With *The Deep*, one of the rare paintings created in Pollock's last years, he returns to a more "classical" organization of the composition. Instead of a surface entirely covered and worked in a homogeneous manner, the painting presents a somber fracture at the center of a clear mass that suggests the space beyond its surface, the internal space that tends to bury the image. Through the rending of the layer of white that threatens to cover the black, or, inversely, through the black that chases away the white and sucks it into the void it has created, an indeterminate floating space is introduced. Pollock here seems once again to confront the problem of depth and the inscription of a shape on a ground, a question that returned in moments of crisis throughout his career. — C. S.

Liubov Popova
1889–1924

Liubov Sergeevna Popova was born April 24, 1889, near Moscow. After graduating from high school in Yalta, she studied in Moscow at the Arsenieva Gymnasium in 1907–08 and at the same time attended the studios of Stanislav Zhukovsky and Konstantin Yuon. In the course of her travels in 1909–10, she saw Mikhail Vrubel's work in Kiev, ancient Russian churches in Pskov and Novgorod, and early Renaissance art in Italy. In 1912, Popova worked at The Tower, a Moscow studio, with Vladimir Tatlin and other artists. That winter, she visited Paris, where she worked in the studios of the Cubist painters Le Fauconnier and Jean Metzinger. In 1913, Popova returned to Russia, but the following year she journeyed again to France and to Italy, where she gained familiarity with Futurism.

In her work of 1912 to 1915, Popova was concerned with Cubist form and the representation of movement; after 1915 her nonrepresentational style revealed the influence of icon painting. She participated in many exhibitions of advanced art in Russia during this period: the *Jack of Diamonds* shows of 1914 and 1916 in Moscow; *Tramway V: First Futurist Exhibition of Paintings* and *0.10: The Last Futurist Exhibition*, both in 1915 in St. Petersburg; *The Store* in 1916, *Fifth State Exhibition: From Impressionism to Nonobjective Art* in 1918–19, and *Tenth State Exhibition: Nonobjective Creation and Suprematism* in 1919, all in Moscow. In 1916, Popova joined the Supremus group, which was organized by Kazimir Malevich. She taught at Svomas (Free State Art Studios) and Vkhutemas (Higher State Art-Technical Institute) from 1918 onward and was a member of Inkhuk (Institute of Painterly Culture) from 1920 to 1923.

The artist participated in the *5 x 5 = 25* exhibition in 1921 and in the *Erste russische Kunstausstellung*, held under the auspices of the Russian government in Berlin in 1922. In 1921, Popova turned away from studio painting to execute utilitarian Productivist art: she designed textiles, dresses, books, porcelain, costumes, and theater sets (the latter for Vsevolod Meierkhold's productions of Fernand Crommelynk's *The Magnanimous*

Cuckold, 1922, and Serge Tretiakov's *Earth in Turmoil*, 1923). Popova died May 25, 1924, in Moscow.

Birsk, 1916 (cat. no. 102)

Women formed an essential part of the Russian avant-garde, changing the face—and gender—of art in the process. Chief among them was Popova, the well-heeled daughter of a textile merchant. Popova's skill lay in her mastery of Parisian Cubism and Milanese Futurism, all the while maintaining her roots in a Russian artistic idiom. This is especially apparent in the commanding view of Birsk, a small town near the Urals, painted in 1916.

Popova began this painting on the occasion of a summer visit to her former governess, who lived in Birsk. Popova turned to a style that was already anachronistic in 1916; the houses are fragmented and depicted in sliding planes of color that seem a cross between those favored by Umberto Boccioni, Georges Braque, and Juan Gris. These shades, however, are too intense to be characteristic of her Western mentors. They evoke paintings on glass, or the brilliance of Russian folk costumes. At this time, Popova was still undecided as to her theoretical position. *Birsk* satisfied both the fragmentation of space so dear to the Cubists and the problem of luminous and shifting forms taken up by the Futurists. Like some of the works that Kazimir Malevich painted a few years earlier, it is an example of Russian Cubo-Futurism. *Birsk* was one of the last Western-oriented works that Popova painted before turning her attention to the artistic needs dictated by the October Revolution. By 1917, she adopted the theoretical implications of non-objective painting fully and began making Productivist art—art with a practical social function. In part this involved designing bold textile patterns that are anticipated in the cascading cliffs of *Birsk*.

It is ironic that Popova chose a frankly Western style to paint this work. Birsk is a city in Bashkir; its historical culture is Islamic and, until 1929, its writing system was Arabic. There, Popova may have gathered information for her later embarkation into textile design. Birsk has a strong local tradition of weaving and counted-thread embroidery, with geometric designs, diamonds, and cross-shaped figures providing an interesting parallel to the geometric solids of Popova's designs of the early 1920s. — C. L.

Robert Rauschenberg
b. 1925

Robert Rauschenberg was born Milton Rauschenberg on October 22, 1925, in Port Arthur, Texas. He began to study pharmacology at the University of Texas at Austin before being drafted into the United States Navy, where he served as a neuropsychiatric technician in the Navy Hospital Corps, San Diego. In 1947, he enrolled at the Kansas City Art Institute and traveled to Paris to study at the Académie Julian the following year.

In the fall of 1948, he returned to the United States to study under Josef Albers at Black Mountain College, near Asheville, North Carolina, which he continued to attend intermittently through 1952. While taking classes at the Art Students League, New York, from 1949 to 1951, Rauschenberg was offered his first solo exhibition at the Betty Parsons Gallery. Some of the works from this period included the blueprints, monochromatic white paintings, and black paintings. From the fall of 1952 to the spring of 1953, he traveled to Europe and North Africa with Cy Twombly, whom he had met at the Art Students League. During his travels, Rauschenberg worked on a series of small collages, hanging assemblages and small boxes filled with found elements, which he exhibited in Rome and Florence.

Upon his return to New York in 1953, Rauschenberg completed his series of black paintings, using newspaper as the ground, and began work on sculptures created from wood, stones, and other materials found on the streets; paintings made with tissue paper, dirt, or gold leaf; and more conceptually oriented works such as *Automobile Tire Print* (1953)and *Erased de Kooning Drawing* (1953). By the end of 1953, he had begun his *Red Painting* series on canvases that incorporated newspapers, fabric, and found objects and evolved in 1954 into the Combines, a term Rauschenberg coined for his well-known works that integrated aspects of painting and sculpture and would often include such objects as a stuffed eagle or goat, street signs, or a quilt and pillow. In

late 1953, he met Jasper Johns, with whom he is considered the most influential of artists who reacted against Abstract Expressionism. The two artists had neighboring studios, regularly exchanging ideas and discussing their work, until 1961.

Rauschenberg began to silkscreen paintings in 1962. He had his first career retrospective, organized by the Jewish Museum, New York, in 1963 and was awarded the Grand Prize in Painting at the 1964 Venice *Biennale*. He spent much of the remainder of the 1960s dedicated to more collaborative projects including printmaking, performance, choreography, set design, and art and technology works. In 1966, he co-founded Experiments in Art and Technology, an organization that sought to promote collaborations between artists and engineers.

In 1970, Rauschenberg established a permanent residence and studio in Captiva, Florida, where he still lives. A retrospective organized by the National Collection of Fine Arts, Washington, D.C., traveled throughout the United States in 1976–78. Rauschenberg continued to travel widely, embarking on a number of collaborations with artisans and workshops abroad which culminated in the Rauschenberg Overseas Culture Interchange (ROCI) project from 1985 to 1991. In 1997, the Solomon R. Guggenheim Museum, New York, exhibited the largest retrospective of Rauschenberg's work to date, which traveled to Houston and to Europe in 1998.

Untitled (Red Painting), ca. 1953 (cat. no. 288)

In 1951 and 1952, Rauschenberg created two series of paintings, one monochrome white and pristine, the other all black with clotted, collaged-newspaper surfaces. In 1953, he shifted to the color red. In an interview many years later he told art historian Barbara Rose, "I was trying to move away from black and white. Black *or* white, not black-and-white. So I picked the most difficult color for me to work in." *Untitled (Red Painting)*, like the *Black Paintings*, has a richly textured, mottled skin. The artist has built up a layered, patched surface from overlapping pieces of newspaper and cloth covered with different shades of red paint, with areas of black and white underpainting showing through. Rauschenberg's paintings from the early 1950s reflect his direct exposure to European artists who were similarly concerned with single-color pictures, materiality and surface qualities. In particular, the bloodlike hue and the layered, collaged paper suggesting bandages evoke the contemporaneous work of the Italian artist Alberto Burri, whose studio he visited twice in 1953. Rauschenberg's experimentation with new materials, already evident in this work, expanded dramatically in 1954 and 1955, when he began attaching everyday objects to two and three-dimensional supports to make his Combines. — SRGM

Martial Raysse

b. 1936

Martial Raysse was born into a family of ceramicists February 12, 1936, in Golfe-Juan-Vallauris. He began to paint watercolors from an early age. He studied letters at the Faculté de Nice in 1954, and devoted himself to literature, yet he continued nonetheless to paint and sought a path between literature and painting.

In 1955, he met the artists Ben Vautier and Arman, also from Nice, and became friends with them. During this time, he created his first works: painted masks made with bits of branches or aloe roots gathered on the beaches of Beaulieu-sur-Mer, and thick impasto paintings made with a mixture of plaster and sand. These "materialist" paintings gradually led him to sculpture, and in 1956 he began to create sculptures out of barbed wire and mobiles made from stones and found metals.

Raysse exhibited his "object-poems" and his mobiles for this first time in 1957 in a group show entitled *Les Peintres de vingt ans* at the Longchamp gallery in Nice. Through Arman, Raysse met Yves Klein in 1958 and had his first solo show the same year, *Peinture-Poésie-Sculpture* at the Vieil-Olivier gallery in Beaulieu-sur-Mer. In 1959, he participated in several group shows in Brussels, Monte Carlo, and New York. Searching for a new vocabulary, Raysse created large assemblages with mass-produced objects. Until 1968, he used this method to develop a vision of a "new world, antiseptic and pure," a cycle he called *Hygiène de la vision*, by taking plastic objects of common usage and playing with advertisements in them. In 1960, he participated in the founding of the Nouveaux Réalistes, which gathered in Paris around Pierre Restany. While Raysse used expressive resources from urban reality like the other members of the group, he did not use objects discarded by consumer society, but chose rather to translate standardization and antisepticism.

On the occasion of the exhibition *Dylaby* organized in 1962 at the Stedelijk Museum in Amsterdam, he exhibited an "environment," the

Raysse Beach, an assemblage of incongruous objects in which he introduced neon for the first time. The same year he participated in the New Realists show at the Sidney Janis Gallery, New York, and decided to spend a year at the Chelsea Hotel, a crossroads for artistic French emigrés.

In 1963, he settled in Los Angeles and, until 1968, traveled frequently between France and the United States. Until 1966, he made many works using female stereotypes from advertisements and combined them with neon. At the same time he created a series of works entitled *Made in Japan*, in which he manipulated masterworks from the history of art.

The first retrospective of his works took place in 1965 at the Stedelijk Museum, Amsterdam, when he was twenty-nine years old. Returning to Paris in 1968, he followed the events in May, and was named professor at the Ecole nationale supérieure des arts décoratifs of Paris in December, easing up on his artistic activities for the next three years. During the 1970s, Raysse was drawn to new forms of expression, including video and cinema, and created his first film. At the same time, he worked with painting, and also made assemblages incorporating disparate materials. More recently, Raysse has devoted his attention to public commissions of monumental sculptures.

He received, in December 1982, the French Grand Prix National de Peinture. The retrospective exhibition the Galerie national du Jeu de Paume devoted to him in 1992 bore witness to an attitude resolutely at crosscurrents to the mainstream, and revealed the fundamentally original dimension of Raysse's unusual path.

Suddenly Last Summer (Soudain l'été dernier), 1963 (cat. no. 307)

The theme of the bather appeared for the first time in Raysse's work in 1960, when he included a life-size photo of a girl in a bathing suit holding a parasol, atop a display of sun products and beach toys. Between 1962 and 1964, Raysse frequently reused this visual cliché, multiplying the retouched photographic effigies of young women on the beach. Stressing the most vulgar form of these stereotypes, Raysse shows that "bad taste" (that "dream of a too-desired beauty," he would say) can conceal unsuspected magic and emotion. He used these photographs as what he called a "relay" to dismantle the "fictive space, the trompe-l'oeil" they present to the spectator, the better to emphasize their hidden resources. Operating by means of staggered planes; airbrushed and painted artificial tones of color, arbitrarily defined; and the addition of real objects (in this case a straw hat and beach towel), Raysse keeps his subject free of photographic illusionism, and perspectival space, and thus free of the representational discourse these imply. This purging of figurative conventions liberates latent forces within the image: monumentalized, articulated, displayed three-dimensionally (the real objects link her humorously with reality), Raysse's beach girl is

endowed with a new, borrowed, and nostalgic life (which the title, borrowed from Tennessee Williams, further accentuates); one that is far off but indestructible. To the quick rhythm of her acid fluorescences, she is brilliance, energy, the ideal object of desire. —J. P. A.

James Rosenquist

b. 1933

James Albert Rosenquist was born November 29, 1933, in Grand Forks, North Dakota. He studied at the Minneapolis School of Art in 1948. Between 1952 and 1954, he learned traditional painting techniques from Cameron Booth at the University of Minnesota, while he painted silos and gas stations. In 1955, he moved to New York and enrolled at the Art Students League. In New York, he met Robert Indiana, Jasper Johns, Ellsworth Kelly, and Robert Rauschenberg, among others. During this period, he worked on small-format abstract paintings. From 1957 to 1960, he supported himself by painting billboards, becoming completely conversant with the techniques of enlarging photographic images to paint them on a colossal scale. He subsequently began to incorporate fragmented images from advertising, movies, and commercial art into his works.

His first solo show was held in 1962 at the Green Gallery, New York, and received much attention from the public and the press. Rosenquist stirred viewers' awareness of their relation to mass media, with work characterized by its huge scale, hyperrealism, and popular imagery painted in either bright colors or muted grays. Since 1962, his work has been systematically included in exhibitions of Pop art.

In 1964, he joined the stable of Leo Castelli Gallery, New York, and the Galerie Ileana Sonnabend began to show his work in Paris. In 1968, the artist produced his first "environment paintings," images of enlarged fragments of unre-

lated everyday objects. The artist experimented with sculpture, cinema, and lithography in the early 1970s, and in 1976, he moved to Indian Bay, Florida. At the 1978 Venice *Bienniale*, his painting *F-111* (1964–65), which covered four walls of a room in the international pavilion, depicted historical symbols, signs of affluence, and enlarged details of military hardware, addressing the American propaganda of war. In the late 1970s and 1980s, Rosenquist depicted images of women confronted with machine aesthetics, in layered, fragmented, and dynamic compositions. The current work of the artist continues to demonstrate his commitment to speak to the subconscious of a media-saturated mass culture.

The Whitney Museum of American Art, New York, organized Rosenquist's first important show in 1972. The artist was also honored by several comprehensive exhibitions in the 1980s. A retrospective of his paintings took place in 1991 at the IVAM Centre Julio González, Valencia. The University Art Museum, California State University, Long Beach, mounted a traveling show of his complete graphic work in 1993. In March 1998, the Deutsche Guggenheim Berlin unveiled *Swimmer in the Econo-mist*, the museum's first site-specific commissioned painting. The artist lives and works in New York and Florida.

President Elect, 1960–61 (cat. no. 306)

Rosenquist very quickly found his artistic identity: huge formats, a manner of painting with broad, supple strokes of the brush, and bright colors. The colors are almost always lightened using white, which produces an effect of depth and ambiguity, as do the abrupt changes of scale he continued from his previous career as a billboard painter.

President Elect is one of Rosenquist's few works that appears to be directly inspired by advertising posters. It was made when Kennedy was still an image of optimism for the United States, augmented by the cake and the car as tangible symbols of this new era of postwar prosperity. Rosenquist's originality already distinguishes itself here: in dividing the surface into three parts, he breaks the monotony of the image by multiplying points of view as well as their attendant meanings. The undulation of light on Kennedy's face, and the grisaille hands that transplant themselves like apparitions are characteristic of artist's approach. In these distinct qualities, some have seen the influence of the Surrealists, yet Rosenquist denies their effect on his art. —Cl. S.

Mark Rothko

1903–1970

Marcus Rothkowitz was born September 25, 1903, in Dvinsk, Russia. In 1913, he left Russia and settled with the rest of his family in Portland, Oregon. Rothko attended Yale University, New Haven, on a scholarship from 1921 to 1923. That year, he left Yale without receiving a degree and moved to New York. In 1925, he studied under Max Weber at the Art Students League. He participated in his first group exhibition at the Opportunity Galleries, New York, in 1928. During the early 1930s, Rothko became a close friend of Milton Avery and Adolph Gottlieb. His first solo show took place at the Portland Art Museum in 1933.

Rothko's first solo exhibition in New York was held at the Contemporary Arts Gallery in 1933. In 1935, he was a founding member of the Ten, a group of artists sympathetic to abstraction and expressionism. He executed easel paintings for the WPA Federal Art Project from 1936 to 1937. By 1936, Rothko knew Barnett Newman. In the early 1940s, he worked closely with Gottlieb, developing a painting style with mythological content, simple flat shapes, and imagery inspired by primitive art. By mid-decade, his work incorporated Surrealist techniques and images. Peggy Guggenheim gave Rothko a solo show at Art of This Century in New York in 1945.

In 1947 and 1949, Rothko taught at the California School of Fine Arts, San Francisco, where Clyfford Still was a fellow instructor. With William Baziotes, David Hare, and Robert Motherwell, Rothko founded the short-lived Subjects of the Artist school in New York in 1948. The late 1940s and early 1950s saw the emergence of Rothko's mature style in which frontal, luminous rectangles seem to hover on the canvas surface. In 1958, the artist began his first commission, monumental paintings for the Four Seasons Restaurant in New York. The Museum of Modern Art, New York, gave Rothko an important solo exhibition in 1961. He completed murals for Harvard University in 1962 and in 1964 accepted a mural commission for an interdenominational

chapel in Houston. Rothko took his own life February 25, 1970, in his New York studio. A year later, the Rothko Chapel in Houston was dedicated.

Number 17, 1947 (cat. no. 266)

Like other New York School artists, Rothko used abstract means to express universal human emotions, earnestly striving to create an art of awe-inspiring intensity for a secular world. In order to explain the power of his canvases, some art historians have cited their compositional similarity to Romantic landscape painting and Christian altar decoration. Anna Chave suggests that Rothko's early interest in religious iconography underlies his later work, and she sees a reference to the Madonna and Child in this painting. The forms at left do indeed appear to represent a seated figure nursing a child, in which case the lateral division near the top of the canvas may be read as a horizon line. More often, however, this painting is interpreted as an abstract work made during a transitional period in Rothko's career, developing out of the Surrealistic biological fantasies he was painting in the early 1940s and moving toward the softer-edged compositions infused with color that appeared late in the decade. — SRGM

Dark over Brown No. 14, 1963 (cat. no. 277)

No body of work expresses better than Rothko's the conflicts between a materialistic and a metaphysical interpretation of the artist's purpose. The implicit relationship that *Dark over Brown no. 14* has due to its resemblance to the Rothko Chapel in Houston leads one to opt for a spiritual interpretation. However, the work's contemporaneity with the beginnings of Minimalism also lends itself to an ascetic reading, parallel to the work of some of the artist's younger contemporaries.

Any interpretation remains defective, however, since the work does not favor one reading over another, leaving the observer immersed in an intimate, palpable relationship with it. The painting indeed is not recognizable as any direct metaphor on which one might focus, but rather appears to be a resolutely antagonistic, conflictual expression that no translation into words can resolve, an image that resists language with an imperious silence.

Dark over Brown No. 14 is situated chronologically between the 1958 Seagram Building series and the dark, meditative monochrome series of the Rothko Chapel of 1964–67. With black acrylic painting over the brown, it represents a milestone in the artist's process of refining color to the point of extinction: flat, somber, and matte, its blind blackness contradicts the glazes of the 1950s and 1960s, with their subtle juxtapositions of complementary and triumphant colors. A "meditation table," Michel Ragon has called this work. Thwarting the overly facile emotional attachment of a vision shaped by the "decorative," this painting conveys nothing but the incompressible weight of presence, of shadow over shadow.
— A. B. and B. B.

Number 18, 1963 (cat. no. 276)

By the early 1950s, Rothko had arrived at the format that would order the rest of his life's work: stacked rectangles against a ground. In *Number 18*, horizontal rectangles of color, their edges softened by the touch of the artist's brush, hover over a maroon field. The rich, almost royal colors fall midway between the brilliant oranges, cool blues, and radiant yellows of Rothko's works of the 1950s and his ever-darkening palette that ultimately eclipsed into the blacks and grays of the majority of his last works, made just prior to his suicide.

It has been said that, given the dearth of other formal characteristics, the color in a color-field painting remains like a heavenly signpost, pointing blankly toward the nonverbal and the sublime. This notion is both embodied in and contradicted by Rothko's work. While he tended to assert its abstract nature, he was equally adamant about its expressive content. Painting, he declared, "is a communication about the world to someone else." Rothko saw the world in terms of human hopes being eternally quashed by despair and aspirations forever darkened by angst, ideas that he intended his paintings to express and that were confirmed by his reading of Friedrich Nietzsche's *The Birth of Tragedy*, the book he said came closest to his view of life.

Throughout his career, Rothko was patently unable to reconcile his success as an artist with his resentment of the establishment and the bourgeoisie. His commission for the elite Four Seasons Restaurant, New York (which he ultimately refused), was planned with the intent of giving its monied clients dyspepsia. However, no project gave him greater joy than the murals he created for a chapel in Houston that was sponsored by the baronial de Menil family. In 1958, Rothko was named the national winner of the Solomon R. Guggenheim Museum's International Award. He turned down the prize in distaste and anticipation of the day "when honors can be bestowed simply for the meaning of a man's life work—without enticing pictures into the competitive arena." And yet, ten years later, thinking about his work's reputation within that arena, the artist founded the Mark Rothko Foundation, which in 1986 donated *Number 18* to the museum. — I. S.

Robert Ryman
b. 1930

Robert Ryman was born May 30, 1930, in Nashville. In 1948, he enrolled at Tennessee Polytechnic Institute but transferred the next year to George Peabody College for Teachers in Nashville, where he studied music. In 1950, Ryman enlisted in the United States Army Reserve Corps and was assigned to an Army reserve band during the Korean War. In 1952, he moved to New York and studied with jazz pianist Lenny Tristano. Taking on odd jobs to support himself, Ryman took a position as a guard at the Museum of Modern Art, New York, in June 1953. During that year, the artist made his first paintings.

In 1955, Ryman began what he considers his earliest professional work, a largely monochrome painting titled *Orange Painting*. His work was first exhibited in a staff show at the Museum of Modern Art, New York, in 1958, and later that year he was included in a group show at the Brata Gallery, New York. In the late 1950s, Ryman became friends with artists Dan Flavin and Michael Venezia, both of whom were also working at the Museum of Modern Art. In 1961, the artist married the art historian Lucy Lippard; this marriage ended in divorce. He later married Merrill Wagner. In 1961, he also began to paint on a full-time basis. During the early 1960s, Ryman spent a great deal of time with other artists whose studios were on the Bowery, including Sylvia and Robert Mangold, Sol LeWitt, Eva Hesse, and Tom Doyle. At this time, Ryman began executing his

first paintings on metal (vinyl polymer on aluminum), a support he would use many times again. In 1966, Ryman's work was included in *Systemic Painting* at the Solomon R. Guggenheim Museum, along with twenty-eight other artists including Ellsworth Kelly, Jackson Pollock, and Frank Stella. The artist's first solo exhibition took place at the Paul Bianchini Gallery, New York, in 1967. Two years later, Ryman was included in *When Attitudes Become Form*, a seminal exhibition of works by Minimal and Conceptual artists organized by the Kunsthalle Bern. Throughout his career, Ryman has isolated the most basic components of painting and experimented with their variations.

In 1972, the Solomon R. Guggenheim Museum exhibited thirty-eight of Ryman's works from the years 1965 to 1972, in the artist's first solo exhibition in a New York museum. That summer Ryman was included in *Documenta V* in Kassel. In 1973, the artist was awarded a John Simon Guggenheim Fellowship, and the next year, he had a retrospective exhibition at the Stedelijk Museum, Amsterdam. Additional retrospective exhibitions were organized by the Whitechapel Art Gallery in London in 1977 and by the InK, Halle für Internationale neue Kunst, Zurich, in 1980, the latter of which traveled throughout Europe. A permanent exhibition of Ryman's work was installed at the Hallen für neue Kunst in Schaffhausen in 1983. In 1991, his works from 1958 to 1981 were exhibited at the Espace d'art contemporain, Paris. In 1993 and 1994, an exhibition of Ryman's work traveled to the Tate Gallery, London; the Museo Nacional Centro de Arte Reina Sofía, Madrid; the Museum of Modern Art, New York; the San Francisco Museum of Modern Art; and the Walker Art Center, Minneapolis. In 1994, Ryman was elected a member of the American Academy and Institute of Arts and Letters, New York. He is currently represented by PaceWildenstein in New York, where he lives and works.

Classico 2, 1968 (cat. no. 337)

One of a series of multipaneled works on paper, *Classico 2* is titled after the specific type of paper (called Classico), which Ryman chose for the composition's ground. Throughout his meditations on the elements of painting using a palette confined to white, Ryman has experimented with a variety of paint types as well as different and often nontraditional supports, including paper, canvas, cardboard, metal, wood, and even wax paper. By paring down his medium to white paint, Ryman draws attention to the nuances of support, as well as to the resulting texture, size, color, and finish.

The artist's process is as important as his materials. In the *Classico* series, his process is partially revealed by the finished product itself. To make these works, Ryman attached sheets of paper to each other and to the wall with tape and painted over them with white acrylic paint. When the sheets dried, he removed the tape and mounted each section on foamcore. In *Classico 2*, small ghostlike traces of the tape are visible on the center edges of the six sheets where the tape has been removed; these areas of paper left bare are as significant to the composition as the painted area of the work.

As traditional categories of medium/support and figure/ground become confused in Ryman's paintings, so do strict definitions of color—or its absence—as white turns to yellow, ivory, or gray with changes in material, light, or vantage point of the viewer. For example, the paper of this work boldly stands out as ocher, particularly when juxtaposed with the pure, bright white of the paint. And even within the expanse of white paint, gradations of color are visible. The thinner layer of paint nearer to the edges of the work, for example, appears gray in certain light or as a glowing, pearly halo in others. Moreover, the shiny quality of the Liquitex paint accentuates the paper's matte surface. In contrast to the reflective surface of the paint layer, the thick paper takes on a visually substantial and weighty aspect, differing from Ryman's works on steel, for instance, which often appear mysteriously light and airy.

Though each sheet of paper used in *Classico 2* is a vertical rectangle, when joined the entire composition forms a horizontal block closer to a square, a format commonly chosen by Ryman and described by the artist as "the perfect space." His use of reduced forms and geometric sequences is typical of Minimalist compositions that utilize serial progressions: in so doing, they reference a mass-produced, industrial aesthetic and deemphasize Modernist notions of a handwrought original. Ryman's paintings, which often reveal the presence of the artist with visible brushstrokes as well as with vestiges of tape like those in *Classico 2*, illustrate Hal Foster's view of Minimalism as a culmination of the formal traditions of Modernism as well as the beginning of a critique of that tradition. —S. C.

Richard Serra

b. 1939

Richard Serra was born November 2, 1939, in San Francisco. While working in steel mills to support himself, Serra attended the University of California at Berkeley and Santa Barbara from 1957 to 1961, receiving a B.A. in English Literature. He then studied at Yale University, New Haven, from 1961 to 1964, completing his B.F.A. and M.F.A. Serra trained as a painter at Yale, where he worked with Josef Albers on his book *The Interaction of Color* (1963). During the early 1960s, he came into contact with Philip Guston, Robert Rauschenberg, Ad Reinhardt, and Frank Stella. In 1964 and 1965, Serra traveled to Paris on a Yale Traveling Fellowship, where he frequently visited Brancusi's studio reconstructed at the Musée national d'art moderne. He spent much of the following year in Florence on a Fulbright grant, and traveled throughout southern Europe and north Africa. The young artist was given his first solo exhibition at Galleria La Salita, Rome, in 1966. Later that year he moved to New York, where his circle of friends included Carl Andre, Walter De Maria, Eva Hesse, Sol LeWitt, and Robert Smithson.

In 1966, Serra made his first sculptures out of nontraditional materials such as fiberglass and rubber. From 1968 to 1970, he executed a series of *Splash* pieces, in which molten lead was splashed or cast into the junctures between floor and wall. Serra had his first U.S. solo exhibition at the Leo Castelli Warehouse, New York. By 1969, he had begun the prop pieces, whose parts are not welded together or otherwise attached but are balanced solely by forces of weight and gravity. That year Serra was included in *Nine Young Artists: Theodoron Awards* at the Solomon R. Guggenheim Museum, New York. He produced the first of his numerous short films in 1968 and in the early 1970s experimented with video. The Pasadena Art Museum organized a solo exhibition of Serra's work in 1970, and in the same year he received the John Simon Guggenheim Memorial

Foundation Fellowship. That year he helped Smithson execute *Spiral Jetty* in Salt Lake, Utah; Serra, however, was less intrigued by the vast American landscape than by urban sites, and in 1970 he installed a piece on an abandoned dead-end street in the Bronx. He received the Skowhegan Medal for Sculpture in 1975 and traveled to Spain to study Mozarabic architecture in 1982.

Serra was honored with solo exhibitions at the Kunsthalle Tübingen, West Germany, in 1978; the Musée national d'art moderne, Paris, in 1984; the Museum Haus Lange, Krefeld, in 1985; and the Museum of Modern Art, New York, in 1986. The 1990s saw further honors for Serra's work: a retrospective of his drawings at the Bonnefantenmuseum, Maastricht; the Wilhelm Lehmbruck prize for sculpture in Duisburg in 1991; and the following year, a retrospective at Museo Nacional Centro de Arte Reina Sofía, Madrid. In 1993, Serra was elected a Fellow in the American Academy of Arts and Sciences. In 1994, he was awarded the Praemium Imperiale by the Japan Art Association and an honorary Doctorate of Fine Art from the California College of Arts and Crafts. Serra has continued to exhibit in both group and solo shows in such venues as Leo Castelli Gallery and Gagosian Gallery, New York. He continues to produce large-scale steel structures for sites both in the United States and Europe. In 1997–98, his *Torqued Ellipses* (1997) were exhibited at the Dia Center for the Arts, New York. Serra and his wife, Clara Weyergraf-Serra, live outside New York and in Nova Scotia.

Plinths, 1967 (cat. no. 322)

Plinths belongs to the earliest phase of Serra's career, after his return from a trip to Europe that took the recent Yale graduate first to Paris, where he made drawings in Brancusi's studio at the Musée national d'art moderne, and then to Italy. It was in Rome, in 1966, that he had his first show, exhibiting some odd assemblages of living and stuffed animals in cages, prefiguring Arte Povera.

Back in New York, Serra created works halfway between painting and sculpture, favoring rubber as his material, for its malleability and suppleness. For a little more than a year, he exploited the potential of this material, which took him far away from traditional sculpture, before he subsequently moved on to lead, finding success in working with its physical properties—both in molten form (as in *Splashing*, 1968) and in the form of slabs in precarious balance (in *House of Cards*).

Plinths is rooted both to the wall and to the ground and looks like an extremely painterly solution to the problematics of sculpture. The work is made up of five brush marks congealed (sculpted, that is) in rubber, like brushstrokes constituting a form instead of conveying a form on a support. In this way *Plinths* perfectly illustrates the notion of Process Art, in which an artwork describes its own process of production and completes itself in so doing.

In certain respects, *Plinths* prefigures Serra's later work. The colorlessness of the chosen material predominates, and the artist has emphasized the structural components of the work rather than deflecting the gaze with all sorts of artifice, something he always carefully avoided doing. Above all, however, this instability of elements leaning against a wall or lying on the ground prefigures the formal structures he would later resort to in ever greater size. Only the horizonal mark, hung traditionally from the wall, receives an additional trace of color and light—in the form of a neon tube, a material highly prized at the time, containing its own color.

In spite of all these distancing elements, *Plinths* presents a rectangular configuration not without some connection to the space of traditional painting. In it one may read a sort of critique of this space, which many artists of his generation would soon consider reductive. Serra definitively settles his score with painting and its space in a work like *Plinths*. His "prop pieces," which are decidedly sculptural, would follow several months later.
—A. P.

Pierre Soulages

b. 1919

Pierre Soulages was born December 24, 1919, in Rodez, France. In 1938, he visited Paris and saw the work of Paul Cézanne and Pablo Picasso for the first time. After his discharge from the army in 1941, Soulages studied at the Ecole des Beaux-Arts of Montpellier. During the German occupation, he worked at a vineyard near Montpellier; he met Sonia Delaunay at this time.

In 1946, Soulages settled in Courbevoie, outside Paris, and began painting in earnest. The following year he exhibited his paintings for the first time at the Salon des Réalités Nouvelles and in an exhibition of French abstract painting that toured Germany. His first solo show was held at the Galerie Lydia Conti, Paris, in 1949. That same year, Soulages exhibited for the first time at the Salon de Mai, and began executing stage designs.

During the 1950s, Soulages achieved international recognition for his bold, geometric gestures

in black paint on a white ground. He often exhibited this work with the Art Informel group. In 1953, he participated in the São Paulo *Bienal*, where he won a purchase prize, and in the *Younger European Painters* exhibition presented at the Solomon R. Guggenheim Museum and circulated in the United States. From this time until 1966, he showed at the Kootz Gallery, New York. Solo exhibitions of Soulages's work were held in London, New York, and Chicago in 1955. While visiting the United States in 1957, he met William Baziotes, Willem de Kooning, Robert Motherwell, and Mark Rothko. This same year he received the Grand Prize at the Tokyo Biennial. In 1958, the artist visited the Far East, where he admired calligraphy and rock gardens.

A Soulages retrospective was held at the Kestner-Gesellschaft, Hannover, in 1960, followed by others in Essen, the Hague, and Zurich the next year. He traveled to Mexico in 1961 and saw the Mayan temples of the Yucatán peninsula. During the 1960s, 1970s, and 1980s, he was honored with retrospectives at major museums in Europe and the United States; the last important one took place at the Musée d'art moderne de la Ville de Paris in 1996. He has received many prizes, among them the Guggenheim International Award for France in 1960 and the Grand Prize of Art of the City of Paris in 1975. The artist lives in Paris.

Painting, 195 × 130 cm, May 1953 (Peinture, 195 × 130 cm, mai 1953), May 1953 (cat. no. 269)

In 1947, Soulages had abandoned his classic small brush for palette knives, straightedges, and large house-painting brushes. He started to transform his former calligraphic lines into planar trails in an attempt to reduce the amount of time required to read a work, up to the mere instant. In this effort to explore time in relation to color, form, space, structure, and rhythm, *Painting, 195 × 130 cm, May 1953* is one of eleven paintings in a transitional series of work. This painting possesses most of the distinctive characteristics of Soulages's mature style: stable and clearly organized volumes of dark and massive color, predominantly black, roughly applied on a white ground in broad slab-like strokes. Meanwhile, the few oblique lines that link together the main vertical and horizontal strokes unite the composition into a large "sign" reminiscent of the graphic qualities of Soulages's earliest work. Although this sign easily reads as a cross, it is not used as a referential object or as a religious symbol, but as a geometrical figure, whose structural qualities convey a sense of immanence and stability. To accentuate this effect, Soulages highlights the cross-like shape of the composition, with rectangular windows of light sharply cut into the white background. By illuminating the painting from behind, Soulages created a similar effect to the one produced in the dim interiors of old, large monuments, when a ray of light filters through a narrow window and the black hues are deepened, conferring a pillar of

solidity. Finally, the black and white contrast combined with the shadowlike color thinly applied on the corners, creates a warm chiaroscuro resembling what Soulages experienced for the same time inside of the Romanesque church of Sainte-Foy de Conques, where as a child he decided to become a painter and for which he eventually designed stained glass.

In *Painting, 195 × 130 cm, May 1953*, every action converges toward achieving architectonic strength and ascetic spirituality. Soulages's use of large formats, and his belief that the more limited the means the stronger the expression, led critics to compare his work with the American Action Painters, but the comparison falls flat as soon as it is mentioned that his exploration is one of architectonic permanence rather than gestural transience.

Part of the Ecole de Paris, a loose group of abstract painters, Soulages is also often associated with Art Informel, a movement born after World War II that included Jean Degottex, Jean Dubuffet, Henri Michaux, and Wols, among others. Although always opposed to this label, whose definition was in contradiction with Soulages's use of geometry and his disdain for intimate emotions in painting, he nonetheless repeatedly exhibited with the group. — S. P.

Painting, 131 × 162 cm, August 14, 1956 (Peinture, 131 × 162 cm, 14 août 1956), 1956 (cat. no. 270)

The painting of Soulages, wrote James Johnson Sweeney, "is not the description of something, nor a symbol of something other than itself; it is in itself an integrated visual unity." In 1947, Soulages began to group physically prominent brush marks into large gestural forms. From this point onward, black remained the basis of his palette; it was "a limited means" for him to achieve intense effects. As he wrote, "the absence of color . . . confers an intense and violent presence to the colors, even white." Around 1955, singular marks gave way to juxtaposed and multiplied brushstrokes; "by their repetition (a relationship of shape, one almost identical to the next) a rhythm was born, a rhythm of spatial relationships," according to Sweeney.

By titling his work *Painting*, followed by its dimensions and date, Soulages rejected illusion and message and asserted the materiality of the painting. For him, "the refusal of description . . . is not a desire for purity, nor discretion, but rather a profound necessity, a need for pictorial, . . . poetic intensity." This canvas dating from 1956 is characterized by its somber material: brushed on in huge, superimposed strokes, full of powerful gesture and authority, the black threatens to invade the whole canvas. Left partially visible where the gesture ends, the canvas is exposed to sight like an intangible source of light, or a floating base for a fantastic edifice. The impression of flatness that dominated the earlier works, in which the mark merged with the picture plane, gives way to the emergence of shapes that stand

out from the canvas and press into the viewers' space, suggesting another texture, one that is both denser and darker. — M. T.

Painting, 220 × 366 cm, May 14, 1968 (Peinture, 220 × 366 cm, 14 mai 1968), 1968 (cat. no. 284)

Painting, May 14, 1968. A broad surface, 220 centimeters tall and 366 centimeters wide, covered almost in its entirety by the color black. May 14, 1968: a moment among so many others in which a canvas became a painting. A canvas very large in format, which certainly was nothing new—since the 1950s, Soulages had been painting works of similar dimensions. *Painting, 220 × 366 cm, May 14, 1968* is covered with a smooth but also thick material, which leaves an impression of solidity. It is the product of repeated repaintings, which made possible an equal number of variations in the blacks. The painting material also has transparent qualities: as one draws near to the white breaches breaking up the large black planes in several spots, the layer of paint is sometimes more fluid, more translucent, with a gray of light. Overall the color is applied from the top downward, or from the bottom up: barely perceptible traces left by the painter's gestures confirm this verticality. It is not, however, an absolute rule: one sees other, shorter marks that are horizontal or circular, although the frontality remains predominant.

The painting is based on a contrast of colors: the streams of black let the white background show through in rather imprecise, irregular areas that are sometimes crossed with black marks or spots. The work appears to be made up of five large planes of black, which become more and more confused as one moves to the right. There is, however, no proper direction for "reading" the painting: it "offers itself as a unique whole." It does not present itself as a sign on a background, which was the case with many of Soulages's previous works, but rather as a homogeneous surface. It represents a frozen, motionless space, a moment in which a balance between the black surfaces and the white gaps is struck, and in which light is created. — A. P.

Richard Stankiewicz

1922–1983

Richard Peter Stankiewicz was born October 18, 1922, in Philadelphia and was raised in Detroit. From 1941 to 1947, Stankiewicz served in the Navy as a radio-telegrapher and technician in Alaska and Hawaii. He remained in Hawaii to paint for several months after his discharge. In 1948, he moved to New York to study at the Hans Hofmann School of Fine Arts, where he became friends with the artist Jean Follett. Stankiewicz studied sculpture in Paris with Fernand Léger and Ossip Zadkine under the G.I. Bill from 1950 to 1951. Shortly after his return to New York in 1951, Stankiewicz began experimenting with junk excavated from the courtyard of his loft building, incorporating this material into his sculpture. Not long thereafter he taught himself how to weld.

In 1952, Stankiewicz was an organizer of the Hansa Gallery, New York, where he had his first solo show the following year. He held various offices in this cooperative gallery until 1958, when he resigned. In 1955, he was chosen by Thomas Hess for a group show organized at the Stable Gallery, New York. His work was included in the Whitney Annual in 1956, and the Carnegie International and Venice *Biennale* in 1958. In 1961, he participated in *The Art of Assemblage* at the Museum of Modern Art, New York. That same year, the sculptor moved to western Massachusetts. He began teaching at the State University of New York in Albany in 1967, where he was honored with a retrospective at the University Art Gallery in 1979. His work was exhibited regularly in solo shows at the Zabriskie Gallery, New York, from 1972 to 1997. Stankiewicz died in 1983.

Europe on a Cycle, 1953 (cat. no. 278)

It was during a stay in Paris, in 1950 and 1951, that Stankiewicz made his first attempts at sculpture, moving from the studio of Léger to that of Zadkine. Very quickly, understanding that the technique of modeling was not for him, he took a more Abstract Expressionist approach aligned with automatic writing and spontaneous improvisation. He began to assemble wire frameworks that were sometimes covered with plaster, and which he said were inspired by insects. Returning to New York, he devoted himself definitively to sculpture. The fortuitous discovery of the beauty of a piece of rusted scrap metal led him to learn welding and to incorporate into his assemblages fragments from broken-down machinery. His approach, which is far from being isolated (many artists practiced "junk sculpture" both in the United States and in Europe: Eduardo Chillida, David Smith, Jean Tinguely, . . .), was notable for its attempt to preserve the identity of the broken-down element while incorporating it into a poetic ensemble that was sometimes sarcastic, sometimes humorous.

His preoccupation with formal issues, and the considered and controlled aspect of his approach, introduce a subtle contradiction to his respect for industrial waste. More than a criticism of industrial society, Stankiewicz's sculpture offers a nostalgic poetic description of the machine. The contradiction between an aesthetic of waste and lyrical formalism is already visible in *Europe on a Cycle*. While the piling-up of rusted scrap metal is immediately striking, the impression of formal rigor and extreme lightness makes itself felt at the same time. The comparison with the *Sculpture métamécanique automobile* by Tinguely (1954) illustrates the specific approach of each artist: limited repertoire of abstract forms for Tinguely, spontaneous disorder of natural forms for Stankiewicz, balanced and mechanized construction for one, natural disturbance of elements for the other. Sustained by its romantic title, this work evokes the relaxed casualness of a bicycle trip off the beaten path; the memories collected here find themselves subject to the momentum of the route, of the relentless escape suggested by the precarious and unstable balance of the work. Its linear qualities—the precise line, almost fragile and at the same time crushing, of metal shafts—curiously recall the poetry of the drawings of Paul Klee. — MNAM

Clyfford Still

1904–1980

Clyfford Still was born November 30, 1904, in Grandin, North Dakota. He attended Spokane University in Washington for a year in 1926 and again from 1931 to 1933. After graduation, he taught at Washington State College in Pullman until 1941. Still spent the summers of 1934 and 1935 at the Trask Foundation (now Yaddo) in Saratoga Springs, New York. From 1941 to 1943, he worked in defense factories in California. In 1943, his first solo show took place at the San Francisco Museum of Art, and he met Mark Rothko in Berkeley at this time. The same year Still moved to Richmond, where he taught at the Richmond Professional Institute.

When Still was in New York in 1945, Rothko introduced him to Peggy Guggenheim, who gave him a solo exhibition at her Art of This Century gallery in early 1946. Later that year, the artist returned to San Francisco, where he taught for the next four years at the California School of Fine Arts. Solo exhibitions of his work were held at the Betty Parsons Gallery, New York, in 1947, 1950, and 1951 and at the California Palace of the Legion of Honor, San Francisco, in 1947. In New York in 1948, Still worked with Rothko and others on developing the concept of the school that became known as the Subjects of the Artist. He resettled in San Francisco for two years before returning again to New York. A Still retrospective took place at the Albright Art Gallery, Buffalo, in 1959. In 1961, he settled on his farm near Westminster, Maryland.

Solo exhibitions of Still's paintings were presented by the Institute of Contemporary Art of the University of Pennsylvania in Philadelphia in 1963 and at the Marlborough-Gerson Gallery, New York, in 1969–70. He received the Award of Merit for Painting in 1972 from the American Academy of Arts and Letters, of which he became a member in 1978, and the Skowhegan Medal for Painting and Sculpture in 1975. Also in 1975, a permanent installation of a group of his works opened at the San Francisco Museum of Modern Art. The Metropolitan Museum of Art, New York, gave him

a exhibition in 1980; Still died June 23 of that same year in Baltimore.

1948, 1948 (cat. no. 267)

Nineteen forty-eight, the title and date of this work, marked a new beginning within Still's art. In that year, Still recalled all of his works from the Betty Parsons Gallery and renamed them back at his studio. Expunging all verbal references to nature, mind, and body, Still replaced titles such as *Green Wheat*, *Premonition*, and *Yellow Pelvis* with a neutral numbering system. He spent the next two years in a period of retreat, making his work over into an internally reflexive, self-sufficient system, into a paradigm of independence. He described the outcome in terms of "a new implication, as unique as any science or form. . . . My work is equally independent at the moment—alive now, not proven by a continuum." This solipsistic conceit both informed and echoed Clement Greenberg's canonization of Abstract Expressionism as an art that did not refer to anything apart from itself.

Despite his efforts to distance his art from nature, it is difficult not to see topography within Still's works. In *1948*, the paint seems to form tectonic plates that spread across the canvas and collide into one another, giving rise to jagged peaks and chasms. Its palette of blood reds, humus ochers, and earthy browns, fissured by mineral facets of yellow and blue, reinforces this sense of primordial creation. In his description of his approach to painting, Still sounds like a rock-climber navigating difficult terrain: "As the blues and reds or blacks leap and quiver in their tenuous ambience, or rise in austere thrusts to carry their power infinitely beyond the bounds of their limiting field, I move with them." — I. S.

Sophie Taeuber-Arp

1889–1943

Born September 19, 1889, in Davos, Switzerland, Sophie Taeuber attended classes at the Ecole des arts décoratifs de Saint-Gall from 1906 to 1910 and studied art and design in Munich and then Hamburg. In 1913, she returned to Munich and

joined the Van Debschitz School, and the following year, she moved to Zurich where she met Jean Arp, whom she married eight years later.

During World War I, she took part in the Dadaist activities at the Cabaret Voltaire in Zurich with Arp, Hugo Ball, Emmy Hennings, Richard Huelsenbeck, Marcel Janco, and Tristan Tzara. At that time, she also started teaching composition, weaving, and embroidery at the Ecole d'art et métiers. Between 1916 and 1918, Arp and Taeuber-Arp collaborated on their first *Duos*, in the form of collages, textile designs, and sculptures. Only a few of Taeuber-Arp's own works have survived from this period—there are paintings that show her strong interest in abstract art, while a series of sculptures, reminiscent of the forms used by hat and wig makers, evoke the human head.

At the end of the war, Taeuber-Arp joined the movement called La Vie Nouvelle, a group that sought to incorporate abstract art into daily life. This expanded her practice of art into the fields of architecture and interior decoration. Between 1926 and 1928, Taeuber-Arp collaborated with her husband and Theo van Doesburg on the design of a restaurant in the Aubette Palais, Strasbourg, and in 1927, a house was built for Nelly van Doesburg in Meudon according to plans by Taeuber-Arp. In 1926, Taeuber-Arp and her husband settled in Meudon on the outskirts of Paris. They joined the Cercle et Carré and showed their work together with that group. Beginning in 1930, Taeuber-Arp began to achieve recognition throughout Europe for her abstract compositions. In 1932, she joined the Abstraction-Création group and although she broke with the group two years later, she participated in the movement's group shows in Sweden and Poland. During this period, she created painted wooden reliefs and abstract paintings, many of which were large geometric compositions of primary colors on black and white backgrounds.

In 1937, she started designing and editing a magazine called *Plastique* in collaboration with César Domela; they produced five issues over the next two years. Due to the fact that Taeuber-Arp and Arp were naturalized French citizens—she was born Swiss and he was born German—World War II was a very precarious time for the couple; they tried from 1941 onward to travel to the United States. On January 12, 1943, in Zurich, Taeuber-Arp died tragically, asphyxiated by a coal heater.

Dada Head (*Dada Kopf*), ca. 1918–19 (cat. no. 165)

This form in turned wood, which suggests the dummies of haberdashers and hairdressers, follows the marionettes that the artist created using primary shapes for the staging of Carlo Gozzi's play, *The Stag King*, in 1918. Taeuber-Arp made three other *Dada Heads* made of turned and painted wood between 1918 and 1920, one of which was later titled *Portrait of Arp*, mounted on a long rod serving as a neck and furnished with a protruding nose. In 1937, Taeuber-Arp revived

this isolated sculptural idea in another series of sculptures, the most well-known of which is the *Conjugal Sculpture* created with Arp.

At once humorous doll-portraits and utilitarian objects (which can be used, as Arp pointed out, as hatracks), these "object-heads" belong to the Dada spirit of play. In this respect, they are related to Raoul Hausmann's *Mechanical Head (The Spirit of Our Times)(Der Geist unserer Zeit [Mechanischer Kopf])* (1919, Musée national d'art moderne, Paris). However, their perfectly smooth surfaces, the sinuous elegance of the arabesques that envelop them, and their lively colors display more concern for pure decoration than for Dadaism.
— Ch. D.

Yves Tanguy

1900–1955

Raymond Georges Yves Tanguy was born January 5, 1900, in Paris. While attending lycée during the 1910s, he met Pierre Matisse, his future dealer and lifelong friend. In 1918, he joined the Merchant Marine and traveled to Africa, South America, and England. During military service at Lunéville in 1920, Tanguy became a friend of the poet Jacques Prévert. He returned to Paris in 1922 after volunteer service in Tunis and began sketching café scenes that were praised by Maurice de Vlaminck. After Tanguy saw Giorgio de Chirico's work in 1923, he decided to become a painter. In 1924, he, Prévert, and Marcel Duhamel moved into a house that was to become a gathering place for the Surrealists. Tanguy became interested in Surrealism in 1924, when he saw the periodical *La Révolution surréaliste*. André Breton welcomed him into the Surrealist group the following year.

Despite his lack of formal training, Tanguy's art developed quickly and his mature style emerged by 1927. His first solo show was held in 1927 at the Galerie Surréaliste, Paris. In 1928, he participated with Jean Arp, Max Ernst, André Masson, Joan Miró, Pablo Picasso, and others in the Surrealist exhibition at the Galerie au Sacre du Printemps, Paris. Tanguy incorporated into his work the images of geological formations he had

observed during a trip to Africa in 1930. He exhibited extensively during the 1930s in solo and Surrealist group shows in New York, Brussels, Paris, and London.

In 1939, Tanguy met the painter Kay Sage in Paris and later that year traveled with her to the American southwest. They married in 1940 and settled in Woodbury, Connecticut. In 1942, Tanguy participated in the *Artists in Exile* show at the Pierre Matisse Gallery, New York, where he exhibited frequently until 1950. In 1947, his work was included in the exhibition *Le Surréalisme en 1947*, organized by Breton and Marcel Duchamp at the Galerie Maeght in Paris. He became a United States citizen in 1948. In 1953, he visited Rome, Milan, and Paris on the occasion of solo shows in those cities. The following year he shared an exhibition with Sage at the Wadsworth Atheneum, Hartford, and appeared in Hans Richter's film *8 x 8*. A retrospective of Tanguy's work was held at the Museum of Modern Art, New York, eight months after his death on January 15, 1955, in Woodbury.

Promontory Palace (*Palais promontoire*), 1931 (cat. no. 175)

Following his trip to Africa in 1930, Tanguy produced a group of landscapes that have been termed *les coulées* (flowing forms) for their molten character. Perhaps the most striking of the series is *Promontory Palace*, in which a rigid, multitiered mass dominates a broad, flat plain. This corrugated mesa and other buttes in the center foreground stand firm as the surrounding viscous landscape succumbs to some persistent melting force. The small abstract shapes, some of which are disturbingly anthropomorphic, inhabit the scene in various stages of metamorphosis: some appear to melt or ooze, others seem to collapse or deflate, and still others secrete or sputter white liquids or gases.

In the natural world, such geologic metamorphosis would require intense heat and volcanic activity. Yet Tanguy's restrained grays and muted pinks, accented with cool blue and pale green and yellow, deny the presence of fire and earth. Instead, Tanguy creates a Surrealist terrain where molten and frozen, figurative and abstract, literal and suggestive elements exist in perfect harmony. Tanguy's use of a specific horizon line, his naturalistic modeling of forms, and his depiction of landscape evocative of an actual coastline, permit us a conceptual foothold in known experience. Yet our foothold gives way as Tanguy's abstract shapes transform known experience into a familiar but irrational fantasy. The power of his imagery derives from the delicate tension between the logic of sensation and the freedom of imagination.
— E. C. C.

Antoni Tàpies

b. 1923

Antoni Tàpies was born December 13, 1923, in Barcelona. His adolescence was disrupted by the Spanish Civil War and a serious illness that lasted two years. Tàpies began to study law in Barcelona in 1944 but decided instead within two years to devote himself exclusively to art. He was essentially self-taught as a painter; the few art classes he attended left little impression on him. Shortly after deciding to become an artist, he began attending clandestine meetings of the Blaus, an iconoclastic group of Catalan artists and writers who produced the review *Dau al Set*.

Tàpies's early work was influenced by the art of Max Ernst, Paul Klee, Joan Miró, and Eastern philosophy. His art was exhibited for the first time in the controversial Salo d'Octubre of Barcelona in 1948. He soon began to develop a recognizable personal style related to *matière* painting, or Art Informel, a movement that focused on the materials of art-making. The approach resulted in textural richness, but its more important aim was the exploration of the transformative qualities of matter. Tàpies freely adopted bits of detritus, earth, and stone—mediums that evoke solidity and mass—in his large-scale works.

In 1950, his first solo show was held at the Galeries Laietanes, Barcelona, and he was included in the *Carnegie International* in Pittsburgh. That same year, the French government awarded Tàpies a scholarship that enabled him to spend a year in Paris. His first solo show in New York was presented in 1953 at the Martha Jackson Gallery, who arranged for his work to be shown the following year in various parts of this country. During the 1950s and 1960s, Tàpies exhibited in major museums and galleries throughout the United States, Europe, Japan, and South America. In 1966, he began his collection of writings, *La practica de l'art*. In 1969, he and the poet Joan Brossa published their book, *Frègoli*; a second collaborative effort, *Nocturn Matinal*, appeared the follow-

ing year. Tàpies received the Rubens Prize of Siegen, Germany, in 1972.

Among his more recent exhibitions were retrospectives at the Musée national d'art moderne, Paris, in 1973 and at the Albright-Knox Art Gallery, Buffalo, in 1977. The following year, he published his prize-winning autobiography, *Memòria personal*. In the early 1980s, he continued diversifying his mediums, producing his first ceramic sculptures and designing sets for Jacques Dupin's play *L'Eboulement*. By 1992, three volumes of the catalogue raisonné of Tàpies's work had been published. The following year he and Cristina Iglesias represented Spain at the forty-fifth Venice *Biennale*, where he shared the award for painting with Richard Hamilton. A retrospective exhibition was organized by the Jeu de Paume in Paris, the Fundació Antoni Tàpies, and the Solomon R. Guggenheim Museum, New York, which was on view at the Guggenheim SoHo in 1995. Tàpies lives in Barcelona.

Large Brown Triangle (Gran triangle marró), 1963 (cat. no. 291)

Geometric abstraction has always "bored" Tàpies. In the 1960s, however, after a more material, more baroque period, he began to favor simple forms—such as letters of the alphabet and geometric figures—immediately recognizable to all, but to which he would give an "other" meaning, to use art historian Michel Tapié's expression. Geometrical diagrams are one of the sources for an entire tradition of painting considered first and foremost as a medium for meditation; thus in Tantric painting, which Tàpies has studied in depth, the triangle symbolizes fire and the exaltation of the male principle. Here, in a more obvious fashion, perhaps the triangle also represents (since the painting is but a "sign, a suggestion of reality," according to the artist) the tall, wood frameworks one sees in the old houses Tàpies is so fond of. He has constantly, in fact, found inspiration in his most immediate, everyday environment: rustic objects, windows, doors, or walls. This work was made according to a technique the artist discovered in the 1950s. With direct cuts, he left human marks on the prepared, solid ground, consisting of a blend of glue, sand, and oil. The absolute, austere monochromatic nature of the work generates for Tàpies an inner color capable of expressing essential values, an "almost indefinable mystical feeling, fundamental for an artist."
—Cl. S.

Jean Tinguely

1925–1991

Jean Tinguely was born May 22, 1925 in Fribourg, Switzerland. He attended the Ecole des Beaux-Arts, Basel. During the early 1940s, he apprenticed as a decorator and attended courses in the General Trade School, Basel. His works from this early period are abstract paintings inspired by the Surrealists and wire sculptures. It was during this time that he met Daniel Spoerri, with whom he worked on a theater project. In 1951, he married Eva Aeppli, and the following year they moved to France.

His first show took place at the Arnaud gallery in Paris in 1945, the same year he joined the Kinetic artists group of the Galerie Denise René. After settling in Impasse Ronsin, close to Brancusi's studio, he met Yves Klein and Niki de Saint-Phalle. In 1959, Tinguely wrote the *Für Statik* manifesto and distributed it in the form of leaflets from an airplane over the city of Düsseldorf. His *Méta-matics*, or automatic drawing machines, were exhibited in 1959, too, at the Galerie Iris Clert, Paris.

In 1960, he blew up his first self-destructing sculpture, *Hommage à New York* (1960), in the garden of the Museum of Modern Art, New York. While in New York, he became acquainted with Jasper Johns and Robert Rauschenberg. During the 1960s, he was associated with the Nouveaux Réalistes group, with whom he explored the idea of appropriating common and everyday objects. These found objects were then transfigured into moving mobiles and bizarre machines. In 1961 and 1962, Tinguely also produced sonorous sculptures made out of radio parts. He moved to Soisy-sur-Ecole near Essonne in 1963 with de Saint-Phalle, and in 1966 they collaborated with Per Olof Ultvedt to create *Hon*, a gigantic cloth and metal woman that the spectator could climb inside. Tinguely also executed *Le Paradis fantastique*, a commission for the French pavilion at Expo '67 in Montreal, together with de Saint-Phalle.

In 1970, for the tenth anniversary of the Nouveaux Réalistes group, he created *La Vittoria*, a self-destructing machine that exploded in the plaza of the Duomo in Milan. In the 1970s and 1980s, he continued to work with machines. As a complement to the fire resulting from the self-destructing machines, Tinguely executed various fountains, including the *Fasnacht Fountain* (*Fasnacht Brunner*, 1977) in Basel and the *Igor Stravinsky Fountain* (*Fountaine Stravinsky*, 1983) in the plaza in front of the Centre Georges Pompidou in Paris.

After Tinguely's mother passed away in 1979, the theme of death as well as the church and the liturgy became important to his work. In 1984, at the Kornfeld Gallery, Bern, he presented the *Inferno*, one of his most extreme pieces, composed of thirty autonomous mobile sculptures. This work traveled to Munich and to the Musée national d'art moderne, Paris, for his retrospective held in 1989. In 1990, a Tinguely exhibition was presented at the Tret'yakov Gallery in Moscow, which was expanded and shown in 1991 at the Musée d'art et d'histoire in Fribourg. Tinguely died in 1991 in Bern.

Méta-matic n° 1, 1959 (cat. no. 297)

The drawing-machine, several specimens of which date from 1955, was perfected by Tinguely in 1959. A show at the Galerie Iris Clert, Paris, in July of that year brought together the twenty-odd works of the series, while in the autumn, *Méta-matic n° 17* created a great stir at the first Paris *Biennale*. The museum director, Pontus Hulten, compared these machines to Marcel Duchamp's readymades, as much for their respective importance as for their complexity. The drawing-machine is, in fact, at once an ironic commentary on Tachisme or Art Informel (terms for French postwar abstraction)— since the machine produces abstract works of art by the minute, with fine results—and a playful construction that demands the viewer's complicity. Indeed, the dream of the latter's participation in the artwork is fully realized here; Tinguely in fact was perhaps the only artist who achieved this goal without distorting the nature of artistic research. The role of the artist, of course, here finds itself redefined, and the artwork is no longer a simple object of contemplation, since it contains its own system of creation and takes the place of the artist-demiurge. The drawing-machine would soon become the tool of the first Happening organized by Tinguely in 1959, at the Institute of Contemporary Art, London. There, one of the *Méta-matics*, activated by cyclists, unrolled whole kilometers of paper over the audience. Tinguely, who later organized all sorts of different activities, particularly with the self-destructive machines, was the first to inaugurate the Happening in postwar Europe. — A. P.

Baluba, 1961–62 (cat. no. 298)

Shortly after the founding of the Nouveaux Réalistes group, Tinguely created his *Baluba* series, in which he used all manner of everyday objects, including plastic toys, animal fur, and scrap iron. These works form part of an aesthetic ambience comparable to that of Spoerri's "snare-paintings" and Arman's "*poubelles*" (wastebaskets), all of which incorporate detritus as legitimate art material. For Tinguely, the works from this series were a kind of parody of classical sculpture: he used industrial tins as pedestals and carefully arranged the elements, which in this case he crowned with a feather-duster as a kind of head-dress. Yet once spectators press the command pedal and set the sculpture in motion, they witness a joyous celebration, where all the different elements are shaken in every direction. What, in its stillness, had seemed incomplete and not very satisfying suddenly becomes, once animated, a kind of absurd enchantment.

Moreover, Tinguely's work immediately presents itself as a critical eye on all the participant forms exalted both by the "gesture and action" of certain artists and the "transformable" works produced by Kinetic art (*cinétisme*). *Baluba* was apparently titled after a Congolese tribe that was in the midst of extreme political turmoil during the early 1960s, and, perhaps not so incidently in this case, was known among anthropologists for a particular elaborate hairstyle. The work is literally a "tin can" sculpture, an antimonument or a moving celebration of the "*quincaillerie paresseuse*" (lazy hardware) described elsewhere by Duchamp. It is also, in an age of movement, a self-propelled machine that suggests, covered as it is with fetishes and amulets, a mechanical, dancing form of ceremony seeking its source in the moving body. — A. B. and B. B.

Niele Toroni

b. 1937

Niele Toroni was born March 15, 1937 in Locarno-Muralto in Switzerland. In 1956, he completed his studies at the Ecole Normale and left to teach at Maroggia, on the banks of Lake Murano, beginning to paint as an autodidact. In 1959, he settled in Paris and decided to become a painter. A year before creating his first imprints, Toroni spent one year painting squares already printed on linoleum; he painted and repainted these squares ceaselessly, reproducing the most mechanical gesture, which remained a painter's gesture nonetheless.

In 1967, with Daniel Buren, Olivier Mosset and Michel Parmentier, he organized different manifestations, pretexts for a radical criticism of painting. The first *Imprints of a No. 50 Brush Repeated at Regular Intervals of 30 cm*, as all of his works are titled, were exhibited at the Salon de la Jeune Peinture of 1967. The day of the opening, the group, which would go on to call itself BMPT, distributed a tract that said: "Since painting is to propose a trampoline for the imagination . . . since painting has a use . . . since painting is painting by way of aesthetics, flowers, women, eroticism, and the day-to-day environment . . . we are not painters." In 1970, the group adopted its label BMPT (Buren, Mosset, Parmentier, Toroni). Each painter, working with objective parameters, practiced his own plastic endeavors. Thereafter, Toroni refused any discourse on his work and expressed only his method of working, which opened to an infinite number of possibilities. This work used tools (yardstick, level, brush number 50), a force of work and a time of work (reproduction of imprints made at three o'clock, eight o'clock or twelve o'clock). An imprint, which is a form "in itself," has no meaning beyond itself. Its repetition gives the work of Toroni an atemporal character which makes it impossible to differentiate a work from 1967 from a work from 1987. Only the space within which it is inscribed and the supports vary: "canvas, cotton, paper, waxed canvas, walls, floors . . . generally white grounds."

Toroni was recognized abroad before being recognized in France, although he showed his works regularly at the Galerie Yvon Lambert, Paris. In 1977, the Stedelijk van Abbe-museum, Eindhoven, devoted an exhibition to him, followed by the Kunsthalle Bern in 1978. In 1989, he showed in New York for the first time at the Marian Goodman Gallery. The following year, he was included in the Musée national d'art moderne, Paris, as well as in the Musée Cantini, Marseilles. In 1992, the Kamakura gallery presented his works. Many exhibitions have been organized in Germany: Kunsthalle Winterthur, in 1988; Kunstverein, Stuttgart in 1991; and Galerie Kewenig, Cologne, in 1993.

The artist lives and works in Paris, faithful to the principle of art he defined in 1967, which he affirms as permanent: "I think that by reason of the absurd, one can say that the whole history of painting has always been the artist's imprint. But to leave the imprint of painting before leaving my artist's imprint has been my motivation. . . . Today, I am still here and I am painting."

Imprints of a No. 50 Brush Repeated at Regular Intervals of 30 cm (Empreintes de pinceau n° 50 répétées à intervalles réguliers de 30 cm), 1967 (cat. no. 342)

This is a white oilcloth that Toroni recommends should be hung from the highest point of the molding and left to unroll down to the ground. If it turns out that the piece is longer than the wall, he advises that the remainder be rolled outward. The work, and its method, are emblematic: the artist defines it, just as it defines the artist. "The visible work here and now asks certain questions (it calls things, and itself, into question)."

Why would Toroni ever vary his work? Why would he ever change it? He might do otherwise, but, by doing nothing else, he denies the existence of all otherwise. Why should he seek to be different when the principle upholding his proposition remains so efficient and can only exist in the affirmation of sameness? In his brief association with the BMPT group, Toroni could not help but "call painting into question." The *Imprints of a No. 50 Brush Repeated at Regular Intervals of 30 cm* are in staggered arrangements of five. It is a distribution, a system, of the simplest sort. Any critique of the disposition would itself replace the disposition. But the question here was never that of dwelling on the method, but rather on what this method called to our attention. — B. B.

Cy Twombly

b. 1928

Cy Twombly was born April 25, 1928 in Lexington, Virginia. From 1948 to 1951, he studied at the School of the Museum of Fine Arts, Boston; Washington and Lee University, Lexington; and the Art Students League, New York, where he met Robert Rauschenberg. At Rauschenberg's encouragement, he attended Black Mountain College, near Asheville, North Carolina in 1951 and 1952, where he studied under Franz Kline, Robert Motherwell, and Ben Shahn.

The Kootz Gallery, New York, organized his first individual exhibition in 1951. At this time his work was influenced by Kline's black and white gestural expressionism, as well as by Paul Klee's childlike imagery. In 1952, Twombly received a grant from the Virginia Museum of Fine Arts that enabled him to travel to North Africa, Spain, Italy, and France. Upon his return in 1953, he served in the army as a cryptologist. From 1955 to 1959, he worked in New York and Italy, finally settling in Rome. It was during this period that he began to create his first abstract sculptures, which, although varied in shape and material, were always coated with white paint. In Italy, he began to work on a larger scale and distanced himself from his former expressionist scribbles, moving toward a more literal use of text and numbers, drawing inspiration from poetry, mythology, and classic history. He subsequently created a vocabulary of various signs and marks, sometimes sexually charged, that read on a metaphorical level rather than according to any form of traditional iconography.

Twombly was invited to the Venice *Biennale* in 1964. In 1968, the Milwaukee Art Center mounted the first retrospective of his art. The artist has been honored by numerous shows, including major retrospectives at the Kunsthaus Zurich in 1987; the Musée national d'art moderne, Paris, in 1988; and the Museum of Modern Art, New York, in 1994, with additional venues in Houston, Los Angeles, and Berlin. In 1995, the opening of the Cy Twombly Gallery opened, exhibiting works made by the artist since 1954, in Houston. Twombly lives and works in Lexington and Italy.

Untitled (Rome, June 1960), June 1960 (cat. no. 281)

Cy Twombly's paintings of the early 1960s consist of white canvases upon which he has applied scribblings and scratches in a furious flurry of crayon, pencil, and paint. The pigments are squeezed from the tube, remaining as globules that appear to hang tenuously from the surface or, as in *Untitled (Rome, June 1960)*, ejaculations of paint that drip off the canvas and are invaded by crayon and pencil smears. Like Rauschenberg and Jasper Johns, Twombly employed the Abstract Expressionists' liberating aleatory use of paint, but without their heroic pretensions or universalist goals. Twombly and his colleagues utilized an iconography of everyday life (such as representations of numbers and letters) and incorporated found objects into their work, embracing banal methods such as stenciling. There is a suggestion of carelessness and defilement inherent in Twombly's paintings; they elicit comparisons with the sexual graffiti in a public latrine.

In the late 1950s, Twombly settled in Rome. Some of the main elements of his mature works—the graffitilike writing on a surface that suggests a wall, an emphasis on the material properties of his mediums—dovetail with the leading

concerns of continental painters, particularly of those associated with Informale (the Italian equivalent of Art Informel). His work is filled with references to his adopted home as well as to a broader neoclassical tradition; he often alludes to mythological subjects, Old Master painters, and local places or events through his titles and scrawled words or phrases on the surfaces of the works. Idyllic landscapes and their connotation of bacchanalian pleasures have consistently provided Twombly with inspiration. In his painting, the explosive sexual charge of splatters and scribbles is complicated by a hermetic language of modern charts and graphs as if, according to art critic Roberta Smith, "an overeducated bibliophiliac suddenly—graphically, nearly obscenely—[speaks] in tongues." — J. B.

Theo van Doesburg

1883–1931

Christian Emil Marie Küpper, who adopted the pseudonym Theo van Doesburg, was born August 30, 1883, in Utrecht. His first exhibition of paintings was held in 1908 in the Hague. In the early 1910s, he wrote poetry and established himself as an art critic. From 1914 to 1916, van Doesburg served in the Dutch army, after which time he settled in Leiden and began his collaboration with the architects J. J. P. Oud and Jan Wils. In 1917, they founded the group De Stijl and the periodical of the same name; other original members were Vilmos Huszár, Piet Mondrian, Bart van der Leck, and Georges Vantongerloo. Van Doesburg executed decorations for Oud's *De Vonk* project in Noordwijkerhout in 1917.

In 1920, he resumed his writing, using the pen name I. K. Bonset and later Aldo Camini. Van Doesburg visited Berlin and Weimar in 1921 and the following year taught at the Weimar Bauhaus, where he associated with Raoul Hausmann, Le Corbusier, Ludwig Mies van der Rohe, and Hans Richter. He was interested in Dadaism at this time and worked with Kurt Schwitters as well as Jean

Arp, Tristan Tzara, and others on the review *Mécano* in 1922. Exhibitions of the architectural designs of Gerrit Rietveld, van Doesburg, and Cor van Eesteren were held in Paris in 1923 at Léonce Rosenberg's Galerie l'Effort Moderne and in 1924 at the Ecole spéciale d'architecture.

The Landesmuseum of Weimar presented a solo show of van Doesburg's work in 1924. That same year he lectured on modern literature in Prague, Vienna, and Hannover, and the Bauhaus published his *Grundbegriffe der neuen gestaltenden Kunst* (*Principles of Neo-Plastic Art*). A new phase of De Stijl was declared by van Doesburg in his manifesto of "Elementarism," published in 1926. During that year he collaborated with Arp and Sophie Taeuber-Arp on the decoration of the restaurant-cabaret L'Aubette in Strasbourg. Van Doesburg returned to Paris in 1929 and began working on a house at Meudon-Val-Fleury with van Eesteren. Also in that year he published the first issue of *Art concret*, the organ of the Paris-based group of the same name. Van Doesburg was the moving force behind the formation of the group Abstraction-Création in Paris. The artist died March 7, 1931, in Davos, Switzerland.

Composition XI (Kompositie 11), 1918 (cat. no. 137)

When the painters of the De Stijl movement formed a group in the spring of 1917, the similar conclusions each had come to over a period of individual investigation reinforced their unity and, by 1918, they arrived at a reduction of form and color to a pure, elemental level. van Doesburg's paintings of this time demonstrate a synthesis of Mondrian's and van der Leck's work.

Composition XI is one of van Doesburg's abstract geometric compositions of rectangular color planes floating on the surface of the canvas. Color is limited to subdued red, yellow, and blue on an off-white ground: a variation on his more common palette of primaries on white. While a representational origin can be found for most of these abstract works, none has come to light for the Guggenheim's picture. In his exploration of the relationship between line, plane, and color, van Doesburg has arranged the planes over the background to achieve balance through an intuitive rather than a systematic method of placement. As he later wrote, in a passage that could easily describe this painting, "the aim is: to create a harmonious whole in which the equilibrium of the whole, an aesthetic unity, is achieved by means of multiple exchanges and by cancelling out the positions and postures of the figures, the areas of space and masses and lines of movement in the picture (by relationships)." — SRGM

Pure Painting, 1920 (cat. no. 138)

Emulating Mondrian, and also influenced by the positivist and universalist mystique of the Dutch philosopher M. H. J. Schoenmaekers (author of the *Elements of Expressive Mathematics*, 1916), van Doesburg began to explore the domain of a rigorously geometric abstraction. He used only a lim-

ited play of verticals and horizontals containing violently contrasting color fields, limited in turn to the three primary colors—blue, red, and yellow—in combination with black, white, and gray. The painted surface was supposed to be as anonymous as possible, to liberate the painting from the artist's subjectivity. The viewer, freed from the usual attention given to technical particularities, could therefore concentrate entirely on the conception. The painter's intention, by thus limiting his means of expression to elementary shapes, was to go beyond a conjectural modernity to reach the universal. This *Pure Painting*, defined as such by its black and gray painted frame that contains it while also being part of it, shares the spatial concerns, developed in the motif of tiling, of the Neo-Plastic ceilings of van Doesburg's mythic habitations. — Ch. D.

Counter-Composition XIII (Contra-Compositie XIII), 1925–26 (cat. no. 139)

About 1924 van Doesburg rebelled against Mondrian's programmatic insistence on the restriction of line to vertical and horizontal orientations and produced his first *Counter-Composition*. The direction consequently taken by Neo-Plasticism was designated "Elementarism" by van Doesburg, who described its method of construction as "based on the neutralization of positive and negative directions by the diagonal and, as far as color is concerned, by the dissonant. Equilibrated relations are not an ultimate result." Mondrian considered this redefinition of Neo-Plasticism heretical; he was soon to resign from the De Stijl group.

This canvas upholds the Neo-Plastic dictum of "peripheric" composition. The focus is decentralized and there are no empty, inactive areas. The geometric planes are emphasized equally, related by contrasts of color, scale, and direction. One's eyes follow the trajectories of isosceles triangles and stray beyond the canvas to complete mentally the larger triangles sliced off by its edges. The placement of the vertical axis to the left of center and the barely off-square proportions of the support create a sense of shifting balance. — L. F.

Georges Vantongerloo
1886–1965

Georges Vantongerloo was born November 24, 1886, in Antwerp. At the turn of the century, he studied at the Académies des Beaux-Arts of Antwerp and of Brussels. He spent the years 1914–18 in the Netherlands, where his work attracted the attention of the queen. While working on architectural designs there, Vantongerloo met Piet Mondrian, Bart van der Leck, and Theo van Doesburg and collaborated with them on the magazine *De Stijl*, which was founded in 1917. Soon after his return to Brussels in 1918 he moved to Menton, France. In France he developed a close friendship with the artist and architect Max Bill, who was to organize many Vantongerloo exhibitions. In 1924, Vantongerloo published his pamphlet "L'Art et son avenir" in Antwerp.

In 1928, the artist-architect-theorist moved from Menton to Paris; there, in 1931, he became vice-president of the artists' association Abstraction-Création, a position he held until 1937. His models of bridges and a proposed airport were exhibited at the Musée des arts décoratifs, Paris, in 1930. In 1936, he participated in the exhibition *Cubism and Abstract Art* at the Museum of Modern Art, New York. His first solo show was held at the Galerie de Berri, Paris in 1943. Vantongerloo shared an exhibition with Max Bill and Antoine Pevsner in 1949 at the Kunsthaus Zurich. His seventy-fifth birthday was observed with a solo exhibition at the Galerie Suzanne Bollag, Zurich, in 1961. The following year Bill organized a large Vantongerloo retrospective for the Marlborough New London Gallery, London. Vantongerloo died October 5, 1965, in Paris.

Construction of Volumetric Interrelationships Derived from the Inscribed Square and the Square Circumscribed by a Circle (Construction des rapports des volumes émanant du carré inscrit et du carré circonscrit d'un cercle), 1924 (cat. no. 140)

Vantongerloo based his sculpture on the volumetric translation of the De Stijl principle that allowed only horizontal and vertical lines in a composition. The variation of volume and proportion in his work was determined geometrically, often accord-

ing to mathematical formulae. Mathematics was for Vantongerloo a convention that established order in the world, a rationalization of nature that could be combined successfully with an aesthetic intention to result in the production of a work of art. In this approach he felt closest to the medieval artist who composed within the constraints of geometric convention, and to the ancient Egyptians, whose solution to the "problem" of the pyramid of Cheops consisted in "the inscribed and circumscribed squares of a circle."

In one of his books Vantongerloo juxtaposed a diagram for the present work with an analytic sketch of the rose window at the cathedral of Amiens, but the asymmetry of the De Stijl image distinguishes it from the medieval subject. As the diagram shows and the title indicates, the extensions of the sculpture are determined by the lines of the inscribed and circumscribed squares of a circle. However, the relationships of its volumes result as much from the creative selectivity of the artist as from mathematical regulation. Overall, the effects of changing light and the juxtapositions of volumetric masses in space produce subtle coloristic modulation and a relationship with the environment suggestive of architecture. — L. F.

Volumetric Interrelationships Derived from the Cone (*Rapport des volumes émanant du cône*), 1927 (cat. no. 141)

Created in stone, wood, cement, and plaster, always on a small scale, Vantongerloo's abstract sculptures present themselves as juxtapositions of vertical and horizontal rectangular parallelepipeds, asymmetrically interwoven, most often around empty spaces that they narrowly delimit. These "studies of space" were designed as the geometric expression of balances between volume and void, that is to say between what Vantongerloo considered as the opposite poles of the universal unit: the positive and the negative, construction and deconstruction, the concrete and the abstract, the visible and the invisible, matter and spirit. Their similarity to models resembles the architecture and furniture projects developed within the De Stijl group by J. J. P. Oud, Gerrit Rietveld, van Doesburg, or by Vantongerloo himself between 1925 and 1930. On the other hand, their deliberate stasis, reinforced by the absence of any color, gives these rigid constructions an austere purity that protects them from any utilitarian contamination.

This particular sculpture, which belongs to the series of *Constructions* developed by Vantongerloo between 1919 and 1929 from algebraic formulas, is distinguishable from other works in the series by the broader space given to voids and by a more airy articulation of its different elements. In this, the work prefigures that which would become one of the preoccupations of Vantongerloo during the 1930s, sculpture with open planes in free space. — J. P. A.

Bram Van Velde
1895–1981

Abraham G. Van Velde was born October 19, 1895, in Zoeterwoude, near Leyden, the middle of three children. From the age of twelve, Van Velde was employed, along with his brother, Geer, at Schaijk Kramers, a painting and interior design firm. In 1915, twice registered in the records of the Mauritshuis of the Hague, Van Velde studied painting as an autodidact, copying the great masters. A collector himself, Eduard H. Kramers noticed his employee's aptitude for painting, and provided him with a small stipend in 1922, encouraging him to travel to Munich, then Worpswede. This village in northern Germany had been famous since 1890 for its community of Expressionist artists, and notably for the presence of the artist Paula Modersohn-Becker. Between 1922 and 1924, Van Velde painted many oils and watercolors of an expressionistic inspiration there.

In 1924, Van Velde left Germany for Paris, where he went through a long period of isolation, settling in a small studio. His brother, Geer, also a painter, joined him in August of that year, and tried unsuccessfully to sell his drawings. In February 1927, Van Velde exhibited his work from Worpswede in the gallery Das Graphische Cabinet and sent a series of canvases to Berlin; just as in Paris, recognition did not come easily, although in November the two brothers were admitted to participate in the Artistes Indépendants in Paris. Threatened by deportation as a foreigner, Van Velde married his German companion, also a painter, Sophie Caroline Kloker, known as Lilly.

The first article devoted to the two brothers was published by Jan Greshoff, in the art review *Art d'Anvers*, in June 1929, and their works were exhibited in the Salon des Indépendants at the Grand Palais in 1930. During the 1930s, Van Velde traveled to the south of France, Corsica, and

Mallorca. Upon returning to Paris, he settled on boulevard Arago with his brother Geer, who introduced him to Marthe Arnaud-Kuntz, Samuel Beckett's girlfriend, who was his only true moral support at the beginning of the war. Unknown up until then, Van Velde was supported after the war by a mere handful of friends, including Samuel Beckett, whom he met in 1936, Georges Duthuit, Edouard Loeb, and Jacques Putman, who organized his first exhibition at the Galerie de Mai in 1946, and later at the Galerie Maeght (1947–52).

In 1948, Aimé Maeght organized his first exhibition at the Kootz Gallery, New York. It would take another ten years—and the exhibition organized by Michel Warren in 1957—for the Parisian critics and public to give him their attention. His first large retrospective was organized by the Kunsthalle Bern in 1958, its director Franz Meyer recognizing in him one of the most original artists in postwar European paintings. He died in 1981 in Grimaud, France.

Untitled, 1965 (cat. no. 283)

Van Velde created this canvas roughly twenty years after returning to painting, and in a completely changed context of life and work. After the failure of his first New York exhibition in 1948, Van Velde found himself in isolation, stemming from the cultural rivalry between France and the United States after the war. Nonetheless, as art historian Serge Guilbaut has noted, "What Bram Van Velde was expressing in his painting, that highly individual art, . . . given only to the inner life under cover of a somewhat awkward modernity, was very similar . . . to what the new generation of American painters were trying to get off the ground." It was not until the 1960s that Van Velde's career developed internationally, when numerous important exhibitions were organized both in Europe and the United States.

In terms of the organization of this 1965 canvas, art historian Meyer noted, "As a whole it lacks facility, although nothing is blocked. . . . Everywhere there is movement, a current (or wind)." It had been the same Meyer who early on saw Van Velde caught between the antagonistic pair, Henri Matisse and Pablo Picasso, taking from the former "the consciousness of the painting as an autonomous reality," and from the latter, "the consciousness of the reality to be created through the artistic act."

This duality, this contradiction that Van Velde assumes in his pictorial technique—that of a first, almost rigid schema to which would be added, in a long process of rupture and transformation, heavily painted masses—became the basis of his painting. As we see here, the geometric aspect, made up of triangles, ellipses, and imprecise ovals (in which Picon sees the "mask's eyehole" revealed), little by little became softened and muted by successive layers of color.

Van Velde thus creates an "inner space," ceaselessly crossed by the flashes of his personal life, which he allows to enter the surface of the canvas

in an indecisive flow. Above and beyond abstraction and figuration, neither a declaration nor a manifesto, his slowed-down gesture unfailingly depicts, in negative fashion, man's precarious and fragile condition. — M. T.

Claude Viallat
b. 1936

Claude Viallat was born May 18, 1936 in Nimes. From 1955 to 1959, he studied at the Ecole des Beaux-Arts, Montpellier, before serving in the military in Algeria. After moving to Paris in 1962 and attending the Ecole des Beaux-Arts there, he settled in Nice, where he began to paint while teaching at the Ecole des arts décoratifs. By the summer of 1967, critical of lyric and geometric abstraction, he renounced easel painting and began to systematically work with only one form—a palette shape, which became his mark. Even though his production was based on a unique form, it indeed evolved. He used various kinds of supports, and questioned the components of the pictorial act by separating the canvas from the frame. He exploited its mobility by folding it, and used diverse coloration processes, including dying the canvas. In addition to impregnation techniques, the canvas was colored by external elements such as the rain, the sun, or fire, and in 1970 the artist used textiles like lifts and sunshades as a canvas. He also made different objects that referred to crafts or "primitive practices."

In the summer of 1969, a time when he was critical of traditional and institutionalized exhibition contexts, he organized exhibitions with other painters from the same generation—Daniel Dezeuze and Patrick Saytour—which were presented in natural environments of southern French villages. They announced the formation of the Supports-Surfaces group, of which Viallat was an essential member. Several exhibitions took place in Paris in 1970 before the group dissolved in discord.

In 1972, Viallat was included in the exhibition *12 Ans d'art contemporain en France*, and in the *Amsterdam Paris Düsseldorf* exhibition organized by the Solomon R. Guggenheim Museum, New York. Since 1968, Viallat has continuously shown his work at the Galerie Jean Fournier, Paris. Various teaching positions have led him to reside in Marseilles, Limoges, or Nimes, where he now lives and where he became director of the Ecole des Beaux-Arts in 1979. The Musée national d'art moderne, Paris, organized a retrospective of his oeuvre in 1982.

Net (Filet), 1970 (cat. no. 345)

This large net of rope, parts of which were dipped in tar, was presented in 1970 at the Musée d'art moderne de la Ville de Paris in the *Supports-Surfaces* exhibition, and a few months later in the group show, *Travaux de l'été 1970*, at the Galerie Jean Fournier. In the context of his reflection on the constituent elements of painting, Viallat could not avoid considering thread as well, which when woven makes up the canvas. The net is also a means for reproducing the image of the painting and systematically repeated impressions. Each empty space, the contours of which vary according to the way the piece is hung, evokes the form that Viallat reproduces in each of his works. Sculptural object or painting, the net—whether suspended in space or resting on the ground, without top or bottom or privileged side—is typical of the sort of flexible device that Viallat likes to exploit when he hangs something.

It also reminds us that we need to reconsider the range of Viallat's practices, since one tends to limit him too readily to a simple reflection on painting. The work indeed makes it possible to look again at one of the aspects of a multifaceted oeuvre in the light of critical approaches contemporary with his oeuvre.

Among these, one may find in *Net* a relationship with Post-Minimal and Conceptual concerns which, though seldom invoked in reference to Viallat's work, make plain the artist's immediate contemporaneity with the international avant-gardes of the time. — A. P. and B. B.

Jacques de la Villeglé
b. 1926

Jacques de la Villeglé was born March 27, 1926, in Quimper, France. He attended the Ecole des Beaux-Arts, Rennes, from 1944 to 1946, where he met Raymond Hains. From 1947 to 1949, Villeglé studied architecture at the Ecole Nationale Supérieure des Beaux-Arts, Nantes. He moved to Paris at the end of his studies and began an intense collaboration with Hains that continued into the 1950s.

Seeking to embody their fragmented vision, Villeglé and Hains experimented with compositions of torn publicity posters. Searching for an alternative to abstract art, they created their first décollage in 1949—it was a work made by appropriating ripped handbills from the street, and thus its composition resulted from the subtractive actions of others, in direct opposition to the intentional, constructive technique of collage. They defined their work with posters as a chance meeting with the countless persons who anonymously defaced the originals.

From 1950 to 1954, Villeglé and Hains worked on the color film *Pénélope*. Using single, double, or triple lenses of rippled glass, the artists manipulated and reorganized images according to their dominant colors and lines. This experience led to experiments with the effect of deforming glass lenses on regular typography. Distorting letters geometrically, they developed the idea of the ultimate alphabet that defied pronunciation, and used this new alphabet in their publication *Hépérile éclaté* (1953), which was extrapolated from a poem by Camille Bryen.

Villeglé and Hains had their first show together at the Galerie Colette Allendy, Paris, in 1957. In 1960, Villeglé and Hains signed the manifesto of the Nouveaux Réalistes with Arman, François Dufrêne, Yves Klein, Jacques Mahé, Martial Raysse, Daniel Spoerri, Jean Tinguely, and the critic Pierre Restany. Although many of the artists had shown their work together in the past, their

signing of this manifesto marked their rejection of traditional painting and their desire to collaborate more closely. Loosely organized, the artists worked together on a number of group actions and shows until 1964.

After 1961, although he continued to produce some poster pieces, Hains increasingly turned his attention to other avenues of expression and especially to word play. Villeglé, on the other hand, concentrated on the production of décollage works and has developed his own particular style using mainly printed posters. In an attempt to escape the traditional role of the artist and to avoid having the lacerated poster technique turn into a new academic style, he has assumed the position of sociological observer and attempted to systematize his technique. In 1977, his book *Le lacéré anonyme* was published, and his work was the subject of a ten-volume catalogue raisonné published in 1989, the same year that *Urbi et Orbi*, an anthology of his writings, was published. Villeglé lives and works in Paris.

Tapis Maillot, 1959 (cat. no. 295)

Unlike the great majority of Villeglé's works, whose titles are generally drawn from the street name identifying the place of collection, *Maillot Carpet* owes its appellation to a double circumstance. It was in February 1959 at Porte Maillot in Paris (on the site of today's Palais des Congrès) that these film posters were torn off the fences surrounding the former amusement park, a favorite site of the postwar imagination, where Raymond Queneau located the principal scenes of his novel *Pierrot, mon ami* (1945). The names of the cinemas can still be identified (Demours, Cinéac-Ternes, Royal-Maillot, Maillot, Windsor). The typography, which has taken on an "exploded" character due to the effects of superimposition and tearing, fits well with the line of research into illegible letters formalized by Villeglé and Hains with the publication of *Hépérile éclaté*.

During the soirées organized in June 1959 at the studio of François Dufrêne under the title *Lacéré anonyme* , Villeglé used this sequence of posters as a floor covering, along with another, subsequently divided sequence (which included *Triplé Maillot*). Cleaned and returned to its mural state, it has nonetheless kept the title of *Tapis*, evoking "the lockstitch of the *Paysan de Paris*, our suburban Gobelins, woven on the low-warp of the sidewalks at election time" and saluted, with pleasure, by Pierre Restany. — D. A.

Maurice de Vlaminck
1876–1958

Maurice de Vlaminck was born April 4, 1876, in Paris and was raised in Vesinet, France, by parents who were both musicians. After mediocre studies, he became, in turn, a racing cyclist, violin teacher and orchestra musician, and anarchist journalist. Beginning in 1896, he served in the military for three years.

After meeting André Derain, he decided to work together with him; in 1900, they shared a studio in Chatou. In 1901, Vlaminck settled in Rueil-Malmaison. Vlaminck approached painting as an autodidact; he often boasted later of never having taken a painting course in an academy or atelier, nor ever having visited a museum. Nevertheless, he owed his discovery of pure color to a visit to an exhibition devoted to Vincent van Gogh at the Galerie Bernheim Jeune, Paris, in 1901, which ceaselessly influenced him in his work. In 1902, the artist began to collect African statues, which were a second source of inspiration for his art.

His painting was shown for the first time in public in 1904, at Berthe Weill's in Paris. He participated in the Salon d'Automne and the Salon des Indépendants of 1905. In 1907, Ambroise Vollard, who had bought Vlaminck's entire studio, organized the artist's first solo show.

Vlaminck traveled to England in 1911, visiting London and Southampton, and then joined Derain in the south of France in 1913. In 1914, he moved to Côteau Saint-Michel, in Bougival, where he learned of the outbreak of World War I. He was drafted but managed to continue to paint throughout the war.

After his military service, Vlaminck settled in Oise, near Valmondois. In February of 1919, a large exhibition that assured his definitive recognition was organized at the Druet gallery, Paris. In 1920, Vlaminck acquired a house in Auvers-sur-Oise, the town in which van Gogh spent the end of his life and is buried. During this year, Vlaminck participated in the Salon des Artistes Indépendants in March and at the Salon d'Automne in October. In 1922, an exhibition of

his works was shown at the Brummer Galleries, New York. Three years later, Vlaminck settled definitively in Eure-et-Loir. He renewed a style more suited to his temperament: "What I wanted to paint was the object itself, with its weight, density, as if to represent the material itself with which it was made."

A retrospective of his works was presented in 1933 at the Bernheim Jeune gallery, Paris, followed by a retrospective organized at the Palais des Beaux-Arts, Brussels. During the course of the many exhibitions that took place at the end of his life, Vlaminck remained faithful to his style and executed a great number of watercolors, woodcuts, and lithographs, as well as writing novels, poems, and essays. He died in 1958 at Reuil-la-Garderlière, in Eure-et-Loir.

The Hills around Rueil (Les Coteaux de Rueil), 1906 (cat. no. 4)

The *Paris-Journal* reported in 1911: "Vlaminck's studio is the Chatou bridge. . . . Since he paints what he feels and not what he sees, a fisherman said to him one day, with obvious brutality: 'What happens to nature when you get hold of her?'" From that same studio came the view of Rueil-Malmaison shown in *The Hills around Rueil*. He spent the ten most important years of his artistic career in Rueil-Malmaison, working closely with Derain. It was in this decidedly gentle landscape on the outskirts of Paris that Vlaminck painted his most violently Fauvist canvases, without ever going to the south of France.

The Hills around Rueil dates a year after the decisive moment when Vlaminck was introduced to Henri Matisse and van Gogh's paintings, which were exhibited at the Salon des Indépendants in 1905. "I found in [van Gogh] certain of my own aspirations," wrote Vlaminck, "an almost religious feeling for the interpretation of nature." Thus, we may situate this typically Fauvist landscape under the sign of van Gogh for several reasons: the new, lyrical relationship between artist and nature, a rapport that is translated through a purely subjective system of color equivalences; the use of pure colors in relationships of harmony or of particularly violent disharmony (more violent in Vlaminck's painting than in that of other Fauves); the expression of distance, or what Pierre Francastel calls "the autonomous spatial quality of colors in their pure state," through color, as when, for example, blue imparts a sense of distance, while yellow seems nearby; and last, for the great freedom of the brushwork. — N. P.

Andy Warhol

1928–1987

Andrew Warhola was born August 6, 1928, in Pittsburgh. He received his B.F.A. from the Carnegie Institute of Technology, Pittsburgh, in 1949. That same year he came to New York, where he soon became successful as a commercial artist and illustrator. During the 1950s, Warhol's drawings were published in *Glamour* and other magazines and displayed in department stores; he became known for his illustrations of I. Miller shoes. In 1952, the Hugo Gallery in New York presented a show of Warhol's illustrations for Truman Capote's writings. He traveled in Europe and Asia in 1956.

By the early 1960s, Warhol began to paint comic-strip characters and images derived from advertisements; this work was characterized by repetition of banal subjects such as Coca-Cola bottles and soup cans. He also painted celebrities at this time. Warhol's new painting was exhibited for the first time in 1962: initially at the Ferus Gallery, Los Angeles, then in a solo exhibition at the Stable Gallery, New York. By 1963, he had substituted a silkscreen process for hand painting. Working with assistants, he produced series of disasters, flowers, cows, and portraits, as well as three-dimensional facsimile Brillo boxes and cartons of other well-known household products.

Starting in the mid-1960s, at The Factory, his New York studio, Warhol concentrated on making films that were marked by repetition and an emphasis on boredom. In the early 1970s, he began to paint again, returning to gestural brushwork, and produced monumental portraits of Mao Tse-tung, commissioned portraits, and the *Hammer and Sickle* series. He also became interested in writing: his autobiography, *The Philosophy of Andy Warhol (From A to B and Back Again)*, was published in 1975, and The Factory published *Interview* magazine. A major retrospective of Warhol's work organized by the Pasadena Art Museum in 1970 traveled in the United States and abroad. Warhol died February 22, 1987, in New York.

Orange Disaster, 1963 (cat. no. 305)

Warhol announced his disengagement from the process of aesthetic creation in 1963: "I think somebody should be able to do all my paintings for me," he told art critic G. R. Swenson. The Abstract Expressionists had seen the artist as a heroic figure, alone capable of imparting his poetic vision of the world through gestural abstraction. Warhol, like other Pop artists, used found printed images from newspapers, publicity stills, and advertisements as his subject matter; he adopted silkscreening, a technique of mass reproduction, as his medium. And, unlike the Abstract Expressionists, who searched for a spiritual pinnacle in their art, Warhol aligned himself with the signs of contemporary mass culture. His embrace of subjects traditionally considered debased—from celebrity worship to food labels—has been interpreted both as an exuberant affirmation of American culture and as a thoughtless espousal of the "low." The artist's perpetual examination of themes of death and disaster suggest yet another dimension to his art.

Warhol was preoccupied with news reports of violent death—suicides, car crashes, assassinations, and executions. In the early 1960s, he began to make paintings, such as *Orange Disaster*, with the serial application of images revolving around the theme of death. "When you see a gruesome picture over and over again," he commented, "it doesn't really have any effect." Yet *Orange Disaster*, with its electric chair repeated fifteen times, belies this statement. Warhol's painting speaks to the constant reiteration of tragedy in the media, and becomes, perhaps, an attempt to exorcise this image of death through repetition. However, it also emphasizes the pathos of the empty chair waiting for its next victim, the jarring orange only accentuating the horror of the isolated seat in a room with a sign blaring SILENCE.

Warhol's death and disaster pictures underscore the importance of the *vanitas* theme—that death will take us all—in his oeuvre. Warhol's *vanitas* imagery has a particularly American cast: he recorded American disasters, the consumption of American products (including movie stars), and, as art historian Sidra Stich has pointed out, American modes of death, such as execution by electrocution. —J. B.

Ten Lizes, 1963 (cat. no. 308)

Liz once, Liz twice, Liz three times, four times, ten times more. . . .

Liz with passion, *con brio*. Liz at once so *close* that we call her by her first name (as we do Marilyn or Marlene, whereas we say Garbo), and yet so *far away*—with something of the Mona Lisa.

Her multiplied image presses on the silvery surface and unfolds like the syncopated fragment of a cinematic image sequence against the frozen field of the painting. Warhol here uses his signature silkscreen process, to which the canvas grants a painterly aura. The reproduction leads back to the original, a back-and-forth movement between multiplicity and singularity. The motif uniformly repeats itself even though this time the framing and inking attenuates the mechanical coldness of the cut-out images: Liz "still moves," just as all the other subjects Warhol takes hold of also move and vacillate, those stars of cinema and the mass media and the gossip pages of the most "with-it" magazines. In his quest for a dry art, Warhol often constructs a trembling narrative, as if in spite of himself. To mark his distance from the gestural heroism of the Abstract Expressionists, he favors mechanized procedure over the cult of the agile hand. His images are produced and reproduced in the manner of advanced consumerism, yet the mere act of manipulating the subject redeems them and grants them the dignity of painting. We will never really know whether Warhol's intention was to trivialize painting or to save his subjects from the vulgarity of mass distribution to which they were abandoned. Quite possibly his plan lay somewhere between the two. "Most Famous" as well as "Most Wanted": the image of the prisoner echoes thus the prisoner of the image.

"Sly eyewitness" of the society of spectacle whose morbid fascination with that world is in so many ways betrayed in his work, Warhol himself remains the cynical, lucid product of an America that his work reflects and he himself adores. —B. B.

Lawrence Weiner

b. 1942

Lawrence Weiner, one of the central figures of Conceptual Art, was born February 10, 1942, in the Bronx, New York. Upon graduating from high school, Weiner worked in a variety of jobs—on an oil tanker, on the docks, and unloading railroad cars. He traveled throughout North America before returning to New York, where he exhibited at Seth Siegelaub's gallery in 1964 and 1965. Weiner's early work included experiments with systematic approaches to shaped canvases and, later, cutting out squares of material from carpeting or walls.

A turning point in Weiner's approach came in 1968, when he created a work for an outdoor exhibition organized by Siegelaub at Windham College in Putney, Vermont. As his contribution to the exhibition, Weiner proposed to define the space

for his work with rather unobtrusive means: *A SERIES OF STAKES SET IN THE GROUND AT REGULAR INTERVALS TO FORM A RECTANGLE—TWINE STRUNG FROM STAKE TO STAKE TO DEMARK A GRID—A RECTANGLE REMOVED FROM THIS RECTANGLE.* When students cut down the twine because it hampered their access across the campus lawn, Weiner realized that his piece could have been even less obtrusive: viewers could have experienced the same effect Weiner desired simply by reading a verbal description of the work. Not long after this, Weiner turned to language as the primary vehicle for his work, concluding in 1968 that:

"1. The artist may construct the piece.
"2. The piece may be fabricated.
"3. The piece may not be built.
[Each being equal and consistent with the intent of the artist, the decision as to condition rests with the receiver upon the occasion of receivership.]"

Like other Conceptual artists who gained international recognition in the late 1960s and early 1970s, Weiner has investigated forms of display and distribution that challenge traditional assumptions about the nature of the art object. As the sole contribution to a presentation organized by Siegelaub in 1968, Weiner created a small book entitled *Statements*; since the work consisted of nothing but words, there was no reason to display a physical object. That same year Weiner also contributed pages to Siegelaub's "Xeroxbook," a compendium of photocopies by seven Conceptually oriented artists.

The wall installations that have been a primary medium for Weiner since the 1970s consist solely of words in a nondescript lettering painted on the wall. The lettering need not be done by the artist himself, as long as the sign painter complies with the instructions dictated by the artist. Although this body of work focuses on the potential for language to serve as an art form, the subjects of his epigrammatic statements are often materials, or a physical action or process, as exemplified by such works as *ONE QUART GREEN EXTERIOR INDUSTRIAL ENAMEL THROWN ON A BRICK WALL* (1968) or *EARTH TO EARTH ASHES TO ASHES DUST TO DUST* (1970). Other times the subject involves a translation from one language to another or an encounter with a national boundary, as in *THE JOINING OF FRANCE GERMANY AND SWITZERLAND BY ROPE* (1969). In the succeeding decades, Weiner explored the interaction of punctuation, shapes, and color to serve as inflections of meaning for his texts. In 1997, he created *Homeport*, an interactive environment for the contemporary art web site, äda'web, in which visitors can explore a space defined by linguistic rather than geographic features.

Recent solo exhibitions of the artist's work have been mounted at the Hirshhorn Museum and Sculpture Garden, Washington, D.C. (1990), the Institute of Contemporary Arts, London (1991), the Dia Center for the Arts, New York (1991), the Musée d'art contemporain, Bordeaux (1991 and 1992), the San Francisco Museum of Modern Art (1992), the Walker Art Center, Minneapolis (1994), the Philadelphia Museum of Art (1994), and the Museum Ludwig, Cologne (1995). In addition to publishing numerous books, Weiner has produced various films and videos, including *Beached* (1970), *Do You Believe in Water?* (1976), and *Plowman's Lunch* (1982). Weiner lives in New York and Amsterdam.

Cat. #029 (1969) THE RESIDUE OF A FLARE IGNITED UPON A BOUNDARY, 1969 (cat. no. 341)

Weiner was one of a group of artists working in the mid-1960s and 1970s who began using language as material and subject matter and began prioritizing ideas over the physical object. Termed Conceptual Art or Idea Art, this classification encompassed a variety of different approaches to artmaking though all shared a certain rejection of the traditional, "bourgeois" values of the art world including norms of authorship and ownership. The art object as commodity was treated as suspect and much of the work made was ephemeral or produced no object to be sold. Weiner has called himself a Marxist and, in this light, we can interpret Weiner's works as "owned" by every viewer who creates in their own mind a subjective imagining of the situation or process described by Weiner's words. For the artist, language is and functions as what it represents, but, unlike an actual construction, a linguistic work is open to each viewer's differing conception of, for example, what the residue of a flare looks like, or on which boundary it was ignited. As this particular work has actually been realized in the physical materials described—in 1969, the artist set off a flare on the boundary between Amsterdam and Amstelreem—it exemplifies how Weiner's works exist as both fact and possibility.

Over the years, Weiner's works have become more abstract and more difficult to realize outside of his written formulations, which often refer to circumstances or forces acting upon an unnamed object. Most of his works, however, deal with how materials (even if anonymous) may be manipulated, and depend on the viewer's knowledge of certain physical concepts. While his works imply action, Wiener is not overly concerned with process. He has characterized his work as more akin to "the traces of what an artist does." — S. C.

Wols
1913–1951

Wols was born Alfred Otto Wolfgang Schulze on May 27, 1913, in Berlin. In 1919, the family moved to Dresden, where he developed his considerable talent in music. During a visit to Berlin in 1932 Wols met László Moholy-Nagy, on whose advice he settled in Paris. There he supported himself as a photographer and became acquainted with Jean Arp, Alberto Giacometti, Fernand Léger, and Amédée Ozenfant. After moving to Spain in 1933, he was ordered back to Germany for labor service; his refusal to return resulted in lifelong expatriation. Wols was imprisoned in Barcelona in 1935 for his controversial political attitudes. Upon his release several months later, he was sent back to France.

In 1937, Wols was an official photographer at the *Exposition internationale* in Paris. The same year, he exhibited his photographs at a small Parisian gallery. This success was immediately followed by the outbreak of World War II and his internment in several French camps. When Wols was freed in 1940, he settled in the coastal town of Cassis. As the fighting drew nearer in 1942, he fled inland to Dieulefit, where he befriended the poet Henri-Pierre Roché. In 1945, Roché brought Wols's work to the attention of René Drouin, who gave him a solo exhibition at his gallery later that year. Wols visited Paris for the exhibition and remained there, becoming friends with the painters Camille Bryen and Georges Mathieu. In 1947, he exhibited his first large paintings in a second solo exhibition at the Galerie René Drouin and received praise from Jean-Paul Sartre. That same year he participated in the Salon des Réalités Nouvelles and illustrated books by Antonin Artaud, Franz Kafka, and Sartre. The artist's dependency on alcohol, which apparently developed in the internment camps, became so severe that he underwent treatment in 1951. Afterward, Wols moved to Champigny, in the country near Paris. In 1951, he was given a solo exhibition at the Galerie Nina Dausset in Paris. Wols died September 1, 1951, in Champigny-sur-Marne.

Blue Pomegranate (Grenade bleue), 1946
(cat. no. 251)

After creating thousands of small drawings and watercolors, Wols came back to Paris after the Liberation and began to paint in oil, perhaps at the prompting of his dealer René Drouin. Prior to this, he had never worked on canvas before, for he had found "the gymnastics that it requires of the arms and forearms" to be too demanding. Thus around 1946, in a creative frenzy, nearly one hundred fifty paintings came into being, about forty of which (including this canvas, acquired by the writer and critic Jean Paulhan), were presented at the Galerie René Drouin in 1947. Artaud, Giacometti, Sartre, and others immediately figured among the most ardent defenders of his work.

Although Wols was still using what he called the "eyes closed" creative method, the atmosphere of his works had changed: the dream world of the watercolors vanished, giving way to a more tragic vision, and the general tonality became more subdued, despite occasional points of bright red similar to spots of blood, and harder, blacker, more combustible lines, as in this *Blue Pomegranate* (the title is probably posthumous, since Wols, according to his friends, refused all *a priori* interpretation of his work). Bryen, who together with Wols took part in the *HMPSMTB* exhibition organized by Mathieu in 1948, recalled: "He painted with anger and disgust, as if fighting with the devil, at times using a paintbrush, more often resorting to splattering and rubbing with a crumpled rag soaked in turpentine, using streaks of paint straight from the tube." In this hand-to-hand combat with the material of painting, the blotted, exploded, scratched surface is transformed, as his most fervent critic Werner Haftmann writes, into a "membrane of resonance for all of life's movements, all of life's impulses." Wols's approach attracted many followers in the 1950s and 1960s. Yet the quarrels from those years over lyrical, gestural, or informal abstraction mattered little to Wols; what he was seeking more than anything was to share his convictions. As he said in one of his marvelous and humorous aphorisms, "A crack in the sidewalk is more important than Mont Blanc, and man inferior to a bee." The *Blue Pomegranate*, despite its small size, gives a similar impression of magnitude and cosmic mystery. — Cl. S.

Gilberto Zorio

b. 1944

Gilberto Zorio was born September 21, 1944, in Andomo Micca, Italy. He entered Turin's Accademia di Belle Arti in 1963 to study painting. However, he soon moved on to sculpture and had his first solo show of three-dimensional works in 1967 at the Galleria Sperone, Turin. Associated with the revolutionary Arte Povera movement, Zorio exhibited in a number of the defining group shows of Arte Povera in 1967 and 1968. He was included in a group exhibition, *Nine Young Artists: Theodoron Awards*, at the Solomon R. Guggenheim Museum, New York, in 1969. Around this time, Zorio embarked upon a series dealing with language, *To Purify Words (Per purificare le parole)*, a theme he would investigate through the early 1980s. In 1970, Zorio graduated from the Accademia and, in 1971, he began teaching at the Liceo Artistico, Turin.

Zorio's work emphasizes process and alchemy, exploring transformative natural phenomena like evaporation or oxidation and the effects wrought upon materials by these chemical interventions. He has always been preoccupied with the idea of energy. This focus led him to examine the properties of electricity, incorporating a lamp or incandescent tubes in some pieces. In other works, he adopted star and javelin forms—both archetypal constructs intimating energy. Zorio frequently employs fragile materials in his sculpture, creating giant stars from terra-cotta or perching Pyrex alembics containing liquid solutions upon slender steel javelins. He tends to suspend or balance these components in purposely precarious installations, suggesting the tensions and transience of the physical realm.

In 1976, the Kunstmuseum Lucerne already recognized Zorio with a significant exhibition. A mid-career retrospective of the artist's work followed at the Stedelijk Museum, Amsterdam, in 1979. A monograph on Zorio was published in Italian in 1982. By 1984, he had started another series utilizing a primeval form, that of the canoe, which he made from assorted materials such as pitch or steel. The canoe, along with the star and javelin, became a recurrent motif in Zorio's oeuvre. In 1985, the Württembergischer Kunstverein in Stuttgart organized a major retrospective, which traveled in 1986 to the Musée national d'art moderne, Paris; the Centre d'art contemporain, Geneva; and the Stedelijk Van Abbemuseum, Eindhoven. In 1992, an exhibition took place at the Centro per l'Arte Contemporanea Luigi Pecci, Prato. Zorio lives and works in Turin.

To Purify Words (Per purificare le parole), 1969
(cat. no. 329)

To Purify Words is the generic title Zorio began using in 1969 for works made of a broad range of materials: terra-cotta, leather, glass, etc. The title always designates a circulation and exchange, in a real as well as a metaphorical sense, between the potential viewer/actor and the work, which presents the opening of a receptacle filled with alcohol. The "word" (*parola*) of man running through the work is purified by the alcohol and thus "fulfilled." *To Purify Words* induces an obligatory, inescapable reaction between the work itself and the person who becomes an integral part of the work, experiences it, and in so doing reveals its meaning.

The distinct form of this relatively early work differs from many of the characteristic pieces that make up Zorio's vocabulary from the late 1960s; it marks, nonetheless, an essential step in the series, with its twofold signification, which is both mental and physical. Zorio's earliest works, dating from 1967–69, consisted of strange objects resulting from completed or still-ongoing actions that brought physical forces and chemical reactions into play. The works that Zorio presented at the celebrated 1969 exhibition entitled *Live in Your Head: When Attitudes Become Form*, organized by Harald Szeemann for the Kunsthalle Bern, however, seem like pure process: such as *Torcia* (1969), in which flaming torches are suspended above the ground and then fall when the fire consuming them reaches the rope, causing the collapse and destruction of the work; or this *To Purify Words*, reduced to a structure that supports a tube in which the alcohol is supposed to mix with the words coming out of one's mouth.

To Purify Words reminds us just how vague and indeterminate the notions prevalent during that time, of "Process Art," "Anti-Form," and "Post-Minimalism," really are; by their very nature these procedures elude all classification. By 1966, Zorio was already part of a fluid international milieu, when he was included in the *Nine at Castelli* show in New York, along with another Italian, Giovanni Anselmo, reminding us, lest we deliberately forget, that the intellectual debate of that time had not yet taken on the imperialistic and at times anti-historical cast that it would assume in subsequent years. — B. B.

Index of Catalogue Reproductions

Photo Credits